Webb, Leland. "The Runaways." *Playboy Magazine*, vol. 7,
 no. 6 (June 1960), pp. 1, 26–27.

Weck, Alyce. "Months of Hard Work Preface Smooth-Running
 Salon of Art," *Capital Times* (Madison, WI),
 November 17, 1961.

"The Week in Indiana Art." *Indianapolis Star*, June 25, 1961,
 sec. 8, p. 5.

"The Week in Indiana Art." *Indianapolis Star*, October 16, 1961.

WFMT Chicago Fine Arts Guide (January 1961), cover, pp. 4,
 13–14, 21, 27, 31, 33, 38, 43, 45–46, 48, 50, 55, 57–58, 67, 74.

"Win Prizes for Art Work." *Chicago Tribune*, 1951.

"Xylon." *Neue Züricher Zeitung* (Zurich), February 22, 1956,
 pp. 1–2.

"Xylon." *Volksrecht* (Zurich), March 3, 1956, p. 53.

Zacarias, Martha. "Prof One of Best in his Art." *Pioneer*
 (California State University-Hayward), April 16, 1985, p. 5.

"191 Grants Totaling $860,000 Awarded by Guggenheim Fund." *New York Herald Tribune*, April 21, 1952, pp. 8, 24.

"191 to Get Grants from Guggenheim." *New York Times*, April 21, 1952, p. 12.

"Other Books of the Week." *New York Times Book Review*, February 14, 1954, p. 31.

Parsons, Barbara Galuszka. "'I Can't Go On; I'll Go On:' A Conversation with Misch Kohn." *California Printmaker*, no. 1 (Winter 1993), cover, pp. 6–10.

Patterson, Connie. "Kokomo Was Important to Misch Kohn's Development." *Kokomo Tribune*, March 29, 1987, p. C11.

Payne, Robert. "Tiger in the Pass." *New York Times*, March 4, 1956.

"People and Events." *Chicago Tribune*, February 20, 1965.

"People Make the News." *News-Clarion* (Chicago), April 10, 1965, p. 3.

Philbrick, Richard. "Chicagoan Wins Art Grants." *Chicago Tribune*(?), 1959.

Porter, Bob. "Art: Artist-Teacher Misch Kohn; A Busy, Articulate Visitor." *Dallas Times Herald*, January 10, 1964, sec. I, p. 13.

Portner, Leslie Judd. "Art in Washington." *Washington Post and Times Herald*, October 12, 1958, p. E7.

Preston, Stuart. "American Graphic Art." *New York Times*, July 8, 1951, p. 2.

———. "Art: U.S.I.A. Prepares a Print Show." *New York Times*, February 22, 1964, p. 17.

———. "Heralds of the Season." *New York Times*, September 11, 1949, sec. II, p. 6.

"Preview of Print Gallery." *Chicago Sun-Times*, November 12, 1959, sec. 2, p. 11.

"Printmaker Exhibition Starts in SF." *Palo Alto Times* (CA), March 31, 1962, p. 9.

"Printmaker's Art." *New York Times Magazine*, April 29, 1958, pp. 28–29.

"Prints." *December*, vol. III, no. 3 (Summer 1961), front and back covers, pp. 33–36.

"Professor Kohn Receives Honor." *Chicago Tribune*, 1961.

"Professors at Work." *Illinois Institute of Technology Reports* (December 1965), p. 4.

"A Proper Setting for the Artist." *Brightside*, June 2, 1974, p. 11.

"Quickie Exhibit." *The Dallas Morning News*, January 11, 1964, sec. I, p. 13.

"Reception Today Marks Opening of Art Museum." *Journal-Gazette* (Ft. Wayne, IN), September 17, 1961, p. 10A.

Robb, Marilyn. "Past and Future Prints." *ARTnews*, vol. 48, no. 10 (February 1950), p. 53.

Roster, Laila. "Printmaking on the Rise." *Sunday Star-Bulletin and Advertiser* (Honolulu), October 19, 1975, p. C11.

Rotzler, Willy. "Xylon." *Graphis* (Zurich), vol. 12, no. 65 (May–June 1956), pp. 256–262, 268, 273.

"Segunda Bienal Interamericana de Mexico." *Artes de Mexico*, vol. 6, no. 34 (1961), p. 17.

Seldis, Henry J. "Printmaker Kohn Impresses." *Los Angeles Times*, January 26, 1962, part II, p. 2.

Selz, Peter. "How To Look at a Picture." *University of Chicago Home Study Course* (Chicago: University of Chicago Press), frontispiece.

———. "Three Dimensional Wood Engravings: The Work of Misch Kohn." *Print Magazine*, vol. VII, no. 5 (November 1952), pp. 37–44.

"Show to Honor Misch Kohn." *Kokomo Tribune*, October 8, 1987, p. 7.

"Sophistication and Purity!" *Hannoversche Presse* (Hannover), February 19, 1963.

Stone, Dennis. "Toward the Third Dimension." *Art Scene*, March 1968, p. 13.

Stuttgarter Zeitung (Stuttgart), December 15, 1962.

Süddeutsche Zeitung (Munich), June 24, 1963.

"Tamarind: An Anniversary Album, 1960–1980." *The Tamarind Papers*, vol. IV, no. 1 (Winter 1980–81), p. 8.

"Teachers Plan." *Kokomo Tribune*, March 29, 1966, p. 16.

Temko, Allan. "Printmaking: Where Image, Process Are One." *San Francisco Chronicle*, November 19, 1981, p. 72.

Tillim, Sidney. "In the Galleries." *Arts Magazine*, vol. 34, no. 2 (November 1959), p. 60.

———. "Misch Kohn." *Arts Magazine*, vol. 38, no. 2 (November 1963), p. 36.

"U.S. Buys Etchings by Chicagoan." *Chicago Daily News*, October 31, 1963, p. 29.

von Groschwitz, Gustave. "American Prints: A New Phase." *Cincinnati Museum Bulletin*, vol. 7, no. 1 (January 1962), pp. 26–27.

———. "American Prints Today." *Studio*, vol. 158 (October 1959), pp. 65–69.

Joray, Charles N. and James Ong. "Kohn's Work Known Around the World." *Kokomo Magazine* (1990), p. 17.

Karshan, Donald H. "American Printmaking, 1670–1968." *Art in America*, vol. 56, no. 4 (July–August 1968), pp. 22–55.

Kennelly, Martha. "Cal State Bids Goodbye to Art Prof Misch Kohn." *Daily Review* (Hayward, CA), March 31, 1986, p. 12.

Key, Donald. "Misch Kohn's Graphics Shown at Jewish Center." *Milwaukee Journal*, March 4, 1962.

"Kohn Exhibit Opens at Art Museum." *News-Sentinel* (Ft. Wayne, IN), September 14, 1961, p. 24.

"Kohn Is Named Assistant Professor at Tech School." *Southeast Economist*, c. August 16, 1951, p. 2.

"Kohn Is Selected Second Time for Foundation Grant." *Kokomo Tribune*, 1953, p. 14.

"Kohn Wood-Engraving Exhibition on Display." *Los Angeles Times*, November 18, 1957, part III, p. 8.

"Kokomo Artist Begins Guggenheim Study." *Indianapolis News*, July 5, 1952.

Kuhns, Kay C. "Misch Kohn Revisits Boyhood Haunts Here, Discusses Future." *Kokomo Tribune*, December 5, 1960, p. 1.

———. "10 Years of Prints by Kokomo's Misch Kohn Being Viewed in NY." *Kokomo Tribune*, November 1, 1959, p. 16.

La Farge, Henry A. "Four American Printmakers in Joint Show." *ARTnews*, vol. 55, no. 2 (April 1956), p. 82.

Levin, Kim. "Misch Kohn." *ARTnews*, vol. 62, no. 7 (November 1963), p. 52.

Lewalter, Christian E. "Die Ganze Richtung Passt Ihm Nicht." *Die Zeit* (Hamburg), November 24, 1955, p. 4.

Lewis, Jo Ann. "At the Galleries." *Washington Star-News*, May 18, 1974, p. B6.

Lewis, Virginia. "Close to the Artist." *Carnegie Magazine*, vol. XXIV (December 1950).

Lieberman, William S. "Printmaking and the American Woodcut Today." *Perspectives USA*, no. 12 (Summer 1955), pp. 55–8.

Lichtblau, Charlotte. "175 Prints Shown at Modern Museum." *Philadelphia Inquirer*.

Loach, Roberta. "Joe Zirker-Misch Kohn." *Visual Dialog*, vol. 2, no. 1 (September–October–November 1976), p. 29.

———. "Misch Kohn." *Visual Dialog*, vol. 3, no. 3 (March–April–May 1978), pp. 9–12.

"Local Artist Alters Stance on Show Boycott." *Hyde Park Herald* (Chicago), June 17, 1970, p. 13.

"Local Man Promoted at IIT; Is Noted Artist and Designer." *Woodlawn Booster* (Chicago), August 15, 1951, p. 1.

Longren, Lillian. "Reviews and Previews." *ARTnews*, vol. 58, no. 6 (October 1959), p. 15.

Louchheim, Aline B. "New Group to Promote Graphic Art." *New York Times*, September 14, 1952, p. 10X.

Martin, Lawrence. "'Pursuit of Freedom' tells Long Battle for Civil Liberties." *Chicago Tribune*(?)

McNulty, Kneeland. "A Decade of American Printmaking." *Philadelphia Museum of Art Bulletin*, vol. 48, no. 235 (Autumn 1952), pp. 9, 13.

"Misch Kohn Art." *This Week in Chicago*, vol. 63, no. 18 (November 24, 1951), p. 16.

"Misch Kohn Brings One-man Show to Festival." *Fine Arts Festival* (Kokomo, IN: 1966).

"Misch Kohn Exhibition to Open at Wabash." *Indianapolis Star*, March 12, 1961.

"Misch Kohn Helps Overcome Chicago's Second-City Stigma." *Chicago Daily News*(?), January 26, 1969.

"Misch Kohn Is Showing Art Work." *Kokomo Tribune*, October 26, 1951.

"Misch Kohn Prints Through June 7 at Brooklyn Museum." *Antiques and Art Weekly*, May 22, 1981.

"Misch Kohn to Show Wood Engraving." *Art Alliance Bulletin* (Philadelphia), vol. 32 (March 1954), p. 5.

"'Misch' Kohn Wins Honor for Engraving." *Kokomo Tribune*, c. November 1949.

"Misch Kohn's Works on Exhibit at Ball State." *Kokomo Tribune*, August 14, 1962, second ed. p. 9.

Morehouse, Lucille E. *Indianapolis Star*, November, 1943.

———. *Indianapolis Star*, November 6, 1949.

"New, Old Artists Featured in U, BYU Shows." *Salt Lake Tribune*, March 26, 1972.

"New York Critic Praises Art Work of Former Kokomoan." *Kokomo Tribune*, March, 1955.

"New York: The Taste Shaper." *Look*, vol. 22, no. 4 (February 18, 1958), p. 50.

"1994 Distinguished Artist Misch Kohn." *California Printmaker*, no. 2 (June 1994), cover, pp. 10–14.

"Northwest Printmakers Star the Experimental." *Art Digest*, vol. 24 (March 15, 1950), p. 22.

2nd Fellowship." *North Town News* (Chicago), October 13, 1954. [Reproduced from *Edgewater Uptown News* (Chicago), October 12, 1954, p. 3.]

Fittipaldi, Tom. "Rock in Today's Church." *Music Ministry*, vol. 8, no. 1 (September 1975), p. 4.

"Florentine Academy Honors ID Professor." *Illinois Institute of Technology Reports*, vol. 4, no. 4 (April 1965), p. 4.

Ford, Ken. "Kohn Reception Draws Family, Friends." *Kokomo Tribune*, May 10, 1991, pp. 1, 11.

———. "Misch Kohn Still Making Waves as Graphic Artist." *Kokomo Tribune*, October 11, 1987, p. 37.

Foreign Services Journal (January 1960).

"Former City Resident's Engravings Receive Enthusiastic Reception in West Coast Museum." *Kokomo Tribune*, December 8, 1957, p. 12.

Freemantle, Christopher E. "New York Commentary." *Studio*, vol. 148, no. 741 (December 1954), p. 189.

"French Wins 2 Awards in Herron's Print Show." *Indianapolis Star*, May 13, 1956, sec. 7, p. 6.

Fried, Alexander. "A Quintet of Choice Exhibits." *San Francisco Examiner*, April 8, 1962, p. 9.

Friedlander, Alberta. "Fascinating Print Exhibit." *Chicago Daily News*, January 28, 1961.

"The Front Cover." *Chicago Sunday Tribune Magazine of Books*, June 29, 1947, part 4, cover, p. 8.

Garmel, Marion. "Treasure Trove from Kokomo on Display at University Gallery." *Indianapolis News*, January 17, 1991, p. F12.

Genauer, Emily. "Art and Artists: Prints on Parade as Season Opens." *Herald Tribune Book Review*, September 19, 1954.

Golden, Harry. *Playboy Magazine* (December 1966), p. 172.

"Gost iz Sjedinjenih Država." *Večernji List* (Zagreb), February 8, 1964.

Grafly, Dorothy. "Artists from 19 States Show Work in Print Fair." *Sunday Bulletin* (Philadelphia), January 17, 1960, p. 8.

———. "Prints in Philadelphia." *Christian Science Monitor*, February 19, 1955.

"Graphic Arts." *Tiger's Eye*, vol. 1 (June 1949), p. 20.

"Graphics." *New York Times*, September 11, 1949.

Gray, Cleve. "Print Review: Looking for a Gift?" *Art in America*, vol. 51, no. 6 (December 1963), p. 50.

———. "Tamarind Workshop." *Art in America*, vol. 51, no. 5 (October 1963), p. 99.

Gregor, Katherine. "The Knowing Hand." *Artweek*, vol. 19, no. 19 (May 14, 1988), p. 5.

Guest-Mckellar, Alice. "Collecting Hoosier Art Is a Tradition." *Kokomo Magazine* (1990), cover, pp. 16–18.

Haas, Irvin. "The Print Collector." *ARTnews*, vol. 54, no. 1 (March 1955), p. 11.

Haslem, Jane. "Misch Kohn: Combined Technique Prints." *Jane Haslem Gallery Newsletter* (September–October–November 1986), cover.

———. "Misch Kohn: Recent Prints." *Jane Haslem Gallery Newsletter* (November 1976).

Haydon, Harold. "Innovation, Mastery in Kohn Prints." *Chicago Sun-Times*, February 20, 1966, sec. 4, p. 9.

———. "The Artist." *Chicago Magazine* (Winter 1968), pp. 102–108.

Holland, Frank. "American Prints Open Institute's Transformed Gallery." *Chicago Sun-Times*, November 22, 1959, sec. 3, p. 13.

———. "Art." *Chicago Sun-Times*, June 1, 1952.

"Honors for Kohn." *Daily Review* (Hayward, CA), February 25, 1994, p. CUE-8.

Hopkins, Marilyn. "Printmaking in Chicago." *Saver* (Winter 1971), cover, pp. 15–18.

"I.I.T. Artists Get Grants to Aid Work." *Chicago Tribune*, c. 1960.

"IIT Professors Teach Abroad." *Illinois Institute of Technology Reports* (c. Spring 1965).

"In Art Circles." *Cincinnati Enquirer*, January 22, 1961, sec. D, p. 6.

"Indiana's First Biennial," *Art Digest*, vol. 26, no. 17 (June 1, 1952), pp. 11–12.

Indianapolis Star, May 13, 1956.

Indianapolis Times, September 30, 1951.

"Italian Academy Confers Honor on Misch Kohn." *Kokomo Tribune*, March 9, 1965, p. 2.

Itami, Michi. "Misch Kohn." *Printmaking Today*, vol. 3, no. 2 (Summer 1994), cover, pp. 10–11.

Johnson, Una E. "The Brooklyn Museum National Print Annual, 1955." *Brooklyn Museum Bulletin*, vol. 16 (Spring 1955), p. 9.

———. "New Expressions in Fine Printmaking." *Brooklyn Museum Bulletin*, vol. 14, no. 1 (Fall 1952), pp. 6–7, 30.

"Assemble Kohn Etchings for Display in 40 Museums During Next Two Years." *Kokomo Tribune*, November 6, 1960, p. 2.

"Awards Are Made in Two Art Shows." *New York Times*, October 30, 1949, p. 71.

Baker, Kenneth. "A Life's Work of Puzzles and Master Printmaking." *San Francisco Chronicle*, May 18, 1988, p. E3.

Bassin, A. "Dva Grafika." *Naši Rasgledi* (Ljubljana), November 23, 1963.

Bedno, Jane. "The Demand for Graphics." *Hyde Park-Kenwood Voices* (Chicago), November 1969, p. 7.

Benson, Gertrude. "Rosenwald Collection of Engravings after Watteau Are Given to Museum." *Philadelphia Inquirer*, April 4, 1954, p. 10C.

"Blue Rebozo." *Indianapolis Star*, July 2, 1961.

Bradbury, Ray. "Remembrances of Things Future." *Playboy Magazine* (January 1965), p. 99.

Brooke, Rebecca. "Kokomo's Kohn." *Indiana Alumni* (March–April 1993), pp. 30–31.

"Bull Fight." *Indianapolis Star*, March 28, 1954, p. 12.

Burrey, Suzanne. "Exhibition of Wood Engraving at Weyhe Gallery." *Arts Digest*, vol. 29, no. 11 (March 1, 1955), p. 25.

Butler, Henry. "Nationally Known Artists Exhibit Prints at Herron Alumni Show." *Indianapolis Times*, c. 1952.

Campbell, Lawrence. "Exhibition of Wood Engraving at Weyhe Gallery." *ARTnews*, vol. 54, no. 1 (March 1955), p. 50.

Canaday, John. "American Prints." *New York Times*, September 20, 1959, p. 17.

———. "A Quiet Market." *New York Times*, February 28, 1960, sec. II, p. 13.

———. "Obscure But Exemplary." *New York Times*, July 22, 1962, p. X15.

"Carving a Career." *Indianapolis Star Magazine*, September 11, 1955, p. 44.

Chanin, A.L. "The World of Art: Two Museum Exhibits Which Explore the American Print." *Compass* (New York), September 21, 1952, p. 24.

"Chicago Art Institute Exhibition of Prints and Drawings." *Pictures on Exhibit*, vol. 14 (November 1951), pp. 58–9.

Chicago Sunday Tribune, March 30, 1941.

Chronicle, February 1953.

Cincinnati Enquirer, January 29, 1961, sec. C, p. 10.

Congress Weekly, April 4, 1955.

Conrad, Barnaby. "The Art of Tauromachy." *Glamour* (August 1952), p. 125.

Conroy, Jack. *New Anvil*, vol. 1, no. 7 (July–August 1940), inside front cover.

Courier-Times (Newcastle, IN), September 15, 1962.

Coyne, Jean A. "Beyond Illustration: The Art of Playboy." *Communication Arts*, vol. 13, no. 6 (November–December 1972), p. 39.

December, vol. IV, no. 1 (Winter 1963), pp. 175–176.

Depolo, J. "Suvremeni Koncept." *Vjesnik* (Zagreb), December 12, 1963.

Descargues, Pierre. "Le Salon de Mai." *Le Monde* (Paris), May, 1953, p. 8.

Devree, Howard. "American Round-Up: Contemporary Work at the Whitney and National Academy." *New York Times*, November 18, 1956, p. 16X.

———. "Misch Kohn and Kaethe Kollwitz Prints Feature Week's Graphic Art Shows." *New York Times*, March 12, 1955, p. 10.

———. "Personal Collection." *New York Times*, June 29, 1952, p. X7.

———. "Print Harvest." *New York Times*, May 1, 1955.

"Display Work of Lithographers." *Chicago Tribune*, February 24, 1963, sec. 5, p. 7.

"Distinguished Young Local Artist Given Grant." *Kokomo Tribune*, June 28, 1952. p. 12.

"Doctorate to be Presented." *Kokomo Tribune*, May 5, 1991, p. 2.

Donohoe, Victoria. "Art News." *Philadelphia Inquirer*, November 4, 1962.

Drummond, Dorothy. "Coast to Coast." *Art Digest*, vol. 27 (November 15, 1952), p. 11.

Duemling, Hertha Stein. "Modern, Old Graphic Art on Exhibit." *News-Sentinel* (Ft. Wayne, IN), December 8, 1951.

Elkoff, Marvin. "Collecting Original Art Prints." *Holiday*, vol. 39, no. 2 (February 1966), pp. 102, 104.

"Examination." *Los Angeles Times*, July 20, 1961, part 3, p. 1.

"Exhibit of Misch Kohn's Work Closes at Institute." *Kokomo Tribune*, July 31, 1961, p. 6.

"Exhibit Opens at Art Museum." *Post and Times-Star* (Cincinnati), January 27, 1961, p. 31.

"Ex-Hoosier Artist Wins Fellowship." *Indianapolis Star*, April 28, 1952.

"Experiments with Wood Engraving Color: Artist Receives

Wick, Peter A. *Modern Prints*. Boston: Museum of Fine Arts, 1955.

World Print Competition 77. San Francisco: San Francisco Museum of Modern Art/California College of Arts and Crafts, 1977.

WPA Artwork in Non-Federal Repositories. Washington, DC: U.S. General Services Administration, 1996.

WPA/FAP Graphics. Washington, DC: Smithsonian Institution Traveling Exhibition Service, 1976.

XILON: Esposizione Internazionale di Xilografia. Zurich: Ente Civico pro Portogruaro, 1957.

XYLON 1956: Mednarodna Razstava Lesorezov. Ljubljana: Moderna Galerija, 1956.

Xylon: Mednarodna Razstava Lesoreza. Ljubljana: Mestna Galerija, 1966.

Yochim, Louise Dunn. *Harvest of Freedom*. Chicago: American References, 1989.

Yood. James. *Second Sight: Printmaking in Chicago 1935–1995*. Evanston, IL: Mary and Leigh Block Gallery, Northwestern University, 1996.

Zeventiende Salon de Mai. Amsterdam: Stedelijk Museum, 1961.

Zigrosser, Carl. *Amerikansk Grafik*. Stockholm: Riksförbundet för bildende kunst, 1953.

———. *The Appeal of Prints*. Kennet Square, PA: Leary's Book Co., 1970.

———. *Between Two Wars: Prints by American Artists 1914–1941*. New York: Whitney Museum of American Art, 1941.

———. *The Book of Fine Prints*. New York: Crown Publishers, 1958. [Reissued New York: Crown Publishers, 1983.]

———. *Kohn*. Ljubljana: Mala Galerija, 1963.

———. *Misch Kohn*. Klagenfurt, Austria: Galerie 61, 1963.

———. *Misch Kohn*. New York: American Federation of Arts, 1961.

———. *Prints and Their Creators: A World History*. New York: Crown Publishers, 1974.

———. *Prints: Misch Kohn 1949–1959*. New York: Weyhe Gallery, 1959.

Film

Museum of Science and Industry, Chicago, in conjunction with WBBM. Television documentary on etching processes, c. 1959.

Weiner, Peter. *A Portrait: Misch Kohn*. 30 min. film for National Educational Television, 1967.

Record Album

Bebop. New York: New World Records, c. 1976

Periodicals

Acacia. vol. 4, no. 3 (Spring 1987), cover, pp. 3, 14.

Ahlander, Leslie Judd. "Fine Print Exhibition at National." *Washington Post*, September 20, 1959, p. E7.

"American Prints of the 20th Century." *American Artist*, vol. 18, no. 9 (November 1954), p. 30.

Anderson, David. "Chicago Artist Loves That DAR." *Chicago Sun-Times*, December 11, 1961, p. 3.

"Antreasian Print Show Winner." *Indianapolis Star*, May 13, 1962.

"Art Association Hears Discussion by Misch Kohn." *Kokomo Tribune*, April 24, 1954.

"Art Exhibit." *Kokomo Tribune*, April 17, 1966, p. 11.

"Art in New York." *Time*, April 27, 1970, p. 4.

"Art of Kokomo Man Exhibited." *Kokomo Tribune*, May 11, 1953, p. 16.

"Artist will speak at Adobe Art Center." *Daily Review* (Hayward, CA), February 16, 1973, p. 26.

Ashton, Dore. "Art: Irregular Mosaics." *New York Times*, October 8, 1959, p. 70M.

———. "Brooklyn Reviews Today's American Print Techniques." *Art Digest*, vol. 26, no. 20 (September 15, 1952), p. 7.

———. "Prints Old and New." *New York Times*, May 27, 1956, p. X11.

Askew, Rual. "Acceptances Picked for Annual Exhibit." *Dallas Morning News*, January 10, 1964.

———. "Kohn to Jury DMFA's Print-Drawing Show." *Dallas Morning News*, December 21, 1963.

Olsen, Sandra Haller. *A Survey of American Printmaking from the Collection of the Memorial Art Gallery of the University of Rochester*. Rochester, NY: University of Rochester, 1987.

Pasadena Third Biennial National Print Exhibition. Pasadena: Pasadena Art Museum, 1962.

Paul, Arthur. *Beyond Illustration: The Art of Playboy*. Chicago: Playboy Magazine, 1971.

———. *Playboy Executive Calendar 1973*. Chicago: Playboy/Rathcon, 1972.

Peterdi, Gabor. *Printmaking: Methods Old and New*. New York: Macmillan & Co., 1959.

Polley, Trude and Zoran Krzisnik. *Hommage à Josefin*. Klagenfurt, Austria: Galerie 61, 1988.

Primera Bienal Interamericana de Pintura y Grabado. Mexico City: Instituto Nacional de Bellas Artes, 1958.

Prints 1942–1952. Memphis, TN: Brooks Art Gallery, 1953.

Prints: New Points of View. Oakland, CA: Western Association of Art Museums, 1979.

Prized Impressions: Gifts from The Print Center of Philadelphia. Philadelphia: The Print Center, 1997.

Purchase Exhibition of Fine Prints in Memory of Gilman L. Sessions, '25/Exhibition of International Prints/Additions to the Rental Library. Clinton, NY: Edward W. Root Art Center, Hamilton College, 1961.

The Pursuit and Measure of Excellence. Greensboro, SC: Weatherspoon Art Gallery, 1960.

Pursuit of Freedom: A History of Civil Liberty in Illinois 1787–1942. Chicago: Chicago Civil Liberties Committee, 1941.

Ross, John. *100 Prints of the Year 1962*. New York: Society of American Graphic Artists, Inc., 1963.

Ross, John and Clare Romano. *The Complete Intaglio Print*. New York: Free Press, 1972.

———. *The Complete New Techniques in Printmaking*. New York: Free Press, 1972.

———. *The Complete Printmaker*. New York: Free Press, 1972.

Rumpel, Heinrich. *Wood Engraving*. Geneva, Switzerland: Les Éditions de Bonvent, 1972.

Saff, Donald J. *Modern Masters of Intaglio*. New York: Queens College of the City University of New York, n.d. (c. 1974).

Sander, David M. *Wood Engraving: An Adventure in Printmaking*. New York: Viking Press, 1978.

Schmeckebier, Laurence Eli. *American Printmakers*. Syracuse, NY: Syracuse University School of Art, 1962.

Shobaken, Bruce R., George W. Zoretich, and Edwin W. Zoller. *Prints and Printmaking*. University Park, PA: Pennsylvania State University, 1960.

Sotriffer, Kristian. *Printmaking History and Technique*. London: Thames and Hudson, 1968.

Spence, James Robert. "Misch Kohn: A Critical Study of His Printmaking." Unpublished Ph.D. dissertation, University of Wisconsin, 1965.

Sport in Art. New York: American Federation of Arts, 1955.

Sternberg, Harry. *Woodcut*. New York: Pitman Pub. Corp.

Stubbe, Wolf. *Die Grafik des 20ten Jahrhunderts*. Berlin: Rembrandt Verlag, 1962.

The Student Independent. Chicago: Illinois Institute of Technology, 1953.

The Student Independent 8. Chicago: Illinois Institute of Technology, 1969.

Tahir, Abe M., Jr. *The All-American Wood Engravers*. New Orleans: Tahir Gallery, 1983.

Tamarind Lithography Workshop. *Lithographs from the Tamarind Workshop*. Los Angeles: University of California-Los Angeles Art Galleries, 1962.

Toledo Collectors of Modern Art. Toledo, OH: Toledo Museum of Art, 1969.

Twenty-Second Annual Exhibition Northwest Printmakers. Seattle: Seattle Art Museum, 1950.

United American Artists of Chicago. *Calendar 1941*. Chicago: United American Artists of Chicago, 1941.

United States Information Agency Graphic Arts Program. *List No. 2*. n.d.

———. *List No. 3*. n.d.

von Moschzisker, Bertha. *Curator's Choice*. Philadelphia: The Print Club, 1956.

Walkey, Frederick P. *The Boston Printmakers' 32nd National Exhibition*. Lincoln, MA: DeCordova Museum, 1979.

Washington Print Club. *Washington Print Club Members' Show*. Washington, DC: Washington Print Club, 1976.

Wayne, June. *About Tamarind*. Los Angeles: Tamarind Lithography Workshop, 1969.

Weller, A.S. *Graphic Arts—U.S.A.* Urbana: University of Illinois, 1954.

Hoover, James W. *Misch Kohn: A Hometown Collection.* Kokomo, IN: Kokomo-Howard County Public Library, 1991.

Internationale Graphik 1952. Salzburg: Kunst der Gegenwart Galerie, 1952.

Joachim, Harold. *Misch Kohn: 25 Years.* Washington, DC: Haslem Fine Arts, 1974.

Johnson, Una E. *American Prints and Printmakers.* Garden City, NY: Doubleday & Co., 1980.

———. *American Woodcuts 1670–1950.* Brooklyn: The Brooklyn Museum, 1950.

———. *Fourteenth National Print Exhibition.* Brooklyn: The Brooklyn Museum, 1964.

———. *Golden Years of American Drawings.* Brooklyn: The Brooklyn Museum, 1957.

———. *Incisori Americani Contemporanei.* Rome: The Brooklyn Museum, 1957.

———. *Sixteenth National Print Exhibition: Two Decades of American Prints 1947–1968.* Brooklyn: The Brooklyn Museum, 1968.

———. *Ten Years of American Prints 1947–1956.* Brooklyn: The Brooklyn Museum, 1956.

Joray, Charles N. *The Hoosier Art Collection of the Kokomo-Howard County Public Library.* Kokomo, IN: Kokomo-Howard County Public Library, 1989.

Knigin, Michael and Murray Zimiles. *The Contemporary Lithographic Workshop Around the World.* New York: Van Nostrand Reinhold Co., 1974.

Kohn, Misch. *The Encyclopedia Americana International Edition.* 1971–1995. s.v. "Engraving."

———. *The Encyclopedia Americana International Edition.* 1971–1995. s.v. "Lithograph."

———. "USA." *Meisterwerke der Graphik und Zeichnung.* Arbon, Switzerland: Erziehungs-Departement des Kantons Thurgau, 1954.

Konow, Jurgen Von. *Om Grafik.* Malmö, Sweden: Allhems Förlag, 1956.

LaLiberte, Norman and Alex Mongelon. *Twentieth Century Woodcuts: History and Modern Techniques.* New York: Van Nostrand Reinhold Co., 1971.

Landau, Ellen G. *Artists for Victory.* Washington: Library of Congress, 1983.

Les Peintres Graveurs Actuels aux Etats Unis. Paris: Bibliothèque Nationale, 1951.

Levine, Bobbie. "Three Prints by Misch Kohn in the University of Michigan Museum of Art." Unpublished manuscript, University of Michigan Museum of Art, 1982.

Lieberman, William S. *Recent Drawings USA.* New York: Museum of Modern Art, 1956.

Litchfield, Dorothy Hale. *The Fabulous Decade: A Collection of Prints of the 1950s.* Philadelphia: Free Library of Philadelphia, 1964.

Lo Monaco, Louis. *La Gravure en Taille-Douce: Art, Histoire, Technique.* Paris: Arts et Métiers Graphiques, Flammarion, 1992.

Los Angeles Printmaking Society 2nd National Exhibition. Los Angeles: Otis Art Institute of Los Angeles County, 1974.

Marty, Martin E. *Ecumenical Art.* Chicago: St. Benet Gallery, 1966.

Meilach, Donna. *Printmaking.* New York: Pitman Pub. Corp., 1965.

Metz, Kathryn. *Misch Kohn: Three Decades of Printmaking.* Santa Cruz: Eloise Pickard Smith Gallery, Cowell College, University of California-Santa Cruz, 1981.

Misch Kohn. Louisville, KY: Allen R. Hite Art Institute, 1964.

Modern Woodcuts. Philadelphia: Philadelphia Art Alliance, 1949.

Moderne Amerikaanse Grafiek. The Hague: Gemeentemuseum, 1953.

Moderne Maler Aus Chicago. Washington, DC: U.S. Information Service, n.d.

Moran, Joe. *International Printmaking Invitational.* San Bernardino: California State College, 1983.

Moser, Joann. *Atelier 17.* Madison: Regents of the University of Wisconsin System, 1977.

———. *Novija Americka Grafika.* Banja Luka, Serbia: Galerija Doma Kulture, 1989.

Museum of Modern Art. *American Prints Today 1960–1985.* New York: Museum of Modern Art, 1986.

Nebraska Art Association Autumn Show. Lincoln: University Art Galleries, 1951.

The 1960 International Biennial of Prints. Cincinnati: Cincinnati Art Museum, 1960.

Contemporary Printmakers of the Americas. Washington: Organization of American States, 1976.

Contemporary Prints and Watercolors. New York: National Academy of Design, 1956.

Covenant Club of Illinois and American Jewish Arts Club. *Exhibition by Contemporary Jewish Artists of Chicago*. Chicago: Covenant Club, 1941.

DeCordova and Dana Museum. *Fifty American Printmakers*. Lincoln, MA: DeCordova and Dana Museum, 1961.

Dewey, Tom, II. *The First National Invitational Color Blend Print Exhibition*. Memphis, TN: S.C. Toof & Co., 1978.

Eichenberg, Fritz. *The Art of the Print*. New York: Harry N. Abrams, 1976.

———. *Lithography and Silkscreen*. New York: Harry N. Abrams, 1978.

———., ed. *Artist's Proof*. New York: New York Graphic Society, 1971. Issue 1, Issue 7.

Ellis, George. *6th Hawaii National Print Exhibition*. Honolulu: Honolulu Academy of Arts, 1983.

Esslin, Martin. *Misch Kohn Prints/Chicago—California: A Retrospective*. Berkeley, CA: KALA Institute Gallery, 1988.

Evans, Carol. *Prints from Blocks 1900–1985: Twentieth-Century American Woodcuts, Wood Engravings, and Linocuts*. New York: Associated American Artists, 1985.

Evans, Robert J. and Maureen A. McKenna. *After the Great Crash: New Deal Art in Illinois*. Springfield: Illinois State Museum, 1983.

Exhibition of Current American Prints 1950. Pittsburgh: Carnegie Institute, 1950.

Exposition de Gravures. Paris: U.S. Embassy, 1951.

Exposition Internationale de la Gravure Contemporaine. Paris: Les Presses Artistiques, 1949.

Farmer, Jane. *American Prints from Wood*. Washington, DC: Smithsonian Institution Press, 1975.

Feldman, Jesse. *Farewell to Israel*. Chicago: privately published, 1955.

A Few (Open) Secrets About the University of Chicago Press. Chicago: The University of Chicago Press, 1968.

Fifth National Print Annual Exhibition. Brooklyn: The Brooklyn Museum, 1951.

Fortieth Anniversary Exhibition. Philadelphia: The Print Club, 1955.

Fourth National Print Annual Exhibition. Brooklyn: The Brooklyn Museum, 1950.

Garver, Thomas H., Warrington Colescott, and Scott Gordon. *New American Graphics 2*. Madison, WI: Madison Art Center, 1982.

Geske, Norman. *The Art of Printmaking*. Lincoln: University of Nebraska Art Galleries, 1966.

Getlein, Frank and Dorothy. *The Bite of the Print*. New York: Clarkson N. Potter, 1963.

Gilkey, Gordon W. *Participating Printmakers in the International Print Exhibition*. Portland, OR: Portland Art Museum, 1997.

Grafica Contemporanea Americana. Venice: Galleria Bevilacqua La Masa, 1977.

Graphik 63. Vienna: Graphische Sammlung Albertina, 1963.

Gravures Americaines d'Aujourd'hui. Paris: Centre Culturel Americain, 1957.

Haslem, Jane. *American Paintings and Graphics*. Washington, DC: Haslem Fine Arts, 1973.

———. *American Prints Drawings Paintings*. Washington, DC: Jane Haslem Gallery, 1981.

———. *The Innovators: Renaissance in American Printmaking*. Washington, DC: Haslem Fine Arts, 1973.

Hayter, Stanley William. *About Prints*. London: Oxford University Press, 1962.

Hedendaagse Grafiek/USA. Utrecht, The Netherlands: Centraal Museum Utrecht, 1966.

Heintzelman, Arthur W. *Contemporary American Prints*. Boston: Boston Public Library, 1953.

———. *Incisiori degli Stati Uniti*. Rome: Calcografia Nazionale, n.d.

Heller, Jules. *Printmaking Today*. New York: Henry Holt & Co., 1958.

———. *Printmaking Today: A Studio Handbook*. New York: Holt, Rinehart and Winston, 1972.

Heyman, Therese Thau. *Cream of California Prints*. Oakland: Oakland Museum, 1987.

———. *Prints California*. Oakland: Oakland Museum, 1975.

Hoosier Art Collection of the Kokomo-Howard County Public Library. Kokomo, IN: Kokomo-Howard County Public Library, 1993.

Artists of Chicago and Vicinity, 56th Annual Exhibition. Chicago: Art Institute of Chicago, 1952.

Artists of Chicago and Vicinity, 58th Annual Exhibition. Chicago: Art Institute of Chicago, 1955.

Artists of Chicago and Vicinity, 61st Annual Exhibition. Chicago: Art Institute of Chicago, 1958.

Artists of Chicago and Vicinity, 62nd Annual Exhibition. Chicago: Art Institute of Chicago, 1959.

Association Française d'Action Artistique. *La Gravure Americaine d'Aujourd'hui*. Paris: Les Presses Artistiques, 1959.

Ausstellung Kinder und Künstler. Arbon, Switzerland: Ausstellungorganisation Graf-Bourquin, 1955.

Baro, Gene. *Misch Kohn: The California Years*. New York: The Brooklyn Museum, 1981.

————. *Thirty Years of American Printmaking*. Brooklyn: The Brooklyn Museum, 1976.

————. *Twenty-Second National Print Exhibition*. Brooklyn: The Brooklyn Museum, 1981.

Beall, Karen. *American Prints in the Library of Congress; A Catalog of the Collection*. Baltimore: published for the Library of Congress by Johns Hopkins University Press, 1970.

Beck, Sydney and Elizabeth E. Roth. *Music in Prints*. New York: New York Public Library, 1965.

Bermingham, Peter. *The Art of Poetry*. Washington: National Collection of Fine Arts, Smithsonian Institution Press, 1976.

Bernstein, Barbara. "Federal Art in Illinois." Unpublished manuscript, Illinois Arts Council, 1976.

Biggs, John R. *Woodcuts, Linocuts and Prints by Related Methods of Relief Printmaking*. London: Blandford Press, 1958.

Bradbury, Ray. *The Art of Playboy*. New York: Alfred van der Marck Editions, 1985.

Buckland-Wright, John. *Etching and Engraving: Techniques and the Modern Trend*. New York: Viking Press, 1953. [Reissued New York: Dover Publications, 1973.]

Cahill, Holger, William S. Lieberman, Henry-Russell Hitchcock, and Arthur Drexler. *Savremena Umetnost u SAD*. Beograd, Jugoslavia: Komisija za kulturne vese sa inostranstvom FNRJ, 1956.

California Society of Printmakers National Print Exhibition. Richmond: Richmond Art Center, 1972.

Castleman, Riva. *American Impressions: Prints Since Pollock*. New York: Alfred A. Knopf, 1985.

Castro, Julio. *Ibizagrafic-72*. Ibiza, Spain: Museo de Arte Contemporaneo de Ibiza, 1972.

Catalog of the Eighth National Exhibition of Prints Made During the Current Year. Washington, DC: Library of Congress, 1950.

Catalog of the Ninth National Exhibition of Prints Made During the Current Year. Washington, DC: Library of Congress, 1951.

Catalog of the 12th National Exhibition of Prints Made During the Current Year. Washington, DC: Library of Congress, 1954.

Catalog of the 13th National Exhibition of Prints Made During the Current Year. Washington, DC: Library of Congress, 1955.

Catalog of the 15th National Exhibition of Prints Made During the Current Year. Washington, DC: Library of Congress, 1957.

Catalog of the 16th National Exhibition of Prints Made During the Current Year. Washington, DC: Library of Congress, 1958.

Catalog of the 17th National Exhibition of Prints Made During the Current Year. Washington, DC: Library of Congress, 1959.

Catalog of the 21st National Exhibition of Prints. Washington, DC: Library of Congress, 1971.

Catalog of the 23rd National Exhibition of Prints. Washington, DC: Library of Congress, 1973.

Catalog of the 25th National Exhibition of Prints. Washington, DC: Library of Congress, 1977.

Catalogue of the One Hundred and Fifty-Second Annual Exhibition. Philadelphia: Pennsylvania Academy of the Fine Arts, 1957.

Catalogue of the One Hundred and Fifty-Sixth Annual Exhibition. Philadelphia: Pennsylvania Academy of the Fine Arts, 1961.

Catalogue Raisonné, Tamarind Lithography Workshop, Inc., 1960–1970. Albuquerque: University of New Mexico Art Museum, 1989.

Chamberlain, Walter. *Wood Engraving*. London: Thames and Hudson, 1978.

Christensen, Erwin O. *A Pictorial History of Western Art*. New York: New American Library of World Literature, 1964.

Cline, Clint. *Colorado First National Print and Drawing Competition*. Boulder: University of Colorado, 1974.

Contemporary American Prints. New York: IBM Gallery, 1966.

Bibliography
Books, Catalogues and Brochures

I Mednarodna Grafična Razstava. Ljubljana: Moderna Galerija, 1955.

I Mednarodna Grafična Razstava. Ljubljana: Moderna Galerija, 1955.

I Miedzynarodowe Biennale Grafiki. Cracow: Bureau des Expositions Artistiques, 1966.

Ière Exposition Biennale Internationale de Gravure à Tokio. Tokyo: Musée National d'Art Moderne, 1957.

II Mednarodna Grafična Razstava. Ljubljana: Moderna Galerija, 1957.

III Miedzynarodowe Biennale Grafiki. Cracow: Ministerstwo Kultury i Sztuki Zwiazek Polskich Artystow Plastykow, 1970.

IV Mednarodna Grafična Razstava. Ljubljana: Moderna Galerija, 1961.

IV Mostra di Pittura Americana. Bordighera, Italy: 1957.

5th Hawaii National Print Exhibition. Honolulu: Honolulu Academy of Arts, 1980.

V Mednarodna Grafična Razstava. Ljubljana: Moderna Galerija, 1963.

VI Mednarodna Grafična Razstava. Ljubljana: Moderna Galerija, 1965.

VII Bienal de São Paulo Catalogo. São Paulo: Fundaçao Bienal de S. Paulo, 1963.

VII Mednarodna Grafična Razstava. Ljubljana: Moderna Galerija, 1967.

8 Mednarodna Grafična Razstava. Ljubljana: Moderna Galerija, 1969.

9 Mednarodna Grafična Razstava. Ljubljana: Moderna Galerija, 1971.

14 Artists. Springfield: Illinois State Museum, 1965.

14 Mednarodni Grafični Bienale. Ljubljana: Moderna Galerija, 1981.

19th- and 20th-Century European and American Prints. Honolulu: Honolulu Academy of Arts, 1990.

30 Contemporary American Prints. New York: IBM Gallery, 1964.

47 Midwestern Printmakers. Chicago: 1020 Art Center, 1956.

50 Contemporary American Printmakers. Chicago: University of Illinois, 1956.

50 Indiana Prints: First Biennial Exhibition. Indianapolis: John Herron Art Museum, 1952.

50 Indiana Prints: Second Biennial Exhibition. Indianapolis: John Herron Art Museum, 1954.

50 Indiana Prints: Third Biennial Exhibition. Indianapolis: John Herron Art Museum, 1956.

50 Indiana Prints: Fourth Biennial Exhibition. Indianapolis: John Herron Art Museum, 1958.

50 Indiana Prints: Sixth Biennial Exhibition. Indianapolis: John Herron Art Museum, 1962.

52nd Annual Exhibition by Artists of Chicago and Vicinity. Chicago: Art Institute of Chicago, 1948.

53rd Annual Exhibition by Artists of Chicago and Vicinity. Chicago: Art Institute of Chicago, 1949.

53 Peintres de Chicago. Nancy, France: Musée des Beaux Arts, under the auspices of the U.S. Embassy.

66th Annual Exhibition by Artists of Chicago and Vicinity. Chicago: Art Institute of Chicago, 1963.

69th Annual Exhibition by Artists of Chicago and Vicinity. Chicago: Art Institute of Chicago, 1966.

71st Annual Exhibition by Artists of Chicago and Vicinity. Chicago: Art Institute of Chicago, 1968.

Adhémar, Jean. *Twentieth-Century Graphics*. New York: Praeger Publishers, 1971.

American Graphic Art. Bombay, India: United States Information Service, n.d.

American Prints 1913–1963. Leeds: Arts Council of Great Britain, 1976.

American Prints Today. Indianapolis: John Herron Art Museum, 1943.

American Prints Today/1959. New York: Print Council of America, 1959.

American Prints Today/1962. New York: Print Council of America, 1962.

Anderson, Donald M. *Design*. New York: Henry Holt & Co.

Annual Exhibition 1966: Sculpture and Prints. New York: Whitney Museum of American Art, 1966.

Art School: The John Herron Art Institute/Art Association of Indianapolis 1941–1942 Catalogue of the Winter School. Indianapolis: John Herron Art Institute, 1941.

Art Under the New Deal. Columbia, SC: Columbia Museum of Art, 1969.

Artists of Chicago and Vicinity, 54th Annual Exhibition. Chicago: Art Institute of Chicago, 1950.

Artists of Chicago and Vicinity, 55th Annual Exhibition. Chicago: Art Institute of Chicago, 1951.

1981 "21st Annual Exhibition of Editorial and Advertising Art,"
Chicago. The Artists Guild of Chicago Award

1988 "28th Annual Exhibition of Advertising Art," Art Directors
Club of America. Merit Award, Certificate of
Excellence, and Medal Award

1991 Honorary Doctorate of Fine Arts, Indiana University-
Bloomington

1994 Distinguished Artist Award, California Society of
Printmakers

1996 "International Print Exhibition," Portland Art Museum.
Purchase Prize

1958 "16th National Exhibition of Prints Made During the Current Year," Library of Congress. Purchase Prize (*Three Kings*)

"35th Annual Exhibition of Etching and Engraving," The Print Club, Philadelphia Museum of Art. Charles M. Lea Prize (*Lion*)

"50 Indiana Prints: Fourth Biennial Exhibition," John Herron Art Museum. Maco Press Prize (*The City*)

"61st Annual Exhibition by Artists of Chicago and Vicinity," Art Institute of Chicago. Pauline Palmer Prize (*Three Kings*)

1959 "33rd Annual Exhibition of Woodcuts and Wood Engravings," The Print Club, Philadelphia Museum of Art. Eugenia F. Atwood Prize (*Job*)

"17th National Exhibition of Prints Made During the Current Year," Library of Congress. Purchase Prize (*Job*)

"62nd Annual Exhibition by Artists of Chicago and Vicinity," Art Institute of Chicago. Pauline Palmer Purchase Prize (*Lion*)

"American Prints Today/1959," Print Council of America. "Equal and Outstanding Excellence" Prize (*Lion*)

1960 Ford Foundation Grant to tour 20-year retrospective exhibition through the American Federation of Arts

"37th Annual Exhibition of Etching and Engraving," Philadelphia Print Club, Philadelphia Museum of Art. Philadelphia Museum of Art Prize (*Prometheus*)

Central Free Library Print Fair, Philadelphia. George Burr Memorial Gold Medal (*Horse as a Constellation*)

Salon de Mai, Paris. Prize (*Colossus*)

"First Annual Exhibition of Advertising and Editorial Art," Chicago. Award of Excellence

"28th Annual Exhibition of Advertising Art," Chicago. Award

1961 Tamarind Fellowship in Lithography, Los Angeles Advisory Artists' Committee, Print Council of America

"IV International Biennale of Prints," Ljubljana. Third Prize (*Adam Kadmon*)

"Invitation Competitive Exhibition," Philadelphia Print Club, Philadelphia Museum of Art. Charles M. Lea Prize (*Absalom*)

Pasadena National Print Club. Purchase Award

"Society of Typographic Arts, 34th Annual Design in Chicago Printing Exhibition," Art Institute of Chicago. Award of Excellence (2)

1962 Honorary Fellow, *Academia della Belle Arti del Disigno*, Florence, Italy

"National Print Exhibition Third Biennial," Pasadena Art Museum, California. Purchase Prize (*Man*)

"Invitational Exhibition of Lithography and Intaglio Prints," Philadelphia Print Club, Philadelphia Museum of Art. William H. Walker Memorial Prize (*Giant*)

III International Biennale, Mexico City. Major prize

"50 Indiana Prints: Sixth Biennial Exhibition," John Herron Art Museum. Mr. and Mrs. Samuel R. Harrell Prize (*Man*)

1964 "50 Indiana Prints: Seventh Biennial Exhibition," John Herron Art Museum. Mr. and Mrs. Samuel R. Harrell Prize (*Tiger*)

"Juried Members' Exhibition," The Print Club, Philadelphia. Honorable Mention (*Mob*)

1965 "*VI International Biennale de Gravure*," Moderna Galerija, Ljubljana. Prize

First Lifetime Honorary Membership, Kokomo Art Association

1968 "16th National Print Annual Exhibition," The Brooklyn Museum. Purchase Prize (*End Game*)

The Print Club, Philadelphia. Purchase Prize

"A Portrait of Misch Kohn" by film-maker Peter Weiner, CINE Golden Eagle Award

1969 The Print Club, Philadelphia. International Graphic Arts Society Prize

1971 Outstanding Educator of America Award

1972 Appointed to Library of Congress Pennell Collection Acquisitions Committee (term extended through 1979)

1974 "Second National Exhibition, Los Angeles Printmaking Society," Otis Art Institute of Los Angeles County. Harland D. Goldwater, M.D., First Prize, Purchase Prize Award

1975 Elected Associate, National Academy of Design, New York

1976 Elected Academician, National Academy of Design, New York

1980 National Endowment for the Arts Visual Artists Fellowship

Honors and Awards

1938 Indiana State Fair, 2nd and 4th Prizes, Fine Arts

1939 Indiana State Fair, First Prize

1940 Indiana State Fair, First Prize, Prints

1941 "National Exhibition of Contemporary Jewish Artists," Covenant Club, Chicago. First Prize, oil painting

Indiana State Fair, 2nd and 5th Prizes, Fine Arts

Illinois Art Project, W.P.A. Art Program, Chicago. Commendation

1942 "All-American Print Show," John Herron Art Museum. Third Prize (*Portrait of Franz Biberkopf*)

1943 "American Prints Today," John Herron Art Museum. Honorable Mention

1946 Indiana State Fair, First Prize, Prints and Fourth Prize, Fine Arts (watercolor)

1948 "52nd Annual Exhibition by Artists of Chicago and Vicinity," Art Institute of Chicago. Town and Country Arts Club Purchase Prize (*Marionette Dance*)

1949 "47th Annual Exhibition of Watercolors and Prints," Pennsylvania Academy of the Fine Arts. Alice McFadden Eyre Gold Medal (*Prisoners*)

1950 "22nd Annual International Exhibition of Prints," Northwest Printmakers, Seattle Museum of Art. Purchase Prize (*Fishermen*)

"Fourth Annual National Print Exhibition," The Brooklyn Museum. Purchase Prize (*Death Rides a Dark Horse*)

"8th National Exhibition of Prints Made During the Current Year," Library of Congress. Purchase Prize (*Bull Fight*)

"24th Annual Exhibition of Woodcuts and Wood Engravings," The Print Club, Philadelphia Museum of Art. Eugenia F. Atwood Prize (*Struggle*)

1951 "25th Annual Exhibition of Woodcuts and Wood Engravings," The Print Club, Philadelphia Museum of Art. Eugenia F. Atwood Purchase Prize (*The Glass Blower*)

"Fifth Annual National Print Exhibition," The Brooklyn Museum. Purchase Prize (*The Glass Blower*)

"55th Annual Exhibition by Artists of Chicago and Vicinity," Art Institute of Chicago. Pauline Palmer Purchase Prize (*Sleeping Soldier*)

1952 "50 Indiana Prints: First Biennial Exhibition," John Herron Art Museum. Art Association Prize (*Portrait of a Contemporary*)

"56th Annual Exhibition by Artists of Chicago and Vicinity," Art Institute of Chicago. Renaissance Prize (*A Season in Hell*)

"50th Annual International Exhibition of Watercolors, Prints and Drawings," Pennsylvania Academy of the Fine Arts. Joseph Pennell Memorial Medal (*Fishermen*)

John Simon Guggenheim Fellowship for work in France: "Studies of Color Processes in the Field of Printmaking," (fellowship period August 1, 1952–July 31, 1953)

"26th Annual Exhibition of Woodcuts and Wood Engravings," The Print Club, Philadelphia. Honorable Mention (*Sleeping Soldier*)

1953 John Simon Guggenheim Fellowship: "Creative Activity in the Field of Printmaking," (fellowship period August 1, 1953–July 31, 1954; postponed and not used until 1955)

"27th Annual Exhibition of Woodcuts and Wood Engravings," The Print Club, Philadelphia. Honorable Mention (*Three Visitors with Entourage*)

1954 "50 Indiana Prints: Second Biennial Exhibition," John Herron Art Museum. Indiana Society of Printmakers Prize (*Warrior Jagatai*)

1955 "29th Annual Exhibition of Wood engraving, Woodcuts, and Block Prints," The Print Club, Philadelphia Museum of Art. Eugenia F. Atwood Purchase Prize (*Kabuki Samurai*)

1956 Boston Printmakers Annual Exhibition, Purchase Prize (*Florentine Figure*)

"30th Annual Exhibition of Wood engraving, Woodcuts, and Block Prints," The Print Club, Philadelphia Museum of Art. Eugenia F. Atwood Purchase Prize (*Processional*)

"50 Indiana Prints: Third Biennial Exhibition," John Herron Art Museum. Allen W. Clowes Prize (*Florentine Figure*)

National Academy of Design. National Academy of Design Prize (*Kabuki Samurai*)

1957 "31st Annual Exhibition of Wood Engraving, Woodcuts, and Block Prints," The Print Club, Philadelphia Museum of Art. Honorable Mention (*The City*)

University of Michigan, Special Collections Library,

 University Library, Ann Arbor

 Blind Joy, 1968, PS 586.L72 [as *Ligature '68*]

University of Oregon Museum of Art, Eugene

 "They Also Serve,", 1939, WPA56:1:246 [as *Church*]

Utah Museum of Fine Arts, University of Utah-

 Salt Lake City

 General, 1970, 1972.042.012.005, gift of

 Dr. Christopher A. and Janet Graf

 Long Beaked Bird, 1970, 1972.042.012.006, gift of

 Dr. Christopher A. and Janet Graf

 Double Portrait of the Artists, 1971, 1972.042.012.007,

 gift of Dr. Christopher A. and Janet Graf

 [as *Untitled (Janis Joplin and Mies van der Rohe)*]

Walker Art Center, Minneapolis

 Lion, 1957, 65.70, The Leon B. Walker Memorial

 Collection (gift of Ione and Hudson Walker, NY)

 Three Kings, 1957, 65.71, The Leon B. Walker

 Memorial Collection (gift of Ione and Hudson

 Walker, NY)

Washington University Gallery of Art, St. Louis, MO.

 Giant, 1961, WU 3940, University purchase, Plant

 Replacement Fund

West Chester University, West Chester, PA.

 Sleeping Soldier, 1951

Wright Museum of Art, Beloit College, Beloit, WI.

 Blind Joy, 1968, 70.7.3, gift of the Wisconsin-

 Minnesota Poetry Circuit

Soldiers, 1961, 1962.16.85

Spotted Beast, 1961, 1962.16.93

Stranger, 1961, 1962.16.86

Stranger II, 1961, 1962.16.87

Three Generals, 1961, 1962.16.98

Woman, 1961, 1962.16.102

Ikaros, 1961, 1973.17.40, gift of the Tamarind
Lithography Workshop Inc.

Patriarch, 1961, 1973.17.41, gift of the Tamarind
Lithography Workshop Inc.

Three Generals, 1961, 1973.17.42, gift of the Tamarind
Lithography Workshop Inc.

Small Bird, 1965.20.1, gift of the ASUCLA Art Rental
Program

United States Information Agency, Washington, DC.

General, 1957

Baron von Z, 1960

Convocation of Strangers, 1960

Figure with a 5, 1963

Requiem, 1963

The Mathematician, 1963

Mob, 1964

Two Generals, 1965

Car Number Three, 1968

University Art Museum/Pacific Film Archive, University of California-Berkeley

Kabuki Samurai, 1954, 1966.13, gift of Peter Selz

University Art Museum, University of New Mexico-Albuquerque

Three Kings, 1957, 68.166, gift of Garo Z. Antreasian

Beast, 1961

Black Beast, 1961

Figure, 1961

Figure, 1961

Giant, 1961

Grand Canyon, 1961

Head, 1961

Landscape, 1961

Patriarch, 1961

Patriarch II, 1961

Procession, 1961

Red Beast, 1961

Simon, 1961

Soldiers, 1961

Spotted Beast, 1961

Stranger, 1961

Stranger II, 1961

Three Generals, 1961

Oedipus, 1962, 75.57, gift of Thomas F. Barrow
[dated 1963]

University of Iowa Museum of Art, Iowa City

Ikaros, 1961, 1973.123, gift of Tamarind Lithography
Workshop

Patriarch, 1961, 1973.124, gift of Tamarind
Lithography Workshop

The Last General, 1961, X1968.173 [as *Head*]

Three Generals, 1961, 1973.125, gift of Tamarind
Lithography Workshop

General, 1970, 1972.213, gift of Christopher and
Janet Graf

Long Beaked Bird, 1970, 1972.212, gift of Christopher
and Janet Graf

Double Portrait of the Artists, 1971, 1972.214, gift of
Christopher and Janet Graf

University of Maine Museum of Art, Orono

Blind Joy, 1968

General, 1970

Long Beaked Bird, 1970

Double Portrait of the Artists, 1971 [as *No Title (Janis
Joplin and Miles van der Rohe)*]

University of Michigan Museum of Art, Ann Arbor

Colossus, 1959, 1959/2.103, museum purchase

The Last General, 1961, 1962/2.2, gift of the Ravinia
Festival Association, 1962

Calligraphic Landscape, 1962, 1982/1.195, The Marvin
Felheim Collection

Figure with a 5, 1963, 1972/2.18, gift of The Ann Arbor
Art Association, in memory of Ruby S.
Churchhill

Rose Art Museum, Brandeis University, Waltham, MA.

Patriarch, 1962, 1971.748, gift of Mr. Philip Pinsof

San Diego Museum of Art, San Diego, CA.

Figure, 1961, 1962.83, gift of the Gleich Foundation

Grand Canyon, 1961, 1962.162, gift of the Gleich
Foundation

Patriarch, 1961, 1962.84, gift of the Gleich Foundation

Patriarch II, 1961 1962.163, gift of the Gleich
Foundation

Seattle Art Museum, Seattle, WA.

Fishermen, 1949, 69.286, gift of the Northwest
Printmakers Society

Sheldon Memorial Art Gallery, University of Nebraska-Lincoln

The Glass Blower, 1950, 1951.H-331, F.M. Hall
Collection

Warrior Jagatai, 1953, H-381, F.M. Hall Collection

General, 1970, 1972.U-1106, gift of Dr. and Mrs.
Christopher A. Graf

Long Beaked Bird, 1970, 1972.U-1105, gift of Dr. and
Mrs. Christopher Graf

Double Portrait of the Artists, 1971, 1972.U-1107, gift of
Dr. and Mrs. Christopher Graf [as *Untitled (Janis
Joplin and Mies van der Rohe)*]

The David and Alfred Smart Museum of Art, University of Chicago

The Last General, 1961, 1987.19, gift of Jesse and
Penny Wheeler [dated 1962]

Smith College Museum of Art, Northampton, MA.

General, 1970, 1972:30-5 TR2280, gift of Dr. and Mrs.
Christopher A. Graf

Long Beaked Bird, 1970, 1972:30-6 TR2280, gift of Dr.
and Mrs. Christopher A. Graf

Double Portrait of the Artists, 1971, 1972:30-7 TR2280,
gift of Dr. and Mrs. Christopher A. Graf [as
Untitled (Janis Joplin and Mies van der Rohe)]

Southern Illinois University, University Museum, Carbondale

The Fisherman, 1940, 164901, gift of the Illinois Art
Project

Lupe, 1940, TG34967, gift of the Illinois Art Project

Stanford University Museum of Art, Stanford, CA.

Absalom, 1959, 1991.129, gift of Laura Volkerding [as
Absolom]

Spotted Beast, 1961, 1991.254, gift of Laura Volkerding

The Last General, 1961, 1983.70, given in honor of
Professor Albert E. Elsen by Mr. and Mrs. Robert
Rees [as *Untitled*, dated 1962]

Bearded Man, 1963, 1987.173, gift of Laura Volkerding
[as *Untitled (Small Head)*]

Syracuse University Art Collection, Syracuse, NY.

Lion, 1957, 1963.182, purchase

G.B., 1963, 1965.62, purchase

Two Generals II, 1965, 1990.248 [as *Two Generals*]

Blind Joy, 1968, 1969.86.4 [as *Untitled*]

Tusculum College, Greeneville, TN.

Blind Joy, 1968

UCLA at the Armand Hammer Museum of Art and Cultural Center, Grunwald Center for the Graphic Arts, Los Angeles, CA.

The following 19 Tamarind impressions were gifts of
Mr. and Mrs. Fred Grunwald:

Beast, 1961, 1962.16.100

Black Beast, 1961, 1962.16.92

Figure, 1961, 1962.16.94

Figure, 1961, 1962.16.99

Giant, 1961, 1962.16.101

Grand Canyon, 1961, 1962.16.95

Head, 1961, 1962.16.91

Landscape, 1961, 1962.16.96

Patriarch, 1961, 1962.16.88

Patriarch II, 1961, 1962.16.89

Procession, 1961, 1962.16.84

Red Beast, 1961, 1962.16.90

Simon, 1961, 1962.16.97

Adam Kadmon, 1960, 65-95-112, Lola Downin Peck Fund purchase from the Carl and Laura Zigrosser Collection

Baron von Z, 1960, 65-95-110, Staunton B. Peck Fund purchase from the Carl and Laura Zigrosser Collection [black only]

Baron von Z, 1960, 65-95-111, Staunton B. Peck Fund purchase from the Carl and Laura Zigrosser Collection [color *chine collé*]

Man, 1960, 65-95-108, Staunton B. Peck Fund purchase from the Carl and Laura Zigrosser Collection

Giant, 1961, 62-37-4, William H. Walker Prize, Invitational Exhibition of Lithography and Intaglio Prints, Gift of the Print Club

Giant, 1961, 65-95-113

Hawk, 1961, 64-203-5, acquired by exchange [dated 1963]

Man, 1961, 64-203-2, acquired by exchange

Procession, 1961, 64-203-1, acquired by exchange

Red Beast, 1961, 64-203-3, acquired by exchange

Patriarch, 1962, 64-203-4, acquired by exchange [artist's proof]

Three Generals, 1962, 62-78-14, Print Club Permanent Collection [color]

Three Generals, 1962, 62-78-15, Print Club Permanent Collection [black only]

Laughing Man, 1963, 65-95-105, Staunton B. Peck Fund purchase from the Carl and Laura Zigrosser Collection

Little Baron, 1963, 65-95-104, Staunton B. Peck Fund purchase from the Carol and Laura Zigrosser Collection

The Wall, 1963, 64-203-6, acquired by exchange

Tiger, 1963, 64-203-7, acquired by exchange

Cyclist No. 3, 1969, 69-69-2, purchased with funds given by The Print Club for Print Club Permanent Collection

General, 1970, 72-274-6, gift of Dr. Christopher A. and Janet Graf

Long Beaked Bird, 1970, 72-274-5, gift of Dr. Christopher A. and Janet Graf

Double Portrait of the Artists, 1971, 72-274-7, gift of Dr. Christopher A. and Janet Graf [as *Janis Joplin and Mies van der Rohe*]

Picker Art Gallery, Colgate University, Hamilton, NY.

Bull Fight, 1949, 1957.6, gift of the American Academy of Arts and Letters through the Childe Hassam Fund

Tiger, 1949, x89.28, museum purchase

Portland Art Museum, Portland, OR.

Giant, 1961 [BAT]

Double Portrait of the Artists, 1971 [as *Mies van der Rohe and Janis Joplin*]

The Enormous Room, 1996, Purchase Prize, International Print Exhibition

Princeton University Libraries, Princeton, NJ.

Little Lion, 1958, 2240

John and Mable Ringling Museum of Art, Sarasota, FL.

Kabuki Samurai, 1954, gift of the Members' Guild

Giant, 1961, gift of Mr. Murray Lebwohl in honor of Edward O. Korany

General, 1970, gift of Dr. Christopher A. and Janet Graf

Long Beaked Bird, 1970, gift of Dr. Christopher A. and Janet Graf

Double Portrait of the Artists, 1971, gift of Dr. Christopher and Janet Graf [as *Untitled (Janis Joplin and Mies van der Rohe)*]

Rockford College Department of Art, Rockford, IL.

General, 1970, RC #1430

Long Beaked Bird, 1970, RC #1429

Double Portrait of the Artists, 1971, RC #1389 [as *Untitled (Portrait of Janis Joplin and Mies van der Rohe)*]

Roosevelt University, Chicago

Three Generals, 1961

Rosary College, River Forest, IL.

G.B., 1963

The Oakland Museum of California

Silver Valley [I], 1982, A84.60.10, gift of the artist.

Peppers Art Gallery, University of Redlands, Redlands, CA.

Little Herald, 1958, purchase

Philadelphia Museum of Art

"They Also Serve," 1939, 3-1943-580, Federal Works Agency, Works Projects Administration deposit [as *(Figures Outside Church)*]

Exile, 1939, 2-1943-39, Federal Works Agency, Works Projects Administration deposit

John Brown, 1939, 3-1943-576, Federal Works Agency, Works Projects Administration deposit

Solomon Cucumber, 1940, 2-1943-48, Federal Works Agency, Works Projects Administration deposit

Woman in Red Jacket, 1940, 2-1943-33, Federal Works Agency, Works Projects Administration deposit

Man with a Pipe, 1941, 2-1943-49, Federal Works Agency, Works Projects Administration deposit

Death Rides a Dark Horse, 1949, 64-203-10, acquired by exchange

Prisoners, 1949, 61-60-28, Print Club Permanent Collection

Struggle, 1949, 50-68-1, Eugenia F. Atwood Prize, 24th Annual Exhibition of Wood Engraving, Woodcuts and Block Prints, 1950, gift of The Print Club

Tiger, 1949, 50-69-14, Print Club Permanent Collection

Mountain Climber, 1950, 55-62-19, gift of Mrs. R. Sturgis Ingersoll

The Glass Blower, 1950, 51-39-2, Eugenia F. Atwood Prize, 25th Annual Exhibition of Woodcuts and Wood Engravings, 1951, gift of The Print Club

A Season in Hell, 1951, 52-31-53, Thomas Skelton Harrison Fund purchase

Sleeping Soldier, 1951, 64-203-9, acquired by exchange

Barrier, 1954, 61-60-27, Print Club Permanent Collection

Cathedral I/Notre Dame, 1954, 65-95-102, Staunton B. Peck Fund purchase from the Carl and Laura Zigrosser Collection

Kabuki Samurai, 1954, 55-36-2, Eugenia F. Atwood Prize, 29th Annual Exhibition of Wood Engraving, Woodcuts and Block Prints, 1955, gift of The Print Club

Processional, 1955, 65-95-107, Staunton B. Peck Fund purchase from the Carl and Laura Zigrosser Collection

Processional, 1955, Eugenia F. Atwood Prize, 30th Annual Exhibition of Wood Engraving, Woodcuts and Block Prints, 1956, gift of The Print Club

Bird, 1956, 65-95-101, Staunton B. Peck Fund purchase from the Carl and Laura Zigrosser Collection [dated 1957]

Lion, 1957, 61-41-1, anonymous gift

Lion, 1957, 58-54-4, gift of The Print Club

The City, 1957, 61-60-29, Print Club Permanent Collection

Three Kings, 1957, 60-56-14, Thomas Skelton Harrison Fund purchase

Three Kings, 1957 (on Horseback), 65-95-106, Staunton B. Peck Fund purchase from the Carl and Laura Zigrosser Collection

Little Herald, 1958, 60-56-15, Thomas Skelton Harrison Fund purchase

Little Lion, 1958, 60-56-17, Thomas Skelton Harrison Fund purchase

Absalom, 1959, 61-43-7, Charles M. Lea Prize, Invitational Competitive Exhibition, gift of The Print Club

Colossus, 1959, 60-56-13, Thomas Skelton Harrison Fund purchase

Horse I, 1959, 60-56-16, Thomas Skelton Harrison Fund purchase

Job, 1959, 59-36-5, Eugenia F. Atwood Prize, 33rd Annual Exhibition of Woodcuts and Wood Engravings, gift of The Print Club

Prometheus, 1959, 60-63-1, Philadelphia Museum of Art Prize, 37th Annual Exhibition of Etching and Engraving, gift of The Print Club

Adam Kadmon, 1960, 65-95-109, Lola Downin Peck Fund purchase from the Carl and Laura Zigrosser Collection [trial proof]

**National Museum of American Art, Smithsonian
Institution, Washington, DC.**

"They Also Serve," 1974.38.36, gift of Jean Nichols
[as *Untitled (Church)*]

Girl Without Violin, 1974.38.35, gift of Jean Nichols

Solomon Cucumber, 1967.72.136, transfer from the
Washington, DC Public Library

The Fisherman, 1940, 1967.72.138, transfer from the
Washington, DC Public Library

Woman in Red Jacket, 1940, 1967.72.137, transfer from
the Washington, DC Public Library

Lake Summer Steamers, 1941, 1974.38.34, gift of
Jean Nichols [as *Lake Summer*]

Trio, 1949, 1973.24.6, museum purchase

Cathedral No. 2, 1967.107.1, museum purchase
[as *The Cathedral II*]

Labyrinth, 1955, 1973.24.5, museum purchase

Hawk, 1961, 1965.49, museum purchase

Ikaros, 1961, 1973.89.1, gift of the Tamarind
Lithography Workshop, Inc.

Patriarch, 1961, 1973.89.2, gift of the Tamarind
Lithography Workshop, Inc.

Red Beast, 1961, 1966.44, museum purchase

Red Beast, 1961, 1976.108.72, gift of the Woodward
Foundation

Three Generals, 1961, 1973.89.3, gift of the Tamarind
Lithography Workshop, Inc.

Three Generals, 1961, 1976.108.73, gift of the
Woodward Foundation

Blind Joy, 1968, 1970.264.4, gift of Arthur Y. Schulson
[as *Untitled*]

General, 1970, 1972.105.6, gift of Dr. Christopher A.
Graf and Janet Graf

Long Beaked Bird, 1970, 1972.105.5, gift of
Dr. Christopher A. Graf and Janet Graf

Double Portrait of the Artists, 1971, 1972.105.7, gift of
Dr. Christopher A. Graf and Janet Graf [as *Janis
Joplin and Mies van der Rohe*]

The New York Public Library

Bull Fight, 1949

Fishermen, 1949

Trio, 1949

A Season in Hell, 1951

[Exhibition announcement], 1951

Chicken, 1953

Phoenix, 1953

Warrior Jagatai, 1954

Bird Catcher, 1954 [dated 1956]

Cathedral I/Notre Dame, 1954 [as *Cathedral II*]

Processional, 1955

Bird, 1956

Horseman, 1957

Three Kings, 1957 [small]

Patriarch, 1961 [as *Patriarch II*]

Three Generals, 1961

Three Kings, 1962

Laughing Man, 1963

The City, 1965

General, 1970, gift of Dr. Christopher A. Graf and
Janet Graf, 1972

Long Beaked Bird, 1970, gift of Dr. Christopher A. Graf
and Janet Graf, 1972

Two Birds, 1970

Double Portrait of the Artists, 1971, gift of Dr.
Christopher Graf and Janet Graf, 1972 [as
Untitled [Janis Joplin and Mies van der Rohe)]

Northern Illinois University Art Museum, DeKalb

Woman, 1961, gift of Mel Pfaelzer [artist's proof, as
Figure]

Lady Madonna II, gift of Dr. Philip Falk [as *Cyclist*]

General, 1970, gift of Dr. Philip Falk

General, 1970, gift of Dr. Frederick Nause and Dr.
Christopher Graf

Long Beaked Bird, 1970, purchased with funds donated
by Dr. Frederick Nause and Dr. Christopher Graf

Double Portrait of the Artists, 1971, purchased with
funds donated by Dr. Frederick Nause and
Christopher Graf [as *Untitled (Janis Joplin with
Mies van der Rohe Double Portrait)*]

Norton Simon Museum, Pasadena, CA.

Man, 1961, Third Biennial Print Exhibition Purchase
Award, 1962 [as *Man II*]

Musée National de Varsovie, Poland

What Am I Doing Here?, 1969

Museum Boijmans Van Beuningen, Rotterdam

Death Rides a Dark Horse, 1949, MB.1965/111, gift of
the artist

Baron von Z, 1960, MB.1965/109, museum purchase

Large Bird, 1965, museum purchase

**Museum of American Art of The Pennsylvania Academy of
the Fine Arts, Philadelphia**

Requiem, 1963, 1965.12, Lambert Fund purchase

**Museum of American History, Smithsonian Institution,
Washington, DC.**

Kabuki Samurai, 1954

Museum of Art, Rio de Janeiro

Tiger, 1949

**Museum of Art and Archaeology, University of Missouri-
Columbia**

Double Portrait of the Artists, 1971 [as *Untitled (Janis
Joplin and Mies van der Rohe)*]

Museum of Contemporary Art, Chicago

Blind Joy, 1968

Museum of Fine Arts, Boston

Tiger, 1949, 54.889, gift of W.G. Russell Allen

Museum of Fine Arts, Springfield, MA.

General, 1970

Museum of Modern Art, New York

Fishermen, 1949, 95.56, gift of Abby Aldrich
Rockefeller (by exchange)

Tiger, 1949, 433.49, Spaeth Foundation

Trio, 1949, 49.57, gift of Mrs. B.J. Garfunkel

Warrior Jagatai, 1953, 96.56, Abby Aldrich Rockefeller
Fund (by exchange)

Processional, 1955, 94.56, anonymous gift

General, 1957, 515.63, gift of Dr. Henry Allen Moe

Absalom, 1959, 156.60, gift of Mrs. Donald B. Straus

The following 19 Tamarind impressions are the gift of
Kleiner, Bell & Co:

Beast, 1961, 897.67

Black Beast, 1961, 884.67

Figure, 1961, 891.67

Figure, 1961, 896.67

Giant, 1961, 898.67

Grand Canyon, 1961, 892.67

Head, 1961, 883.67

Landscape, 1961, 893.67

Patriarch, 1961, 887.67

Patriarch II, 1961, 881.67

Procession, 1961, 888.67

Red Beast, 1961, 882.67

Simon, 1961, 894.67

Soldiers, 1961, 889.67

Spotted Beast, 1961, 890.67

Stranger, 1961, 885.67

Stranger II, 1961, 886.67

Three Generals, 1961, 895.67

Woman, 1961, 899.67

Ikaros, 1961, 340.73, gift of Tamarind Lithography
Workshop

Patriarch, 1961, 341.73, gift of Tamarind Lithography
Workshop

Three Generals, 1961, 342.73, gift of Tamarind
Lithography Workshop

Blow Up Your Balloon and Tie with an E, 537.76, Janet
K. Ruttenberg Fund

National Bezalel Museum, Jerusalem

Sleeping Soldier, 1951

National Gallery of Victoria, Melbourne, Australia

Tiger, 1949

National Museum, Stockholm

Three Visitors with Entourage, 1952

Hostile Landscape, 1953

Red Beast, 1961, M.69.79.15, gift of the Michael and
Dorothy Blankfort Tamarind Collection through
the Contemporary Art Council

Simon, 1961, M.64.53.25, gift of Mr. and Mrs. Michael
Blankfort through the Contemporary Art Council

Soldiers, 1961, M.62.44.49, gift of the Michael and
Dorothy Blankfort Tamarind Collection

Spotted Beast, 1961, M.64.53.22, gift of Mr. and Mrs.
Michael Blankfort through the Contemporary Art
Council

Stranger, 1961, M.65.70.18, gift of Michael and
Dorothy Blankfort

Stranger II, 1961, M.65.70.19, gift of Michael and
Dorothy Blankfort

Three Generals, 1961, M.64.53.26, gift of Mr. and Mrs.
Michael Blankfort through the Contemporary Art
Council

Woman, 1961, M.69.79.17, gift of the Michael and
Dorothy Blankfort Tamarind Collection through
the Contemporary Art Council

Madison Art Center, Madison, WI.

Law, 1964 [as *Cop*, dated 1965], 73.0.29, museum
purchase

Double Portrait of the Artists, 1971 [as Untitled (Janis
Joplin and Mies van der Rohe)], 78.15.9, gift of
Dr. and Mrs. Christopher A. Graf

Mednarodni Grafični Likovni Center, Ljubljana

General, 1957, 2206/G, transfer from Moderna
Galerija Collection

Goliath, 1959, 2207/G, transfer from Moderna Galerija
Collection

Memorial Art Gallery, University of Rochester, NY.

Kabuki Samurai, 56.54, Marion Stratton Gould Fund

Memphis Brooks Museum of Art, Memphis, TN.

Tiger, 1949, 53.10, Brooks Memorial Art Gallery
purchase

Lion, 1957, 60.1, Memphis Park Commission purchase

Metropolitan Museum of Art, New York

Lucy, 1940, 43.47.326, gift of the W.P.A.

Processional, 1955, 56.655, gift of the artist

Three Kings, 1957 [on Horseback], 57.674, gift of the
artist

Three Kings, 1962, 1962.716, gift of the artist [as
Untitled (Three Figures)]

Milwaukee Art Museum, Milwaukee, WI.

John Brown, 1939, M1943.193, loan to MAI from
Milwaukee Public Museum; allocated to MPM by
Federal Works Agency, Works Projects
Administration Art Program

Phoenix, 1953, M1972.7, gift of Mrs. William D. Vogel

Costumed Figure, 1957, M1991.384, gift of Mary and
John Gedo

Blind Joy, 1968 [as *Untitled*], M1991.492, gift of Mary
and John Gedo

**Montclair State University Art Galleries, Upper
Montclair, NJ.**

Cathedral No. 3, 1954 [as *Cathedral I*]

Monterey Museum of Art, Monterey, CA.

Lake Summer Steamers, 1941, 89.37, gift of Captain
John B. Robertson, USN (Ret.) [as *Lake Summer*]

Kabuki Samurai, 1954, 81.63, gift of Cdr. and Mrs.
Richard Rodriguez

Imaginary Ancestor, 1957, 96.169 [dated 1959]

Little Lion, 1958, 96.171 [as *Gold Lion*]

Hawk, 1961, 96.168 [dated 1963]

Eight, 1977, 96.170

Mulvane Art Museum, Washburn University, Topeka, KS.

Woman in Red Jacket, 1940, 43-33-26

General, 1970, 73-33-322, gift of Drs. Graf and Nause

Long Beaked Bird, 1970, 73-33-321, Gift of Drs. Graf
and Nause

Double Portrait of the Artists, 1971, 73-33-299, gift of
Drs. Graf and Nause [as *XXII*]

Musée d'Art Moderne, Paris

Bull Fight, 1949

Fishermen, 1949, Pennell Fund [as *Fisherman*, dated 1950]

Tiger, 1949, Pennell Fund

Mountain Climber, 1950, Pennell Fund [dated 1951]

Sea Study, 1952, Pennell Fund [dated 1953]

Three Visitors with Entourage, 1952, Pennell Fund [dated 1953]

Cathedral I/Notre Dame, 1954 [as *(New Year's Card)*, dated 1958?]

Processional, 1955, gift

Bird, 1956, gift of the artist

Florentine Figure, 1956, Pennell Fund

Horseman, 1957, Pennell Fund

Imaginary Ancestor, 1957, Pennell Fund

My Grandfather's Mustache, 1957, Pennell Fund

My Other Ancestor, 1957, Pennell Fund [as *Imaginary Other Ancestor*]

The City, 1957, Pennell Fund

Three Kings, 1957, Pennell Fund

Three Kings, 1957 [on Horseback], gift

General, 1957, Pennell Fund

Little Lion, 1958, Pennell Fund

Margaret, 1958, Pennell Fund [dated 1959]

Oedipus, 1958, Pennell Fund [dated 1959]

Sigmund, 1958, Pennell Fund [dated 1959]

Stefan, 1958, Pennell Fund [as *Stephan*]

Absalom, 1959, Pennell Fund

Horse as a Constellation, 1959, Pennell Fund

Horse I, Pennell Fund

Job, 1959, Pennell Fund

Prometheus, 1959, Pennell Fund

Baron von Z, 1960, Pennell Fund

Figure, 1961, Pennell Fund [as *Prophet*]

Giant, 1961, Pennell Fund

Hawk, 1961, Pennell Fund

Man, 1962, Pennell Fund

Three Generals, 1962, Pennell Fund

G.B., 1963, Pennell Fund

Requiem, 1963, Pennell Fund

Figure, 1968, 69-37, Pennell Fund

General, 1970, 73-20, gift

Long Beaked Bird, 1970, 73-20, gift

Long Beaked Bird, 1970, 72-16, Pennell Fund

Double Portrait of the Artists, 1971, 73-20, gift [as *Untitled (Janis Joplin and Mies)*]

Blue Rainbow, 1974, 76-9, Pennell Fund

Autobiographical Print: Norsk Biennale, 1977, 3-78, Pennell Fund

Black Warrior Basin, 1980, DLC/PP-1981:56

Los Angeles County Museum of Art

A Season in Hell, 1951, 58.33.1, Los Angeles County Funds purchase

Three Kings, 1957, P.316.58-2, Los Angeles County Funds purchase

Beast, 1961, M.64.53.27, gift of Mr. and Mrs. Michael Blankfort through the Contemporary Art Council

Beast, 1961, M.62.51.2, gift of Bohuslav Horak [cancellation proof]

Black Beast, 1961, M.62.44.50, gift of the Michael and Dorothy Blankfort Tamarind Collection

Figure, 1961, M.64.53.23, gift of Mr. and Mrs. Michael Blankfort through the Contemporary Art Council

Figure, 1961, M.62.44.52, gift of the Michael and Dorothy Blankfort Tamarind Collection

Giant, 1961, M.69.79.16, gift of the Michael and Dorothy Blankfort Tamarind Collection through the Contemporary Art Council

Giant, 1961, M.62.51.1, gift of Bohuslav Horak [cancellation proof] .

Grand Canyon, 1961, M.62.44.51, gift of the Michael and Dorothy Blankfort Tamarind Collection

Head, 1961, M.65.70.22, gift of Michael and Dorothy Blankfort [through the Contemporary Art Council]

Landscape, 1961, M.64.53.24, gift of Mr. and Mrs. Michael Blankfort through the Contemporary Art Council

Patriarch, 1961, M.65.70.20, gift of Michael and Dorothy Blankfort

Patriarch II, 1961, M.65.70.21, gift of Michael and Dorothy Blankfort

Procession, 1961, M.63.44.48, gift of the Michael and Dorothy Blankfort Tamarind Collection

Honolulu Academy of Arts

Processional, 1955, 16,592, purchase

Man, 1961, 16,594, purchase

Two Generals, 1965, 16,593, purchase

Little Triumph Wagon, 1968, 16,591, purchase [as *Small Triumph Wagon*]

Blue Labyrinth, 1979, 17,554, gift of Mr. Kei-Pak Lo, 1980 [as *Labyrinth*]

Illinois State Museum, Springfield

Trio, 1949

Conference, 1965

Blind Joy, 1968

What Am I Doing Here?, 1969

Indiana University Art Museum-Bloomington

The Park is a Lonely Place This Day, 1942, 92.46

The Last General, 1961, 63.162 [as *Head*]

Indiana University-Kokomo

Large Bird, 1965

Transformations, 1992

Indianapolis Museum of Art

The City, 1945, 49.46-d [as woodcut, dated 1949]

General, 1970

Long Beaked Bird, 1970

Double Portrait of the Artists, 1971 [as *Untitled (Mies van der Rohe and Janis Joplin)*]

Kalamazoo Institute of Arts, Kalamazoo, MI.

Sleeping Soldier, 1951 [dated 1950], 1964/5.722, museum purchase

Street Scene, 1964 [dated 1965], 1964/5.723, museum purchase

Baron von Z., 1960 [as *Baron von L.*], 1965/6.52, museum purchase

John Michael Kohler Arts Center, Sheboygan, WI.

General, 1970

Long Beaked Bird, 1970

Double Portrait of the Artists, 1971 [as *Untitled (Janis Joplin and Mies van der Rohe)*]

Kokomo-Center Township Consolidated School Corporation, Kokomo, IN.

Wildcat, 1964

Kokomo-Howard County Public Library, Hoosier Art Collection, Kokomo, IN.

The Cello Player, 1940, given in memory of David and Geraldine Wood by their son, Joe Mike Wood

Tiger, 1949, gift of the artist in honor of Anna and Jacob Kohn

A Friend of the Family, 1965, gift of the artist in honor of Anna and Jacob Kohn

Dark Bird, 1970, gift of the artist in honor of Anna and Jacob Kohn

Letter from Japan, 1989, gift of the artist in honor of Anna and Jacob Kohn

Krannert Art Museum and Kinkead Pavilion, Champaign, IL.

"They Also Serve," 1939, 43-04-220, [as *The People*]

Portrait of Franz Biberkopf, 1940, 43-04-219 [as *Franz Biberkoph*]

Wasteland, 1940, 43-04-221

Man with a Pipe, 1941, 43-04-498

Phoenix, 1953, 56-08-001

Lakeside Gallery, Lakeside, MI.

Processional, 1955

Law, 1964, 1-21-8

The Lottery, 1965 [artist imp], 1-19-8

End Game, 1968 [1st trial proof], 1-9-8 [as *End Game II*]

Lady Madonna, 1968, 1-13-8

Laocoon, 1968, 1-12-8 [as *"Lacoon"*]

Also 1-28-0

Reflections, 1968, 1-14-8

General, 1970

Long Beaked Bird, 1970

Long Beaked Bird, 1970 [as *Bird with a Long Beak*]

Double Portrait of the Artists, 1971 [as *Mies van der Rohe with Janis Joplin*]

Library of Congress, Washington, DC.

Survivors, 1943, gift

Bull Fight, 1949, Pennell Fund

The College Board, New York

3-8-5, 1977

Step Garden, 1977

Columbia Museum of Art, Columbia, SC.

Official, 1967, 1968.13, museum purchase

Coos Art Museum, Coos Bay, OR.

Trio, 1949

General, 1957 [II state, dated 1959]

Long Beaked Bird, 1970

Corning Museum of Glass, Corning, NY.

The Glass Blower, 1950, museum purchase

Dallas Public Library

General, 1957

Davidson College Art Gallery, Davidson, NC.

General, 1970, gift of Dr. Frederick P. Nause

Long Beaked Bird, gift of Dr. Christopher A. Graf

Double Portrait of the Artists, 1971, gift of Lakeside
 Studio [as *Janis Joplin and Mies van der Rohe*]

Davison Art Center, Wesleyan University, Middletown, CT.

Three Visitors with Entourage, 1952

Labyrinth, 1955

Horse I, 1959

Des Moines Art Center

Trio, 1949, 56.7, James D. Edmundson Fund
 [dated 1950]

Kabuki Samurai, 1954, 1994.221, John C. Huseby Print
 Collection, through bequest [as *Kabuki*]

Tiger, 1963, 64.2, anonymous gift

Detroit Institute of Arts

Three Kings, 1957, 59.416, Founders Society Purchase,
 Elizabeth P. Kirby Fund

Woman, 1961, 64.64, Founders Society Purchase,
 Director's Discretionary Fund

Elvehjem Museum of Art, University of Wisconsin-Madison

Florentine Figure, 1956, 60.3.6, University Fund
 purchase

The City, 1957, 60.3.7, University Fund purchase

The Last General, 1961, 69.34.1, gift of James S.
 Watrous [as *Head of a General*]

Fogg Art Museum, Harvard University, Cambridge, MA.

Fishermen, 1949, M13194, gift of Meta and
 Paul J. Sachs

Uncle V., 1958, M13654, purchase

Three Kings, 1962, 0095.1994.0000, anonymous loan
 [as *New Year's Card*]

Fort Wayne Museum of Art, Fort Wayne, IN.

General, 1970, 1987.12, gift of
 Mr. and Mrs. Tom McClain

The Free Library of Philadelphia

Sleeping Soldier, 1951

Cathedral I/Notre Dame, 1954 [as *Cathedral No. 3*]

Lion, 1957

Figure with a 5, 1963

Georgetown University, Washington, DC.

Sleeping Soldier, 1951

Processional, 1955 [dated 1956]

Florentine Figure, 1956

Figure with a 5, 1963

Mob, 1963 [incorrectly dated 1955 by the artist]

Mod, 1965

Portrait of L, 1965 [dated 1967]

Two Figures (I), 1968

Greater Lafayette Museum of Art, Lafayette, IN.

Patriarch, 1962 [dated 1963], 95.22, gift of Professor
 and Mrs. Edward Stowe Akeley

John Simon Guggenheim Memorial Foundation, New York

Kabuki Samurai, 1954 [as *Kabuki*]

Tiger, 1963

Hamilton College, Clinton, NY.

Mountain Climber, 1950

Allen R. Hite Art Institute, University of Louisville, KY.

Oma, 1960

Death Rides a Dark Horse, 1949, gift of the U.S. Embassy, 1956

Fishermen, 1949, purchased from the artist, 1950

Trio, 1949, purchased from the artist, 1950

The Glass Blower, 1950, gift of the artist, 1953

Sleeping Soldier, 1951, purchased from the artist, 1953

Hostile Landscape, 1953, gift of the artist, 1953

Processional, 1955, gift of Valery-Radot, 1956

Imaginary Ancestor, 1957, purchased from the artist, 1965

Three Kings, 1957, gift of the artist, 1965

General, 1957, purchased from the artist, 1965

Oedipus, 1958, purchased from the artist, 1965

The Last General, 1961, purchased from the artist, 1965 [dated 1962]

Requiem, 1963, gift of the artist, 1965 [dated 1965]

Antique Personage, 1964, purchased from the artist, 1965 [dated 1965]

Two Generals, 1965, purchased from the artist, 1965

Mary and Leigh Block Gallery, Northwestern University, Evanston, IL.

Walking Figure, 1963, gift of Neva Krohn [as *Walking Man*]

Boston Public Library

Death Rides a Dark Horse, 1949

Fishermen, 1949 [as *Fisherman*, dated 1950]

Tiger, 1949

The Glass Blower, 1950

Sea Study, 1952 [dated 1953]

Three Visitors with Entourage, 1952 [dated 1953]

Processional, 1955, gift of the artist

Bird, 1956 [as Untitled]

Florentine Figure, 1956, Purchase Prize Award, Boston Printmakers Annual Exhibition

Horseman, 1957

Three Kings, 1957

Stefan, 1958 [as *Stephan*]

Horse I, 1959

Horse as a Constellation, 1959

Three Kings, 1962 [as *New Year's Greeting*]

Double Portrait of the Artists, 1971 [as *Mies and Janis*]

Bowdoin College Museum of Art, Brunswick, ME.

Phoenix, 1968, 1969.50, Helen Johnson Chase Fund purchase

General, 1970, 1972.62.12, gift of Dr. and Mrs. Christopher A. Graf

Long Beaked Bird, 1970, 1972.62.11, gift of Dr. and Mrs. Christopher A. Graf

Double Portrait of the Artists, 1971, 1972.62.3, gift of Dr. and Mrs. Christopher A. Graf [as *Untitled (Janis Joplin and Mies van der Rohe)*]

The Brooklyn Museum, Brooklyn, NY.

Death Rides a Dark Horse, 1949, 50.27, Purchase Prize Award, The Brooklyn Museum Fourth National Print Annual Exhibition

The Glass Blower, 1950, 51.42, Purchase Prize Award, The Brooklyn Museum Fifth National Print Annual Exhibition

Lion, 1957, 85.187.27, gift of IBM Gallery of Art and Science

End Game, 1968, 68.112, Purchase Prize Award, The Brooklyn Museum 16th National Print Annual Exhibition

Bucknell University, Lewisburg, PA.

Double Portrait of the Artists, 1971

California State University-Fullerton

General, 1970, CSUF 35, gift of the Patrons of the Library

Long Beaked Bird, 1970, CSUF 33, gift of the Patrons of the Library

Double Portrait of the Artists, 1971, CSUF 34, gift of the Patrons of the Library [as *Untitled (Janis Joplin and Mies van der Robe)*]

Cincinnati Art Museum

Horse I, 1959, 1960.425, The Edwin and Virginia Helm Irwin Memorial, purchase

Cleveland Museum of Art

Bull Fight, 1949, 1963.596, anonymous gift

Baron von Z, 1960, 1963.595, anonymous gift

Lake Summer Steamers, 1941, 814a–c.1943

Man with a Pipe, 1941, 817.1943

Marionette Dance, 1947, 48.652, gift of the Town and Country Arts Club, purchase prize

Death Rides a Dark Horse, 1949, 59.30, gift of the artist in memory of Dr. Matthew Taubenhaus

The Glass Blower, 1950, 59.31, gift of the artist in memory of Dr. Matthew Taubenhaus

Sleeping Soldier, 1951, 51.126, Pauline Palmer Purchase Prize from the Chicago Artists Exhibition

Horseman, 1957, 1959.29, gift of the artist in memory of Dr. Matthew Taubenhaus

Lion, 1957, 59.14, Pauline Palmer Purchase Prize, 62nd Annual Exhibition by Artists of Chicago and Vicinity

My Other Ancestor, 1957, 61.354, The Contemporary Print Fund

Sigmund, 1958, 1977.28, gift of Philip Pinsof

Adam Kadmon, 1960, 61.353 [artist's proof]

Giant, 1961, 1962.584

The following 18 Tamarind impressions are a gift of Burt Kleiner:

Beast, 1961, 63.1561

Black Beast, 1961, 63.1553

Figure, 1961, 63.1555

Figure, 1961, 63.1560

Giant, 1961, 63.1562

Grand Canyon, 1961, 63.1557

Head, 1961, 63.1552

Patriarch, 1961, 63.1556

Patriarch II, 1961, 63.1550

Procession, 1961, 63.1546

Red Beast, 1961, 63.1551

Simon, 1961, 63.1558

Soldiers, 1961, 63.1547

Spotted Beast, 1961, 63.1554

Stranger, 1961, 63.1548

Stranger II, 1961, 63.1549

Three Generals, 1961, 63.1559

Woman, 1961, 63.1563

Patriarch, 1962, 1963.69, gift of the Print and Drawing Club [plus six additional impressions]

Fallen Figure, 1963, 64.282, gift of Martha Dickinson [as *Figure*]

Mod, 1965, 1966.195

Dark Bird, 1970, 1971.359, Print and Drawing Club Fund

Double Portrait of the Artists, 1971, 1972.1039, Print and Drawing Club Fund [as *Untitled (Janis Joplin and Mies van der Rohe)*]

Disappearing 8 (II), 1975, 1976.422, gift of the artist

Aging Artist, 1976, 1980.118, gift of the artist

Numbers, 1979, 1980.119, gift of the artist

Black Warrior Basin, 1980, 1980.93, gift of Howard G. Haas

Baltimore Museum of Art

Exile, 1939, L.1943.9.225, United States General Service Administration deposit

John Brown, 1939, L.1943.9.226, United States General Service Administration deposit

Girl Without Violin, 1940, L.1943.9.258, United States General Service Administration deposit

Tiger, 1949, 59.118, museum purchase

Three Generals, 1962, 62.112, museum purchase

General, 1970, 72.80.12, gift of Dr. and Mrs. Christopher Graf

Long Beaked Bird, 1970, 72.80.11, gift of Dr. and Mrs. Christopher Graf

Double Portrait of the Artists, 1971, 72.80.1, gift of Dr. and Mrs. Christopher Graf [as *Untitled (Janis Joplin and Mies van der Rohe)*]

David Winton Bell Gallery, Brown University, Providence, RI.

Three Visitors with Entourage, 1952, Department of Art purchase [as *Three Visitors with Entourage from a Friendly Country*]

Bibliothèque Nationale de France, Departement des Estampes et de la Photographie, Paris

Bull Fight, 1949, purchased from the artist, 1950

Public Collections

Academia de Artes, Mexico City

Blue Rebozo, #2165 [as *Cabeza de Mujer*]

Bull, 1944, #2163 [as *The Wounded Bull "Toro,"* linoleum cut]

Bull Fight, 1944 [as *Toreando*, dated 1949]

Mexican Landscape, 1944, #2169 [as *Paisaje*, black only]

Mexican Landscape, 1944, #2167 [as *Paisaje*, two-color]

Mexican Woman, 1944, #2168 [as *Indígena*]

Seated Woman, 1944, #2166 [as *Mujer Sentada*]

Two Mexican Women, 1944, #2162 [as *Dos Indígenas*]

The Achenbach Foundation for Graphic Arts, The Fine Arts Museums of San Francisco

Death Rides a Dark Horse, 1949, 1965.68.16, purchase

Figure, 1961, 1964.146.2, gift of Wesley Chamberlain [as *Man*]

Patriarch, 1962, 1964.147.1, gift of the Print and Drawing Club of the Art Institute of Chicago [dated 1963]

General, 1970, 1972.56.11, gift of Dr. and Mrs. Christopher A. Graf in memory of Dr. E. Gunter Troche

Long Beaked Bird, 1970, 1972.56.10, gift of Dr. and Mrs. Christopher A. Graf in memory of Dr. E. Gunter Troche

Double Portrait of the Artists, 1971, 1972.56.12, gift of Dr. and Mrs. Christopher A. Graf in memory of Dr. E. Gunter Troche [as *Vladimir Nabokov and Janis Joplin*]

Graffiti, 1983, 1983.1.40, gift of the Graphic Arts Council

Ackland Art Museum, University of North Carolina-Chapel Hill

Lion, 1957, 58.2.162, gift of Dr. W.P. Jacocks

Little Baron, 1963, 70.24.2, Ackland Fund purchase

General, 1970, 72.42.8, gift of Dr. Christopher A. Graf and Janet Graf

Long Beaked Bird, 1970, 72.42.7, gift of Dr. Christopher A. Graf and Janet Graf [as *Long Bearded Bird*]

Double Portrait of the Artists, 1971, 72.42.9, gift of Dr. Christopher A. Graf and Janet Graf

Albion College, Albion, MI.

Prometheus, 1953, 1955.36, museum purchase

Three Kings, 1957

Patriarch, 1962, 1963.314, gift of the Print and Drawing Club, Art Institute of Chicago

Fallen Figure, 1963

Allegheny College, Meadville, PA.

Sleeping Soldier, 1951, #256, gift of the class of 1952, purchase

Art Institute of Chicago

"They Also Serve," 1939, 56.635, gift of Shapiro
Also 913.1943 [as *Church*]
459.1943 [as *Worshippers*]
1940.1265 [as *The People*]

Exile, 1939, 1940.1262, anonymous gift
Also 469.1943
828.1943 [incorrectly identified as lithograph]

John Brown, 1939, 460a–b.1943

Girl Without Violin, 1940, 463.1943

Going Home, 1940, 1940.1263

Lucy, 1940, 1940.1266
Also 462.1943 [as *Lucey*]

Portrait of Franz Biberkopf, 1940, 823.43 [black only]
Also 465.43
466.43
1940.1264

Pursuit of Freedom, 1940 [full set of 14 chapter plates plus two frontispieces, unaccessioned]

The Cello Player, 1940, 464.1943

The Fisherman, 1940, 1940.1261

Untitled [Four Workmen in a Factory], 1940, 1940.1273

Untitled [Horse-Drawn Cart], 1940, 1940.1274

Untitled [Schniewind Card], c. 1940 (2), unaccessioned

Untitled [Three Workmen with Industrial Scene], 1940, 1940.1272

Untitled [Two Men in a Village Scene], 1940, 1940.1275

Untitled [Two Men in Top Hats], 1940, 1940.1270

Untitled [Workman's Family at Table], 1940, 1940.1271

Wasteland, 1940, 468.1943

Woman in Red Jacket, 1940, 467.1943

Arletty, 1941, 461.1943 [as *Ardality*]

"The 28th Annual Exhibition of Advertising Art."
Art Directors Club, Chicago

1989 *"Novija Američka Grafika."* Dom Kulture, Banja
Luka, Serbia. April

"Art and Ideas." Kalamazoo Institute of Arts, MI

1990 "Days of Yore and More: Former Directors of The
Print Club Select in Celebration of 75 Years."
Philadelphia Museum of Art. May 19–June 30

1990–91 "19th- and 20th-Century European and American
Prints from the Collection of the Honolulu
Academy of Arts."
Fukuoka Prefectural Museum of Art, Japan.
October 6–November 4, 1990
Navio Museum of Art. December 1–25
Museum of Fine Arts, Gifu.
January 5–February 11, 1991
Marui Imai, Sapporo. February 14–26
Naha Civic Hall. March 2–21

1991 "Selections from the Hoosier Art Collection of the
Kokomo-Howard County Public Library." Leah
Ransburg Art Gallery, University of
Indianapolis. January–February 1

1992–93 "Face It: Twentieth Century Portraits and Self-
Portraits." Museum of Art and Archaeology,
University of Missouri-Columbia.
December 19–February 21

1995 "Selections from the Print Collection of John C.
Huseby." Des Moines Art Center.
April 29–July 16

1996 "Generations: Chicago Prints and Printmakers."
Suburban Fine Arts Center, Highland Park, IL.
May 24–June 18

"Second Sight: Printmaking in Chicago 1935–1995."
Mary and Leigh Block Gallery, Northwestern
University, Evanston, IL.
September 27–December 8

1997 "International Print Exhibition." Portland Art
Museum. February 14–May 11

"Berkeley Salutes KALA." Berkeley Store Gallery.
May 23–June 30

"Prized Impressions: Gifts from The Print Center of
Philadelphia." Philadelphia Museum of Art.
July 12–September 14

"The Edward Stowe Akeley Collection." Greater
Lafayette Museum of Art.
September 20–November 16

1998 "Master Printmakers: Misch Kohn and Gabor
Peterdi." Rhode Island College, Bannister
Gallery. April

University of Wisconsin-Milwaukee. July 1–23
Southern Illinois University-Carbondale.
 August 20–September 23
University of Alabama-Birmingham.
 October 15–November 15
University of Arkansas-Fayetteville.
 February 11–29, 1980
A3A Gallery, Savannah, GA

1979 "Music in Prints." New York Public Library

1979–80 "The Boston Printmakers 32nd National
 Exhibition." DeCordova Museum.
 December 2–February 3

1979–81 "Prints: New Points of View." Traveling exhibition
 circulated by the Western Association of Art
 Museums

1980 "5th Hawaii National Print Exhibition." Honolulu
 Academy of Arts. February 9–March 23

"Diversions: Images of Entertainment and
 Amusement." Des Moines Art Center.
 April 28–June 24

"Illinois Prints from the Library of Congress."
 Illinois State Museum, Springfield

Group exhibition. University of Virginia-
 Charlottesville

1981 "21st Annual Exhibition of Editorial and
 Advertising Art." Artists Guild, Chicago

"14 Mednarodni Grafični Bienale." Moderna Galerija,
 Ljubljana

1981–82 "Twenty-Second Biennial National Print
 Exhibition." The Brooklyn Museum.
 November 3–February 3

1982 "New American Graphics 2." Madison Art Center,
 WI. March 13–April 25

1983 "6th Hawaii National Print Exhibition." Honolulu
 Academy of Arts. January 20–February 20

"The All-American Wood Engravers." Tahir Gallery,
 New Orleans. March 1–31

"After the Great Crash: New Deal Art in Illinois."
 Illinois State Museum, Springfield.
 April 3–May 29

"International Printmaking Invitational." Art
 Gallery, California State College-San Bernardino.
 April 20–May 27

California Palace of the Legion of Honor. May

1983–84 "Artists for Victory."
 Library of Congress. February 2–July 31, 1983
 Central Intelligence Agency Fine Arts
 Commission, McLean, VA.
 August 7–September 4
 U.S. Army Air Defense Museum, Fort Bliss, TX.
 September 25–October 23
 Mather Gallery, Case Western Reserve
 University, Cleveland, OH.
 November 1–December 11
 Lyndon Baines Johnson Library and Museum,
 Austin, TX. February 19–March 18, 1984
 Presidential Museum, Odessa, TX.
 April 8–May 6

1985 "Prints from Blocks 1900–1985: Twentieth Century
 American Woodcuts, Wood Engravings, and
 Linocuts." Associated American Artists Gallery,
 New York. April 24–May 31

1987 "A Survey of American Printmaking from the
 Collection of the Memorial Art Gallery of the
 University of Rochester." University of
 Rochester, NY. May 3–June 12

"Cream of California Prints." The Oakland
 Museum. May 8–September 27

1988 *"Hommage à Josefin."* Galerie 61, Klagenfurt, Austria.
 November 9–23

1976–78 "WPA/FAP Graphics." Smithsonian Institution
Traveling Exhibition Service
Timberline Lodge, Government Camp, OR.
May 1–30, 1976
Minnesota Historical Society, St. Paul.
August 7–September 5
Carl Solway Gallery, Cincinnati.
September 25–October 24
Concord College, Athens, WV.
November 13–December 12
Freedman Art Gallery, Albright College,
Reading, PA. January 1–30, 1977
Dulin Gallery of Art, Knoxville, TN.
April 9–May 8
College of Fine Arts, University of Texas-Austin.
May 28–June 26
Dalhousie University Art Gallery, Halifax, Nova
Scotia. July 16–August 14
Edward W. Root Art Center, Hamilton College,
Clinton, NY. September 3–October 1
Scottsdale Center for the Arts, AZ.
October 22–November 20
Rodman Hall Arts Centre, St. Catherines,
Ontario. December 10, 1977–January 8, 1978
Dane G. Hansen Memorial Museum Association,
Logan, KS. January 28–February 26
Charles B. Goddard Center for Visual and
Performing Arts, Ardmore, OK.
March 18–April 16
Historical Society of Delaware, Wilmington.
May 6–June 4
Art Gallery, Memorial University of
Newfoundland, St. John's. June 24–July 23

1976–77 "New Ways With Paper." National Collection
of Fine Arts, Washington, DC.
November, 1976–February 20, 1977

"The Art of Poetry." National Collection of Fine
Arts. November 19, 1976–January 23, 1977

"Twentieth Biennial National Print Exhibition: 30
Years of American Printmaking." The Brooklyn
Museum. November 20, 1976–January 30, 1977

"Contemporary Printmakers of the Americas."
Circulated by the Organization of American
States

1977 Gallery group exhibition. Jane Haslem Gallery.
May

"25th National Exhibition of Prints." Library of
Congress/National Collection of Fine Arts.
May 27–September 18

"Graphica Contemporanea Americana." Galleria
Bevilacqua La Masa, Venice.
September 21–October 5

"World Print Competition 77." San Francisco
Museum of Modern Art. Circulated through
the Smithsonian Institution Traveling Exhibition
Service

c. 1977 "American Prints of the 40's." Jane Haslem Gallery.
Through February 25

1977–82 Prints and illustrated books from the collection of
the Museum of Modern Art. The Hermitage,
Leningrad

1978–80 "The First National Invitational Color Blend
Print Exhibition."
Georgia Southern College, Statesboro.
April 2–30, 1978
Wharton School of Business, Philadelphia.
June 20–August 25
University Museum Cultural Center, University
of Mississippi-Oxford. September 1–28
Mississippi Museum of Art, Jackson.
October 6–29
Mint Museum, Charlotte, NC.
November 26–December 24
Appalachian State University-Boone, NC.
January 1–30, 1979
University of South Carolina-Columbia.
February 1–22
Augusta College, Augusta, GA. March 1–25
Agnes Scott College, Decatur, GA. April 8–29
Elmhurst College, IL. May 8–June 22

"Exposition du Club Des Laureates de Biennales Internationales de la Gravure." Kunsthalle Bremen, Germany, and other German cities

1973 "Contemporary American Graphics." State University of New York-Binghamton. Traveled to Institute of Soviet-American Relations, Moscow. June

"23rd National Exhibition of Prints." National Collection of Fine Arts, Washington, DC. September 21–November 25

"History of American Printmaking 1945–1965." Jane Haslem Gallery, Washington, DC. October

"American Painting and Graphics." Jane Haslem Gallery

1973–74 New acquisitions exhibition. California Palace of the Legion of Honor, San Francisco. December 1–January 13

1974 "149th Annual Exhibition." National Academy of Design, New York. February 23–March 16

"Colorado First National Print and Drawing Competition." Henderson Museum, University of Colorado-Boulder. May 5–June 5

"Composition in Black and White." Jane Haslem Gallery. October

"Los Angeles Printmaking Society 2nd National Exhibition." Otis Art Institute of Los Angeles County. October 3–November 10

"Artist Inspired—U.S. Grade A." Jane Haslem Gallery. November

c. 1974 "Modern Masters of Intaglio." Queens College, City University of New York. June 15–October 22

1975 Gallery group exhibition. Jane Haslem Gallery. January

Group exhibition of newly elected members' work. National Academy of Design Gallery, New York. April 8–9

"Prints California."
Oakland Museum. April 26–July 6
Contemporary Graphics Center of the Santa Barbara Museum of Art.
August 1–September 2

"Printmaking West." Utah State University Galleries, Logan. October–November 14

1975–77 "American Prints from Wood." Smithsonian Institution Traveling Exhibition Service
University of Maine-Augusta.
October 25–November 23, 1975
Northeast Missouri State University-Kirksville.
January 31–February 29, 1976
Monmouth Museum, Lincroft, NJ.
March 20–June 6
Elvehjem Art Center, Madison, WI.
August 14–October 31
Brunnier Gallery, Iowa State University-Ames.
November 20–December 19
Brooks Memorial Art Gallery, Memphis, TN.
January 8–February 6, 1977
Dulin Gallery of Art, Knoxville, TN.
February 26–March 27
Squires Art Gallery, Virginia Polytechnic Institute and State University, Blacksburg.
April 16–May 15
Niagara Council of the Arts, NY. June 4–July 3

1976 "American Prints 1913–1963." Leeds City Art Gallery, Great Britain. July 16–August 22

"Joseph Zirker: Monoprints/Misch Kohn: Prints." Smith Andersen Gallery, San Francisco. August 3–25

Postcard exhibition. Ohlone College, Fremont, CA

"Washington Print Club Members' Show." Washington, DC

c. 1976 "Artist's Proof/The Multiple Image." Fine Arts Museums of San Francisco Downtown Center. November–December 1

c. 1968 "Prints by Albert Christ-Janer, Misch Kohn, and
Gabor Peterdi." The Print Club, Philadelphia.
April 7–25

1968–69 "Sixteenth Biennial National Print Exhibition: Two
Decades of American Prints 1947–1968."
The Brooklyn Museum. October 29, 1968–
January 26, 1969

"The Scope of Lithography: Tamarind Lithography
Workshop, 1960–68." San Francisco Museum of
Modern Art

1969 "The 164th Annual Exhibition of Watercolors,
Prints, and Drawings." Pennsylvania Academy
of the Fine Arts

"Art Under the New Deal." Columbia Museum of
Art, SC. February 12–March 10

"Toledo Collectors of Modern Art." Toledo Museum
of Art, OH. March 9–April 6

"*8 Mednarodna Grafična Razstava*." Moderna Galerija,
Ljubljana. June 6–August 31

Group exhibition: city views. New York Public
Library. Fall

International invitational graphic art exhibition.
Florence

1970 Group exhibition: Lakeside Gallery. Southern
Nevada State University. January

"Contemporary American Prints." Krannert Art
Museum, Champaign, IL. February 8–March 1

"*III Miedzynarodowe Biennale Grafiki*." Cracow.
Opening May 29

"*XXXV Biennale*." Venice

1971 "21st National Exhibition of Prints." Sheldon
Memorial Art Gallery, University of Nebraska-
Lincoln. January 17–February 14

"*9 Mednarodna Grafična Razstava*." Moderna Galerija,
Ljubljana. June 5–August 31

1971–74 "Beyond Illustration: The Art of Playboy."
Rotonda della Besana, Milan.
September 10–October 10, 1971
Royal College of Art, London.
November 17–December 12
Koninklijk Museum voor Schone Kunsten,
Belgium. January 8–February 6, 1972
Gemeentemuseum, Arnhem, The Netherlands.
February 26–April 9
Malkasten, Düsseldorf, Germany. May 18–June 8
Neue Galerie Im Altenkurhaus, Aachen,
Germany. July 1–August 27
Kunstverein München, Munich.
September 29–October 29
Musée des Arts Decoratifs, Lausanne.
November 22, 1972–January 8, 1973
Central Museum of Art, Tokyo.
February 13–March 11
Umeda Kindai Museum, Osaka.
March 15–April 8
Bunka Kaikan, Fukuoka. May 15–26
Lowe Art Museum, University of Miami, FL.
July 25–September 9
New York Cultural Center. January 2–30, 1974
Los Angeles Municipal Museum.
March 26–April 28
Syntex Art Gallery, Palo Alto, CA.
May 19–July 15

1972 "The California Society of Printmakers National
Print Exhibition." Richmond Art Center.
March 30–April 30

Group exhibition. Alliance for the Visual Arts,
University of Utah-Salt Lake City. April

"*Ibizagrafic*: First Biannual International Graphic
Arts Exhibition." Museum of Contemporary Art,
Ibiza, Spain. May 21–October

"First Norwegian International Print Biennale."
Fredrikstad. Opening August 11

"VI Mednarodna Grafična Razstava." Moderna
Galerija, Ljubljana. Opening June 19

"14 Artists." Illinois State Museum, Springfield.
October 30–December 31

Group exhibition. Everson Art Museum, NY.

Group exhibition. Franklyn Siden Gallery, Detroit

Group circulating exhibition of modern religious
works. Museum of Modern Art

c. 1965 *"Moderne Maler Aus Chicago."* U.S. Information
Service

1966 "Fifteenth Biennial National Print Exhibition." The
Brooklyn Museum. January 31–May 29

Recent etchings and lithographs. Contemporary
Prints and Drawings Gallery, Chicago.
February–March 5

"Northwest Printmakers 37th International
Exhibition."
Seattle Art Museum. February 15–April 3
Portland Art Museum. April 10–May 10

"Contemporary American Prints." IBM Gallery,
New York. March 14–April 2

"Ecumenical Art." St. Benet Gallery, Chicago.
March 27–April 23

"69th Exhibition by Artists of Chicago and
Vicinity." Art Institute of Chicago. April 1–May 1

"Seventh Annual Religious Art Show." Baptist
Graduate Student Center, Chicago.
April 17–May 7

"Kokomo Fine Arts Festival." April 28–May 4

"XYLON IV." Frankische Galerie, Zurich.
May 20–June 19. Continued to Mestna Galerija,
Ljubljana

"I Miedzynarodowe Biennale Grafiki." Cracow, Poland.
June

"Contemporary Graphic Art/USA." Centraal
Museum Utrecht, The Netherlands.
June 22–July 28. Circulated under the auspices
of the U.S. Embassy in Paris

"Printmaking U.S.A." Purdue University.
October 3–28

"The Art of Printmaking." Sheldon Memorial Art
Gallery, University of Nebraska-Lincoln.
October 11–21

1966–67 "Annual Exhibition 1966: Sculpture and Prints."
Whitney Museum of American Art.
December 16–February 5

1967 *"VII Mednarodna Grafična Razstava."* Moderna
Galerija, Ljubljana. June 3–August 31

1968 "71st Annual Exhibition by Artists of Chicago and
Vicinity." Art Institute of Chicago.
March 30–May 12

The Print Club exhibition. Associated American
Artists Gallery, New York. May

"American Printmaking 1670–1968." Guild Hall,
East Hampton, Long Island, NY.
July 20–August 11

"Art Expo." DeCordova Museum. September 20–22

"Graphic International." Wiener Secession, Vienna.
November

"Two American Printmakers: Misch Kohn and Adja
Yunkers." Grand Rapids Art Museum, MI.
November 3–December 1

"Contemporary Art for Young Collectors: 22nd
Annual Exhibit." Renaissance Society, University
of Chicago. December 1–22

"International Exhibition of Graphic Arts."
Florentine Union, Strozzi Palace, Florence.
December 1–31

"II Miedzynarodowe Biennale Grafiki." Cracow

"One Hundred and Fifty-Eighth Annual Exhibition
of Watercolors, Prints, and Drawings."
Pennsylvania Academy of the Fine Arts

c. 1963 "Black and White Exhibition." The Print Club,
Philadelphia. February 7–28

1963–68 "Graphic Arts—USA." Circulated by the
United States Information Agency
USSR: Alma Ata. October 5–November 1, 1963
Moscow. December 6, 1963–January 15, 1964
Yerevan. February 12–March 14
Leningrad. April 8–May 11
Rumania: Constanta. October 1–14
Ploesti. November 2–15
Bucharest. December 7–27
Czechoslovakia: Prague.
January 19–February 11, 1965
Bratislava. February 26–March 21
Poland: Cracow. February 3–17
Warsaw. March 5–26
Szcecin. April 6–20
Yugoslavia: Ljubljana. June 17–July 18
Belgrade. September 24–October 24
Continuing through 1967–68

1964 "30 Contemporary American Prints." IBM Gallery,
New York. February 17–March 13. Also traveled
throughout Europe via USIA

"Fourteenth Biennial National Print Exhibition."
The Brooklyn Museum. March 3–August 16

"Fifty Indiana Prints: Seventh Biennial Exhibition."
John Herron Art Museum. May 17–June 7

"American Art Today." New York World's Fair.
June 15–October 22

"Carl Zigrosser: Curatorial Retrospective."
Philadelphia Museum of Art.
September 21–November 1

"Juried Members Exhibition." The Print Club,
Philadelphia. December 4–24

"XYLON: International Invitational Woodcut
Exhibition." Zurich and Amsterdam

1964–66 "The Fabulous Decade: A Collection of Prints
of the 1950s."
Free Library of Philadelphia.
May 15–June 6, 1964
The Heckscher Museum, Huntington,
Long Island, NY. September 6–27
University Galleries, Southern Illinois
University, Carbondale.
October 10–November 1
Texas Christian University, Ft. Worth.
November 14–December 6
Huntington Galleries, WV. January 2–24, 1965
Flint Institute of Art, MI. February 6–28
Mercer University, Macon, GA. March 13–April 4
University Gallery, University of Florida-
Gainesville. April 17–May 9
College of Arts and Architecture, Pennsylvania
State University-University Park.
June 26–July 28
Art Department, Western Michigan University-
Kalamazoo. September 11–October 3
Hathorn Gallery, Skidmore College, Sarasota
Springs, NY. October 16–November 7
Bixler Art and Music Center, Colby College,
Waterville, ME. November 20–December 12
Reeve Memorial Union, Wisconsin State College-
Oshkosh. January 1–23, 1966
Lamont Art Gallery, Phillips Exeter Academy,
Exeter, NH. February 5–27
State Teachers College, East Stroudsberg, PA.
March 13–April 3
Mobile Art Gallery, AL. October 8–30
Asia-American Program, University of Hawaii-
Honolulu. November 12–December 4

1965 "The One Hundred and Sixtieth Annual
Exhibition." Pennsylvania Academy of the Fine
Arts. January 22–March 7

Group exhibition. The Print Club, Philadelphia.
March

1962–64 "American Prints Today/1962." Circulated by the Print Council of America. Three groups of eight museums held simultaneous showings; subsequently, the exhibition was circulated through the Smithsonian Institution Traveling Exhibition Service

Museum of Fine Arts, Boston.
September 20–October 21, 1962

Art Institute of Chicago.
September 21–October 21

Cincinnati Art Museum.
September 20–October 15

Los Angeles County Museum.
September 19–October 4

Whitney Museum of American Art, NY.
September 19–October 21

Philadelphia Museum of Art.
September 20–October 15

Achenbach Foundation for Graphic Arts, San Francisco. September 20–October 15

National Gallery of Art, Washington, DC.
September 23–October 14

Albany Institute of History and Art, NY.
November 5–December 29

Baltimore Museum of Art.
November 5–December 28

Cleveland Museum of Art.
November 6–December 30

Colorado Springs Fine Arts Center.
November 6–December 28

Detroit Institute of Arts.
November 6–December 30

Flint Institute of Arts, MI.
November 6–December 30

Currier Gallery of Art, Manchester, NH.
November 10–December 26

John and Mable Ringling Museum of Art, Sarasota, FL. November 5–December 26

Columbia Museum of Art, SC.
January 15–February 15, 1963

Dallas Museum of Fine Arts.
January 13–February 10

Wadsworth Athaneum, Hartford.
January 16–February 17

Museum of Fine Arts, Houston.
January 15–February 15

J.B. Speed Art Museum, Louisville.
January 15–February 14

Brooks Memorial Art Gallery, Memphis.
January 13–February 15

Walker Art Center, Minneapolis.
January 13–February 17

City Art Museum, St. Louis.
January 15–February 15

Sheldon Memorial Art Gallery, Lincoln, NE.
September 1–22, 1964

1963 "Lithographs from the Tamarind Workshop." Art Institute of Chicago. March 1–31

"100 Prints of the Year 1962." Associated American Artists Gallery, New York. March

"Contemporary Figure Drawings." Flint College, MI. March 19–October 17

"Expert's Choice." The Print Club, Philadelphia. April

"66th Annual Exhibition by Artists of Chicago and Vicinity." Art Institute of Chicago. April 19–June 2

"*V Mednarodna Grafična Razstava*." Moderna Galerija, Ljubljana. June 9–September 30

"*VII Bienal,* São Paulo." Brazil. September–December

"*Graphik 63*: Selections from the Fifth International Exhibition of Graphic Art in Ljubljana." Albertina Museum, Vienna. October 21–December 22

"37th Annual Exhibition of Etching and Engraving." The Print Club, Philadelphia Museum of Art

"*Segunda Bienal Interamericana de Mexico.*"
Mexico City

1960–61 "The First Biennial of Prints, Drawings, and
Watercolors." Art Institute of Chicago.
December 17–February 18

1961 "Invitation Competitive Exhibition."
The Print Club, Philadelphia Museum of Art.
January 13–February 14

"The One Hundred and Fifty-Sixth Annual
Exhibition." Pennsylvania Academy of the Fine
Arts. January 22–February 26

"Fifty American Printmakers." DeCordova
Museum, Lincoln, MA. April 30–June 11

"The Eye and Industry." Art Institute of Chicago.
May 20–June 30

"17th *Salon de Mai.*" Paris. Circulated to Stedelijk
Museum, Amsterdam, June 7–July 7

"*IV Mednarodna Grafična Razstava.*" Moderna
Galerija, Ljubljana. June 11–September 15

"Purchase Exhibition of Fine Prints in Memory of
Gilman L. Sessions, '25/Exhibition of
International Prints/Additions to the Rental
Library." Edward W. Root Art Center, Hamilton
College, Clinton, NY. September 17–October 15

"Second Annual Invitation Print Exhibition."
Brooks Memorial Art Gallery, Memphis.
November 6–28

1962 "Pasadena Third Biennial National Print
Exhibition." Pasadena Art Museum.
January 7–February 10

"American Printmakers 1962." Syracuse University.
January 21–February 28

"Invitational Exhibition of Lithography and Intaglio
Prints." The Print Club, Philadelphia Museum of
Art. February 12–March 2

"Thirteenth Biennial National Print Exhibition."
The Brooklyn Museum. March 6–June 3

"30th Anniversary International Exhibition." Tokyo
Metropolitan Museum. April 1–20, then circulat-
ed to 10 principal cities in Japan through 1962

"International Prints, 1962." Cincinnati Art
Museum. April 5–May 13

"Fifty Indiana Prints: Sixth Biennial Exhibition."
John Herron Art Museum. May 13–June 10

"Prints of the World." South London Art Gallery,
Camberwell. June. Circulated throughout the UK
for 12 months

"Ravinia Festival Art Exhibition." Little Gallery,
Chicago

"*Tercera Bienal Interamericana de Mexico.*"
Mexico City

1962–63 "Hayter and Atelier 17." Circulated by the
American Federation of Arts
Associated American Artists, New York.
February 3–17, 1962
Mulvane Art Center, Topeka, KS. April 15–30
Jacksonville Art Museum, FL. September 7–25
Atlanta Public Library Gallery, GA. October 8–29
Quincy Art Club, IL. February 3–28, 1963

"Contemporary American Woodcuts." Circulated
throughout Germany by the United States
Information Service, Bonn
America House, Essen.
September 13–October 5, 1962
America House, Freiburg.
October 12–November 5
America House, Darmstadt.
November 9–December 3
America House, Stuttgart.
December 7, 1962–January 2, 1963
America House, Berlin. January 11–February 2
America House, Hannover. February 8–March 4
America House, Kassel. March 8–April 1
America House, Tübingen. April 5–30
America House, Cologne. May 6–31
America House, Munich. June 5–28

Museum of Fine Arts, Boston.
September 15–October 15
National Gallery of Art, Washington, DC.
September 15–October 18
Cincinnati Art Museum.
September 15–October 20
Achenbach Foundation for Graphic Arts,
San Francisco. September 12–October 18
Los Angeles County Museum.
September 16–October 18
Art Institute of Chicago.
November 10–December 6
City Art Museum, St. Louis.
November 10–December 22
Brooks Memorial Art Gallery, Memphis.
November 10–December 20
Wadsworth Athanaeum, Hartford, CT.
November 10, 1959–January 3, 1960
Walker Art Center, Minneapolis.
November 15–December 20
Norfolk Museum, VA.
November 8–December 6
Currier Gallery of Art, Manchester, NH.
November 10–December 22
Detroit Institute of Arts.
November 10–December 22
Three post-season showings were also held at
the Dallas Museum of Fine Arts; Amherst
College, MA; and the J.B. Speed Art Museum,
Louisville

"33rd Annual Exhibition of Woodcuts and Wood
Engravings." The Print Club, Philadelphia
Museum of Art

Group exhibition. Musée Nationale d'Art
Moderne/Bibliothèque Nationale, Paris

"The One Hundred and Fifty-Fourth Annual
Exhibition of Watercolors, Prints, and
Drawings." Pennsylvania Academy of the
Fine Arts

1959–60 Contemporary American graphic art. Borzo Art
Gallery, Holland. October 15–November 6, then
traveling through February 28, 1960

"Incisiori Americani Contemporanei." Organized by
The Brooklyn Museum and circulated by the
United States Information Agency to Trieste,
Rome, Spoleto, Carino d'Ampezzo, Milan, and
Turin

1960 "Contemporary Relief Prints." Sheldon Memorial
Art Gallery, University of Nebraska-Lincoln.
January

"Print Fair." Central Free Library of Philadelphia.
January 18–February 26

"37th Annual Exhibition of Etching and
Engraving." The Print Club, Philadelphia
Museum of Art. March

"The Pursuit and Measure of Excellence."
Weatherspoon Art Gallery, University of North
Carolina-Greensboro. Through March 22

"American Prints 1950–1960." Yale University Art
Gallery, New Haven, CT. March 23–May 24

"The 1960 International Biennial of Prints."
Cincinnati Art Museum. April 1–May 22

"Twelfth Annual National Print Biennial." The
Brooklyn Museum. May 10–July 27. Circulated
through the American Federation of Arts.
September 1960–September 1962

Group exhibition organized by The Print Club,
Philadelphia. Long Beach Island Art Foundation.
Summer

"La Gravure Americaine d'Aujourd'hui." Cabinet des
Estampes, Chateau de Rohan, Strasbourg.
October 15–November 13

"First Annual Exhibition of Advertising and
Editorial Art." Chicago

"28th Annual Exhibition of Advertising Art."
Chicago

Exhibition in honor of centennial of Joseph
 Pennell's birth. Philadelphia Art Alliance.
 November 21–December 15

"*IV Bienal.*" São Paulo, Brazil

"*IV Mostra di Pittura Americana.*" Bordighera, Italy

1957–58 "*53 Peintres de Chicago.*" Exhibition circulated by the
 United States Information Agency
 Musée des Beaux-Arts, Nancy.
 November 7–December 2, 1957
 Palais Saint-Vasst, Arras.
 December 15, 1957–January 11, 1958
 Musée de Picardie, Amiens.
 January 18–February 9
 Musée de Rouen. February 19–March 19
 Musée des Beaux-Arts, Nantes.
 March 28–April 28
 Salle des Fêtes, Limoges. May 10–June 5
 La Napoule Art Foundation, La Napoule. July

"*Gravures Americaines d'Aujourd'hui.*"
 Centre Culturel Americain, Paris.
 December 14, 1957–January 15, 1958

1958 "35th Annual Exhibition of Etching and
 Engraving." The Print Club, Philadelphia
 Museum of Art. April 11–May 2

"Eleventh Biennial National Print Exhibition."
 The Brooklyn Museum. April 15–June 29

"Fourth Biennial Exhibition: 50 Indiana Prints."
 John Herron Art Museum. May 11–June 8

"*Primera Bienal Interamericana de Pintura y Grabado.*"
 Instituto Nacional de Bellas Artes, Mexico City.
 June 6–August 20

"Artists of Chicago and Vicinity, 61st Annual
 Exhibition." Art Institute of Chicago. July 16–30

Gabor Peterdi, Misch Kohn, Danny Pierce. IFA
 Galleries, Washington, DC. October

Group exhibition. Institute of Contemporary Art,
 Boston

1958–59 "16th National Exhibition of Prints Made
 During the Current Year."
 Library of Congress. May 1–September 1, 1958
 Oak Ridge Community Art Center, TN.
 October 3–19
 University of Tennessee. October 22–December 3
 Hudson River Museum, Yonkers, NY.
 December 8, 1958–January 5, 1959
 New Paltz State Teachers College, NY.
 January 8–February 8
 Harper College, Endicott, NY.
 February 12–March 15
 Wittenberg College, Springfield, OH.
 March 26–April 26
 Germany. May–September

"Prints by 20 U.S. Artists." The Brooklyn Museum.
 November 4, 1958–January 26, 1959

1959 "American Acquisitions—Recent Additions of
 Prints to the Museum Collection." Museum of
 Modern Art. April 2–May 31

"17th National Exhibition of Prints Made During
 the Current Year." Library of Congress.
 May 1–September 1

"Artists of Chicago and Vicinity, 62nd Annual
 Exhibition." Art Institute of Chicago.
 May 13–June 28

"*Troisième Exposition Internationale de Gravure.*"
 Ljubljana. June 7–September 15

25th Anniversary exhibition. Associated American
 Artists, New York. Fall.

"American Prints Today/1959." Exhibition
 circulated by the Print Council of America to
 two groups of eight museums
 Whitney Museum of American Art.
 September 15–October 11
 Philadelphia Museum of Art.
 September 15–October 25
 Baltimore Museum of Art.
 September 15–October 18

J.B. Speed Art Museum, Louisville.
February 15–March 10
Dallas Museum of Fine Arts. March 25–April 20
Denver Art Museum. May 5–30
Los Angeles County Museum. June 15–July 10
California Palace of the Legion of Honor,
San Francisco. July 28–August 26
Australia. November

1956 "30th Annual Exhibition of Woodcuts and Wood
Engravings." The Print Club, Philadelphia
Museum of Art. January

*"Xylon: II Exposition Internationale de Gravures sur
Bois."* Galerie Helmhaus, Zurich.
February 18–March 18
Moderna Galerija, Ljubljana. May 12–30

"Four American Printmakers." New York Public
Library. February 20–May 14

"47 Midwestern Printmakers." 1020 Art Center,
Chicago. February 28–April 1

"Candidates for Grants in Art for the Year 1956."
American Academy of Arts and Letters,
New York. March 3–18

"50 Contemporary American Printmakers."
University of Illinois. March 4–25

"Ten Years of American Prints 1947–1956/Tenth
Annual National Print Exhibition."
The Brooklyn Museum. May 2–July 1
Dallas Museum of Fine Arts.
November 25–December 25
Exhibition circulated to Japan and Canada
under the auspices of the U.S. Government,
American Federation of Arts, and
Japan Society

"50 Indiana Prints: Third Biennial Exhibition."
John Herron Art Museum. May 13–June 10

"Modern Art in the United States from the
Collection of the Museum of Modern Art,
New York." Umetnicki Paviljon na
Kalemegdanu, Muzej Fresaka, Galerija ULUS,
Belgrade. July 7–August 6

"Contemporary Prints and Watercolors."
National Academy of Design, New York.
November 15–December 2

Boston Printmakers Annual Exhibition

1956–57 "Curator's Choice." The Print Club, Philadelphia.
November 9–30, 1956
Davison Art Center, Wesleyan University,
Middletown, CT. January 1–23, 1957
Cincinnati Art Museum. February 1–March 4
Alabama Polytechnic Institute, Auburn.
March 15–April 25

1957 "The One Hundred and Fifty-Second Annual
Exhibition of Watercolors, Prints, and
Drawings." Pennsylvania Academy of the Fine
Arts. January 20–February 24

"Golden Years of American Drawings."
The Brooklyn Museum. January 22–March 17

"Candidates for Grants in Arts." American
Academy of Arts and Letters Gallery, New York.
March 15–31

"15th National Exhibition of Prints Made During
the Current Year." Library of Congress.
May 1–September 1

American Academy of Arts and Letters Annual
Exhibition. Academy Gallery, New York.
May 23–June 23

"Deuxième Exposition Internationale de Gravure."
Ljubljana. June 2–September 15

"First International Biennial Exhibition of Prints."
Tokyo. June 15–July 14

"XILON: *Esposizione Internazionale di Xilografia.*"
Zurich, Ljubljana, Berlin, Wuppertal, Nancy,
Vienna. August 24–September 15

"25th Anniversary Exhibition of the Frank Hall
Collection." Sheldon Memorial Art Gallery,
University of Nebraska-Lincoln. October

"Moderne Amerikaanse Grafiek." Gemeentemuseum's
Gravenhage, The Hague. October 23–December 6

"The 51st Annual Exhibition of Watercolors, Prints
and Drawings." Pennsylvania Academy of the
Fine Arts

"XYLON: International Invitational Woodcut
Exhibition." Art Gallery, Zurich, Switzerland.
Traveled to Moderna Galerija, Ljubljana

1953–54 "100 Examples of Fine Printing in America."
Smithsonian Institution. Circulated to France,
Germany, Italy, Switzerland, Holland

"Amerikansk Grafik." Riksförbundet för bildende
kunst. Stockholm

1954 "Graphic Arts—U.S.A." University of Illinois.
February 7–March 7

Recent acquisitions. Philadelphia Museum of Art.
March–June

"Eighth Annual National Print Exhibition."
The Brooklyn Museum. April 28–June 27

"12th National Exhibition of Prints Made During
the Current Year."
Library of Congress. May 1–August 1
Memorial Art Gallery, University of
Rochester, NY

"Meisterwerke der Graphik und Zeichnung." Schloss
Arbon, Thurgau, Switzerland. May 2–30

"Second Biennial Exhibition: 50 Indiana Prints."
John Herron Art Museum. May 16–June 13

"American Prints of the Twentieth Century."
Museum of Modern Art.
September–November 14

c. 1954 "American Graphic Art." Circulated by the United
States Information Service to Bombay, India

1954–55 "International Colour-Woodcut Exhibition,"
Victoria and Albert Museum, London.
November 18–January 16
Birmingham City Art Gallery. February
Manchester City Art Gallery. March

1955 "29th Annual Exhibition of Wood Engravings,
Woodcuts, and Block Prints." The Print Club,
Philadelphia Museum of Art. February

Second Biennial Xylon exhibition. Helmhaus
Galerie, Zurich. Opened February 18.
Traveled to Ljubljana and Germany

"Ninth Annual National Print Exhibition."
The Brooklyn Museum. April 27–June 26

"13th National Exhibition of Prints Made During
the Current Year."
Library of Congress. May 1–September 1
Memorial Art Gallery, University of Rochester

American Printmakers. Bridgestone Gallery,
Tokyo. May

"40th Anniversary Exhibition." The Print Club,
Philadelphia. May 4–June 1

"Artists of Chicago and Vicinity, 58th Annual
Exhibition." Art Institute of Chicago.
June 2–July 4

"Ausstellung Kinder und Künstler." Schloss Arbon,
Thurgau. July 2–24

"Première Exposition Internationale de Gravure."
Moderna Galerija, Ljubljana. July 3–September 4

"Moderne Kunst aus USA." Stadelschen
Kunstinstitut, Frankfurt. November

c. 1955 *"Incisiori degli Stati Uniti."* Calcografia Nazionale,
Rome

1955–56 "Sport in Art." American Federation of Arts
Museum of Fine Arts, Boston.
November 15–December 15, 1955
Corcoran Gallery of Art, Washington, DC.
January 5–30, 1956

"Artists of Chicago and Vicinity, 55th Annual Exhibition." Art Institute of Chicago. May 31–July 8

"Some American Prints, 1949–50, from the Museum Collection." Museum of Modern Art. July 3–September 13

"Nebraska Art Association Autumn Show." Sheldon Memorial Gallery, University of Nebraska-Lincoln. October–November

"*Exposition de Gravures*." American Embassy, Paris. October 12–November 5. Subsequently circulated to the French provinces

Group exhibition. Watkins Gallery, American University, Washington, DC

"*Les Peintres Graveurs Actuels aux Etats Unis*." Bibliothèque Nationale, Paris

"23rd Annual Exhibition of Northwest Printmakers." Seattle Art Museum

1952 "26th Annual Exhibition of Woodcuts and Wood Engravings." The Print Club, Philadelphia. January

"Modern American Color Prints." San Francisco Museum of Art. January 1–20

"Museum Menagerie (Posters)." San Francisco Museum of Art. January 8–February 3

"Sixth Annual National Print Exhibition. The Brooklyn Museum. March 19–May 1 San Francisco Museum of Art. May 8–June 1

"50 Indiana Prints: First Biennial Exhibition of Graphic Art." John Herron Art Museum. May 18–June 15

"Artists of Chicago and Vicinity, 56th Annual Exhibition." Art Institute of Chicago. May 31–July 13

"A Decade of American Printmaking." Philadelphia Museum of Art. June 7–November 9

"*Internationale Graphik*." Kunst der Gegenwart Galerie, Salzburg, Austria. July 27–August 31. Continued on to the Secession Gallery, Vienna

"New Expressions in Fine Printmaking—Methods, Materials and Ideas." The Brooklyn Museum. September 15–November 23

c. 1952 "Third National Invitational Print Exhibition." Indiana University Fine Arts Center, Bloomington. Through January 31

Prints by Alumni. John Herron Art Institute. Through May 22

"Modern Woodcuts." Weyhe Gallery. September 7–28

Group print exhibition by 100 living artists. Museum of Modern Art. September–October

"50th Annual International Exhibition of Watercolors, Prints and Drawings." Pennsylvania Academy of the Fine Arts. October 18–November 23

1953 "Contemporary American Prints." Albert H. Wiggin Gallery, Boston Public Library. January 5–31

"27th Annual Exhibition of Woodcuts and Wood Engravings." The Print Club, Philadelphia. January

"Prints 1942–1952." Brooks Art Gallery, Memphis, TN. April 1–27

"Seventh Annual National Print Exhibition." The Brooklyn Museum. April 22–June 21 San Francisco Museum of Art. November 4–22

Ninth Annual *Salon de Mai*. Musée d'Art Moderne, Paris. May 7–31

"*Jeune Gravure Contemporaine*." Galerie le Garrec, Paris. May 15–June 6

"46th Indiana Artists' Annual Exhibition of Paintings and Sculpture." John Herron Art Museum. Through May 22

"47th Annual Exhibition of Watercolors and Prints."
Pennsylvania Academy of the Fine Arts.
October 29–December 5

"Modern Woodcuts." Philadelphia Art Alliance.
November 9–December 4

Modern American prints from the collection of the
Museum of Modern Art. Gimpel Gallery, London

Modern woodcuts. University of Wyoming-
Laramie

1949–51 *"Exposition Internationale de la Gravure
Contemporaine."* Petit Palais, Paris. June 2–29.
Continued to American Embassies in Paris,
Nuremberg, Berlin, Munich, Hamburg,
Heidelberg, Stuttgart, Karlsruhe, Frankfurt

1950 "Weyhe Woodcuts." University Art Museum,
University of Minnesota-Minneapolis.
February 1–27

"Contemporary American Prints Selected by Five
Print-Makers." Renaissance Society, University
of Chicago. Through February 23

"Twenty-Second Annual Exhibition/Northwest
Printmakers." Seattle Art Museum.
March 8–April 2

"Eighth National Exhibition of Prints Made During
the Current Year."
Library of Congress.
April 24–September 1
Carnegie Institute, Pittsburgh.
October 19–December 31

"Artists of Chicago and Vicinity, 54th Annual
Exhibition." Art Institute of Chicago.
June 1–July 30

Color lithograph exhibition. George Binet Gallery,
New York

Survey of American prints. The Brooklyn Museum

Animal print exhibition. Museum of Modern Art

Group exhibition: young printmakers.
Museum of Modern Art

"24th Annual Exhibition of Wood Engravings,
Wood Cuts and Block Prints." Philadelphia
Museum of Art

International print exhibition. University of
Indiana-Bloomington

1950–51 "Fourth Annual National Print Exhibition."
The Brooklyn Museum. March 22–May 21, 1950
Des Moines Art Center. August 13–September 17
Cincinnati Art Museum. October 1–22
South Bend Art Association, IN. November 5–26
J.B. Speed Art Museum, Louisville, KY.
December 10, 1950–January 7, 1951
University of Colorado-Boulder.
January 21–February 15
Henry Gallery, University of Washington-Seattle.
March 1–22
San Francisco Museum of Art. April 5–26
Fine Arts Society of San Diego. May 8–29

"American Woodcuts 1670–1950." The Brooklyn
Museum. November 9, 1950–January 9, 1951

1951 "25th Annual Exhibition of Wood Engravings and
Woodcuts." The Print Club, Philadelphia
Museum of Art. January

"Contemporary Art in the United States." Worcester
Art Museum, MA. January 25–March 4

"Modern American Color Prints." Dallas Museum
of Fine Arts. March 4–25

"Fifth Annual National Print Exhibition."
The Brooklyn Museum. March 21–May 20

"Exhibition of 4." Illinois Institute of Technology,
Chicago. April 4–25

"Ninth National Exhibition of Prints Made During
the Current Year." Library of Congress.
May 1–August 1

"Between Two Wars: Prints by American Artists 1914–1941." Whitney Museum of American Art. March 3–31

"All-American Print Show." John Herron Art Museum, Indianapolis. March 7–April 7

"San Francisco Art Association 6th Annual Watercolor Exhibition." May 6–31

1943 "American Prints Today." John Herron Art Museum. March 7–April 4

"The 22nd Annual International Water Color Exhibition." Art Institute of Chicago. May 13–August 22

"America in the War." Simultaneously shown in 26 museums. October–November
Brooks Memorial Art Gallery, Memphis, TN.
Butler Art Institute, Youngstown, OH.
Gibbes Memorial Art Gallery, Charleston, SC.
Cincinnati Art Museum
Cleveland Museum of Art
Corcoran Gallery of Art, Washington, DC.
Currier Gallery of Art, Manchester, NH.
Everhart Museum of Natural History, Science and Art, Scranton, PA.
Fine Arts Gallery, San Diego, CA.
Fort Wayne Art School and Museum, IN.
Kennedy Galleries, New York
Layton Art Gallery, Milwaukee
Museum of Fine Arts, Houston
William Rockhill Nelson Gallery of Art/Atkins Museum of Fine Arts, Kansas City, MO.
Norfolk Museum of Arts and Sciences, VA.
Portland Art Museum, OR.
The Print Club, Philadelphia
San Francisco Museum of Art
Santa Barbara Museum of Art
Seattle Art Museum
Smith College Museum of Art, Northampton, MA.
Swope Art Gallery, Terre Haute, IN.
Virginia Museum of Fine Arts, Richmond
Wichita Art Association, KS.

Wilmington Society of the Fine Arts, DE.
University of Wisconsin-Madison

"100 Prints by American Artists." John Herron Art Museum. October 10–November 7

1944 Group exhibition: Artists from the *Taller de Grafica Popular*. Weyhe Gallery, New York

c. 1944 Group exhibition of Chicago Painters. Associated American Artists, New York. August–September 4

1947 "First Annual National Print Exhibition." The Brooklyn Museum. March 19–May 4

Group exhibition: wood engravings
San Francisco Museum of Art
Portland Art Museum
Springfield Art Museum, MO.
University of Alabama-Tuscaloosa, Moody Gallery of Art
Kalamazoo Institute of Arts, MI.
University of Michigan Museum of Art, Ann Arbor

1948 "Second Annual National Print Exhibition." The Brooklyn Museum. March 23–May 24

"52nd Annual Exhibition by Artists of Chicago and Vicinity." Art Institute of Chicago. June 17–August 15

"First Indiana Print and Drawing Annual Exhibition." Indiana University-Bloomington Department of Art

1949 "53rd Annual Exhibition by Artists of Chicago and Vicinity." Art Institute of Chicago. February 10–March 20

Contemporary American Woodcuts. Weyhe Gallery. September

"Oeuvres Graphiques Americaines." Centre Americain de Documentation, Paris. October 18–28

"Misch Kohn: Three Decades of Printmaking."
Eloise Pickard Smith Gallery, Cowell College,
University of California-Santa Cruz.
November 5–December 6

c. 1983 Evanston Art Center, IL.

1984 St. Xavier University, Chicago. February 1–March 2

1987 "Misch Kohn." College of the Siskiyous, Weed, CA.
September 28–October 30

Temple B'Nai Israel, Kokomo, IN. October 17

1988 "Misch Kohn Prints/Chicago—California:
A Retrospective." Kala Institute Gallery,
Berkeley, CA. April 12–May 21

1991 "Misch Kohn: A Hometown Collection." Kokomo-
Howard County Public Library. May 6

1998– 2000 "Misch Kohn: Beyond the Tradition."
Monterey Museum of Art, CA.
January 17–March 22, 1998
Richard L. Nelson Gallery,
University of California-Davis.
April 13–May 22
The Print Center, Philadelphia.
September 11–October 24
Grinnell College Art Gallery, Grinnell, IA.
February 1–March 15, 1999
Purdue University Galleries, West Lafayette,
IN./Greater Lafayette Museum of Art,
Lafayette, IN. August 23–October 19
Illinois Art Gallery, James R. Thompson Center,
Illinois State Museum, Chicago.
November 12, 1999–January 8, 2000

Group Exhibitions

c. 1939 Group exhibition. Indiana University Fine Arts
Center, Bloomington

1940 "19th International Water Color Exhibition."
Art Institute of Chicago. March 23–May 14

"Modern Prints since 1900." Art Institute of
Chicago. July 18–October 20

"Thirty-Eighth Annual Philadelphia Water Color
and Print Exhibition." Pennsylvania Academy
of the Fine Arts. November 3–December 8

Group exhibition. Howard University,
Washington, DC

National Art Week exhibition. Museum of
Modern Art, New York

Group exhibition. Renaissance Society,
University of Chicago

1941 "San Francisco Art Association Drawings and
Prints." San Francisco Museum of Art.
January 29–February 18

"Prints from the Illinois Art Project." Art Institute
of Chicago. February 6–April 27

"Exhibition by Contemporary Jewish Artists
of Chicago." Covenant Club, Chicago.
March 24–April 3

"San Francisco Art Association 5th Annual
Watercolor Exhibition." San Francisco Museum
of Art

"39th Annual Philadelphia Water Color and Print
Exhibition." Pennsylvania Academy of the Fine
Arts, Philadelphia

1942 "San Francisco Art Association Drawings and
Prints." San Francisco Museum of Art.
February 10–March 1

246

718. Untitled
Line etching
Image: 5 15/16 x 4 1/8" (151 x 105 mm) irregular
Sheet: 6 5/16 x 4 1/2" (176 x 114 mm)
Edition: unique
Printer/Publisher: Mildred Reich had this printed on an offset press
Collections: Private collections
Comments: Sketchy line etching of three woodwind musicians. This was created for Mildred and Sol Reich as an announcement/invitation for her daughter Karen's wedding. Reichs had it printed in offset, maroon ink on white.

1993

719. Horseman
Wood engraving
Image: 5 5/16 x 4 7/16" (151 x 113 mm)
Sheet: 6 1/2 x 4 3/4" (165 x 121 mm)
Edition: 50
Paper: China/India mounted on handmade Misch, no watermark
Collections: Private collections
Comments: Rider with plumed hat blowing horn, astride prancing horse, profile left. Signed and dated in graphite.

720. Landscape with Blue
Engraving, silver ink on handmade embedded paper
Image: 36 x 72" (914 x 1829 mm) irregular
Sheet: 36 x 72" (914 x 1829 mm) irregular
Edition: unique
Paper: Misch handmade embedded
Plate: Lucite
Comments: Abstraction.

1995

721. Gus
Line etching, *chine collé*
Image: 17 5/8 x 15 1/8" (447 x 384 mm) irregular
Sheet: 22 x 30" (558 x 762 mm)
Edition: 25
Paper: China/India [tan] laid onto handmade, Misch watermark
Plate: Zinc
Collections: Private collection
Comments: Portrait of Kohns' friend Gus Cherry. Signed, ed. info, titled, and dated in graphite.

1996

722. Into Summer
Engraving, silver ink, *chine collé* with metal leaf, found objects, aquatint etching, rainbow-roll and color woodcut on handmade embedded paper
Image: 12 1/2 x 23 15/16" (317 x 608 mm) irregular
Sheet: 22 1/8 x 30" (562 x 762 mm)
Edition: 15
Paper: Handmade, Misch watermark
Plate: Lucite
Comments: Abstraction. Signed, titled, and dated in graphite.

723. Kant Again
Etching, *chine collé* with metal-type engraving and color woodcut
Image: 11 15/16 x 15 5/8" (303 x 397 mm) irregular
Plate: 10 15/16 x 14" (278 x 355 mm)
Sheet: 22 5/8 x 22 3/8" (574 x 568 mm)
Edition: unique
Paper: Misch handmade
Plate: Copper
Comments: Abstraction.

724. The Enormous Room
Engraving, *chine collé* with metal leaf, color woodcut, and found objects
Image: 12 3/4 x 23 1/2" (324 x 597 mm) irregular
Plate: 12 1/4 x 23 1/2" (311 x 597 mm)
Sheet: 22 x 30" (558 x 762 mm)
Edition: 10
Paper: China/India and Japanese handmade laid onto Misch handmade
Plate: Lucite
Collections: Portland Art Museum
Publications: Gilkey, Gordon W, *Participating Printmakers in the International Print Exhibition*, cat.
Comments: Abstraction. This same plate was used for *Alaska Highlands* and *Into the North*, both 1997. Signed, ed. info, titled, and dated in graphite.

1997

725. Alaska Highlands
Engraving, *chine collé* with metal leaf, color woodcut, and found objects
Image: 12 3/8 x 23 3/4" (314 x 603 mm)
Plate: 12 1/4 x 23 5/8" (311 x 600 mm)
Sheet: 22 x 29 1/2" (559 x 749 mm)
Edition: E/V 10
Paper: Misch handmade, watermark
Plate: Lucite
Comments: Abstracted landscape. This same plate was used for *The Enormous Room*, 1996 and *Into the North*, 1997.

726. Into the North
Engraving, *chine collé* with color woodcut
Image: 12 1/4 x 23 7/8" (311 x 606 mm)
Plate: 12 1/4 x 23 5/8" (311 x 600 mm)
Sheet: 22 x 30" (559 x 762 mm)
Edition: E/V 10
Paper: Misch handmade, watermark
Plate: Lucite
Comments: Abstracted landscape. This same plate was used for *The Enormous Room*, 1996 and for *Alaska Highlands*, 1997.

707. Untitled
Engraving on handmade embedded paper
Image: 52 x 32" (1320 x 813 mm) irregular
Sheet: 52 x 32" (1320 x 813 mm) irregular
Edition: unique
Paper: Misch handmade embedded
Plate: Lucite
Collections: Private collection
Comments: Abstraction.

708. Untitled
Handmade paper embedded with wood-
cut, etching, engraving, *chine collé*
Image: 32 5/8 x 54 1/2" (828 x 1384 mm)
irregular
Sheet: 32 5/8 x 54 1/2" (828 x 1384 mm)
irregular
Edition: unique
Paper: Misch handmade embedded
Plate: Lucite
Comments: Abstraction.

1991

709. *Transformations*
Alternate title: *Transformations and
Reflections in a Glass Eye*
Engraving, *chine collé* with silver leaf,
metal-type engraving, color woodcut,
and found objects
Image: 22 x 30" (560 x 762 mm) irregular
Sheet: 22 x 30" (560 x 762 mm) irregular
Edition: unique
Paper: Misch handmade
Plate: Lucite
Collections: Private collection
Publications: Itami, Michi, "Misch Kohn,"
Printmaking Today (Summer 1994),
ill. p. 11.
Comments: Abstraction.

710. *Transformations and Reflections*
Alternate title: *Essential for Anyone to
Understand*
Engraving, silver ink, *chine collé* with color
woodcut, etching, wood type, and found
objects
Image: 12 1/2 x 23 7/8" (317 x 606 mm)
irregular
Sheet: 19 5/8 x 28 1/4" (498 x 717 mm)
Edition: E/V
Paper: Misch handmade
Plate: Lucite
Comments: Abstraction.

711. *Transformations* [*Gulf of Mexico*]
Engraving, silver ink, *chine collé* with etch-
ing, rainbow-roll and color woodcut,
wood type, and found objects on hand-
made embedded paper

Image: 34 x 54" (863 x 1372 mm) irregular
Sheet: 34 x 54" (863 x 1372 mm) irregular
Edition: unique
Paper: Misch handmade embedded
Plate: Lucite
Comments: Abstraction.

712. *View From Above*
Engraving, *chine collé* with metal-type
engraving, found objects, rainbow-roll
and color woodcut on handmade
embedded paper
Image: 31 1/2 x 44" (800 x 1117 mm)
irregular
Sheet: 31 1/2 x 44" (800 x 1117 mm)
irregular
Edition: unique
Paper: Misch handmade embedded
Plate: Lucite
Publications: "1994 Distinguished Artist
Misch Kohn," *California Printmaker*
(June 1994), ill. p. 13.
Comments: Abstraction. Incorrectly dated
1990 in *California Printmaker* article.

1992

713. *Cubi 8*
Engraving, silver ink, *chine collé* with
metal-type engraving, rainbow-roll and
color woodcut, wood type, and found
objects on handmade embedded paper
Image: 32 x 54" (813 x 1372 mm) irregular
Sheet: 32 x 54" (813 x 1372 mm) irregular
Edition: unique
Paper: Misch handmade embedded
Paper: Lucite
Comments: Abstraction. Signed and dated
in graphite.

714. *Fifth Variation on 5*
Alternate title: *The Fifth Version*
Engraving, silver ink, *chine collé* with
metal-type engraving, color woodcut,
wood type, and found objects on hand-
made embedded paper
Image: 32 1/2 x 54" (825 x 1372 mm)
irregular
Sheet: 32 1/2 x 54" (825 x 1372 mm)
irregular
Edition: unique
Paper: Misch handmade embedded
Plate: Lucite
Publications: Itami, Michi. "Misch Kohn."
Printmaking Today (Summer 1994),
cover ill.
Comments: Abstraction. This same plate
was used for *Transformation and
Reflection on 8*, 1992.

715. *Transformation and Reflection on 8*
Alternate titles: *Transformations and
Reflections on 8; Transformations and
Reflections in a Glass Eye*
Engraving, silver ink, *chine collé* with
metal-type engraving, rainbow-roll and
color woodcut, wood type, and found
objects on handmade embedded paper
Image: 32 1/2 x 54" (825 x 1372 mm)
irregular
Sheet: 32 1/2 x 54" (825 x 1372 mm)
irregular
Edition: unique
Paper: Misch handmade embedded
Plate: Lucite
Comments: Abstraction. This same plate
was used for *Fifth Variation on 5*, 1992.

716. *Transformations*
Engraving, silver ink, *chine collé* with
metal-type engraving, rainbow-roll and
color woodcut, wood type, and found
objects on handmade embedded paper
Image: 32 x 54" (813 x 1372 mm) irregular
Sheet: 32 x 54" (813 x 1372 mm) irregular
Edition: unique
Paper: Misch handmade embedded
Plate: Lucite
Collections: Indiana University-Kokomo
Publications: Brooke, Rebecca, "Kokomo's
Kohn," *Indiana Alumni* (March/April
1993), ill. p. 31.
Comments: Abstraction. This print was
created especially for Indiana
University-Kokomo in appreciation for
an honorary doctorate of fine arts the
university conferred upon him in 1991.
It ..."contains many references to the
academic world: a page from a physics
textbook, an architectural blueprint, a
scattering of letters Kohn hand-set using
individual pieces of various-sized type."
This same plate was also used for
5-6-7-8, 1987. Signed and dated in
graphite.

717. Untitled
Engraving, *chine collé* with metal-type
engraving, color woodcut, and found
objects on handmade embedded paper
Image: 33 x 53" (838 x 1346 mm) irregular
Sheet: 33 x 53" (838 x 1346 mm) irregular
Edition: unique
Paper: Misch handmade embedded
Plate: Lucite
Comments: Abstraction.

c. 1988

695. *Transformations and Reflections in a Glass Eye*
Sugar-lift ground aquatint etching, engraving, *chine collé* with metal leaf, metal-type engraving, color woodcut, wood type, and handmade papers
Image: Irregular
Paper: Misch handmade
Plate: Copper
Comments: Abstraction. Signed and dated in graphite.

1989

696. *Chicago Theme*
Engraving on handmade paper with embedded woodcut
Image: 72 x 36" (1829 x 914 mm) irregular
Sheet: 72 x 36" (1829 x 914 mm) irregular
Edition: unique
Paper: Misch handmade embedded
Plate: Lucite
Comments: Abstraction.

697. *Chicago Triptych*
Engraving, *chine collé* on handmade paper embedded with color woodcut
Image: 72 x 108" (1829 x 2743 mm) irregular
Sheet: 72 x 36" (1829 x 914 mm) each, irregular
Edition: unique
Paper: Misch handmade embedded mounted on linen
Plate: Lucite (3)
Collections: Fairmount Hotel, Chicago
Comments: Abstraction. Each section of the triptych measures approximately 72 x 36" (1829 x 914 mm).

698. *Garden After Monet*
Alternate title: *Monet's Garden*
Engraving, drypoint, silver ink on handmade embedded paper
Image: 35 x 73" (889 x 1854 mm) irregular
Sheet: 35 x 73" (889 x 1854 mm) irregular
Edition: unique
Paper: Misch handmade embedded
Plate: Lucite
Comments: Abstraction.

699. *Letter from Japan*
Sugar-lift ground aquatint etching, engraving, *chine collé* with wood type, found objects, rainbow-roll and color woodcut
Image: 17 1/2 x 23 1/2" (444 x 597 mm) irregular

Edition: unique
Paper: Misch handmade
Plate: Copper
Collections: Kokomo-Howard County Public Library, Hoosier Art Collection
Publications: Guest-Mckellar, Alice, "Collecting Hooseir Art is a Tradition," *Kokomo Magazine*, 1990, cover ill; *Hoosier Art Collection of the Kokomo-Howard County Public Library*, 1993, cat. p. 12; Hoover, James W., *Misch Kohn: Hometown Collection*, cat.
Comments: Abstraction.

700. *Unique print for Dolly and Joe*
Sugar-lift ground aquatint etching, engraving, *chine collé* with engraving, rainbow-roll and color woodcut, wood type, and found objects
Image: 10 3/4 x 13 3/4" (273 x 349 mm) irregular
Sheet: 17 1/2 x 23 1/2" (444 x 597 mm)
Edition: unique
Paper: Handmade, Misch watermark
Plate: Copper
Collections: Private collection
Comments: Abstraction. Signed, ed. info, titled, and dated in graphite.

701. Untitled
Engraving on embedded paper
Image: 33 1/2 x 50" (851 x 1270 mm) irregular
Sheet: 33 1/2 x 50" (851 x 1270 mm) irregular
Edition: unique
Paper: Misch handmade embedded
Plate: Lucite
Collections: Private collection
Comments: Abstraction.

702. Untitled
Engraving, silver ink on handmade embedded paper
Image: 36 x 72" (914 x 1829 mm) irregular
Sheet: 36 x 72" (914 x 1829 mm) irregular
Edition: unique
Paper: Misch handmade embedded
Plate: Lucite
Comments: Abstraction.

1990

703. *Denver Basin and the Lake Country*
Engraving, drypoint, silver ink, and found objects on handmade embedded paper
Image: 31 1/2 x 45 3/4" (800 x 1162 mm) irregular
Sheet: 34 5/8 x 49 1/2" (879 x 1257 mm) irregular
Edition: unique
Paper: Misch handmade embedded
Plate: Lucite
Comments: Abstraction.

704. *Excavation 8*
Sugar-lift ground aquatint etching, engraving, *chine collé* with metal-type engraving, found objects, rainbow-roll and color woodcut
Image: 10 1/2 x 9 13/16" (267 x 249 mm) irregular
Plate: 8 3/4 x 9 13/16" (222 x 249 mm)
Sheet: 22 3/4 x 24 1/2" (578 x 622 mm)
Edition: E/V 10
Paper: Farnsworth
Plate: Zinc
Comments: Abstraction. Signed, ed. info, titled, and dated in graphite.

705. *I Love Lore*
Sugar-lift ground aquatint etching, engraving, *chine collé* with metal leaf, wood type, rainbow-roll and color woodcut
Image: 5 3/4 x 7 1/4" (146 x 184 mm) irregular
Plate: 5 x 6 1/4" (127 x 159 mm)
Sheet: 8 x 15 1/2" (203 x 394 mm)
Edition: unique
Paper: Handmade, Misch watermark
Plate: Copper
Comments: Abstraction. Given as a Valentine's Day card to his wife. Handwritten inscription verso.

706. Untitled
Embossing on embedded handmade paper
Image: 35 x 49 1/2" (889 x 1257 mm) irregular
Sheet: 35 x 49 1/2" (889 x 1257 mm) irregular
Edition: unique
Paper: Misch handmade embedded, Misch watermark
Plate: Lucite
Comments: Abstraction.

680. Untitled
Etching, engraving, *chine collé* with metal
 leaf, color woodcut, and found objects
Image: 15 1/2 x 29 1/2" (394 x 749 mm)
 irregular
Sheet: 16 3/4 x 19 1/2" (425 x 495 mm)
Edition: unique
Paper: Misch handmade
Plate: Copper
Collections: Private collection
Comments: Abstraction. Signed and dated
 in graphite.

681. Untitled
Etching, printed in relief with high
 embossing, *chine collé* with bronze leaf
Image: 3 7/8 x 4 15/16" (98 x 125 mm)
Sheet: 6 1/4 x 15 7/8" (158 x 403 mm)
 irregular
Edition: 60
Paper: Misch handmade
Plate: Copper
Collections: Private collections
Comments: Abstraction. Sent out as holi-
 day greeting card and note card.
 Handwritten inscriptions, verso.

1988

682. *Chicago Landscape*
Engraving, silver ink on handmade
 embedded paper
Image: 35 1/2 x 72 1/2" (901 x 1841 mm)
 irregular
Sheet: 35 1/2 x 72 1/2" (901 x 1841 mm)
 irregular
Edition: unique
Paper: Misch handmade embedded
Plate: Lucite
Collections: Private collection
Comments: Abstraction. MK in plate, ll;
 signed and dated in graphite.

683. *Diptych on a Chicago Theme*
Engraving, drypoint, embossing on hand-
 made embedded paper
Image: 73 x 72" (1854 x 1829 mm) irregular
Sheet: 73 x 72" (1854 x 1829 mm) irregular
Edition: unique
Paper: Misch handmade embedded
Plate: Lucite (2)
Comments: Abstraction. Work is com-
 posed of two large sections, each mea-
 suring approximately 73 x 36" (1854 x
 914 mm).

684. *Hidden Letter*
Etching, engraving, *chine collé* with
 silver leaf, metal leaf, color woodcut
 and wood type
Image: 19 x 23" (483 x 584 mm) irregular

Plate: 14 15/16 x 23" (379 x 584 mm)
Sheet: 22 x 29 3/4 (558 x 755 mm)
Edition: E/V 20
Paper: Misch handmade
Plate: Copper
Publications: Baker, Kenneth, "A Life's
 Work of Puzzles and Master
 Printmaking," *San Francisco Chronicle*
 5/18/88, ill. p. E-3; Esslin, Martin, *Misch
 Kohn Prints: Chicago-California*, cover ill.
Comments: Abstraction. MK in plate, ll;
 signed, ed. info, titled, and dated in
 graphite.

685. *Landscape with a Gentle Eye*
Engraving on handmade embedded paper
Edition: unique
Paper: Misch handmade embedded
Plate: Lucite
Comments: Abstraction.

686. *Landscape with Blue and Black*
Engraving on handmade embedded paper
Edition: unique
Paper: Misch handmade embedded
Plate: Lucite
Comments: Abstraction.

687. *Landscape with Pink and Blue*
Engraving, embossing, silver ink on hand-
 made embedded paper
Image: 32 x 54 1/2" (813 x 1384 mm)
 irregular
Sheet: 32 x 54 1/2" (813 x 1384 mm)
 irregular
Edition: unique
Paper: Misch handmade embedded
Plate: Lucite
Comments: Abstraction.

688. *Paperwork*
Engraving on handmade embedded paper
Image: 72 1/2 x 35" (1841 x 889 mm)
 irregular
Sheet: 72 1/2 x 35" (1841 x 889 mm)
 irregular
Edition: unique
Paper: Misch handmade embedded
Plate: Lucite
Collections: Private collection
Comments: Abstraction.

689. *Screens*
Aquatint etching, engraving, *chine collé*
 with gold leaf, rainbow-roll and color
 woodcut
Image: 23 3/4 x 17 3/4" (603 x 451 mm)
Sheet: 26 1/2 x 23" (673 x 584 mm) irregular
Edition: 2
Paper: Misch handmade
Plate: Copper

Collections: Private collection
Comments: Abstraction. Signed and dated
 in graphite.

690. *Transformations*
Engraving, woodcut, *chine collé* with silver
 leaf and metal-type engraving on hand-
 made embedded paper
Image: Irregular
Paper: Misch handmade embedded
Plate: Lucite
Comments: Abstraction.

691. Untitled
Engraving, silver ink on handmade
 embedded paper
Image: 70 x 30" (1778 x 762 mm) irregular
Sheet: 70 x 30" (1778 x 762 mm) irregular
Edition: unique
Paper: Misch handmade embedded
Plate: Lucite
Collections: Private collection
Comments: Abstraction.

692. Untitled [155-154]
Etching, engraving, *chine collé* with metal-
 type engraving, rainbow-roll and color
 woodcut, wood type, and found objects
Image: 16 7/8 x 23 3/8" (428 x 593 mm)
 irregular
Plate: 15 x 23" (381 x 584 mm)
Sheet: 22 1/4 x 29 7/8" (565 x 758 mm)
Edition: 10
Paper: Misch handmade, watermarked
Plate: Copper
Comments: Abstraction. Signed and dated
 in graphite.

693. *Windy Day at the Beach*
Sugar-lift ground aquatint etching,
 engraving, *chine collé*
Image: 9 1/4 x 22 1/4" (235 x 565 mm)
 irregular
Sheet: 22 1/4 x 28" (565 x 711 mm)
Edition: E/V 10
Paper: Misch handmade, watermark
Plate: Copper
Comments: Abstraction. Signed, ed. info,
 titled, and dated in graphite.

694. *Yukon Flats*
Engraving, *chine collé* with found objects
Image: 9 9/16 x 20 13/16" (243 x 528 mm)
 irregular
Sheet: 22 1/4 x 30 1/8" (565 x 765 mm)
Edition: 21
Paper: Handmade, Misch watermark
Plate: Lucite
Comments: Abstraction. Signed, ed. info,
 titled, and dated in graphite.

668. *Trenton*
Alternate title: *Monterey Bay*
Etching, drypoint, *chine collé* with metal-
type engraving, found objects, rainbow-
roll and color woodcut
Image: 8 1/8 x 11" (206 x 279 mm) irregular
Plate: 7 7/8 x 10 3/4" (199 x 276 mm)
Sheet: 22 1/4 x 22 3/4" (565 x 578 mm)
Edition: E/V 10
Paper: Misch handmade
Plate: Copper
Collections: Private collection
Comments: Abstraction. E/V utilized dif-
ferent map sections, so each print was
titled according to the different geo-
graphical areas collaged. MK in plate, lr;
signed, ed. info, titled, and dated in
graphite.

669. Untitled
Engraving, *chine collé* with rainbow-roll
and color woodcut, metal-type engrav-
ing, and found objects
Image: 21 3/4 x 29 3/4" (552 x 755 mm)
Plate: 31 3/8 x 35 5/16" (797 x 897 mm)
Edition: unique
Paper: Misch handmade
Plate: Lucite
Comments: Abstraction. This same plate
was used for *Essential to Understand* and
Special Delivery, both 1987.

1987

670. *5-6-7-8*
Engraving, *chine collé* with color woodcut,
wood type, and found objects
Image: 32 x 54" (813 x 1371 mm) irregular
Sheet: 32 x 54" (813 x 1371 mm) irregular
Paper: Japanese handmade laid onto
Misch handmade
Plate: Lucite
Comments: Abstraction. This same plate
was used for *Transformations*, 1992.

671. *After the Excavation*
Etching, engraving, *chine collé* with metal
leaf
Image: 10 1/4 x 19" (260 x 482 mm)
irregular
Plate: 10 x 18 3/4" (254 x 476 mm)
Sheet: 22 x 29 7/8" (558 x 758 mm)
Paper: Farnsworth, Misch watermark
Plate: Copper
Comments: Abstraction. Signed, titled,
and dated in graphite.

672. *Essential to Understand*
Engraving, *chine collé* with silver leaf,
metal-type engraving, rainbow-roll and
color woodcut, found objects
Image: 21 3/4 x 29 3/4" (552 x 755 mm)
irregular
Plate: 31 3/8 x 35 5/16" (797 x 897 mm)
Edition: unique
Paper: Misch handmade
Plate: Lucite
Comments: Abstraction. This same plate
was used for an untitled unique print,
1986, and for *Special Delivery*, 1987.

673. *Excavation*
Sugar-lift ground aquatint etching,
engraving, *chine collé* with silver leaf,
metal-type engraving, found objects,
rainbow-roll and color woodcut
Image: 10 1/4 x 9 7/8" (260 x 251 mm)
irregular
Plate: 8 3/4 x 9 13/16" (222 x 249 mm)
Sheet: 22 x 30 3/8" (558 x 771 mm)
Edition: E/V 10 [20]
Paper: Misch handmade
Plate: Zinc
Comments: Abstraction. Signed, ed. info,
titled, and dated in graphite.

674. *Isle of Coll*
Alternate title: *From Island of Colle*
Etching, engraving, *chine collé* with silver
leaf, color woodcut, and found objects
Image: 18 1/2 x 20 1/2" (470 x 521 mm)
irregular
Plate: 16 5/8 x 19 3/4" (422 x 502 mm)
Sheet: 22 x 30" (558 x 762 mm)
Edition: unique
Paper: Farnsworth, Misch watermark
Plate: Copper
Comments: Abstraction. Signed, titled,
and dated in graphite.

675. *Rocks on the Beach*
Aquatint etching, engraving with spit-
bitten tone
Image: 11 3/4 x 21 3/4" (298 x 552 mm)
Sheet: 22 x 28" (558 x 711 mm) irregular
Edition: unique
Paper: Handmade, Misch watermark
Plate: Copper
Comments: Abstraction. Printed in sepia.
Signed, titled, and dated in graphite.

676. *Silver 5*
Embossing, *chine collé* with silver leaf,
color woodcut, metal-type engraving,
wood type, and found objects on color-
embedded handmade paper
Image: 32 x 48" (813 x 1219 mm) irregular

Sheet: 32 x 48" (813 x 1219 mm) irregular
Edition: unique
Paper: Misch handmade embedded
Plate: Lucite
Comments: Abstraction.

677. *Special Delivery*
Engraving, *chine collé* with silver leaf,
metal-type engraving, color woodcut,
wood type, and found objects
Image: 21 3/4 x 29 3/4" (552 x 755 mm)
irregular
Plate: 31 3/8 x 35 5/16" (797 x 897 mm)
Edition: unique
Paper: Misch handmade
Plate: Lucite
Comments: Abstraction. This same plate
was used for an untitled unique print,
1986, and for *Essential to Understand*,
1987. Signed, ed. info, titled, and dated
in graphite.

678. *The Hayward Print*
A) Engraving, *chine collé* with metal leaf,
line etching on zinc, metal-type engrav-
ing, found objects, rainbow-roll and
color woodcut, B) Lithograph
Image: 12 5/8 x 24" (321 x 609 mm)
irregular
Plate: 12 3/8 x 23 3/4" (314 x 603 mm)
Sheet: 21 1/8 x 30 1/4" (536 x 768 mm)
Edition: 20
Paper: A) Farnsworth, B) commercial
chrome coat
Plate: A) Lucite, B) Aluminum
Printer/Publisher: B) Published commer-
cially by CSUH
Collections: Private collections
Publications: *Acacia* (Spring, 1987), color
cover ill, pp. 3, 14.
Comments: Abstraction. As a contribution
to CSUH, Kohn created this print; pro-
ceeds from the sale were used to estab-
lish an endowment fund for the univer-
sity art gallery. A limited edition of 100
signed lithographs was also published
by CSUH. Signed, ed. info, and dated in
graphite.

679. Untitled
Engraving on handmade embedded paper
Image: 32 x 52" (813 x 1321 mm) irregular
Sheet: 32 x 52" (813 x 1321 mm) irregular
Edition: unique
Paper: Misch handmade embedded
Plate: Lucite
Comments: Abstraction.

656. *Ontario*
Engraving, *chine collé* with silver leaf, etch-
ing, color woodcut, and found objects
Image: 20 3/8 x 30 5/16" (517 x 770 mm)
irregular
Sheet: 20 3/8 x 30 5/16" (517 x 770 mm)
irregular
Edition: unique
Paper: Misch handmade
Plate: Lucite
Comments: Abstraction. This same plate
was used for an untitled print, 1980, *LT
151*, 1983, and *St. Louis*, 1985. MK in
plate, lr; signed, ed. info, titled, and
dated in graphite.

657. *Rio Grande*
Engraving, etching, *chine collé* with metal
leaf and found objects
Image: 11 1/2 x 13 1/4" (292 x 336 mm)
Edition: uneditioned
Paper: China/India and metal leaf laid
onto Misch handmade
Plate: Copper
Comments: Abstraction. Dated in graphite.

658. *Shanghai*
Engraving, *chine collé* with metal leaf, color
woodcut, and found objects
Image: 20 3/16 x 20 13/16" (513 x 513 mm)
irregular
Edition: unique
Paper: China/India and metal leaf laid
onto BFK Rives
Plate: Lucite
Comments: Abstraction. Signed in
graphite.

659. *St. Louis*
Engraving, *chine collé* with etching, color
woodcut, and found objects
Image: 20 3/16 x 29 7/8" (513 x 758 mm)
Sheet: 20 3/16 x 29 7/8" (513 x 758 mm)
irregular
Edition: unique
Paper: Misch handmade
Plate: Lucite
Comments: Abstraction. This same plate
was used for an untitled print, 1980, *LT
151*, 1983, and *Ontario*, 1985. MK in
plate, lr; signed and dated in graphite.

660. *Tao Amaretti*
Engraving, *chine collé* with etching, rain-
bow-roll and color woodcut, metal-type
engraving, wood type, and found
objects
Image: 17 x 20" (432 x 508 mm)
Sheet: 23 x 30 1/2" (584 x 775 mm) irregular
Edition: E/V

Paper: China/India laid onto Misch hand-
made
Plate: Lucite
Comments: Abstraction. This same plate
was used for *Black Warrior Basin*, 1980.
Signed, titled, and dated in graphite.

661. Untitled
Engraving, *chine collé* with metal-type
engraving, rainbow-roll and color wood-
cut on color-embedded handmade paper
Image: 8 x 25 1/2" (203 x 648 mm) irregular
Plate: 7 3/4 x 25" (197 x 635 mm)
Sheet: 19 5/8 x 29 3/4" (498 x 755 mm)
Edition: unique
Paper: Misch handmade embedded, Misch
watermark
Plate: Lucite
Printer/Publisher: CSUH
Comments: Abstraction. This same plate
was used for *Party Line*, 1980. MK in
plate, lr; signed and dated in graphite.

1986

662. *A Memory from Sweden*
Alternate title: *A Memory for Sweden*
Etching, engraving, *chine collé* with silver
leaf, rainbow-roll color woodcut, wood
type, and found objects
Image: 14 1/4 x 18 3/4" (362 x 476 mm)
irregular
Plate: 11 1/4 x 18 3/4" (286 x 476 mm)
Sheet: 22 1/4 x 26 1/2" (565 x 673 mm)
Edition: unique
Paper: Misch handmade
Plate: Copper
Comments: Abstraction. Signed, titled,
and dated in graphite.

663. *Diptych*
Engraving, *chine collé* with rainbow-roll
and color woodcut
Image: 30 1/2 x 45 1/2" (775 x 1158 mm)
Sheet: 30 1/2 x 45 1/2" (775 x 1158 mm)
irregular
Edition: unique
Paper: Misch handmade
Plate: Lucite (2)
Collections: Capital Hilton,
Washington, DC
Publications: *Jane Haslem Gallery Newsletter*
(September/October/November 1986),
cover ill.
Comments: Abstraction. Signed and dated
in graphite.

664. *Excavation Part 3*
Alternate title: *Excavation Part III*
Sugar-lift ground aquatint etching,
engraving, *chine collé* with metal leaf,
rainbow-roll and color woodcut, wood
type
Image: 14 3/4 x 9 13/16" (374 x 249 mm)
irregular
Plate: 8 3/4 x 9 13/16" (222 x 249 mm)
Sheet: 22 1/4 x 23 1/2" (565 x 597 mm)
Edition: unique
Paper: Handmade, Misch watermark
Plate: Zinc
Comments: Abstraction. Signed, titled,
and dated in graphite.

665. *Molinari*
Engraving, *chine collé* with etching, color
woodcut, and found objects
Image: 31 x 44 5/8" (787 x 1133 mm)
irregular
Sheet: 31 x 44 5/8" (787 x 1133 mm)
irregular
Edition: unique
Paper: Misch handmade
Plate: Lucite
Comments: Abstraction. Signed, titled,
and dated in graphite.

666. *SFO and Oakland*
Engraving, *chine collé* with color woodcut
and found objects on color-embedded
handmade paper
Image: 24 x 43 3/4" (609 x 1111 mm)
irregular
Sheet: 24 x 43 3/4" (609 x 1111 mm)
irregular
Edition: unique
Paper: Misch handmade embedded
Plate: Lucite
Comments: Abstraction. Signed, titled,
and dated in graphite.

667. *The Musician*
Alternate title: *Musician*
Wood engraving
Image: 8 x 4 5/8" (203 x 117 mm)
Sheet: 8 1/2 x 5 9/16" (216 x 141 mm)
Edition: 60
Paper: China/India; some mounted on
card stock
Plate: Boxwood
Collections: Private collections
Comments: Full-length musician blowing
horn, 3/4 profile right. Variously dated
1991. Sent out as holiday greeting card.
Signed, titled, and dated in graphite.

1984

643. Untitled
Sugar-lift ground aquatint etching,
 engraving, *chine collé* with metal-type
 engraving, rainbow-roll and color
 woodcut
Image: 10 7/8 x 13 3/4" (276 x 349 mm)
Sheet: 22 x 30 1/2" (558 x 775 mm) irregular
Edition: E/V 10
Paper: Handmade, Misch watermark
Plate: Copper
Comments: Abstraction. Signed, ed. info,
 and dated in graphite.

644. Untitled
Sugar-lift ground aquatint etching,
 engraving, drypoint, *chine collé*
Image: 9 x 12" (228 x 305 mm)
Sheet: 20 3/8 x 22 1/4" (517 x 565 mm)
 irregular
Paper: Handmade, Misch watermark
Plate: Copper
Comments: Abstraction. Signed and dated
 in graphite.

645. Untitled [Wedding anouncement:
 Tamara]
Alternate title: *Herald*
Wood engraving
Image: 7 3/8 x 5 3/16" (187 x 133 mm)
Sheet: 7 3/8 x 10 5/16" (187 x 262 mm)
Edition: 101
Paper: China/India mounted on imprinted
 card stock
Collections: Private collections
Comments: Rider astride prancing horse
 blowing elaborate horn, profile left. This
 print was used as the announcement/
 invitation for the wedding of Kohn's
 younger daughter Tamara to Andrew
 Russell. A few engravings were printed
 separately on larger paper: 11 5/8 x 8 1/2"
 (295 x 330 mm). Signed, ed. info, and
 dated in graphite.

1985

646. *154 Crude*
Engraving, *chine collé* with metal leaf, color
 woodcut, and found objects
Image: 24 x 46 3/4" (609 x 1187 mm)
 irregular
Sheet: 24 x 46 3/4" (609 x 1187 mm)
 irregular
Edition: unique
Paper: Misch handmade
Plate: Lucite
Comments: Abstraction. Signed, ed. info,
 titled, and dated in graphite.

647. *Amaretti 3*
Sugar-lift ground aquatint etching,
 engraving, *chine collé* with metal-type
 engraving, color woodcut, and found
 objects
Image: 12 x 14 1/8" (305 x 358 mm)
 irregular
Plate: 11 x 14" (279 x 355 mm)
Sheet: 22 1/4 x 25 3/8" (565 x 644 mm)
Edition: unique
Paper: Farnsworth, Misch watermark
Plate: Copper
Comments: Abstraction. Signed, ed. info,
 titled, and dated in graphite.

648. *Beckett*
Sugar-lift ground aquatint etching,
 engraving, *chine collé* with gold leaf and
 found objects
Image: Irregular
Plate: 10 x 12" (253 x 302 mm)
Sheet: 21 3/4 x 31 1/2" (552 x 800 mm)
Edition: 10
Plate: Copper
Publications: Esslin, Martin, *Misch Kohn
 Prints: Chicago-California*, ill. p. 3;
 Gregor, Katherine, "A Knowing Hand,"
 Artweek (May 1988), ill. p. 5.
Comments: Abstraction. This same plate
 was used for *Graffiti*, 1983, in reverse.

649. *E.G.B.W.*
Line etching, printed in relief
Image: 21 x 19 3/4" (533 x 502 mm)
 irregular
Sheet: 21 x 19 3/4" (533 x 502 mm) irregular
Edition: uneditioned
Paper: Farnsworth, Misch watermark
Plate: Copper
Comments: Portrait of Emerson Woelffer,
 3/4 profile right. Signed, ed. info, titled,
 and dated in graphite.

650. *Essential for Anyone to Understand*
Engraving, *chine collé* with etching, found
 objects, rainbow-roll and color woodcut
Image: 32 x 54" (813 x 1371 mm) irregular
Sheet: 32 x 54" (813 x 1371 mm) irregular
Edition: unique
Paper: Misch handmade
Plate: Lucite
Comments: Abstraction. Signed and dated
 in graphite.

651. *Fragment from Shanghai*
Engraving, *chine collé* with metal leaf and
 color woodcut
Image: 12 1/16 x 12 15/16" (306 x 328 mm)
 irregular
Edition: unique

Paper: China/India and metal leaf laid
 onto Misch handmade
Plate: Lucite
Comments: Abstraction. Signed, titled,
 and dated in graphite verso.

652. *George's Bank*
Engraving, *chine collé* with etching, found
 objects, rainbow-roll and color woodcut
Image: 20 x 35 5/8" (508 x 905 mm)
 irregular
Sheet: 20 x 35 5/8" (508 x 905 mm) irregular
Edition: unique
Paper: Misch handmade
Plate: Lucite
Comments: Abstraction. Signed in
 graphite.

653. *I Can't Go On, I'll Go On*
Engraving, *chine collé* with etching, color
 woodcut, and found objects
Image: 22 x 48" (558 x 1219 mm) irregular
Sheet: 22 x 48" (558 x 1219 mm)
Edition: unique
Paper: Misch handmade
Plate: Lucite
Comments: Abstraction. This plate was
 used for several other unique prints
 from this time period.

654. *Landscape with Red and Blue*
Alternate title: *Landscape in Red and Blue*
Sugar-lift ground aquatint etching,
 engraving, *chine collé* with found objects,
 rainbow-roll and color woodcut
Image: 11 x 14" (279 x 355 mm) irregular
Sheet: 22 5/16 x 24" (567 x 609 mm)
Edition: unique
Paper: China/India laid onto Misch hand-
 made
Plate: Copper
Comments: Abstraction. This same plate
 was also used for *East of Eden*, late
 1970s/early 1980s. Signed, ed. info,
 titled, and dated in graphite.

655. *Mathematical Barrier*
Engraving, *chine collé* with etching, metal
 leaf, color woodcut, and found objects
Image: 13 1/2 x 19 5/8" (343 x 498 mm)
 irregular
Plate: 11 3/8 x 18 7/8" (289 x 479 mm)
Sheet: 22 x 29 13/16" (558 x 757 mm)
Edition: unique
Paper: Handmade, Misch watermark
Plate: Lucite
Comments: Signed, ed. info, titled, and
 dated in graphite.

633. *Silver Valley [I]*
Sugar-lift ground aquatint etching,
 engraving, *chine collé* with silver ink
Image: 9 x 11 7/8" (229 x 300 mm)
Plate: 9 x 12" (228 x 305 mm)
Sheet: 15 1/8 x 18" (383 x 456 mm)
Edition: 45
Paper: Farnsworth, Misch watermark
Plate: Copper
Collections: Oakland Museum of
 California, private collections
Publications: Heyman, *Cream of California
 Prints*, cat. #24.
Comments: Abstraction. This print was
 included in a portfolio produced for
 CSUH in 1982. The same plate was used
 for *The Valley*, 1982. MK in plate, lr;
 signed, ed. info, titled, and dated in
 graphite.

634. *Silver Valley* [II]
Alternate title: *Hidden Valley*
Sugar-lift ground aquatint etching,
 engraving, *chine collé* with silver leaf
Image: 12 x 18" (305 x 455 mm)
Sheet: 22 1/4 x 29 3/4" (565 x 758 mm)
Edition: E/V 25 [10]
Paper: Farnsworth, Misch watermark
Plate: Copper
Collections: Private collection
Comments: Abstraction. Red ink was
 printed first, then silver leaf was laid
 onto the wet ink; finally, the black plate
 was printed over all. Variously printed
 and dated 1988, 1993. Signed, ed. info,
 titled, and dated in graphite.

635. *Silver Valley* [III]
Sugar-lift ground aquatint etching,
 engraving, *chine collé*
Image: 9 x 11 3/4" (228 x 298 mm)
Sheet: 22 3/8 x 26 3/4" (568 x 679 mm)
 irregular
Paper: China/India laid onto Farnsworth,
 Misch watermark
Plate: Copper
Comments: Abstraction. Printed in sepia.
 MK in plate, lr.

636. *The Valley*
Sugar-lift ground aquatint etching,
 engraving, *chine collé* with rainbow-roll
 and color woodcut
Image: 9 3/8 x 12 5/8" (238 x 320 mm)
 irregular
Plate: 9 x 12" (228 x 305 mm)
Sheet: 19 5/8 x 22 1/4" (498 x 565 mm)
Edition: E/V
Paper: Farnsworth
Plate: Copper

Comments: Abstraction. This same plate
 was used for *Silver Valley [I]* 1982. MK in
 plate, lr; signed, ed. info, titled, and
 dated in graphite.

1983

637. *A Letter To Japan*
Sugar-lift ground aquatint etching,
 engraving, *chine collé* with color wood-
 cut and found objects
Image: 7 15/16 x 10 7/8" (202 x 276 mm)
 irregular
Plate: 8 x 10 3/4" (203 x 273 mm)
Sheet: 18 15/16 x 22" (481 x 558 mm)
Edition: E/V 25
Paper: Handmade, Misch watermark
Plate: Magnesium
Comments: Abstraction. This same plate
 was used for *Campeche* and *My Bauhaus
 Past*, both 1980. Signed, ed. info, titled,
 and dated in graphite.

638. *Graffiti*
Sugar-lift ground aquatint etching,
 engraving, *chine collé* with metal-type
 engraving and color woodcut
Image: 10 x 11 7/8" (253 x 302 mm)
 irregular
Plate: 10 x 12" (253 x 305 mm)
Sheet: 22 1/4 x 25 3/8" (564 x 642 mm)
Edition: Ed 30, 9 AP
Paper: China/India laid onto handmade,
 Misch watermark
Plate: Copper
Printer/Publisher: Achenbach Foundation
 for the Graphic Arts
Collections: Achenbach Foundation for
 Graphic Arts, Fine Arts Museums of San
 Francisco; private collections
Publications: Moser, Joann, *Novija
 Americka Grafika*, ill. p. 16; Parsons,
 Barbara Galuszka, "I Can't Go On; I'll
 Go On," *California Printmaker* (Winter
 1993), cover ill; University of Santa
 Clara Art Department, Lecture Series
 poster ill., 1984.
Comments: Abstraction. Variously printed
 1986. This print was commissioned by
 the Graphic Arts Council of the
 Achenbach Foundation for Graphic Arts
 of the Fine Arts Museums of San
 Francisco. The paper was made espe-
 cially for this print and was not used
 elsewhere. The plate was used later for
 Beckett, 1985, in reverse. Signed, ed. info,
 titled, and dated in graphite.

639. *Japan Mail*
Sugar-lift ground aquatint etching,
 engraving, *chine collé* with silver leaf,
 color woodcut, and found objects
Image: 14 1/2 x 22 11/16" (368 x 576 mm)
 irregular
Plate: 14 x 22 1/2" (355 x 571 mm)
Sheet: 21 15/16 x 18" (557 x 457 mm)
Edition: unique
Paper: Misch handmade
Plate: Magnesium
Comments: Abstraction. Signed, ed. info,
 titled, and dated in graphite.

640. *LT 151*
Engraving, *chine collé* with gold leaf, silver
 leaf, found objects, rainbow-roll and
 color woodcut
Image: 23 3/8 x 29 3/4" (594 x 755 mm)
Sheet: 30 1/4 x 36 1/4" (768 x 921 mm)
Edition: E/V 10
Paper: Japanese Hosho
Plate: Lucite
Comments: Abstraction. This same plate
 used for an untitled print, 1980, and for
 Ontario and *St. Louis*, 1985. Signed,
 titled, and dated in graphite.

641. *Silver Birds on Blue* [Wedding
 announcement: Jessica]
Engraving, etching, silver ink
Image: 7 1/4 x 5 1/8" (184 x 130 mm)
Sheet: 7 1/4 x 5 1/8" (184 x 130 mm)
 irregular
Edition: 120
Paper: Handmade [blue] mounted onto
 card stock
Plate: Copper
Collections: Private collections
Comments: Birds and fluid lines in vertical
 format. This print was used for the
 announcement/invitation for the wed-
 ding of Kohn's older daughter Jessica to
 Frank McGuire.

642. *The Issue is Rape*
Engraving, etching, *chine collé* with metal-
 type engraving, color woodcut, and
 found objects
Image: 18 1/8 x 20 7/8" (460 x 530 mm)
 irregular
Plate: 11 1/4 x 18 7/8" (285 x 479 mm)
Sheet: 22 1/2 x 26 3/8" (565 x 670 mm)
 irregular
Edition: E/V 10
Paper: Handmade, Misch watermark
Plate: Zinc
Comments: Abstraction with pre-printed
 color woodcut. Signed, ed. info, and
 dated in graphite.

Comments: Abstraction. This same plate was used for *LT 151*, 1983, and for *Ontario* and *St. Louis*, both 1985. Note that the plate bleeds off the edge of the paper.

1981

622. *A Summer Day at China Camp*
Sugar-lift ground aquatint etching, engraving, *chine collé* with rainbow-roll and color woodcut
Image: 8 x 12" (203 x 305 mm) irregular
Sheet: 21 1/2 x 36 1/4" (546 x 921 mm)
Edition: 20
Paper: Farnsworth, Misch watermark
Plate: Copper
Publications: Baro, Gene, *Twenty-Second National Print Exhibition*, ill. p. 56.
Comments: Abstraction. MK in plate, ll; signed, ed. info, titled, and dated in graphite.

623. *China Basin*
Engraving, *chine collé* with etching, rainbow-roll and color woodcut
Image: 10 x 23 5/8" (254 x 604 mm) irregular
Sheet: 20 1/4 x 37 3/4" (515 x 960 mm)
Edition: 20
Paper: Eishiro Abe and Misch Kohn handmade
Plate: Lucite
Collections: Private collection
Publications: Metz, Kathryn, *Misch Kohn: Three Decades*, cat. #30.
Comments: Abstraction. 6 press runs. Signed, ed. info, titled, and dated in graphite.

624. *China Camp*
Engraving, etching, *chine collé* with rainbow-roll and color woodcut
Image: 10 x 24" (255 x 610 mm)
Sheet: 20 1/8 x 31 1/2" (510 x 800 mm)
Edition: 10
Plate: Copper
Publications: Baro, Gene, *Twenty-Second National Print Exhibition*, cat. #75, p. 56.
Comments: Abstraction. Signed, ed. info, titled, and dated in graphite.

625. *The Garden*
Sugar-lift ground aquatint etching, drypoint, printed A) black only, B) engraving, *chine collé* with silver and gold leaf
Image: 7 3/8 x 10" (187 x 254 mm)
Sheet: 22 1/8 x 28 1/4" (562 x 718 mm)
States: 2

Paper: Farnsworth, Misch watermark
Plate: Copper
Comments: Abstraction. This same plate was used for *Silver Garden* and *Step Garden*, 1977, and for *See How My Garden Grows*, 1980. The first state was the black line etching only; in the second state *chine collé* and engraving were added. Signed, ed. info, titled, and dated in graphite.

626. *The Unnameable*
Photo-etching, *chine collé*
Image: 11 1/2 x 8 7/8" (292 x 225 mm)
Sheet: 23 1/4 x 16 5/8" (590 x 422 mm)
Edition: 10
Paper: China/India laid onto BFK Rives
Plate: Zinc
Publications: Metz, Kathryn, *Misch Kohn: Three Decades*, cat. #29.
Comments: Abstraction.

627. Untitled
Sugar-lift ground aquatint etching, engraving, *chine collé* with rainbow-roll and color woodcut
Image: 8 x 12" (203 x 305 mm) irregular
Sheet: 22 1/4 x 26 1/4" (565 x 666 mm)
Paper: Farnsworth, Misch watermark
Plate: Copper
Comments: Abstraction. The color palette and plate are the same as in *A Summer Day at China Camp*, 1981, but the collage elements are organized differently. MK in plate, ll; signed and dated in graphite.

628. *West Bend*
Sugar-lift ground aquatint etching, *chine collé* with rainbow-roll and color woodcut
Image: 16 3/8 x 20 3/4" (416 x 527 mm) irregular
Plate: 14 7/8 x 20 3/4" (378 x 527 mm)
Sheet: 22 1/2 x 26 1/4" (565 x 666 mm)
Edition: 20
Paper: Farnsworth, Misch watermark
Plate: Copper
Printer/Publisher: University of Houston, Texas
Comments: Abstraction. Created at a workshop demonstration he gave at the university. Signed, ed. info, titled, and dated in graphite.

629. [Wine Label]
Photo-etching collage
Image: 5 x 3 3/4" (127 x 95 mm)
Sheet: 5 x 3 3/4" (127 x 95 mm)
Edition: unique
Paper: Strathmore single-ply

Printer/Publisher: HNW Vineyards
Comments: This constructivist abstraction was used as a wine label for a Napa Valley Sauvignon Blanc for several years by HNW Vineyards (HNW Cellars, St. Helena, CA).

1982

630. *Abe's World*
Sugar-lift ground aquatint etching, engraving, *chine collé* with color woodcut
Image: 9 3/8 x 22 1/4" (238 x 565 mm) irregular
Plate: 9 x 22" (228 x 558 mm)
Sheet: 19 7/8 x 31 5/8" (505 x 803 mm)
Edition: unique
Paper: Eishiro Abe handmade laid onto Farnsworth
Plate: Copper
Comments: Abstraction. This plate was also used for *Braque's Village*, 1982. It was titled in honor of traditional Japanese papermaker Living National Treasure Eishiro Abe. Signed, ed. info, titled, and dated in graphite.

631. *Braque's Village*
Sugar-lift ground aquatint etching, engraving, *chine collé* with rainbow-roll and color woodcut
Image: 9 5/8 x 22 3/4" (244 x 578 mm) irregular
Plate: 9 1/4 x 22 1/4" (236 x 565 mm)
Edition: unique
Plate: Copper
Collections: Private collection
Comments: Abstraction. This same block was used for *Abe's World*, 1982. Signed, ed. info, titled, and dated in graphite.

632. *Japan Mail*
Sugar-lift ground aquatint etching, engraving, drypoint, *chine collé* with found objects, rainbow-roll and color woodcut
Image: 12 3/8 x 13 1/2" (314 x 343 mm) irregular
Plate: 10 1/2 x 13 1/4" (267 x 336 mm)
Sheet: 22 1/4 x 26" (565 x 660 mm) irregular
Edition: E/V 10
Paper: Farnsworth, Misch watermark
Plate: Copper
Comments: Abstraction. Signed, ed. info, titled, and dated in graphite.

611. *Point Line and Plane*
Alternate title: *Paysage*
Line engraving A) black only, B) *chine collé*
 background paper
Image: 5 x 6 7/8" (127 x 175 mm)
Sheet: 19 5/8 x 29 1/2" (500 x 750 mm)
Edition: 30
States: 2
Paper: China/India laid onto BFK Rives
 or Arches
Plate: Copper
Publications: Baro, Gene, *California Years*,
 cat. #76.
Comments: Abstraction. This plate was
 used variously for a variety of color
 chine collé prints, including *I've Got a
 Ticket to Ride* and *Looking Ahead*, both
 1980. Signed, ed. info, titled, and dated
 in graphite.

612. *Sailing Home*
Alternate title: *Blue Pole*
Sugar-lift ground aquatint etching,
 engraving, drypoint, *chine collé* with
 rainbow-roll and color woodcut
Image: 13 3/4 x 13 5/8" (349 x 346 mm)
 irregular
Plate: 11 3/8 x 13 1/4" (289 x 336 mm)
Sheet: 22 7/8 x 26 3/8" (580 x 669 mm)
Edition: 20
Paper: Farnsworth, Misch watermark
Plate: Copper
Collections: Private collection
Publications: Baro, Gene, *California Years*,
 ill. cat. #77, p. 10.
Comments: Abstraction. This same plate
 was used for *Tiburon*, 1980. 8 press runs.
 Signed, ed. info, titled, and dated in
 graphite.

613. *Scree*
Sugar-lift ground aquatint etching,
 engraving, *chine collé* with found objects,
 rainbow-roll and color woodcut
Image: 9 1/8 x 11 3/8" (232 x 289 mm)
 irregular
Plate: 5 3/4 x 11" (146 x 279 mm)
Sheet: 15 3/4 x 20 1/2" (400 x 520 mm)
Edition: 20
Paper: Japanese handmade
Plate: Zinc
Publications: Baro, Gene, *California Years*,
 cat. #78.
Comments: Abstraction. This same plate
 was used in a 1978 untitled print. 6 press
 runs. Signed, ed. info, titled, and dated
 in graphite.

614. *See How My Garden Grows*
Sugar-lift ground aquatint etching,
 engraving, *chine collé*, printed A) black
 only, B) black etching over collage
 including rainbow-roll and color wood-
 cut
Image: 8 1/2 x 12 5/8" (217 x 321 mm) [B]:
 irregular]
Plate: 8 1/4 x 12 5/8" (209 x 321 mm)
Sheet: 22 x 27 3/4" (559 x 707 mm)
Edition: 20
States: 2
Paper: Farnsworth, Misch watermark
Plate: Copper
Collections: Private collection
Publications: Baro, Gene, *California Years*,
 cat. #79.
Comments: Abstraction. 7 press runs in
 second state with color collage elements.
 This same plate was used for *Silver
 Garden* and *Step Garden*, 1977, and *The
 Garden*, 1981. Signed, ed. info, titled, and
 dated in graphite.

615. *Silver Maze*
Sugar-lift ground aquatint etching,
 engraving, silver ink, *chine collé* with
 found objects, rainbow-roll and color
 woodcut
Image: 22 1/4 x 17 7/8" (565 x 455 mm)
Sheet: 22 1/4 x 17 7/8" (565 x 455 mm)
 irregular
Edition: E/V 10
Paper: Farnsworth
Plate: Copper
Publications: Baro, Gene, *California Years*,
 cat. #80; Metz, Kathryn, *Misch Kohn:
 Three Decades*, cat. #28.
Comments: Abstraction. 5 press runs.
 Signed, ed. info, titled, and dated in
 graphite.

616. *Snake River*
Engraving, *chine collé* with color woodcut
 and found objects
Image: 12 5/8 x 19 1/4" (320 x 487 mm)
 irregular
Plate: 11 1/4 x 18 7/8" (286 x 479 mm)
Sheet: 22 1/2 x 28" (570 x 710 mm)
Edition: 20
Paper: Farnsworth
Plate: Magnesium
Publications: Baro, Gene, *California Years*,
 cat. #81.
Comments: Abstraction. 3 press runs.
 Signed, ed. info, titled, and dated in
 graphite.

617. *State of Grace*
Engraving, *chine collé* with metal leaf and
 color woodcut
Image: 28 x 26" (710 x 660 mm) irregular
Sheet: 41 x 31 5/8" (1040 x 803 mm)
Edition: 20
Paper: Farnsworth
Plate: Lucite
Publications: Baro, Gene, *California Years*,
 cat. #82.
Comments: Abstraction. 7 press runs.
 Signed, ed. info, titled, and dated in
 graphite.

618. *Tiburon*
Sugar-lift ground aquatint etching,
 engraving, drypoint, *chine collé* with
 color woodcut and found objects
Image: 13 3/4 x 13 5/8" (349 x 346 mm)
 irregular
Plate: 11 3/8 x 13 1/4" (289 x 336 mm)
Paper: Farnsworth
Plate: Copper
Comments: Abstraction. This same plate
 was used for *Sailing Home*, 1980. Signed
 and dated in graphite.

619. *Tinguely Machine*
Line engraving and photo-etching
 A) embossing only, B) engraving with
 color collage
Image: 12 11/16 x 18 1/8" (322 x 460 mm)
 irregular
Sheet: 17 3/4 x 22 1/4" (451 x 565 mm)
Edition: uneditioned
States: 2
Paper: BFK Rives
Plate: Copper
Comments: Abstraction. This same plate
 was used for *Kant and the Numbers Game*,
 1977.

620. Untitled
Engraving, *chine collé*
Image: 13 1/4 x 23 3/4" (336 x 603 mm)
 irregular
Sheet: 22 1/4 x 27 7/8" (565 x 708 mm)
Paper: China/India laid onto Farnsworth,
 Misch watermark
Plate: Magnesium
Comments: Abstraction. Signed and dated
 in graphite.

621. Untitled
Engraving, *chine collé* with etching, silver
 leaf, found objects, rainbow-roll and
 color woodcut
Image: 23 3/8 x 29 3/4" (593 x 755 mm)
 irregular
Plate: Lucite

Sheet: 22 1/4 x 29 7/8" (566 x 760 mm)
Edition: 20
Paper: Arches
Plate: Copper
Publications: Baro, Gene, *California Years*, cat. #68.
Comments: Abstraction. 6 press runs. Signed, ed. info, titled, and dated in graphite.

601. *I've Got a Ticket to Ride*
Sugar-lift ground aquatint etching, engraving, *chine collé* with found objects, rainbow-roll and color woodcut
Image: 7 3/4 x 8 1/8" (196 x 207 mm) irregular
Plate: 5 x 7" (127 x 178 mm)
Sheet: 15 3/8 x 20 1/2" (396 x 520 mm)
Edition: E/V 30 [20]
Paper: Japanese handmade
Plate: Copper
Publications: Baro, Gene, *California Years*, cat. #69; Garver, Thomas H., *New American Graphics 2*, cat. p. 55; Metz, Kathryn, *Misch Kohn: Three Decades*, cover ill, cat. #26, exhib. ann. ill.; "Misch Kohn," exhib. poster ill., College of the Siskiyous, 1987; "Misch Kohn Prints/Chicago-California A Retrospective" exhib. ann. ill., Kala Institute, 1988.
Comments: Abstraction. This same plate was used for *Point Line and Plane* (line engraving only) and *Looking Ahead*, both 1980. 5 press runs. Signed, ed. info, titled, and dated in graphite.

602. *Kodak 120*
Alternate title: *Kodak*
Sugar-lift ground aquatint etching, engraving, *chine collé* with found objects, rainbow-roll and color woodcut
Image: 8 1/2 x 23 3/4" (218 x 603 mm) irregular
Plate: 5 1/2 x 23 3/4" (139 x 603 mm)
Sheet: 15 3/4 x 32 3/4" (400 x 830 mm)
Edition: 20
Paper: Farnsworth
Plate: Magnesium
Publications: Baro, Gene, *California Years*, cat. #70.
Comments: Abstraction. 6 press runs. Signed, ed. info, titled and dated in graphite.

603. *Looking Ahead*
Alternate titles: *Paysage*
Sugar-lift ground aquatint etching, engraving, *chine collé* with rainbow-roll and color woodcut

Image: 5 3/8 x 7" (137 x 179 mm) irregular
Plate: 5 x 6 15/16" (127 x 176 mm)
Sheet: 22 1/8 x 28" (562 x 712 mm)
Edition: 10
Paper: Farnsworth
Plate: Copper
Publications: Baro, Gene, *California Years*, cat. #71.
Comments: Abstraction. This same plate was used for *I've Got a Ticket to Ride* and the line engraving *Point, Line and Plane*, both 1980. 6 press runs. Signed, ed. info, titled, and dated in graphite.

604. *Main Event*
Sugar-lift ground aquatint etching, drypoint, engraving, *chine collé* with color woodcut
Image: 23 3/8 x 29 1/2" (594 x 750 mm)
Sheet: 26 x 32" (660 x 813 mm)
Edition: 10
Paper: Farnsworth, Misch watermark
Plate: Zinc
Publications: Baro, Gene, *California Years*, cat. #72.
Comments: Abstraction. 7 press runs.

605. *Main Event II*
Engraving, aquatint, *chine collé* with rainbow-roll and color woodcut
Image: 20 3/16 x 29 7/8" (513 x 759 mm) irregular
Sheet: 25 3/4 x 35 3/4" (654 x 908 mm)
Edition: unique
Paper: Handmade
Plate: Lucite
Comments: Abstraction. Signed, ed. info, titled and dated in graphite.

606. *Marathon*
Engraving, etching, *chine collé* with found objects, rainbow-roll and color woodcut
Image: 17 3/4 x 24" (453 x 611 mm) irregular
Plate: 15 13/16 x 23 5/8" (402 x 600 mm)
Sheet: 24 3/8 x 32 1/8" (620 x 815 mm)
Edition: 20
Paper: Toyoshi
Plate: Magnesium
Publications: Baro, Gene, *California Years*, cat. #73; Peterdi, Gabor, *Printmaking*, (1980), ill. p. 327 [as Untitled].
Comments: Abstraction. 6 press runs.

607. *Moon Shot*
Aquatint etching
Image: 4 x 11 7/8" (102 x 302 mm)
Sheet: 21 1/2 x 29 5/8" (546 x 752 mm)
Edition: uneditioned
Paper: BFK Rives

Plate: Copper
Comments: Constructivist abstraction. Signed, ed. info, titled, and dated in graphite.

608. *My Bauhaus Past*
Engraving, etching, *chine collé* with silver leaf, color woodcut, and found objects
Image: 19 3/8 x 25 3/4" (494 x 665 mm) irregular
Plate: 15 13/16 x 23 5/8" (402 x 600 mm)
Sheet: 24 5/8 x 32 1/8" (625 x 816 mm)
Edition: E/V 20
Paper: Toyoshi
Plate: Magnesium
Publications: Baro, Gene, *California Years*, cat. #74.
Comments: Abstraction. This plate was also used for *Campeche*, 1980, and *A Letter to Japan*, 1983. Significantly varying collage elements in this evolving edition. 6 press runs. Signed, ed. info, titled, and dated in graphite.

609. *Ostrich*
Alternate title: *Tall Bird*
Sugar-lift ground etching with half-tone
Image: 9 1/8 x 6 3/16" (232 x 157 mm) irregular
Sheet: 9 1/8 x 11 7/16" (232 x 291 mm)
Edition: 60
Paper: BFK Rives or handmade
Plate: Copper
Collections: Private collections
Comments: Literal image of ostrich, profile left. Sent out as holiday greeting card, variously dated 1991. Handwritten inscription verso.

610. *Party Line*
Engraving, *chine collé* with etching, found objects, rainbow-roll and color woodcut
Image: 13 1/8 x 27 1/2" (335 x 698 mm) irregular
Plate: 7 3/16 x 25 1/2" (182 x 648 mm)
Sheet: 17 7/8 x 40 1/2" (456 x 1030 mm) irregular
Edition: 10
Paper: Farnsworth
Plate: Lucite
Publications: Baro, Gene, *California Years*, cat. #75.
Comments: Abstraction. 7 press runs. This same plate was used for an untitled print, 1985. MK in plate, lr; signed, ed. info, titled, and dated in graphite.

1980

589. *Ace*
Aquatint, *chine collé* with metal leaf and color woodcut
Image: 11 7/8 x 17 7/8" (299 x 452 mm)
Sheet: 22 5/8 x 26 1/8" (575 x 663 mm)
Edition: 10 [20]
Paper: Arches or Farnsworth, Misch watermark
Plate: Copper
Collections: Private collection
Publications: Baro, Gene, *California Years*, ill. inside front cover, cat. #58; Metz, Kathryn, *Misch Kohn: Three Decades*, cat. #24.
Comments: Constructivist abstraction. 5 press runs. Signed, ed. info, titled, and dated in graphite.

590. *Avignon*
Line etching, engraving, *chine collé*
Image: 9 1/4 x 22 3/8" (130 x 568 mm) irregular
Sheet: 20 3/4 x 39" (527 x 990 mm)
Paper: Japanese chiri laid onto BFK Rives
Plate: Copper
Comments: Abstracted landscape. Signed, ed. info, titled, and dated in graphite.

591. *Black Warrior Basin*
Alternate title: *Texas Canyon*
Engraving, drypoint, embossing, *chine collé* with found objects, rainbow-roll and color woodcut
Image: 17 1/8 x 20" (436 x 509 mm)
Plate: 16 5/8 x 19 3/4" (422 x 502 mm)
Sheet: 23 1/4 x 27 1/4" (596 x 693 mm) irregular
Edition: 20
Paper: Farnsworth, Misch watermark
Plate: Lucite
Collections: Art Institute of Chicago; Library of Congress; private collection
Publications: *14 Grafiči Bienale* (Ljubljana 1981), ill. p. 343; Baro, Gene, *California Years*, cover ill., cat. #59; Garver, Thomas H., *New American Graphics 2*, ill. p. 15, cat. p. 55; Metz, Kathryn, *Misch Kohn: Three Decades*, cat. #25; Moran, Joe, *International Printmaking Invitational*, ill. p. 38.
Comments: Abstraction. This same plate was used for *Tao Amaretti*, 1985. 4 press runs. Signed, ed. info, titled, and dated in graphite.

592. *Campeche*
Sugar-lift ground aquatint etching, engraving, *chine collé* with color woodcut and found objects
Image: 17 x 23 5/8" (430 x 600 mm) irregular
Sheet: 22 1/2 x 28" (572 x 710 mm)
Edition: 20
Paper: Farnsworth, Misch watermark
Plate: Magnesium
Publications: Baro, Gene, *California Years*, cat. #60.
Comments: Abstraction. 6 press runs. This same plate was used for *My Bauhaus Past*, 1980, and *A Letter to Japan*, 1983. Signed, ed. info, titled, and dated in graphite.

593. *Caution Explosive*
Sugar-lift ground aquatint etching, engraving, *chine collé* with metal leaf, found objects, rainbow-roll and color woodcut
Image: 9 1/2 x 12 1/4" (241 x 311 mm) irregular
Plate: 8 x 11" (203 x 279 mm)
Sheet: 19 7/8 x 25 7/8" (505 x 657 mm)
Edition: 20
Paper: Farnsworth, Misch watermark
Plate: Magnesium
Comments: Abstraction. Signed, ed. info, titled, and dated in graphite.

594. *Columbia Basin*
Engraving, *chine collé* with color woodcut and found objects
Image: 28 3/8 x 26 3/8" (718 x 667 mm)
Sheet: 28 3/8 x 26 3/8" (718 x 667 mm)
Edition: 10
Paper: Farnsworth
Plate: Lucite
Publications: Baro, Gene, *California Years*, cat. #61.
Comments: Abstraction. 6 press runs.

595. *Cubi I*
Sugar-lift ground aquatint etching, engraving, *chine collé* with rainbow-roll and color woodcut
Image: 5 x 8 1/4" (127 x 209 mm)
Sheet: 17 1/2 x 21" (444 x 533 mm)
Edition: 20
Paper: Imago
Plate: Copper
Publications: Baro, Gene, *California Years*, ill. back cover, cat. #62.
Comments: Abstraction. This same plate also used for *Cubi II*, 1978. 6 press runs. Signed and dated in graphite.

596. *Excavation*
Sugar-lift ground aquatint etching, engraving, *chine collé* with color woodcut
Image: 13 1/4 x 10 7/8" (335 x 275 mm)
Sheet: 18 7/8 x 21 1/2" (480 x 546 mm)
Edition: 20
Paper: Toyoshi
Plate: Zinc
Publications: Baro, Gene, *California Years*, cat. #64.
Comments: Abstraction. 7 press runs.

597. *Five Gated City I*
Alternate title: *5 Gated City I*
Engraving, etching, *chine collé* with color woodcut
Image: 12 3/4 x 22 3/8" (323 x 570 mm) irregular
Plate: 12 1/4 x 22 1/4" (311 x 565 mm)
Sheet: 21 7/8 x 28" (566 x 712 mm)
Edition: 20
Paper: Farnsworth, Misch watermark
Plate: Copper
Publications: Baro, Gene, *California Years*, cat. #65.
Comments: Abstraction. 7 press runs. Signed, ed. info, titled, and dated in graphite.

598. *Five Gated City II*
Engraving, etching, *chine collé* with color woodcut
Image: 12 3/4 x 19 1/2" (325 x 487 mm)
Sheet: 22 1/2 x 27 7/8" (570 x 709 mm)
Edition: 20
Paper: Farnsworth
Plate: Copper
Publications: Baro, Gene, *California Years*, cat. #66.
Comments: Abstraction. 5 press runs.

599. *Good for One Trip*
Engraving, etching, *chine collé* with color woodcut and found objects
Image: 10 3/4 x 22 3/4" (272 x 578 mm)
Sheet: 22 1/4 x 28 1/8" (565 x 715 mm)
Edition: 20
Paper: Farnsworth
Plate: Copper
Publications: Baro, Gene, *California Years*, cat. #67.
Comments: Abstraction. 4 press runs.

600. *Gusting*
Sugar-lift ground aquatint etching, engraving, *chine collé* with metal leaf, rainbow-roll and color woodcut
Image: 12 1/4 x 18 1/2" (313 x 470 mm) irregular

234

Comments: Abstraction. 6 press runs. Signed, ed. info, titled, and dated in graphite.

578. *Examined by 6*
Sugar-lift ground aquatint etching, dry-point, engraving, *chine collé* with found objects, rainbow-roll and color woodcut
Image: 10 1/8 x 12 1/4" (255 x 310 mm) irregular
Sheet: 22 3/8 x 28 1/8" (568 x 713 mm)
Edition: 20
Paper: Farnsworth, Misch watermark
Plate: Zinc
Publications: Baro, Gene, *California Years*, cat. #50.
Comments: Abstraction. This same plate was used earlier for *Tequila Sunrise*, 1977, *La Poste II* and *W.O.A. 4*, both 1978. 7 press runs.

579. *Excavation II*
Sugar-lift ground aquatint etching, engraving, *chine collé* with color woodcut
Image: 8 3/4 x 9 7/8" (222 x 251 mm) irregular
Plate: 8 3/4 x 9 13/16" (222 x 249 mm)
Sheet: 22 x 22 1/8" (560 x 563 mm)
Edition: E/V 20
Paper: Farnsworth
Plate: Zinc
Publications: Baro, Gene, *California Years*, cat. #52.
Comments: Abstraction. 5 press runs. Signed, ed. info, titled, and dated in graphite.

580. *Excavation II*
Sugar-lift ground aquatint etching, engraving, *chine collé* with color woodcut and found objects
Image: 9 7/8 x 9 7/8" (251 x 252 mm) irregular
Plate: 8 3/4 x 9 13/16" (222 x 249 mm)
Sheet: 22 7/8 x 26 3/8" (580 x 671 mm)
Edition: 10
Paper: Farnsworth
Plate: Zinc
Publications: Baro, Gene, *California Years*, cat. #51.
Comments: Abstraction. 5 press runs. Signed, ed. info, titled, and dated in graphite.

581. *Follow Me*
Aquatint and soft-ground etching, *chine collé* with color woodcut
Image: 17 3/4 x 15 3/8" (451 x 392 mm)
Sheet: 27 x 22 7/8" (685 x 580 mm)

Edition: 20
Paper: Farnsworth, Misch watermark
Plate: Zinc
Publications: Baro, Gene, *California Years*, ill. cat. #53, p. 8; Lo Monaco, Louis, *La Gravure en Taille-Douce*, ill. p. 231.
Comments: Abstraction. 5 press runs. Signed, ed. info, titled, and dated in graphite.

582. *Numbers*
Handmade paper embedded with color woodcut, overprinted with metal type engraving, rainbow-roll and color woodcut
Image: 19 x 25 3/16" (485 x 640 mm) irregular
Sheet: 19 x 25 3/16" (485 x 640 mm) irregular
Edition: unique
Paper: Misch handmade embedded from recycled prints
Printer/Publisher: Paper made at Garner Tullis' Institute for Experimental Printmaking, Santa Cruz
Collections: Art Institute of Chicago
Comments: Abstraction with large color woodcut digits. Most of the prints from this series were printed in 1975 and 1976; the paper was made in 1975.

583. *Special Delivery*
Sugar-lift ground aquatint etching, dry-point, engraving, *chine collé* with silver leaf, color woodcut, and found objects
Image: 19 7/8 x 19 7/8" (504 x 504 mm) irregular
Plate: 20 1/4 x 31 1/2" (514 x 800 mm)
Sheet: 27 1/8 x 37 5/8" (690 x 961 mm)
Edition: E/V 20
Plate: Copper
Collections: Private collection
Publications: Baro, Gene, *California Years*, cat. #56.
Comments: Abstraction. This same plate was used in *America Tectonic*, 1979. 5 press runs. Signed, ed. info, titled, and dated in graphite.

584. Untitled
Sugar-lift ground aquatint etching, dry-point, engraving, silver ink, *chine collé* with rainbow-roll and color woodcut, found objects
Image: 16 1/2 x 19 7/8" (419 x 505 mm) irregular
Plate: 16 1/8 x 19 7/8" (410 x 505 mm)
Plate: Zinc
Comments: Abstraction. This same plate was used for *Silver Barrier*, 1978.

585. *Xylon 8*
Sugar-lift ground aquatint etching, engraving, *chine collé* with found objects, rainbow-roll and color woodcut
Image: 12 1/8 x 19 1/8" (307 x 490 mm) irregular
Sheet: 23 x 27 1/8" (585 x 690 mm)
Edition: E/V 10
Paper: Farnsworth, Misch watermark
Plate: Zinc
Publications: Baro, Gene, *California Years*, cat. #57.
Comments: Abstraction. 2 press runs. Signed, ed. info, titled, and dated in graphite.

c. late 1970s

586. *Clouds*
Aquatint etching
Image: 5 1/2 x 4 9/16" (140 x 116 mm)
Sheet: 11 11/16 x 8 1/8" (297 x 206 mm)
Paper: China/India
Plate: Copper
Comments: Soft treatment in sepia of cumulus clouds. MK in plate, ll; signed and titled in graphite.

c. late 1970s/early 1980s

587. *East of Eden*
Sugar-lift ground aquatint etching, engraving, *chine collé* with rainbow-roll and color woodcut
Image: 11 x 14 1/2" (279 x 368 mm) irregular
Plate: 11 x 14" (279 x 355 mm)
Plate: Zinc
Publications: *6th Hawaii National Print Exhibition* (Honolulu 1983), ill. #58.
Comments: Abstraction. This same plate was used later in *Landscape with Red and Blue*, 1985.

588. *Hokaido*
Sugar-lift ground aquatint etching, engraving, *chine collé* with metal-type engraving, rainbow-roll and color woodcut, wood type
Image: 8 3/4 x 9 7/8" (222 x 251 mm)
Plate: Zinc
Publications: *6th Hawaii National Print Exhibition* (Honolulu 1983), ill. #59.
Comments: Abstraction. This same plate was used in the evolving edition *Excavation* series.

Publications: Baro, Gene, *California Years,*
cat. #44.
Comments: Abstraction. 5 press runs.
Signed, ed. info, titled, and dated in
graphite.

567. *Imaginary Portrait*
Alternate title: *Head of a Gentleman*
Lithograph
Image: 30 x 22 1/8" (762 x 562 mm)
Sheet: 30 x 22 1/8" (762 x 562 mm)
Edition: 25?
Paper: BFK Rives
Plate: Aluminum
Printer/Publisher: CSUH
Comments: Mottled bust-length portrait of
male figure in coat and tie. 3/4 profile
right.

568. *La Poste II*
Alternate title: *La Poste*
Sugar-lift ground aquatint etching,
engraving, *chine collé* with silver leaf,
gold leaf, color woodcut, and found
objects
Image: 8 x 10 5/8" (202 x 276 mm) irregular
Sheet: 22 7/8 x 26 3/8" (580 x 670 mm)
Edition: E/V 25
Paper: Farnsworth, Misch watermark
Plate: Zinc
Publications: Baro, Gene, *California Years,*
cat. #45; Haslem, Jane, *American Prints
Drawings, Paintings,* ill. cat. #62, p. 23
[as *La Poste*].
Comments: Abstraction. This same plate
was used for *Tequila Sunrise,* 1977,
W.O.A. 4, 1978, and for *Examined by 6,*
1979. 3 press runs. Signed, ed. info,
titled, and dated in graphite.

569. *Magda*
Monoprint, *chine collé*
Image: 22 x 13 3/4" (559 x 349 mm)
irregular
Sheet: 29 3/4 x 22 1/4" (755 x 565 mm)
irregular
Edition: unique
Paper: Japanese oatmeal laid onto BFK
Rives
Plate: Copper
Comments: Painterly full-color bust-length
portrait of female figure with short
wavy hair and red lipstick. Signed and
dated in graphite.

570. *Silver Barrier*
Alternate title: *Barrier*
Sugar-lift ground aquatint etching, dry-
point, engraving, *chine collé* with silver
leaf, rainbow-roll and color woodcut
Image: 16 1/8 x 19 7/8" (410 x 506 mm)
irregular
Sheet: 22 1/4 x 28 1/8" (565 x 715 mm)
Edition: E/V 20 [10]
Paper: Farnsworth, Misch watermark
Plate: Zinc
Publications: Baro, Gene, *California Years,*
cat. #55.
Comments: Abstraction. Variously dated
1979. 7 press runs. Signed, ed. info,
titled, and dated in graphite.

571. *Temptation of St. Anthony*
Monoprint
Image: 29 5/8 x 39 3/8" (752 x 1000 mm)
Sheet: 29 5/8 x 39 3/8" (752 x 1000 mm)
Edition: unique
Paper: BFK Rives
Plate: Copper
Comments: Painterly full-color reinterpre-
tation of theme extensively explored in
1973-4.

572. *Temptation of St. Anthony*
Monoprint
Image: 29 3/4 x 39 9/16" (755 x 1005 mm)
Sheet: 29 3/4 x 39 9/16" (755 x 1005 mm)
Edition: unique
Paper: BFK Rives
Plate: Copper
Comments: Second printing from earlier
Temptation of St. Anthony 1978 mono-
print, but altered with additional inking
of plate. Sketchier, more gestural scene,
in full color.

573. Untitled
Sugar-lift ground aquatint etching,
engraving, *chine collé* with color
woodcut
Image: 6 1/2 x 11" (165 x 279 mm) irregular
Plate: 5 3/4 x 11" (146 x 279 mm)
Plate: Zinc
Comments: Abstraction. This same plate
was used later for *Scree,* 1980.

574. *W.O.A. 4*
Sugar-lift ground aquatint etching,
engraving, *chine collé* with silver leaf and
color woodcut
Image: 8 3/8 x 10 7/8" (213 x 278 mm)
irregular
Sheet: 23 1/8 x 26 3/4" (588 x 680 mm)
Edition: 25
Paper: Farnsworth, Misch watermark

Plate: Zinc
Publications: Baro, Gene, *California Years,*
cat. #47.
Comments: Abstraction. This same plate
was also used for *Tequila Sunrise,* 1977,
La Poste II, 1978, and, for *Examined by 6,*
1979. 3 press runs. Signed, ed. info,
titled, and dated in graphite.

1979

575. *American*
Sugar-lift ground aquatint etching,
engraving, *chine collé* with color wood-
cut and found objects
Image: 24 x 17 1/2" (610 x 444 mm)
Sheet: 24 x 17 1/2" (610 x 444 mm)
Edition: 10
Paper: Farnsworth
Plate: Copper
Publications: Baro, Gene, *California Years,*
ill. cat. #48, p. 19.
Comments: Abstraction. 7 press runs.
Signed, ed. info, titled, and dated in
graphite.

576. *America Tectonic*
Line etching, drypoint, engraving, *chine
collé* with silver leaf, color woodcut, and
found objects
Image: 19 3/4 x 29 1/2" (500 x 752 mm)
Sheet: 19 3/4 x 29 1/2" (500 x 752 mm)
Edition: 10
Plate: Copper
Collections: Private collection
Comments: Abstraction. This same plate
was used in *Special Delivery,* 1979.
Signed, ed. info, titled, and dated in
graphite.

577. *Blue Labyrinth*
Alternate title: *Labyrinth*
Sugar-lift ground aquatint etching,
engraving, *chine collé* with rainbow-roll
and color woodcut
Image: 17 7/8 x 22 1/8" (454 x 562 mm)
irregular
Plate: 15 5/8 x 19 1/2" (397 x 495 mm)
Sheet: 22 x 28" (560 x 710 mm) irregular
Edition: 20
Paper: Farnsworth, Misch watermark
Plate: Magnesium
Collections: Honolulu Academy of Arts;
private collections
Publications: Baro, Gene, *California Years,*
cat. #49; *The Collectors Gallery,* Oakland
Museum, ill., n.d; Metz, Kathryn, *Misch
Kohn: Three Decades,* cat. #22.

543. *Five*
Alternate title: *5*
Handmade paper with embedded color
 woodcut, overprinted with metal-type
 engraving and color woodcut
Image: 18 1/2 x 24 1/2" (470 x 622 mm)
 irregular
Sheet: 18 1/2 x 24 1/2" (470 x 622 mm)
 irregular
Edition: unique
Paper: Misch handmade embedded from
 recycled prints
Printer/Publisher: Paper made at Garner
 Tullis' Institute for Experimental
 Printmaking, Santa Cruz
Comments: Abstraction with large color
 woodcut digit. Signed in graphite.

544. *Gertrude's City*
Alternate title: *City*
Sugar-lift ground aquatint etching,
 engraving, *chine collé* with rainbow-roll
 and color woodcut
Image: 12 1/4 x 14 7/8" (310 x 369 mm)
 irregular
Sheet: 22 7/8 x 26 3/4" (578 x 680 mm)
Edition: 25 [20]
Paper: Farnsworth, Misch watermark
Plate: Copper
Collections: Private collection
Publications: Baro, Gene, *California Years*,
 ill. inside back cover, cat. #54; Metz,
 Kathryn, *Misch Kohn: Three Decades*,
 cat. #23 [dated 1979].
Comments: Abstraction. Variously dated
 1979. 5 press runs. Signed, ed. info,
 titled, and dated in graphite.

545. *Kant and the Numbers Game*
Uninked sugar-lift ground aquatint etch-
 ing and engraving, *chine collé* with rain-
 bow-roll and color woodcut
Image: 12 7/16 x 17 5/8" (316 x 447 mm)
 irregular
Sheet: 22 x 25" (559 x 635 mm)
Edition: unique
Paper: Misch handmade embedded from
 recycled prints
Printer/Publisher: Paper made at Garner
 Tullis' Institute for Experimental
 Printmaking, Santa Cruz
Comments: Abstraction with large color
 woodcut digits placed horizontally. This
 same plate was later used for *Tinguely
 Machine*, 1980. Signed, titled, and dated
 in graphite.

546. *La Poste*
Alternate title: *Autobiographical Print*
Drypoint, engraving, and *chine collé* with
 woodcut and found objects
Image: 8 3/8 x 11" (213 x 280 mm) irregular
Sheet: 23 x 26" (585 x 661 mm)
Edition: E/V
Paper: Farnsworth, Misch watermark
Plate: Zinc
Publications: Baro, Gene, *California Years*,
 cat. #34, and exhib. ann. ill.
Comments: Abstraction. Variously dated
 1978, 1982. 3 press runs. Signed, ed. info,
 titled, and dated in graphite.

547. *Landscape*
Sugar-lift ground aquatint etching,
 chine collé
Image: 7 7/8 x 9 7/8" (200 x 251 mm)
Sheet: 18 1/4 x 22 7/8" (463 x 581 mm)
Edition: E/V
Paper: China/India laid onto BFK Rives
Plate: Copper
Comments: Banded abstracted landscape.
 Color proofing done with differently
 colored *chine collé* stripes.

548. *Landscape with Green*
Alternate title: *Landscape with Red and
 Green*
Sugar-lift ground aquatint etching,
 engraving, silver ink, *chine collé* with
 rainbow-roll and color woodcut
Image: 12 3/4 x 21 1/8" (323 x 536 mm)
 irregular
Sheet: 22 7/8 x 26" (582 x 661 mm)
Edition: E/V 25
Paper: Farnsworth
Plate: Magnesium
Collections: Private collection
Publications: Baro, Gene, *California Years*,
 cat. #33; Haslem, Jane, *American Prints,
 Drawings, Paintings*, ill. cat. #61, p. 22 [as
 Landscape with Red and Green]; Walkey,
 Frederick P., *Boston Printmakers' 32nd
 National Exhibition*, ill. #72 [as *Landscape
 with Red and Green*].
Comments: Abstraction. 7 press runs.
 Signed, ed. info, titled, and dated in
 graphite.

549. *Mountain Rocks and Clouds*
Sugar-lift ground aquatint etching,
 engraving, lithograph
Edition: 25
Comments: Abstracted landscape.

550. *Self-Portrait*
Lithograph

Image: 21 3/8 x 22 1/8" (202 x 562 mm)
 irregular
Sheet: 27 11/16 x 22 1/8" (703 x 562 mm)
Edition: 20
Paper: BFK Rives
Plate: Copper
Printer/Publisher: CSUH
Comments: Realistic frontal bust-length
 portrait. Signed in graphite.

551. *Silver Garden*
Drypoint, engraving, etching, and silver
 leaf *chine collé*
Image: 7 3/8 x 9 3/4" (189 x 248 mm)
Sheet: 22 7/8 x 26 3/8" (580 x 675 mm)
 irregular
Edition: 25
Paper: Silver leaf laid onto Japanese hand-
 made laid onto Farnsworth
Plate: Zinc
Collections: Private collections
Publications: Baro, Gene, *California Years*,
 cat. #36.
Comments: Abstraction. This plate was
 also used for *Step Garden*, 1977, *See How
 My Garden Grows*, 1980, and *The Garden*,
 1981. Signed, ed. info, titled, and dated
 in graphite.

552. *Special Delivery*
Sugar-lift ground aquatint etching,
 engraving, *chine collé* with color wood-
 cut and found objects
Image: 8 1/4 x 10 7/8" (210 x 276 mm)
 irregular
Sheet: 22 1/2 x 26 5/8" (570 x 677 mm)
Edition: E/V 25
Paper: Farnsworth, Misch watermark
Plate: Zinc
Publications: Baro, Gene, *California Years*,
 ill. cat. #37, p. 6.
Comments: Abstraction. 6 press runs.
 Signed, ed. info, titled, and dated in
 graphite.

553. *Step Garden*
Sugar-lift ground aquatint etching,
 engraving, and *chine collé* with rainbow-
 roll and color woodcut
Image: 7 1/2 x 9 3/4" (190 x 247 mm)
Sheet: 19 3/4 x 25 3/8" (500 x 643 mm)
Edition: 25 [20]
Paper: Farnsworth, Misch watermark
Plate: Zinc
Collections: The College Board, New York
Publications: Baro, Gene, *California Years*,
 cat. #38; *Prints: New Points of View*,
 cat. #20.
Comments: Abstraction. 4 press runs. This
 same plate was used for *Silver Garden*,

532. *Beckett*
Sugar-lift ground aquatint etching,
 engraving, *chine collé* with metal-type
 engraving and color woodcut
Image: 15 7/8 x 23 5/8" (404 x 600 mm)
Sheet: 22 x 29 7/8" (560 x 760 mm)
Edition: 30 [25]
Paper: Arches or handmade
Plate: Magnesium
Collections: Private collection
Publications: Baro, Gene, *California Years,*
 cat. #28; *Catalog of the 25th National
 Exhibition of Prints,* Library of Congress,
 cat; *Graphica Contemporanea Americana,*
 Venice, cat. #3; Haslem, Jane, *American
 Prints, Drawings, Paintings,* ill. cat. #57,
 p. 21; Loach, Roberta, "Misch Kohn,"
 Visual Dialog (Spring 1978), ill. p. 10;
 Metz, Kathryn, *Misch Kohn: Three
 Decades,* cat. #20; Parsons, Barbara
 Galuszka, "'I Can't Go On; I'll Go On:'
 A Conversation with Misch Kohn,"
 California Printmaker (Winter 1993),
 ill. p. 9.
Comments: Abstraction. Variously dated
 1980. 5 press runs. Signed, ed. info,
 titled, and dated in graphite.

533. *Blow Up Your Balloon and Tie with a 3*
Sugar-lift ground aquatint etching,
 engraving, *chine collé* with color
 woodcut
Image: 5 x 6" (127 x 152 mm)
Edition: 25
Plate: Copper
Comments: Abstraction.

534. *Blue Landscape*
Sugar-lift ground aquatint etching,
 engraving, *chine collé* with rainbow-roll
 color woodcut
Image: 14 x 17 7/8" (355 x 457 mm)
Sheet: 22 3/4 x 26 1/4" (580 x 667 mm)
Edition: 25
Paper: Farnsworth, Misch watermark
Plate: Magnesium
Publications: Baro, Gene, *California Years,*
 ill. cat. #30, p. 16.
Comments: Abstraction. Variously dated
 1987. 6 press runs. Signed, ed. info,
 titled, and dated in graphite.

535. *Blue Rainbow*
Alternate title: *Blue Rainbow and Column*
Lithograph
Image: 19 3/8 x 30 7/8" (492 x 784 mm)
Sheet: 19 3/8 x 30 7/8" (492 x 784 mm)
Edition: 20
Paper: BFK Rives

Printer/Publisher: CSUH, printed by Kohn
 and David Reed
Publications: Dewey, Tom II, *First National
 Invitational Color Blend Print Exhibition
 1978-1980,* ill. p. 42.
Comments: Formalist abstraction. Signed,
 ed. info, and dated in graphite.

536. *Canyon*
Sugar-lift ground aquatint etching,
 engraving, *chine collé* with metal leaf,
 rainbow-roll and color woodcut
Image: 11 3/4 x 33 1/2" (300 x 851 mm)
 irregular
Sheet: 18 3/4 x 37" (475 x 940 mm)
Edition: E/V 25
Paper: Farnsworth or Toyoshi
Plate: Magnesium
Publications: Baro, Gene, *California Years,*
 cat. #31.
Comments: Abstraction. 6 press runs.
 Signed, ed. info, titled, and dated in
 graphite.

537. *Circe*
Sugar-lift ground aquatint etching,
 engraving, *chine collé* with silver leaf and
 color woodcut
Image: 8 7/8 x 10 5/8" (224 x 276 mm)
 irregular
Plate: 5 7/8 x 10 5/8" (149 x 276 mm)
Sheet: 22 5/8 x 26 1/8" (575 x 665 mm)
Edition: E/V 25
Paper: Farnsworth
Plate: Zinc
Collections: Private collection
Publications: Baro, Gene, *California Years,*
 cat. #42.
Comments: Abstraction. Variously dated
 1978. Signed, ed. info, titled, and dated
 in graphite.

538. *Construction With F*
Sugar-lift ground aquatint etching,
 engraving, *chine collé* with color wood-
 cut and engraving
Image: 11 x 15" (280 x 380 mm) irregular
Edition: uneditioned
Paper: Handmade
Plate: Magnesium
Publications: Johnson, Una E., *American
 Prints and Printmakers,* ill. following
 p. 138.
Comments: Abstraction.

539. *Eight*
Alternate title: *Variation on 8*
Lithograph overprinted with engraving,
 silver ink
Image: 15 7/8 x 23 5/8" (404 x 601 mm)

Sheet: 15 7/8 x 23 5/8" (404 x 601 mm)
Edition: 30 [35] [40]
Paper: Farnsworth
Plate: Magnesium
Publications: *5th Hawaii National Print
 Exhibition* (Honolulu 1980) ill. cat. #54;
 Baro, Gene, *California Years,* cat. #43;
 Graphica Contemporanea Americana,
 Venice, cat. #4.
Comments: Abstraction with large full-
 color digits. 6 press runs. Signed, ed.
 info, titled, and dated in graphite.

540. *Eight*
Alternate title: *Variation on 8*
Rainbow-roll color woodcut, engraving,
 silver ink
Image: 16 x 23 1/2" (406 x 597 mm)
Sheet: 16 x 23 1/2" (406 x 597 mm)
Edition: 25
Paper: Farnsworth
Plate: Magnesium
Collections: Monterey Museum of Art
Comments: Abstraction. This engraving is
 the reverse image of the lithograph
 Eight. Signed, ed. info, titled, and dated
 in graphite.

541. *E Kant Ha 5*
Alternate titles: *Kant Ha; Kant Ha!;
 Kant Ha 5*
Sugar-lift ground aquatint etching,
 engraving, silver ink, *chine collé* with
 metal-type engraving and rainbow-roll
 color woodcut
Image: 15 7/8 x 23 3/4" (403 x 602 mm)
Sheet: 23 5/8 x 29 7/8" (569 x 760 mm)
Edition: 25
Paper: China/India laid onto Arches or J.
 Whatman watercolor
Plate: Magnesium
Publications: Baro, Gene, *California Years,*
 cat. #32; *Graphica Contemporanea
 Americana,* Venice, ill. cat. #5.
Comments: Abstraction. Signed, ed. info,
 titled, and dated in graphite.

542. *Embossment*
Alternate title: *Blind Embossing*
Image: 9 3/8 x 19 3/4" (238 x 502 mm)
 irregular
Sheet: 9 3/8 x 19 3/4" (238 x 502 mm)
 irregular
Edition: E/V 20
Paper: Handmade, no watermark
Plate: Magnesium
Comments: Blind embossing of randomly
 placed typographical letters and num-
 bers. Signed, ed. info, and dated in
 graphite.

519. *4 Rainbows*
Sugar-lift ground aquatint etching, rainbow-roll color woodcut, engraving, *chine collé* with rainbow-roll and color woodcut
Image: 24 x 25" (609 x 635 mm)
Edition: E/V 25
Paper: Handmade, Misch watermark
Plate: Copper
Collections: Private collection
Comments: Abstraction. Signed, ed. info, titled, and dated in graphite.

520. *5-8*
Lithograph
Image: 22 1/4 x 24" (565 x 609 mm) irregular
Sheet: 22 1/4 x 24" (565 x 609 mm)
Edition: 15
Plate: Stone
Paper: Farnsworth, Misch watermark
Comments: Abstraction with large digits. Variously dated 1978.

521. *4180*
Handmade embedded paper, *chine collé* with engraving and color woodcut
Edition: unique
Paper: Misch handmade embedded from recycled prints
Printer/Publisher: Paper made at Garner Tullis' Institute for Experimental Printmaking, Santa Cruz
Comments: Abstraction.

522. *A Secret Place Remembered*
Alternate title: *A Secret Place Remembered II*
Sugar-lift ground aquatint etching, drypoint, engraving, silver ink, *chine collé* with rainbow-roll and color woodcut
Image: 17 1/2 x 13 3/4" (445 x 350 mm) irregular
Sheet: 27 3/8 x 23" (695 x 585 mm)
Edition: 25
Paper: Farnsworth, Misch watermark
Plate: Magnesium
Collections: Private collection
Publications: Baro, Gene, *California Years*, cat. #35; *Graphica Contemporanea Americana*, 1977, cat. #6.
Comments: Abstraction. 5 press runs. Signed, ed. info, titled, and dated in graphite.

523. *And Reflections in a Glass Eye*
Engraving, color woodcut
Edition: E/V 25

524. *Autobiographical Print: Bauhaus Archive*
Alternate title: *Autobiographical Print*
Sugar-lift ground aquatint etching, engraving, silver ink, *chine collé* with color woodcut and found objects
Image: 11 1/4 x 17 1/2" (284 x 445 mm) irregular
Sheet: 23 3/8 x 27 5/8" (594 x 700 mm)
Edition: unique
Paper: Japanese chiri laid onto Farnsworth, Misch watermark
Plate: Magnesium
Publications: Baro, Gene, *California Years*, cat. #26.
Comments: Abstraction. 4 press runs. Signed, ed. info, titled, and dated in graphite.

525. *Autobiographical Print: Bienal de España*
Sugar-lift ground aquatint etching, engraving, *chine collé* with silver leaf, color woodcut, metal-type, and found objects
Image: 13 1/2 x 17 1/4" (343 x 438 mm) irregular
Sheet: 21 1/2 x 25 1/2" (546 x 648 mm)
Edition: unique
Paper: Handmade paper, Misch watermark
Plate: Magnesium
Collections: Private collection
Comments: Abstraction. Signed, ed. info, titled, and dated in graphite.

526. *Autobiographical Print: Jane Haslem Gallery*
Sugar-lift ground aquatint etching, engraving, *chine collé* with silver leaf, color woodcut, and found objects
Image: 13 3/4 x 18 1/2" (349 x 470 mm) irregular
Plate: 13 3/4 x 17 3/4" (349 x 451 mm)
Sheet: 23 x 26 1/2" (584 x 673 mm)
Edition: unique
Paper: Farnsworth, Misch watermark
Plate: Magnesium
Collections: Private collection
Comments: Abstraction. Signed, ed. info, titled, and dated in graphite.

527. *Autobiographical Print: Museum of Modern Art*
Sugar-lift ground aquatint etching, engraving, *chine collé* with silver leaf, color woodcut, and found objects
Image: 13 3/4 x 18" (349 x 457 mm) irregular
Sheet: 22 3/4 x 27" (578 x 685 mm)
Edition: unique
Paper: Farnsworth, Misch watermark
Plate: Magnesium
Comments: Abstraction. Signed, ed. info, titled, and dated in graphite.

528. *Autobiographical Print: Norsk Biennale*
Sugar-lift ground aquatint etching, engraving, *chine collé* with silver leaf, color woodcut, and found objects
Image: 13 11/16 x 17 1/2" (347 x 445 mm) irregular
Edition: unique
Paper: Farnsworth, Misch watermark
Plate: Magnesium
Collections: Library of Congress
Comments: Abstraction. Signed and dated in graphite.

529. *Autobiographical Print: San Francisco Museum of Modern Art*
Sugar-lift ground aquatint etching, engraving, *chine collé* with silver leaf, color woodcut, and found objects
Image: 14 x 18 3/8" (355 x 467 mm)
Sheet: 23 1/4 x 27 1/2" (590 x 697 mm)
Edition: unique
Paper: Farnsworth, Misch watermark
Plate: Magnesium
Publications: Baro, Gene, *California Years*, cat. #27; Metz, Kathryn, *Misch Kohn: Three Decades*, cat. #21.
Comments: Abstraction. 4 press runs. Signed, ed. info, titled, and dated in graphite.

530. *Autobiographical Print: Venezia*
Sugar-lift ground aquatint etching, engraving, *chine collé* with metal leaf, color woodcut, and found objects
Image: 14 x 18 3/8" (355 x 467 mm) irregular
Plate: 14 x 18" (355 x 457 mm)
Sheet: 22 3/4 x 27" (578 x 685 mm)
Edition: unique
Paper: Farnsworth, Misch watermark
Plate: Magnesium
Comments: Abstraction. Signed and dated in graphite.

531. *Bearded Man*
Reverse lithograph, silver ink
Image: 33 3/16 x 23 3/4" (843 x 603 mm) irregular
Sheet: 33 3/16 x 23 3/4" (843 x 603 mm)
Edition: 14
Paper: Arches
Plate: Copper
Printer/Publisher: CSUH, printed by David Reed
Comments: Experimental portrait of male figure, profile left. Painted in black tusche on the stone, and then reversed to print in silver ink. Signed and dated in graphite.

Comments: Abstraction with large color woodcut digit. Signed, ed. info, titled, and dated in graphite.

509. *Kant and the Numbers Game*
Alternate title: *Numbers Game*
Embedded handmade paper overprinted with metal-type engraving, rainbow-roll and color woodcut
Image: 18 1/2 x 24" (470 x 610 mm) irregular
Sheet: 18 1/2 x 24" (470 x 610 mm) irregular
Edition: unique
Paper: Misch handmade embedded from recycled prints
Printer/Publisher: Paper made at Garner Tullis' Institute for Experimental Printmaking, Santa Cruz
Publications: *World Print Competition 77*, San Francisco, cat. #127, p. 32.
Comments: Abstraction with large color woodcut digits. 6 press runs. Signed, ed. info, titled, and dated in graphite.

510. *Kant and the Numbers Game*
Embedded handmade paper with etching and color woodcut
Image: 18 1/2 x 24" (470 x 610 mm) irregular
Sheet: 18 1/2 x 24 ' (470 x 610 mm) irregular
Edition: unique
Paper: Farnsworth
Publications: Baro, Gene, *California Years*, cat. #25.
Comments: Abstraction with large color woodcut digits. 6 press runs.

511. *Kant and the Numbers Game with 3-5-8-8*
Embedded handmade paper overprinted with metal-type engraving, rainbow-roll and color woodcut
Image: 18 1/2 x 24" (470 x 610 mm) irregular
Sheet: 18 1/2 x 24" (470 x 610 mm) irregular
Edition: unique
Paper: Misch handmade embedded from recycled prints
Printer/Publisher: Paper made at Garner Tullis' Institute for Experimental Printmaking, Santa Cruz
Comments: Abstraction with large color woodcut digits.

512. *Kant and the Numbers Game with a 3-5-8*
Handmade paper embedded with color woodcut, overprinted with metal-type

engraving, rainbow-roll and color woodcut
Image: 18 1/2 x 24" (470 x 610 mm) irregular
Sheet: 18 1/2 x 24" (470 x 610 mm) irregular
Edition: unique
Paper: Misch handmade embedded from recycled prints
Printer/Publisher: Paper made at Garner Tullis' Institute for Experimental Printmaking, Santa Cruz
Comments: Abstraction with large color woodcut digits.

513. *Kant and the Numbers Game with an 8-5-3*
Handmade paper embedded with metal-type engraving, overprinted with metal-type engraving, rainbow-roll and color woodcut
Image: 18 1/2 x 24" (470 x 610 mm) irregular
Sheet: 18 1/2 x 24" (470 x 610 mm) irregular
Edition: unique
Paper: Misch handmade embedded from recycled prints
Printer/Publisher: Paper made at Garner Tullis' Institute for Experimental Printmaking, Santa Cruz
Comments: Abstraction with large color woodcut digits.

514. *Kant and the Numbers Game [with an 8-5-3]*
Alternate title: *Kant and the Numbers Game*
Handmade paper embedded with color woodcut, overprinted with metal-type engraving, rainbow-roll and color woodcut
Image: 18 3/8 x 24 1/4" (466 x 616 mm) irregular
Sheet: 18 3/8 x 24 1/4" (466 x 616 mm) irregular
Edition: unique
Paper: Misch handmade embedded from recycled prints
Printer/Publisher: Paper made at Garner Tullis' Institute for Experimental Printmaking, Santa Cruz
Comments: Abstraction with large color woodcut digits. Signed, ed. info, titled, and dated in graphite.

515. *Numbers*
Lithograph
Image: 20 7/8 x 27" (530 x 685 mm) irregular
Sheet: 20 7/8 x 27" (530 x 685 mm)
Edition: uneditioned
Paper: BFK Rives

Plate: Aluminum
Printer/Publisher: Illinois State University-Normal
Comments: Abstraction with large digits. Trial proof only. Signed, ed. info, and dated in graphite.

516. *Post Card*
Sugar-lift ground aquatint etching, *chine collé* with photo-etching, color woodcut and engraving
Image: 6 3/4 x 9" (171 x 228 mm) irregular
Sheet: 6 3/4 x 9" (171 x 228 mm)
Edition: unique
Paper: China/India and recycled prints on card stock
Comments: Abstraction with *chine collé*. Created for an exhibition of postcards at Ohlone College (the college provided the postcard). Signed and dated in red pencil.

517. *Untitled 5*
Handmade paper embedded with color woodcut
Image: 18 3/4 x 24 1/4" (476 x 616 mm) irregular
Sheet: 18 3/4 x 24 1/4" (476 x 616 mm) irregular
Edition: unique
Paper: Misch handmade embedded from recycled prints
Printer/Publisher: Paper made at Garner Tullis' Institute for Experimental Printmaking, Santa Cruz
Comments: Abstraction with large color woodcut digit. Signed and dated in red pencil.

1977

518. *3-8-5*
Embedded handmade paper overprinted with rainbow-roll and color woodcut
Image: 19 1/2 x 25 3/4" (495 x 654 mm) irregular
Sheet: 19 1/2 x 25 3/4" (495 x 654 mm) irregular
Edition: unique
Paper: Misch handmade embedded from recycled prints
Printer/Publisher: Paper made at Garner Tullis' Institute for Experimental Printmaking, Santa Cruz
Collections: The College Board, New York
Comments: Abstraction with large color woodcut digits. Signed, ed. info, and dated.

Sheet: 27 1/8 x 34 1/4" (688 x 868 mm)
Edition: 25
Paper: J. Whatman watercolor
Plate: Copper
Publications: Baro, Gene, *California Years,* ill. cat. #23, p. 15.
Comments: Abstraction. 4 press runs. Signed, ed. info, titled, and dated in graphite.

499. *Destroyed 5 with a 5-A*
Sugar-lift ground aquatint etching, engraving, silver ink, *chine collé* with color woodcut
Image: 5 1/8 x 5 7/8" (130 x 149 mm) irregular
Plate: Copper
Comments: Abstraction. This same plate, somewhat modified, was used in *Blow Up Your Balloon with a 5,* 1976.

500. *Disappearing 8 (III)*
Alternate titles: *Disappearing 8 #3; Disappearing 8 with Black*
Sugar-lift ground aquatint etching, engraving, *chine collé* with metal-type engraving, silver leaf, rainbow-roll and color woodcut
Image: 5 1/2 x 23 7/8" (141 x 608 mm)
Sheet: 16 x 32" (406 x 812 mm)
Edition: E/V 20
Paper: Soft Farnsworth
Plate: Magnesium
Collections: Private collection
Publications: Baro, Gene, *California Years,* cat. #63; *Graphica Contemporanea Americana,* Venice, cat. #8 [as *Disappearance*]; Haslem, Jane, *American Prints, Drawings, Paintings,* ill. p. 23.
Comments: Abstraction. Variously dated 1980. Signed, ed. info, titled, and dated in graphite.

501. *Disappearing 8 with 5 Red Lines*
Alternate title: *Disappearing 8 with 5*
Sugar-lift ground aquatint etching, engraving, *chine collé* with metal-type engraving, metal leaf, rainbow-roll and color woodcut
Image: 5 3/8 x 23 3/4" (136 x 603 mm)
Sheet: 18 7/8 x 36 1/2" (479 x 927 mm)
Edition: 25
Paper: Farnsworth
Plate: Magnesium
Comments: A slight modification on the *Disappearing 8* series. Signed, ed. info, titled, and dated in graphite.

502. *Disconnected 5*
Alternate title: *Destruction of 5*
Handmade paper embedded with rainbow-roll and color woodcut
Image: 18 1/2 x 24" (470 x 610 mm) irregular
Sheet: 18 1/2 x 24" (470 x 610 mm) irregular
Edition: unique
Paper: Misch handmade embedded from recycled prints
Printer/Publisher: Paper made at Garner Tullis' Institute for Experimental Printmaking, Santa Cruz
Comments: Abstraction with fragments of large color woodcut digits. Signed and dated in graphite.

503. *Double Eight*
Alternate title: *Double 8*
Handmade paper embedded with color woodcut and metal-type engraving, overprinted with rainbow-roll and color woodcut
Image: 18 3/4 x 25" (476 x 635 mm) irregular
Sheet: 18 3/4 x 25" (476 x 635 mm) irregular
Edition: unique
Paper: Misch handmade embedded from recycled prints
Printer/Publisher: Paper made at Garner Tullis' Institute for Experimental Printmaking, Santa Cruz
Comments: Abstraction with large color woodcut digits. Signed, ed. info, titled, and dated in red pencil.

504. *Eight*
Alternate title: *8*
Lithograph
Image: 12 7/8 x 9 1/2" (327 x 241 mm) irregular
Sheet: 12 7/8 x 9 1/2" (327 x 241 mm) irregular
Paper: BFK Rives
Plate: Stone
Printer/Publisher: Illinois State University-Normal
Comments: Abstraction with large digit 8. Signed, ed. info, and dated in graphite.

505. *Embedded 3*
Handmade paper embedded with metal-type engraving, rainbow-roll and color woodcut
Image: 18 1/2 x 24" (470 x 610 mm) irregular
Sheet: 18 1/2 x 24" (470 x 610 mm) irregular
Edition: unique
Paper: Misch handmade embedded from recycled prints

Printer/Publisher: Paper made at Garner Tullis' Institute for Experimental Printmaking, Santa Cruz
Comments: Abstraction with large color woodcut digits. Signed and dated in graphite.

506. *Embedded 8*
Handmade paper with embedded metal-type engraving and color woodcut, embossing
Image: 18 3/4 x 24 1/4" (476 x 616 mm) irregular
Sheet: 18 3/4 x 24 1/4" (476 x 616 mm) irregular
Edition: unique
Paper: Misch handmade embedded from recycled prints
Printer/Publisher: Paper made at Garner Tullis' Institute for Experimental Printmaking, Santa Cruz
Comments: Abstraction with ghost image of large digit 8 left; embedded torn typographical letters and numbers, right. Signed, titled, and dated in graphite.

507. *Fisica 99*
Alternate titles: *Fisica 89; Fisca 99*
Blind engraving and rainbow-roll color woodcut, *chine collé* with metal leaf, etching, color woodcut, and found objects
Image: 20 7/8 x 25 1/2" (530 x 648 mm) irregular
Sheet: 20 7/8 x 25 1/2" (530 x 648 mm)
Edition: E/V 10 [25]
Paper: Farnsworth
Plate: Copper
Publications: Baro, Gene, *California Years,* cat. #24.
Comments: Abstraction utilizing different pages from a vintage physics book. 4 press runs. Signed, ed. info, titled, and dated in graphite.

508. *Fragmented 8*
Handmade paper embedded with color woodcut, overprinted with rainbow-roll and color woodcut
Image: 18 1/4 x 24" (463 x 609 mm) irregular
Sheet: 18 1/4 x 24" (463 x 609 mm) irregular
Edition: unique
Paper: Misch handmade embedded from recycled prints
Printer/Publisher: Paper made at Garner Tullis' Institute for Experimental Printmaking, Santa Cruz

Publications: Baro, Gene, *California Years*, cat. #17.

Comments: Abstraction. 4 press runs. Signed, ed. info, titled, and dated in graphite.

489. *A Variation on 5*
Handmade paper embedded with color woodcut and metal type engraving
Image: 18 1/4 x 24" (463 x 609 mm) irregular
Sheet: 18 1/4 x 24" (463 x 609 mm) irregular
Edition: unique
Paper: Misch handmade embedded from recycled prints
Printer/Publisher: Paper made at Garner Tullis' Institute for Experimental Printmaking, Santa Cruz
Comments: Abstraction with large color woodcut digit.

490. *Black Pole*
Sugar-lift ground aquatint etching, engraving, *chine collé* with rainbow-roll and color woodcut
Image: 5 x 7 1/2" (127 x 190 mm) irregular
Sheet: 18 x 22 1/4" (458 x 564 mm)
Edition: 20
Paper: Arches
Plate: Zinc
Publications: Baro, Gene, *California Years*, cat. #18.
Comments: Abstraction. 6 press runs.

491. *Blow Up Your Balloon and Tie 5-8-0!*
Sugar-lift ground aquatint etching, drypoint, engraving, *chine collé* with metal-type engraving, rainbow-roll and color woodcut
Image: 5 1/8 x 7 1/2" (130 x 190 mm)
Sheet: 23 1/4 x 26 5/8" (590 x 677 mm)
Edition: 25
Paper: Farnsworth, Misch watermark
Plate: Magnesium
Publications: Baro, Gene, *California Years*, cat. #19.
Comments: Abstraction. This same plate, with different collage elements, was also used for *Blow Up Your Balloon and Tie With an 8*, 1976. 5 press runs.

492. *Blow Up Your Balloon and Tie With a 4*
Alternate titles: *Blow Up Your Balloon and Tie; Blow Up Your Balloon with a 4; Blow Up Your Balloon and Tie with 4-1-0*
Sugar-lift ground aquatint etching, drypoint, engraving, *chine collé* with metal leaf, metal-type engraving, and color woodcut

Image: 5 1/4 x 7 5/8" (133 x 196 mm) irregular
Plate: 5 x 7 3/8" (127 x 187 mm)
Sheet: 21 7/8 x 22 3/8" (555 x 570 mm)
Edition: E/V 20 [25]
Paper: Farnsworth, Misch watermark
Plate: Copper
Publications: Baro, Gene, *California Years*, cat. #29; Loach, Roberta, "Misch Kohn," *Visual Dialog* (Spring 1978), ill. p. 11; *World Print Competition 77*, San Francisco, ill. cat. #126, p. 32 [as *Blow Up Your Balloon and Tie*].
Comments: Abstraction. Variously dated 1977. Signed, ed. info, titled, and dated in graphite.

493. *Blow Up Your Balloon and Tie with a 4-1-0*
Alternate titles: *Blow Up Your Balloon and Tie with a 4; Blow Up Your Balloon and Tie 4-1-0*
Sugar-lift ground aquatint etching, engraving, *chine collé* with metal leaf, metal-type engraving, and color woodcut
Image: 4 7/8 x 5 7/8" (127 x 152 mm) irregular
Sheet: 17 3/4 x 21 3/4" (452 x 551 mm)
Edition: 20
Paper: China/India and metal leaf laid onto Farnsworth, Misch watermark
Plate: Copper
Publications: Baro, Gene, *California Years*, cat. #22.
Comments: Abstraction. Signed, ed. info, and dated in graphite.

494. *Blow Up Your Balloon and Tie with a 4-A-E*
Alternate title: *Blow Up Your Balloon and Tie with an E/4*
Sugar-lift ground aquatint etching, engraving, *chine collé* with color woodcut and metal leaf
Image: 5 x 7 3/8" (127 x 187 mm) irregular
Sheet: 18 x 22 1/4" (457 x 310 mm)
Edition: E/V 25
Paper: Farnsworth, Misch watermark
Plate: Copper
Comments: Abstraction. Signed, ed. info, titled, and dated in graphite.

495. *Blow Up Your Balloon and Tie with an 8*
Alternate title: *Blow Up Your Balloon and Tie with 8*
Sugar-lift ground aquatint etching, engraving, *chine collé* with rainbow-roll and color woodcut
Image: 5 x 7 1/2" (127 x 191 mm)

Sheet: 19 1/4 x 21 5/8" (489 x 549 mm)
Edition: E/V 25 [20]
Paper: Farnsworth, Misch watermark
Plate: Magnesium
Comments: Abstraction. This same plate, with different collage elements, was used for *Blow Up Your Balloon and Tie 5-8-0!*, 1976. Variously dated 1977. Signed, ed. info, titled, and dated in graphite.

496. *Blow Up Your Balloon and Tie with an E*
Alternate titles: *Blow Up Your Balloon and Tie; Blow Up Your Balloon and Tie It with E*
Sugar-lift ground aquatint etching, engraving, embossing, *chine collé* with silver leaf, metal-type engraving, rainbow-roll and color woodcut
Image: 4 15/16 x 6" (125 x 153 mm) irregular
Sheet: 18 1/4 x 22" (464 x 559 mm)
Edition: E/V 20 [25]
Paper: Japanese handmade or Farnsworth, Misch watermark
Plate: Copper
Collections: Museum of Modern Art
Publications: Baro, Gene, *California Years*, cat. #20; "Misch Kohn: Recent Prints," *Jane Haslem Gallery Newsletter* (November 1976), cover ill.
Comments: Abstraction. 5 press runs. Variously dated 1977. Signed, ed. info, titled, and dated in graphite.

497. *Blow Up Your Balloon with a 5*
Alternate titles: *Blow Up Your Balloon and Tie 5; Blow Up Your Balloon and Tie with a 5*
Sugar-lift ground aquatint etching, engraving, *chine collé* with silver leaf and color woodcut
Image: 5 1/8 x 5 7/8" (130 x 150 mm) irregular
Sheet: 22 1/4 x 22 1/4" (565 x 565 mm)
Edition: E/V 25
Paper: Farnsworth, Misch watermark
Plate: Copper
Publications: Baro, Gene, *California Years*, cat. #21.
Comments: Abstraction. 4 press runs. This same plate, somewhat modified, was used in *Destroyed 5 with a 5-A*, 1976. Signed, ed. info, titled, and dated in graphite.

498. *Blue Aquatint*
Rainbow-roll color woodcut, *chine collé* with metal-type engraving, photo-etching, found objects, rainbow-roll and color woodcut
Image: 17 1/4 x 19 7/8" (440 x 505 mm)

Comments: Abstraction with large color woodcut digits. Signed and dated in graphite.

479. *3-8-5*
Handmade embedded paper overprinted with metal-type engraving, rainbow-roll and color woodcut
Image: 18 1/2 x 24" (470 x 610 mm) irregular
Sheet: 18 1/2 x 24" (470 x 610 mm) irregular
Edition: unique
Paper: Misch handmade embedded from recycled prints
Printer/Publisher: Paper made at Garner Tullis' Institute for Experimental Printmaking, Santa Cruz
Comments: Abstraction with large color woodcut digits.

480. *3-8-5*
Handmade paper embedded with color woodcut and metal-type engraving, overprinted with color woodcut
Image: 18 1/2 x 24 1/2" (470 x 622 mm) irregular
Sheet: 18 1/2 x 24 1/2" (470 x 622 mm) irregular
Edition: unique
Paper: Misch handmade embedded from recycled prints
Printer/Publisher: Paper made at Garner Tullis' Institute for Experimental Printmaking, Santa Cruz
Publications: Haslem, Jane, *American Prints, Drawings, Paintings*, ill. #60, p. 22.
Comments: Abstraction with large color woodcut digits.

481. *3-8-5*
Handmade paper embedded with color woodcut, overprinted with metal-type engraving, rainbow-roll and color woodcut
Image: 18 1/2 x 24" (470 x 610 mm) irregular
Sheet: 18 1/2 x 24" (470 x 610 mm) irregular
Edition: unique
Paper: Misch handmade embedded from recycled prints
Printer/Publisher: Paper made at Garner Tullis' Institute for Experimental Printmaking, Santa Cruz
Comments: Abstraction with large color woodcut digits.

482. *3-8-8*
Handmade paper embedded with color woodcut, overprinted with rainbow-roll and color woodcut

Image: 18 1/2 x 24" (470 x 610 mm) irregular
Sheet: 18 1/2 x 24" (470 x 610 mm) irregular
Edition: unique
Paper: Misch handmade embedded from recycled prints
Printer/Publisher: Paper made at Garner Tullis' Institute for Experimental Printmaking, Santa Cruz
Comments: Abstraction with large color woodcut digits. Signed and dated in red pencil.

483. *5*
Alternate titles: *Blue Print 5; Destruction of 5*
Lithograph, printed A) black only, B) black and blue, C) black with rainbow-roll
Image: 13 5/8 x 10 1/8" (346 x 257 mm)
Sheet: 13 5/8 x 10 1/8" (346 x 257 mm) irregular
Edition: A) and C) uneditioned; B) 20
States: 3
Paper: BFK Rives
Plate: Stone (2)
Printer/Publisher: Illinois State University-Normal
Publications: *Graphica Contemporanea Americana*, Venice, ill. cat. #7 [as *Blue Print 5*].
Comments: Similar to image in 1974 *Destruction of 5* triptych. Signed, ed. info, and dated in graphite.

484. *5 and the Numbers Game with an 8-3*
Alternate title: *5-8-8-3*
Handmade embedded paper overprinted with metal-type engraving, rainbow-roll and color woodcut
Image: 18 1/2 x 24" (470 x 610 mm) irregular
Sheet: 18 1/2 x 24" (470 x 610 mm) irregular
Edition: unique
Paper: Misch handmade embedded from recycled prints
Printer/Publisher: Paper made at Garner Tullis' Institute for Experimental Printmaking, Santa Cruz
Comments: Abstraction with large color woodcut digits.

485. *5-8-3 With Sails*
Alternate title: *5-3-8*
Handmade embedded paper overprinted with rainbow-roll and color woodcut
Image: 18 1/2 x 24" (470 x 610 mm) irregular
Sheet: 18 1/2 x 24" (470 x 610 mm) irregular
Edition: unique

Paper: Misch handmade embedded from recycled prints
Printer/Publisher: Paper made at Garner Tullis' Institute for Experimental Printmaking, Santa Cruz
Comments: Abstraction with large color woodcut digits and torn strips of rainbow-roll woodcut. Signed and dated in graphite.

486. *Aging Artist*
Alternate title: *Portrait of an Aging Artist*
Sugar-lift ground aquatint etching, repoussé, *chine collé*
Image: 15 3/4 x 11 1/2" (390 x 293 mm) irregular
Sheet: 32 x 25 3/8" (640 x 545 mm) irregular
Edition: 25 [10]
Paper: China/India laid onto Arches
Plate: Copper
Collections: Art Institute of Chicago
Publications: Metz, Kathryn, *Misch Kohn: Three Decades*, cat. #18.
Comments: Frontal self-portrait bust delineated with choppy strokes and shaded with repoussé. Signed, ed. info, titled, and dated in graphite.

487. *A Ha!*
Alternate titles: *Ah Ha; ah Ha*
Sugar-lift ground aquatint etching, uninked engraving, *chine collé* with metal leaf, engraving, and rainbow-roll color woodcut
Image: 5 1/8 x 6 1/4" (129 x 155 mm)
Sheet: 22 1/2 x 22 1/2" (570 x 570 mm)
Edition: 25
States: 2
Paper: Farnsworth, Misch watermark
Plate: Copper
Publications: Baro, Gene, *California Years*, cat. #16; Loach, Roberta, "Joe Zirker-Misch Kohn," *Visual Dialog* (Sept-Oct-Nov 1976), ill. p. 29.
Comments: Abstraction. 4 press runs. The two states have different *chine collé* treatment. Signed, ed. info, titled, and dated in graphite.

488. *American Ha*
Sugar-lift ground aquatint etching, engraving, and *chine collé* with color woodcut and found objects
Image: 5 1/8 x 8 1/4" (131 x 211 mm) irregular
Sheet: 20 1/8 x 22" (510 x 560 mm)
Edition: 10
Paper: Farnsworth, Misch watermark
Plate: Magnesium

224

469. *Recycled Print*
Handmade paper embedded with recycled
 prints
Image: 18 1/2 x 24" (470 x 609 mm)
 irregular
Sheet: 18 1/2 x 24" (470 x 609 mm) irregular
Edition: unique
Paper: Misch handmade embedded from
 recycled prints
Printer/Publisher: Paper made at Garner
 Tullis' Institute for Experimental
 Printmaking, Santa Cruz
Publications: *Prints by Misch Kohn*
 (Honolulu 1975), cat. #27.
Comments: Abstraction.

470. *Red Point*
Handmade paper embedded with etching
 and color woodcut
Image: 18 1/8 x 22 7/8" (462 x 582 mm)
 irregular
Sheet: 18 1/8 x 22 7/8" (462 x 582 mm)
 irregular
Edition: unique
Paper: Misch handmade embedded from
 recycled prints
Printer/Publisher: Paper made at Garner
 Tullis' Institute for Experimental
 Printmaking, Santa Cruz
Publications: Baro, Gene, *California Years,*
 cat. #13.
Comments: Abstraction. 3 press runs.

471. *The Endless Circle*
Handmade paper embedded with etching
 and color woodcut
Image: 22 1/2 x 28 3/8" (570 x 720 mm)
 irregular
Sheet: 22 1/2 x 28 3/8" (570 x 720 mm)
 irregular
Edition: unique
Paper: Misch handmade embedded from
 recycled prints
Printer/Publisher: Paper made at Garner
 Tullis' Institute for Experimental
 Printmaking, Santa Cruz
Publications: Baro, Gene, *California Years,*
 cat. #9.
Comments: Abstraction. 3 press runs.

472. *Three-Five-Eight*
Alternate title: *3-5-8*
Embedded handmade paper overprinted
 with metal-type engraving, rainbow-roll
 and color woodcut
Image: 18 1/2 x 24 5/8" (469 x 625 mm)
 irregular
Sheet: 18 1/2 x 24 5/8" (469 x 625 mm)
 irregular
Edition: unique

Paper: Misch handmade embedded from
 recycled prints
Printer/Publisher: Paper made at Garner
 Tullis' Institute for Experimental
 Printmaking, Santa Cruz
Comments: Abstraction with large color
 woodcut digits. Signed, ed. info, titled,
 and dated in graphite.

473. *Three-Five-Eight*
Alternate title: *3-5-8*
Embedded paper overprinted in woodcut
Image: 18 1/2 x 24 5/8" (469 x 625 mm)
 irregular
Sheet: 18 1/2 x 24 5/8" (469 x 625 mm)
 irregular
Edition: unique
Paper: Farnsworth
Publications: Baro, Gene, *California Years,*
 cat. #15.
Comments: Abstraction with large color
 woodcut digits. 5 press runs.

474. Untitled [8-5-3]
Handmade paper embedded with color
 woodcut, overprinted with metal-type
 engraving, rainbow-roll and color
 woodcuts
Image: 18 1/2 x 24" (470 x 609 mm)
 irregular
Sheet: 18 1/2 x 24" (470 x 609 mm) irregular
Edition: unique
Paper: Misch handmade embedded from
 recycled prints
Printer/Publisher: Paper made at Garner
 Tullis' Institute for Experimental
 Printmaking, Santa Cruz
Comments: Abstraction with large color
 woodcut digits.

475. Untitled [Bird]
Blind engraving A) without color, B) color
 ink over color collage
Image: 4 3/16 x 5 3/8" (106 x 136 mm)
 irregular
Sheet: 4 3/8 x 10 5/8" (111 x 270 mm)
Edition: 60?
States: 2
Paper: German etching
Plate: Copper
Collections: Private collections
Comments: Representational bird image.
 Sent out as holiday greeting card. Color
 proof is orange over purple *chine collé.*
 Handwritten inscription, verso.

1975-78

476. *Three-Five*
Alternate title: *3-5*
Handmade paper embedded with photo-
 etching, engraving and woodcut, over-
 printed with color woodcut
Image: 18 3/4 x 23 1/2" (475 x 598 mm)
 irregular
Sheet: 18 3/4 x 23 1/2" (475 x 598 mm)
 irregular
Edition: unique
Paper: Misch handmade embedded from
 recycled prints
Printer/Publisher: Paper made at Garner
 Tullis' Institute for Experimental
 Printmaking, Santa Cruz
Publications: Baro, Gene, *California Years,*
 ill. cat. #14, p. 4.
Comments: Abstraction with large color
 woodcut digits. 4 press runs. The
 embedded paper was made in 1975; the
 overprinting was not done until 1978.
 Signed, ed. info, and dated in graphite.

1976

477. *3*
Alternate title: *3-8*
Embedded handmade paper overprinted
 with rainbow-roll and color woodcut
Image: 18 1/2 x 24" (470 x 610 mm)
 irregular
Sheet: 18 1/2 x 24" (470 x 610 mm) irregular
Edition: unique
Paper: Misch handmade embedded from
 recycled prints
Printer/Publisher: Paper made at Garner
 Tullis' Institute for Experimental
 Printmaking, Santa Cruz
Comments: Abstraction with large color
 woodcut digits.

478. *3-3-8-8*
Alternate title: *3-8-3-8*
Handmade embedded paper overprinted
 with metal-type engraving, rainbow-roll
 and color woodcut
Image: 18 1/2 x 24" (470 x 610 mm)
 irregular
Sheet: 18 1/2 x 24" (470 x 610 mm) irregular
Edition: unique
Paper: Misch handmade embedded from
 recycled prints
Printer/Publisher: Paper made at Garner
 Tullis' Institute for Experimental
 Printmaking, Santa Cruz
Collections: Private collection

459. *Eight Kant*
Handmade paper embedded with color woodcut
Image: 22 5/8 x 28 3/8" (576 x 720 mm) irregular
Sheet: 22 5/8 x 28 3/8" (576 x 720 mm) irregular
Edition: unique
Paper: Misch handmade embedded from recycled prints
Printer/Publisher: Paper made at Garner Tullis' Institute for Experimental Printmaking, Santa Cruz
Publications: Baro, Gene, *California Years,* cat. #8.
Comments: Abstraction with large color woodcut digit.

460. *Embedded Paper with a 3-5-0*
Handmade paper embedded with metal type engraving, photo-etching, and rainbow-roll color woodcut
Image: 18 1/2 x 24" (470 x 610 mm) irregular
Sheet: 18 1/2 x 24" (470 x 610 mm) irregular
Edition: unique
Paper: Misch handmade embedded from recycled prints
Printer/Publisher: Paper made at Garner Tullis' Institute for Experimental Printmaking, Santa Cruz
Comments: Abstraction with torn strips of recycled prints. Signed, ed. info, and dated in graphite.

461. *Figure Piece*
Alternate title: *Bird*
Handmade paper embossed and embedded with photo-etching and color woodcut
Image: 18 5/8 x 23 1/4" (472 x 587 mm) irregular
Sheet: 18 5/8 x 23 1/4" (472 x 587 mm) irregular
Edition: 10 [unique]
Paper: Misch handmade embedded from recycled prints
Printer/Publisher: Paper made at Garner Tullis' Institute for Experimental Printmaking, Santa Cruz
Publications: Baro, Gene, *California Years,* cat. #10.
Comments: Abstracted image of bird with body parts and feathers defined by torn strips of recycled prints. 3 press runs. Signed, ed. info, titled, and dated in graphite.

462. *In Foreign Countries—Print*
Handmade paper embedded with photo-etching and color woodcut
Image: 10 7/8 x 14" (277 x 355 mm) irregular
Sheet: 10 7/8 x 14" (277 x 355 mm) irregular
Edition: unique
Paper: Misch handmade embedded from recycled prints
Plate: Copper
Printer/Publisher: Paper made at Garner Tullis' Institute for Experimental Printmaking, Santa Cruz
Publications: Baro, Gene, *California Years,* cat. #11.
Comments: Abstraction with plate composed of various typographic alphabet and number forms. 5 press runs.

463. *Jumbled Type*
Woodcut, metal-type engraving
Image: 6 1/4 x 8 7/8" (158 x 225 mm) irregular
Sheet: 6 1/4 x 17 3/4" (158 x 451 mm) irregular
Edition: E/V 60
Paper: BFK Rives [tan] or various card stocks
Plate: No overall plate
Collections: Private collections
Comments: Abstraction with randomly placed numbers and letters. Sent out as holiday greeting card between 1975 and 1979. Handwritten inscription, verso.

464. *New York to Washington*
Alternate title: *New York—Washington*
Photo-etching aquatint, *chine collé* with rainbow-roll color woodcut, silver leaf, and found objects
Image: 23 3/4 x 20 1/4" (605 x 516 mm) irregular
Sheet: 34 3/4 x 28 1/4" (880 x 717 mm)
Edition: E/V 50
Paper: China/India and silver leaf laid onto Arches
Plate: Copper
Collections: Private collection
Comments: Abstraction with newsprint and train schedules. Signed, ed. info, titled, and dated in graphite.

465. *Night Sky with Constellation in Motion*
Engraving, printed in relief
Image: 15 1/2 x 23 1/2" (394 x 597 mm) irregular
Sheet: 20 x 27 5/8" (508 x 708 mm)
Edition: uneditioned
Paper: China/India
Plate: Magnesium

Comments: Abstraction. This plate was used in several later prints including *Beckett* and *E Kant Ha 5,* both 1977.

466. *O Kant*
Alternate title: *Pyramid*
Rainbow-roll color woodcut, *chine collé* with metal-type engraving, photo-etching, rainbow-roll and color woodcut
Image: 17 1/8 x 20" (434 x 507 mm)
Sheet: 27 1/4 x 34 1/4" (693 x 871 mm)
Edition: E/V 10 [25]
Paper: China/India laid onto Farnsworth, Misch watermark
Plate: Copper
Collections: Private collection
Comments: Abstraction with recycled prints in various media used as collage elements. Signed, ed. info, titled, and dated in graphite.

467. *Palomares Canyon*
Engraving, etching, and *chine collé*
Image: 20 3/8 x 18 1/8" (518 x 460 mm)
Sheet: 33 1/4 x 29 5/8" (842 x 751 mm)
Edition: 30 [20]
Paper: China/India laid onto Toyoshi or Farnsworth, Misch watermark; or Japanese chiri laid onto Hosho
Plate: Zinc
Publications: Baro, Gene, *California Years,* cat. #12; Metz, Kathryn, *Misch Kohn: Three Decades,* cat. #27.
Comments: Abstraction. Variously dated 1980. Signed, ed. info, titled, and dated in graphite.

468. *Paper Piece II*
Handmade paper embedded with rainbow-roll color woodcut
Image: 18 1/2 x 24" (470 x 609 mm) irregular
Sheet: 18 1/2 x 24" (470 x 609 mm) irregular
Edition: unique
Paper: Misch handmade embedded from recycled prints
Printer/Publisher: Paper made at Garner Tullis' Institute for Experimental Printmaking, Santa Cruz
Comments: Abstraction with embedded torn strips of rainbow-roll color woodcut. The blue background cast in this paper was due to the dominant color blue from his recycled prints. Signed and dated in graphite.

Image: 18 1/2 x 24" (470 x 610 mm)
irregular
Sheet: 18 1/2 x 24" (470 x 610 mm) irregular
Edition: unique
Paper: Misch handmade embedded from
recycled prints
Printer/Publisher: Paper made at Garner
Tullis' Institute for Experimental
Printmaking, Santa Cruz
Comments: Abstraction with large color
woodcut digit.

449. *8 and the Numbers Game*
Handmade paper embedded with metal
type engraving, overprinted with color
woodcut
Image: 18 1/2 x 24" (470 x 610 mm)
irregular
Sheet: 18 1/2 x 24" (470 x 610 mm) irregular
Edition: unique
Paper: Misch handmade embedded from
recycled prints
Printer/Publisher: Paper made at Garner
Tullis' Institute for Experimental
Printmaking, Santa Cruz
Comments: Abstraction with large color
woodcut digit.

450. *8 to the 5*
Handmade paper embedded with metal
type engraving, overprinted with color
woodcut
Image: 18 1/2 x 24" (470 x 610 mm)
irregular
Sheet: 18 1/2 x 24" (470 x 610 mm) irregular
Edition: unique
Paper: Misch handmade embedded from
recycled prints
Printer/Publisher: Paper made at Garner
Tullis' Institute for Experimental
Printmaking, Santa Cruz
Comments: Abstraction with large color
woodcut digit.

451. *9 Kant*
Alternate title: *Paper Piece (II)*
Handmade paper embedded with rain-
bow-roll color woodcut and metal type
engraving
Image: 18 3/4 x 24 1/4" (476 x 619 mm)
irregular
Sheet: 18 3/4 x 24 1/4" (476 x 619 mm)
irregular
Edition: unique
Paper: Misch handmade embedded from
recycled prints
Printer/Publisher: Paper made at Garner
Tullis' Institute for Experimental
Printmaking, Santa Cruz

Comments: Abstraction with ribbons of
rainbow-roll color woodcut to left, word
KANT embedded to right.

452. *Bicentennial Eagle*
Alternate title: *Eagle*
Handmade embedded paper with
A) embossing, B) etching
Edition: E/V
States: 2
Paper: Misch handmade embedded from
recycled prints
Publications: *Prints by Misch Kohn*
(Honolulu 1975), cat. #28.

453. *Destroyed 5 with Embedded Rainbow*
Embedded handmade paper with rain-
bow-roll and color woodcut
Image: 18 1/2 x 24" (470 x 610 mm)
irregular
Sheet: 18 1/2 x 24" (470 x 610 mm) irregular
Edition: unique
Paper: Misch handmade embedded from
recycled prints
Printer/Publisher: Paper made at Garner
Tullis' Institute for Experimental
Printmaking, Santa Cruz
Comments: Fragment of large digit 5 to
left; ribbons of rainbow-roll color wood-
cut to right.

454. *Disappearing 8 (I)*
Alternate title: *Destruction of 8*
Engraving, printed in relief
Image: 5 3/8 x 23 5/8" (136 x 600 mm)
Sheet: 12 15/16 x 27 7/8" (328 x 708 mm)
Edition: uneditioned
Paper: China/India or Farnsworth
Plate: Magnesium
Comments: Abstraction. This plate was
also used for the color variants of the
1975-80 *Disappearing 8* series. Signed and
ed. info in graphite.

455. *Disappearing 8 (II)*
Alternate title: *Disappearing Eight*
Sugar-lift ground aquatint etching,
engraving, *chine collé* with metal-type
engraving, silver leaf, rainbow-roll and
color woodcut
Image: 5 1/2 x 23 7/8" (141 x 608 mm)
irregular
Sheet: 19 1/2 x 36 5/8" (496 x 936 mm)
Edition: E/V 25
Paper: Toyoshi
Plate: Magnesium
Collections: Art Institute of Chicago;
private collections

Publications: Baro, Gene, *30 Years of
American Printmaking*, ill. p. 67; Baro,
Gene, *California Years*, cat. #5.
Comments: Abstraction. 6 press runs.
Variously dated 1976. Signed, ed. info,
titled, and dated in graphite.

456. *Eight*
Handmade paper embedded with metal-
type engraving overprinted with color
woodcut
Image: 12 1/4 x 15 3/8" (312 x 390 mm)
irregular
Sheet: 18 1/4 x 24" (465 x 610 mm) irregular
Edition: E/V [unique]
Paper: Misch handmade embedded from
recycled prints
Printer/Publisher: Paper made at Garner
Tullis' Institute for Experimental
Printmaking, Santa Cruz
Publications: Baro, Gene, *California Years*,
cat. #6.
Comments: Abstraction with large color
woodcut digit.

457. *Eight*
Handmade paper embedded with metal-
type engraving, overprinted with rain-
bow-roll color woodcut
Image: 12 x 8" (304 x 163 mm) irregular
Sheet: 18 x 15 3/8" (457 x 390 mm) irregular
Edition: 10 [unique]
Paper: Misch handmade embedded from
recycled prints, mounted on handmade
[tan]
Printer/Publisher: Paper made at Garner
Tullis' Institute for Experimental
Printmaking, Santa Cruz
Comments: Abstraction with large rain-
bow-roll woodcut digit. 2 press runs.
Signed, titled and dated in graphite on
backing paper.

458. *Eight Again*
Handmade paper embedded with color
woodcut
Image: 22 7/8 x 28 1/4" (581 x 718 mm)
irregular
Sheet: 22 7/8 x 28 1/4" (581 x 718 mm)
irregular
Edition: unique
Paper: Misch handmade embedded from
recycled prints
Printer/Publisher: Paper made at Garner
Tullis' Institute for Experimental
Printmaking, Santa Cruz
Publications: Baro, Gene, *California Years*,
cat. #7.
Comments: Abstraction with large color
woodcut digit.

437. *Landscape*
Alternate title: *Landscape in Transition*
Sugar-lift ground aquatint etching,
 chine collé
Image: 8 x 9 7/8" (203 x 251 mm) irregular
Sheet: 15 1/2 x 19 1/4" (394 x 489 mm)
Edition: uneditioned
States: 3
Paper: China/India laid onto BFK Rives
Plate: Copper
Comments: Abstracted landscape in black-
 and-white. The first state is white callig-
 raphy on black background [relief]; in
 the second state the plate was painted
 out and the surfaces lowered, resulting
 in three different levels; in the third
 state the plate was again painted out
 and the surfaces lowered a third time.
 Signed and dated in graphite.

438. *Of Men, Myth and Mind*
Aquatint and photo-etching, *chine collé*
 with newsprint
Image: 18 1/16 x 23" (458 x 584 mm)
 irregular
Plate: 18 3/4 x 23 1/4" (476 x 590 mm)
Sheet: 30 13/16 x 42 1/4" (782 x 107 mm)
Edition: 20
Paper: BFK Rives
Plate: Copper
Comments: Abstraction with newsprint.
 Signed, ed. info, titled, and dated in
 graphite.

439. *Prisoners III*
Monoprint
Image: 21 3/4 x 27 1/2" (552 x 698 mm)
 irregular
Sheet: 29 1/2 x 38 3/4" (749 x 984 mm)
Edition: unique
Paper: BFK Rives
Plate: Copper
Publications: *Misch Kohn: 25 Years*
 (Haslem 1974), cat. #114.
Comments: Another reinterpretation of
 Prisoners theme, this time a softer, more
 painterly—yet still horrific—depiction
 of jailed men. Signed, titled, and dated
 in graphite.

440. *Rainbow I*
Aquatint etching, rainbow-roll color
 woodcut, *chine collé*
Image: 24 x 40" (609 x 1016 mm) irregular
Sheet: 31 x 42 3/8" (787 x 1077 mm)
Edition: 25
Plate: Copper
Collections: Private collection
Comments: Formalist abstraction. Signed,
 ed. info, titled, and dated in graphite.

441. *Silent Portrait*
Aquatint etching, drypoint, *chine collé*
Image: 10 1/4 x 8 3/16" (260 x 224 mm)
Sheet: 30 3/4 x 22 1/4" (781 x 565 mm)
Edition: 25
Paper: China/India laid onto BFK Rives
Plate: Copper
Publications: *Misch Kohn: 25 Years*
 (Haslem 1974), cat. #111.
Comments: Abstracted black-and-white
 portrait of military officer. This plate
 printed in color is known as *Old General*,
 1970. Signed, ed. info, titled, and dated
 in graphite.

442. *Silver Pendulum*
Rainbow-roll color woodcut, aquatint
 etching, *chine collé*
Image: 18 7/8 x 33 1/4" (479 x 844 mm)
 irregular
Plate: 23 7/8 x 39 5/8" (606 x 1006 mm)
Sheet: 30 3/4 x 42" (781 x 1066 mm)
Edition: 25
Paper: China/India laid onto J. Whatman
 watercolor
Plate: Copper
Comments: Formalist abstraction. Signed,
 ed. info, titled, and dated in graphite.

443. *The Prisoners I*
Monoprint
Image: 20 5/8 x 25 1/2" (524 x 648 mm)
 irregular
Plate: 21 3/4 x 27 1/2" (552 x 698 mm)
Sheet: 29 1/2 x 37 3/4" (749 x 959 mm)
Edition: unique
Paper: BFK Rives
Plate: Copper
Publications: *Misch Kohn: 25 Years*
 (Haslem 1974), cat. #112.
Comments: Another reinterpretation of the
 Prisoners theme, with painterly, more
 agitated and gestural marks. Signed,
 titled, and dated in graphite.

444. *The Prisoners II*
Monoprint
Image: 21 3/4 x 27 5/8" (552 x 702 mm)
 irregular
Sheet: 29 3/4 x 39 3/4" (755 x 1009 mm)
Edition: unique
Paper: BFK Rives
Plate: Copper
Publications: *Misch Kohn: 25 Years*
 (Haslem 1974), cat. #113.
Comments: Another reinterpretation of the
 Prisoners theme; painterly and gestural,
 with a reduced number of figures.
 Signed, titled, and dated in graphite.

445. *The Window*
Rainbow-roll color woodcut, *chine collé*
 with sugar-lift ground aquatint etching
Image: 18 7/16 x 27 3/8" (468 x 695 mm)
Sheet: 30 3/4 x 42" (781 x 1067 mm)
Edition: 25
Paper: China/India laid onto BFK Rives
Plate: Copper
Collections: Private collection
Publications: *Misch Kohn: 25 Years*
 (Haslem 1974), cat. #104; *Prints by Misch
 Kohn* (Honolulu 1975), cat. #12.
Comments: Formalist abstraction. Same
 plate used alone for 1962 *Calligraphic
 Landscape* (also known as *The Window*,
 printed in relief in 1973). Variously
 dated 1975. Signed, ed. info, titled, and
 dated in graphite.

446. *White Gray and Black*
Rainbow-roll color woodcut, *chine collé*
Image: 18 3/4 x 33" (476 x 838 mm)
Plate: 24 x 39 1/4" (609 x 997 mm)
Sheet: 29 5/8 x 41 1/2" (752 x 1054 mm)
Edition: 25
Paper: China/India laid onto BFK Rives
Plate: Copper
Publications: *Misch Kohn: 25 Years*
 (Haslem 1974), cat. #108.
Comments: Formalist abstraction. Kohn
 intended for the title to be *White Gray
 Pink and Black*, but titled it hastily, for-
 getting the pink. Signed, ed. info, titled,
 and dated in graphite.

1975

447. *3*
Handmade paper embedded with metal
 type engraving, photo-etching, and rain-
 bow-roll color woodcut, overprinted
 with color woodcut
Image: 18 1/2 x 24" (470 x 610 mm)
 irregular
Sheet: 18 1/2 x 24" (470 x 610 mm) irregular
Edition: unique
Paper: Misch handmade embedded from
 recycled prints
Printer/Publisher: Paper made at Garner
 Tullis' Institute for Experimental
 Printmaking, Santa Cruz
Comments: Abstraction with large color
 woodcut digit. Signed, ed. info, and
 dated in graphite.

448. *8/A 5 Kant*
Handmade paper embedded with metal
 type engraving, overprinted with color
 woodcut

426. *Demonstration*
Chine collé with regular and photo-etching, engraving, and rainbow-roll color woodcut
Image: 17 7/8 x 34 3/4" (454 x 882 mm) irregular
Sheet: 21 x 30 1/16" (533 x 763 mm)
Edition: unique
Paper: Japanese and China/India laid onto BFK Rives
Plate: Copper
Printer/Publisher: Honolulu Academy of Arts
Comments: Abstraction created as a demonstration piece to show students at the Honolulu Academy of Arts how to do *chine collé*. Signed, ed. info, titled, and dated in graphite.

427. *Destruction of 5 (I)*
Alternate title: *Another 5*
Lithograph, printed A) *chine collé* background, B) without *chine collé*
Image: 22 5/8 x 14 1/2" (575 x 368 mm) irregular
Sheet: 31 x 22" (787 x 558 mm)
Edition: 15
States: 2
Paper: BFK Rives
Plate: Stone
Printer/Publisher: CSUH, printed by Kenjilo Nanao
Publications: Cline, Clint, *Colorado First National Print and Drawing Competition*, ill. (triptych), p. 15; *Misch Kohn: 25 Years* (Haslem 1974), cat. #107 [as *Another 5*]; *Prints by Misch Kohn* (Honolulu 1975), cat. #9.
Comments: First in a triptych, single central image of digit 5. Signed, ed. info, titled, and dated in graphite.

428. *Destruction of 5 (II)*
Alternate title: *A Position of 5*
Lithograph, printed A) *chine collé* background, B) without *chine collé*
Image: 22 5/8 x 14 1/2" (575 x 368 mm) irregular
Sheet: 31 x 22" (787 x 558 mm)
Edition: 15
States: 2
Paper: BFK Rives
Plate: Stone
Printer/Publisher: CSUH, printed by Kenjilo Nanao
Publications: Cline, Clint, *Colorado First National Print and Drawing Competition*, ill. (triptych) p. 15; *Misch Kohn: 25 Years* (Haslem 1974), ill. #106 [as *A Position of 5*]; *Prints by Misch Kohn* (Honolulu 1975), cat. #8.

Comments: Second in triptych; central 5 digit more obscured than in first section. Variously dated 1975. Signed, ed. info, titled, and dated in graphite.

429. *Destruction of 5 (III)*
Alternate title: *Destroyed 5*
Lithograph, printed A) *chine collé* background, B) without *chine collé*
Image: 23 5/8 x 16" (600 x 406 mm) irregular
Sheet: 31 x 22" (786 x 560 mm)
Edition: 15
States: 2
Paper: BFK Rives
Plate: Stone
Printer/Publisher: CSUH, printed by Kenjilo Nanao
Collections: Private collection
Publications: Cline, Clint, *Colorado First National Print and Drawing Competition*, ill. (triptych) p. 15; *Misch Kohn: 25 Years* (Haslem 1974), cat. #116 [as *Destroyed 5*]; *Prints by Misch Kohn* (Honolulu 1975), cat. #7.
Comments: Last in triptych; central digit 5 substantially obscured. Signed, ed. info, titled, and dated in graphite.

430. *Emerson Woelffer*
Alternate title: *E.W.*
Wood engraving
Image: 9 9/16 x 7 7/16" (243 x 189 mm)
Sheet: 14 x 10 3/16" (355 x 259 mm)
Edition: 20
Paper: China/India
Comments: Dark portrait of friend and colleague.

431. *E.P. Poet*
Alternate titles: *E.P.; Poet Pound*
Line etching, drypoint, *chine collé*, printed A) without aquatint, B) with aquatint
Image: 11 3/4 x 9 3/16" (298 x 249 mm)
Sheet: 30 1/8 x 22 1/2" (765 x 571 mm)
Edition: 25
States: 2
Paper: Misch handmade
Plate: Copper
Collections: Private collection
Publications: *Misch Kohn: 25 Years* (Haslem 1974), cat. #105.
Comments: Portrait of Ezra Pound. There are significant changes between the two states; the second has a darker, more shaded background, and the Misch Kohn signature in the plate (ur) is semi-obscured. Signed, ed. info, titled, and dated in graphite.

432. *First Proof*
Sugar-lift ground aquatint etching, *chine collé*
Plate: Copper
Publications: *Prints by Misch Kohn* (Honolulu 1975), cat. #26.
Comments: Variously dated 1975.

433. *Fragment/Headlines*
Alternate titles: *Fragment; Headlines*
Photo etching, sugar-lift ground aquatint etching, *chine collé* with woodcut, metal-type engraving, and newsprint, printed A) black only, B) color addition
Image: 7 15/16 x 22 3/4" (202 x 578 mm)
Sheet: 22 1/4 x 30" (565 x 762 mm)
Edition: E/V 25
States: 2
Paper: China/India laid onto BFK Rives or Arches
Plate: Zinc
Publications: Baro, Gene, *California Years*, cat. #3; *Prints by Misch Kohn* (Honolulu 1975), cat. #41.
Comments: Abstraction with newsprint. Variously dated 1978. Signed, ed. info, titled, and dated in graphite.

434. *Head*
Monoprint
Image: 13 13/16 x 16 7/8" (351 x 428 mm)
Sheet: 20 7/8 x 29 5/8" (530 x 752 mm)
Edition: unique
Paper: BFK Rives
Plate: Copper
Comments: Painterly head of a satyr-like male in sepia.

435. *Head of a Lady*
Monoprint
Image: 5 5/8 x 4 3/8" (143 x 111 mm)
Sheet: 23 3/4 x 15 1/4" (603 x 387 mm) irregular
Edition: unique
Paper: BFK Rives
Plate: Copper
Comments: Painterly but delicate bust of a female, 3/4 profile right.

436. *Landscape*
Monoprint
Image: 19 3/4 x 16" (502 x 406 mm)
Sheet: 34 5/16 x 29 1/2" (871 x 749 mm)
Edition: unique
Paper: BFK Rives
Plate: Copper
Comments: Painterly abstracted landscape in multiple colors. Signed and dated in graphite.

412. *Rainbow*
Alternate title: *Rainbow I*
Spit-bitten aquatint etching, *chine collé*
Image: 27 3/4 x 21 3/4" (705 x 552 mm)
 irregular
Sheet: 30 3/4 x 23 3/4" (781 x 603 mm)
Edition: uneditioned proofs only
Paper: China/India laid onto German
 etching
Plate: Copper
Publications: *Misch Kohn: 25 Years*
 (Haslem 1974), cat. #92 [as *Rainbow*],
 cat. #93 [as *Rainbow I*].
Comments: Formalist abstraction. Signed,
 titled, and dated in graphite.

415. *Temptation II*
Lithograph
Image: 22 3/8 x 30 1/4" (568 x 768 mm)
 irregular
Sheet: 22 3/8 x 30 1/4" (568 x 768 mm)
Edition: 25
Paper: Arches
Plate: Aluminum
Publications: *Misch Kohn: 25 Years*
 (Haslem 1974), cat. #100.
Comments: Complex abstracted composi-
 tion depicting the biblical theme.

416. *Temptation of St. Anthony*
Lithograph
Image: 22 3/8 x 30 1/8" (568 x 765 mm)
 irregular
Sheet: 22 3/8 x 30 1/8" (568 x 765 mm)
Edition: 20
Paper: Arches
Plate: Aluminum
Publications: *Catalog of the 23rd National
 Exhibition of Prints*, Library of Congress,
 cat; *Misch Kohn: 25 Years* (Haslem 1974),
 cat. #101.
Comments: Similar to *Temptation II*, but
 less frenetically complex. Signed, ed.
 info, titled, and dated in white pencil.

417. *Temptation of St. Anthony*
Serigraph
Image: 29 3/4 x 41 5/8" (755 x 1057 mm)
 irregular
Sheet: 29 3/4 x 41 5/8" (755 x 1057 mm)
Edition: uneditioned
Paper: BFK Rives
Comments: Similar to other *Temptation*
 works; mid-way in complexity between
 two prior entries.

418. *The Prisoners*
Monoprint
Image: 17 3/4 x 23 1/4" (451 x 590 mm)
 irregular

Sheet: 21 13/16 x 28 1/4" (554 x 717 mm)
Edition: unique
Paper: China/India
Plate: Copper
Publications: *Misch Kohn: 25 Years*
 (Haslem 1974), cat. #96.
Comments: Another reinterpretation of the
 Prisoners theme, this time with much
 greater economy of line and bolder
 strokes. Signed, ed. info, titled, and
 dated in graphite.

419. *The Window*
Aquatint etching, printed in relief
Image: 10 1/2 x 10 1/2" (267 x 267 mm)
Sheet: 22 1/2 x 26" (571 x 660 mm)
Edition: 10
Paper: China/India laid onto Farnsworth,
 Misch watermark
Plate: Copper
Comments: Abstraction. This plate was
 used in 1973 *Homage to C.B.* The image
 was created by directly drawing on the
 plate with asphaltum acid-resist. Signed,
 ed. info, titled, and dated in graphite.

420. Untitled
Sugar-lift ground aquatint etching,
 chine collé
Edition: uneditioned
Plate: Copper
Publications: *Prints by Misch Kohn*
 (Honolulu 1975), cat. #32 [as *AP Bon
 à Tirer*].

1974

421. *Bearded Man*
Sugar-lift ground aquatint etching,
 chine collé
Image: 17 3/4 x 14 3/4" (451 x 374 mm)
 irregular
Sheet: 30 x 22 3/8" (762 x 568 mm)
Edition: 25
Paper: China/India laid onto BFK Rives
Plate: Copper
Collections: Private collection
Publications: Esslin, Martin, *Misch Kohn
 Prints*, ill. p. 3; Gregor, Katherine, "The
 Knowing Hand," *Artweek* (May 1988), ill.
 p. 5; Haslem, Jane, *American Prints,
 Drawings, Paintings*, ill. cat. #64, p. 23;
 Misch Kohn: 25 Years (Haslem 1974),
 ill. #109; *Washington Print Club Members'
 Show*, cat.
Comments: 3/4 profile to left of bearded
 male in striped jacket; a thin line delin-
 eates a rectangle from the top of his
 head to just beneath his collar. Signed,
 ed. info, titled, and dated in graphite.

422. *Blue Pole*
Photo- and aquatint etching, *chine collé*
 with color woodcut and newsprint
Image: 23 5/8 x 20 1/2" (600 x 520 mm)
Sheet: 32 x 25 3/8" (814 x 645 mm)
Edition: E/V 25
Paper: Toyoshi
Plate: Zinc
Collections: Private collection
Publications: Baro, Gene, *California Years*,
 cat. #2; Heyman, Therese Thau, *Prints
 California*, cat; Metz, Kathryn, *Misch
 Kohn: Three Decades*, ill. #17; *Prints by
 Misch Kohn* (Honolulu 1975), cat. #11.
Comments: Abstraction incorporating
 newsprint. Signed, ed. info, titled, and
 dated in graphite.

423. *Blue Rainbow*
Aquatint etching, rainbow-roll color
 woodcut, *chine collé*
Image: 21 x 33" (533 x 838 mm)
Plate: 23 7/8 x 39 1/2" (605 x 1004 mm)
Edition: 30
Plate: Copper
Collections: Library of Congress
Publications: *Los Angeles Printmaking
 Society*, ill. p. 14; *Misch Kohn: 25 Years*
 (Haslem 1974), cat. #117; *Prints by Misch
 Kohn* (Honolulu 1975), cat. #31.
Comments: Formalist abstraction. Signed,
 ed. info, titled, and dated in graphite.

424. *Clouds*
Line etching, *chine collé*
Image: 5 1/4 x 4 3/16" (133 x 106 mm)
Sheet: 19 1/2 x 19 1/2" (495 x 495 mm)
Edition: 20
Paper: Handmade
Plate: Copper
Comments: Flowing line etching of cumu-
 lus clouds. MK in plate, lr; signed, ed.
 info, titled, and dated in graphite.

425. *Dark Figure*
Alternate title: *Figure in the Landscape*
Lithograph, *chine collé*
Image: 22 1/2 x 30 7/8" (565 x 784 mm)
 irregular
Sheet: 29 5/8 x 41 1/2" (752 x 1054 mm)
Edition: 10
Paper: BFK Rives
Plate: Stone
Publications: *Misch Kohn: 25 Years*
 (Haslem 1974), cat. #115.
Comments: Dark bust of figure, 3/4 profile
 right, against mottled background.
 Signed, ed. info, titled, and dated in
 graphite.

Comments: Abstraction with typographical letters and numbers as counterpoint to bold black linear strokes. "Misch Kohn" in stone, lr; signed, ed. info, titled, and dated in graphite.

404. *Homage to C.B.*
Sugar-lift ground aquatint etching, rainbow-roll color woodcut, *chine collé*
Image: 20 3/4 x 15 5/8" (527 x 397 mm)
Sheet: 28 1/8 x 20 3/4" (714 x 527 mm)
Edition: 50 [25]
Paper: China/India laid onto BFK Rives
Plate: Copper
Publications: Cline, Clint, *Colorado First National Print and Drawing Competition*, ill. p. 14; *Contemporary Printmakers of the Americas*, ill; *Misch Kohn: 25 Years* (Haslem 1974), cat. #94.
Comments: Abstraction; center etched plate was also used for *The Window*, 1973. C.B. is Charles Brand, who built Kohn's etching press. Signed, ed. info, titled, and dated in graphite.

405. *Labyrinth*
Alternate titles: *Little Labyrinth; Silver Labyrinth; Silver Line; White Line*
Sugar-lift ground aquatint etching, engraving, printed A) black only, B) intaglio, *chine collé,* C) relief, *chine collé,* D) metal leaf *chine collé*
Image: 5 15/16 x 4 15/16" (152 x 126 mm)
Sheet: 30 3/4 x 20 1/2" (782 x 520 mm)
Edition: E/V 25
States: 4
Paper: Arches or Farnsworth handmade
Plate: Copper
Collections: Private collections
Publications: Baro, Gene, *30 Years of American Printmaking*, ill. p. 68; Baro, Gene, *California Years*, ill., cat. #4, p. 13; Metz, Kathryn, *Misch Kohn: Three Decades*, cat. #19 [as *Silver Labyrinth*]; *Misch Kohn: 25 Years* (Haslem 1974), cat. #98 [as *Silver Labyrinth*], cat. #99 [as *White Line*]; *Prints by Misch Kohn* (Honolulu 1975), cat. #24 [as *Silver Labyrinth*].
Comments: Complex abstraction, printed variously. Variously dated 1974. Signed, ed. info, titled, and dated in graphite.

406. *Mountains and Cityscape*
Alternate titles: *Cityscape; Mountains*
Photo-etching, printed in relief
Image: 6 9/16 x 8 3/4" (166 x 222 mm) irregular
Sheet: 6 9/16 x 17 1/2" (166 x 444 mm) irregular

Edition: 60
Paper: Handmade
Plate: Zinc
Collections: Private collections
Comments: Abstracted cityscape, foreground, against mountains in background. This was originally a 30 x 40" drawing, which Kohn later reproduced as a photo-etching on zinc. Sent out as holiday greeting card. Variously dated 1982. Written inscription verso.

407. *Nervous Mass Waiting*
Alternate title: *A Processional of Figures*
Lithograph
Image: 22 3/8 x 30 1/16" (568 x 763 mm)
Sheet: 22 3/8 x 30 1/16" (568 x 763 mm)
Edition: 20 [10]
Paper: BFK Rives
Plate: Aluminum
Printer/Publisher: CSUH (1978)
Publications: *Misch Kohn: 25 Years* (Haslem 1974), cat. #91.
Comments: Abstracted and softly delineated parade of figures. Variously printed and dated 1978. Signed, titled, and dated in graphite.

408. *Pendulum*
Alternate title: *Pendulum with 4 Red Poles*
Aquatint etching, rainbow-roll color woodcut, *chine collé*
Image: 21 9/16 x 27 3/4" (548 x 705 mm) irregular
Plate: 19 3/4 x 27 3/4" (502 x 705 mm)
Sheet: 23 7/8 x 30 3/4" (606 x 781 mm)
Edition: 25
Paper: BFK Rives
Plate: Copper
Publications: *Misch Kohn: 25 Years* (Haslem 1974), cat. #102; *Prints by Misch Kohn* (Honolulu 1975), ill. #30.
Comments: Formalist abstraction. Signed, ed. info, titled, and dated in graphite.

409. *Pendulum II*
Alternate title: *Rainbow 2*
Rainbow-roll color woodcut, *chine collé*
Image: 27 3/4 x 21 3/4" (705 x 552 mm) irregular
Sheet: 30 3/4 x 24" (781 x 610 mm)
Edition: 25 [50]
Paper: China/India laid onto BFK Rives
Plate: Copper
Publications: *Misch Kohn: 25 Years* (Haslem 1974), ill. #103.
Comments: Formalist abstraction. Signed, ed. info, titled, and dated in graphite.

410. *Personage*
Lithograph
Image: 21 3/4 x 16" (552 x 406 mm) irregular
Sheet: 26 x 19 3/4" (660 x 502 mm)
Edition: 20
Paper: Misch handmade laid
Plate: Aluminum
Printer/Publisher: CSUH
Comments: Mottled half-length figure reminiscent of 1961 Tamarind figures. Left arm outstretched but truncated; little facial or anatomical delineation. Signed, ed. info, titled, and dated in graphite.

411. *Pink Cloud*
Photo-etching, rainbow-roll color woodcut, *chine collé*
Image: 19 5/8 x 22 1/2" (498 x 565 mm)
Sheet: 29 1/2 x 33 3/4" (749 x 857 mm)
Edition: 50
Paper: China/India laid onto BFK Rives
Plate: Copper
Collections: Private collection
Publications: Haslem, Jane, *The Innovators*, cat; *Misch Kohn: 25 Years* (Haslem 1974), cat. #97.
Comments: Seated female figure, profile left, floating on screened cloud against pastel background. Signed, ed. info, titled, and dated in graphite.

412. *Portly Man*
Line etching, drypoint
Image: 7 3/16 x 3 13/16" (182 x 99 mm)
Sheet: 30 3/4 x 21 1/8" (781 x 536 mm)
Edition: 25
Paper: China/India laid onto BFK Rives
Plate: Copper
Publications: *Misch Kohn: 25 Years* (Haslem 1974), cat. #110.
Comments: Closely-cropped head of jowly gentleman in suit and tie. Signed, ed. info, titled, and dated in graphite.

413. *Prisoners*
Monoprint
Image: 21 5/8 x 27 5/8" (549 x 702 mm)
Sheet: 38 3/4 x 30 3/4" (984 x 952 mm) irregular
Edition: unique
Paper: Japanese handmade [violet] laid onto BFK Rives
Plate: Copper
Publications: *Misch Kohn: 25 Years* (Haslem 1974), cat. #95.
Comments: Painterly reinterpretation of 1949 print with softer lines. Signed, titled, and dated in graphite.

394. *Two Cronies*
Monoprint
Image: 27 1/4 x 21 3/4" (692 x 552 mm)
Sheet: 41 1/2 x 33 1/2" (1054 x 851 mm)
Edition: unique
Paper: BFK Rives
Plate: Copper
Collections: Private collection
Comments: Painterly image of two musta-
chioed Mediterranean gentlemen facing
each other. A unique print but very simi-
lar to *Two Figures from Verona,* next cita-
tion. Signed, titled, and dated (1978,
date of transferral) in graphite.

395. *Two Figures from Verona*
Monoprint
Image: 27 1/2 x 21 7/8" (698 x 708 mm)
Sheet: 41 1/2 x 29 5/8" (1054 x 752 mm)
Edition: unique
Paper: BFK Rives
Plate: Copper
Comments: Painterly image of two musta-
chioed Mediterranean gentlemen facing
each other. Signed, titled, and dated in
graphite.

1971

396. *Double Portrait of the Artists*
Alternate titles: *Mies and Janis; Mies van der
Rohe with Janis Joplin;* Untitled (Janis
Joplin and Mies van der Rohe); Untitled
(Janis Joplin with Mies van der Rohe
double portrait); Untitled (Portrait of
Janis Joplin and Mies van der Rohe);
XXII
Lithograph, photo-etching serigraph
Image: 16 1/8 x 21 5/8" (411 x 550 mm)
Sheet: 16 1/8 x 21 5/8" (411 x 550 mm)
Edition: 20 [50]
Paper: Arches
Plate: Stone
Printer/Publisher: Lakeside Studio Press,
printed by Jack Lemon
Collections: Achenbach Foundation for the
Graphic Arts, Fine Arts Museums of San
Francisco; Ackland Art Museum; Art
Institute of Chicago; Baltimore Museum
of Art; Boston Public Library; Bowdoin
College Museum of Art; Bucknell
University; California State University-
Fullerton; Davidson College Art Gallery;
Indianapolis Museum of Art; John
Michael Kohler Arts Center; Lakeside
Gallery; Library of Congress; Madison
Art Center; Mulvane Art Museum,
Washburn University; Museum of Art
and Archaeology, University of

Missouri-Columbia; National Museum
of American Art, Smithsonian
Institution; New York Public Library;
Northern Illinois University Art
Museum; Philadelphia Museum of Art;
Portland Art Museum; John and Mable
Ringling Museum of Art; Rockford
College Department of Art; Sheldon
Memorial Art Gallery, University of
Nebraska-Lincoln; Smith College
Museum of Art; University of Iowa
Museum of Art; University of Maine
Museum of Art; Utah Museum of Fine
Arts, University of Utah
Publications: *Misch Kohn: 25 Years*
(Haslem 1974), cat. #88; Yochim, Louise
Dunn, *Harvest of Freedom,* ill. p. 181.
Comments: Diptych with portrait of Mies
van der Rohe, profile right, at left, and
Janis Joplin, frontal view, at right.
Signed, ed. info, titled, and dated in
graphite; Lakeside Studio and printer
blind stamps.

397. *Portrait of Mies*
Photo-serigraph
Image: 21 1/4 x 16 1/2" (540 x 417 mm)
Sheet: 21 1/4 x 16 1/2" (540 x 417 mm)
Edition: unique
Paper: Silk
Collections: Private collection
Comments: This portrait of Mies van der
Rohe was utilized in the 1971 diptych
with Janis Joplin, *Double Portrait of the
Artists.* The photograph was reproduced
onto silkscreen, then Kohn manipulated
the silkscreen to alter the image before
transferring it onto the lithographic
stone. This is the original manipulated
screen.

1972

398. *Cat*
Sugar-lift ground aquatint etching, printed
in relief
Image: 9 7/8 x 15 3/4" (251 x 400 mm)
irregular
Sheet: 17 1/4 x 25" (438 x 635 mm)
Edition: 30
Paper: J. Whatman watercolor
Plate: Copper
Comments: Abstracted howling cat with
mottled coat, profile left. Signed, ed.
info, titled, and dated in graphite.

399. *The Sea*
Sugar-lift ground aquatint etching,
chine collé
Image: 9 3/4 x 10 3/4" (247 x 273 mm)

Sheet: 20 5/8 x 29 5/8" (524 x 752 mm)
Edition: uneditioned
Paper: China/India laid onto BFK Rives
Plate: Copper
Comments: Roiling waters of the sea.
Signed, titled, and dated in graphite.

400. *Uncle Vanya*
Spit-bitten sugar-lift ground aquatint etch-
ing, *chine collé*
Image: 9 3/4 x 7 1/2" (247 x 191 mm)
irregular
Sheet: 22 1/2 x 18" (565 x 457 mm)
Paper: China/India laid onto BFK Rives
Plate: Copper
Comments: Bust of bearded, somewhat
disheveled male, 3/4 profile right.
Signed, titled, and dated in graphite.

1973

401. *Clouds*
Aquatint etching, silver ink
Image: 5 1/2 x 7 1/4" (140 x 185 mm)
Sheet: 17 3/4 x 28 7/8" (450 x 732 mm)
Edition: 25
Paper: Arches
Plate: Copper
Publications: Baro, Gene, *The California
Years,* cat. #1; *Misch Kohn: 25 Years*
(Haslem 1974), cat. #77.
Comments: Monumental evocation of
stormy sky in this small piece. 2 press
runs. Signed, ed. info, titled, and dated
in graphite.

402. *Experimental Portrait*
Lithograph
Image: 30 1/8 x 22 3/8" (765 x 568 mm)
irregular
Sheet: 30 1/8 x 22 3/8" (765 x 568 mm)
Edition: unique
Paper: BFK Rives
Plate: Zinc
Comments: Mottled two-color lithograph
of figure, 3/4 profile left, with indistinct
features.

403. *Graffiti*
Lithograph with metal offset woodcut
type
Image: 22 3/8 x 30 1/16" (568 x 763 mm)
irregular
Sheet: 22 3/8 x 30 1/16" (568 x 763 mm)
irregular
Edition: 10 [1?]
Paper: Arches
Plate: Zinc
Publications: *Misch Kohn: 25 Years*
(Haslem 1974), cat. #90.

Two-color lithograph. Signed, ed. info, titled, and dated in graphite; studio blind stamp.

384. *Long Beaked Bird*
Alternate titles: *Bird with a Long Beak; Long-Beaked Bird*
Sugar-lift ground aquatint etching, *chine collé*, printed A) black only, B) black etching over color collage
Image: 23 1/2 x 19 3/4" (597 x 502 mm) irregular
Sheet: 34 3/4 x 29 1/2" (882 x 750 mm)
Edition: 40 [50] [25]
States: 2
Paper: China/India laid onto BFK Rives
Plate: Copper
Collections: Lakeside Gallery [as *Bird with a Long Beak*]; Library of Congress; private collection
Publications: *9 Mednarodna Grafična Razstava* (Ljubljana 1971), ill. cat. #801, p. 251; *Misch Kohn: 25 Years* (Haslem 1974), cat. #79; *Prints by Misch Kohn* (Honolulu 1975), cat. #3.
Comments: Large bird with long beak and scruffy feathers, profile right. Signed, ed. info, titled, and dated in graphite.

385. *Night Watch*
Alternate titles: *Night Watch I; Night Watch II*
Sugar-lift ground and regular aquatint etching, *chine collé*
Image: 19 3/4 x 23 15/16" (502 x 608 mm)
Sheet: 29 3/8 x 37 3/4" (746 x 959 mm)
Edition: 50 [75]
Paper: China/India, or China/India laid onto BFK Rives
Plate: Copper
Collections: Private collection
Publications: *9 Mednarodna Grafična Razstava* (Ljubljana 1971), cat. #802, p. 251; *Misch Kohn: 25 Years* (Haslem 1974), cat. #86; *Prints by Misch Kohn* (Honolulu 1975), cat. #6.
Comments: Nocturnal scene of two groups of four officers facing each other along a shallow semi-circular base. Signed, ed. info, titled, and dated in graphite.

386. *Night Watch II*
Alternate titles: *Night Watch; Night Watch 2*
Sugar-lift ground and regular aquatint etching
Image: 21 7/8 x 23 1/4" (555 x 590 mm)
Sheet: 25 1/2 x 30 1/2" (647 x 775 mm)
Edition: 50
Paper: BFK Rives
Plate: Copper

Publications: Haslem, Jane, *American Paintings and Graphics*, ill. cat. #44, p. 25 [as *Night Watch*]; *Misch Kohn: 25 Years* (Haslem 1974), cat. #87.
Comments: Similar in composition to *Night Watch*, but semi-circular base is even more shallow. Signed, ed. info, titled, and dated in graphite.

387. *Old General*
Sugar-lift ground aquatint etching, engraving, drypoint, *chine collé*
Image: 10 3/8 x 8 3/8" (264 x 213 mm) irregular
Plate: 10 1/4 x 8 1/4" (260 x 210 mm)
Sheet: 18 1/2 x 16 7/8" (470 x 428 mm)
Edition: 50
Paper: German etching
Plate: Copper
Publications: Metz, Kathryn, *Misch Kohn: Three Decades*, cat. #15.
Comments: Bust of befuddled, bald, mustachioed officer with blue eyes. This plate was also used for 1974 *Silent Portrait*. 3 press runs. Signed, ed. info, titled, and dated in graphite.

388. *Osprey*
Sugar-lift ground aquatint etching
Edition: 50
Plate: Copper

389. *Portrait*
Sugar-lift ground aquatint etching, *chine collé*
Image: 14 5/8 x 5" (371 x 127 mm) irregular
Sheet: 26 3/8 x 17 1/2" (670 x 444 mm)
Edition: 25
Paper: Farnsworth, Misch watermark
Plate: Copper
Publications: Haslem, Jane, *American Paintings and Graphics*, ill. cat. #37, p. 22; *Misch Kohn: 25 Years* (Haslem 1974), ill. #85.
Comments: Fluid lines both describe and deface this half-length portrait of a bearded male, 3/4 profile right. Signed, ed. info, titled, and dated in graphite.

390. *Portrait with One Blue Eye*
Sugar-lift ground aquatint etching, *chine collé*
Image: 24 3/4 x 20 1/4" (629 x 514 mm) irregular
Plate: 27 1/2 x 21" (698 x 533 mm)
Sheet: 41 1/4 x 29 1/2" (1048 x 749 mm)
Edition: 50
Paper: BFK Rives
Plate: Copper
Collections: Private collection

Publications: *California Society of Printmakers National Print Exhibition*, cat; *Misch Kohn: 25 Years* (Haslem 1974), cat. #76.
Comments: Bald official with elaborately ornamented costume. This plate was used for 1967 *Portrait of L*, black etching with background *chine collé* only. Variously dated 1973. Signed, ed. info, titled, and dated in graphite.

391. *Small Cyclist*
Photo etching, *chine collé* with color woodcut
Image: 17 7/8 x 14 3/8" (454 x 365 mm) irregular
Sheet: 30 x 22 1/4" (762 x 565 mm)
Edition: E/V 50
Paper: Arches
Plate: Copper
Publications: Haslem, Jane, *American Prints, Drawings, Paintings*, ill. cat. #63, p. 23; *Misch Kohn: 25 Years* (Haslem 1974), ill. #84.
Comments: Continuation of *End Game* series, but smaller in format. Signed, ed. info, titled, and dated in graphite.

392. *The Numbers Game*
Photo-etching aquatint, *chine collé*
Image: 11 1/2 x 8 3/4" (292 x 222 mm) irregular
Sheet: 23 x 15" (584 x 381 mm)
Edition: 50
Paper: China/India laid onto BFK Rives
Plate: Copper
Comments: Kohn's first purely formal, constructivist composition with shapes and numbers; he did not return to this format until 1975. M KOHN randomly in plate, lr. Signed, ed. info, titled, and dated in graphite.

393. *Two Birds*
Sugar-lift ground aquatint etching, *chine collé*
Image: 15 13/16 x 19 7/8" (402 x 505 mm) irregular
Sheet: 25 x 34 1/8" (635 x 867 mm)
Edition: 50
Paper: China/India laid onto Japanese Wampu
Plate: Copper
Collections: New York Public Library
Comments: Two birds, facing opposite directions, against shaded background. Signed, ed. info, titled, and dated in graphite.

Sheldon Memorial Art Gallery, University of Nebraska-Lincoln; Smith College Museum of Art; University of Iowa Museum of Art; University of Maine Museum of Art; Utah Museum of Fine Arts, University of Utah

Publications: Metz, Kathryn, *Misch Kohn: Three Decades*, cat. #16; *Misch Kohn: 25 Years* (Haslem 1974), cat. #75; *Prints by Misch Kohn* (Honolulu 1975), cat. #5.

Comments: Half-length view of befuddled bald military official against mottled red background. Five color lithograph. Signed, ed. info, titled, and dated in graphite; studio blind stamp.

376. *General*
Sugar-lift ground aquatint etching, monotype
Image: 34 1/2 x 17 7/8" (876 x 454 mm)
Sheet: 41 1/2 x 29 5/8" (1054 x 752 mm)
Edition: unique
Paper: BFK Rives
Plate: Copper
Comments: Painterly full-length portrait of portly, bearded officer, profile left. Kohn used the black etching of the 1968 *Ornate Figure* as a foundation for this elaborately decorated monotype.

377. *Gray and Black Intaglio*
Photo-etching aquatint
Image: 15 1/2 x 22" (394 x 559 mm)
Sheet: 22 3/8 x 31" (568 x 787 mm)
States: 2
Paper: J. Whatman watercolor
Plate: Copper
Comments: Abstracted image utilizing some of the same elements of 1968 *Laocoön*. Signed, ed. info, titled, and dated in graphite.

378. *Hawk*
Sugar-lift ground aquatint etching, printed A) intaglio, B) relief, C) *chine collé*
Image: 30 x 35" (762 x 889 mm) irregular
Edition: E/V 50
States: 3
Paper: BFK Rives, Arches, or German etching
Plate: Copper
Collections: First National Bank of Chicago; private collection
Comments: Fairly literal representation of a bird, profile right. Three main states, but variations within. Signed, ed. info, titled, and dated in graphite.

379. *Hawk*
Sugar-lift ground aquatint etching, printed A) relief, B) intaglio, C) repoussé, D) *chine collé*
Image: 19 1/2 x 23 3/4" (495 x 603 mm) irregular
Sheet: 22 1/4 x 30" (565 x 762 mm)
Edition: 50
States: 4
Paper: Heavyweight Arches
Plate: Copper
Collections: Private collections
Publications: *Misch Kohn: 25 Years* (Haslem 1974), cat. #83.
Comments: Fairly literal representation of bird, profile left, with outstretched wing. Some of the repoussé prints utilized silver ink. Signed, ed. info, titled, and dated in graphite.

380. *Hippopotamus*
Alternate title: *Tammy's Hippo*
Sugar-lift ground aquatint etching, *chine collé*, printed A) intaglio, B) relief
Image: 23 5/8 x 35 3/4" (600 x 908 mm) irregular
Sheet: 29 7/8 x 41" (759 x 1041 mm)
Edition: 50
States: 2
Paper: China/India laid onto BFK Rives
Plate: Copper
Collections: Private collections
Publications: *III Miedzynarodowe Biennale Grafiki* (Cracow 1970), ill. p. 252.
Comments: Bulbous animal, 3/4 profile right. Signed, ed. info, titled, and dated in graphite.

381. *Horseman*
Alternate titles: *Figure on Horseback; Horseman with Hawk*
Sugar lift-ground aquatint etching, printed A) black only, B) black etching over *chine collé* with metal leaf
Image: 19 1/2 x 16 3/4" (495 x 425 mm) irregular
Sheet: 26 3/8 x 23" (670 x 584 mm)
Edition: A) 25, B) 50
States: 2
Paper: China/India and metal leaf laid onto BFK Rives
Plate: Copper
Publications: Haslem, Jane, *American Paintings and Graphics*, ill. cat. #40, p. 23 [*chine collé*], cat. #42, p. 24 [black only]; Hopkins, Marilyn, "Printmaking in Chicago," *Saver* (Winter 1971), color cover ill., p. 16; *Misch Kohn: 25 Years* (Haslem 1974), ill. #80; *Prints by Misch Kohn* (Honolulu 1975), cat. #40.

Comments: Hooded rider with hawk on upraised arm astride a prancing horse, profile right. Signed, ed. info, titled, and dated in graphite.

382. *Janis*
Photo-serigraph
Image: 30 1/8 x 19 1/4" (765 x 489 mm)
Sheet: 41 5/8 x 29 7/8" (1057 x 759 mm)
Edition: 10
Paper: BFK Rives
Collections: Private collections
Comments: Portrait of Janis Joplin. Signed, ed. info, titled, and dated in graphite.

383. *Long Beaked Bird*
Alternate titles: *Long-Beaked Bird; Long Bearded Bird; The Long Beaked Bird*
Lithograph
Image: 28 3/4 x 19 11/16" (730 x 500 mm) irregular
Sheet: 31 x 22" (787 x 559 mm)
Edition: 40, CP
Paper: Arches
Plate: Stone (2)
Printer/Publisher: Lakeside Studio Press, printed by Jack Lemon
Collections: Achenbach Foundation for the Graphic Arts, Fine Arts Museums of San Francisco; Ackland Art Museum [as *Long Bearded Bird*]; Baltimore Museum of Art; Bowdoin College Museum of Art; California State University-Fullerton; Coos Art Museum; Davidson College Art Gallery; Indianapolis Museum of Art; John Michael Kohler Arts Center; Lakeside Gallery; Library of Congress; Mulvane Art Museum; National Museum of American Art, Smithsonian Institution; New York Public Library; Northern Illinois University Art Museum; Philadelphia Museum of Art; John and Mable Ringling Museum of Art; Rockford College Department of Art; Sheldon Memorial Art Gallery, University of Nebraska-Lincoln; Smith College Museum of Art; University of Iowa Museum of Art; University of Maine Museum of Art; Utah Museum of Fine Arts, University of Utah
Publications: Haslem, Jane, *American Paintings and Graphics*, ill. cat. #41, p. 24; Knigin, Michael and Murray Zimiles, *The Contemporary Lithographic Workshop Around the World*, ill. p. 107; *Misch Kohn: 25 Years* (Haslem 1974), cat. #81; *Prints by Misch Kohn* (Honolulu 1975), cat. #4.
Comments: Large bird with long beak, profile left, against mottled background.

366. *What Am I Doing Here?*
Alternate title: *Cyclist (What Am I Doing Here?)*
Serigraph
Image: 35 x 29 1/2" (889 x 749 mm) irregular
Sheet: 41 1/4 x 29 1/2" (1048 x 749 mm)
Edition: 50 [10]
Paper: BFK Rives
Collections: Illinois State Museum; Musée National de Varsovie (Poland); private collection
Publications: *III Miedzynarodowe Biennale Grafiki* (Cracow 1970), cat. p. 252; *Misch Kohn: 25 Years* (Haslem 1974), cat. #70.
Comments: Another variant of the *End Game* series, with abstracted figure on motorcycle, profile left. All prints in red ink. Signed, ed. info, titled, and dated in graphite.

367. *Wounded Soldier in a Sea of Grass*
Monoprint
Image: 21 3/4 x 27 1/2" (552 x 698 mm)
Sheet: 29 1/2 x 41 1/2" (749 x 1054 mm)
Edition: unique
Paper: BFK Rives
Plate: Copper
Comments: Painterly depiction of four uniformed soldiers, fully armed, wading through high grasses right to left in picture plane. Signed, titled, and dated in graphite.

c. late 1960s

368. *Lis I*
Etching

369. *Primee*
Etching

1970

370. *Bearded Man*
Alternate titles: *French Painter; Portrait*
Sugar-lift ground aquatint etching, *chine collé*
Image: 4 3/8 x 3 3/8" (110 x 86 mm) irregular
Sheet: 18 1/4 x 15 3/8" (463 x 390 mm)
Edition: 25
Paper: China/India laid onto BFK Rives
Plate: Copper
Collections: Private collection
Publications: *Misch Kohn: 25 Years* (Haslem 1974), cat. #89; *Prints by Misch Kohn* (Honolulu 1975), cat. #13.

Comments: Somber male with bushy eyebrows and full beard, 3/4 profile right. Signed, ed. info, and dated in graphite.

371. *Cocktail Party*
Alternate titles: *Processional; Processionals*
Sugar-lift ground aquatint etching, printed A) intaglio, B) relief
Image: 20 1/4 x 30" (514 x 762 mm) irregular
Sheet: 25 x 36 1/2" (635 x 927 mm)
States: 2
Paper: Japanese Wampu
Plate: Copper
Comments: Bulbous shapes and lyrical lines define an abstracted group of people in an interior setting. Similar in image to 1969 *Cocktail Party*. Signed, titled, and dated in graphite.

372. *Dark Bird*
Alternate title: *Hawk*
Sugar-lift ground aquatint etching, printed in relief
Image: 16 3/4 x 23 1/2" (423 x 595 mm) irregular
Sheet: 29 5/16 x 35 1/4" (745 x 895 mm)
Edition: 50
Paper: China/India
Plate: Copper
Collections: Art Institute of Chicago; Kokomo-Howard County Public Library, Hoosier Art Collection; private collection
Publications: *9 Mednarodna Grafična Razstava* (Ljubljana 1971), cat. #803, p. 251; Eichenberg, Fritz, *Art of the Print*, ill. p. 323; Garmel, Marion, "Treasure Trove from Kokomo on Display..." *Indianapolis News* 1/17/91, ill. p. F-12; *Graphica Contemporanea Americana*, Venice, cat. #2; Haslem, Jane, *American Paintings and Graphics*, ill. cat. #39, p. 23; *Hoosier Art Collection of the Kokomo-Howard County Public Library*, 1993, cat. p. 12; Hoover, James W., *Misch Kohn: Hometown Collection*, cat; Joray, Charles N., *Hoosier Art Collection of the Kokomo-Howard County Public Library*, 1989, ill. p. 19; *Misch Kohn: 25 Years* (Haslem 1974), ill. #82; "New, Old Artists Featured in U, BYU Shows," *Salt Lake Tribune* 3/26/72, ill; *Prints by Misch Kohn* (Honolulu 1975), cat. #16.
Comments: Fairly literal representation of bird, profile left. Signed, ed. info, titled, and dated in graphite.

373. *Embarcation for Cythera*
Photo-etching aquatint, printed in relief
Image: 15 1/2 x 20 1/16" (394 x 509 mm) irregular
Sheet: 24 5/8 x 32" (625 x 812 mm)
Paper: Japanese Hosho
Plate: Copper
Publications: *Prints by Misch Kohn* (Honolulu 1975), cat. #18.
Comments: Abstracted image with elements used in the earlier *Laocoön* print. The inspiration and title reference Greek mythology. Signed, titled, and dated in graphite.

374. *End Game 3*
Photo-etching, *chine collé* with metal leaf and woodcut
Image: 18 x 14 7/8" (457 x 378 mm) irregular
Plate: 18 x 14 1/2" (457 x 368 mm)
Sheet: 28 x 19 3/4" (711 x 502 mm)
Edition: 25
Paper: China/India and metal leaf laid onto BFK Rives
Plate: Copper
Comments: A continuation of the *End Game* series inspired by Samuel Beckett. Signed, ed. info, titled, and dated in graphite.

375. *General*
Lithograph
Image: 28 1/2 x 19 3/8" (724 x 492 mm) irregular
Sheet: 31 x 22 1/8" (787 x 562 mm)
Edition: 50
Paper: BFK Rives or Arches
Plate: Stone (5)
Printer/Publisher: Lakeside Studio Press, printed by Jack Lemon
Collections: Achenbach Foundation for the Graphic Arts, Fine Arts Museums of San Francisco; Ackland Art Museum; Baltimore Museum of Art; Bowdoin College Museum of Art; California State University-Fullerton; Davidson College Art Gallery; Fort Wayne Museum of Art; Indianapolis Museum of Art; John Michael Kohler Arts Center; Lakeside Gallery; Library of Congress; Mulvane Art Museum, Washburn University; Museum of Fine Arts, Springfield, MA; National Museum of American Art, Smithsonian Institution; New York Public Library; Northern Illinois University Art Museum (2); Philadelphia Museum of Art; John and Mable Ringling Museum of Art; Rockford College Department of Art;

1969

355. *Bead Game Sequence*
Photo-serigraph
Image: 18 1/8 x 17 3/4" (460 x 451 mm)
 irregular
Sheet: 29 3/4 x 28 1/2" (755 x 724 mm)
Edition: 30
Paper: BFK Rives laid onto BFK Rives
Comments: Abstraction commissioned to
 be used as an illustration for a record
 album for a rock group in Boston. The
 album was never produced because the
 artist was stabbed in the throat and was
 unable to return to singing. Signed, ed,
 info, titled, and dated in graphite.

356. *Cocktail Party*
Alternate titles: *The Group; The
 Group/Cocktail Party*
Sugar-lift ground aquatint etching, printed
 in relief
Image: 19 7/8 x 23 7/8" (505 x 606 mm)
 irregular
Sheet: 24 3/4 x 32 1/2" (628 x 825 mm)
Edition: 50
Paper: Japanese Wampu
Plate: Copper
Publications: *III Miedzynarodowe Biennale
 Grafiki* (Cracow 1970), cat. p. 252; *Misch
 Kohn: 25 Years* (Haslem 1974), cat. #71;
 "Misch Kohn Prints," Weyhe Gallery
 exhib. poster ill, April 1970.
Comments: Continuous line etching of a
 group of people, foreground, against
 archetypal background scene. Variously
 dated 1970. Similar in image to 1970
 Cocktail Party. Signed, titled, and dated
 in graphite.

357. *Conflict*
Alternate title: *Combat*
Photo-serigraph
Image: 16 5/8 x 28 1/4" (898 x 717 mm)
 irregular
Sheet: 29 11/16 x 41 3/8" (754 x 1051 mm)
Edition: 50
Paper: BFK Rives
Comments: Abstracted figures defined and
 obscured by multiple screening. Signed,
 ed. info, titled, and dated in graphite.

358. *Cronos*
Alternate titles: *Figure; Running Figure*
Photo-serigraph
Image: 21 5/8 x 18 1/2" (540 x 470 mm)
 irregular
Sheet: 33 3/4 x 29 5/8" (857 x 752 mm)
Edition: 50
Paper: BFK Rives

Comments: Abstracted figure defined and
 obscured by multiple screening.
 Variously dated 1971. Signed, ed. info,
 titled, and dated in graphite.

359. *Cyclist No. 3*
Alternate title: *Cyclist 3*
Photo-serigraph
Image: 19 3/4 x 20 1/8" (501 x 511 mm)
 irregular
Sheet: 31 1/8 x 29 1/2" (790 x 749 mm)
Edition: 40
Paper: BFK Rives
Printer/Publisher: Philadelphia Print Club
Collections: Philadelphia Museum of Art;
 private collection
Publications: *8 Mednarodna Grafična
 Razstava* (Ljubljana 1969), cat. #800 [as
 Cyclist]; *Catalog of the 21st National
 Exhibition*, Library of Congress, cat;
 Misch Kohn: 25 Years (Haslem 1974),
 cat. #69 [as *Cyclist*]; Philadelphia Print
 Club, publication announcement for this
 print, ill.
Comments: Abstracted figure on motor-
 cycle, commissioned by the Philadelphia
 Print Club. 30 of the 40 impressions
 were reserved for Print Club members;
 the edition sold out by the Print Club in
 2 1/2 days. Signed, ed. info, titled, and
 dated in graphite.

360. *Processional*
Alternate title: *Group*
Serigraph
Image: 28 1/4 x 34 3/4" (717 x 882 mm)
 irregular
Sheet: 29 7/8 x 41 3/4" (759 x 1060 mm)
Edition: 50
Paper: BFK Rives
Comments: Abstracted parade of figures
 with bulbous, lyrical shapes. Variously
 dated 1970. Signed, ed. info, titled, and
 dated in graphite.

361. *Running Figure*
Sugar-lift ground aquatint etching,
 chine collé
Image: 23 3/4 x 17 5/8" (603 x 447 mm)
 irregular
Sheet: 29 7/8 x 22" (759 x 559 mm)
Edition: unique
Paper: China/India laid onto J. Whatman
 watercolor
Plate: Copper
Comments: Fleeing female figure delin-
 eated by fluid lines, hair flying out
 behind, profile right. This single trial
 proof was never editioned.

362. *The Bike Rider*
Photo-etching, serigraph
Image: 22 3/4 x 28 3/4" (578 x 730mm)
Sheet: 22 3/4 x 28 3/4" (578 x 730 mm)
Edition: 200 (following artist's impres-
 sions)
Paper: Heavyweight commercial card
 stock
Publications: *The Student Independent 8*,
 Institute of Design, 1969, inside covers
Comments: Another version of a female
 motorcyclist, the image is formed by
 four circles interlocking around a rectan-
 gle. It was printed in red ink and was
 created for a 1969 portfolio published by
 Kohn's students at the Institute of
 Design.

363. *The Bird*
Alternate titles: *Bird; Small Bird in Line*
Sugar-lift ground aquatint etching,
 chine collé
Image: 22 1/4 x 19 3/8" (565 x 492 mm)
 irregular
Sheet: 38 1/4 x 29 1/2" (971 x 749 mm)
Edition: 50
Paper: China/India laid onto BFK Rives
Plate: Copper
Publications: *Misch Kohn: 25 Years*
 (Haslem 1974), cat. #72
 [as *Small Bird in Line*].
Comments: Long-feathered bird with long
 beak, profile right. Signed, ed. info,
 titled, and dated in graphite.

364. *The Group*
Serigraph
Image: 43 1/2 x 37 1/2" (1105 x 952 mm)
 irregular
Sheet: 46 x 39 1/2" (1168 x 1003 mm)
Edition: 25?
Collections: Private collection
Comments: An exuberant grouping of
 abstract figures with bulbous forms and
 lyrical shapes. "Misch Kohn" in screen,
 lr; signed and dated in graphite.

365. *Variation on Lady Madonna*
Photo-serigraph
Image: 35 3/4 x 36 1/2" (408 x 927 mm)
 irregular
Sheet: 38 x 50" (965 x 1270 mm)
Edition: 25
Paper: Commercial heavy weight
 chrome coat
Comments: Greatly expanded image of
 Lady Madonna, printed in brown.

Edition: 50
States: 2
Paper: Japanese Wampu
Plate: Copper
Collections: North Carolina National
 Bank, Charlotte; private collections
Publications: *Misch Kohn: 25 Years*
 (Haslem 1974), ill. #61; *Prints by Misch
 Kohn* (Honolulu 1975), cat. #35; Ross,
 John and Clare Romano, *The Complete
 Intaglio Print*, ill. p. 49; Ross, John and
 Clare Romano, *The Complete New
 Techniques in Printmaking*, ill. p. 27; Ross,
 John and Clare Romano, *The Complete
 Printmaker*, ill. p. 123.
Comments: The most elaborate of the
 prints in this media, requiring a very
 elaborate and difficult printing process.
 A single bemedaled and uniformed
 figure, profile left, against white back-
 ground. Signed, ed. info, titled, and
 dated in graphite.

344. *Phoenix*
Sugar-lift ground aquatint etching, printed
 A) intaglio, B) relief
Image: 9 7/8 x 7 3/4" (251 x 197 mm)
 irregular
Sheet: 14 3/4 x 13 15/16" (375 x 354 mm)
Edition: 50
States: 2
Plate: Copper
Collections: Bowdoin College Museum of
 Art [relief state]
Publications: *A Few (Open) Secrets About
 the University of Chicago Press*, cover ill.
 [relief state].
Comments: Ethereal phoenix rising
 through wispy flames and air currents.
 Signed, ed. info, titled, and dated in
 graphite.

345. *Phoenix [II]*
Sugar-lift ground aquatint etching
Image: 9 7/8 x 7 3/4" (251 x 197 mm)
 irregular
Plate: Copper
Comments: Very similar to the other
 Phoenix 1968, but not as elaborately
 delineated, and with lines of greater
 thickness.

346. *Portrait with Shifty Eyes*
Alternate title: *Head*
Sugar-lift ground aquatint etching,
 chine collé
Image: 7 7/8 x 4 7/8" (200 x 124 mm)
 irregular
Sheet: 21 1/4 x 14" (540 x 355 mm)
Edition: 10

Paper: China/India laid onto BFK Rives
Plate: Copper
Comments: Closely-cropped head, with
 features—especially beady eyes and
 prominent nose—defined by calligraphic
 lines. Signed, ed. info, titled, and dated
 in graphite.

347. *Reflections*
Photo-etching
Image: 15 1/2 x 12" (394 x 305 mm)
Edition: 50
Collections: Lakeside Gallery
Comments: Multiple screened abstract
 figure. Signed, ed. info, titled, and dated
 in graphite.

348. *Requiem*
Sugar-lift ground aquatint etching
Image: 19 5/8 x 23 3/4" (498 x 603 mm)
Sheet: 29 1/4 x 32" (743 x 813 mm)
Edition: 50
Paper: BFK Rives
Plate: Copper
Publications: *8 Mednarodna Grafična
 Razstava* (Ljubljana 1969), cat. #801;
 Misch Kohn: 25 Years (Haslem 1974),
 cat. #62.
Comments: Three prone bodies with heavy
 aquatint protest the violence of the late
 1960s, here and abroad. Signed, ed. info,
 titled, and dated in graphite.

349. *Turkey*
Sugar-lift ground aquatint etching,
 chine collé
Image: 13 x 10 3/8" (330 x 263 mm)
 irregular
Sheet: 21 1/2 x 15" (546 x 381 mm)
Edition: 25
Paper: China/India laid onto BFK Rives
Plate: Copper
Publications: *Misch Kohn: 25 Years*
 (Haslem 1974), cat. #63.
Comments: Literal portrait of male turkey
 with full plumage, profile right.
 Variously dated 1969. Signed and dated
 in graphite.

350. *Two Figures [I]*
Sugar-lift ground aquatint etching, printed
 in relief
Image: 21 x 14 1/8" (533 x 359 mm)
Sheet: 41 1/8 x 29 1/2" (1045 x 749 mm)
Edition: uneditioned
Paper: BFK Rives
Plate: Zinc
Collections: Georgetown University

Comments: Abstracted couple with bul-
 bous protrusions and fluid lines. Signed,
 titled, and dated in graphite.

351. *Two Figures [II]*
Sugar-lift ground aquatint etching, printed
 in relief
Image: 20 7/8 x 14" (530 x 355 mm)
Sheet: 17 3/8 x 16 5/8" (441 x 422 mm)
Edition: 30
Paper: China/India or heavyweight BFK
 Rives
Plate: Copper
Publications: *Misch Kohn: 25 Years*
 (Haslem 1974), cat. #74.
Comments: Abstracted couple with bul-
 bous protrusions; thicker lines and
 wider format than *Two Figures [I]* of this
 year. Variously dated 1969. Signed,
 titled, and dated in graphite.

352. *Viet Nam Soldier*
Sugar-lift ground aquatint etching,
 chine collé
Image: 35 5/8 x 18" (905 x 457 mm)
Sheet: 40 7/8 x 27 3/8" (1038 x 695 mm)
Edition: unique
Paper: China/India laid onto J. Whatman
 watercolor
Plate: Copper
Comments: Tired helmeted soldier with
 rifle over shoulder stares despondantly
 to right out across rice fields. Signed, ed.
 info, titled, and dated in graphite.

353. *Winged Figure*
Photo-serigraph
Image: 14 x 14 1/8" (355 x 359 mm)
 irregular
Sheet: 14 x 14 1/8" (355 x 359 mm)
Edition: uneditioned
Paper: BFK Rives
Comments: Abstracted figure simultane-
 ously defined and obscured by multiple
 screening.

c. 1968

354. *Figure*
Line etching, *chine collé*
Image: 6 x 3 1/2" (152 x 89 mm)
Sheet: 12 3/4 x 11 3/8" (324 x 302 mm)
Edition: uneditioned
Paper: China/India
Plate: Copper
Comments: Abstracted figure. Signed, ed.
 info, and titled in graphite.

A Studio Handbook (1972), ill. p. 237; Johnson, Una E., *16th National Print Exhibition,* ill. p. 29; *Misch Kohn: 25 Years* (Haslem 1974), cat. #78.

Comments: The first in the *End Game* series of prints, inspired by Samuel Beckett's play; the image is an abstracted figure astride a motorcycle, profile left. Variously dated 1970. Signed, ed. info, titled, and dated in graphite.

334. *End Game 2*
Alternate titles: *End Game; End Game II*
Photo-etching, *chine collé,* printed in relief
Image: 18 x 14 9/16" (458 x 369 mm)
Sheet: 30 1/4 x 26" (768 x 660 mm)
Edition: E/V 50
Paper: China/India laid onto J. Whatman watercolor
Plate: Copper
Collections: Lakeside Gallery; private collection
Comments: Second in the *End Game* series inspired by Samuel Beckett. Similar conceptualization to *End Game,* but with slightly different imagery and different color treatment. Signed, ed. info, titled, and dated in graphite.

335. *Figure*
Alternate titles: *America; Figure Portrait*
Photo-etching and aquatint, printed A) relief, B) intaglio
Image: 16 x 12 3/4" (406 x 324 mm) irregular
Sheet: 24 1/2 x 14 1/2" (622 x 368 mm)
Edition: 50
States: 2
Paper: BFK Rives
Collections: Library of Congress
Publications: *71st Annual Exhibition by Artists of Chicago and Vicinity,* Art Institute of Chicago, cat. #48 [as *Figure Portrait*]; Eichenberg, Fritz, *Art of the Print,* ill. (detail) p. 313, ill. (full) p. 324; *Prints by Misch Kohn* (Honolulu 1975), cat. #15.
Comments: Multiple screens enigmatically obscure female image. This work was inspired by John Donne's poem, *America Newfoundland.* Variously dated 1969. Signed, ed. info, titled, and dated in graphite.

336. *Ibis*
Alternate title: *Strange Bird*
Sugar-lift ground aquatint etching, drypoint, *chine collé*
Image: 22 7/8 x 19 1/4" (581 x 489 mm) irregular

Plate: 23 3/4 x 19 3/4" (603 x 502 mm)
Sheet: 31 1/4 x 22 3/4" (794 x 578 mm)
Edition: 25 [50]
Paper: China/India laid onto J. Whatman watercolor
Plate: Copper
Publications: *Misch Kohn: 25 Years* (Haslem 1974), cat. #65.
Comments: Strange bird with long beak, featherless neck, and plump body, profile right. Signed, ed. info, titled, and dated in graphite.

337. *Lady Cyclist*
Alternate title: *Girl on a Motorcycle*
Photo-serigraph
Image: 21 5/8 x 29 5/8" (549 x 752 mm)
Sheet: 29 1/2 x 39 7/8" (749 x 1013 mm)
Edition: 50
Paper: BFK Rives
Publications: Bedno, Jane, "The Demand for Graphics," *Hyde Park-Kenwood Voices* (November 1969), ill. p. 7 [as *Cyclist*].
Comments: Cartoon-like female in scoop-necked dress astride boldly delineated motorcycle. Signed and dated in graphite.

338. *Lady Madonna*
Photo-etching serigraph, printed in relief
Image: 20 1/4 x 17 1/4" (514 x 438 mm) irregular
Sheet: 33 x 29 1/2" (838 x 749 mm)
Edition: 50
Paper: BFK Rives
Collections: Lakeside Gallery; Central National Bank, Chicago
Publications: *Misch Kohn: 25 Years* (Haslem 1974), cat. #73.
Comments: Same figure used in *Blind Joy* print, but dissimilar screening. Title reference from Beatles song. Variously dated 1969. Signed, titled, and dated in graphite.

339. *Lady Madonna II*
Alternate titles: *Cyclist; The Cyclist*
Photo-etching serigraph, printed in relief
Image: 19 1/4 x 21" (489 x 533 mm) irregular
Sheet: 24 3/8 x 29 3/4" (619 x 755 mm)
Edition: 30
Paper: BFK Rives
Collections: Northern Illinois University Art Museum [as *Cyclist*]
Comments: Second in the *Lady Madonna* series, with reversed and altered image. Variously dated 1971. Signed, ed. info, titled, and dated in graphite.

340. *Laocoön*
Alternate title: *Lacoön*
Photo-etching with aquatint, printed A) intaglio, B) relief
Image: 15 7/8 x 20" (403 x 508 mm) irregular
Sheet: 20 1/2 x 27 1/2" (521 x 698 mm)
Edition: 50
States: 2
Paper: BFK Rives
Plate: Copper
Collections: Lakeside Gallery [as *Lacoon*], (2)
Publications: Metz, Kathryn, *Misch Kohn: Three Decades,* cat. #14; *Misch Kohn: 25 Years* (Haslem 1974), cat. #66; *Prints by Misch Kohn* (Honolulu 1975), ill. cat. #14.
Comments: Abstracted landscape. Most extant prints are the darker intaglio state. Signed, ed. info, titled, and dated in graphite.

341. *Little Triumph Wagon*
Alternate titles: *Kleine Triumpf Wagon; Small Triumph Wagon*
Photo-etching, *chine collé,* printed in relief
Image: 17 9/16 x 14 7/16" (446 x 367 mm)
Sheet: 26 1/4 x 20 1/8" (665 x 511 mm)
Plate: Copper
Collections: Honolulu Academy of Arts
Publications: *Prints by Misch Kohn* (Honolulu 1975), cat. #10.
Comments: An image in the *End Game* series inspired by Samuel Beckett. Variously dated 1969. Signed, ed. info, titled, and dated in graphite.

342. *Motorcyclist*
Alternate title: *Motorcycle*
Sugar-lift ground aquatint etching, printed in relief
Image: 7 3/8 x 5 1/4" (187 x 133 mm)
Sheet: 12 1/2 x 7 1/2" (317 x 190 mm)
Edition: 150
Paper: China/India
Plate: Copper
Comments: Lone motorcyclist rides in front of cityscape. Elements of this plate were used in the 1964 *Street Scene.* Signed, ed. info, titled, and dated in graphite.

343. *Ornate Figure*
Sugar-lift ground aquatint etching, *chine collé,* printed A) black only, B) black etching over color collage
Image: 34 11/16 x 17 3/4" (880 x 451 mm) irregular
Sheet: 36 5/8 x 24 3/4" (676 x 628 mm)

and 20th-Century Prints from the Honolulu Academy of Arts, ill. #93, p. 98, p. 156; Haslem, Jane, *American Painting and Graphics,* ill. cat. #43, p. 25; Haslem, Jane, *The Innovators,* ill; *Misch Kohn: 25 Years* (Haslem 1974), cat. #50; Parsons, Barbara Galuszka, "I Can't Go On; I'll Go On," *California Printmaker* (Winter 1993), ill. p. 7; *Prints by Misch Kohn* (Honolulu 1975), ill. #25; *USIA Graphics Art Program, List #2* cat. p. 5, *List #3* cat. p. 5; *Westart* (November 1975), ill. p. 1.

Comments: Two bald, mustachioed military officers, their uniforms defined by assorted mechanical parts, coins, and gauges, caucus against a black background. Signed, titled, and dated in graphite.

326. *Two Generals II*
Sugar-lift ground aquatint and soft-ground etching
Image: 19 5/8 x 15 1/2" (498 x 394 mm)
Sheet: 17 1/2 x 22 1/2" (444 x 565 mm)
Edition: 50
Paper: BFK Rives
Plate: Copper
Printer/Publisher: Lacouriere, Paris, printed by Jacques Frelaut
Collections: Syracuse University Art Collection
Publications: *Annual Exhibition 1966,* Whitney Museum of American Art, cat. #27, p. 73; Metz, Kathryn, *Misch Kohn: Three Decades,* cat. #11.
Comments: Two mustachioed officers in military hat and uniform confront each other. Similar in delineation and conceptualization to *Two Generals,* but larger. Signed, ed. info, titled, and dated in graphite.

1966

327. *Running Figure*
Sugar-lift ground aquatint etching, printed in relief
Image: 23 1/2 x 25 1/4" (597 x 641 mm) irregular
Sheet: 23 1/2 x 25 1/4" (597 x 641 mm)
Edition: uneditioned
Paper: Farnsworth
Plate: Copper
Comments: Frenetic female figure dashing into picture plane from right margin, hair flying behind her. Complex and abstracted figures and structures round out the background of this white-on-black print.

1967

328. *Official*
Alternate title: *The Official*
Sugar lift ground aquatint etching, *chine collé,* printed A) black only, B) black etching over color collage
Image: 4 15/16 x 2 3/4" (125 x 70 mm) irregular
Sheet: 14 1/2 x 18 1/4" (368 x 463 mm)
Edition: 50
States: 2
Paper: China/India laid onto J. Whatman watercolor
Plate: Copper
Collections: Columbia Museum of Art; private collection
Publications: *Misch Kohn: 25 Years* (Haslem 1974), cat. #64.
Comments: Bald, scowling military official in 3/4 length view, staring off toward right of picture plane. Signed, ed. info, titled, and dated in graphite.

329. *Portrait of L*
Sugar-lift ground aquatint etching, *chine collé*
Image: 27 1/2 x 21" (698 x 535 mm) irregular
Sheet: 37 3/16 x 28 1/4" (945 x 717 mm)
Edition: 50
Paper: China/India laid onto BFK Rives
Plate: Copper
Collections: Georgetown University
Comments: Portrait of Mauricio Lasansky, broad-shouldered and mustachioed; this same plate was used for 1970 *Portrait with One Blue Eye.* Variously dated 1967. Signed, ed. info, titled, and dated in graphite.

330. *Red Mustache*
Sugar-lift ground aquatint etching, *chine collé*
Plate: Copper

1968

331. *Blind Joy*
Alternate titles: *Cyclist; The Cyclist; Ligature '68*
Photo-etching serigraph, printed in relief
Image: 18 1/4 x 13 3/16" (462 x 335 mm) irregular
Sheet: 24 x 18 1/2" (610 x 470 mm)
Edition: 50
Paper: BFK Rives mounted on chrome coat
Printer/Publisher: Acorn Press, Chicago, in the portfolio *Ligature '68.*

Collections: Illinois State Museum; Milwaukee Art Museum [as Untitled]; Museum of Contemporary Art, Chicago; National Museum of American Art, Smithsonian Institution [as Untitled]; Syracuse University Art Collection [as Untitled]; Tusculum College; University of Maine Museum of Art; University of Michigan Special Collections Library, University Library; Wright Museum of Art, Beloit College; private collections
Publications: Bermingham, Peter, *The Art of Poetry,* ill. cat. #24; *Ligature '68,* ill; Metz, Kathryn, *Misch Kohn: Three Decades,* cat. #13; *Misch Kohn: 25 Years* (Haslem 1974), cat. #68 [as *Cyclist*].
Comments: Multi-screened image of female seated in floating chair illustrating the poem *Blind Joy* by John Frederick Nims in the portfolio *Ligature '68,* a cooperative effort of 10 artists and 10 poets. Signed, ed. info, titled, and dated in graphite.

332. *Car Number Three*
Alternate titles: *Car III; Car Number 3; Car No. 3*
Serigraph
Image: 21 1/8 x 31 3/8" (536 x 797 mm) irregular
Sheet: 29 3/4 x 41 3/8" (756 x 1051 mm)
Edition: 50
Paper: BFK Rives
Collections: United States Information Agency; private collection
Publications: *Misch Kohn: 25 Years* (Haslem 1974), cat. #67; *USIA Graphic Arts Program, List #2* cat. p. 5, *List #3* cat. p. 5.
Comments: Sleek sports car, facing right, with multiple screens defining background and auto framework. Signed, ed. info, titled, and dated in graphite.

333. *End Game*
Sugar-lift ground aquatint etching, serigraph, *chine collé,* metal leaf
Image: 24 x 18" (610 x 458 mm)
Sheet: 35 1/2 x 26 1/2" (902 x 673 mm)
Edition: 50
Paper: BFK Rives
Plate: Copper
Collections: Brooklyn Museum; Lakeside Gallery
Publications: *8 Mednarodna Grafična Razstava* (Ljubljana 1969), ill. p. 245, cat. #799; Eichenberg, Fritz, *Art of the Print,* ill. p. 544; Eichenberg, Fritz, *Lithography and Silkscreen,* ill. p. 134; Heller, Jules, *Printmaking Today:*

Edition: 50 [10]
Paper: BFK Rives
Plate: Stone
Printer/Publisher: Bohuslav Horak's
 studio, Paris
Collections: First National Bank of
 Chicago (2); Museum Boijmans Van
 Beuningen, Rotterdam
Publications: *Misch Kohn: 25 Years*
 (Haslem 1974), cat. #54.
Comments: Standing bird, 3/4 profile left;
 mottled body and feathers defined by
 linear swirls and soft areas of wash.
 Signed, titled, and dated in graphite.

318. *Large Bird*
Alternate titles: *Bird; Roadrunner; Strange
 Bird*
Sugar-lift ground aquatint etching,
 chine collé, printed A) intaglio,
 B) colored *chine collé*, C) relief
Image: 23 x 33 1/8" (587 x 845 mm)
 irregular
Sheet: 24 5/8 x 36 3/4" (625 x 933 mm)
States: 3
Paper: Japanese Wampu
Plate: Copper
Collections: Indiana University, Kokomo;
 private collection
Publications: *Contemporary American
 Prints*, IBM Gallery, cat; Hoover,
 James W., *Misch Kohn: Hometown
 Collection*, cat.
Comments: Diagonal composition with
 large bird that fills the picture plane;
 dramatic calligraphic swirls define the
 feathers, body, and, particularly, the
 spiral tail. Variously dated 1966. Signed,
 titled, and dated in graphite.

319. *Law*
Alternate titles: *Cop; Law Motorcycle;
 Motorcycle*
Lithograph
Image: 18 1/2 x 25 1/4" (470 x 641 mm)
 irregular
Sheet: 22 1/8 x 30 1/8" (562 x 765 mm)
Edition: 50
Paper: BFK Rives
Plate: Stone
Printer/Publisher: Boruslav Horak's
 studio, Paris
Collections: Private collections
Publications: Haslem, Jane, *American
 Paintings and Graphics*, ill. p. 22, cat. #38;
 Misch Kohn: 25 Years (Haslem 1974),
 ill. #53.
Comments: Gestural depiction of motor-
 cycle rider with star on fuel tank, riding
 profile left out of picture plane. Signed,
 ed. info, titled, and dated in graphite.

320. *Mod*
Aquatint etching
Image: 19 1/4 x 23 3/8" (491 x 592 mm)
 irregular
Sheet: 22 1/4 x 29 7/8" (565 x 758 mm)
Edition: 50
Paper: BFK Rives
Plate: Copper
Printer/Publisher: Lacouriere, Paris,
 printed by Jacques Frelaut
Collections: Art Institute of Chicago;
 Georgetown University; private
 collections
Publications: *Contemporary American
 Prints*, IBM Gallery, cat.
Comments: Helmeted rider on customized
 motorcycle. Signed, ed. info, titled, and
 dated in graphite.

321. *Small Bird*
Sugar-lift ground aquatint etching,
 chine collé
Image: 17 x 14 3/8" (431 x 365 mm)
 irregular
Sheet: 25 3/4 x 19 3/4" (654 x 502 mm)
Edition: 50
Paper: BFK Rives
Plate: Copper
Printer/Publisher: Lacouriere, Paris,
 printed by Jacques Frelaut for UCLA
Collections: UCLA at the Armand
 Hammer Museum of Art and Cultural
 Center, Grunwald Center for the
 Graphic Arts
Publications: *Misch Kohn: 25 Years*
 (Haslem 1974), ill. #58.
Comments: Bird with star on chest, facing
 left. Commissioned by the University of
 California, Los Angeles. Signed, titled,
 and dated in graphite.

322. *Small Lottery*
Sugar-lift ground aquatint etching
Image: 13 1/2 x 10 7/8" (343 x 276 mm)
Sheet: 22 1/4 x 15" (565 x 381 mm)
Edition: 50
Paper: BFK Rives
Plate: Copper
Printer/Publisher: Lacouriere, Paris,
 printed by Jacques Frelaut
Comments: Portly Parisian street vendor
 with beret in front of large lottery wheel.
 Signed, ed. info, titled, and dated in
 graphite.

323. *The City*
Sugar-lift ground aquatint etching,
 chine collé, printed in relief
Image: 29 3/4 x 21 7/8" (755 x 555 mm)
 irregular

Sheet: 38 5/8 x 27 1/4" (981 x 692 mm)
Edition: 50
Paper: China/India laid onto J. Whatman
 watercolor
Plate: Copper
Collections: New York Public Library
Publications: *I Miedzynarodowe Biennale
 Grafiki* (Cracow 1966), ill. cat. #754;
 VII Mednarodna Grafična Razstava
 (Ljubljana 1967), cat. #739; *69th Annual
 Exhibition by Artists of Chicago and
 Vicinity*, Art Institute of Chicago,
 cat. #80; *Misch Kohn: 25 Years*
 (Haslem 1974), cat. #59.
Comments: Cut and torn recycled prints
 form the backdrop for this vibrant
 abstracted urban landscape. Bust of
 bewildered male figure, 3/4 profile
 right, center foreground.

324. *The Lottery*
Alternate title: *Lottery*
Sugar-lift ground aquatint etching,
 chine collé, printed A) black only,
 B) black etching over color collage
Image: 19 1/4 x 15 3/8" (495 x 390 mm)
 irregular
Sheet: 25 7/8 x 19 5/8" (657 x 498 mm)
Edition: 50
States: 2
Paper: China/India laid onto BFK Rives
Plate: Copper
Printer/Publisher: Lacouriere, Paris,
 printed by Jacques Frelaut
Collections: Lakeside Gallery
Publications: *Misch Kohn: 25 Years*
 (Haslem 1974), cat. #49.
Comments: Oval plaque with motif of
 Parisian street vendor standing in front
 of large lottery wheel. Signed, ed. info,
 titled, and dated in graphite.

325. *Two Generals*
Sugar-lift ground aquatint etching, printed
 in relief
Image: 13 5/8 x 11" (346 x 279 mm)
Sheet: 25 15/16 x 19 3/4" (659 x 502 mm)
Edition: 50
Paper: BFK Rives
Plate: Copper
Printer/Publisher: Lacouriere, Paris,
 printed by Jacques Frelaut
Collections: Bibliothèque Nationale de
 France, Departement des Estampes et de
 la Photographie; Coopers and Lybrand,
 Washington, DC; Honolulu Academy of
 Arts; United States Information Agency;
 private collections
Publications: *VII Mednarodna Grafična
 Razstava* (Ljubjlana 1967), cat. #740; *19th-*

310. *Measure of Man*
Alternate title: *The Measure of Man*
Sugar-lift ground aquatint etching, with
A) watercolor, B) *chine collé*
Image: 22 3/4 x 31 7/8" (578 x 807 mm)
irregular
Sheet: 27 x 39 1/4" (685 x 997 mm)
Edition: 50
States: 2
Paper: J. Whatman watercolor
Plate: Copper
Publications: *VI Mednarodna Grafična
Razstava* (Ljubljana 1965), cat. #901;
Bradbury, Ray, "Remembrances of
Things Future," *Playboy Magazine*
(January 1965), ill. p. 99; *Misch Kohn:
25 Years* (Haslem 1974), cat. #48; *Prints
by Misch Kohn* (Honolulu 1975), cat. #37.
Comments: Male figure in full stride with
arms outstretched, silhouetted against
concentric circles. A trial color proof,
with watercolor added subsequent to
the printing, was not editioned. Signed,
ed. info, titled, and dated in graphite.

311. *Mob*
Alternate title: *The Mob*
Sugar-lift ground aquatint etching, printed
in relief
Image: 13 x 19 1/2" (330 x 495 mm)
irregular
Sheet: 23 x 29" (584 x 736 mm)
Edition: 50
Paper: Japanese Wampu
Plate: Copper
Collections: Georgetown University;
United States Information Agency;
private collection
Publications: *Misch Kohn: 25 Years*
(Haslem 1974), cat. #56; *Prints by Misch
Kohn* (Honolulu 1975), cat. #19; *USIA
Graphic Arts Program, List #2* cat. p. 5,
List #3 cat. p. 5.
Comments: Abstracted group of figures
defined by calligraphic swirls of varying
thicknesses. Georgetown University's
print incorrectly dated 1955 on the print
by the artist. Signed, ed. info, titled, and
dated in graphite.

312. *Old Actor*
Line etching, drypoint
Image: 3 1/2 x 2 3/4" (89 x 70 mm)
Sheet: 22 1/4 x 15" (565 x 381 mm)
Edition: 20
Paper: Arches
Plate: Copper
Comments: Closely-cropped bald male
with elegant mustache and goatee, pro-
file left. Signed, ed. info, titled, and
dated in graphite.

313. *Street Scene*
Sugar-lift ground aquatint etching,
chine collé, printed in relief
Image: 19 x 17 1/8" (483 x 435 mm)
irregular
Sheet: 29 3/8 x 25" (746 mm x 635 mm)
Edition: 50
Paper: China/India laid onto J. Whatman
watercolor
Plate: Copper
Collections: Kalamazoo Institute of Arts
Publications: *Misch Kohn: 25 Years*
(Haslem 1974), ill. #47.
Comments: Chaotic layering of recycled
prints recalls the constant movement of
the city. A lone motorcyclist rides into
picture plane from left. Variously dated
1965. Elements of this plate were used in
the 1968 *Motorcyclist*. Signed, titled, and
dated in graphite.

314. *Wildcat*
Sugar lift-ground aquatint etching,
chine collé
Image: 15 13/16 x 19 13/16" (402 x 487 mm)
irregular
Sheet: 21 1/4 x 26 5/16" (540 x 668 mm)
Edition: 30 [50]
Paper: China/India laid onto handmade,
Misch watermark
Plate: Copper
Collections: Kokomo-Center Township
Consolidated School Corporation;
private collection
Publications: 1934–1964 Kokomo High
School Reunion brochure, cover ill;
Catalogue of the 160th Annual Exhibition,
Philadelphia, cat. #433; Hoover,
James W., *Misch Kohn: Hometown
Collection*, cat; *Misch Kohn: 25 Years*
(Haslem 1974), cat. #46.
Comments: Prowling cat defined by calli-
graphic swirls, moving off picture plane,
head to right. This print was used to
illustrate the high school mascot for
Kohn's 30-year reunion brochure.
Signed, ed. info, titled, and dated in
graphite.

1965

315. *A Friend of the Family*
Alternate title: *Friend of the Family*
Lithograph
Image: 14 x 8 1/4" (355 x 413 mm) irregular
Sheet: 25 x 18" (635 x 457 mm)
Edition: 50
Paper: BFK Rives
Plate: Stone

Printer/Publisher: Bohuslav Horak's
studio, Paris
Collections: Kokomo-Howard County
Public Library, Hoosier Art Collection
Publications: *Hoosier Art Collection of the
Kokomo-Howard County Public Library,*
1993, cat. p. 12; Hoover, James W., *Misch
Kohn: Hometown Collection*, cat; Joray,
Charles N., *Hoosier Art Collection of the
Kokomo-Howard County Public Library,*
1989, ill. p. 18; *Misch Kohn: 25 Years*
(Haslem 1974), cat. #60; *Prints by Misch
Kohn* (Honolulu 1975), cat. #29; Rosary
College, River Forest, IL, exhib. poster
ill., 1967.
Comments: Bald military officer with han-
dlebar mustache calmly gazes out of pic-
ture plane, left. Signed, titled, and dated
in graphite.

316. *Conference*
Alternate titles: *Four Generals; The
Conference*
Lithograph, printed A) black only,
B) black and gray
Image: 20 7/8 x 30 1/2" (530 x 775 mm)
irregular
Sheet: 25 x 35 3/8" (635 x 898 mm)
Edition: 35
States: 2
Paper: BFK Rives
Plate: Stone (2)
Printer/Publisher: Bohuslav Horak's
studio, Paris
Collections: Illinois State Museum; private
collection
Publications: *I Miedzynarodowe Biennale
Grafiki* (Cracow 1966), cat. #753; *VII
Mednarodna Grafična Razstava*
(Ljubljana 1967), ill. p. 213, cat. #738;
Contemporary American Prints, IBM
Gallery, cat; Metz, Kathryn, *Misch Kohn:
Three Decades*, cat. #12; *Misch Kohn:
25 Years* (Haslem 1974), cat. #57.
Comments: Meeting of four military offi-
cers, their uniforms partially delineated
by photo-mechanical reproductions of
machine parts and diagrams. The second
state color trial proof shows a gray ghost
image behind the main figures, fore-
ground; this color state was experimen-
tal and was never editioned. Signed, ed.
info, titled, and dated in graphite.

317. *Large Bird*
Alternate title: *Bird*
Lithograph
Image: 25 1/4 x 20 1/4" (641 x 514 mm)
irregular
Sheet: 35 5/8 x 25 1/4" (905 x 641 mm)

Paper: BFK Rives
Plate: Copper
Collections: Private collection
Publications: *Misch Kohn: 25 Years*
 (Haslem 1974), cat. #33.
Comments: Snarling tiger with mouth
 wide open, tail curving down, in profile
 left. Color collage elements in grays and
 blacks only. Variously dated 1968.
 Signed and dated in graphite.

300. *Walking Figure*
Alternate titles: *Figure; Little King; Red
 King; Walking Man*
Line etching, *chine collé*, printed A) black
 only, B) red only
Image: 2 3/4 x 1 3/8" (70 x 36 mm) irregular
Sheet: 10 3/4 x 6 5/8" (273 x 168 mm)
Edition: 50
States: 2
Paper: China/India laid onto BFK Rives
Plate: Copper
Collections: Mary and Leigh Block Gallery,
 Northwestern University; private collec-
 tions
Publications: *Misch Kohn*, University of
 Louisville, cat. #37 [as *Little King*];
 Spence, cat. p. 159 [as *Red King*]; Yood,
 James, *Second Sight*, color ill. p. 147,
 cat. #81 p. 61.
Comments: This print was originally cre-
 ated for a miniature print competition,
 but after Kohn created this and other
 small pieces, he decided not to submit
 them. A few sent out as holiday greeting
 cards. Variously dated 1964. Signed,
 titled, and dated in graphite.

1964

301. *A Mediocre Artist*
Etching
Publications: *I Miedzynarodowe Biennale
 Grafiki* (Cracow 1966), cat. #755.

302. *Antique Personage*
Sugar-lift ground aquatint etching,
 chine collé, printed A) black only,
 B) black etching over color collage
Image: 18 x 14 3/8" (458 x 365 mm)
 irregular
Plate: 21 5/6 x 17 5/16" (550 x 440 mm)
Sheet: 38 x 27" (990 x 685 mm)
Edition: 50 [30] [25]
States: 2
Paper: China/India laid onto J. Whatman
 watercolor
Plate: Copper

Collections: Bibliothèque Nationale de
 France, Departement des Estampes et de
 la Photographie
Publications: *Misch Kohn: 25 Years*
 (Haslem 1974), ill. #55.
Comments: Bearded gentleman with elab-
 orate hat and costume, profile right in
 oval plaque. Variously dated 1965, 1966.
 Original intent was for edition to
 include 25 black-and-white and 25 color,
 but edition was never completed.
 Signed, ed. info, titled, and dated in
 graphite.

303. *Atomic Man*
Wood engraving
Image: 11 1/8 x 13 1/2" (282 x 343 mm)
Sheet: 19 5/16 x 23 13/16" (490 x 605 mm)
Edition: 20
Paper: China/India
Comments: Second state of 1962 *Man of
 Fear* wood engraving with significantly
 modified profile. Signed, ed. info, titled,
 and dated in graphite.

304. *Bearded Man*
Sugar-lift ground aquatint etching, printed
 in relief
Image: 19 3/4 x 16" (502 x 406 mm)
 irregular
Sheet: 29 3/4 x 22 1/4" (755 x 565 mm)
Paper: J. Whatman watercolor
Plate: Copper
Comments: Experimental print with calli-
 graphic drips and blobs defining the
 bust of a bearded male. Little linear
 emphasis except for right side of head.
 Signed in graphite.

305. *Formes Etendées*
Wood engraving
Image: 5 13/16 x 9 11/16" (147 x 246 mm)
Sheet: 13 7/8 x 23" (352 x 584 mm)
Edition: uneditioned
Paper: China/India
Comments: Abstracted landscape forms.
 Signed, titled, and dated in graphite.

306. *Jew*
Sugar-lift ground aquatint etching, *chine
 collé* with metal leaf and recycled prints
Image: 13 x 9" (330 x 228 mm)
Edition: unique
Plate: Copper
Printer/Publisher: *Playboy Magazine*, fol-
 lowing printing of artist's impression
Publications: *Playboy Magazine*
 (December 1966), ill. p. 172.
Comments: Large central figure, right,
 against background of graffiti and

blood. Commissioned by and repro-
duced in *Playboy Magazine* to illustrate
an article.

307. *Law*
Alternate titles: *Cop; The Law*
Sugar lift-ground aquatint etching,
 chine collé, printed A) black only,
 B) black etching over color collage,
 metal leaf
Image: 14 1/2 x 17 3/4" (368 x 451 mm)
 irregular
Sheet: 22 5/8 x 27 5/8" (574 x 702 mm)
Edition: 50
States: 2
Paper: China/India laid onto J. Whatman
 watercolor
Plate: Copper
Collections: Lakeside Gallery; Madison
 Art Center
Publications: *Misch Kohn: 25 Years*
 (Haslem 1974), cat. #51 [black], cat. #52
 [color *chine collé*].
Comments: Rider in official uniform
 astride a motorcycle, riding left out of
 the picture plane. Variously dated 1965.
 Signed, ed. info, titled, and dated in
 graphite.

308. *Lear*
Alternate titles: *Antique Personage; Head;
 Man with Hat*
Line etching, *chine collé*
Image: 2 7/8 x 2 3/8" (73 x 60 mm) irregular
Sheet: 15 1/2 x 12 5/8" (393 x 320 mm)
Edition: 50
Paper: China/India laid onto BFK Rives
Plate: Copper
Publications: *Misch Kohn*, University of
 Louisville, cat. #36; Spence, cat. p. 159
 [as *Head*].
Comments: Miniature print of male head,
 bearded and with plumed hat, 3/4 pro-
 file to left. Signed, titled, and dated in
 graphite.

309. *Leda*
Alternate title: *Contessa*
Line etching, *chine collé*
Image: 2 3/4 x 2" (55 x 51 mm) irregular
Sheet: 16 1/4 x 13 1/8" (413 x 333 mm)
Paper: China/India laid onto Apta
Plate: Copper
Publications: Spence, cat. p. 159
 [as *Contessa*].
Comments: Finely drawn miniature of
 female head with curly hair, pearls.
 Signed and dated in graphite.

291. *Obediah*
Aquatint etching
Image: 24 3/4 x 14" (629 x 355 mm)
Edition: 30
Plate: Copper
Publications: Spence, cat. p. 157.
Comments: Obediah was a character that
was played by Gigi (Louis Gilbert) in
film and on stage.

292. *Portrait in the Manner of L*
Line etching, *chine collé*
Image: 9 15/16 x 7 7/8" (252 x 200 mm)
irregular
Sheet: 25 x 18 3/8" (635 x 467 mm)
Edition: 50 [30]
Paper: China/India laid onto Japanese
Hosho
Plate: Copper
Publications: *Misch Kohn*, University of
Louisville, cat. #28; *Misch Kohn: 25 Years*
(Haslem 1974), ill. #34; Spence, ill. #49,
cat. p. 157.
Comments: Portrait of Lucas van Leyden
in line etching, 3/4 profile to left.
Variously dated 1964. Signed, titled, and
dated in graphite.

293. *Processional*
Sugar-lift ground aquatint etching,
chine collé
Image: 14 3/8 x 20" (365 x 508 mm)
irregular
Sheet: 20 3/8 x 27 1/2" (517 x 698 mm)
Edition: 30
Paper: China/India laid onto J. Whatman
watercolor
Plate: Copper
Comments: Fluid parade of extremely
abstracted figures, defined by calli-
graphic lines of varying thicknesses.
Signed, ed. info, titled, and dated in
graphite.

294. *Requiem*
Sugar-lift ground aquatint etching,
chine collé
Image: 22 5/8 x 32 1/2" (574 x 826 mm)
irregular
Sheet: 28 1/2 x 40 7/16" (724 x 1027 mm)
Edition: 50
Paper: BFK Rives
Plate: Copper
Collections: Bibliothèque Nationale de
France, Departement des Estampes et de
la Photographie; Library of Congress;
Museum of American Art of the
Pennsylvania Academy of the Fine Arts;
United States Information Agency

Publications: *Catalogue of the 160th Annual
Exhibition*, Philadelphia, cat. #434;
Johnson, Una, *Brooklyn Museum 14th
National Print Exhibition*, cat; Library of
Congress 1970, cat. #27; *Misch Kohn*,
University of Louisville, cat. #15; *Misch
Kohn: 25 Years* (Haslem 1974), cat. #37;
Prints by Misch Kohn (Honolulu 1975),
cat. #38; Spence, cat. p. 158; *USIA
Graphic Arts Program, List #2* cat. p. 5,
List #3, cat. p. 5.
Comments: Similar in concept to 1963
Fallen Figure, but figure is more vaguely
delineated, facing head to right, and
background has taken on the character-
istics of a wall, with names of famous
philosophers—and of his recently-
deceased father—inscribed therein.
Variously dated 1964, 1965. Signed, ed.
info, titled, and dated in graphite.

295. *Smiling Man*
Wood engraving
Image: 5 1/16 x 3 15/16" (128 x 100 mm)
Sheet: 16 1/2 x 10 15/16" (419 x 278 mm)
Edition: 30
Paper: China/India
Publications: Spence, ill. #47, cat. p. 158.
Comments: Closely-cropped portrait of
male with big nose, with concentric lines
defining the facial features. Variously
dated 1964. Signed, titled, and dated in
graphite.

296. *The Mathematician*
Alternate title: *Mathematician*
Sugar-lift ground aquatint etching,
chine collé
Image: 20 3/4 x 12 3/8" (527 x 314 mm)
irregular
Sheet: 30 x 22 1/4" (762 x 565 mm)
Edition: 30?
Paper: China/India laid onto Arches
Plate: Copper
Collections: United States Information
Agency; private collections
Publications: Spence, cat. p. 158; *USIA
Graphic Arts Program, List #2* cat. p. 5,
List #3 cat. p. 5.
Comments: Geometrically-delineated por-
trait of bearded male, profile right.
Variously dated 1964. Signed, titled, and
dated in graphite.

297. *The Wall*
Sugar-lift ground aquatint etching, dry-
point, *chine collé*
Image: 17 3/4 x 23 3/4" (451 x 603 mm)
irregular
Sheet: 25 1/4 x 30 3/8" (641 x 771 mm)

Edition: 30
Paper: China/India laid onto J. Whatman
watercolor
Plate: Copper
Collections: Philadelphia Museum of Art
Publications: *Misch Kohn*, University of
Louisville, cat. #18; *Misch Kohn: 25 Years*
(Haslem 1974), cat. #39; Spence,
cat. p. 158; Zigrosser, *Misch Kohn*,
Galerie 61, cat.
Comments: The third print in the trilogy
memorializing the artist's father's death.
This figure, more specifically delineated
than in *Requiem*, lies in front of a crum-
bling wall marked by typographic let-
ters and numbers, head to right at center
front of picture plane. Signed, ed. info,
titled, and dated in graphite.

298. *Tiger*
Alternate titles: *New Tiger; Tiger Revisited*
Sugar-lift ground aquatint etching,
chine collé
Image: 19 7/8 x 31 7/8" (504 x 809 mm)
irregular
Sheet: 28 3/4 x 39 1/2" (730 x 1003 mm)
Edition: 25 [EV 35] All impressions printed
over a collage of colored papers, 25
stable and 10 with variations in color
and position of paper tears.
States: 2/EV
Paper: China/India laid onto BFK Rives
Plate: Copper
Collections: Des Moines Art Center; John
Simon Guggenheim Memorial
Foundation; Philadelphia Museum of
Art; private collections
Publications: *VI Mednarodna Grafična
Razstava* (Ljubljana 1965), color ill. #7,
cat. #902; *Des Moines Art Center Bulletin*
(September 1964), cover ill; *Misch Kohn*,
University of Louisville, cat. #10; *Prints
by Misch Kohn* (Honolulu 1975), cat. #1;
Spence, ill. #43, cat. p. 157.
Comments: Snarling tiger, profile right, all
prints with etching over colored collage
papers; 25 consistent and 10 in evolving
edition. Des Moines Art Center incor-
rectly identifies their print as lithograph.
Signed, ed. info, titled, and dated in
graphite.

299. *Tiger*
Sugar-lift ground aquatint etching, printed
A) black only, B) black etching over
black and gray *chine collé*
Image: 14 9/16 x 23 1/2" (370 x 597 mm)
irregular
Sheet: 22 3/8 x 29 7/8" (568 x 760 mm)
States: 2

Publications: *VI Mednarodna Grafična Razstava* (Ljubljana 1965), cat. #900; Spence, cat. p. 158.

Comments: Prostrate figure lying foreground in picture plane, textured patterning from background drips down on top of him as if it were blood. One of three works memorializing the death of the artist's father. Signed, ed. info, titled, and dated in graphite.

283. *Figure With a 5*
Sugar-lift ground aquatint etching, *chine collé*, printed A) black only, B) black etching over color collage
Image: 23 3/4 x 17 3/4" (603 x 453 mm) irregular
Sheet: 30 x 26" (762 x 660 mm)
Edition: 50
States: 2
Paper: China/India laid onto J. Whatman watercolor
Plate: Copper
Collections: Free Library of Philadelphia; Georgetown University; United States Information Agency; University of Michigan Museum of Art
Publications: Esslin, Martin, *Misch Kohn Prints*, ill. p. 2; Metz, Kathryn, *Misch Kohn: Three Decades*, cat. #8; *Misch Kohn: 25 Years* (Haslem 1974), ill. #43; Saff, Donald J., *Modern Masters of Intaglio*, ill. #24; Spence, cat. p. 158; *USIA Graphic Arts Program*, List #2 cat. p. 5, List #3 cat. p. 5.
Comments: Flat frontal view of military officer, body defined by calligraphic swirls, holding the reversed digit 5 in his upraised right hand. Signed, ed. info, titled, and dated in graphite.

284. *French Painter*
Alternate title: *Head*
Sugar-lift ground aquatint etching, *chine collé*
Image: 13 3/4 x 19 3/8" (349 x 492 mm) irregular
Sheet: 26 1/4 x 22 3/8" (667 x 568 mm)
Edition: uneditioned
States: 2
Paper: China/India laid onto BFK Rives
Plate: Copper
Comments: Bearded gentleman with hat, 3/4 profile left. Second state cross-hatching defines his jacket and there is heavier aquatinting on hat and clothes. Second state has MK in plate, ur.

285. *Friendly Cow*
Sugar-lift ground aquatint etching, *chine collé*
Image: 18 x 24" (457 x 610 mm)
Edition: uneditioned
Plate: Copper
Publications: Spence, cat. p. 157.
Comments: Spence: "Rich-textured bovine in flying gallop left to right. Inspired by a verse in R.L. Stevenson's *Child's Garden of Verses*."

286. *G.B.*
Sugar-lift ground aquatint etching, *chine collé*
Image: 20 1/2 x 16 1/2" (520 x 419 mm) irregular
Plate: 23 1/8 x 19" (590 x 480 mm)
Sheet: 29 1/8 x 24 1/2" (749 x 622 mm)
Edition: 50 [30]
Paper: China/India laid onto J. Whatman watercolor
Plate: Copper
Collections: Library of Congress; Rosary College; Syracuse University Art Collection
Publications: *A One-Man Exhibition of Prints by Misch Kohn*, Monmouth Art Center, cover ill; Esslin, Martin, *Misch Kohn Prints*, cover ill; Library of Congress 1970, cat. #7; *Misch Kohn: 25 Years* (Haslem 1974), ill. #41; *Prints by Misch Kohn* (Honolulu 1975), cat. #39; Spence, cat. p. 157; "Two American Printmakers," Grand Rapids Art Museum, exhib. ann. ill., November, 1968.
Comments: Bust of George Bernard Shaw, 3/4 profile right, the flowing lines simultaneously describing and defacing the image. Signed, ed. info, titled, and dated in graphite.

287. *Gigi*
Line etching
Image: 16 x 9" (406 x 228 mm)
Edition: 30
Plate: Copper
Publications: Spence, cat. p. 157.
Comments: Spence: "Bust length portrait in pure line of old actor, Louis Gilbert; head-on view in vertical format."

288. *Gigi*
Line etching
Image: 10 7/8 x 15 7/8" (276 x 403 mm) irregular
Edition: 30
Plate: Copper
Collections: Private collection

Publications: Spence, cat. p. 157.
Comments: Second portrait of actor Louis Gilbert, but in horizontal format with subject off-center to right. Variously dated 1964. Signed, ed. info, titled, and dated in graphite.

289. *Laughing Man*
Alternate title: [Laughing Man]
Wood engraving
Image: 5 5/8 x 7 1/2" (143 x 191 mm)
Sheet: 10 1/4 x 13 5/8" (261 x 346 mm)
Edition: 30 [10]
Paper: China/India
Collections: New York Public Library; Philadelphia Museum of Art; private collections
Publications: *Misch Kohn*, University of Louisville, cat. #30; *Misch Kohn: 25 Years* (Haslem 1974), ill. #36; Spence, cat. p. 158; *Xylon* (Ljubljana 1966), cat. #113; Zigrosser, *Misch Kohn*, Galerie 61, cat.
Comments: Closely cropped face of male with hat and big grin showing his teeth. This image was carved into a previously-used block; the engraver cut off the old image and sold the blocks, but they were very thin, so the block cracked after 10 prints were pulled. Signed, ed. info, titled, and dated in graphite.

290. *Little Baron*
Alternate titles: *Baron; Little General; Official*; [The General]
Wood engraving
Image: 4 15/16 x 2 7/16" (126 x 63 mm) irregular
Sheet: 16 1/16 x 9 1/16" (409 x 230 mm)
Edition: 50
Paper: China/India
Collections: Ackland Art Museum; Coopers and Lybrand, Washington, DC; Philadelphia Museum of Art; private collections
Publications: Metz, Kathryn, *Misch Kohn: Three Decades*, cat. #9 [as *Little General*]; *Misch Kohn*, University of Louisville, cat. #26 [as *Untitled*]; *Misch Kohn: 25 Years* (Haslem 1974), cat. #38; *Prints by Misch Kohn* (Honolulu 1975), cat. #22; Spence, cat. p. 158; Zigrosser, *Misch Kohn*, Galerie 61, cat.
Comments: Full-length portrait of a military officer carved into an old French block. The words PIERRON and RUE SEGUIER 13 appear in reverse as part of the design. Signed, titled, and dated in graphite.

Rose Art Museum, Brandeis University; private collections

Publications: *Misch Kohn,* University of Louisville, cat. #23; *Misch Kohn: 25 Years* (Haslem 1974), cat. #45; Spence, cat. p. 156; Yood, James, *Second Sight,* ill. p. 146, cat. #81 p. 61.

Comments: Omega-shaped head and neck starkly embossed on black background. Black lines of varying lengths and thicknesses vaguely define facial features. Variously dated 1963. This print was commissioned as a gift for the Print and Drawing Club members of the Art Institute of Chicago. Signed, ed. info, titled, and dated in graphite.

275. *Three Generals*
Sugar-lift ground aquatint etching, *chine collé,* printed A) black only, B) black etching over color collage
Image: 19 7/8 x 15 1/4" (507 x 388 mm) irregular
Sheet: 27 1/4 x 21" (692 x 533 mm)
Edition: 40
States: 2
Paper: Heavyweight A. Millbourn
Plate: Copper
Printer/Publisher: Philadelphia Print Club
Collections: Baltimore Museum of Art; Library of Congress; Philadelphia Museum of Art (2); private collections
Publications: Canaday, John, "Obscure But Exemplary," *New York Times* 5/22/62, ill. p. X-15; Library of Congress 1970, cat. #32; Spence, cat. p. 156.
Comments: Three bald military officers coalescent such that only four legs show in this frontal stance. Their uniforms are defined by calligraphic swirls and jumbled alphabetical letters and numbers. This print was commissioned by the Philadelphia Print Club; the edition sold out. Signed, ed. info, titled, and dated in graphite.

276. *Three Kings*
Alternate title: *[Three Figures] New Year's Greeting*
Wood engraving
Image: 5 1/8 x 4 1/4" (131 x 108 mm)
Sheet: 6 7/8 x 5 1/8" (174 x 129 mm)
Edition: 60
Paper: China/India mounted on card stock
Collections: Boston Public Library; Fogg Art Museum, Harvard University; Metropolitan Museum of Art; New York Public Library; private collections
Publications: Spence, cat. p. 158; Zigrosser, *Misch Kohn,* Galerie 61, cat. [dated 1963]

Comments: Monumental feeling is evoked by this small engraving featuring three highly textured and abstracted figures, coalescent and massive. Variously dated 1963, 1964. Sent out as holiday greeting card, with inscription on mounting paper, verso. Signed and dated in graphite.

1962, 1973

277. *Calligraphic Landscape*
Alternate titles: *Gates to the City; The Window*
Sugar-lift ground aquatint etching, printed in A) intaglio, *chine collé,* B) relief with additional engraving
Image: 12 x 8 3/4" (305 x 222 mm)
Sheet: 30 1/4 x 21 3/4" (768 x 552 mm)
Edition: A) 30, B) 25
States: 2
Paper: China/India laid onto J. Whatman watercolor or Japanese Wampu
Plate: Copper
Collections: University of Michigan Museum of Art
Comments: Abstraction of calligraphic lines in vertical format. This print was first pulled in intaglio in 1962 with *chine collé* background, titled *Calligraphic Landscape.* In 1973 Kohn added engraving with a multiple graver tool and printed it in relief as *The Window,* and later also used this plate in the 1974 rainbow-roll color woodcut relief *The Window.* Signed and dated in graphite.

1963

278. *Bearded Man*
Alternate title: *Small Head*
Wood engraving
Image: 3 1/8 x 2 1/16" (79 x 52 mm)
Sheet: 15 x 7 1/2" (381 x 190 mm)
Paper: China/India or Basingwerk parchment
Collections: Stanford University Museum of Art; private collections
Publications: Metz, Kathryn, *Misch Kohn: Three Decades,* cat. #10; *Misch Kohn: 25 Years* (Haslem 1974), cat. #40; Spence, cat. p. 156.
Comments: Highly textured closely-cropped bearded head; a darkened swath cuts across the eye area. Variously dated 1964. Signed and dated in graphite.

279. *Boxer*
Line etching, drypoint, *chine collé*
Image: 9 x 3 11/16" (228 x 937 mm)
Sheet: 19 3/8 x 12 1/2" (492 x 318 mm)
Edition: 50
Paper: China/India laid onto BFK Rives
Plate: Copper
Publications: *Misch Kohn,* University of Louisville, cat. #29; *Misch Kohn: 25 Years* (Haslem 1974), cat. #42.
Comments: Frontal 3/4 length male nude, left arm crossed against chest. Signed, titled, and dated in graphite.

280. *Boxer*
Sugar-lift ground aquatint etching, printed in relief
Image: 23 3/4 x 18" (249 x 457 mm)
Sheet: 30 x 25 1/2" (762 x 648 mm)
Paper: J. Whatman watercolor
Plate: Copper
Publications: *Misch Kohn,* University of Louisville, cover ill., cat. #22; Spence, cat. p. 157.
Comments: 3/4 length male nude defined by linear drips, arms up as if defending himself, against a black background. Signed, titled, and dated in graphite.

281. *Calligraphic Head*
Sugar lift-ground aquatint etching, *chine collé*
Image: 27 5/8 x 21 3/4" (702 x 552 mm) irregular
Sheet: 35 1/4 x 27" (895 x 686 mm)
Edition: 30 [uneditioned]
Paper: China/India laid onto J. Whatman watercolor
Plate: Copper
Publications: Spence, cat. p. 157.
Comments: Flat-topped head and neck defined by calligraphic swirls that inscribe names of family and friends. Although intended for an edition of 30, only proofs were ever printed. Signed, titled, and dated in graphite.

282. *Fallen Figure*
Alternate title: *Figure*
Sugar-lift ground aquatint etching, *chine collé*
Image: 17 3/4 x 23 3/4" (452 x 602 mm) irregular
Sheet: 22 3/8 x 30 7/8" (568 x 785 mm)
Edition: 30 [50]
Paper: China/India laid onto J. Whatman watercolor
Plate: Copper
Collections: Albion College; Art Institute of Chicago [as *Figure*]

Publications: *50 Indiana Prints: Sixth Biennial*, cat. #34; *Misch Kohn*, University of Louisville, cat. #8; Ross, John, *100 Prints of the Year 1962*, cat. #51; Spence, cat. p. 155; Zigrosser, *Misch Kohn, Galerie 61*, cat.

Comments: Linear swirls define a male figure with arms outstretched and legs spread, but all members truncated due to picture format. Similar but lighter in texture and color than 1959 *Colossus*. Signed, ed. info, titled, and dated in graphite.

266. *Contemporary Man*
Alternate title: *A Contemporary*
Sugar-lift ground aquatint etching, printed A) intaglio, B) relief, C) color
Image: 23 3/4 x 20" (603 x 508 mm)
Sheet: 39 5/8 x 26 3/4" (1006 x 679 mm)
Edition: 50
States: 3
Paper: J. Whatman watercolor, 1958
Plate: Copper
Publications: *Misch Kohn*, University of Louisville, cat. #24. Spence, cat. p. 155; Zigrosser, *Misch Kohn, Galerie 61*, cat.
Comments: Softly amorphous head shape, featureless but richly textured, against a black background. Signed, ed. info, titled, and dated in graphite.

267. *Head*
Alternate title: *Small Head*
Wood engraving
Image: 4 5/16 x 5" (125 x 127 mm)
Sheet: 14 1/4 x 21 1/2" (262 x 546 mm)
Paper: China/India
Comments: Closely-cropped textural head of a smiling male with hat. Variously dated 1963, 1975. Several prints were pulled during 1975 because Kohn had been deeply involved in making hand-made paper, and wanted a change of pace with the wood engravings. Signed and dated in graphite.

268. *Horse*
Alternate title: *The Horse*
Sugar-lift ground aquatint etching, *chine collé*
Image: 14 3/8 x 17" (365 x 431 mm) irregular
Sheet: 19 7/8 x 26" (505 x 660 mm)
Edition: 8?
Paper: China/India laid onto BFK Rives
Plate: Copper
Comments: A prancing horse with right foreleg lifted; body and features defined by calligraphic swirling lines. This plate

was destroyed after only a few prints were made and a full edition was never completed. Signed, titled, and dated in graphite.

269. *Man*
Wood engraving
Image: 24 1/4 x 14" (616 x 355 mm)
Sheet: 30 x 17 3/8" (762 x 441 mm)
Edition: 10 [11]
Paper: China/India
Collections: Library of Congress
Publications: *V Mednarodna Grafična Razstava* (Ljubljana 1963), ill. #XXXVII, cat. #807; *VII Bienal de São Paulo*, cat. #14, p. 224; Eichenberg, Fritz, "Creative Freedom vs. Socialist Realism," *Artist's Proof* (1964), ill. p. 8; *Graphik 63* (Vienna), cat. #807, p. 56; Gray, Cleve, "Print Review," *Art in America* (December 1963), ill. p. 50; Library of Congress 1970, cat. #20; *Misch Kohn*, University of Louisville, cat. #6; *Misch Kohn: 25 Years* (Haslem 1974), ill. #32; *Prints by Misch Kohn* (Honolulu 1975), cat. #21; *Xylon* (Ljubljana 1966), cat. #112.
Comments: Similar in format and concept to *Man* 1961 etching. The block for this work was destroyed after a small number of prints; it cracked on the press. Signed, ed. info, titled, and dated in graphite.

270. *Man Fragment*
Alternate titles: *Head Fragment; Man (Fragment)*
Sugar-lift ground aquatint etching, *chine collé*
Image: 10 3/4 x 15 5/8" (273 x 397 mm) irregular
Sheet: 13 7/8 x 18 1/2" (352 x 470 mm)
Edition: 30
Paper: China/India laid onto BFK Rives
Plate: Copper
Collections: Private collections
Publications: *Misch Kohn*, University of Louisville, cat. #34; Spence, cat. p. 156.
Comments: Broad face in 3/4 profile right, cropped just above eyes and below chin. Features defined by calligraphic swirls. Variously dated 1964. Signed, ed. info, titled, and dated in graphite.

271. *Man of Fear*
Sugar-lift ground aquatint etching
Image: 15 7/8 x 19 7/8" (403 x 505 mm) irregular
Sheet: 21 1/2 x 25 3/8" (546 x 644 mm)
Edition: 30
Paper: J. Whatman watercolor

Plate: Copper
Publications: Spence, cat. p. 155; Zigrosser, *Misch Kohn*, Galerie 61, cat.
Comments: Flat-topped head on squat neck; features mostly obscured by the calligraphic lines texturizing the form. Signed, ed. info, titled, and dated in graphite.

272. *Man of Fear*
Wood engraving
Image: 11 3/16 x 13 1/2" (284 x 343 mm)
Sheet: 17 7/16 x 20 3/8" (443 x 517 mm)
Paper: China/India
Comments: Similar in format to etching from same year, but with greater definition between head and neck and more defined facial features. Heavily textured background. Signed and titled in graphite.

273. *Oedipus*
Wood engraving
Image: 10 1/4 x 7 1/8" (261 x 182 mm)
Sheet: 19 3/4 x 16" (502 x 406 mm)
Edition: 30
Paper: China/India
Collections: University Art Museum, University of New Mexico; private collection
Publications: Gallery Two, Rockville, MD, cat.; *Misch Kohn*, University of Louisville, cat. #31; *Misch Kohn: 25 Years* (Haslem 1974), cat. #44; *Prints by Misch Kohn* (Honolulu 1975), cat. #34; Spence, cat. p. 156.
Comments: Similar to 1959 etching, but head in 3/4 profile to left; nose predominant and mouth open. Heavily textured background and bust (cropped at top and right margin). Variously dated 1963. Signed, titled, and dated in graphite.

274. *Patriarch*
Sugar-lift ground aquatint etching, printed in relief
Image: 19 7/8 x 15 7/8" (506 x 405 mm) irregular
Sheet: 36 3/4 x 25 1/4" (933 x 641 mm)
Edition: 125
Paper: Japanese Wampu
Plate: Copper
Printer/Publisher: Print and Drawing Club, Art Institute of Chicago
Collections: Achenbach Foundation for the Graphic Arts, Fine Arts Museums of San Francisco; Albion College; Art Institute of Chicago; Greater Lafayette Museum of Art; Philadelphia Museum of Art;

la Photographie; Elvehjem Museum of Art; Indiana University Art Museum; David and Alfred Smart Museum of Art, University of Chicago; Stanford University Museum of Art; University of Iowa Museum of Art; University of Michigan Museum of Art; private collections

Publications: Eichenberg, Fritz, *Artist's Proof* (1961), ill. p. 32; Mesenel, J., "Blizu in Daleč," (Ljubljana), ill; *Misch Kohn*, University of Louisville, cat. #27; *Misch Kohn: 25 Years* (Haslem 1974), cat. #31; Spence, ill. #40, cat. p. 152; Zigrosser, *Misch Kohn*, Galerie 61, cat.

Comments: Frontal view of bust of military officer; body and generalized features are formed by calligraphic swirls. This print was commissioned by the Ravinia Festival Association, Highland Park, IL; a limited edition of 100 black-and-white prints were pulled, in addition to 25 [30] artist's impressions, the latter featuring color collage. In the first experimental state the background was inked. Variously dated 1962. Signed, ed. info, titled, and dated in graphite.

261. *The Mountain*
Alternate title: *Mountain*
Sugar-lift ground aquatint etching, drypoint, *chine collé*
Image: 19 13/16 x 31 3/4" (503 x 806 mm)
Sheet: 26 5/8 x 38 1/2" (676 x 978 mm)
Edition: 30
Paper: China/India laid onto J. Whatman watercolor
Plate: Copper
Publications: *Misch Kohn*, University of Louisville, cat. #11; Spence, cat. p. 155.
Comments: Abstracted landscape with swirling calligraphic lines defining complex vistas. Signed, ed. info, titled, and dated in graphite.

262. *Three Generals*
Alternate title: *Three Generals in Black and White*
Lithograph
Image: 27 x 19 1/2" (686 x 495 mm) irregular
Sheet: 35 1/16 x 27 1/2" (889 x 698 mm)
Edition: 10 ExP
Paper: BFK Rives
Plate: Stone
Printer/Publisher: Tamarind Lithography Workshop, Inc., #367, printed by George Miyasaki
Collections: Museum of Modern Art; National Museum of American Art,

Smithsonian Institution; UCLA at the Armand Hammer Museum of Art and Cultural Center, Grunwald Center for the Graphic Arts; University of Iowa Museum of Art

Publications: *Catalogue Raisonné, Tamarind 1960-1970*, cat. p. 130; Spence, cat. p. 154 [as *Three Generals in Black and White*]

Comments: Three barrel-chested and bemedaled officers presenting a united front. This stone was held from Tamarind #359, run 6; the light wash tones throughout the linear drawing have been eliminated, and there have been minor addition of lines in the shoulders and legs of the figures. Signed, ed. info, and dated in graphite; Tamarind and printer blind stamps.

263. *Three Generals*
Lithograph
Image: 27 9/16 x 20 3/16" (700 x 513 mm) irregular
Sheet: 34 3/4 x 26 5/8" (883 x 677 mm) irregular
Edition: Ed 20, 9 TI, PrP, 3 AP, 2 TP, CP
Paper: BFK Rives or white Nacre
Plate: Stone, zinc (5)
Printer/Publisher: Tamarind Lithography Workshop, Inc., #359, printed by George Miyasaki
Collections: Art Institute of Chicago; Los Angeles County Museum of Art; Museum of Modern Art; National Museum of American Art, Smithsonian Institution; New York Public Library; Roosevelt University; UCLA at the Armand Hammer Museum of Art and Cultural Center, Grunwald Center for the Graphic Arts; University Art Museum, University of New Mexico; private collection
Publications: *Catalogue Raisonné, Tamarind 1960-1970*, ill. p. 129; Spence, cat. p. 154.
Comments: Gaily-colored version of Tamarind #367, which used the black stone from this version. Printed August 14-24, 1961. Tamarind: "A six-color lithograph pulled as follows: 1. Zinc: yellow. Execution: crayon; tusche mixed with water and applied with brush. 2. Zinc: gray-olive. Execution: same as above. 3. Zinc: orange. Execution: crayon. 4. Zinc: red. Execution: crayon; tusche mixed with water and applied with brush. 5. Zinc: blue. Execution: tusche mixed with water and applied with brush. 6. Stone: green. Execution: tusche mixed with water and applied with brush and

pen...One of trial proofs was printed in violet instead of green in the 6th run;..in the other run #4 (red) was omitted." Kohn retained one unchopped and defaced impression to be torn and used for a collage. Signed, ed. info, titled, and dated in graphite; Tamarind and printer blind stamps.

264. *Woman*
Alternate title: *Figure*
Lithograph
Image: 38 9/16 x 27 1/4" (980 x 692 mm) irregular
Sheet: 41 5/16 x 29 3/8" (1049 x 747 mm)
Edition: Ed 30, 9 TI, PrP, 2 AP, 4 TP, CP
Paper: BFK Rives or white Nacre
Plate: Stone
Printer/Publisher: Tamarind Lithography Workshop, Inc., #374, printed by Bohuslav Horak
Collections: Art Institute of Chicago; Detroit Institute of Arts; Los Angeles County Museum of Art; Museum of Modern Art; Northern Illinois University Art Museum; UCLA at the Armand Hammer Museum of Art and Cultural Center, Grunwald Center for the Graphic Arts
Publications: *VII Bienal de São Paulo*, cat. #11, p. 224 [as *Figure*]; *American Prints 1960-1985* (MOMA, 1986), ill. p. 206; *Catalogue Raisonné, Tamarind 1960-1970*, ill. p. 130; Marty, Martin, *Ecumenical Art*, cat. ill. [as *Figure*]; *Misch Kohn: 25 Years* (Haslem 1974), cat. #27 [as *Figure*]; Spence, cat. p. 155; Tamarind Lithography Workshop, *Lithographs from the Tamarind Workshop*, cat. #67, p. 29.
Comments: Massive figure with truncated arms outstretched; body defined through amorphous and textured patterning. Printed August 31-September 5, 1961. Signed, ed. info, titled, and dated in graphite; Tamarind and printer blind stamps.

1962

265. *Colossus II*
Sugar-lift ground aquatint etching, *chine collé*
Image: 34 x 23 1/8" (863 x 587 mm) irregular
Sheet: 38 7/8 x 26 3/4" (987 x 679 mm)
Edition: 30 [50]
Paper: China/India laid onto J. Whatman watercolor
Plate: Copper

Tamarind: "A three-color lithograph printed as follows: 1. Zinc: orange. Execution: liquid tusche dripped on plate. 2. Zinc: yellow. Execution: liquid tusche dripped on plate. 3. Zinc: violet. Execution: liquid tusche dripped on plate; rubbing crayon." Signed, ed. info, titled, and dated in graphite; Tamarind and printer blind stamps.

256. *Soldiers*
Alternate titles: *3 Generals; 4 Generals; Conference; Four Generals; Three Generals*
Lithograph
Image: 15 3/4 x 11 1/4" (401 x 286 mm) irregular
Sheet: 22 5/16 x 15" (567 x 382 mm) irregular
Edition: Ed 20, 9 TI, BAT, 3 AP, CP
Paper: BFK Rives or white Arches
Plate: Stone (2), zinc
Printer/Publisher: Tamarind Lithography Workshop, Inc. #333, printed by Harold Keeler
Collections: Art Institute of Chicago; Los Angeles County Museum of Art; Museum of Modern Art; UCLA at the Armand Hammer Museum of Art and Cultural Center, Grunwald Center for the Graphic Arts; University Art Museum, University of New Mexico; private collections
Publications: *Catalogue Raisonné, Tamarind 1960-1970*, ill. p. 128; *Misch Kohn*, University of Louisville, cat. #38 [as *Three Generals*]; *Misch Kohn: 25 Years* (Haslem 1974), cat. #29 [as *4 Generals*]; Spence, cat. p. 153.
Comments: Three overlapping figures presenting a united front; their bodies are defined by calligraphic swirls. Printed July 7-August 18, 1961. Tamarind: "A three-color lithograph printed as follows: 1. Stone: red-brown. Execution: liquid tusche applied with brush; rubbing ink. 2. Zinc: ochre. Execution: liquid tusche and solvent applied with brush. 3. Stone: black. Execution: liquid tusche applied with brush; image blotted while still wet." Signed, ed. info, and dated in graphite; Tamarind and printer blind stamps.

257. *Spotted Beast*
Alternate titles: *Dog; Spotted Bull*
Lithograph
Image: 16 1/2 x 24 3/4" (420 x 629 mm) irregular
Sheet: 22 7/16 x 29 15/16" (570 x 760 mm) irregular

Edition: Ed 20, 9 TI, BAT, 2 AP, 3 TP, 1 CTP
Paper: BFK Rives or white Arches
Plate: Zinc (3)
Printer/Publisher: Tamarind Lithography Workshop, Inc., #344, printed by Bohuslav Horak
Collections: Art Institute of Chicago; Los Angeles County Museum of Art; Museum of Modern Art; Stanford University Museum of Art; UCLA at the Armand Hammer Museum of Art and Cultural Center, Grunwald Center for the Graphic Arts; University Art Museum, University of New Mexico; private collection
Publications: *Catalogue Raisonné, Tamarind 1960-1970*, ill. p. 129; Hoover, James W., *Misch Kohn: Hometown Collection*, cat; *Misch Kohn*, University of Louisville, cat. #17; Spence, cat. p. 154.
Comments: Stocky animal with mottled coat, 3/4 profile left, against a black background. Printed July 18-August 2, 1961. Tamarind: "A three-color lithograph printed as follows: 1. Zinc: olive. Execution: liquid tusche and water applied with brush. 2. Zinc: rose. Execution: liquid tusche, liquid tusche and water applied with brush. 3. Zinc: black. Execution: liquid tusche, liquid tusche and water applied with brush; lithographic crayon; lithographic pencil." Signed, ed. info, titled, and dated in graphite; Tamarind and printer blind stamps.

258. *Stranger*
Lithograph
Image: 13 5/16 x 10 7/16" (338 x 265 mm) irregular
Sheet: 22 1/4 x 15 1/4" (566 x 387 mm) irregular
Edition: Ed 20, 9 TI, 4 AP
Paper: White Arches or white Nacre
Plate: Stone (2)
Printer/Publisher: Tamarind Lithography Workshop, Inc., #334, printed by Joe Funk
Collections: Art Institute of Chicago; Los Angeles County Museum of Art; Museum of Modern Art; UCLA at the Armand Hammer Museum of Art and Cultural Center, Grunwald Center for the Graphic Arts; University Art Museum, University of New Mexico
Publications: *Catalogue Raisonné, Tamarind 1960-1970*, ill. p. 128; Spence, cat. p. 153.
Comments: Scraggly, worn bust of bearded male dressed in loose clothes. Printed July 7-14, 1961. This same stone used for

run #1 and #2 was held to be used, with different color and image, for Tamarind #334A. Tamarind: "A three-color lithograph printed as follows: 1. Stone: red. Execution: liquid tusche applied with brush; rubbing ink; deletions made with acid. 2. Stone (from run #1): blue green. Execution: see run #1 above. 3. Stone: olive green. Execution: liquid tusche applied with brush and pen." Signed, ed. info, titled, and dated in graphite; Tamarind and printer blind stamps.

259. *Stranger II*
Lithograph
Image: 13 1/4 x 10 1/16" (337 x 256 mm) irregular
Sheet: 22 5/16 x 14 15/16" (567 x 379 mm) irregular
Edition: Ed 18, 9 TI, 4 AP
Paper: BFK Rives or white Arches
Plate: Stone
Printer/Publisher: Tamarind Lithography Workshop, Inc., #334A, printed by John Muench
Collections: Art Institute of Chicago; Los Angeles County Museum of Art; Museum of Modern Art; UCLA at the Armand Hammer Museum of Art and Cultural Center, Grunwald Center for the Graphic Arts; University Art Museum, University of New Mexico
Publications: *Catalogue Raisonné, Tamarind 1960-1970*, ill. p. 128; Spence, cat. p. 153.
Comments: This black-and-white version of Tamarind #334 evokes greater misery. The line drawing has been eliminated, and the wash has been lightened. Printed July 10-11, 1961. Signed, ed. info, titled, and dated in graphite; Tamarind and printer blind stamps.

260. *The Last General*
Alternate titles: *General's Head; Head; Head of a General; Last General*
Sugar-lift ground aquatint etching, gouging, printed in relief; A) background *chine collé*, B) colored *chine collé* collage, C) black background, D) light background
Image: 16 x 10 3/4" (407 x 273 mm) irregular
Sheet: 30 7/8 x 22 5/16" (785 x 567 mm)
Edition: 25 [30]/100
States: 4
Paper: China/India laid onto A. Millbourn or Japanese Wampu
Plate: Copper
Collections: Bibliothèque Nationale de France, Departement des Estampes et de

University of Louisville, cat. #19; Spence, cat. p. 153; Zigrosser, *Misch Kohn*, Galerie 61, cat.

Comments: Massive square-shouldered figure overwhelms the picture plane; amorphous textures define the body framework. Printed July 11-14, 1961. Tamarind: "Execution: liquid tusche, liquid tusche and water applied with brush as wash; rubbing ink." Signed, ed. info, titled, and dated in graphite; Tamarind and printer blind stamps.

251. *Patriarch*
Alternate titles: *Figure of the Prophet; Patriarch II*
Sugar-lift ground aquatint etching, printed A) relief, *chine collé*, (B) serigraph, gold leaf, *chine collé*
Image: 15 7/8 x 9 7/8" (403 x 251 mm) irregular
Sheet: 21 1/4 x 14 1/2" (540 x 368 mm)
Edition: 35
States: 2
Paper: China/India and gold leaf laid onto Arches or A. Millbourne
Plate: Copper
Collections: New York Public Library [as *Patriarch II*, black only]
Publications: Spence, cat. p. 156 [as *Figure of the Prophet*].
Comments: Slender 3/4 length figure with arms truncated but outstetched. This print was created for submission to Cleveland Museum of Art's Print Club commission competition for members' gifts. Execution: goldleaf laid over china paper, then the plate was printed in relief; finally, a sugar-lift ground aquatint etching was printed over all. Signed, ed. info, titled, and dated in graphite.

252. *Patriarch II*
Alternate title: *Patriarch*
Lithograph
Image: 18 11/16 x 12 15/16" (475 x 329 mm) irregular
Sheet: 22 3/16 x 15" (564 x 382 mm) irregular
Edition: 20, 9 TI, PrP, 5 AP
Paper: BFK Rives or white Arches
Plate: Stone
Printer/Publisher: Tamarind Lithography Workshop, Inc., #338, printed by Bohuslav Horak.
Collections: Art Institute of Chicago; Los Angeles County Museum of Art; Museum of Modern Art; San Diego Museum of Art; UCLA at the Armand

Hammer Museum of Art and Cultural Center, Grunwald Center for the Graphic Arts; University Art Museum, University of New Mexico
Publications: *Catalogue Raisonné, Tamarind 1960-1970*, ill. p. 129; Spence, cat. p. 153.
Comments: Softly amorphous textures define a 3/4 length body, with arms truncated but outstretched. Printed July 12-13, 1961. Tamarind: "Execution: liquid tusche, liquid tusche and water applied with brush and pen; rubbing ink; lithographic pencil." Signed, ed. info, titled, and dated in graphite; Tamarind and printer blind stamps.

253. *Procession*
Alternate title: *Processional*
Lithograph
Image: 23 x 34 1/2" (585 x 871 mm) irregular
Sheet: 25 7/8 x 37 1/4" (657 x 946 mm) irregular
Edition: Ed 20, 1 BAT, 3 TP, 2 AP, 9 TI, 1 CP
Paper: BFK Rives or white Nacre
Plate: Stone, zinc (2)
Printer/Publisher: Tamarind Lithography Workshop, Inc., #332, printed by Bohuslav Horak
Collections: Art Institute of Chicago; Los Angeles County Museum of Art; Museum of Modern Art; Philadelphia Museum of Art; UCLA at the Armand Hammer Museum of Art and Cultural Center, Grunwald Center for the Graphic Arts; University Art Museum, University of New Mexico
Publications: *Catalogue Raisonné, Tamarind 1960-1970*, ill, p. 128; Spence, cat. p. 153.
Comments: Rhythmic and complex parade of abstracted figures. Printed July 6-8 1961. Tamarind: "The three-color lithograph printed as follows: 1. Stone: gray. Execution: liquid tusche applied with brush. 2. Zinc: red. Execution: liquid tusche and water applied with brush. 3. Zinc: black. Execution: liquid tusche, liquid tusche and solvent, applied with brush; deletions made with acid." Kohn also retained two unchopped proofs of this print to be torn for use in collage. Signed, ed. info, and dated in graphite; Tamarind and printer blind stamps.

254. *Red Beast*
Lithograph
Image: 24 x 31 3/8" (609 x 797 mm) irregular
Sheet: 29 3/4 x 41 5/8" (755 x 1057 mm)

Edition: Ed 20, 9 TI, PrP, 5 AP
Paper: BFK Rives or white Nacre
Plate: Zinc (2)
Printer/Publisher: Tamarind Lithography Workshop, Inc., #339, printed by Bohuslav Horak (TI), and by Joe Funk (all other impressions)
Collections: Art Institute of Chicago; Los Angeles County Museum of Art; Museum of Modern Art; Philadelphia Museum of Art; National Museum of American Art, Smithsonian Institution (2); UCLA at the Armand Hammer Museum of Art and Cultural Center, Grunwald Center for the Graphic Arts; University Art Museum, University of New Mexico; private collections
Publications: *Catalogue Raisonné, Tamarind 1960-1970*, ill. p. 129; Spence, cat. p. 153.
Comments: Feisty beast with upraised tail and curly hair, profile left. Printed July 13-21, 1961. Tamarind: "A two-color lithograph printed as follows: 1. Zinc: red. Execution: liquid tusche, liquid tusche and water, applied with brush. 2. Zinc: olive. Execution: liquid tusche, liquid tusche and water, applied with brush." The zinc plate from run #2 was held for Tamarind #343. Signed, ed. info, titled, and dated in graphite; Tamarind and printer blind stamps.

255. *Simon*
Lithograph
Image: 20 7/8 x 15 11/16" (531 x 399 mm) irregular
Sheet: 30 3/16 x 22 1/4" (767 x 565 mm) irregular
Edition: ED 20, 9 TI, BAT, 3 AP, 2 TP, CP
Paper: BFK Rives or white Nacre
Plate: Zinc (3)
Printer/Publisher: Tamarind Lithography Workshop, Inc., #357, printed by Bohuslav Horak
Collections: Art Institute of Chicago; Los Angeles County Museum of Art; Museum of Modern Art; UCLA at the Armand Hammer Museum of Art and Cultural Center, Grunwald Center for the Graphic Arts; University Art Museum, University of New Mexico
Publications: *Catalogue Raisonné, Tamarind 1960-1970*, ill. p. 129; *Misch Kohn*, University of Louisville, cat. #20; Spence, cat. p. 154; Tamarind Lithography Workshop, *Lithographs from the Tamarind Workshop*, cat. #64, p. 29.
Comments: Bust in 3/4 profile to left; outline and features defined by slender dripped lines. Printed August 8-15, 1961.

Spence, cat. p. 157; Zigrosser, *Misch Kohn,* Galerie 61, cat.
Comments: Imposing bird with outstretched wing. Variously dated 1963. Signed, ed. info, titled, and dated in graphite.

245. *Head*
Lithograph
Image: 12 7/8 x 9 3/4" (327 x 247 mm) irregular
Sheet: 22 5/16 x 15 1/8" (567 x 385 mm) irregular
Edition: Ed 14, 9 TI, PrP
Paper: BFK Rives or white Arches
Plate: Stone
Printer/Publisher: Tamarind Lithography Workshop, Inc., #341, printed by Bohuslav Horak
Collections: Art Institute of Chicago; Los Angeles County Museum of Art; Museum of Modern Art; UCLA at the Armand Hammer Museum of Art and Cultural Center, Grunwald Center for the Graphic Arts; University Art Museum, University of New Mexico.
Publications: *Catalogue Raisonné, Tamarind 1960-1970,* ill. p. 129. Spence, cat. p. 154; Tamarind Lithography Workshop, *Lithographs from the Tamarind Workshop,* cat. #62, p. 29.
Comments: Bald male with partially-obscured facial features. Printed July 18-21, 1961. Tamarind: "Execution: liquid tusche and water applied with brush; lithographic pencil; rubbing ink." Signed, ed. info, and dated in graphite; Tamarind and printer blind stamps.

246. *Ikaros*
Lithograph
Image: 30 x 22 1/4" (762 x 565 mm)
Sheet: 30 x 22 1/4" (762 x 565 mm)
Edition: 10 ExP, 1 PrP
Paper: BFK Rives
Plate: Stone
Printer/Publisher: Tamarind Lithography Workshop, Inc., #330, printed by Bohuslav Horak
Collections: Museum of Modern Art; National Museum of American Art, Smithsonian Institution; UCLA at the Armand Hammer Museum of Art and Cultural Center, Grunwald Center for the Graphic Arts; University of Iowa Museum of Art
Publications: *Catalogue Raisonné, Tamarind 1960-1970,* cat. p. 128; Spence, cat. p. 152.
Comments: Abstracted winged figure careening to lower right in picture

plane. Printed July 5-6, 1961. Signed and ed. info in graphite; Tamarind blind stamp.

247. *Landscape*
Lithograph
Image: 7 15/16 x 12 1/4" (201 x 312 mm) irregular
Sheet: 11 7/8 x 15 15/16" (302 x 406 mm) irregular
Edition: Ed 20, 9 TI, BAT, 2 AP, 3 TP
Paper: BFK Rives or Crisbrook Waterleaf
Plate: Stone (2)
Printer/Publisher: Tamarind Lithography Workshop, Inc., #354, printed by Harold Keeler
Collections: Los Angeles County Museum of Art; Museum of Modern Art; UCLA at the Armand Hammer Museum of Art and Cultural Center, Grunwald Center for the Graphic Arts; University Art Museum, University of New Mexico; private collection
Publications: *Catalogue Raisonné, Tamarind 1960-1970,* ill. p. 129; Spence, cat. p. 154.
Comments: Abstracted landscape shimmering with desert colors. Printed July 27-August 8, 1961. Tamarind: "A two-color lithograph printed as follows: 1. Stone: orange. Execution: liquid tusche dripped and blotted on stone; rubbing ink. 2. Stone: green. Execution: liquid tusche dripped and blotted on stone; lithographic crayon." Signed, ed. info, and dated in graphite; Tamarind and printer blind stamps.

248. *Man*
Alternate title: *Man II*
Sugar-lift ground aquatint etching, drypoint, line engraving, *chine collé*
Image: 31 7/8 x 20" (809 x 508 mm) irregular
Sheet: 41 1/2 x 29 5/8" (1054 x 752 mm)
Edition: 30
States: 2
Paper: China/India
Plate: Copper
Collections: Honolulu Academy of Arts; Norton Simon Museum; Philadelphia Museum of Art
Publications: *VII Bienal de São Paulo,* cat. #13, p. 224; *December* (Winter 1963), ill. p. 175; Marty, Martin, *Ecumenical Art,* cat. ill. [incorrectly identified as wood engraving]; *Misch Kohn: 25 Years* (Haslem 1974), cat. #26; *Pasadena Third Biennial National Print Exhibition,* ill. cat. #40; *Prints by Misch Kohn* (Honolulu 1975), cat. #36; Schmeckebier,

Laurence E., *American Printmakers,* ill. p. 33; Spence, ill. #46, cat. p. 156.
Comments: Featureless bust, threatening in its amorphous delineation and isolation against a white background. Signed, ed. info, titled, and dated in graphite.

249. *Patriarch*
Alternate title: *Patriarch (Experimental)*
Lithograph
Image: 26 7/8 x 19 1/8" (683 x 486 mm)
Sheet: 30 x 22 5/16" (762 x 565 mm)
Edition: 10 ExP, PrP
Paper: BFK Rives
Plate: Stone
Printer/Publisher: Tamarind Lithography Workshop, Inc., #340, printed by Bohuslav Horak
Collections: Museum of Modern Art; National Museum of American Art, Smithsonian Institution; UCLA at the Armand Hammer Museum of Art and Cultural Center, Grunwald Center for the Graphic Arts; University of Iowa Museum of Art
Publications: *Catalogue Raisonné, Tamarind 1960-1970,* cat. p. 129; Spence, cat. p. 153-4 [as *Patriarch (Experimental)*, but description and ed. info confused with p. 153 *Patriarch,* prior].
Comments: Three-quarter length male figure, white against a lavender background. Printed July 14-18, 1961. The stone was originally intended to be printed over Tamarind #336, but the artist later decided against this. Signed and ed. info in graphite; Tamarind and printer blind stamps.

250. *Patriarch*
Lithograph
Image: 27 3/16 x 19 1/8" (691 x 486 mm) irregular
Sheet: 29 15/16 x 22 5/16" (761 x 567 mm)
Edition: Ed 30, 9 TI, PrP, 4 AP
Paper: BFK Rives or white Arches
Plate: Stone
Printer/Publisher: Tamarind Lithography Workshop, Inc., #336, printed by Bohuslav Horak
Collections: Art Institute of Chicago; Los Angeles County Museum of Art; Museum of Modern Art; San Diego Museum of Art; UCLA at the Armand Hammer Museum of Art and Cultural Center, Grunwald Center for the Graphic Arts; University Art Museum, University of New Mexico
Publications: *Catalogue Raisonné, Tamarind 1960-1970,* ill. p. 128; *Misch Kohn,*

50 Indiana Prints: Sixth Biennial, cat. #33; *Catalogue Raisonné, Tamarind 1960-1970*, ill. p. 129; Library of Congress 1970, cat. #26; Spence, cat. p. 155.

Comments: Textured, amorphous patterning defines 3/4 length view of featureless male body without linear emphasis. Printed August 21-24, 1961. Tamarind: "Execution: gum stop-out; liquid tusche and solvent applied with brush and blotted; rubbing ink." Signed, ed. info, and dated in graphite; Tamarind and printer blind stamps.

241. *Figure*
Alternate titles: *Patriarch; Patriarch II*
Lithograph
Image: 24 5/8 x 16 1/8" (625 x 410 mm) irregular
Sheet: 30 1/8 x 22 3/8" (765 x 568 mm) irregular
Edition: Ed 11, 9 TI, PrP, 4 AP, 4 CTP
States: 2
Paper: BFK Rives or white Nacre
Plate: Zinc (3)
Printer/Publisher: Tamarind Lithography Workshop, Inc., #347, printed by Bohuslav Horak.
Collections: Art Institute of Chicago; Los Angeles County Museum of Art; Museum of Modern Art; UCLA at the Armand Hammer Museum of Art and Cultural Center, Grunwald Center for the Graphic Arts; University Art Museum, University of New Mexico
Publications: *Catalogue Raisonné, Tamarind 1960-1970*, ill. p. 129; Metz, Kathryn, *Misch Kohn: Three Decades*, cat. #7 [incorrectly identified as *Patriarch (Experimental)*]; *Misch Kohn*, University of Louisville, cat. #16 [as *Patriarch II*]; *Misch Kohn: 25 Years* (Haslem 1974), cat. #30 [as *Patriarch II*]; Spence, cat. p. 154; Tamarind Lithography Workshop, *Lithographs from the Tamarind Workshop*, cat. #63, p. 29; Zigrosser, *Misch Kohn*, Galerie 61, cat.
Comments: Textured, amorphous patterning defines 3/4 length view of featureless male body without linear emphasis. Printed July 24-August 2, 1961. Tamarind: "A three-color lithograph printed as follows: 1. Zinc: blue. Execution: drawing made on paper with liquid tusche applied with brush and blotted onto plate; lithographic crayon. 2. Zinc: gray. Execution: liquid tusche and water applied with brush. 3. Zinc: orange. Execution: liquid tusche and water applied with brush as wash;

zincographique applied with pen and as spatter." A black proof for the color run is also extant. Signed, ed info, titled, and dated in graphite; Tamarind and printer blind stamps.

242. *Giant*
Alternate titles: *Figure; Giant Colossus*
Lithograph
Image: 38 1/2 x 27" (978 x 685 mm) irregular
Sheet: 41 1/2 x 29 3/4" (1054 x 756 mm)
Edition: Ed 30, 9 TI, PrP, 2 AP, 3 TP
Paper: BFK Rives or white Nacre
Plate: Stone
Printer/Publisher: Tamarind Lithography Workshop, Inc., #372, printed by Bohuslav Horak
Collections: Art Institute of Chicago (2); Library of Congress; Los Angeles County Museum of Art (2); Museum of Modern Art; Philadelphia Museum of Art (2); Portland Art Museum; John and Mable Ringling Museum of Art; UCLA at the Armand Hammer Museum of Art and Cultural Center, Grunwald Center for the Graphic Arts; University Art Museum, University of New Mexico; Washington University Gallery of Art; private collections
Publications: *V Mednarodna Grafična Razstava* (Ljubljana 1963), cat. #805; *VII Bienal de São Paulo*, cat. #12, p. 224; *American Prints Today/1962*, ill. #23, p. 33; *Catalogue Raisonné, Tamarind 1960-1970*, ill. p. 130; Library of Congress 1970, cat. #9; Marty, Martin, *Ecumenical Art*, cat; *Misch Kohn: 25 Years* (Haslem 1974), cat. #28; Schmeckebier, Lawrence, *American Printmakers 1962*, cat. p. 63; Spence, ill. #44; cat. p. 155; Tamarind Lithography Workshop, *Lithographs from the Tamarind Workshop*, ill. #66 p. 10, cat. p. 29; Weyhe Gallery exhib. poster ill. 1961; Zigrosser, *Misch Kohn*, Galerie 61, exhib. ann. ill., cat.
Comments: Textured, amorphous patterning defines 3/4 length view of massive, featureless male body with left arm upraised; no linear emphasis. Printed August 29-31, 1961. Tamarind: "Execution: gum stop-out; liquid tusche on paper blotted onto stone; rubbing ink." Signed, ed. info, titled, and dated in graphite; Tamarind and printer blind stamps.

243. *Grand Canyon*
Lithograph
Image: 9 11/16 x 13 1/16" (246 x 332 mm) irregular
Sheet: 15 1/16 x 20 1/16" (383 x 510 mm) irregular
Edition: Ed 20, 9 TI, PrP, AP, CP
Paper: BFK Rives or Crisbrook Waterleaf
Plate: Stone
Printer/Publisher: Tamarind Lithography Workshop, Inc., #353, printed by Harold Keeler
Collections: Art Insitute of Chicago; Los Angeles County Museum of Art; Museum of Modern Art; San Diego Museum of Art; UCLA at the Armand Hammer Museum of Art and Cultural Center, Grunwald Center for the Graphic Arts; University Art Museum, University of New Mexico
Publications: *Catalogue Raisonné, Tamarind 1960-1970*, ill. p. 129; Spence, cat. p. 154.
Comments: Abstracted landscape. Printed July 27-August 10, 1961. Tamarind: "Execution: liquid tusche applied with brush on paper blotted onto stone; liquid tusche and water applied as wash; rubbing ink." Signed, ed. info, and dated in graphite; Tamarind and printer blind stamps.

244. *Hawk*
Sugar-lift ground aquatint etching, *chine collé*, printed A) black only, B) black etching over color collage
Image: 23 3/4 x 19 7/8" (603 x 505 mm) irregular
Sheet: 31 3/8 x 26 7/8" (797 x 683 mm)
Edition: 50 [30]
States: 2
Paper: China/India laid onto J. Whatman watercolor
Plate: Copper
Collections: Library of Congress; Museum Boymans/van Beuningen, Rotterdam; Monterey Museum of Art; National Museum of American Art, Smithsonian Institution; Philadelphia Museum of Art; private collections
Publications: "Ameriški Umetnik Misch Kohn v Mali Galeriji," *Ljubljana*, 1963, ill; "Art Exhibit," *Kokomo Tribune* 4/17/66, ill; Hopkins, Marilyn, "Printmaking in Chicago," *Saver* (Winter 1971), ill; Library of Congress 1970, cat. #12; *Misch Kohn*, University of Louisville, cat. #12; *Misch Kohn: 25 Years* (Haslem 1974), ill. #35; *Prints by Misch Kohn* (Honolulu 1975), cover ill., cat. #2;

not meant to be an alternative title for this piece. Signed, ed. info, titled, and dated in graphite.

233. *Oma*
Hard-ground etching, *chine collé*
Image: 23 3/4 x 19 3/4" (603 x 502 mm) irregular
Sheet: 32 x 25 5/8" (812 x 651 mm)
Edition: 30
Paper: J. Whatman watercolor
Plate: Zinc
Collections: Allen R. Hite Art Institute, University of Louisville; private collection
Publications: "Art Museum," *News-Sentinel* (Ft. Wayne, IN), 9/14/61, ill; *Misch Kohn*, University of Louisville, cat. #9; Spence, ill. #48, cat. p. 152; Zigrosser-AFA, ill. #38, cat. #157.
Comments: Economy of line describes this portrait of the artist's aged mother-in-law, who lived with them. Signed, ed. info, titled, and dated in graphite.

234. *Stefan*
Alternate title: *Stephan*
Line etching, drypoint, *chine collé*
Image: 9 15/16 x 7 15/16" (252 x 202 mm) irregular
Sheet: 18 3/4 x 15 1/4" (476 x 387 mm)
Edition: 30
Paper: China/India laid onto J. Whatman watercolor
Plate: Copper
Publications: Spence, cat. p. 156.
Comments: Sensitive line etching of Kohns' friend Stefan Varro in 3/4 view to right. Signed, ed. info, titled, and dated in graphite.

235. *The Runaways*
Alternate title: *Running Horse*
Sugar-lift ground aquatint etching, engraving, *chine collé*
Image: 11 1/8 x 16 5/8" (282 x 422 mm) irregular
Edition: unique
Plate: Copper
Publications: Spence, cat. p. 152 [as *Running Horse*]; Webb, Leland, "The Runaways," *Playboy Magazine* (June 1960), ill. pp. 26-7.
Comments: Dappled horse leaping out of the picture plane to right, against a sketchily gestural rural background. This unique print was created for *Playboy Magazine* to illustrate the story "The Runaways."

c. 1960

236. *Portrait of an Artist*
Line etching, *chine collé*
Image: 10 x 7 7/8" (254 x 200 mm) irregular
Sheet: 29 1/2 x 20 3/4" (749 x 527 mm)
Paper: China/India laid onto BFK Rives
Plate: Copper
Comments: Portrait of a Jewish artist from New York from the 1920–'30s, 3/4 profile right.

1961

237. *Beast*
Lithograph
Image: 19 3/4 x 28 1/2" (502 x 724 mm) irregular
Sheet: 27 1/4 x 39 1/16" (693 x 993 mm) irregular
Edition: Ed 20, 9 TI, PrP, 3 AP, 2 TP, CP
Paper: BFK Rives or natural Nacre
Plate: Stone
Printer/Publisher: Tamarind Lithography Workshop, Inc., #368, printed by George Miyasaki
Collections: Art Institute of Chicago; Los Angeles County Museum of Art (2); Museum of Modern Art; UCLA at the Armand Hammer Museum of Art and Cultural Center, Grunwald Center for the Graphic Arts; University Art Museum, University of New Mexico
Publications: *Catalogue Raisonné, Tamarind 1960-1970*, ill. p. 130; Spence, cat. p. 153; Tamarind Lithography Workshop, *Lithographs from the Tamarind Workshop*, cat. #65, p. 29.,
Comments: Stocky four-legged animal, profile left. Printed August 29, 1961. Tamarind: "Execution: liquid tusche, liquid tusche and solvent, applied with brush; portions of drawing blotted; lithographic pencil; rubbing ink." Signed, ed. info, and dated in graphite; Tamarind and printer blind stamps.

238. *Black Beast*
Alternate title: *Lion*
Lithograph
Image: 24 1/2 x 30 3/4" (623 x 781 mm) irregular
Sheet: 29 5/16 x 41 1/4" (745 x 1048 mm) irregular
Edition: Ed 20, 9 TI, PrP, 2 AP
Paper: BFK Rives or white Nacre
Plate: Zinc
Printer/Publisher: Tamarind Lithography Workshop, Inc., #343, printed by John Muench

Collections: Art Institute of Chicago; Los Angeles County Museum of Art; Museum of Modern Art; UCLA at the Armand Hammer Museum of Art and Cultural Center, Grunwald Center for the Graphic Arts; University Art Museum, University of New Mexico
Publications: *Catalogue Raisonné, Tamarind 1960-1970*, ill. p. 129; Spence, cat. p. 154.
Comments: Frisky animal in profile left, with short tail upraised. Printed July 18, 1961. This plate was used for Tamarind #339, run #2, but differs from 339 in color and in image, for the wash tones accenting the linear drawing have been eliminated. Signed, ed. info, and dated in graphite; Tamarind and printer blind stamps.

239. *Convocation of Strangers*
Sugar-lift ground aquatint etching, *chine collé*, printed A) black only, B) black etching over color collage
Image: 15 1/2 x 20" (394 x 508 mm)
Edition: 30
States: 2
Plate: Copper
Collections: United States Information Agency
Publications: *Hedendaagse Grafiek*, cat. #15; Spence, cat. p. 155; *USIA Graphic Arts Program, List #2* cat. p. 5, *List #3* cat. p. 5.

240. *Figure*
Alternate titles: *Man; Prophet*
Lithograph
Image: 23 9/16 x 16 5/16" (599 x 430 mm) irregular
Sheet: 30 1/4 x 22 5/16" (768 x 567 mm) irregular
Edition: Ed 20, 9 TI, PrP, 2 AP, 2 TP
Paper: BFK Rives, white Nacre, or white Arches
Plate: Stone
Printer/Publisher: Tamarind Lithography Workshop, Inc., #364, printed by Bohuslav Horak
Collections: Achenbach Foundation for Graphic Arts, Fine Arts Museums of San Francisco [as *Man*]; Art Institute of Chicago; Library of Congress; Los Angeles County Museum of Art; Museum of Modern Art; San Diego Museum of Art; UCLA at the Armand Hammer Museum of Art and Cultural Center, Grunwald Center for the Graphic Arts; University Art Museum, University of New Mexico
Publications: *V Mednarodna Grafična Razstava* (Ljubljana 1963), cat. #806;

Edition: 30
Paper: China/India laid onto J. Whatman watercolor
Plate: Copper
Publications: Spence, cat. p. 151; Zigrosser-AFA, cat. #152.
Comments: Similar in composition and treatment to *Goliath*, but head tilted back and facing slightly to left. Signed, ed. info, titled, and dated in graphite.

225. *Job*
Wood engraving
Image: 23 5/8 x 13 5/8" (600 x 346 mm)
Sheet: 27 1/2 x 19 1/2" (698 x 495 mm)
Edition: 30
Paper: China/India
Collections: Library of Congress; Philadelphia Museum of Art
Publications: *Catalog of the 17th National Exhibition of Prints*, Library of Congress, cat. p. 5; Library of Congress 1970, cat. #18; *Misch Kohn: 25 Years* (Haslem 1974), ill. #21; Spence, cat. p. 150; Tahir, Abe, *All-American Wood Engravers*, ill. #53; Zigrosser-AFA, cat. #146; Zigrosser, *Misch Kohn Prints*, Weyhe Gallery 1959, cat. #8.
Comments: Full-length standing figure with hands circling above head; elaborate background engraved with various textures. Signed, ed. info, titled, and dated in graphite.

226. *Phoenix*
Sugar-lift ground aquatint etching
Image: 9 7/8 x 7 7/8" (251 x 200 mm)
Edition: 25
Plate: Copper
Collections: Coopers and Lybrand, Washington, DC
Publications: *Misch Kohn: 25 Years* (Haslem 1974), cat. #24.

227. *Prometheus*
Sugar-lift ground aquatint etching, *chine collé*
Image: 18 x 33 1/4" (459 x 844 mm) irregular
Sheet: 26 5/8 x 37" (676 x 940 mm)
Edition: 30
Paper: China/India laid onto J. Whatman watercolor
Plate: Zinc
Collections: Library of Congress; Philadelphia Museum of Art
Publications: *December* (Winter 1963), ill. p. 176; Library of Congress 1970, cat. #25; *Misch Kohn*, University of Louisville, ill. #1; *Misch Kohn: 25 Years*

(Haslem 1974), cat. #22; Spence, cat. p. 151; Zigrosser-AFA, ill. #35, cat. #149; Zigrosser, *Misch Kohn, Galerie 61*, cat; Zigrosser, *Misch Kohn Prints*, Weyhe Gallery 1959, cat. #24.
Comments: Recumbant male nude defined by flowing lines, head to left, with one knee upraised. Signed, ed. info, titled, and dated in graphite.

1960

228. *Adam Kadmon*
Sugar-lift ground aquatint etching, *chine collé*
Image: 29 3/4 x 19 3/4" (755 x 502 mm)
Sheet: 36 x 25 3/4" (914 x 654 mm)
Edition: 30
Paper: China/India laid onto J. Whatman watercolor
Plate: Copper
Collections: Art Institute of Chicago; Philadelphia Museum of Art (2)
Publications: *IV Mednarodna Grafična Razstava* (Ljubljana 1961), cat. #791; "Prints," *December* (Summer 1961), ill. p. 36; Spence, cat. p. 152; Zigrosser-AFA, cat. #160.
Comments: An experimental, textural depiction of the primordial man. Facial and bodily features are indeterminate. Signed, ed. info, titled, and dated in graphite.

229. *Baron von Z.*
Sugar-lift ground aquatint etching, *chine collé*, printed A) black only, B) black etching over color collage
Image: 32 3/4 x 13 7/8" (834 x 353 mm) irregular
Sheet: 38 x 26 3/8" (965 x 670 mm)
Edition: 50 [30]
States: 2
Paper: China/India laid onto J. Whatman watercolor, 1952
Plate: Copper
Collections: Cleveland Museum of Art; Kalamazoo Institute of Arts; Library of Congress; Museum Boijmans Van Beuningen, Rotterdam; Philadelphia Museum of Art (2); United States Information Agency
Publications: *30 Contemporary American Prints*, IBM Gallery, ill. p. 3, pp. 2, 4; *International Prints, 1962*, Cincinnati, ill; Library of Congress 1970, cat. #2; "Misch Kohn Graphic Show opens at Jewish Center," Milwaukee, ill; *Misch Kohn: 25 Years* (Haslem 1974), cat. #25;

Preston, Stuart, "Art: USIA Prepares a Print Show," *New York Times* 2/22/64 ill; "Prints," *December* (Summer 1961), front and back cover ill; Schmeckebier, Lawrence, *American Printmakers 1962*, cat. p. 63; Spence, cat. p. 152; *USIA Graphic Arts Program, List #2* cat. p. 5, *List #3* cat. p. 5; *WFMT Fine Arts Guide*, ill. p. 13; Zigrosser-AFA, ill. #40, cat. #159; Zigrosser, *Misch Kohn, Galerie 61*, cat.
Comments: Full-length portrait of bemedaled military officer standing at attention. Signed, ed. info, titled, and dated in graphite.

230. *Battle of the Ten Men*
Sugar-lift ground aquatint etching
Image: 15 3/4 x 24" (400 x 609 mm) irregular
Edition: 30
Plate: Copper
Publications: Spence, cat. p. 152; Zigrosser-AFA, cat. #161.
Comments: Frieze of male nudes in motion; image inspired by Pollaiuolo's *Battle of the Naked Men*.

231. *Man*
Sugar-lift ground aquatint etching
Image: 19 1/2 x 19 3/4" (495 x 502 mm)
Edition: 30
Plate: Copper
Publications: Spence, cat. p. 152.
Comments: Spence: "Head only, a tour de force exercise in Tchelitchew-like concentric circles."

232. *Man*
Alternate title: *Six New Poems and a Parable*
Sugar-lift ground aquatint etching, *chine collé*
Image: 29 3/4 x 19 7/8" (756 x 505 mm) irregular
Sheet: 35 1/8 x 25" (892 x 635 mm)
Edition: 30
Paper: China/India laid onto J. Whatman watercolor, 1952
Plate: Copper
Collections: Philadelphia Museum of Art
Publications: *50 Indiana Prints: Sixth Biennial*, cat. #32; Paul, Arthur, *Beyond Illustration*, ill; Zigrosser-AFA, ill. #39, cat. #158.
Comments: Similar in treatment to 1959 *Job* and *Goliath* etchings, but more gestural, fluid lines. Variously dated 1961. This print was used at one point as an illustration for *Six New Poems and a Parable* by Carl Sandberg, but this was

by Artists of Chicago and Vicinity, Art Institute of Chicago, cat. #60; *Catalogue of the 156th Annual Exhibition*, Philadelphia, cat. #210; Library of Congress 1970, cat. #1; *Misch Kohn*, University of Louisville, cat. #14; *Misch Kohn: 25 Years* (Haslem 1974), cat. #16; "Prints," *December* (Summer 1961), ill. p. 33; Spence, cat. p. 151; Zigrosser-AFA, cat. #154.

Comments: Enigmatic figure defined without linear emphasis, moving quickly to right with hair flying behind. Signed, ed. info, titled, and dated in graphite.

218. *Basketball*
Alternate title: *Basket Ball*
Sugar-lift ground aquatint etching, *chine collé*, printed A) black only, B) black etching over color collage
Image: 17 x 12" (432 x 305 mm) irregular
Edition: 30
Plate: Copper (2)
Publications: *Misch Kohn*, University of Louisville, cat. #33; "Misch Kohn Exhibition to Open at Wabash," *Indianapolis Star* 3/12/61, ill; Spence, cat. p. 151; Zigrosser-AFA, ill. #37, cat. #156.

Comments: Literal depiction of basketball players; center figure holds ball high over his head. This print was commissioned by Andrew Ross of the National Broadcasting Company for a promotional campaign on sports. The other three artists who were part of this project were Baskin, Landau, and Frasconi. Kohn was specifically asked to represent basketball. Two plates were used for this etching.

219. *Colossus*
Sugar-lift ground aquatint etching, *chine collé*
Image: 31 3/4 x 20" (806 x 508 mm) irregular
Sheet: 37 1/2 x 26" (952 x 660 mm)
Edition: 30
Paper: China/India laid onto J. Whatman watercolor
Plate: Copper
Collections: University of Michigan Museum of Art; Philadelphia Museum of Art; private collection
Publications: *IV Mednarodna Grafična Razstava* (Ljubljana 1961), ill. #XXII, cat. #789; *American Prints 1950-60*, Yale University Art Gallery, cat. #26; *Misch Kohn*, University of Louisville, cat. #7; *Misch Kohn: 25 Years* (Haslem 1974), cat. #6 [dated 1952]; Spence, ill. #45, cat.

p. 151; *WFMT Fine Arts Guide*, ill. p. 43; *Zeventiende Salon de Mai*, Amsterdam, cat. #175; Zigrosser-AFA, ill. #34, cat. #151; Zigrosser, *Misch Kohn*, Galerie 61, cat; Zigrosser, *Misch Kohn Prints*, Weyhe Gallery 1959, ill. p. 4, cat. #23.

Comments: Three-quarter length view of square-headed figure silhouetted against white background. Facial and bodily features indeterminate. Signed, ed. info, titled, and dated in graphite.

220. [Exhibition Announcement]
Sugar-lift ground aquatint etching
Image: 4 1/2 x 5" (114 x 127 mm)
Edition: 300
Collections: Private collections
Publications: Zigrosser-AFA, p. 27.
Comments: Created as exhibition announcement for Kohn's solo show at the Little Gallery, Chicago, March 4-31.

221. *Goliath*
Alternate title: *Giant*
Sugar-lift ground aquatint etching, *chine collé*, printed A) black only, B) black etching over color collage
Image: 24 x 19 7/8" (609 x 454 mm) irregular
Sheet: 36 x 25 5/8" (914 x 651 mm)
Edition: 30
States: 2
Paper: China/India laid onto J. Whatman watercolor
Plate: Zinc
Collections: Mednarodni Grafični Likovni Center, Ljubljana (formerly Moderna Galerija Collection)
Publications: Spence, cat. p. 151 [as *Giant*]; second citation p. 151 [as *Goliath*]; Zigrosser-AFA, cat. #147 [as *Giant*], cat. #148 [as *Goliath*].
Comments: Squat, stocky nude male, with calligraphic swirls defining his anatomy. Signed, ed. info, titled (variously), and dated in graphite.

222. *Horse I*
Alternate title: *Horse No. 1*
Sugar-lift ground aquatint etching, *chine collé*
Image: 19 5/8 x 23 3/4" (498 x 603 mm) irregular
Sheet: 25 3/8 x 31 7/8" (644 x 809 mm)
Edition: 30
Paper: China/India laid onto J. Whatman watercolor or BFK Rives
Plate: Copper
Collections: Boston Public Library; Cincinnati Art Museum; Davison Art

Center, Wesleyan University; Library of Congress; Philadelphia Museum of Art; private collections
Publications: *IV Mednarodna Grafična Razstava* (Ljubljana 1961), cat. #790; "40 Misch Kohn Prints on Display in Museum," Evansville, IN, 5/21/61, ill; *1960 International Biennial of Prints*, Cincinnati Art Museum, cover ill; *Catalogue of the 156th Annual Exhibition*, Philadelphia, cat. #211; Library of Congress 1970, cat. #13; *Misch Kohn: 25 Years* (Haslem 1974), cat. #20; Spence, ill. #37, cat. p. 151; von Groschwitz, Gustave, "American Prints: A New Phase," *Cincinnati Museum Bulletin* (January 1962), ill. p. 27; *WFMT Fine Arts Guide*, ill. p. 57; Zigrosser-AFA, ill. #33, cat. #150; Zigrosser, *Misch Kohn Prints*, Weyhe Gallery 1959, ill. p. 5, cat. #21.
Comments: High-stepping horse in profile left, body defined by sugar-syrup blobs and drips. Signed, ed. info, titled and dated in graphite.

223. *Horse as a Constellation*
Sugar-lift ground aquatint etching, *chine collé*
Image: 17 3/4 x 29 1/2" (451 x 750 mm) irregular
Plate: 18 x 30" (457 x 762 mm)
Sheet: 29 1/2 x 41 1/2" (750 x 1054 mm)
Edition: 30
Paper: China/India laid onto BFK Rives
Plate: Copper
Collections: Boston Public Library; Library of Congress; private collections
Publications: Grafly, Dorothy, "Artists from 19 States Show Work in Print Fair," *Sunday Bulletin* (Philadelphia) 1/17/60, ill. p. 8; Library of Congress 1970, cat. #14; *Misch Kohn: 25 Years* (Haslem 1974), cat. #23; Spence, cat. p. 151; *WFMT Fine Arts Guide*, ill. p. 46; Zigrosser, *Appeal of Prints*, ill. p. 135; Zigrosser-AFA, ill. #32, cat. #149; Zigrosser, *Misch Kohn Prints*, Weyhe Gallery 1959, cover ill, cat. #22.
Comments: High-stepping horse with wispy tail in profile right, body defined by sugar-syrup blobs and drips. Signed, ed. info, titled, and dated in graphite.

224. *Job*
Sugar-lift ground aquatint etching, *chine collé*
Image: 23 3/4 x 19 7/8" (603 x 505 mm) irregular
Sheet: 37 x 26 1/2" (940 x 673 mm)

Publications: Ford, Ken, "Misch Kohn Still Making Waves as Graphic Artist," *Kokomo Tribune,* 10/11/87, ill. p. 37; Library of Congress 1970, cat. #23; *Misch Kohn,* University of Louisville, cat. #12; *Misch Kohn: 25 Years* (Haslem 1974), cat. #17; Spence, ill. #41, cat. p. 151; Stubbe, Wolf, *Die Grafik des 20ten Jahrhunderts,* ill. p. 140; *WFMT Fine Arts Guide,* ill. p. 38; Zigrosser-AFA, ill. #36, cat. #155; Zigrosser, *Misch Kohn Prints,* Weyhe Gallery 1959, cat. #25.

Comments: Male bust defined by calligraphic swirls; mouth open and 3/4 profile right. Variously dated 1959. Signed, ed. info, titled, and dated in graphite.

211. *Rooster*
Alternate title: *The Rooster*
Sugar-lift ground aquatint etching, *chine collé*
Image: 14 3/16 x 19 7/8" (360 x 505 mm)
Sheet: 21 5/8 x 30" (549 x 762 mm)
Edition: 30
Paper: China/India laid onto J. Whatman watercolor
Plate: Zinc
Publications: Spence, cat. p. 150; Zigrosser-AFA, cat. #145.
Comments: Single central image of crowing bird moving to right against plain black background. Variously dated 1961. Signed, ed. info, titled, and dated in graphite.

212. *Sigmund*
Spit-bitten aquatint etching, line etching, *chine collé*
Image: 16 x 12 3/8" (406 x 314 mm)
Sheet: 23 1/4 x 17 3/4" (594 x 450 mm)
Edition: 30 [25]
Paper: China/India laid onto Japanese Hosho
Plate: Copper
Collections: Art Institute of Chicago; Library of Congress
Publications: *Catalogue of the 156th Annual Exhibition,* Philadelphia, cat. #214; Library of Congress 1970, cat. #29; Spence, cat. p. 150; Zigrosser-AFA, cat. #142; Zigrosser, *Misch Kohn Prints,* Weyhe Gallery 1959, cat. #19.
Comments: Somber 3/4 view portrait of Sigmund Freud. Variously dated 1959. Signed, ed. info, titled, and dated in graphite.

213. *Stefan*
Alternate titles: *Portrait of Stephan; Stephan*
Sugar-lift ground aquatint etching, *chine collé*
Image: 17 7/8 x 15 1/4" (454 x 387 mm) irregular
Sheet: 24 3/8 x 20" (619 x 508 mm)
Edition: 15 [30]
Paper: China/India laid onto Japanese Hosho
Plate: Zinc
Collections: Boston Public Library; Library of Congress
Publications: Library of Congress 1970, cat. #30; Spence, cat. p. 150; Zigrosser-AFA, ill. #31, cat. #143; Zigrosser, *Misch Kohn Prints,* Weyhe Gallery 1959, cat. #15.
Comments: Elegant portrait of Kohns' friend Stefan Varro. Signed, ed. info, titled, and dated in graphite.

214. *Three Kings*
Wood engraving
Image: 10 7/8 x 6 13/16" (276 x 173 mm)
Sheet: 14 x 10 9/16" (355 x 268 mm)
Edition: 10
Paper: China/India
Publications: Spence, cat. p. 150; Zigrosser-AFA, cat. #140.
Comments: Another treatment of the three kings theme, with figures striding left in elaborate costume and hats, against a full moon and textured sky.

215. *Uncle V.*
Line and aquatint etching, *chine collé*
Image: 18 1/4 x 12 1/2" (464 x 318 mm) irregular
Sheet: 24 1/4 x 16 3/8" (616 x 416 mm)
Edition: 30 [20]
Paper: China/India laid onto Apta
Plate: Copper
Collections: Fogg Art Museum, Harvard University; private collection
Publications: Spence, cat. p. 150; Zigrosser-AFA, cat. #138.
Comments: A sympathetic portrait of the Kohns' friend Stefan Varro. Although the image was done in line etching, the width of the lines necessitated aquatinting. Variously dated 1959. Signed, ed. info, titled, and dated in graphite.

1958, 1961

216. *Little Herald*
Alternate titles: *Christmas Herald; Horseman; The Little Herald; The Herald*
Sugar-lift ground aquatint etching, *chine collé,* printed A) black only, B) black etching over color collage
Image: 12 x 7 1/2" (305 x 191 mm) irregular
Sheet: 17 3/8 x 13" (442 x 330 mm)
Edition: 30 [50]
States: 2
Paper: China/India laid onto Apta or Farnsworth
Plate: Copper
Printer/Publisher: United Nations International Children's Emergency Fund (UNICEF), following printing of 50 artist's impressions
Collections: Peppers Art Gallery, University of Redlands; Philadelphia Museum of Art; private collections
Publications: Anderson, David, "Chicago Artist Loves that DAR," *Chicago Sun Times,* 12/11/61 ill. p. 3; Ford, Ken, "Misch Kohn still making waves as graphic artist," *Kokomo Tribune* 10/11/87, ill. p. 37; Spence, cat. p. 150; Zigrosser-AFA, cat. #137; Zigrosser, *Misch Kohn Prints,* Weyhe Gallery 1959, cat. #20 [as *Christmas Herald*].
Comments: Calligraphic swirls define a trumpeting rider on horseback. This print was originally pulled in 1958; in 1961 it was produced commercially by UNICEF for their 1961 holiday card series, and that same year Kohn printed 20 additional artist's impressions. Signed, ed. info, titled, and dated in graphite.

1959

217. *Absalom*
Alternate title: *Absolom*
Sugar-lift ground aquatint etching, *chine collé*
Image: 27 7/8 x 21 7/8" (709 x 557 mm) irregular
Sheet: 36 x 26 5/8" (914 x 676 mm)
Edition: 30
Paper: China/India laid onto J. Whatman watercolor, 1952
Plate: Copper
Collections: Library of Congress; Museum of Modern Art; Philadelphia Museum of Art; Stanford University Museum of Art
Publications: *VII Bienal de São Paulo,* cat. #10, p. 224; *66th Annual Exhibition*

204. *Wild Onion*
Etching
Image: 18 x 6" (457 x 152 mm)
Edition: 30
Plate: Copper
Publications: Spence, cat. p. 149; Zigrosser-
AFA, cat. #129.

1957, 1958

205. *General*
Alternate title: *The General*
Sugar-lift ground aquatint etching,
 chine collé, printed A) black only,
 B) black etching over color collage,
 C) black etching over alternate color
 collage
Image: 17 5/8 x 9 1/8" (448 x 232 mm)
 irregular
Plate: 17 1/8 x 9" (435 x 229 mm)
Sheet: 30 13/16 x 22 1/4" (783 x 565 mm)
 irregular
Edition: A) black 30 [25], B) 1st state
 color 15, C) 2nd state color 50
States: 3
Paper: China/India and Japan laid
 onto single-ply or Farnsworth, Misch
 watermark
Plate: Copper
Collections: Bibliothèque Nationale de
 France, Departement des Estampes et de
 la Photographie; Coos Art Museum;
 Dallas Public Library; Library of
 Congress; Mednarodni Grafični Likovni
 Center, Ljubljana (formerly Moderna
 Galerija Collection); Museum of Modern
 Art; United States Information Agency;
 private collections
Publications: "1994 Distinguished Artist
 Misch Kohn," *California Printmaker* (June
 1994), ill. p. 13 [incorrectly identified as
 My Grandfather's Mustache]; Eichenberg,
 Fritz, *Artist's Proof* (1961), ill. p. 32;
 Elkoff, Marvin, "Collecting Original Art
 Prints," *Holiday* (February 1966), color
 ill. p. 104; Ford, Ken, "Misch Kohn Still
 Making Waves as Graphic Artist,"
 Kokomo Tribune, 10/11/87, ill. p. 37;
 Grafica Contemporanea Americana, Venice,
 cat. #1; Hoover, James W., *Misch Kohn:
 Hometown Collection*, cat; Karshan,
 Donald, "American Printmaking," *Art in
 America* (July-August 1968), ill. p. 37;
 Key, Donald, "Misch Kohn's Graphics
 Shown..." *Milwaukee Journal*, 3/4/62, ill;
 Library of Congress 1970, cat. #8; *Misch
 Kohn*, University of Louisville, cat. #35;
 Misch Kohn: 25 Years (Haslem 1974),
 ill. #18; *Prints by Misch Kohn* (Honolulu

1975), cat. #17; "Quickie Exhibit," *Dallas
 Morning News* 1/11/64, ill. Section I,
 p. 13; Spence, ill. #42, cat. p. 149; "Top
 Designers at Home," *American Home*
 (September 1970), ill; *WFMT Fine Arts
 Guide*, ill. p. 45; Zigrosser-AFA, color
 ill. #29, cat. #135; Zigrosser, *Misch Kohn*,
 Galerie 61, cat; Zigrosser, *Misch Kohn
 Prints*, Weyhe Gallery, 1959, cat. #18.
Comments: Befuddled and bespectacled,
 mustachioed military officer. This etch-
 ing was first made in 1957 in black only;
 a first state of colored *chine collé* was
 printed in 1958 [edition of 15]; later that
 year and continuing in 1959 a second,
 different state of colored *chine collé* was
 pulled [edition of 50; variously cited as
 25 and 30]. This second state in color is
 occasionally titled *The General II State* in
 graphite on the prints. Signed, ed. info,
 titled, and dated in graphite.

1958

206. *A Garden*
Sugar-lift ground aquatint etching
Image: 15 7/8 x 19 5/8" (403 x 498 mm)
Edition: 30
Plate: Copper
Publications: Spence, cat. p. 150; Zigrosser-
 AFA, cat. #136.
Comments: 3-4 plates used for this multi-
 color etching.

207. *Baroque Figure*
Wood engraving
Image: 27 1/2 x 8 3/4" (698 x 222 mm)
Sheet: 31 1/4 x 13 7/8" (794 x 237 mm)
Edition: 30
Paper: China/India
Publications: "Art of Misch Kohn," exhib.
 ann. ill, Saint Mary's College, Notre
 Dame, IN, 1959; LaLiberte, Norman and
 Alex Mongelon, *Twentieth Century
 Woodcuts*, ill. p. 68 [detail]; Spence, cat.
 p. 150; Zigrosser-AFA, cat. #141.
Comments: Full-length portrait of a female
 in a large, plumed hat, elaborate long
 dress, and high heels. Signed, ed. info,
 titled, and dated in graphite.

208. *Little Lion*
Alternate titles: *Gold Lion; Little Gold Lion;
 The Gold Lion*
Sugar-lift ground aquatint etching,
 chine collé, printed A) black only,
 B) black etching over color collage,
 including gold leaf
Image: 13 7/8 x 17" (356 x 432 mm)
 irregular

Sheet: 21 1/2 x 27" (546 x 686 mm)
Edition: 30
States: 2
Paper: China/India and gold leaf laid onto
 single-ply wove or Farnsworth, Misch
 watermark
Plate: Copper
Collections: Library of Congress; Monterey
 Museum of Art; Philadelphia Museum
 of Art; Princeton University Libraries;
 private collections
Publications: Hoover, James W., *Misch
 Kohn: Hometown Collection*, cat; Library
 of Congress 1970, cat. #19; *Misch Kohn:
 25 Years* (Haslem 1974), cat. #14 [as *Gold
 Lion*]; Patterson, Connie. "Kokomo was
 Important to Misch Kohn's
 Development," *Kokomo Tribune* 3/29/87,
 ill, p. C11; Spence, cat. p. 150; Zigrosser-
 AFA, ill. #30, cat. #139; Zigrosser, *Misch
 Kohn Prints*, Weyhe Gallery 1959,
 cat. #14.
Comments: Stocky lion with tail upraised,
 large claws, profile left with head turned
 frontally; most impressions printed over
 gold leaf paper. Signed, ed. info, titled,
 and dated in graphite.

209. *Margaret*
Alternate title: *Peter*
Line etching with aquatint, *chine collé*
Image: 14 1/4 x 9 5/8" (360 x 244 mm)
 irregular
Sheet: 21 13/16 x 15 3/4" (554 x 400 mm)
Edition: 30 [15]
Paper: China/India laid onto J. Whatman
 watercolor
Plate: Zinc
Collections: Library of Congress
Publications: Library of Congress 1970,
 cat. #21; Spence, cat. p. 150; Zigrosser-
 AFA, cat. #144; Zigrosser, *Misch Kohn
 Prints*, Weyhe Gallery 1959, cat. #17.
Comments: Line etching of artist's sister-
 in-law. Variously dated 1959. Signed, ed.
 info, titled, and dated in graphite.

210. *Oedipus*
Sugar-lift ground aquatint etching,
 chine collé
Image: 20 x 15 7/8" (508 x 405 mm)
 irregular
Sheet: 29 1/2 x 21 9/16" (750 x 548 mm)
Edition: 30
Paper: China/India laid onto French Apta
Plate: Zinc
Collections: Bibliothèque Nationale de
 France, Departement des Estampes et de
 la Photographie; Library of Congress

198. *My Grandfather's Mustache*
Alternate title: *Grandfather's Mustache*
Sugar-lift ground aquatint etching, *chine collé*, printed A) black only, B) black etching over color collage
Image: 17 x 9" (431 x 228 mm)
Sheet: 27 1/8 x 18 1/2" (689 x 470 mm)
Edition: A) black 10, B) color 30
States: 2
Paper: China/India laid onto BFK Rives
Plate: Copper
Collections: Library of Congress
Publications: Library of Congress 1970, cat. #10; *Misch Kohn: 25 Years* (Haslem 1974), ill. #15; Polley, Trude and Zoran Krzisnik, *Hommage à Josefin*, color ill. [detail]; Schmeckebier, Lawrence, *American Printmakers 1962*, cat. p. 63; Spence, ill. #36, cat. p. 149; *WFMT Fine Arts Guide*, ill. p. 48; Zigrosser-AFA, ill. #28, cat. #133; Zigrosser, *Misch Kohn*, Galerie 61, cat; Zigrosser, *Misch Kohn Prints*, Weyhe Gallery 1959, cat. #16.
Comments: Bust of mustachioed imaginary ancestor, defined by calligraphic swirls. Black-and-white state has China/India paper as background only; most impressions over colored collage elements. Variously dated 1958. Signed, ed. info, titled, and dated in graphite.

199. *My Other Ancestor*
Alternate title: *Imaginary Other Ancestor*
Sugar-lift ground and regular aquatint etching, drypoint, *chine collé*, printed A) intaglio, B) relief
Image: 19 5/8 x 15 3/4" (500 x 400 mm) irregular
Sheet: 26 3/8 x 21" (670 x 533 mm)
Edition: 30 [25] [15]
States: 2
Paper: China/India laid onto BFK Rives or Apta
Plate: Copper
Collections: Art Institute of Chicago; Library of Congress
Publications: *Catalogue of the 156th Annual Exhibition*, Philadelphia, cat. #213; Library of Congress 1970, ill. #17, p. 244; *Misch Kohn*, University of Louisville, cat. #13; "Prints," *December* (Summer 1961), ill. p. 34; Spence, cat. p. 149; Zigrosser-AFA, cat. #126; Zigrosser, *Misch Kohn*, Galerie 61, cat; Zigrosser, *Misch Kohn Prints*, Weyhe Gallery 1959, cat. #11.
Comments: Isolated bust with concentric swirls, lines, and dots marking the facial features of this imaginary ancestor. Few, if any, relief prints extant. Signed, ed. info, titled, and dated in graphite.

200. *The City*
Lithograph
Image: 20 1/4 x 37" (514 x 940 mm) irregular
Sheet: 23 7/8 x 38 7/8" (606 x 987 mm)
Edition: 10
Paper: China/India
Plate: Stone (2)
Publications: Spence, cat. p. 148; Zigrosser-AFA, ill. #23, cat. #124.
Comments: Abstracted figures against elaborate sylized cityscape. Printed from two stones, side by side. Signed, ed. info, titled, and dated in graphite.

201. *The City*
Alternate title: *City*
Wood engraving
Image: 13 7/8 x 30 7/8" (352 x 785 mm)
Sheet: 19 5/8 x 34 5/8" (498 x 879 mm)
Edition: 21 [30]
Paper: China/India
Collections: Elvehjem Museum of Art, University of Wisconsin; Library of Congress; Philadelphia Museum of Art; private collections
Publications: *50 Indiana Prints: Fourth Biennial*, ill. #26; Library of Congress 1970, cat. #4; *Misch Kohn*, University of Louisville, cat. #5; *Misch Kohn: 25 Years* (Haslem 1974), cat. #12; Spence, ill. #33; cat. p. 149; Zigrosser-AFA, ill. #27, cat. #132; Zigrosser, *Misch Kohn*, Galerie 61, cat; Zigrosser, *Misch Kohn Prints*, Weyhe Gallery 1959, cat. #7.
Comments: Similar in composition to the 1957 lithographic version, but with more intricate patterning and reversed image. Signed, ed. info, titled, and dated in graphite.

202. *Three Kings*
Alternate title: *Trio*
Sugar-lift ground and regular aquatint etching, printed A) intaglio, B) relief
Image: 27 3/8 x 21 3/4" (695 x 552 mm)
Sheet: 33 1/8 x 27" (842 x 685 mm)
Edition: 30 [15]
Paper: China/India laid onto BFK Rives or J. Whatman watercolor
Plate: Copper
Collections: Albion College; Bibliothèque Nationale de France, Departement des Estampes et de la Photographie; Detroit Institute of Arts; Library of Congress; Los Angeles County Museum of Art; Philadelphia Museum of Art; University Art Museum, University of New Mexico; Walker Art Center; private collections

Publications: *50 Indiana Prints: Fourth Biennial*, cat. #25; *American Prints Today/1959*, ill. cat. #29; Anderson, Donald M., *Design*, ill; *Artists of Chicago and Vicinity, 61st Annual Exhibition*, Art Institute of Chicago, cat; *Catalogue of the 16th National Exhibition of Prints*, Library of Congress, cat. p. 4; Friedlander, Alberta, "Fascinating Print Exhibit," *Chicago Daily News* 1/28/61, ill; *La Gravure Americaine d'Aujourd'hui*, Paris, cat. #28 p. 40; *La Gravure Americaine d'Aujourd'hui*, Strasbourg, 1960, exhib. ann. cover ill; Library of Congress 1970, cat. #34; Metz, Kathryn, *Misch Kohn: Three Decades*, cat. #4; *Misch Kohn*, University of Louisville, cat. #2; *Misch Kohn: 25 Years* (Haslem 1974), ill. #11; *Prints by Misch Kohn* (Honolulu 1975), cat. #20; *Pursuit and Measure of Excellence*, Weatherspoon Art Gallery, cat; Spence, ill. #39, cat. pp. 148-9; Stubbe, Wolf, *Die Grafik des 20ten Jahrhunderts*, ill. p. 278; *WFMT Fine Arts Guide*, ill. p. 14; Zigrosser-AFA, ill. #26, cat. #128; Zigrosser, *Misch Kohn*, Galerie 61, ill; Zigrosser, *Misch Kohn Prints*, Weyhe Gallery 1959, ill. p. 3, cat. #13
Comments: From the imaginary ancestors series, powerless, encrusted memories of a lost grandeur. Most extant prints are printed in relief (black background), as Kohn had designed this piece for surface printing. Signed, ed. info, titled, and dated in graphite.

203. *Three Kings*
Alternate title: *Three Kings on Horseback*
Wood engraving
Image: 13 3/8 x 4 5/8" (340 x 118 mm)
Sheet: 14 3/4 x 12" (375 x 304 mm)
Edition: 60
Paper: China/India mounted on double-ply wove card stock
Collections: Boston Public Library; Library of Congress; Metropolitan Museum of Art; New York Public Library; Philadelphia Museum of Art; private collections
Publications: Library of Congress 1970, cat. #33; Spence, cat. p. 149; Zigrosser-AFA, cat. #131.
Comments: Three kings on horseback, foreground; bold, black lines of rich background sky layered against intricate engraving. Sent out as holiday greeting card. Signed, ed. info, titled, and dated in graphite.

1957

191. *Costumed Figure*
Line etching, *chine collé*
Image: 19 3/8 x 8" (492 x 203 mm)
Sheet: 27 3/8 x 17 1/16" (695 x 433 mm)
Edition: 15
Paper: China/India laid onto heavyweight
wove, watermark 658
Plate: Zinc
Collections: Milwaukee Art Museum
Publications: Spence, cat. p. 148; Zigrosser-
AFA, cat. #122.
Comments: Full-length frontal portrait of
elaborately costumed historical figure in
continuous line etching. Signed, ed. info,
titled, and dated in graphite.

192. *Florentine Figure*
Sugar-lift ground aquatint etching,
chine collé
Image: 16 x 9 15/16" (406 x 252 mm)
Sheet: 26 7/16 x 15 5/8" (671 x 397 mm)
Edition: 30
Paper: China/India laid onto Apta
Plate: Zinc
Publications: Spence, cat. p. 148; Zigrosser-
AFA, cat. #119; Zigrosser, *Misch Kohn
Prints,* Weyhe Gallery 1959, cat. #9.
Comments: One of the first sugar-lift
ground aquatint etchings. An isolated
full-length costumed figure defined by
calligraphic swirls against plain white
background. Variously dated 1956
(incorrectly), and 1963. Signed, ed. info,
titled, and dated in graphite.

193. *Fragment*
Lithograph
Image: 20 3/8 x 11 3/4" (517 x 298 mm)
irregular
Sheet: 28 x 15 1/4" (711 x 387 mm)
Edition: 10
Paper: China/India
Plate: Stone
Comments: Fragment of 1957 lithograph
The City. Signed, titled, and dated in
graphite.

194. *Horseman*
Alternate title: *Horseman (Herald)*
Sugar-lift ground aquatint etching,
chine collé
Image: 19 15/16 x 15 13/16" (505 x 402 mm)
irregular
Sheet: 25 7/8 x 19 13/16" (658 x 503 mm)
Edition: 30 [25]
Paper: China/India laid onto single-ply
wove
Plate: Zinc

Collections: Art Institute of Chicago;
Boston Public Library; Library of
Congress; New York Public Library
Publications: *Catalogue of the 156th Annual
Exhibition,* Philadelphia, cat. #212;
Library of Congress 1970, cat. #15;
"Misch Kohn Graphic Show Opens at
Jewish Center," ill; "Misch Kohn
Paintings-Graphics," Jewish Community
Center, exhib. ann. ill. March 1962;
Spence, ill. #35, cat. p. 148; *WFMT Fine
Arts Guide,* ill. p. 67; Zigrosser-AFA,
ill. #25, cat. #126; Zigrosser, *Misch Kohn
Prints,* Weyhe Gallery 1959, cat. #10
Comments: Gaily-drawn rider with
plumed hat astride a prancing horse,
profile left, defined by calligraphic
swirling lines. Variously dated 1959.
Signed, ed. info, titled, and dated in
graphite.

195. *Imaginary Ancestor*
Sugar-lift ground aquatint etching,
chine collé, printed A) black only,
B) black etching over color collage
Image: 20 x 13 3/4" (508 x 351 mm)
irregular
Sheet: 30 7/8 x 22 7/16" (785 x 570 mm)
Edition: 30 [50]
States: 2
Paper: China/India laid onto Japanese
Hosho or Apta
Plate: Copper
Collections: Bibliothèque Nationale de
France, Departement des Estampes et de
la Photographie; Library of Congress;
Monterey Museum of Art; private
collections
Publications: Hoover, James W., *Misch
Kohn: Hometown Collection,* cat. [dated
1961]; Library of Congress 1970, cat. #16;
Misch Kohn: 25 Years (Haslem 1974),
ill. #19; Spence, cat. p. 149 [black state,
1958], p. 152 [color *chine collé* state,
1961]; *Toledo Collectors of Modern Art,* cat;
Zigrosser-AFA, cat. #134.
Comments: Frontal bust of mustachioed
male wearing an elaborate plumed hat.
Variously dated 1958, 1959. Colored col-
lage pieces added in 1961; most prints in
collections this second state. Signed, ed.
info, titled, and dated in graphite.

196. *King*
Etching, aquatint
Image: 16 3/4 x 13 3/4" (425 x 349 mm)
Edition: 5
Plate: Copper
Publications: Spence, cat. p. 148; Zigrosser-
AFA, cat. #123.

Comments: Spence: "Quarter-length por-
trait of bearded man in Tudor garb."

197. *Lion*
Alternate title: *The Lion*
Sugar-lift ground aquatint etching,
burin engraving, *chine collé,*
printed A) intaglio, B) relief
Image: 17 3/4 x 29 5/8" (453 x 757 mm)
irregular
Sheet: 24 1/4 x 36" (643 x 895 mm)
Edition: A) intaglio 30, B) relief 15 [10] [20]
States: 2
Paper: China/India laid onto J. Whatman
watercolor, 1952
Plate: Copper
Collections: Ackland Art Center; Art
Institute of Chicago; The Brooklyn
Museum; Coopers and Lybrand,
Washington, DC; The Free Library of
Philadelphia; Memphis Brooks Museum
of Art; Philadelphia Museum of Art (2);
Syracuse University Art Collection;
Walker Art Center, Minneapolis; private
collections
Publications: *50 Indiana Prints: Fourth
Biennial Exhibition,* cat. #27; Ahlander,
Leslie Judd, "Fine Print Exhibition at
National," *Washington Post* 9/20/59, ill.
p. E-7; *Artists of Chicago and Vicinity,
62nd Annual Exhibition,* Art Institute of
Chicago, ill. cat. #92; Canaday, John,
"American Prints," *New York Times*
9/20/59, ill. p. 17; Fried, Alexander, "A
Quintet of Choice Exhibits," *San
Francisco Examiner* 4/8/62, ill. p. 9;
Getlein, *The Bite of the Print,* ill. p. 263;
Haslem, Jane, *American Prints, Drawings,
Paintings,* ill. p. 21, cat. #56; *La Gravure
Americaine d'Aujourd'hui,* cat. #28;
Litchfield, *The Fabulous Decade,* cat. #30;
Metz, Kathryn, *Misch Kohn: Three
Decades,* ill. cat. #5; *Misch Kohn,* Art
Institute of Chicago exhib. ann. ill.
January 1961; *Misch Kohn: 25 Years*
(Haslem 1974), ill. #13; "Preview of Print
Gallery," *Chicago Sun-Times,* 11/12/59,
ill. section 2, p. 11; *American Prints
Today/1959,* ill. cat. #28; Sotriffer, ill.
p. 116, pl. 57; Spence, ill. #34, cat. p. 148;
von Groschwitz, Gustave, "American
Prints Today," Studio (October 1959), ill.
p. 67; *WFMT Fine Arts Guide,* ill. p. 21;
Zigrosser-AFA, cat. #125-a (intaglio),
#125-b (relief); Zigrosser, *Misch Kohn
Prints,* Weyhe Gallery 1959, cat. #12
Comments: Snarling lion, profile left with
upraised tail, defined by calligraphic
swirls. Most extant prints are the
intaglio state. Signed, ed. info, titled,
and dated in graphite.

184. *Farewell to Israel*
Serigraph
Image: 8 5/8 x 18 1/4" (219 x 463 mm)
 irregular
Sheet: 8 5/8 x 18 1/4" (219 x 463 mm)
Printer/Publisher: Book privately pub-
 lished in Chicago by Jesse Feldman fol-
 lowing the printing of the artist's
 impressions.
Collections: Private collection
Publications: Feldman, Jesse, *Farewell to
 Israel*, 1955, cover color ill.
Comments: Cityscape, left, merging into
 rural landscape, right. Printed in red
 and used as the dust jacket cover illus-
 tration for a book of poetry by Jesse
 Hugo Feldman entitled *Farewell to Israel
 and other poems*. Printed privately at the
 University of Chicago Press. Signed in
 screen, ll; print signed in graphite.

185. *Labyrinth*
Wood engraving
Image: 8 5/8 x 11 13/16" (219 x 301 mm)
Sheet: 14 5/8 x 17 5/8" (371 x 447 mm)
Edition: 30
Paper: China/India
Collections: Davison Art Center, Wesleyan
 University; National Museum of
 American Art, Smithsonian Institution
Publications: Farmer, Jane, *American Prints
 from Wood*, ill. p. 41, cat. #77; Spence,
 cat. p. 147; Zigrosser-AFA, cat. #117.
Comments: Abstraction of highly
 embossed white forms in rhythmic
 counterpoint to bold blacks. This block
 was also printed in 1963. Signed, ed.
 info, titled, and dated in graphite.

186. *Landscape*
Alternate title: *Landscape Forms*
Wood engraving
Image: 7 7/8 x 12 1/16" (200 x 306 mm)
Sheet: 11 3/4 x 13 3/4" (298 x 349 mm)
Edition: 30
States: 2
Paper: China/India
Comments: Abstracted landscape, with the
 second state revealing more transparent
 forms in space. Signed, ed. info, titled,
 and dated in graphite.

187. *Processional*
Alternate title: *Procession*
Wood engraving
Image: 4 1/4 x 13 1/4" (108 x 337 mm)
Sheet: 8 1/2 x 21 3/4" (216 x 552 mm)
Edition: 60 [50]
Paper: China/India

Collections: Bibliothèque Nationale de
 France, Departement des Estampes et de
 la Photographie; Boston Public Library;
 Georgetown University; Honolulu
 Academy of Arts; Lakeside Gallery;
 Library of Congress; Metropolitan
 Museum of Art; Museum of Modern Art,
 New York; New York Public Library;
 Philadelphia Museum of Art (2); private
 collections
Publications: *Ière Exposition Biennale
 Internationale de Gravure à Tokio*, cat. #22
 [as *Procession*]; *50 Contemporary American
 Printmakers*, University of Illinois, cover
 ill; Christensen, Erwin, *A Pictorial
 History of Western Art*, ill. #340, p. 419;
 Foreign Services Journal (January 1960),
 ill; Gallery Two, Rockville, MD, cat.;
 Johnson, Una, *Ten Years of American
 Prints*, cat. p. 46; Library of Congress
 1970, cat. #24; Metz, Kathryn, *Misch
 Kohn: Three Decades*, ill. cat. #3; Parsons,
 Barbara Galuszka, "I Can't Go On; I'll
 Go On," *California Printmaker* (Winter
 1993), ill. p. 8; *Prints by Misch Kohn*
 (Honolulu 1975), ill. #23; Roster, Laila,
 "Printmaking on the Rise," *Sunday Star-
 Bulletin and Advertiser* (Honolulu),
 10/19/75 ill. p. C11; Rotzler, Willy,
 "Xylon," *Graphis* (May/June 1956), ill. p.
 262; Temko, Allan, "Printmaking: Where
 Image, Process are One," *San Francisco
 Chronicle*, 11/19/81 ill. p. 72; Spence, ill.
 #31, cat. p. 147; Zigrosser-AFA, ill. #21,
 cat. #118; Zigrosser, *Misch Kohn Prints*,
 Weyhe Gallery 1959, cat. #6.
Comments: A parade of human and eques-
 trian figures moving right against a
 cityscape background of elaborate,
 domed buildings. Sent out as holiday
 greeting card. The print was engraved in
 December 1955, but most of the edition
 was printed in 1956, although some
 prints variously dated 1957. Signed, ed.
 info, titled, and dated in graphite.

1956

188. *Bird*
Alternate titles: [Bird]; [Greeting Card]
Wood engraving
Image: 4 1/16 x 6" (103 x 152 mm) irregular
Sheet: 10 1/4 x 6 3/4" (260 x 171 mm)
Edition: 60
Paper: China/India mounted on card stock
Collections: Boston Public Library; Library
 of Congress; New York Public Library;
 Philadelphia Museum of Art; private
 collections

Publications: Library of Congress 1970,
 cat. #11; Spence, cat. p. 149; Zigrosser-
 AFA, cat. #130.
Comments: Abstracted bird with swirling
 plumage, profile right. Sent out as holi-
 day greeting card in 1956 and 1966.
 Variously dated 1957, 1966. Holiday
 inscription printed in red, verso, on
 mounting paper.

189. *Florentine Figure*
Wood engraving
Image: 15 1/4 x 8 1/2" (385 x 215 mm)
Sheet: 22 1/2 x 14 1/8" (565 x 358 mm)
Edition: 30 [15]
Paper: China/India laid onto single-ply
 wove
Collections: Boston Public Library;
 Elvehjem Museum of Art, University of
 Wisconsin-Madison; Georgetown
 University; Library of Congress; private
 collections
Publications: *Ière Exposition Biennale
 Internationale de Gravure à Tokio*, cat. #21;
 50 Indiana Prints: Third Biennial, ill. #33;
 Catalogue of the 15th National Exhibition,
 Library of Congress, cat. p. 6;
 Contemporary Prints and Watercolors,
 National Academy of Design, cat. #40,
 p. 14; "French Wins 2 Awards in
 Herron's Print Show," *Indianapolis Star*,
 5/13/56, ill. Section 6, p. 7; Library of
 Congress 1970, cat. #6; *Misch Kohn: 25
 Years* (Haslem 1974), cat. #10; Bruce R.
 Shobaken, George W. Zoretich, and
 Edwin W. Zoller, *Prints and Printmaking*,
 ill. plate B-1, and p. 28; Spence, cat.
 p. 147, ill. #32; *WFMT Fine Arts Guide*,
 ill. p. 31; Zigrosser-AFA, ill. #22,
 cat. #121; Zigrosser, *Misch Kohn Prints*,
 Weyhe Gallery 1959, cat. #5.
Comments: Elaborately costumed figure
 posed against ornamental cityscape.
 Variously dated 1957. Signed, ed. info,
 titled, and dated in graphite.

190. *Processional*
Line etching
Image: 7 1/4 x 14 3/4" (184 x 374 mm)
Edition: 30
Plate: Copper
Publications: Spence, cat. p. 148; Zigrosser-
 AFA, cat. #120.
Comments: Spence: "Continuous line etch-
 ing of many figures in procession before
 a medieval fortress."

176. *Hostile Landscape*
Alternate titles: *Night Landscape; Paysage Hostile*
Wood engraving
Image: 5 7/8 x 23 1/4" (149 x 590 mm)
Sheet: 14 1/2 x 27 3/8" (368 x 695 mm)
Edition: 30
Paper: China/India
Publications: Spence, cat. p. 146 [as *Night Landscape*]; Zigrosser-AFA cat. #101 [as *Night Landscape*].
Comments: Abstracted landscape with numerous spiny protrusions in bold black, contrasting with bright whites and interstices filled with intricate engravings. Variously dated 1955. Signed, ed. info, titled, and dated in graphite.

177. *Kabuki Samurai*
Alternate titles: *Kabuki; Kubuki Samurai; Samurai*
Wood engraving
Image: 20 x 14 7/8" (508 x 378 mm)
Sheet: 25 3/4 x 20 5/8" (654 x 524 mm)
Edition: 30 [20] [5] [3]
States: 2
Paper: China/India
Collections: Des Moines Art Center; Memorial Art Gallery, University of Rochester; Monterey Museum of Art; Museum of American History, Smithsonian Institution; Philadelphia Museum of Art; John and Mable Ringling Museum of Art; John Simon Guggenheim Memorial Foundation; University Art Museum/Pacific Film Archive, University of California, Berkeley; private collections
Publications: *Ière Exposition Biennale Internationale de Gravure à Tokio*, cat. #23; *Artists of Chicago and Vicinity, 58th Annual Exhibition*, Art Institute of Chicago, cat. #108; *Ninth National Print Annual Exhibition*, Brooklyn, cat; 50 *Indiana Prints: Third Biennial*, cat. #34; *American Graphic Art*, Bombay: USIS, ill. frontispiece; Burrey, Suzanne, "Exhibition of Wood Engraving at Weyhe Gallery," *Art Digest* (March 1955), ill. p. 11; *Catalog of the 13th National Exhibition of Prints*, Library of Congress, cat. p. 10; *Catalogue of the 152nd Annual Exhibition*, Philadelphia, cat. #85; *Contemporary Prints and Watercolors*, National Academy of Design, cat. #89, p. 18; Devree, Howard, "American Round-Up," *New York Times* 11/18/56, ill. p. 16X; "Gravures Americaines d'Aujourd'hui," *Centre Culturel*

Americain, 1957, cat. #71; Haas, Irvin, "The Print Collector," *ARTnews* (March 1955), ill. p. 11; Haslem, Jane, *American Prints, Drawings, Paintings*, ill. p. 22, cat. #58; Hayter, S.W., *About Prints* (1962), ill. pl. 5; Johnson, Una, *American Prints and Printmakers*, ill. p. 89; *Misch Kohn*, University of Louisville, cat. #32; *Misch Kohn*, Weyhe Gallery 1955, ill. cover [detail], ill. inside; *Misch Kohn: 25 Years* (Haslem 1974), cat. #9; Olsen, Sandra Haller, *Survey of American Printmaking*, ill. p. 39; Peterdi, Gabor, *Printmaking* (1959), ill; *Prints by Misch Kohn* (Honolulu 1975), cat. #33; Spence, ill. #30, cat. p. 147 [dated 1955]; von Moschzisker, Bertha, *Curator's Choice*, Philadelphia, ill; *XILON* (Zurich 1957), cat. #267; *Xylon 1956* (Ljubljana), cat. #264; Zigrosser-AFA, ill. #20, cat. #114; Zigrosser, *Misch Kohn Prints*, Weyhe Gallery 1959, cat. #4.
Comments: Costumed Japanese dancer in stylized pose. Variously dated 1955. Signed, ed. info, titled, and dated in graphite.

178. *Landscape Fragment*
Alternate titles: *Fragment; Fragment I*
Wood engraving
Image: 8 9/16 x 3 1/4" (217 x 82 mm)
Sheet: 13 7/8 x 7 1/4" (352 x 184 mm)
Edition: 20
Paper: China/India
Publications: *Misch Kohn*, Weyhe Gallery 1955, cat. #22; Spence, cat. p. 146; Zigrosser-AFA, cat. #108.
Comments: Abstracted vertical landscape forms with angular hard edges. Variously dated 1955. Signed, ed. info, and dated in graphite.

179. *Long Landscape*
Wood engraving
Image: 8 3/4 x 26 13/16" (222 x 681 mm)
Sheet: 14 x 31 9/16" (355 x 802 mm)
Edition: 30
Paper: China/India
Publications: Spence, cat. p. 146; Zigrosser-AFA, cat. #100.
Comments: Abstracted horizontal composition with bold, thick black lines layered against a background of intricate engraving. Signed, ed. info, titled, and dated in graphite.

180. *Portrait*
Alternate title: *Head*
Wood engraving
Image: 17 3/8 x 11 1/8" (441 x 282 mm)

Sheet: 23 5/8 x 16 7/8" (600 x 428 mm)
Edition: 30 [10]
Paper: China/India
Publications: Spence, cat. p. 147 [as *Head*]; Zigrosser-AFA, cat. #111 [as *Head*].
Comments: Abstracted male bust with thick, bold black lines layered against a background of intricate engraving. Signed, ed. info, titled, and dated in graphite.

181. *Prometheus*
Alternate title: *Fragment II*
Wood engraving
Image: 8 3/4 x 9" (222 x 228 mm)
Sheet: 14 3/8 x 21 3/8" (365 x 543 mm)
Edition: 30
Paper: China/India
Publications: Spence, cat. p. 147 [dated 1955]; Zigrosser-AFA, cat. #116 [dated 1955].
Comments: The left two-thirds of the *Prometheus* wood block from 1953. Variously dated 1955. Signed, titled, and dated in graphite.

182. *Sea Study Fragment*
Alternate titles: *Sea Forms; Sea Study*
Wood engraving
Image: 2 7/8 x 2 5/8" (73 x 66 mm)
Sheet: 7 x 6 3/4" (178 x 171 mm)
Edition: 10 [20]
Paper: China/India
Publications: *Misch Kohn*, Weyhe Gallery 1955, cat. #26 [as *Sea Forms*]; Spence, cat. p. 146 [as *Sea Forms*]; Zigrosser-AFA, cat. #107 [as *Sea Forms*]
Comments: Rhythmic, swirling lines define an underwater scene. Variously dated 1955. Signed, ed. info, titled, and dated in graphite.

1955

183. *Cathedral No. 5*
Alternate title: *Cathedral*
Wood engraving
Image: 10 1/4 x 6 5/8" (260 x 168 mm)
Sheet: 20 1/4 x 15 3/8" (514 x 390 mm)
Edition: 30
Paper: China/India
Publications: Spence, ill. #25, cat. p. 147; Zigrosser-AFA, cat. #115.
Comments: The last and most subjective treatment of the Notre Dame de Paris cathedrals; only the spires and the rose window of the west facade remain. Signed, ed. info, titled, and dated in graphite.

Choice, Philadelphia, cat; Zigrosser-AFA, cat. #98
Comments: Full-length parade of abstracted standing figures, foreground, layered against intricate background engraving. This print was engraved in France, but most prints were pulled in 1954 back in Chicago. Variously dated 1954. Signed, ed. info, titled, and dated in graphite.

168. *Warrior Jagatai*
Alternate title: *Jagatai*
Wood engraving
Image: 23 x 11 5/8" (584 x 295 mm)
Sheet: 29 7/8 x 13 1/2" (759 x 343 mm)
Edition: 20 [30]
Paper: China/India
Collections: Museum of Modern Art; New York Public Library; Sheldon Memorial Art Gallery, University of Nebraska-Lincoln; private collections
Publications: *47 Midwestern Printmakers,* cat. #252; 50 *Indiana Prints: Second Biennial,* ill. #32; *Catalogue of the 152nd Annual Exhibition,* Philadelphia, cat. #90; Geske, Norman, *The Art of Printmaking,* ill. I-6, p. 11; Heller, Jules, *Printmaking Today* (1958), ill. p. 75; Kohn, Misch, "USA," *Meisterwerke der Graphik und Zeichnung,* cat. #395; Metz, Kathryn, *Misch Kohn: Three Decades,* cat. #2; *Misch Kohn,* Weyhe Gallery 1955, ill; *Misch Kohn: 25 Years* (Haslem 1974), cat. #8; "Prints," *December* (Summer 1961), ill. p. 35; Spence, cat. p. 147; *WFMT Fine Arts Guide,* ill. p. 5; Zigrosser-AFA, cat. #113.
Comments: Full-length abstracted portrait of Jagatai, the son of Genghis Khan, in bold blacks against an intricately engraved background. Variously dated 1954, 1955. Signed, ed. info, titled, and dated in graphite.

1954

169. *Barrier*
Wood engraving
Image: 17 1/2 x 27 3/8" (445 x 695 mm)
Sheet: 22 1/4 x 31 1/2" (565 x 800 mm)
Edition: 20 [21] [30]
Paper: China/India
Collections: Philadelphia Museum of Art; private collection
Publications: *Ière Exposition Biennale Internationale de Gravure à Tokio,* cat. #25; *47 Midwestern Printmakers,* cat. #251; Eichenberg, Fritz, *The Art of the Print,* ill.

p. 127; "Gravures Americaines d'Aujourd'hui," *Centre Culturel Americain,* 1957, cat. #72; *Misch Kohn,* University of Louisville, cat. #4; *Misch Kohn,* Weyhe Gallery 1955, cat. #12; *Misch Kohn: 25 Years* (Haslem 1974), cat. #7; *WFMT Fine Arts Guide,* ill, p. 58; Zigrosser-AFA, ill. #19, cat. #106; Zigrosser, *Misch Kohn,* Galerie 61, cat.
Comments: Abstracted landscape with bold blacks and almost three-dimensional whites. Variously dated 1955, 1956. Signed, ed. info, titled, and dated in graphite.

170. *Bird Catcher*
Wood engraving
Image: 9 3/4 x 3 5/8" (247 x 92 mm)
Sheet: 18 1/4 x 6 1/2" (463 x 165 mm)
Edition: 30 [20]
Paper: China/India
Collections: New York Public Library
Publications: *Misch Kohn,* Weyhe Gallery 1955, cat. #19; Spence, cat. p. 147; Zigrosser-AFA, cat. #112
Comments: Full-length portrait of male figure dragging a net with birds to his right. Variously dated 1955, 1956. Signed, ed. info, and dated in graphite.

171. *Cathedral I/Notre Dame*
Alternate titles: *Cathedral; Cathedral I; Cathedral II; Cathedral III; Cathedral No. 1; Cathedral No. 3;* [*New Year's Card*]
Wood engraving
Image: 6 15/16 x 4 15/16" (178 x 127 mm)
Sheet: 12 x 8 3/8" (304 x 212 mm)
Edition: 60
Paper: China/India mounted on card stock
Collections: Free Library of Philadelphia [as *Cathedral No. 3*]; Library of Congress [as *New Year's Card*]; New York Public Library [as *Cathedral II*]; Philadelphia Museum of Art; private collections
Publications: *Ausstellung Kinder und Künstler,* ill. back cover; *Misch Kohn,* Weyhe Gallery 1955, cat. #24 [as *Cathedral*]; Spence, ill. #24, cat. p. 146; *WFMT Fine Arts Guide,* ill. p. 33; Zigrosser-AFA, cat. #102 [as *Cathedral No. 1*]
Comments: A literal frontal depiction of Notre Dame de Paris, western elevation. Variously titled and dated. Sent out as holiday greeting card. The first and most literal of a series of five cathedral prints made during 1954 and 1955. Signed, ed. info, titled, and dated in grahite.

172. *Cathedral II*
Alternate titles: *Cathedral No. 2; The Cathedral II*
Wood engraving
Image: 9 x 8 11/16" (228 x 220 mm)
Sheet: 14 1/16 x 18 3/4" (357 x 476 mm)
Edition: 20
Paper: China/India
Collections: National Museum of American Art, Smithsonian Institution
Publications: Spence, cat. p. 146; Zigrosser-AFA, cat. #103.
Comments: A more abstracted version of the spires of Notre Dame de Paris in a square format. Signed, ed. info, titled, and dated in graphite.

173. *Cathedral No. 3*
Alternate title: *Cathedral I*
Wood engraving
Image: 8 5/8 x 3 1/4" (210 x 154 mm)
Sheet: 14 3/16 x 10 5/8" (360 x 270 mm)
Edition: 20
Collections: Montclair State University Art Galleries [as *Cathedral I*]
Publications: Spence, cat. p. 146; Zigrosser-AFA, cat. #104.
Comments: Vertical depiction of a more stylized frontal section of Notre Dame de Paris. Signed, ed. info, titled, and dated in graphite.

174. *Cathedral No. 4*
Wood engraving
Image: 9 1/8 x 6" (232 x 152 mm)
Edition: 20
Publications: Spence, cat. p. 146; Zigrosser-AFA, cat. #105.
Comments: Another in the Cathedral series, this print has not been extant since at least 1960.

175. *Ecce Homo*
Wood engraving
Image: 15 7/8 x 17 1/4" (403 x 438 mm)
Sheet: 18 1/2 x 23 7/8" (470 x 606 mm)
Edition: 30 [6]
Paper: China/India
Collections: Private collection
Publications: Marty, Martin E., *Ecumenical Art,* cat; *Misch Kohn,* Weyhe Gallery 1955, cat. #15; Spence, cat. p. 145; *WFMT Fine Arts Guide,* ill, p. 55; Zigrosser-AFA, cat. #99.
Comments: Broad bold lines define the head of Christ, tilted downward to left. Softer treatment than in 1953 *Ecce Homo* print. Signed, ed. info, titled, and dated in graphite.

Comments: Spence: "Rather indeterminate landscape vista, calligraphic in treatment of natural forms."

160. *Landscape Forms I*
Alternate titles: *Landscape; Landscape Forms*
Wood engraving
Image: 13 7/8 x 17 7/8" (352 x 454 mm)
Sheet: 20 1/2 x 24 3/4" (521 x 628 mm)
Edition: 20 [30]
Paper: China/India
Printer/Publisher: Mourlot, Paris
Publications: *Misch Kohn*, Weyhe Gallery 1955, cat. #27; Spence, cat. p. 146; Zigrosser-AFA, cat. #109
Comments: Abstracted landscape with broad, bold forms against a background of intricate engraved lines. Variously dated 1954, 1955. Block engraved in Paris but few printed there (in 1953) because Kohn didn't want to tie up Mourlot's press with the small blocks; most prints pulled in Chicago after his return. This title had also been used for another block cut in 1953 and discarded. Signed, ed. info, titled, and dated in graphite.

161. *Landscape Forms No. 2*
Wood engraving
Image: 5 1/2 x 11 1/2" (140 x 292 mm)
Edition: 20
Printer/Publisher: Institute of Design (edition of 500 following the edition of 20 artist's impressions)
Publications: *The Student Independent*, Institute of Design 1953; Spence, cat. p. 145; Zigrosser-AFA, cat. #94, discussed p. 27.
Comments: Spence: "Imagery is that of *Hostile Landscape* (wood engraving), ...but less ominously sharp and jagged and more diffuse in composition." This block was cut in France but not printed until the artist's return to Chicago. The print was included in a 1953 portfolio published by Kohn's students at the Institute of Design in an edition of 500 (in addition to 20 artist's proofs).

162. *Landscape Forms No. 3*
Alternate titles: *Landscape Forms; Landscape Forms 3; The Web I; The Web II*
Wood engraving
Image: 4 7/8 x 7 1/8" (124 x 181 mm)
Sheet: 11 7/16 x 13 5/8" (290 x 346 mm)
Edition: 20
Paper: China/India

Printer/Publisher: Institute of Design, Chicago (edition of 500 following the edition of 20 artist's impressions)
Publications: *The Student Independent*, Institute of Design, 1953; Spence, cat. p. 145; Zigrosser-AFA, cat. #95, discussed p. 27.
Comments: Abstracted landscape with bold black forms in circular motion layered over more intricate background engraving. This block was cut in France but not printed until the artist's return to Chicago. The print was included in a 1953 portfolio published by Kohn's students at the Institute of Design in an edition of 500 (in addition to 20 artist's proofs). Variously dated 1954 and variously titled. Signed, ed. info, titled, and signed in graphite.

163. *Little Horseman*
Alternate titles: *Horseman; The Rider*
Wood engraving, printed A) black, B) light brown
Image: 4 5/8 x 3 5/16" (117 x 84 mm)
Sheet: 5 7/16 x 4" (138 x 101 mm)
Edition: 30
States: 2
Paper: Japanese Hosho or China/India mounted on double-ply wove
Collections: Private collection
Publications: *Misch Kohn*, Weyhe Gallery 1955, cat. #18 [as *The Rider*]; Spence, cat. p. 145 [as *Horseman*]; Zigrosser-AFA, cat. #93.
Comments: Similar in composition to *Death Rides a Dark Horse*, but more gaily drawn. Sent out as holiday greeting card. This block was engraved in France but not printed until Kohn's return to Chicago. Handwritten holiday inscription on mounting paper verso.

164. *Phoenix*
Wood engraving
Image: 17 1/2 x 27" (444 x 686 mm)
Sheet: 24 x 34 3/4" (609 x 882 mm)
Edition: 30 [13]
States: 2
Paper: China/India
Printer/Publisher: Mourlot, Paris
Collections: Krannert Art Museum and Kinkead Pavilion; Milwaukee Art Museum; New York Public Library; College of Fine and Applied Arts, University of Illinois, Urbana
Publications: *Ière Exposition Biennale Internationale de Gravure à Tokio*, cat. #24; *50 Indiana Prints: Second Biennial*, cat. #31; *50 Indiana Prints: Third Biennial*,

cat. #35; *Misch Kohn*, Weyhe Gallery 1955, cat. #6; Spence, ill. #27, cat. p. 144; von Moschzisker, Bertha, *Curator's Choice*, Philadelphia, cat; Zigrosser-AFA, cat. #92.
Comments: A squawking bird rising from flames and flying off to left. Variously dated 1954, 1955. This wood block was first used for the 1953 *Ecce Homo* wood engraving, but the block was planed and repolished after a few impressions and then used for this *Phoenix*. Kohn had wanted to pull more prints, but the block was defective, with a hollow space in its center which did not print perfectly. A color plate was proofed in black for a four-block multi-color engraving, but Kohn never finished any in this state because he preferred the black-and-white version. Signed, ed. info, titled, and dated in graphite.

165. *Prometheus*
Wood engraving
Image: 8 5/8 x 12" (219 x 305 mm)
Paper: China/India, Japan Rice, or single-ply laid
Collections: Albion College
Publications: *Misch Kohn*, Weyhe Gallery 1955, cat. #20.
Comments: Numerous spiny, jagged black forms provide the framework for an abstracted head leaning to left. This block cracked after a few impressions, and most *Prometheus* prints are only the left two-thirds of the block (see #181). Signed and dated in graphite.

166. *The Battle*
Lithograph
Image: 19 3/4 x 26 3/4" (502 x 679 mm)
Edition: 20
Plate: Stone
Printer/Publisher: Clot, Paris
Publications: Spence, cat. p. 144; Zigrosser-AFA, cat. #97.
Comments: Color lithograph.

167. *The Warriors*
Wood engraving
Image: 13 1/2 x 17 3/16" (343 x 436 mm)
Sheet: 16 3/8 x 23 7/8" (416 x 606 mm)
Edition: 30
Paper: China/India
Publications: *Catalog of the 12th National Exhibition*, Library of Congress, cat. p. 10; *Misch Kohn*, Weyhe Gallery 1955, cat. #28; Spence, cat. p. 145; von Moschzisker, Bertha, *Curator's*

Kohn's return to the States in 1953. Signed, ed. info, and dated in graphite.

151. *Grasses*
Wood engraving
Image: 3 1/8 x 2 3/4" (79 x 70 mm) irregular
Sheet: 3 5/8 x 6 7/8" (92 x 174 mm)
Edition: 200
Paper: Commercial card stock
Collections: Private collections
Publications: Zigrosser-AFA, cat. p. 27
Comments: Layering of abstract imagery around grasses, foreground. This print was created as the exhibition announcement for Kohn's solo show at the Linn Gallery in Chicago, May, 1952. Two wood blocks were used for this two-color [red/blue] print.

152. *Sea Study*
Wood engraving, printed A) black only, B) five-color tempera
Image: 13 3/4 x 17 1/2" (349 x 444 mm)
Sheet: 18 5/8 x 25 7/8" (473 x 657 mm)
Edition: 30
States: 2
Paper: China/India
Printer/Publisher: Mourlot, Paris
Collections: Boston Public Library; Library of Congress
Publications: Library of Congress 1970, cat. #28; *Misch Kohn*, Weyhe Gallery 1955, cat. #7; Spence, ill. #23, cat. p. 144; *XILON* (Zurich 1957), cat. #268; *Xylon 1956* (Ljubljana), cat. #263; Zigrosser-AFA, cat. #87
Comments: Dense image of three fish swimming to the left. Five colors added by hand as a trial proof after the print was pulled in black only. This was the second print Kohn pulled in Paris while on his Guggenheim grant. Signed and dated in graphite.

153. *Three Visitors with Entourage*
Alternate titles: *The Visitors; Three Visitors with Entourage from a Friendly Country; Trois Visiteurs avec Entourage; Trois Visiteurs avec Entourage d'un Pays Amical*
Wood engraving
Image: 13 3/4 x 17 1/2" (348 x 445 mm)
Sheet: 20 9/16 x 24 1/2" (522 x 622 mm)
Edition: 30
States: 2
Paper: China/India
Printer/Publisher: Mourlot, Paris
Collections: David Winton Bell Gallery, Brown University; Boston Public Library; Davison Art Center, Wesleyan University; Library of Congress;

National Museum, Stockholm; private collection
Publications: *47 Midwestern Printmakers*, ill. p. 25, cat. #253; *American Prints 1950-1960*, Yale University Art Gallery, cat. #25; *Misch Kohn*, Weyhe Gallery 1955, ill; *Misch Kohn: 25 Years* (Haslem 1974), ill. #5; Library of Congress 1970, cat. #35; Spence, cat. p. 144; Zigrosser-AFA, ill. #17, cat. #85; Zigrosser, *Amerikansk Grafik*, Stockholm, cat. #39; Zigrosser, *Misch Kohn Prints*, Weyhe Gallery 1959, cat. #3
Comments: Enigmatic treatment of *Three Kings* theme, with processional surrounded by mountainous, hazardous-looking landscape. Variously dated 1953. This work, the first print he did in Paris, was submitted as part of the documentation supporting Kohn's second Guggenheim Fellowship application. Signed, ed. info, titled, and dated in graphite.

1953

154. *Chicken*
Alternate title: *The Chicken*
Wood engraving
Image: 3 3/16 x 4 5/8" (809 x 124 mm) irregular
Sheet: 5 3/4 x 8 1/8" (117 x 310 mm)
Edition: 60
Paper: China/India mounted on double-ply wove
Collections: New York Public Library
Publications: *Misch Kohn*, Weyhe Gallery 1955, cat. #25; Spence, cat. p. 147; Zigrosser-AFA, cat. #110
Comments: Squawking chicken profile left. Variously dated 1954. Sent out as holiday greeting card. Signed, titled, and dated in graphite.

155. *Ecce Homo*
Wood engraving, printed A) black only, B) color
Image: 17 5/16 x 26 7/8" (440 x 682 mm)
Sheet: 24 x 35 1/8" (609 x 892 mm)
Edition: 5
States: 2
Paper: China/India
Printer/Publisher: Mourlot, Paris
Publications: Spence, cat. p. 144; Zigrosser-AFA, cat. #90
Comments: Stylized head with abstracted crown of thorns, leaning to right. Variously dated 1954, 1955. After pulling five impressions, Kohn had the block

maker plane the surface and repolish the block, which he then used to engrave the 1953 *Phoenix*. A color working proof was pulled in January 1953, but Kohn disliked the results, and never finished any in this state.

156. *Fish*
Engraving, printed A) black only, B) color aquatint
Image: 8 x 30" (203 x 762 mm)
Edition: 5 [10]
States: 2
Plate: Copper
Printer/Publisher: Atelier 17, Paris
Publications: Spence, cat. p. 144; Zigrosser-AFA, cat. #89

157. *Hostile Landscape*
Alternate title: *Paysage Hostile*
Lithograph
Image: 13 3/4 x 18 3/4" (349 x 476 mm)
Edition: 20
Plate: Stone (4)
Printer/Publisher: Clot, Paris
Publications: Spence, cat. p. 145; Zigrosser-AFA, cat. #88
Comments: Four-color lithograph.

158. *Hostile Landscape*
Alternate title: *Paysage Hostile*
Wood engraving
Image: 8 5/8 x 27 1/4" (220 x 693 mm)
Sheet: 14 x 34 1/4" (357 x 870 mm)
Edition: 30 [20]
Paper: China/India
Printer/Publisher: Mourlot, Paris
Collections: Bibliothèque Nationale de France, Departement des Estampes et de la Photographie; National Museum, Stockholm
Publications: *Misch Kohn*, Weyhe Gallery 1955, cat. #13; Spence, ill. #28, cat. p. 145; Zigrosser-AFA, ill. #18, cat. #91; Zigrosser, *Amerikansk Grafik*, Stockholm, cat. #38
Comments: Abstracted landscape with bold, black jagged triangular forms. Signed, ed info, titled, and dated in graphite.

159. *Landscape*
Lithograph
Image: 13 3/4 x 18 5/8" (349 x 473 mm)
Edition: 20
Plate: Stone
Printer/Publisher: Clot, Paris
Publications: Spence, cat. p. 144; Zigrosser-AFA, cat. #96

Association 1951, cat; Spence, cat. p. 143; *WFMT Fine Arts Guide,* ill. p. 50; Zigrosser-AFA, cat. #78

Comments: Full-length portrait of male glassblower, with bulb of glass at end of blowing tube, inspired by glassblowers the Kohns had seen while in Europe in 1950. Variously dated 1951. Signed, titled, and dated in graphite.

1951

144. *A Season in Hell*
Alternate title: *Season in Hell*
Wood engraving
Image: 28 5/8 x 19 1/8" (727 x 486 mm)
Sheet: 32 7/8 x 24 1/8" (835 x 613 mm)
Edition: 20 [30]
States: 2
Paper: China/India
Collections: Los Angeles County Museum of Art; New York Public Library; Philadelphia Museum of Art; private collections
Publications: "Art of Kokomo Man Exhibited," *Kokomo Tribune* 5/11/53, ill. p. 16; *Artists of Chicago and Vicinity 56th Annual Exhibition,* Art Institute of Chicago, cat. #108; Butler, Henry, "Nationally Known Artists Exhibit Prints at Herron Alumni Show," *Indianapolis Times,* Spring 1952, ill; Castleman, Riva, *American Impressions,* ill. #23 [reproduced sideways]; *Misch Kohn,* Weyhe Gallery 1955, cat. #17; *Misch Kohn: 25 Years* (Haslem 1974), cat. #3; Selz, Peter, *Print Magazine* (November 1952), p. 43 [1st state]; Spence, ill. #20, cat. p. 143; Zigrosser-AFA, ill. #15, cat. #82; Zigrosser, *Amerikansk Grafik* (Stockholm, 1953), cat. #7, p. 8.
Comments: Two male figures clawing to escape from a restraining web. The first state shows no restraint around left figure, left hand of this figure is incomplete, and various background sections have not been carved out. Signed, ed. info, titled, and dated in graphite.

145. [Exhibition Announcement]
Wood engraving
Image: 4 x 3 3/4" (102 x 95 mm) irregular
Sheet: 4 3/16 x 8" (106 x 203 mm)
Edition: 200
Paper: Commercial card stock
Collections: New York Public Library
Publications: Zigrosser-AFA, cat. p. 27

Comments: Layering of abstract imagery around outstretched hand. This print was created as the exhibition announcement for Kohn's solo show at the Art Institute of Chicago, October 19– December 2, 1951. Exhibition information printed in red to right of image printed in gray.

146. *Fallen Horse*
Wood engraving
Image: 10 9/16 x 14" (268 x 355 mm)
Sheet: 13 5/16 x 21 7/8" (338 x 555 mm)
Edition: 20 [30]
Paper: China/India
Publications: *Misch Kohn,* Weyhe 1955, cat. #21; Spence, cat. p. 144; Zigrosser-AFA, cat. #84
Comments: Prone horse with limbs akimbo.

147. *Portrait of a Contemporary*
Alternate titles: *Head of a Contemporary; Head (Screaming); Portrait of a Contemporary after P* [Picasso]
Wood engraving
Image: 21 1/8 x 14" (536 x 355 mm)
Sheet: 28 x 23" (711 x 584 mm)
Edition: 30
Paper: China/India
Publications: *50 Indiana Prints: First Biennial,* ill. cat. #28 (as *Head of a Contemporary*); *Catalog of the Ninth National Exhibition,* Library of Congress, cat. p. 12; "Indiana's First Biennial," *Art Digest* (June 1952), ill. p. 11 [as *Head of a Contemporary*]; Selz, Peter, *Print Magazine* (November 1952), ill. p. 43; Spence, ill. #19, cat. p. 143 [as *Head of a Contemporary*]; Zigrosser-AFA, cat. #81
Comments: Dramatic image of semi-cubistic head, head tilted back with mouth open and teeth protruding, profile left.

148. *Sleeping Soldier*
Alternate title: *The Sleeping Soldier*
Wood engraving
Image: 17 1/2 x 23 1/2" (445 x 597 mm)
Sheet: 21 3/8 x 27 1/2" (543 x 700 mm)
Edition: 30
Paper: China/India
Collections: Allegheny College; Art Institute of Chicago; Bibliothèque Nationale de France, Departement des Estampes et de la Photographie; The Free Library of Philadelphia; Georgetown University; Kalamazoo Institute of Arts; National Bezalel Museum, Jerusalem; Philadelphia

Museum of Art; West Chester University, PA; private collections
Publications: *Artists of Chicago and Vicinity, 55th Annual Exhibition,* Art Institute of Chicago, cat. #94; *Catalogue of the 152nd Annual Exhibition,* Philadelphia, cat. #87; "Distinguished Young Local Artist Given Grant," *Kokomo Tribune,* 1952, ill; Heintzelman, Arthur, *Contemporary American Prints,* cat. p. 13; *Misch Kohn,* University of Louisville, cat. #25; *Misch Kohn,* Weyhe Gallery 1955, cat. #8; Selz, Peter, *Print Magazine* (November 1952), ill. p. 40; Spence, ill. #21, cat. p. 143; *Storm King Art Center Schedule of Exhibitions 1963* (Mountainville, NY), ill; "Win Prizes for Art Work," *Kokomo Tribune,* ill; Yood, James, *Second Sight,* ill. fig. 5 p. 18, cat. #80 p. 145; Zigrosser-AFA, ill. #14, cat. #80; Zigrosser, *Misch Kohn,* Galerie 61, cat.
Comments: Black moon shines over three jagged mountain peaks framing a prone male figure, center foreground. Signed, titled, and dated in graphite.

c. 1951

149. Untitled [Dove and Tree]
Wood engraving
Image: 4 x 5 1/16" (102 x 128 mm)
Sheet: 8 x 10" (203 x 254 mm)
Edition: 100
Paper: Commercial stock run on letter press
Comments: Bird of peace flies into picture plane from right, holding olive branch in its beak for abstracted tree, center foreground. The black ink block was printed first, then the red block was overprinted. "A Christmas Carmen" poem by John Greenleaf Whittier and handwritten signatures verso. Sent out as holiday greeting card.

1952

150. *Bowl of Fish*
Lithograph
Image: 11 1/2 x 16" (292 x 406 mm)
Edition: 20 [15]
Plate: Stone
Printer/Publisher: Clot, Paris
Collections: Private collection
Publications: Spence, cat. p. 144; Zigrosser-AFA, cat. #86
Comments: Line engraving of several fish in a bowl. This block was engraved in Paris, but most prints were pulled after

Howard County Public Library exhib. ann. (May 1991) ill; "Misch Kohn," Museum of Modern Art postcard, 1984, ill; *Misch Kohn*, Weyhe Gallery 1955, cat. #1; *Misch Kohn: 25 Years* (Haslem 1974), cover ill, cat. #2; *Modern Woodcuts*, Philadelphia Art Alliance, cat. #12; *Museum of Modern Art 1957 Calendar*, ill. p. 24; "New York: Taste Shaper," *Look Magazine* (February 1958), ill. p. 50; Patterson, Connie, "Kokomo was Important to Kohn's Development," *Kokomo Tribune* 3/29/87, ill. p. C11; Payne, Robert, "Tiger in the Pass," *New York Times Book Review*, 3/4/56, ill. p. 4; Preston, Stuart, "American Graphic Art," *New York Times*, 7/8/51, ill. p. 2; *Prints 1942-1952* (Memphis), ill. cat. #18, p. 2; *Prized Impressions*, Philadelphia, ill., and exhib. poster; Rumpel, Heinrich, *Wood Engraving*, ill. p. 108; Selz, Peter, *Print Magazine* (November 1952), ill. p. 38; "Show to Honor Misch Kohn," *Kokomo Tribune*, 9/8/87, ill. p. 7; Spence, ill. #14, cat. p. 143; *Twenty-Second Annual Exhibition*, Seattle Art Museum, cat. #67; von Moschzisker, Bertha, *Curator's Choice*, Philadelphia, cat; Wick, Peter, *Modern Prints*, Boston Museum, ill. #26; Zigrosser-AFA, ill. #11, cat. #71; Zigrosser, *Misch Kohn Prints*, Weyhe Gallery 1959, cat. #1; Zigrosser, *Prints and Their Creators*, ill. #652

Comments: Ferocious tiger glaring at viewer, head to right; stylized nocturnal landscape in background. Kohn's most published print. The block cracked after the first print was pulled; he had intended to print 15, then added 6 more, then a third time printed an additional 9 for the final edition of 30. Signed, ed. info, titled, and dated in graphite.

139. *Trio*
Alternate titles: *Jazz Musicians; Jazz Trio; The Three Musicians*
Wood engraving
Image: 23 1/4 x 15 13/16" (590 x 400 mm)
Sheet: 29 1/4 x 21 1/4" (743 x 243 mm)
Edition: 30
Paper: China/India
Collections: Bibliothèque Nationale de France, Departement des Estampes et de la Photographie; Coos Art Museum; Des Moines Art Center; Illinois State Museum; Museum of Modern Art, New York; National Museum of American Art, Smithsonian Institution; New York Public Library

Publications: *Artists of Chicago and Vicinity, 54th Annual Exhibition*, Art Institute of Chicago, cat. #115; Beck, Sydney and Elizabeth Roth, *Music in Prints*, ill. cat. #52; *Bebop*, record album cover ill., New World Records, NY, 1976-7; CSUH Department of Music's Jazz Band Concert program 11/20/84, cover ill; Farmer, Jane, *American Prints from Wood*, ill. p. 40, cat. #73; Fittipaldi, Tom, "Rock in Today's Church," *Music Ministry* (September 1975), ill. p. 4 [as *Jazz Trio*]; Haslem, Jane, *American Prints, Drawings, Paintings*, ill. p. 22, cat. #59; Kohn, Misch, "USA," *Meisterwerke der Graphik und Zeichnung* (Arbon 1954), cat. #394; *Misch Kohn: 25 Years* (Haslem 1974), ill. #1; Selz, Peter. "How to Look at a Picture," University of Chicago, ill. frontispiece; Selz, Peter, *Print Magazine* (November 1952), ill. p. 39 [dated 1950]; Spence, ill. #17, cat. p. 143; *XILON* (Zurich 1957), cat. #266; *XYLON 1956* (Ljubljana), ill. cat. #262; "Xylon," *Volksrecht*, 3/3/56, ill; Zigrosser-AFA, cat. #75

Comments: Rhythmic interpretation of jazz improvisation. Variously dated 1950, 1951, 1955. Signed, ed. info, titled, and dated in graphite.

c. 1949

140. Untitled [Three Angels Blowing Horns]
Linoleum cut
Image: 5 1/2 x 4 1/8" (140 x 105 mm) irregular
Sheet: 6 7/8 x 9 7/8" (175 x 251 mm)
Edition: 100
Paper: Commercial card stock printed on a letter press
Collections: Private collections
Comments: Three angels stacked vertically, blowing trumpets. Sent out as holiday greeting card. MISCH AND LORE KOHN printed at bottom.

1950

141. *Medea*
Wood engraving
Image: 16 1/2 x 22 9/16" (419 x 573 mm)
Sheet: 18 5/8 x 28 1/16" (473 x 713 mm)
Edition: 30
Paper: China/India
Publications: Spence, cat. p. 143; Zigrosser-AFA, cat. #76.

Comments: Sinewy fallen figure enveloped by sharp, bold shadows. Signed, ed. info, titled, and dated in graphite.

142. *Mountain Climber*
Alternate titles: *Mountain; The Mountain; The Mountain Climber; The Mountaineer*
Wood engraving
Image: 27 3/8 x 10 1/2" (695 x 267 mm)
Sheet: 30 5/8 x 14 1/8" (778 x 359 mm)
Edition: 3 [20] [30]
States: 2
Paper: China/India
Collections: Hamilton College; Library of Congress; Philadelphia Museum of Art; private collection
Publications: "Carving a Career," *Indianapolis Star Magazine*, 9/11/55, ill. p. 44; *Catalogue of the 152nd Annual Exhibition*, Philadelphia, cat. #86 [as *Mountain*]; Library of Congress 1970, cat. #22; *Misch Kohn*, University of Louisville, 1964, cat. #3; *Misch Kohn*, Weyhe Gallery 1955, cat. #9; *Purchase Exhibition of Fine Prints*, Hamilton College, cat. #79; Spence, cat. p. 144 [dated 1951]; *Sport in Art* (AFA 1955), ill. #65; Zigrosser-AFA, ill. #16, cat. #83
Comments: Stylized climber at lower right attempts to scale high peaks. Variously dated 1951. Signed, ed. info, titled, and dated in graphite.

143. *The Glass Blower*
Alternate titles: *Glass Blower; Glassblower*
Wood engraving
Image: 27 3/4 x 10 5/8" (708 x 270 mm)
Sheet: 31 7/8 x 14 1/4" (812 x 362 mm)
Edition: 30
Paper: China/India
Collections: Art Institute of Chicago; Bibliothèque Nationale de France, Departement des Estampes et de la Photographie; Boston Public Library; The Brooklyn Museum; The Corning Museum of Glass; Philadelphia Museum of Art; Sheldon Memorial Art Gallery, University of Nebraska-Lincoln; private collections
Publications: *Catalogue of the 152nd Annual Exhibition*, Philadelphia, cat. #89; *Fifth National Exhibition* (Brooklyn 1951), ill; Johnson, Una, "New Expressions in Fine Printmaking," *Brooklyn Museum Bulletin* (Fall 1952), ill. p. 7, cat. #43 p. 30; Johnson, Una, *Ten Years of American Prints*, ill. fig. 11 p. 23; *Misch Kohn*, Weyhe 1955, cat. #5; *Misch Kohn: 25 Years* (Haslem 1974), cat. #4; Nebraska Art

cover and interior ill; "Printmaker's Art," *New York Times Magazine,* 4/29/58, ill. p. 29; *Prints 1942-1952* (Memphis), cat. #9, p. 4; Robb, Marilyn, "Past and Future Prints," *ARTnews* (February 1950), ill. p. 53; Spence, ill. #15, cat. p. 143; Zigrosser-AFA, ill. #13, cat. #73; Zigrosser, *Misch Kohn,* Galerie 61, cat.

Comments: Headless horseman astride a steed, profile left. First state 3 impressions. Signed and dated in graphite.

133. *Fish*
Line engraving
Image: 5 1/8 x 27 1/2" (130 x 698 mm)
Sheet: 11 3/8 x 35 3/8" (288 x 898 mm)
Edition: 5 [10]
Paper: Basingwerk
Plate: Copper
Printer/Publisher: Atelier 17, New York
Comments: Line engraving of a fish. Signed and dated in graphite.

134. *Fish*
Alternate title: *Two Fish*
Wood engraving
Image: 4 x 6" (101 x 152 mm)
Sheet: 4 15/16 x 13 7/8" (125 x 352 mm)
Edition: 60
Paper: China/India
Collections: Private collections
Publications: *Misch Kohn,* Weyhe Gallery, 1955, cat. #23; Spence, cat. p. 143 [as *Two Fish,* dated 1950]; Zigrosser-AFA, cat. #79 [as *Two Fish*]
Comments: Stylized image of fish. Sent out as holiday greeting card. Variously dated 1950. Printed and signed holiday inscription verso. Signed, ed. info, and dated in graphite.

135. *Fishermen*
Alternate titles: *Fisherman; The Fisherman*
Wood engraving
Image: 23 3/4 x 15 13/16" (605 x 403 mm)
Sheet: 30 1/8 x 22 7/8" (765 x 581 mm)
Edition: 5 [30] [20]
Paper: China/India
Collections: Bibliothèque Nationale de France, Departement des Estampes et de la Photographie; Boston Public Library; Fogg Art Museum, Harvard University; Library of Congress; Museum of Modern Art; New York Public Library; Seattle Art Museum
Publications: *50 Indiana Prints: First Biennial,* cat. #27; Drummond, Dorothy, "Coast to Coast," *Art Digest* (November 15, 1952), ill. p. 11; Library of Congress 1970, cat. #5; *Misch Kohn,*

Weyhe Gallery, 1955, cat. #4; Nebraska Art Association, 1951, cat; "Northwest Printmakers Star the Experimental," *Art Digest* (March 1950), ill. p. 22; *Twenty-Second Annual Exhibition,* Seattle Art Museum, cat. #66; Selz, Peter, *Print Magazine* (November 1952), ill. p. 42; Spence, ill. #18, cat. p. 143 [dated 1950]; Zigrosser-AFA, cat. #77; Zigrosser, *Misch Kohn Prints,* Weyhe Gallery 1959, cat. #2

Comments: Large stylized fisherman, left foreground, examining his nets; smaller fisherman to right background. Signed, ed. info, titled, and dated in graphite.

136. *Prisoners*
Wood engraving
Image: 15 3/8 x 23 1/2" (391 x 597 mm)
Sheet: 19 7/8 x 27 1/4" (505 x 692 mm)
Edition: 20 [5]
Paper: China/India
Collections: Philadelphia Museum of Art
Publications: "1994 Distinguished Artist Misch Kohn," *California Printmaker* (June 1994), ill. p. 12 (incorrectly identified as *Death Rides a Dark Horse*); *Misch Kohn,* Weyhe Gallery 1955, cat. #14; Spence, ill. #16, cat. p. 143; *WFMT Fine Arts Guide,* ill. p. 27; Zigrosser-AFA, ill. #12, cat. #72
Comments: Dramatic image of five grimacing faces behind bars, facing left. The block cracked after five prints; subsequently some fragments of this block were printed and disseminated. Signed, titled, and dated in graphite.

137. *Struggle*
Alternate title: *The Struggle*
Wood engraving
Image: 23 1/8 x 15 7/8" (587 x 403 mm)
Sheet: 27 3/8 x 19 3/8" (695 x 492 mm)
Edition: 30
Paper: China/India
Collections: Philadelphia Museum of Art; private collections
Publications: *Misch Kohn,* Weyhe Gallery, 1955, cat. #16; *Fortieth Anniversary Exhibition,* Philadelphia Print Club, cat; Spence, cat. p. 143; Zigrosser-AFA, cat. #74
Comments: Forceful battle between two men against dramatic background divided by numerous angles and textured planes. Variously dated 1950, 1956. Signed, ed. info, titled, and dated in graphite.

138. *Tiger*
Alternate title: *The Tiger*
Wood engraving
Image: 16 3/8 x 23 5/8" (416 x 606 mm)
Sheet: 19 1/2 x 27 3/8" (495 x 695 mm)
Edition: Edition: 15 [21] [30]
Paper: China/India or single-ply laid
Collections: Baltimore Museum of Art; Boston Public Library; Kokomo-Howard County Public Library, Hoosier Art Collection; Library of Congress; Memphis Brooks Museum of Art; Museum of Art, Rio de Janeiro; Museum of Fine Arts, Boston; Museum of Modern Art, New York; National Gallery of Victoria, Melbourne; Philadelphia Museum of Art; Picker Art Gallery, Colgate University; private collections
Publications: *American Prints 1913-1963,* ill. p. 25, cat. #69; "American Prints of the 20th Century," *American Artist* (November 1954), ill. p. 30; Biggs, John R., *Woodcuts, Linocuts,...,* ill. fig. #135; Cahill, Holger, ill. p. 94, cat. #173 p. 85; *Catalogue of the 152nd Annual Exhibition,* Philadelphia, cat. #88; *Chronicle* (February 1953), ill; "Distinguished Young Local Artist Given Grant," *Kokomo Tribune,* 1952, ill; *Exposition de Gravures,* Paris, 1951, ill. inside front cover, cat. #30; Gallery Two, Rockville, MD, cat.; Genauer, Emily, "Art and Artists: Prints on Parade," *New York Herald Tribune* 9/19/54, ill; *Hoosier Art Collection,* 1993, cat. p. 12; Hoover, James, *Misch Kohn: Hometown Collection,* cat; *Indianapolis Times,* 9/30/51, ill; *Internationale Grafik 1952,* Salzburg, cat. #147; Joray, Charles, *Hoosier Art Collection,* 1989, ill. back cover; Joray, Charles and James Ong, "Kohn's Work Known Around the World," *Kokomo Magazine* (1990), ill. p. 17; "Kohn Wood-Engraving Exhibition on Display," *Los Angeles Times* 11/18/57, ill. Part III, p. 8; Lewalter, Christian, "Die ganze Richtung Passt Ihm Nicht," *Die Zeit* 11/24/55, ill. p. 4; Library of Congress 1970, ill. #36, p. 245; Lichtblau, Charlotte, "175 Prints Shown at Modern Museum," *Philadelphia Inquirer,* ill; Lieberman, William, *Perspectives USA* (Summer 1955), ill. between pp. 48-49; Louchheim, Aline, "New Group to Promote Graphic Art," *New York Times* 9/14/52, ill. p. 10X; McNulty, Kneeland, "A Decade of American Printmaking," *Philadelphia Museum Bulletin* (Autumn 1952), ill. p. 9; "Misch Kohn," Kokomo-

c. 1946

126. *Greetings/Three Kings*
Woodcut
Image: 5 x 3 7/8" (127 x 98 mm)
Sheet: 5 1/2 x 8 9/16" (140 x 217 mm)
Edition: 60?
Paper: Maroon commercial wove
Comments: Three kings, profile right.
MISCH in lower hem of left king. Sent
out as holiday greeting card.
Handwritten inscription, right.

c. 1946-47

127. *Greetings*
Woodcut
Image: 5 15/16 x 7 15/16" (151 x 202 mm)
Sheet: 6 13/16 x 10" (173 x 254 mm)
Paper: Lightweight single-ply wove
Collections: Private collections
Comments: Two-color image of angel
blowing trumpet flying over cityscape.
Sent out as holiday greeting card.

1947

128. *Marionette Dance*
Linoleum cut, printed A) paper, B) linen
Image: 26 1/2 x 17" (673 x 432 mm)
irregular
Plate: 22 1/2 x 10 13/16" (570 x 275 mm)
Sheet: 26 5/8 x 17" (677 x 433 mm)
Edition: 10
States: 2
Paper: 8 impressions on Peruvian linen
[hemp] with considerable variation in
shrinkage, and 2 on China/India
Collections: Art Institute of Chicago
Publications: *52nd Annual Exhibition*, Art
Institute of Chicago, ill. cat. #103;
Spence, cat. p. 142; Zigrosser-AFA,
cat. #67.
Comments: Two semi-Cubist figures in a
complex interaction, with geometric and
linear patterning. Two linoleum blocks
used for this two-color linoleum cut.

1948

129. *Fantasy*
Alternate titles: *Fallen Figure; Sacred and
Profane Love*
Wood engraving
Image: 24 1/4 x 12 1/4" (616 x 311 mm)
Sheet: 27 9/16 x 14 3/16" (700 x 360 mm)
Edition: 15 [30]
States: 2
Paper: China/India

Plate: Maple block
Collections: Private collections
Publications: *Modern Woodcuts*,
Philadelphia Art Alliance, cat. #13;
Spence, cat. p. 142; Zigrosser-AFA,
cat. #69.
Comments: Spence: "Dream-like and
erotic, with picture-space dominated by
large nude female with long hair;
smaller male figure falls past her at left
and a second male kneels in mid-
distance." Inspired by Robinson Jeffer's
"Tamar." This print was the first large
wood engraving. Variously dated 1949.
First state 15 impressions. Signed, ed.
info, titled, and dated in graphite.

130. *The Old King in Thule*
Alternate title: *The Old King of Thule*
Wood engraving
Image: 12 1/8 x 9 5/8" (308 x 244 mm)
Sheet: 14 x 12 1/8" (355 x 308 mm)
Edition: 10
Paper: China/India
Plate: Maple block
Collections: Private collections
Publications: *Exposition Internationale de la
Gravure Contemporaine*, cat. #79, p. 21;
Spence, cat. p. 142; Zigrosser-AFA,
cat. #68.
Comments: Nocturnal image of seated
monarch in elaborate costume 3/4 pro-
file right, with goblet in raised hands.
Signed, ed. info, titled, and dated in
graphite.

1949

131. *Bull Fight*
Alternate titles: *Bullfight; The Bull Fight;
The Bullfight*
Wood engraving
Image: 15 1/2 x 23 1/4" (394 x 591 mm)
Sheet: 17 13/16 x 26 15/16" (452 x 685 mm)
Edition: 30
Paper: China/India
Collections: Bibliothèque Nationale de
France, Departement des Estampes et de
la Photographie; Cleveland Museum of
Art; Colgate University; Library of
Congress; Musée d'Art Moderne, Paris;
New York Public Library; Picker Art
Gallery; private collections
Publications: Adhémar, *Twentieth Century
Graphics*, ill. p. 225; "Art Museum," *Ft.
Wayne* (IN) *News-Sentinel*, 9/14/61, ill;
Buckland-Wright, *Etching and Engraving*,
ill. p. 219; "Bull Fight," *Indianapolis Star*,
3/28/54, ill. p. 12; "Carving a Career,"

Indianapolis Star Magazine, 9/11/53, ill.
p. 44; *Catalog of the Eighth National
Exhibition*, Library of Congress, p. 11;
*Exhibition of Current American Prints
1950*, Carnegie Institute, cat. #53;
Library of Congress 1970, cat. #3; *Misch
Kohn*, Weyhe Gallery 1955, cat. #3;
"Misch Kohn to Show Wood
Engraving," *Philadelphia Art Alliance
Bulletin* (March 1954), ill. p. 5; *Modern
Woodcuts*, Philadelphia Art Alliance,
cat. #14; Nebraska Art Association 1951,
cat; "Other Books..." *New York Times
Book Review*, 2/14/54, ill. p. 31; Selz,
Print Magazine (November 1952), ill.
p. 42; Spence, ill. #13, cat. p. 143;
"Teachers Plan," *Kokomo Tribune*,
3/29/66, ill. p. 16; Zigrosser-AFA,
ill. #10, cat. #70.
Comments: Stylized depiction of last
moments of a bull fight, with matador at
right, dying bull charging to right.
Signed, ed. info, titled, and dated in
graphite.

132. *Death Rides a Dark Horse*
Wood engraving
Image: 21 7/8 x 15 3/4" (555 x 400 mm)
Sheet: 27 1/2 x 19 3/8" (698 x 492 mm)
Edition: 3 [30] [50]
States: 2
Paper: China/India
Collections: Achenbach Foundation for the
Graphic Arts, The Fine Arts Museums of
San Francisco; Art Institute of Chicago;
Bibliothèque Nationale de France,
Departement des Estampes et de la
Photographie; Boston Public Library;
The Brooklyn Museum; Museum
Boijmans Van Beuningen; Philadelphia
Museum of Art; private collections
Publications: Ashton, Dore, "Brooklyn
Reviews..." *Art Digest* (September 1952),
ill. of prelim. sketch for this print, p. 7;
Evans, Carol, *Prints from Blocks*, cat. #86,
p. 13; *Fourth National Exhibition*,
Brooklyn, 1950, ill; Johnson, Una,
American Woodcuts, ill. p. 40; Johnson,
Una, "New Expressions in Fine
Printmaking," *Brooklyn Museum Bulletin*,
ill. p. 6: prelim. sketch, print, p. 30:
cat. #44a, print; cat #44b-d, prelim. pen
and ink sketches; Johnson, Una, *Ten
Years of American Prints*, ill. fig. 10 p. 22;
Johnson, Una, *16th National Print
Exhibition*, ill, p. 28; Marty, *Ecumenical
Art*, ill; Metz, Kathryn, *Misch Kohn: Three
Decades*, cat. #1; *Modern Woodcuts*,
Philadelphia Art Alliance, cat. #15;
Moderne Amerikaanse Grafiek, The Hague,

Plate: Stone
Printer/Publisher: *Taller de Grafica Popular,*
 Mexico City
Collections: Academia de Artes,
 Mexico City
Publications: Spence, cat. p. 140; Zigrosser-
 AFA, cat. #51.

116. *The Bullfighter*
Alternate title: *Bullfighter*
Wood engraving
Image: 4 3/4 x 3 1/2" (121 x 89 mm)
Sheet: 6 5/8 x 5 1/8" (168 x 130 mm)
Edition: 20
Paper: China/India
Collections: Private collection
Publications: Spence, ill. #11, cat. p. 141;
 Zigrosser-AFA, cat. #60.
Comments: Half-length portrait of Carlos
 Arruza in his "suit of lights," profile left,
 holding his sword. Signed and dated in
 graphite.

117. *The Park Lagoon*
Lithograph
Image: 12 x 17 1/4" (305 x 438 mm)
Edition: 18
Plate: Stone (3)
Publications: Spence, cat. p. 142; Zigrosser-
 AFA, cat. #64.
Comments: Spence: "Kidney-shaped
 pools, water lilies, and trees viewed
 from above." Three-color lithograph.

118. *Two Mexican Women*
Alternate titles: *Two Seated Women with
 Maguey; Two Women; Two Women with
 Maguey*
Wood engraving
Image: 2 11/16 x 4 1/8" (68 x 105 mm)
Sheet: 4 15/16 x 7" (125 x 178 mm)
Edition: 20
Paper: China/India
Printer/Publisher: *Taller de Grafica Popular,*
 Mexico City
Collections: Academia de Artes,
 Mexico City; private collections
Publications: Spence, ill. #9, cat. p. 141;
 Zigrosser-AFA, cat. #56.
Comments: Large maguey plant to left,
 two women in traditional costume
 seated to right. KM vertically in plate, lr;
 signed and dated in graphite.

c. 1944

119. *Art*
Wood engraving
Image: 4 15/16 x 3 15/16" (125 x 100 mm)
Sheet: 11 x 8 1/2" (279 x 216 mm)
Edition: 100+
Paper: Lightweight single-ply light
 gray wove
Collections: Private collection
Comments: Invitation to art auction at
 54th Place studio workshop. An interior
 map on inside of invitation also drawn
 by Kohn. Exhibiting artists: Angel
 Bracho, Eleanor Coen, Len Farb, Max
 Kahn, Misch Kohn, Leopoldo Mendez,
 Pablo O'Higgins, Wes Sharer, Frank
 Vavrushka, Isadore Weiner

1945

120. *Dragon*
Linoleum cut, printed A) paper, B) linen
Image: 4 x 6" (101 x 152 mm) irregular
States: 2
Paper: China/India, linen
Comments: Stylized dragon looking back
 over its shoulder at a dove. Printed on
 linen fabric in terra-cotta color ink
 which Kohn's wife made into a dress.
 Impressions on paper also printed in
 black.

121. *The City*
Linoleum cut
Image: 8 1/8 x 5" (206 x 127 mm)
Sheet: 13 1/2 x 9 1/2" (342 x 241 mm)
Edition: 36 [15]
Collections: Indianapolis Museum of Art
Publications: Morehouse, Lucille,
 Indianapolis Star, 11/6/49; Spence, cat.
 p. 142; Zigrosser-AFA, cat. #65.
Comments: Abstracted city buildings used
 as a design for textile printing. This
 four-color linoleum cut was originally
 created in 1945 as an edition of 15. Later,
 it was included in the Herron Art School
 Alumni Portfolio (edition of 36) a project
 done by six Herron Art School graduates
 as a fund raiser in 1949. Each portfolio
 contains prints by Garo Antreasian, John
 Bernhardt, Edwin Fulwider, Misch
 Kohn, and Orfeo Vian.

122. *Two Dancers*
Woodcut, printed A) paper, B) linen
Image: c. 12 x 10" (305 x 254 mm) irregular
States: 2
Paper: China/India, linen

Comments: Two stylized dancers. This
 two-color woodcut was printed onto
 curtains following artist's impressions
 on paper.

c. 1945

123. *Art for Christmas*
Wood engraving
Image: 5 x 3 15/16" (127 x 100 mm)
Sheet: 11 x 8 1/2" (279 x 216 mm)
Paper: Lightweight single-ply light
 brown wove
Collections: Private collection
Comments: Invitation to art sale at 54th
 Place studio workshop. Exhibiting
 artists: Eleanor Coen, Max Kahn, Misch
 Kohn, Morris Topchevsky, Wes Sharer,
 Isadore Weiner, Frank Vavrushka.

c. 1945-46

124. Untitled [Cellist]
Linoleum cut, printed A) paper, B) linen
Image: 10 1/16 x 8" (255 x 203 mm)
 irregular
Sheet: 13 9/16 x 10 7/8" (344 x 276 mm)
Edition: uneditioned
States: 2
Paper: Double-ply wove, linen
Collections: Private collection
Comments: Stylized female cellist in this
 trial proof of a design for curtains. Two
 linoleum blocks were used for this two-
 color print.

1946

125. *The City in Black and White*
Linoleum cut, printed A) paper, B) silk, in
 shades of green
Image: 11 13/16 x 19 3/4" (300 x 502 mm)
Sheet: 15 9/16 x 20 3/8" (395 x 517 mm)
Edition: 30 [25] [15]
States: 2
Paper: China/India, silk
Collections: Private collections
Publications: *53rd Annual Exhibition,* Art
 Institute of Chicago, cat. #154; Spence,
 cat. p. 142; Zigrosser-AFA, cat. #66.
Comments: Abstracted urban landscape;
 right half printed in relief, left half
 printed in intaglio. Most prints may
 have been pulled in 1948. Originally
 designed for curtains in the Kohns'
 Chicago apartment; when they moved
 out of that residence for a trip to Europe,
 they gave them away. Variously printed
 on silk for use as a scarf.

104. *The River*
Lithograph
Image: 10 3/4 x 16 1/8" (273 x 409 mm)
Sheet: 13 3/4 x 18 3/8" (349 x 467 mm)
Edition: 10
Paper: BFK Rives
Plate: Stone
Publications: Spence, cat. p. 140; Zigrosser-AFA, cat. #40.
Comments: Tugboat steaming down river and under bridges; urban buildings on embankments. Signed, ed. info, titled, and dated in graphite.

105. *Uncle Harry*
Lithograph
Image: 15 1/8 x 11 3/4" (384 x 298 mm) irregular
Sheet: 18 x 13 1/2" (457 x 343 mm)
Edition: 12
Paper: China/India
Plate: Stone (4)
Publications: Spence, cat. p. 140; Zigrosser-AFA, cat. #41.
Comments: Central image in four colors of a portly male in bowler, hands folded across stomach. Variously dated 1944. Has been ascribed to WPA. Signed, titled, and dated in graphite.

106. Untitled [Announcement of Art Sale]
Lithograph, colored pencil
Image: 8 x 9" (203 x 228 mm)
Sheet: 8 x 9" (203 x 228 mm)
Edition: 50
Paper: Strathmore single-ply
Plate: Stone
Collections: Private collection
Comments: Map with directions to Kohn's studio. Created for sale/auction he held to raise money for his trip to Mexico.

1944

107. *Bull Fight*
Alternate title: *Man and Bull*
Wood engraving
Image: 4 3/8 x 6 5/8" (111 x 168 mm)
Sheet: 6 1/16 x 8 7/8" (154 x 225 mm)
Edition: 20
Paper: China/India
Printer/Publisher: *Taller de Grafica Popular,* Mexico City
Collections: Academia de Artes, Mexico City; private collections
Publications: Spence, cat. p. 141 [as *Man and Bull*]; Zigrosser-AFA cat. #58.
Comments: Bullfighter at left preparing to stab bull; three bandoliers already stuck in animal's back. Bull's face is partially

obscured by bullfighter's cape. Academia de Artes' incorrectly identified as a linoleum cut. Variously dated 1949. MK in block, lr; signed and dated in graphite.

108. *Bull Fight*
Wood engraving
Image: 6 5/8 x 9 9/16" (168 x 243 mm)
Sheet: 7 7/8 x 10 9/16" (200 x 268 mm)
Edition: 20
Printer/Publisher: *Taller de Grafica Popular,* Mexico City
Collections: Private collections
Publications: Nebraska Art Association 1951, cat; Spence, cat. p. 141; Zigrosser-AFA, cat. #59.
Comments: Bull goring a horse; bullfighter looking on from right. MK in block, ll; signed in graphite.

109. *Bullfighter Carlos Arruza*
Alternate title: *Bull Fighter (Arruza)*
Wood engraving
Image: 9 7/8 x 2 15/16" (250 x 75 mm)
Sheet: 14 x 7 7/16" (255 x 189 mm)
Edition: 18
Paper: China/India
Collections: Private collections
Publications: Spence, cat. p. 141; Zigrosser-AFA, cat. #61 [as *Bull Fighter (Arruza)*].
Comments: Full-length portrait of the matador in his "suit of lights." Kohn had met Arruza in Acapulco, where the latter was recuperating from a stab wound from one of his "fans." Variously dated 1945. Signed and dated in graphite.

110. *Homage to Miro*
Woodcut
Image: 11 x 10" (279 x 254 mm) irregular
Paper: China/India
Comments: Miro-esque abstraction. Two blocks used for this color woodcut.

111. *Mexican Landscape*
Alternate titles: *Landscape (Mexico); Mexican Landscape (Pauhuatlán)*
Lithograph, printed A) black only, B) black and gray
Image: 9 1/4 x 13 3/4" (235 x 349 mm) irregular
Sheet: 12 5/8 x 19" (320 x 482 mm)
Edition: 18 [10]
States: 2
Paper: Strathmore double-ply
Plate: Stone (2)
Printer/Publisher: *Taller de Grafica Popular,* Mexico City

Collections: Academia de Artes, Mexico City (2)
Publications: Spence, ill. #8, cat. p. 141; Zigrosser-AFA, ill. #9, cat. #55.
Comments: Mexican valley scene with road winding through fields, foreground, up into mountains, background. Signed, ed. info, titled, and dated in graphite.

112. *Mexican Woman*
Lithograph, printed A) black only, B) three-color
Image: 14 1/4 x 8 1/2" (362 x 216 mm)
Edition: 18
Plate: Stone (3)
Printer/Publisher: *Taller de Grafica Popular,* Mexico City
Collections: Academia de Artes, Mexico City
Publications: Spence, cat. p. 141; Zigrosser-AFA, cat. #53.
Comments: Spence: "Seated figure in full-length frontal view, rendered in pink, blue, and brownish-black."

113. *Sand, Rocks, and Tree Stump*
Wood engraving
Image: 3 1/2 x 7 1/4" (89 x 184 mm)
Sheet: 4 5/8 x 10 5/8" (117 x 270 mm) irregular
Edition: 8
Paper: China/India
Collections: Private collection
Publications: Spence, ill. #12, cat. p. 141; Zigrosser-AFA, cat. #62.
Comments: Stylized landscape with deformed tree stump to left foreground, rocks and sand center foreground, the sea or clouds background. This block had been left over from the *Pursuit of Freedom* series.

114. *Seated Mexican Woman*
Alternate title: *Seated Woman*
Lithograph
Image: 14 1/2 x 8 1/2" (368 x 216 mm)
Edition: 10
Plate: Stone
Printer/Publisher: *Taller de Grafica Popular,* Mexico City
Spence, cat. p. 141; Zigrosser-AFA, cat. #52.
Comments: Color lithograph.

115. *Seated Woman*
Lithograph, printed A) black only, B) color
Image: 14 1/2 x 8 1/2" (368 x 216 mm)
Edition: 20

with an addition that hardened the crayons and permitted the drawing of very fine lines. Many of the drawings of park scenes were done from the top floor of Mies van der Rohe's building at the Institute of Design, which looked out over the park. Signed, titled, and dated in graphite.

92. *The Park is a Lonely Place This Day*
Lithograph
Image: 10 7/8 x 8 5/8" (276 x 220 mm)
Sheet: 18 9/16 x 12 1/16" (472 x 307 mm)
Edition: 6 [10]
Plate: Stone
Paper: Strathmore? single-ply wove
Collections: Indiana University Art Museum; private collection
Publications: Spence, cat. p. 139; Zigrosser-AFA, cat. #35.
Comments: Deserted wooded park on a cloudy winter day. Signed, ed. info, titled, and dated in graphite.

93. *The Studio*
Lithograph
Image: 13 1/4 x 19 3/4" (336 x 502 mm)
Edition: 10
Plate: Stone
Publications: Spence, cat. p. 139; Zigrosser-AFA, cat. #37.
Comments: Spence: "Empty studio with still-life on table in foreground."

c. 1942

94. *Isabelle Kohn*
Linoleum cut
Image: 4 1/2 x 3 3/4" (114 x 95 mm) irregular
Collections: Private collection
Comments: Stylized girl with flowing tresses in sleeveless patterned dress, facing right with head turned frontally. Created as a bookmark. ISABELLE [backwards] KOHN [N backwards] vertical in block, left margin.

1943

95. *Blue Rebozo*
Alternate title: *The Blue Rebozo*
Lithograph
Image: 13 5/8 x 8 7/8" (346 x 225 mm)
Sheet: 15 3/8 x 11" (390 x 279 mm)
Edition: 18
Paper: BFK Rives
Plate: Stone (4)

Printer/Publisher: *Taller de Grafica Popular,* Mexico City
Collections: Academia de Artes, Mexico City
Publications: "Distinguished Young Local Artist Given Grant," *Kokomo Tribune,* 1952, ill; "Blue Rebozo," *Indianapolis Star* 7/2/61, ill; "The Week in Indiana Art," *Indianapolis Star* 6/25/61, ill; Spence, cat. p. 141. Zigrosser-AFA, ill. #8, cat. #54.
Comments: Four-color lithograph of a bust of young woman looking left, with head wrapped in blue shawl. Variously dated 1944. Signed, ed. info, titled, and dated in graphite.

96. *Bull*
Alternate title: *Wounded Bull*
Wood engraving
Image: 2 3/4 x 4 1/4" (70 x 108 mm)
Sheet: 3 3/8 x 5 5/8" (88 x 143 mm)
Edition: 20
Paper: China/India
Printer/Publisher: *Taller de Grafica Popular,* Mexico City
Collections: Academia de Artes, Mexico City; private collection
Publications: Spence, cat. p. 141 [dated 1944]; Zigrosser-AFA, cat. #57.
Comments: Central image of bull with two bandoliers stuck in its back, flying cape wrapped around its left horn. Variously dated 1944. MK in block, ll; signed, ed. info, and dated in graphite.

97. *Chicago Street Scene*
Lithograph
Image: 7 x 9 3/8" (178 x 238 mm)
Edition: 5
Plate: Stone
Publications: Spence, cat. p. 140; Zigrosser-AFA, cat. #50.
Comments: Spence: "Hopper-like description of store fronts seen head-on."

98. *Landscape in Sicily*
Lithograph
Image: 9 x 12 7/8" (228 x 327 mm)
Edition: 10
Plate: Stone
Publications: Spence, cat. p. 140; Zigrosser-AFA, cat. #47.
Comments: Spence: "Panoramic view of mountainous terrain, with soldiers marching mid-distance." Sepia lithograph.

99. *Max*
Alternate title: *Max Kahn*
Lithograph
Image: 8 1/2 x 5 3/4" (216 x 146 mm)
Edition: 10
Plate: Stone
Publications: Spence, cat. p. 140; Zigrosser-AFA, cat. #48.
Comments: Portrait of the artist's teacher and friend.

100. *Parachutists*
Lithograph
Image: 18 x 10 1/8" (457 x 257 mm)
Edition: 10
Plate: Stone
Publications: Spence, cat. p. 140; Zigrosser-AFA, cat. #46.
Comments: Color lithograph.

101. *Still Life*
Alternate title: *Still Life and Open Window*
Lithograph
Image: 16 1/2 x 10 3/8" (419 x 263 mm)
Edition: 5
Plate: Stone
Publications: Zigrosser-AFA, cat. #44.

102. *Street Scene*
Lithograph
Image: 25 x 19" (635 x 482 mm)
Edition: 10
Plate: Stone
Publications: Spence, cat p. 140; Zigrosser-AFA, cat. #43.
Comments: Spence: "Woman of streets in fur collar walking past brownstone fronts."

103. *Survivors*
Lithograph
Image: 10 1/2 x 13 3/4" (267 x 349 mm) irregular
Sheet: 14 1/8 x 15" (359 x 381 mm)
Edition: 27
Paper: China/India
Plate: Stone (2)
Collections: Library of Congress
Publications: Landau, Ellen G., *Artists for Victory,* cat. p. 60; Library of Congress 1970, cat. #31; Spence, cat. p. 140; Zigrosser-AFA, cat. #45.
Comments: Central image of lifeboat full of people adrift at sea. This two-color lithograph was included in the exhibition *America in the War,* sponsored by Artists for Victory, 1943, and shown simultaneously in 26 museums. Has been ascribed to WPA. Signed, ed. info, titled, and dated in graphite.

Comments: Four-color print virtually
identical in image to the black/white
Chicago, 1940.

82. *Christmas Eve*
Lithograph
Image: 5 1/2 x 8 7/8" (140 x 225 mm)
Edition: 165
Paper: Strathmore double-ply
Plate: Stone (5)
Collections: Private collections
Publications: Spence, cat. p. 139; Zigrosser-
 AFA, cat. #33.
Comments: Fanciful imagery including a
 female with rolling pin to left, and
 flying horse to right. Five-color litho-
 graph commissioned by curator Carl
 Schniewind as a holiday gift for mem-
 bers of the Print and Drawing Club of
 the Art Institute of Chicago.

83. *Lake Summer Steamers*
Alternate title: *Lake Summer*
Lithograph
Image: 12 x 17 3/4" (305 x 451 mm)
Sheet: 17 1/16 x 22 15/16" (433 x 583 mm)
Edition: 18
Paper: Strathmore double-ply
Plate: Stone (3)
Printer/Publisher: WPA
Collections: Art Institute of Chicago (3);
 Monterey Museum of Art; National
 Museum of American Art, Smithsonian
 Institution
Publications: Spence, cat. p. 138; Zigrosser-
 AFA, cat. #27.
Comments: Three-color view of a lake sur-
 rounded by winding brick wall fore-
 ground; stylized trees in grassy back-
 ground. WPA #6880. Titled, signed, and
 dated in graphite.

84. *Lament*
Wood engraving
Image: 4 15/16 x 7" (125 x 178 mm)
Sheet: 8 3/4 x 9 3/16" (222 x 233 mm)
 irregular
Edition: 1000 [of calendar], plus artist's
 impressions
Collections: Private collections
Publications: Covenant Club, cat. #49;
 United American Artists, *Calendar* ill. for
 June, 1941.
Comments: Nocturnal scene of grievers
 with skeletal nag center foreground, and
 burned-out brick building center back-
 ground. KOHN in block, ll.

85. *Man with a Pipe*
Alternate titles: *Man with Pipe; Old Man;
 Old Man with a Pipe*
Lithographic tusche wash drawing on
 serigraph, printed A) black only, B) five-
 color
Image: 23 1/4 x 14 5/8" (591 x 371 mm)
Sheet: 26 x 20" (661 x 508 mm)
Edition: 20 [35]
States: 2
Paper: Strathmore single- and double-ply
 or Alexandro Japanese
Plate: Stone (5)
Printer/Publisher: WPA
Collections: Art Institute of Chicago (2);
 Krannert Art Museum; Philadelphia
 Museum of Art
Publications: Evans and McKenna, *After
 the Great Crash*, ill. cat. #41, p. 24;
 Spence, cat. p. 138; Zigrosser-AFA,
 ill. #7, cat. #29.
Comments: Five-color portrait of seated
 gentleman 3/4 profile right, holding
 pipe in his lap. WPA #6070. Philadelphia
 Museum of Art has one of their two
 prints incorrectly identified as a litho-
 graph. Signed, ed. info, titled, and dated
 in graphite.

86. *Woman in Magenta*
Lithograph
Image: 18 1/8 x 10 1/2" (460 x 267 mm)
Edition: 18
Plate: Stone (3)
Printer/Publisher: WPA
Publications: Spence, cat. p. 138; Zigrosser-
 AFA, cat. #24.
Comments: Three-color lithograph.

1942

87. *Artist and His Wife*
Alternate titles: *The Studio; The Studio
 (Artist and Wife with Gas Masks)*
Lithograph
Image: 13 1/2 x 19 5/8" (343 x 498 mm)
Sheet: 17 3/8 x 24 1/2" (441 x 622 mm)
Edition: 13 [10]
Paper: Strathmore double-ply or Poype
Plate: Stone
Printer/Publisher: WPA?
Publications: Spence, cat. p. 139; Zigrosser-
 AFA, cat. #38.
Comments: Miro-esque scene of painter,
 left background, and wife, right fore-
 ground, both wearing gas masks; para-
 chutists in far background. Signed, ed.
 info, titled, and dated in graphite.

88. *Creek in Winter*
Alternate titles: *Winter; Winter in Park;
 Winter in the Park*
Lithograph
Image: 12 1/2 x 8" (317 x 203 mm) irregular
Edition: 10
Plate: Stone
Publications: *American Prints Today*, John
 Herron 1943, ill. p. 4; cat. pp. 2, 6.
 Spence, cat. p. 139; Zigrosser-AFA,
 cat. #36.
Comments: Ice skaters, center foreground,
 against wooded nocturnal setting.

89. *Junk Man*
Lithograph
Image: 8 3/8 x 5 1/8" (213 x 130 mm)
Edition: 10
Plate: Stone
Collections: Private collection
Publications: Spence, cat. p. 140; Zigrosser-
 AFA, cat. #49.
Comments: Central image of male with hat
 and pipe in his left hand, foreground;
 cello in background painting. Variously
 dated 1943. Signed, titled, and dated H.
 Misch Kohn in graphite.

90. *Night Piece*
Lithograph
Image: 13 5/8 x 12 3/4" (346 x 324 mm)
Edition: 5
Plate: Stone
Publications: Spence, cat. p. 139; Zigrosser-
 AFA, cat. #39.
Comments: Nocturnal view of buildings in
 disrepair.

91. *The Park*
Alternate title: *In the Park*
Lithograph
Image: 9 3/8 x 13 13/16" (238 x 351 mm)
 irregular
Sheet: 14 x 19 1/4" (355 x 489 mm)
Edition: 18
Paper: China/India
Plate: Blue stone
Printer/Publisher: WPA?
Publications: Spence, cat. p. 139; Zigrosser-
 AFA, cat. #34.
Comments: Wooded park with three paths
 and various visitors, including a woman
 walking her dog, right foreground, and
 a mother with child on a bench, left fore-
 ground. This image was drawn on blue
 stone, a surface that enabled artists to
 use hard carnauba-wax crayons. These
 crayons were made by Kahn, Coen, and
 Kohn in their studio according to the
 formula created by Bolton Brown, but

67. Untitled
Woodcut
Image: 3 x 2" (76 x 51 mm)
Edition: 18?
Paper: Single-ply wove
Collections: Private collection
Comments: Elaborate plant in foreground; muscular male figure, upper right. May have been an illustration for a literary tale; specific reference unknown. KOHN vertically in plate, ur.

68. Untitled
Woodcut
Image: 4 x 3" (102 x 76 mm)
Edition: 18?
Paper: Single-ply wove
Collections: Private collection
Comments: Bearded male head, profile left, floating against a black background. May have been an illustration for a literary tale; specific reference unknown. HK in block, ll.

69. Untitled
Woodcut
Image: 5 x 3" (127 x 76 mm)
Edition: 18?
Paper: Single-ply wove
Collections: Private collection
Comments: Nude figure and resting horse, background; prone figure foreground. May have been an illustration for a literary tale; specific reference unknown. KOHN vertically in block, ll.

70. Untitled
Wood engraving
Image: 6 x 3 15/16" (153 x 100 mm)
Sheet: 8 3/8 x 6 1/2" (213 x 165 mm)
Paper: Single-ply wove
Plate: Boxwood
Collections: Private collection
Comments: Wooded scene with various figures, horses. HK vertically in block, 2/3 down on left margin.

71. Untitled
Wood engraving
Image: 6 x 5 1/4" (153 x 133 mm)
Sheet: 9 x 5 7/8" (228 x 149 mm)
Paper: Basingwerk parchment
Plate: Boxwood
Collections: Private collection
Comments: Two horses resting, foreground; single figure to left, couple in background.

72. Untitled [Costumed Dancers]
Woodcut
Image: 6 7/8 x 5" (175 x 127 mm)
Sheet: 11 1/2 x 6 3/8" (292 x 162 mm)
Paper: Single-ply wove
Collections: Private collection
Comments: Nocturnal scene with costumed dancers. Believed to be a commissioned illustration of a Russian folk tale; specific reference unknown. HK vertically in block, ll.

73. Untitled [Nativity Scene]
Woodcut
Image: 5 x 5 7/8" (127 x 149 mm)
Sheet: 6 5/8 x 7 1/8" (168 x 181 mm)
Paper: Heavily-textured double-ply mounted on commercial silvered stock
Collections: Private collections
Comments: Nativity scene with costumed figures in European village. Sent out as holiday greeting card.

74. Untitled [Portrait]
Wood engraving
Image: 4 x 3 1/4" (102 x 83 mm)
Sheet: 7 x 6" (178 x 153 mm)
Paper: China/India
Collections: Private collection
Comments: Bust-length 3/4 profile left of young woman friend that played the violin.

75. Untitled [Schniewind Card]
Wood engraving, printed A) black, B) brown
Image: 5 1/8 x 4 1/16" (130 x 103 mm each block; 212 mm width together)
Sheet: 6 9/16 x 8 15/16" (167 x 227 mm)
Paper: China/India
Collections: Art Institute of Chicago (2)
Comments: Left block is image of clown, 3/4 profile right, and acrobat; right block has carved inscription below frieze of horses and circus performers. The two blocks are printed side by side as a diptych, and were printed variously in black and in brown.

76. *Mining Country*
Comments: Angular images of slag, cars, and rooftops.

1941

77. *Acrobats*
Lithograph
Image: 11 x 8 3/4" (280 x 222 mm)
Edition: 8

Plate: Stone (4)
Printer/Publisher: WPA
Publications: Spence, cat. p. 138; Zigrosser-AFA, cat. #21.
Comments: Four-color lithograph.

78. *Arletty*
Alternate titles: *Ardality; Ardletty*
Lithograph
Image: 17 1/2 x 13 3/8" (445 x 340 mm) irregular
Sheet: 25 13/16 x 19 7/8" (656 x 504 mm)
Edition: 15 [6]
Paper: Single-ply wove
Plate: Stone (4)
Printer/Publisher: WPA
Collections: Art Institute of Chicago; private collection
Publications: Spence, cat. p. 138; Zigrosser-AFA, cat. #25.
Comments: Four-color image of a female figure in yellow dress foreground; curtains against background window parted to reveal horses and circus tents. Signed, ed. info, titled, and dated in graphite.

79. *Artist in his Studio*
Wood engraving
Image: 6 1/8 x 3 3/4" (155 x 95 mm)
Edition: 10
Printer/Publisher: WPA
Publications: Spence, cat. p. 139; Zigrosser-AFA, cat. #31.

80. *Camouflage*
Serigraph
Image: 24 x 15" (610 x 381 mm)
Edition: 30
Printer/Publisher: WPA
Publications: Spence, cat. p. 139; Zigrosser-AFA, cat. #30.
Comments: Four color image of netting covering gun emplacement in order to conceal it. The WPA administration had asked artists to create some works with military themes; this was one of Kohn's prints that responded to that request.

81. *Chicago River*
Alternate titles: *Chicago River (Bridge and Tugs); Illinois River Scene*
Lithograph
Image: 9 7/8 x 11 3/4" (251 x 298 mm)
Edition: 18
Plate: Stone (4)
Printer/Publisher: WPA
Publications: Spence, cat. p. 138; Zigrosser-AFA, cat. #23.

Publications: *New Anvil* (July-August 1940), ill. inside front cover.
Comments: Group of four miners, right foreground, in front of mine shaft. Illustration for Don West's poem "Toil and Hunger," published in July-August 1940 edition of *New Anvil* literary magazine.

55. Untitled [Crucifixion]
Wood engraving
Image: 3 x 2 1/8" (76 x 54 mm)
Sheet: 5 3/4 x 4" (146 x 102 mm)
Paper: China/India
Collections: Private collection
Comments: Crucified Jesus, background, with hooded onlookers and praying woman, lower right foreground. Signed and dated in graphite.

56. Untitled [Four Workmen in a Steel Factory Scene]
Alternate title: [Four Men in a Steel Factory]
Wood engraving
Image: 2 15/16 x 10 1/16" (74 x 256 mm)
Sheet: 4 3/4 x 12 5/16" (120 x 313 mm) irregular
Paper: China/India
Printer/Publisher: WPA
Collections: Art Institute of Chicago
Comments: Four workers manipulating a coal furnace, center; train right foreground with factory buildings and smokestacks behind.

57. Untitled [Horse-Drawn Cart]
Wood engraving
Image: 3 1/2 x 4" (90 x 102 mm)
Sheet: 4 7/16 x 4 5/8" (113 x 117 mm)
Paper: China/India
Printer/Publisher: WPA
Collections: Art Institute of Chicago
Comments: Two thin horses pulling a cart. M I S C H vertically in block, ll.

58. Untitled [Three Workmen with Industrial Scene]
Wood engraving
Image: 3 1/8 x 4" (80 x 102 mm)
Sheet: 4 1/2 x 4 5/8" (115 x 117 mm)
Paper: China/India
Printer/Publisher: WPA
Collections: Art Institute of Chicago
Comments: Three male workers clustered in group, right foreground; factory scenes to left.

59. Untitled [Two Men in a Village Scene]
Wood engraving
Image: 3 1/8 x 4" (80 x 100 mm)
Sheet: 4 5/16 x 5 1/16" (110 x 129 mm) irregular
Paper: China/India
Printer/Publisher: WPA
Collections: Art Institute of Chicago
Comments: Two men left foreground; European folk-style houses background and right foreground.

60. Untitled [Two Men in Top Hats]
Wood engraving
Image: 3 1/4 x 4" (82 x 100 mm)
Sheet: 4 1/2 x 4 1/2" (114 x 115 mm) irregular
Paper: China/India
Printer/Publisher: WPA
Collections: Art Institute of Chicago
Comments: Two men in top hats before polling booth. May have been originally intended for use as an illustration for the *Pursuit of Freedom* project.

61. Untitled [Workman's Family at Table]
Wood engraving
Image: 3 1/8 x 4" (81 x 101 mm)
Sheet: 5 1/4 x 7 7/8" (134 x 200 mm)
Paper: China/India
Printer/Publisher: WPA
Collections: Art Institute of Chicago
Comments: Five people eating together around a table.

62. *Wasteland*
Lithograph
Image: 12 3/8 x 17 5/8" (316 x 447 mm) irregular
Sheet: 20 x 25 1/2" (508 x 648 mm)
Edition: 10
Paper: Strathmore double-ply
Plate: Stone
Printer/Publisher: WPA
Collections: Art Institute of Chicago; Krannert Art Museum
Publications: Spence, ill. #2, cat. p. 137; Zigrosser-AFA, ill. #4, cat. #14.
Comments: Nocturnal scene of caravan of carts and pedestrians heading left across picture plane, foreground; bombed out building in background. Signed, ed. info, titled, and dated in graphite.

63. *Woman in Red Jacket*
Alternate titles: *Red Jacket; Woman in Red; Woman with Red Jacket*
Lithograph
Image: 11 7/8 x 8 1/2" (302 x 216 mm) irregular

Sheet: 14 1/8 x 11 1/2" (359 x 292 mm)
Edition: 10 [18]
Paper: Strathmore double-ply
Plate: Stone (3)
Printer/Publisher: WPA
Collections: Art Institute of Chicago; Mulvane Art Museum, Washburn University; National Museum of American Art, Smithsonian Institution; Philadelphia Museum of Art
Publications: Spence, cat. p. 137 [as *Woman with Red Jacket*]; Zigrosser-AFA, cat. #19.
Comments: Tired woman with red vest and striped shirt, arms crossed in foreground. WPA #4981; accepted by Illinois FAP April 26, 1941. Variously dated 1941, 1942. Three-color lithograph [Kohn was going to add one additional stone, but satisfied with it as it was, he never added the last color]. Philadelphia Museum of Art's print is incorrectly identified as a linocut. Signed, ed. info, titled, and dated in graphite.

c. 1940

64. *Drummer*
Alternate title: *The Drummer*
Lithograph
Plate: Stone
Printer/Publisher: WPA?
Collections: Art Institute of Chicago
Comments: Color lithograph.

65. *Nikotoska*
Woodcut
Image: 5 x 6 15/16" (127 x 176 mm)
Sheet: 9 x 11 7/8" (228 x 302 mm)
Paper: Commercial single-ply or card stock
Collections: Private collection
Comments: Village scene with woman riding atop oxen-pulled cart; all figures in traditional costumes. Believed to be a commissioned illustration for a Russian folk tale; specific reference unknown. Signed "Harris Kohn" in graphite.

66. *Street Scene*
Wood engraving
Image: 2 7/8 x 10" (73 x 254 mm)
Sheet: 4 5/8 x 12 3/4" (117 x 324 mm)
Edition: 18?
Paper: China/India
Printer/Publisher: WPA
Collections: Private collection
Comments: Urban scene with auto crossing by store fronts under train trestle, center; trio of standing figures to left, and busts of three men, lower right.

Publications: *Pursuit of Freedom: History of Civil Liberty in Illinois 1787-1942,* ill. Chapter XII, p. 154; Spence, cat. p. 139; Zigrosser-AFA, cat. #32, pp. 26-7.
Comments: Depiction of a demonstration of unemployed workers demanding food, shelter, and a stop to housing evictions.

46. *Pursuit of Freedom: The Rights of Labor*
Alternate title: *Haymarket*
Wood engraving
Image: 2 7/8 x 4" (73 x 102 mm)
Edition: 8
Paper: China/India
Printer/Publisher: Chicago Civil Liberties Committee (Following Kohn's printing of 8 complete sets of artist's impressions on China/India, this Committee published the series of 16 prints from the original blocks as a book, publication data below)
Collections: Art Institute of Chicago; private collection
Publications: *Pursuit of Freedom: History of Civil Liberty in Illinois 1787-1942,* ill. Chapter XIII, p. 170; Spence, cat. p. 139; Zigrosser-AFA, cat. #32, pp. 26-7.
Comments: Policemen beating up demonstrating workers.

47. *Pursuit of Freedom: Unconstitutional Police Methods*
Wood engraving
Image: 2 7/8 x 4" (73 x 102 mm)
Edition: 8
Paper: China/India
Printer/Publisher: Chicago Civil Liberties Committee (Following Kohn's printing of 8 complete sets of artist's impressions on China/India, this Committee published the series of 16 prints from the original blocks as a book, publication data below)
Collections: Art Institute of Chicago; private collection
Publications: *Pursuit of Freedom: History of Civil Liberty in Illinois 1787-1942,* ill. Chapter XI, p. 142; Spence, cat. p. 139; Zigrosser-AFA, cat. #32, pp. 26-7.
Comments: Two uniformed policemen use undue force on an unconscious victim.

48. *Solomon Cucumber*
Lithograph
Image: 11 3/4 x 9" (299 x 229 mm)
Sheet: 14 1/2 x 11 1/2" (369 x 292 mm)
Edition: 11 [18]
Paper: Strathmore double-ply wove
Plate: Stone (5)

Printer/Publisher: WPA
Collections: National Museum of American Art, Smithsonian Institution; Philadelphia Museum of Art
Publications: *Art Under the New Deal,* cat. #46; Morehouse, Lucille E., *Indianapolis Star* 11/43, ill; Spence, cat. p. 138 [dated 1941]; *WPA/FAP Graphics,* SITES 1976, cat. #18; Zigrosser, *Between Two Wars,* cat. #204; Zigrosser-AFA, ill. #6, cat. #20.
Comments: Five-color portrait of a young male with cap, 3/4 profile left. Subject has been alternatively described as an illustration for a Jewish fairy tale, a neighborhood boy, and a compilation of different people into an imaginary portrait. WPA #4722. Variously dated 1941. Signed, ed. info, titled, and dated in graphite.

49. *Tamar's Dream*
Woodcut
Image: 17 5/8 x 6 1/2" (448 x 165 mm)
Sheet: 20 x 8 13/16" (508 x 224 mm)
Edition: 18
Paper: China/India
Plate: Maple plank
Printer/Publisher: WPA
Publications: Spence, cat. p. 136; Zigrosser-AFA, cat. #5.
Comments: Group of figures with long tresses astride a horse. Illustration for/inspired by Robinson Jeffer's poem "Tamar." Signed, ed. info, titled, and dated in graphite.

50. *The Bird Catcher*
Alternate title: *Man with Bird*
Lithograph, printed A) black only, B) four-color
Image: 12 1/2 x 8" (318 x 203 mm) irregular
Sheet: 15 1/2 x 12 3/4" (394 x 324 mm)
Edition: 18 [16: A) 8, B) 8]
States: 2
Paper: A) China/India, B) Strathmore double-ply
Plate: Stone (4)
Publications: Spence, cat. p. 141 [as *Man with Bird,* dated 1944]; Zigrosser-AFA, cat. #63 [as *Man with Bird,* dated 1944].
Comments: Full-length portrait of muscular male holding bird in right hand. Variously dated 1944.

51. *The Cello Player*
Alternate titles: *Cello Player; The Cellist*
Lithograph
Image: 18 1/16 x 12 3/4" (460 x 323 mm) irregular

Sheet: 23 x 13 13/16" (585 x 351 mm)
Edition: 20 [15] [10]
Paper: Strathmore double-ply
Plate: Stone (4)
Printer/Publisher: WPA
Collections: Art Institute of Chicago; Kokomo-Howard County Public Library, Hoosier Art Collection; private collections
Publications: *Hoosier Art Collection of the Kokomo-Howard County Public Library,* 1993, color ill. p. 13, cat. p. 12; Spence, cat. p. 137; Zigrosser-AFA, cat. #7.
Comments: Four-color portrait of a male cellist holding his cello, foreground. Variously dated 1941. Signed, ed. info, titled, and dated in graphite.

52. *The Fisherman*
Alternate titles: *Fisherman; The Net Maker*
Lithograph
Image: 14 7/8 x 10 1/4" (379 x 260 mm) irregular
Sheet: 17 3/8 x 10 5/8" (441 x 270 mm)
Edition: 18 [10]
Paper: Strathmore double-ply
Plate: Stone (4)
Printer/Publisher: WPA
Collections: Art Institute of Chicago; National Museum of American Art, Smithsonian Institution; Southern Illinois University Museum; private collection
Publications: *Art Under the New Deal,* cat. #45; Bernstein, Barbara, *Federal Art in Illinois,* cat; Spence, cat. p. 136; Zigrosser-AFA, cat. #6.
Comments: Four-color image of fisherman mending nets seated right foreground; rough sea and angry sky background. WPA #4198. Signed, ed. info, titled (variously), and dated in graphite.

53. *The Painter*
Lithograph
Image: 8 x 4 1/2" (203 x 114 mm)
Edition: 10
Plate: Stone
Printer/Publisher: WPA
Publications: Spence, cat. p. 137; Zigrosser-AFA, cat. #13.

54. *Toil*
Wood engraving
Image: 3 x 4 7/8" (76 x 124 mm)
Edition: 18?
Paper: China/India
Printer/Publisher: WPA?
Collections: Private collection

original blocks as a book, publication data below)

Collections: Art Institute of Chicago; private collection

Publications: *Pursuit of Freedom: History of Civil Liberty in Illinois 1787-1942*, ill. Chapter VII, p. 94; Spence, cat. p. 139; Zigrosser-AFA, cat. #32, pp. 26-7.

Comments: Two males hold an almost nude male, center, in preparation for a lynching.

39. *Pursuit of Freedom: Frontispiece*
Wood engraving
Image: 5 x 3 3/4" (127 x 95 mm)
Sheet: 7 3/8 x 6 5/8" (187 x 168 mm)
Edition: 18
States: 2
Paper: China/India
Printer/Publisher: Chicago Civil Liberties Committee (Following Kohn's printing of 8 complete sets of artist's impressions on China/India, this Committee published the series of 16 prints from the original blocks as a book, publication data below)
Collections: Art Institute of Chicago; private collection
Publications: *Pursuit of Freedom: A History of Civil Liberty in Illinois 1787-1942*, frontispiece ill; Spence, cat. p. 139; Zigrosser-AFA, cat. #32, pp. 26-7.
Comments: Prone figure on back, head to right, foreground; figure with arms outstretched toward open window, background. Second state has upper left corner carved away. MISCH KOHN in block, ll; signed and titled in graphite.

40. *Pursuit of Freedom: In Pursuit of Freedom*
Wood engraving
Image: 2 7/8 x 4" (73 x 102 mm)
Edition: 8
Paper: China/India
Printer/Publisher: Chicago Civil Liberties Committee (Following Kohn's printing of 8 complete sets of artist's impressions on China/India, this Committee published the series of 16 prints from the original blocks as a book, publication data below)
Collections: Art Institute of Chicago; private collection
Publications: *Pursuit of Freedom: A History of Civil Liberty in Illinois 1787-1942*, ill. Chapter I, p. 1; Spence, cat. p. 139; Zigrosser-AFA, cat. #32, pp. 26-7.
Comments: Couple holding child with one hand moves away from the viewer around the corner of a brick wall.

41. *Pursuit of Freedom: Organized Mob Violence*
Alternate title: *Ku Klux Klan*
Wood engraving
Image: 2 7/8 x 4" (73 x 102 mm)
Edition: 8
Paper: China/India
Printer/Publisher: Chicago Civil Liberties Committee (Following Kohn's printing of 8 complete sets of artist's impressions on China/India, this Committee published the series of 16 prints from the original blocks as a book, publication data below)
Collections: Art Institute of Chicago; private collection
Publications: *Pursuit of Freedom: History of Civil Liberty in Illinois 1787-1942*, ill. Chapter X, p. 130; Spence, cat. p. 139; Zigrosser-AFA, cat. #32, pp. 26-7.
Comments: Hooded Ku Klux Klan members burn a male nude at the cross.

42. *Pursuit of Freedom: Preface*
Alternate title: *Eternal Vigilance is the Price of Freedom*
Wood engraving
Image: 3 x 1 3/4" (76 x 44 mm)
Sheet: 7 15/16 x 3" (202 x 76 mm)
Edition: 11
States: 2
Paper: China/India
Printer/Publisher: Chicago Civil Liberties Committee (Following Kohn's printing of 8 complete sets of artist's impressions on China/India, this Committee published the series of 16 prints from the original blocks as a book, publication data below)
Collections: Art Institute of Chicago; private collection
Publications: *Pursuit of Freedom: A History of Civil Liberty in Illinois 1787-1942*, title page ornament; Spence, cat. p. 139; Zigrosser-AFA, cat. #32, pp. 26-7.
Comments: Male with back to viewer, outstretched arms and head tilted back; strong diagonal from background urban scene. Second state has triangular area completely cut out from center right margin. Signed and titled in graphite.

43. *Pursuit of Freedom: Rights of Aliens*
Wood engraving
Image: 2 7/8 x 4" (73 x 102 mm)
Edition: 8
Paper: China/India
Printer/Publisher: Chicago Civil Liberties Committee (Following Kohn's printing of 8 complete sets of artist's impressions

on China/India, this Committee published the series of 16 prints from the original blocks as a book, publication data below)
Collections: Art Institute of Chicago; private collection
Publications: Martin, Lawrence, "Pursuit of Freedom tells Long Battle for Civil Liberties," ill. p. 8M; *Pursuit of Freedom: History of Civil Liberty in Illinois 1787-1942*, ill. Chapter VIII, p. 109; Spence, cat. p. 139; Zigrosser-AFA, cat. #32, pp. 26-7.
Comments: Melee of Ku Klux Klan members, a horse, and a dead figure, center foreground; Nazi swastika dominates mid-center. This image may have been intended to illustrate Chapter IX, "Anti-Semitism," but was inadvertently switched by the publisher.

44. *Pursuit of Freedom: Rights of Political Minorities*
Alternate title: *Prisoners*
Wood engraving
Image: 2 7/8 x 4" (73 x 102 mm)
Edition: 8
Paper: China/India
Printer/Publisher: Chicago Civil Liberties Committee (Following Kohn's printing of 8 complete sets of artist's impressions on China/India, this Committee published the series of 16 prints from the original blocks as a book, publication data below)
Collections: Art Institute of Chicago; private collection
Publications: *Pursuit of Freedom: History of Civil Liberty in Illinois 1787-1942*, ill. Chapter VI, p. 83; Spence, cat. p. 139; Zigrosser-AFA, cat. #32, pp. 26-7.
Comments: Male figure, left, shackled to the cracking columns of a courthouse.

45. *Pursuit of Freedom: Rights of the Unemployed*
Wood engraving
Image: 2 7/8 x 4" (73 x 102 mm)
Edition: 8
Paper: China/India
Printer/Publisher: Chicago Civil Liberties Committee (Following Kohn's printing of 8 complete sets of artist's impressions on China/India, this Committee published the series of 16 prints from the original blocks as a book, publication data below)
Collections: Art Institute of Chicago; private collection

Sheet: 23 x 16" (584 x 406 mm)
Edition: 19 [24] [8] [10]
States: 2
Paper: Strathmore double-ply
Plate: Stone (4)
Printer/Publisher: WPA
Collections: Art Institute of Chicago (3);
 Krannert Art Museum; private
 collections
Publications: *American Prints Today*, John
 Herron 1943, cat. #56, p. 6; Spence,
 ill. #3, cat. p. 138; Zigrosser-AFA, ill. #5,
 cat. #16.
Comments: Male with cap left foreground,
 peering outside of picture plane; reced-
 ing rural landscape in background.
 Inspired by Alfred Doblin's novel. WPA
 #4532. Variously dated 1941, 1942.
 Signed, titled, and dated in graphite.

32. *Pursuit of Freedom: Academic Freedom*
Alternate title: *Burning of Books*
Wood engraving
Image: 2 7/8 x 4" (73 x 102 mm)
Edition: 8
Paper: China/India
Printer/Publisher: Chicago Civil Liberties
 Committee (Following Kohn's printing
 of 8 complete sets of artist's impressions
 on China/India, this Committee pub-
 lished the series of 16 prints from the
 original blocks as a book, publication
 data below)
Collections: Art Institute of Chicago;
 private collections
Publications: *Pursuit of Freedom: History of
 Civil Liberty in Illinois 1787-1942*, ill.
 Chapter V, p. 65; Spence, cat. p. 139;
 Zigrosser-AFA, cat. #32, pp. 26-7.
Comments: Depiction of the president of
 the University of Chicago (center) and
 Mr. Walgreen of Walgreen's Drug Store,
 burning books in front of the university.

33. *Pursuit of Freedom: Anti-Semitism*
Alternate title: *Justice*
Wood engraving
Image: 2 7/8 x 4" (73 x 102 mm)
Edition: 8
Paper: China/India
Printer/Publisher: Chicago Civil Liberties
 Committee (Following Kohn's printing
 of 8 complete sets of artist's impressions
 on China/India, this Committee pub-
 lished the series of 16 prints from the
 original blocks as a book, publication
 data below)
Collections: Art Institute of Chicago;
 private collection

Publications: *Pursuit of Freedom: History of
 Civil Liberty in Illinois 1787-1942*, ill.
 Chapter IX, p. 120; Spence, cat. p. 139;
 Zigrosser-AFA, cat. #32, pp. 26-7.
Comments: Large Picasso-esque male,
 right, holds scales of justice that appear
 to be cracking and/or unequal. This
 image may have been intended to illus-
 trate Chapter VII, "Rights of Aliens,"
 but was inadvertently switched by the
 publisher.

34. *Pursuit of Freedom: Censorship*
Wood engraving
Image: 2 7/8 x 4" (73 x 102 mm)
Edition: 8
Paper: China/India
Printer/Publisher: Chicago Civil Liberties
 Committee (Following Kohn's printing
 of 8 complete sets of artist's impressions
 on China/India, this Committee pub-
 lished the series of 16 prints from the
 original blocks as a book, publication
 data below)
Collections: Art Institute of Chicago;
 private collection
Publications: *Pursuit of Freedom: History of
 Civil Liberty in Illinois 1787-1942*, ill.
 Chapter IV, p. 44; Spence, cat. p. 139;
 Zigrosser-AFA, cat. #32, pp. 26-7.
Comments: Depiction of the censorship of
 the film *Fight for Life* (an educational
 film dealing with the Chicago Maternity
 Center) under the obscenity statutes.

35. *Pursuit of Freedom: Freedom of Conscience*
Wood engraving
Image: 2 7/8 x 4" (73 x 102 mm)
Edition: 8
Paper: China/India
Printer/Publisher: Chicago Civil Liberties
 Committee (Following Kohn's printing
 of 8 complete sets of artist's impressions
 on China/India, this Committee pub-
 lished the series of 16 prints from the
 original blocks as a book, publication
 data below)
Collections: Art Institute of Chicago;
 private collection
Publications: *Pursuit of Freedom: History of
 Civil Liberty in Illinois 1787-1942*, ill.
 Chapter XIV, p.199; Spence, cat. p. 139;
 Zigrosser-AFA, cat. #32, pp. 26-7.
Comments: Prone conscientious objector
 with face of a skeleton and holding
 flower up in right hand is speared with
 a bayonet by a woman fleeing to right
 out of picture plane.

36. *Pursuit of Freedom: Freedom of Religion*
Alternate title: *Freedom of Speech*
Wood engraving
Image: 2 7/8 x 4" (73 x 102 mm)
Edition: 8
Paper: China/India
Printer/Publisher: Chicago Civil Liberties
 Committee (Following Kohn's printing
 of 8 complete sets of artist's impressions
 on China/India, this Committee pub-
 lished the series of 16 prints from the
 original blocks as a book, publication
 data below)
Collections: Art Institute of Chicago;
 private collection
Publications: *Pursuit of Freedom: History of
 Civil Liberty in Illinois 1787-1942*, ill.
 Chapter II, p. 5; Spence, cat. p. 139;
 Zigrosser-AFA, cat. #32, pp. 26-7.
Comments: Male brandishing whip, right
 foreground, forces Jehovah's Witness
 down to his knees to kiss the American
 flag. Signed and dated in graphite.

37. *Pursuit of Freedom: Freedom of the Press*
Alternate title: *Freedom of Press*
Wood engraving
Image: 2 7/8 x 4" (73 x 102 mm)
Edition: 8
Paper: China/India
Printer/Publisher: Chicago Civil Liberties
 Committee (Following Kohn's printing
 of 8 complete sets of artist's impressions
 on China/India, this Committee pub-
 lished the series of 16 prints from the
 original blocks in a book, publication
 data below)
Collections: Art Institute of Chicago;
 private collection
Publications: *Pursuit of Freedom: History of
 Civil Liberty in Illinois 1787-1942*, ill.
 Chapter III, p. 20; Spence, cat. p. 139;
 Zigrosser-AFA, cat. #32, pp. 26-7.
Comments: Editor Elijah Lovejoy lying on
 his back, a victim of mob violence, in
 front of his printing press, with paper
 headlined "Abolition" clutched in his
 left hand.

38. *Pursuit of Freedom: Freedom without
 Equality*
Wood engraving
Image: 2 7/8 x 4" (73 x 102 mm)
Edition: 8
Paper: China/India
Printer/Publisher: Chicago Civil Liberties
 Committee (Following Kohn's printing
 of 8 complete sets of artist's impressions
 on China/India, this Committee pub-
 lished the series of 16 prints from the

21. *Girl Without Violin*
Lithograph
Image: 18 1/4 x 10 3/4" (465 x 273 mm)
 irregular
Sheet: 23 x 14 1/2" (584 x 368 mm)
Edition: 18 [11]
Paper: Strathmore double-ply
Plate: Stone (4)
Printer/Publisher: WPA
Collections: Art Institute of Chicago;
 Baltimore Museum of Art;
 National Museum of American Art,
 Smithsonian Institution
Publications: Spence, cat. p. 137; Zigrosser-
 AFA, cat. #8.
Comments: Four-color waist-length por-
 trait of blond woman in red shirt, profile
 left, with hands outstretched. "I was
 going with a violinist at the time [;] it is
 her portrait....The title was a joke
 because she was never without that
 violin." [Misch Kohn letter to Carl
 Zigrosser, c. August 4, 1960. *Archives of
 American Art*, Reel 4629, frame 799.]
 Signed, ed. info, titled, and dated in
 graphite.

22. *Going Home*
Lithograph
Image: 12 x 16 3/4" (306 x 424 mm)
 irregular
Sheet: 14 1/2 x 21" (369 x 534 mm)
Edition: 18 [11]
Paper: Strathmore (?) double ply
Plate: Stone (4)
Printer/Publisher: WPA
Collections: Art Institute of Chicago
Publications: Spence, cat. p. 137; Zigrosser-
 AFA, cat. #10.
Comments: Four-color image of horse-
 drawn wagon with single male occu-
 pant, foreground, in rural background.
 Signed, ed. info, titled, and dated in
 graphite.

23. *Head of Job*
Alternate title: *Job*
Lithograph
Image: 19 3/8 x 14 3/8" (492 x 365 mm)
 irregular
Sheet: 24 3/8 x 18 3/4" (619 x 476 mm)
Edition: 6
Paper: Poype
Plate: Stone
Printer/Publisher: WPA
Publications: Spence, cat. p. 137 [as *Job*];
 Zigrosser-AFA, cat. #11 [as *Job*].
Comments: Male bust with scarf and
 upturned collar, 3/4 profile left. Signed,
 ed. info, titled, and dated in graphite.

24. *Hunger*
Wood engraving
Image: 3 x 2 1/4" (76 x 57 mm)
Edition: 18
Paper: China/India
Printer/Publisher: WPA?
Collections: Private collection
Publications: *New Anvil* (July-August
 1940), ill. inside front cover.
Comments: Three women with kerchiefs,
 foreground. Illustration for poem by
 Don West "Toil and Hunger," published
 in July-August 1940 issue of *New Anvil*
 literary magazine.

25. *Lucy*
Alternate titles: *Lucey; Lucy Chavez*
Lithograph
Image: 19 3/4 x 10 5/8" (504 x 271 mm)
 irregular
Sheet: 23 3/16 x 15 1/16" (589 x 383 mm)
Edition: 5 [12]
Paper: BFK Rives
Plate: Stone (4)
Printer/Publisher: WPA
Collections: Art Institute of Chicago (2);
 Metropolitan Museum of Art
Publications: Spence, cat. p. 137; Zigrosser-
 AFA, cat. #18 [as *Lucy Chavez*].
Comments: Four-color bust-length portrait
 of woman with head in right hand, left
 arm crossed in front of her. Signed, ed.
 info, titled, and dated in graphite.

26. *Lupe*
Lithograph
Image: 16 3/4 x 10 1/2" (425 x 267 mm)
 irregular
Sheet: 22 1/8 x 14 3/8" (562 x 365 mm)
Edition: 18
Paper: Strathmore double-ply
Plate: Stone (3)
Printer/Publisher: WPA
Collections: Southern Illinois University
 Museum
Publications: Spence, cat. p. 138; Zigrosser-
 AFA, cat. #26.
Comments: Three-color bust-length por-
 trait of young girl in short-sleeved blue
 dress with collar. Signed, ed. info, titled,
 and dated in graphite.

27. *Masquerade*
Woodcut
Image: 5 3/8 x 8 7/16" (137 x 214 mm)
Sheet: 10 7/8 x 8 7/16" (276 x 214 mm)
Printer/Publisher: United American
 Artists in offset press
Comments: Announcement for "The
 Gayest, Most sophisticated social event

of the year UNITED ARTISTS and their
MODELS BALL MASQUERADE. The
social event of National Art Week.
Tommy Gray's Swing Band." MISCH
and UAA 40 in block, ll and lc.

28. *Merry Xmas*
Woodcut
Image: 4 13/16 x 3 13/16" (122 x 97 mm)
Sheet: 5 1/8 x 4 1/8" (130 x 105 mm); mount-
 ing sheet 11 1/2 x 4 13/16" (292 x 122 mm)
Edition: 60
Paper: China/India mounted on commer-
 cial card stock
Comments: Seated clown 3/4 profile left;
 MERRY XMAS center left.

29. *Piece Work*
Alternate titles: *Machinist; Machinist
 (Piece Work); Piecework*
Linoleum cut
Image: 10 x 7 7/8" (254 x 200 mm)
Sheet: 17 15/16 x 13 7/8" (456 x 352 mm)
Edition: 30
Paper: China/India
Printer/Publisher: WPA?
Publications: Spence, ill. #7, cat. p. 140
 [as *Machinist (Piece Work)*]; Zigrosser-
 AFA, cat. #42 [as *Machinist (Piece Work)*,
 woodcut, dated 1943].
Comments: Worker bent over large saw.
 Signed, ed. info, titled, and dated in
 graphite.

30. *Polish Man*
Alternate title: *Portrait*
Lithograph
Image: 16 3/4 x 12" (425 x 305 mm)
 irregular
Sheet: 23 x 14 1/4" (584 x 362 mm)
Edition: 10
Paper: BFK Rives or Strathmore
 double-ply
Plate: Stone (4)
Printer/Publisher: WPA
Publications: Spence, cat. p. 138; Zigrosser-
 AFA, cat. #22.
Comments: Four-color portrait of male
 with handlebar mustache in blue vest,
 white sleeves rolled up and arms
 crossed. Signed, ed. info, titled, and
 dated in graphite.

31. *Portrait of Franz Biberkopf*
Alternate titles: *F. Bickerkopf; Frans
 Bebirkopf; Franz Biberkopf; Franz Biberkoph*
Lithograph, printed A) black only,
 B) four-color
Image: 19 5/8 x 10 1/2" (498 x 267 mm)
 irregular

Comments: Central white church building in background; group of figures standing, right foreground, with single kneeling figure, left foreground. Title *"They Also Serve"* is taken from the Biblical quotation, "They also serve who only stand and wait." WPA #3949. Signed, ed. info, titled (variously), and dated in graphite.

10. Untitled
Lithograph
Image: 10 1/2 x 8 3/4" (267 x 222 mm)
Sheet: 14 5/8 x 11 3/8" (371 x 289 mm)
Edition: 6?
Paper: BFK Rives
Plate: Stone
Printer/Publisher: John Herron Art Institute
Collections: Private collection
Comments: Frontal bust-length view of young woman with frilly collar.

11. Untitled
Lithograph
Image: 11 5/16 x 8 3/4" (287 x 222 mm)
Sheet: 16 x 11 7/16" (406 x 291 mm)
Edition: 6?
Paper: Single-ply wove
Plate: Stone
Printer/Publisher: John Herron Art Institute
Collections: Private collection
Comments: Bust-length portrait of a young girl, 3/4 profile left, with eyes cast down. Signed Harris Kohn, dated May 27, 1939 in graphite.

12. Untitled
Woodcut
Image: 4 15/16 x 3 3/4" (125 x 95 mm)
Sheet: 8 3/8 x 6 3/4" (213 x 171 mm)
Paper: China/India
Printer/Publisher: Max Kahn's studio, Chicago. WPA?
Collections: Private collections
Comments: Deeply gouged, stylized portrait of male with head in his hand, 3/4 profile right.

13. Untitled [Dance in the Meadow]
Lithograph
Image: 11 3/8 x 8 3/8" (289 x 213 mm) irregular
Sheet: 15 1/4 x 11 7/16" (387 x 290 mm)
Edition: 6?
Paper: BFK Rives
Plate: Stone
Printer/Publisher: John Herron Art Institute

Collections: Private collection
Comments: Bucolic scene of woman dancing with young girl, foreground; hilly pastureland with grazing horses, background. Signed Harris Kohn, dated May 27, 1939 in graphite.

14. Untitled [Still Life and Girl at Open Door]
Lithograph
Image: 12 7/8 x 16 11/16" (327 x 424 mm)
Sheet: 16 x 21 3/4" (406 x 552 mm)
Edition: 6?
Paper: Double-ply wove with FRANCE watermark
Plate: Stone
Printer/Publisher: John Herron Art Institute
Collections: Private collection
Comments: Floral bouquet on table, left foreground; girl in sleveless long dress standing at open door, right background. KOHN horizontally in stone, ll.

c. late 1930s

15. Untitled [Running Horse]
Linoleum cut
Image: 4 1/16 x 5" (103 x 127 mm)
Paper: China/India
Collections: Private collection
Comments: Horse with neck twisted around towards its back in a wooded scene. This print was originally printed in dark blue ink. HK vertically in plate, ll.

1940

16. *Chicago*
Lithograph
Image: 12 1/2 x 20 1/2" (317 x 520 mm)
Edition: 6
Printer/Publisher: WPA
Plate: Stone
Publications: Spence, cat. p. 137; Zigrosser-AFA, cat. #9.
Comments: Spence: "Distant view up river, with bridges above, tugboats below, and buildings to either side." Virtually identical to 1941 *Chicago River (Bridge and Tugs)*, but larger and black only.

17. *Elegie*
Alternate title: *Elegy*
Lithograph, printed A) black only, B) four-color

Image: 16 1/2 x 12 3/8" (419 x 314 mm) irregular
Sheet: 23 x 14 9/16" (584 x 370 mm)
Edition: 10
States: 2
Paper: Strathmore double-ply
Plate: Stone (4)
Printer/Publisher: Max Kahn's studio, Chicago. WPA
Publications: Spence, cat. p. 137; Zigrosser-AFA, cat. #12.
Comments: Nocturnal scene of women weeping at graveyard. Signed, ed. info, titled, and dated in graphite.

18. *Emily*
Wood engraving
Image: 3 x 2 1/8" (76 x 54 mm)
Sheet: 5 1/8 x 3 1/8" (130 x 79 mm)
Edition: 18
Printer/Publisher: WPA?
Collections: Private collection
Comments: Bust-length, angular portrait of female with arms crossed. Signed, titled, and dated in graphite.

19. *Exodus*
Lithograph
Image: 10 7/16 x 19 1/2" (265 x 495 mm) irregular
Sheet: 14 5/8 x 23" (371 x 584 mm)
Edition: 18
Paper: Strathmore double-ply
Plate: Stone
Printer/Publisher: WPA
Publications: Spence, cat. p. 137; Zigrosser-AFA, cat. #15.
Comments: Caravan of laden horse-drawn wagons against a rural landscape; faint urban outline in upper left background. Signed, ed. info, titled, and dated in graphite.

20. *Girl with a Cat*
Alternate title: *Girl with Cat*
Serigraph
Image: 23 1/16 x 14 5/8" (586 x 371 mm) irregular
Sheet: 26 x 19 7/8" (406 x 505 mm)
Edition: 20
Paper: Strathmore double-ply
Printer/Publisher: WPA
Publications: Spence, cat. p. 138; Zigrosser-AFA, cat. #28.
Comments: Four-color waist-length portrait of girl with tabby cat in her arms. Signed in graphite.

1938

1. *Dream No. 4*
Lithograph
Image: 6 1/4 x 9 1/8" (159 x 232 mm)
Sheet: 8 x 11 7/16" (203 x 291 mm)
Edition: 6?
Paper: Single-ply wove
Plate: Stone
Printer/Publisher: John Herron Art
 Institute
Collections: Private collection
Comments: Half-draped female reclining
 on Victorian-style couch. Signed, titled,
 and dated in graphite.

2. *Self Portrait*
Etching, *chine collé*
Image: 6 x 4 1/4" (152 x 108 mm)
Sheet: 7 3/4 x 6" (197 x 152 mm)
Edition: 6
Paper: Single-ply laid
Plate: Copper
Collections: Private collection
Comments: Bust of young male in coat and
 tie, 3/4 profile right. Kohn's first etching
 and, possibly, his first print. Produced
 while he was a student at the John
 Herron Art Institute on a small etching
 press belonging to a friend. H. KOHN in
 plate, ll; signed, ed. info, and dated in
 graphite.

3. Untitled [Figure]
Lithograph
Image: 6 7/8 x 2 1/16" (175 x 52 mm)
Sheet: 11 3/8 x 5 1/2" (289 x 140 mm)
Paper: Single-ply wove
Plate: Stone
Printer/Publisher: John Herron Art
 Institute
Collections: Private collection
Comments: An ethereal young woman in
 long, flowered dress.

1939

4. *Clown*
Alternate title: *The Clown*
Lithograph, printed A) black only,
 B) four-color
Image: 17 5/8 x 13 1/2" (447 x 343 mm)
 irregular
Sheet: 22 15/16 x 16" (583 x 406 mm)
Edition: 5 [10]
States: 2
Paper: BFK Rives, Strathmore, or Poype
Plate: Stone (4)
Printer/Publisher: WPA
Collections: Private collections

Publications: *Art School: John Herron Art
 Institute Catalogue*, ill. p. 29; Spence,
 cat. p. 136; Zigrosser-AFA, ill. #3, cat. #4
 [dated 1940].
Comments: Full-frame image of sad clown,
 3/4 profile left with arms folded.
 Signed, ed. info, titled, and dated in
 graphite.

5. *Exile*
Alternate title: *Exiles*
Wood engraving
Image: 7 5/8 x 13 1/8" (194 x 333 mm)
 irregular
Sheet: 8 3/4 x 15 7/8" (222 x 403 mm)
Edition: 10
States: 2
Paper: China/India
Printer/Publisher: WPA
Collections: Art Institute of Chicago (3);
 Baltimore Museum of Art; Philadelphia
 Museum of Art
Publications: Spence, cat. p. 136; Zigrosser-
 AFA, cat. #2.
Comments: Group of standing figures,
 center foreground, against burning
 building in a devastated night land-
 scape; other figures left background,
 right foreground. WPA #3948. Art
 Institute of Chicago has both 1st and
 2nd states of the wood engravings; one
 is incorrectly identified as a lithograph;
 Philadelphia Museum of Art's two
 impressions are also incorrectly identi-
 fied as lithographs. Signed, titled, and
 dated in graphite.

6. *John Brown*
Woodcut
Image: 9 1/2 x 6 1/8" (241 x 156 mm)
Sheet: 12 1/8 x 9 1/4" (308 x 235 mm)
Edition: 10 [25]
Paper: China/India
Printer/Publisher: WPA
Collections: Art Institute of Chicago (2);
 Baltimore Museum of Art; Milwaukee
 Art Museum; Philadelphia Museum
 of Art
Publications: Spence, ill. #5, cat. p. 136;
 Zigrosser-AFA, ill. #2, cat. #3.
Comments: Full-frame stylized portrait,
 deep gouging. WPA #3947. Media has
 been variously listed as "relief" and
 linocut. Philadelphia Museum of Art's
 print is incorrectly identified as a litho-
 graph. Signed, ed. info, titled, and dated
 in graphite.

7. *Season's Greetings*
Lithograph
Image: 6 1/4 x 8" (159 x 203 mm)
Sheet: 6 15/16 x 8 1/2" (176 x 216 mm)
Paper: Single-ply wove, hand-sewn into
 Japanese handmade [brown]
Plate: Stone (5)
Collections: Private collection
Comments: Fanciful scene with clown at
 right, flying animals and humans in
 background. Two five-color lithographs
 presented as a diptych. Sent out as holi-
 day greeting card. "Harris Kohn" signed
 in black ink, right section.

8. *Sleeping Woman*
Lithograph
Image: 18 1/2 x 14 1/2" (470 x 368 mm)
 irregular
Sheet: 23 x 16 1/8" (584 x 409 mm)
Edition: 10
Paper: BFK Rives
Plate: Stone
Printer/Publisher: Max Kahn's studio,
 Chicago
Publications: *Cincinnati Enquirer* 1/29/61,
 ill. Section C, p. 10; Spence, ill. #4,
 cat. p 136; Zigrosser-AFA, ill. #1, cat. #1
Comments: Dark bust-length portrait of
 woman with head leaning on her right
 shoulder. This was the first print Kohn
 created in Chicago after his move there
 in late 1939 from New York City. Signed,
 titled, and dated in graphite.

9. *"They Also Serve"*
Alternate titles: *Church; Figures in Front of a
 Church; The People;* Untitled [Church];
 Untitled [Figures Outside Church];
 Worshippers
Lithograph, printed A) four-color,
 B) blue/white only
Image: 21 x 14 7/8" (534 x 378 mm)
 irregular
Sheet: 26 x 18 1/4" (660 x 464 mm)
Edition: 11 [15]
States: 2
Paper: Printed variously on single and
 double-ply wove, Strathmore double-
 ply, and Fabriano
Plate: Stone (4)
Printer/Publisher: WPA
Collections: Art Institute of Chicago (4);
 Krannert Art Museum; National
 Museum of American Art, Smithsonian
 Institution; Philadelphia Museum of Art;
 University of Oregon Museum of Art
Publications: Spence, cat. p. 136; Zigrosser-
 AFA, cat. #17.

Catalogue Raisonné

This is a catalogue of all known prints by Misch Kohn, current as of August 1, 1997. The prints are listed chronologically by year, with titles listed alphabetically within each year. Alternate titles, whether noted as such by the artist, or as they appear in the catalogues of museums, galleries, or exhibitions, are included as necessary. Foreign language translations are not included unless they were so designated by the artist.

The dimensions of the images are given first in inches, then in millimeters, height by width, measured at the largest point. Plate or image dimensions may vary up to 5/8," depending on the degree to which different papers absorbed and released the water with which they were dampened for printing. All post-1974 impressions printed on sheets of hand-made paper are at least slightly irregular, so are not separately designated as such herein. Unless otherwise noted, the plate size and the image size are equal.

Edition sizes are stated if known. It will be noted that in certain instances more than one number may appear in this field; this may be accounted for as follows: A) the artist printed a smaller edition, and later was encouraged by market forces to print additional impressions; B) a larger edition was intended by the artist, but the edition was never completed, and later prints may have been inscribed with the actual number of impressions; C) more than one edition number was inscribed on different impressions of the same image by the artist.

It also will be noted that numerous prints—particularly in the 1970s and 1980s—have been marked as "E/V;" these are evolving editions/*editions variées* in which each impression is unique, although printed from the same plate. The series of impressions from 1975-76 printed on paper fabricated by Kohn at Garner Tullis' Institute for Experimental Printmaking were designated by this E/V label in the catalogue for his 1981 Brooklyn Museum exhibition. However, as each print is actu-

ally a unique impression with distinctive embedding and/or overprinting, I have decided to designate each separately, although it runs counter to the Brooklyn Museum classification.

Unless otherwise noted, the impressions were printed in black ink in a single state only, and were printed by Kohn at his home studio. Inscriptions are noted in the comments section; lack of a notation indicates that the impression(s) of this image that were examined were unsigned and undated.

In the event that an early print was not available for me to examine, I have included the description taken from James R. Spence's 1965 doctoral dissertation, when available. Much of the information in Spence's manuscript was drawn from the Zigrosser monograph (New York: American Federation of Arts, 1961) which accompanied Kohn's twenty-year survey exhibition.

To help the reader locate images of the prints, abbreviated bibliographic citations have been included with each entry. Similarly, this catalogue notes impressions in public collections around the world which may be available to view; however, this is not a complete list of museums where Kohn's work may be found. Complete bibliographic citations and public collections are listed separately elsewhere in this publication.

Self-Portrait, 1977
Lithograph
21 3/8 x 22 1/8"

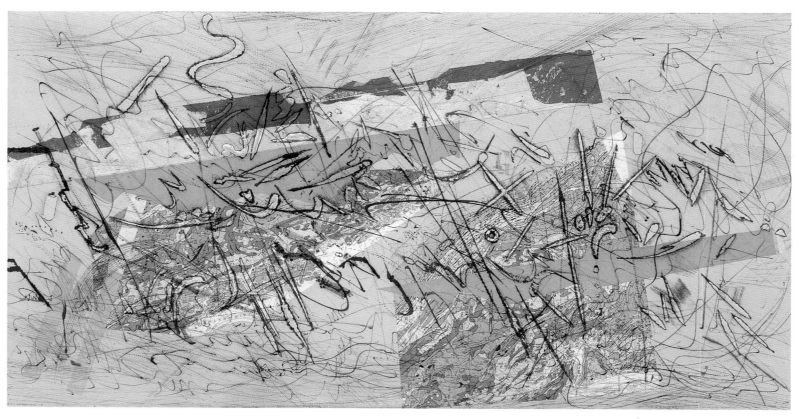

Alaska Highlands, 1997
Engraving, chine collé with metal leaf, color woodcut,
and found objects
12 3/8 x 23 3/4"

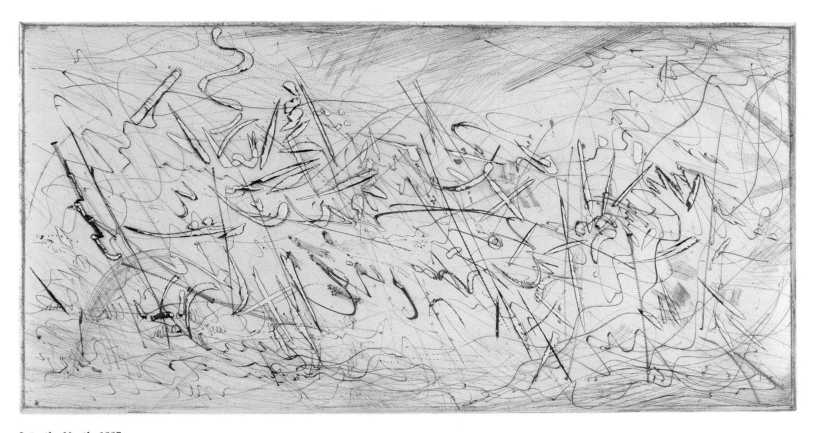

Into the North, *1997*
Engraving, chine collé with color woodcut
12 1/4 x 23 7/8"

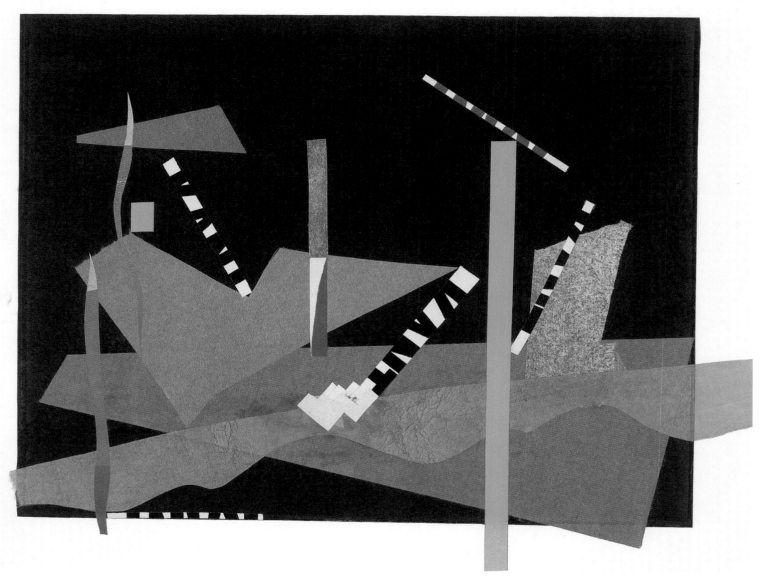

Kant Again, 1996
Etching, chine collé with metal-type engraving and
color woodcut
11 15/16 x 15 5/8″

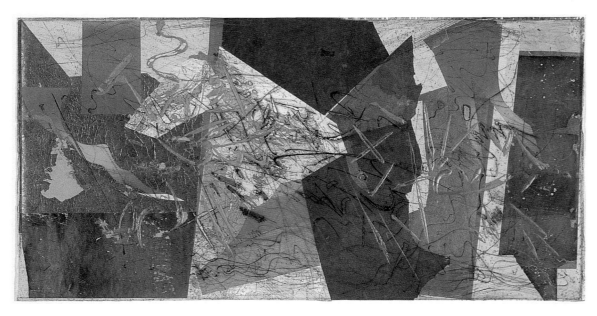

Into Summer, *1996*
Engraving, silver ink, chine collé with metal leaf,
 found objects, aquatint etching, rainbow-roll and
 color woodcut on handmade embedded paper
12 1/2 x 23 15/16"

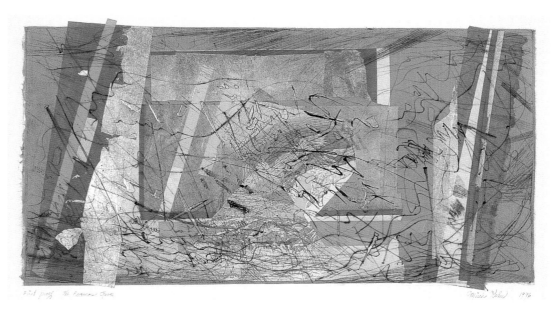

The Enormous Room, *1996*
Engraving, chine collé with metal leaf, color woodcut,
 and found objects
12 3/4 x 23 1/2"
Collection Portland Art Museum

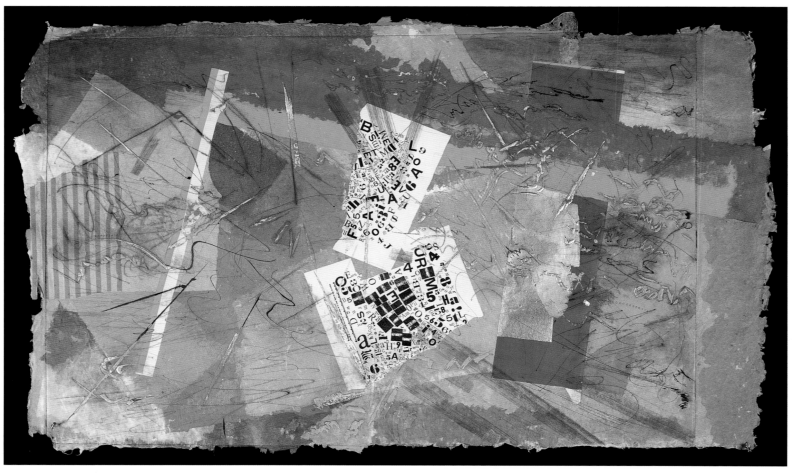

Untitled, 1992
Engraving, chine collé with metal-type engraving,
color woodcut, and found objects on handmade embedded paper
33 x 53"

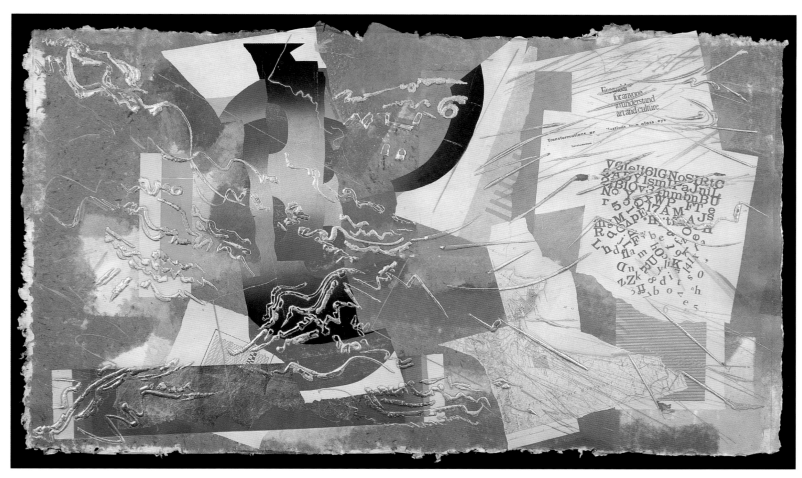

Cubi 8, *1992*
Engraving, silver ink, chine collé with metal-type engraving,
 rainbow-roll and color woodcut, wood type, and found objects
 on handmade embedded paper
32 x 54"

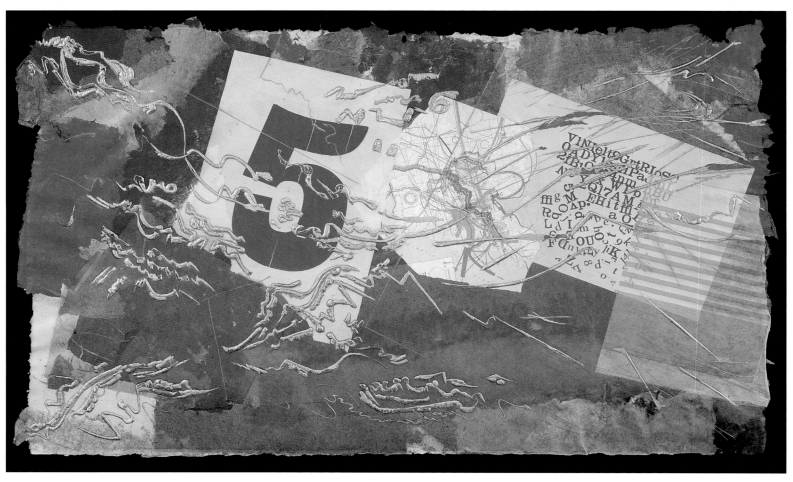

Fifth Variation on 5, 1992
Engraving, silver ink, chine collé with metal-type engraving,
color woodcut, wood type, and found objects
on handmade embedded paper
32 1/2 x 54"

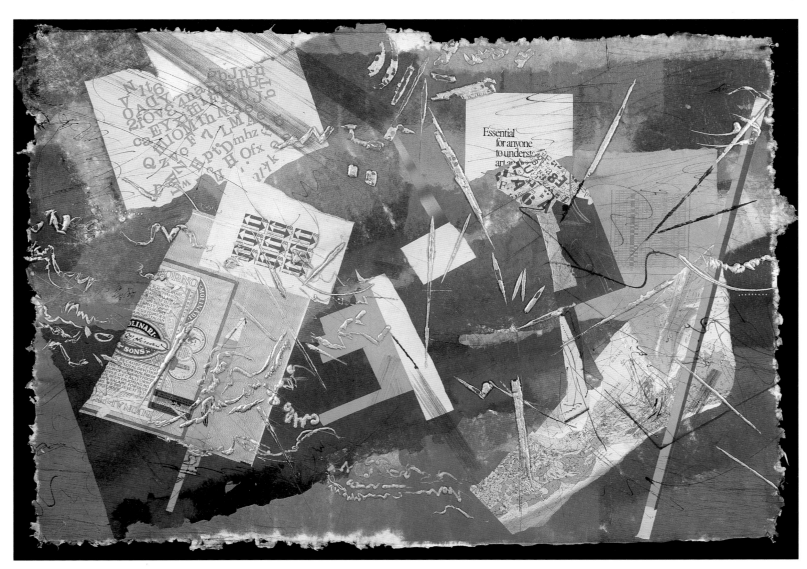

View from Above, *1991*
Engraving, chine collé with metal-type engraving,
 found objects, rainbow-roll and color woodcut on
 handmade embedded paper
31 1/2 x 44"

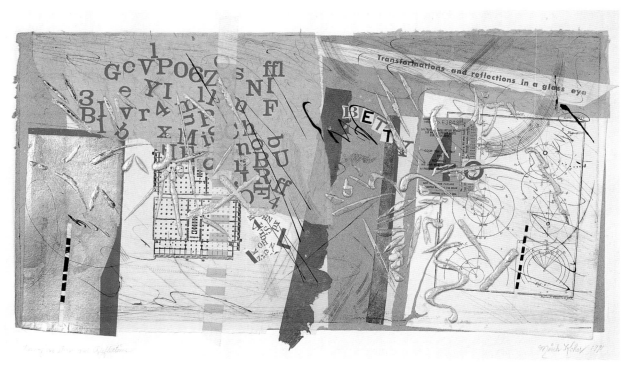

Transformations, *1991*
Engraving, chine collé with silver leaf, metal-type engraving,
color woodcut, and found objects
22 x 30"
Collection Betty Friedman

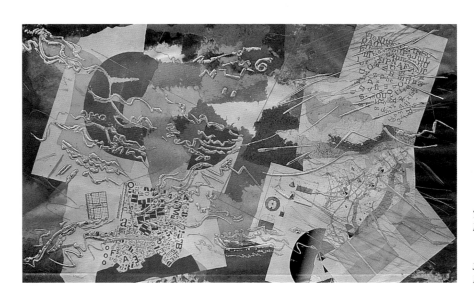

Transformations [Gulf of Mexico], *1991*
Engraving, silver ink, chine collé with etching,
rainbow-roll and color woodcut, wood type,
and found objects on handmade embedded paper
34 x 54"
Private collection

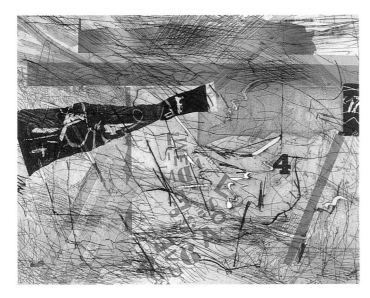

Unique Print for Dolly and Joe, *1989*
Sugar-lift ground aquatint etching, engraving, chine collé
 with engraving, rainbow-roll and color woodcut, wood type
 and found objects
10 3/4 x 13 3/4"
Private collection

Denver Basin and the Lake Country, *1990*
Engraving, drypoint, silver ink, and found
objects on handmade embedded paper
37 1/2 x 45 3/4"

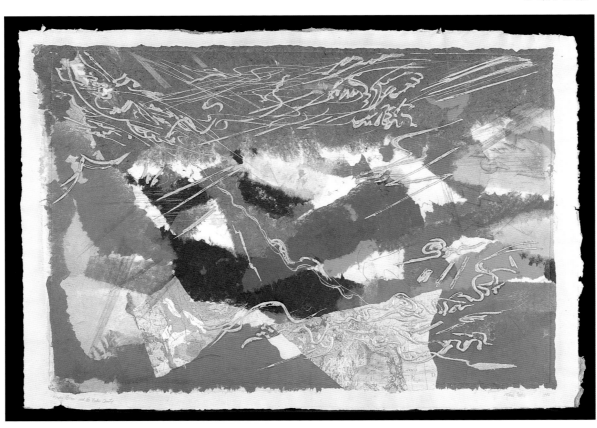

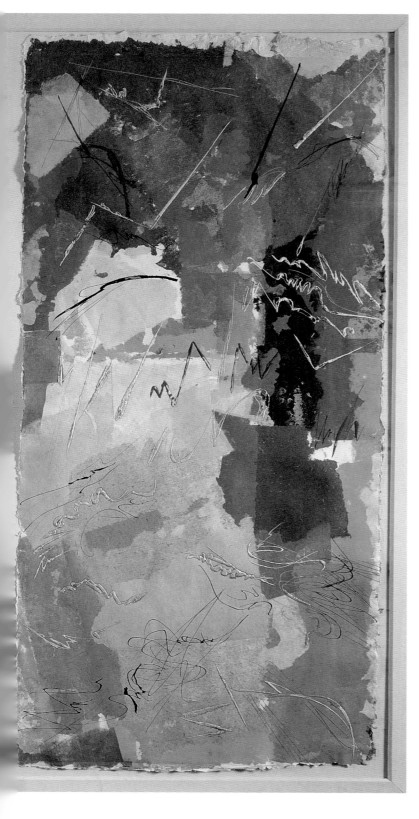

Chicago Triptych, 1989
Engraving, chine collé on handmade paper
* embedded with color woodcut*
72 x 108 '
Collection Fairmount Hotel, Chicago

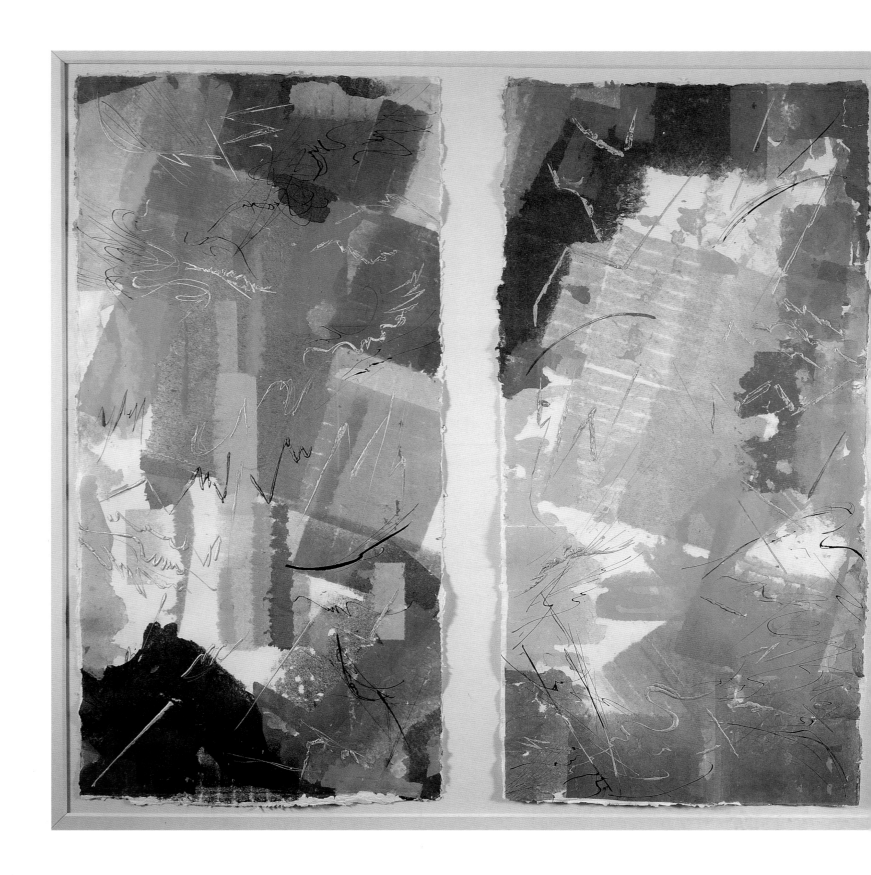

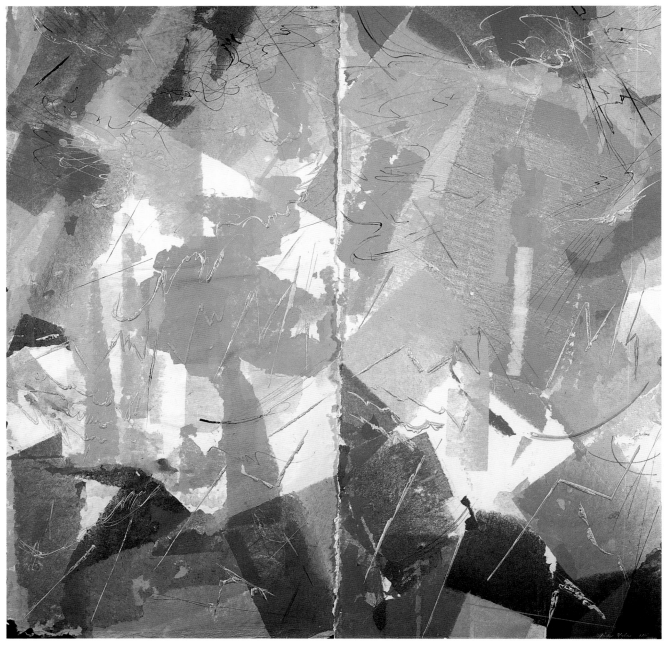

Diptych on a Chicago Theme, *1988*
Engraving, drypoint, embossing on handmade embedded paper
73 x 72"

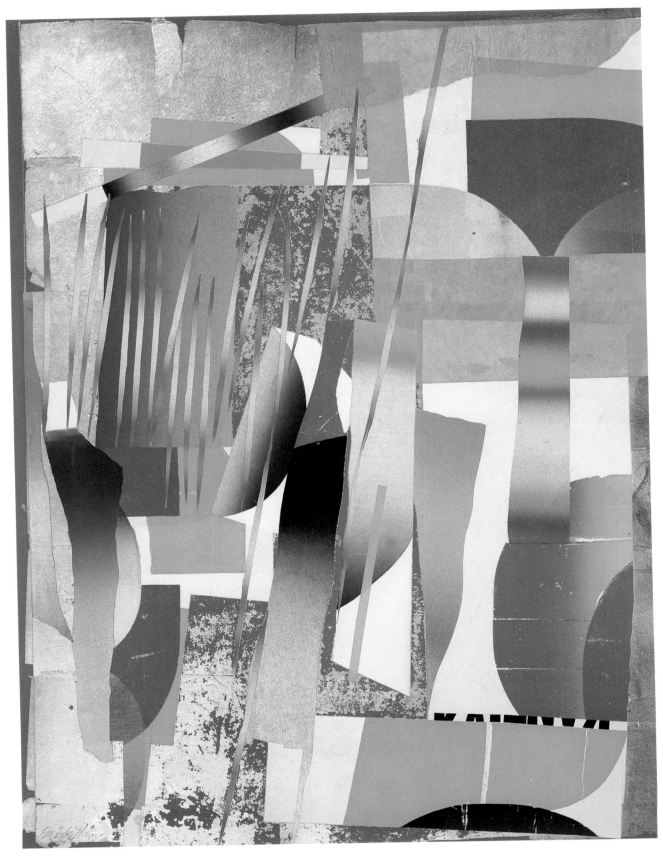

Screens, *1988*
Aquatint etching, engraving, chine collé with gold leaf,
 rainbow-roll and color woodcut
23 3/4 x 17 3/4"

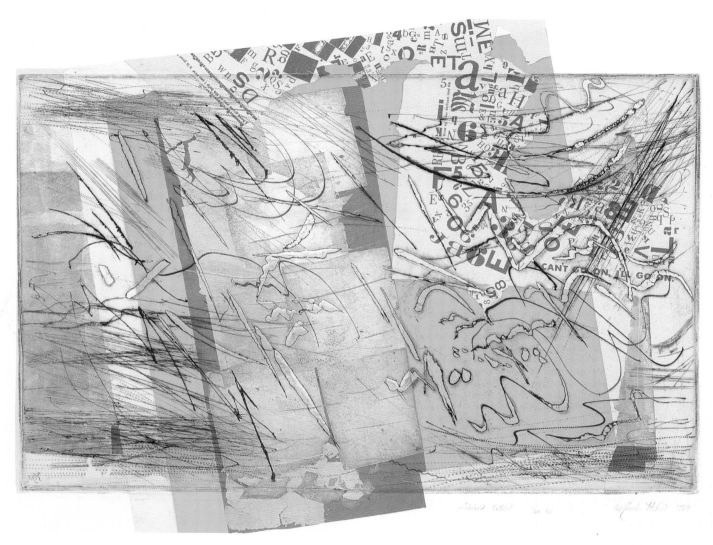

Hidden Letter, *1988*
Etching, engraving, chine collé with silver leaf,
metal leaf, color woodcut, and wood type
19 x 23"

Special Delivery, 1987
Engraving, chine collé with silver leaf,
metal-type engraving, color woodcut,
wood type, and found objects
21 3/4 x 29 3/4"

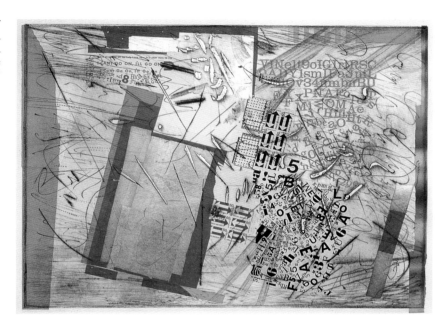

Untitled [155-154], *1988*
Etching, engraving, chine collé with metal-type engraving,
* rainbow-roll and color woodcut, wood type, and found objects*
16 7/8 x 23 3/8"

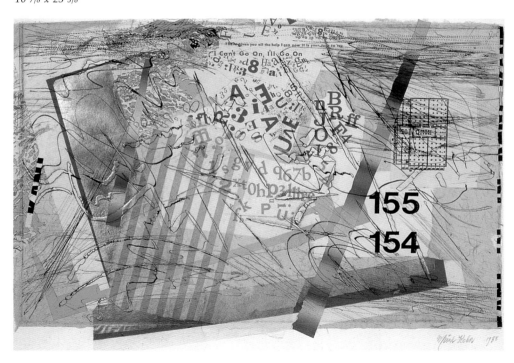

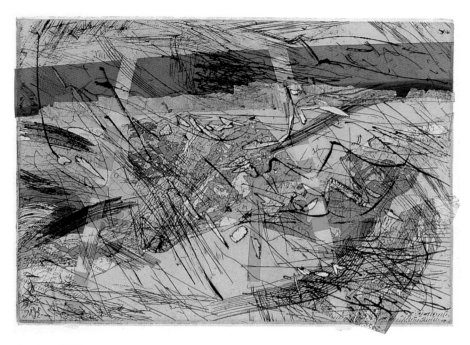

Trenton, *1986*
Etching, drypoint, chine collé with metal-type engraving,
 found objects, rainbow-roll and color woodcut
8 1/8 x 11"

Isle of Coll, *1987*
Etching, engraving, chine collé with silver leaf,
color woodcut, and found objects
18 1/2 x 20 1/2"

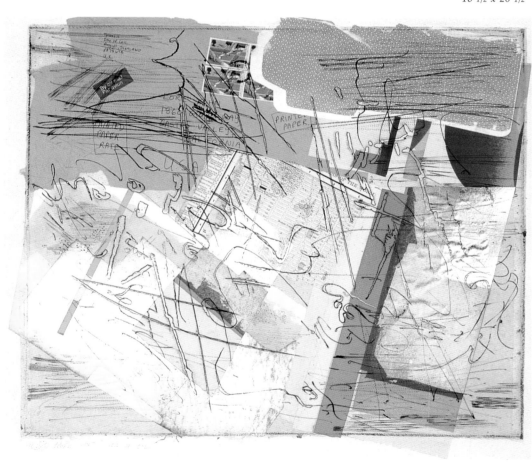

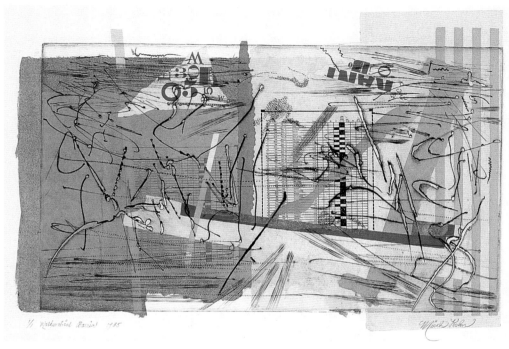

Mathematical Barrier, 1985
Engraving, chine collé with etching, metal leaf, color woodcut,
 and found objects
13 1/2 x 19 5/8"

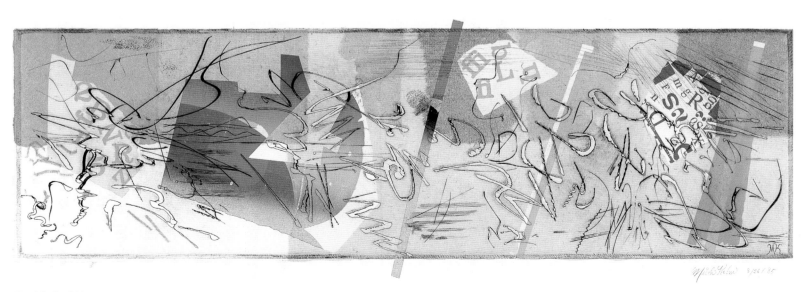

Untitled, 1985
Engraving, chine collé with metal-type engraving,
 rainbow-roll and color woodcut on color-embedded handmade paper
8 x 25 1/2"

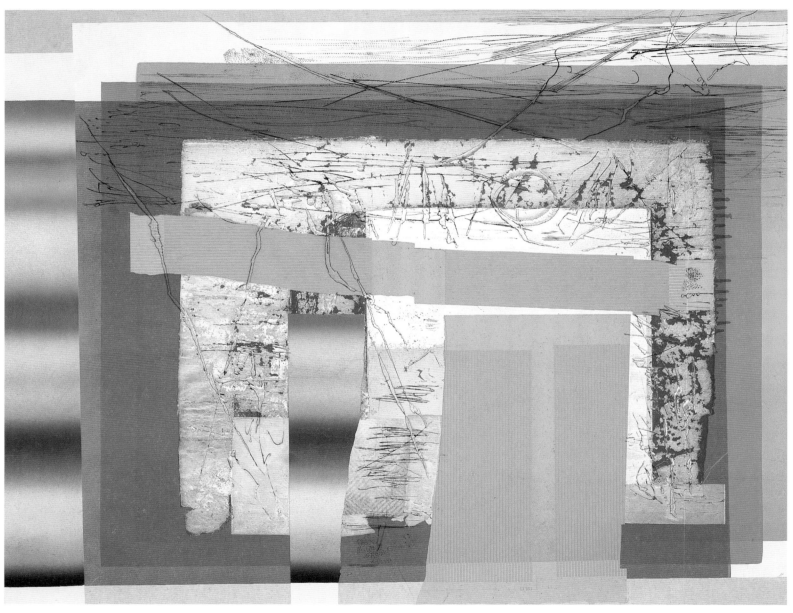

LT 151, *1983*
Engraving, chine collé with gold leaf, silver leaf,
found objects, rainbow-roll and color woodcut
23 3/8 x 29 3/4"

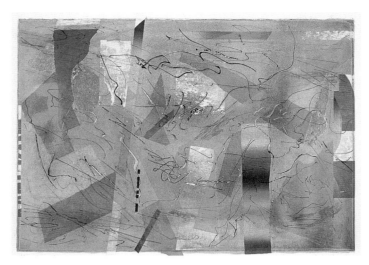

West Bend, *1981*
Sugar-lift ground aquatint etching, chine collé with
 rainbow-roll and color woodcut
15 x 20 3/4"

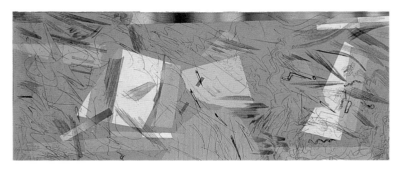

China Camp, *1981*
Engraving, etching, chine collé with rainbow-roll
 and color woodcut
10 x 24"

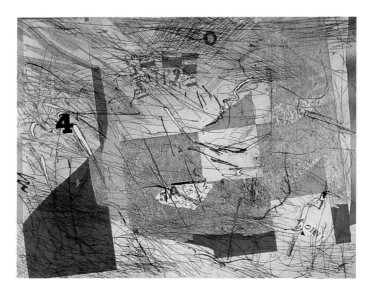

Untitled, *1984*
Sugar-lift ground aquatint etching, engraving,
 chine collé with metal-type engraving,
 rainbow-roll and color woodcut
10 7/8 x 13 3/4"

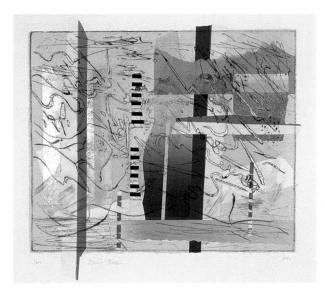

Sailing Home, *1980*
Sugar-lift ground aquatint etching, engraving, drypoint,
chine collé with rainbow-roll and color woodcut
13 3/4 x 13 5/8"

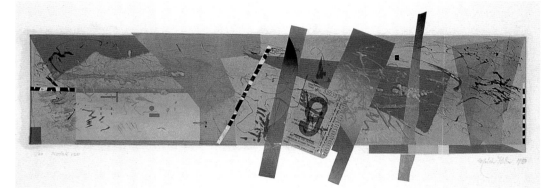

Kodak 120, *1980*
Sugar-lift ground aquatint etching, engraving,
chine collé with found objects, rainbow-roll and
color woodcut
8 1/2 x 23 3/4"

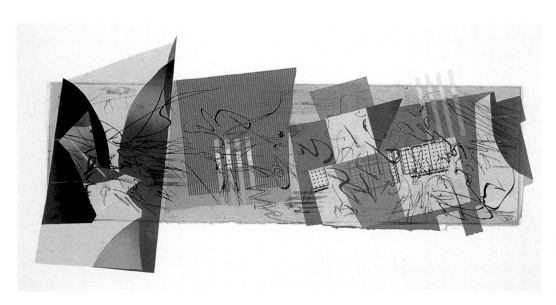

Party Line, *1980*
Engraving, chine collé with etching,
found objects, rainbow-roll and
color woodcut
13 1/8 x 27 1/2"

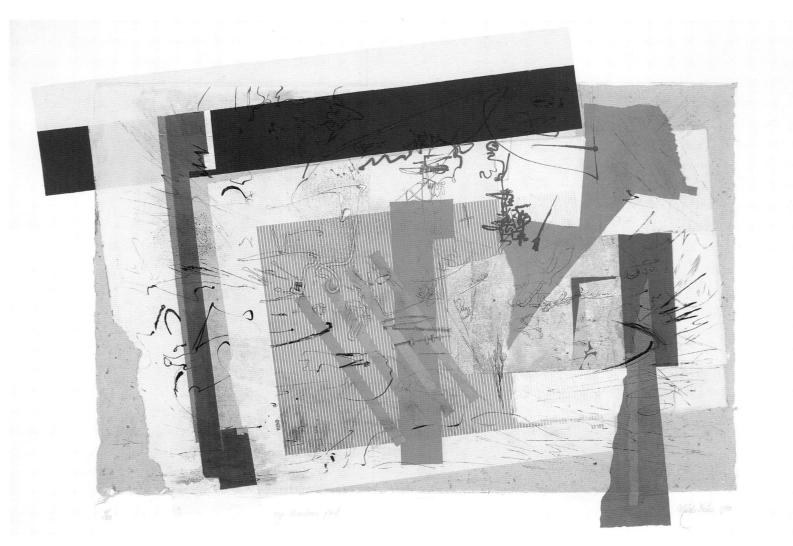

My Bauhaus Past, 1980
*Engraving, etching, chine collé with silver leaf,
 color woodcut, and found objects*
19 3/8 x 25 3/4"

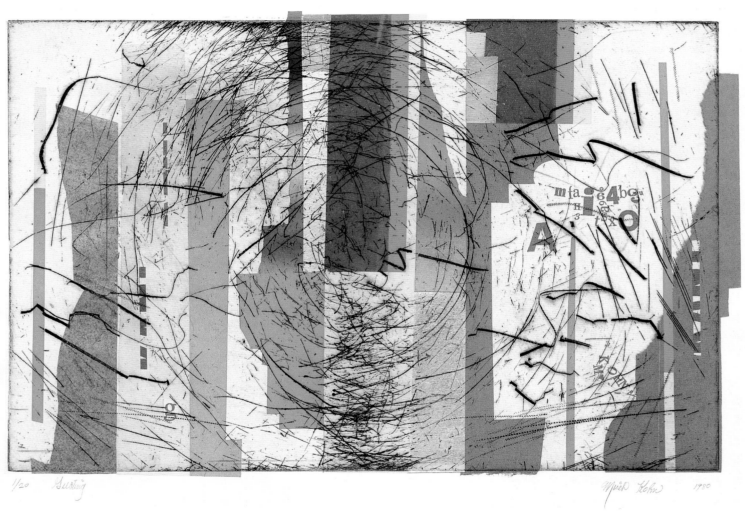

1/20 Gusting Misch Kohn 1980

Gusting, *1980*
Sugar-lift ground aquatint etching, engraving,
chine collé with metal leaf, rainbow-roll and color woodcut
12 1/4 x 18 1/2"

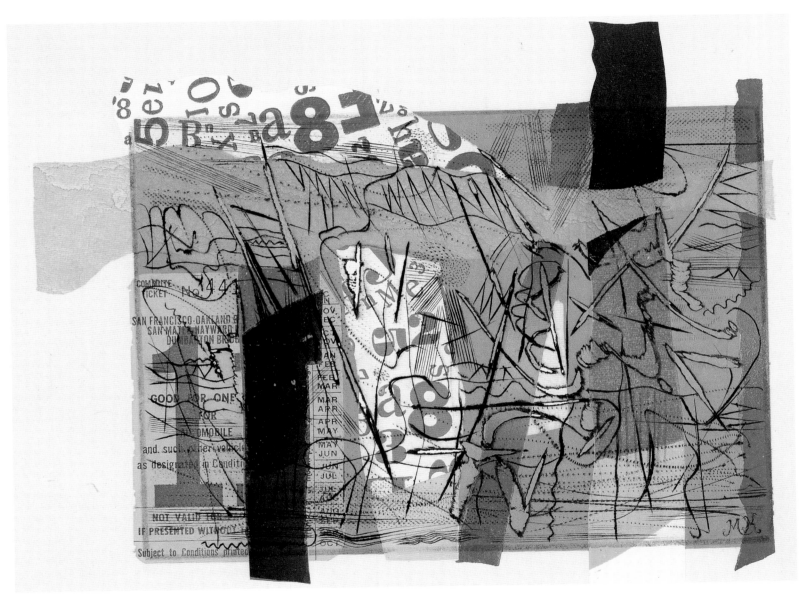

I've Got a Ticket to Ride, *1980*
Sugar-lift ground aquatint etching, engraving,
* chine collé with found objects, rainbow-roll and color woodcut*
7 3/4 x 8 1/8"

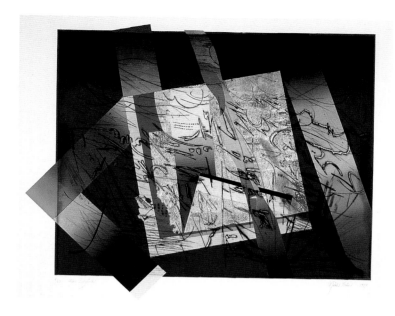

Blue Labyrinth, 1979
Sugar-lift ground aquatint etching, engraving, chine collé
with rainbow-roll and color woodcut
17 7/8 x 22 1/8"

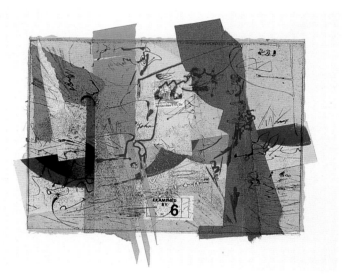

Examined by 6, 1979
Sugar-lift ground aquatint etching, drypoint, engraving,
chine collé with found objects, rainbow-roll and color woodcut
10 1/8 x 12 1/4"

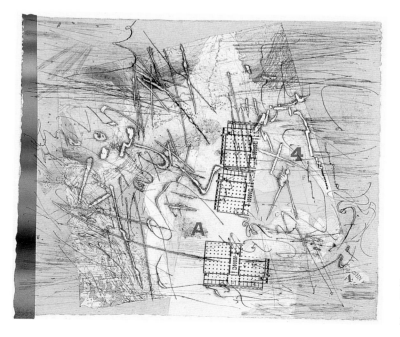

Black Warrior Basin, 1980
Engraving, drypoint, embossing, chine collé with
found objects, rainbow-roll and color woodcut
17 1/8 x 20"

142

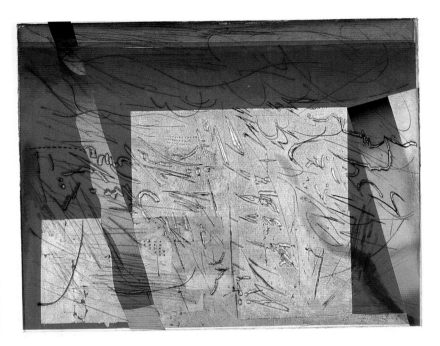

Silver Barrier, 1978
*Sugar-lift ground aquatint etching, drypoint,
engraving, chine collé with silver leaf,
rainbow-roll and color woodcut
16 1/8 x 19 7/8"*

Houston, 1978
*Drypoint, engraving, chine collé with metal leaf,
 engraving, rainbow-roll and color woodcut
15 7/8 x 19 7/8"*

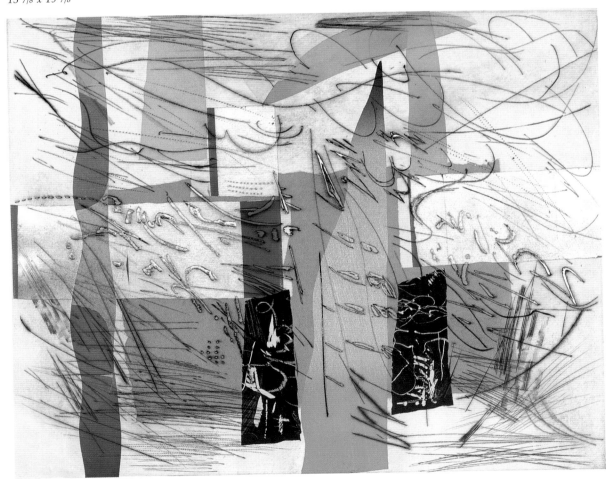

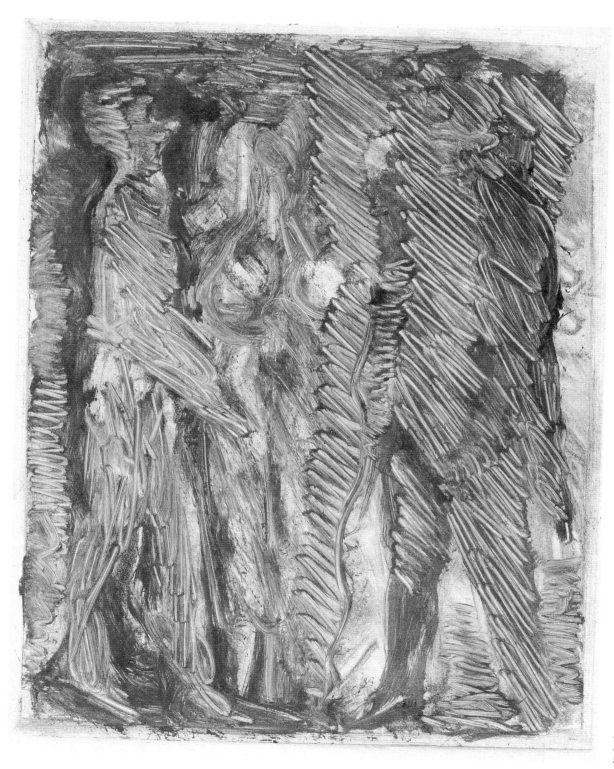

Figures, *1978*
Monoprint
5 7/16 x 4 1/4"

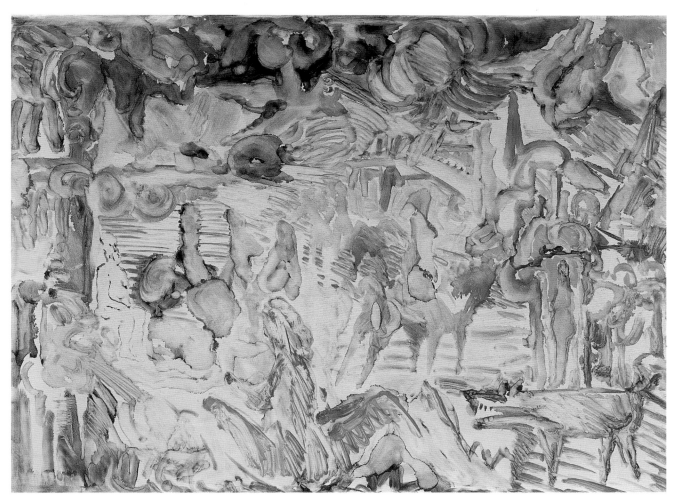

Temptation of St. Anthony, *1978*
Monoprint
29 5/8 x 39 3/8″

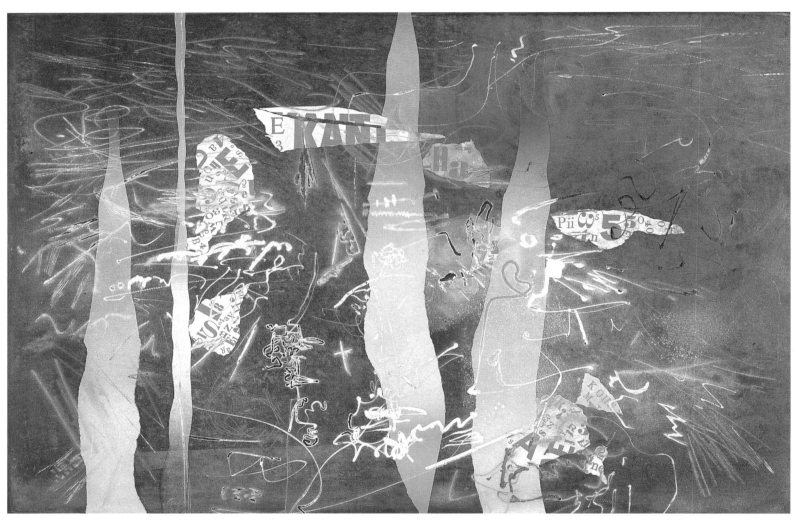

E Kant Ha 5, *1977.*
Sugar-lift ground aquatint etching, engraving, silver ink,
chine collé with metal-type engraving and rainbow-roll color woodcut
15 7/8 x 23 3/4"

138

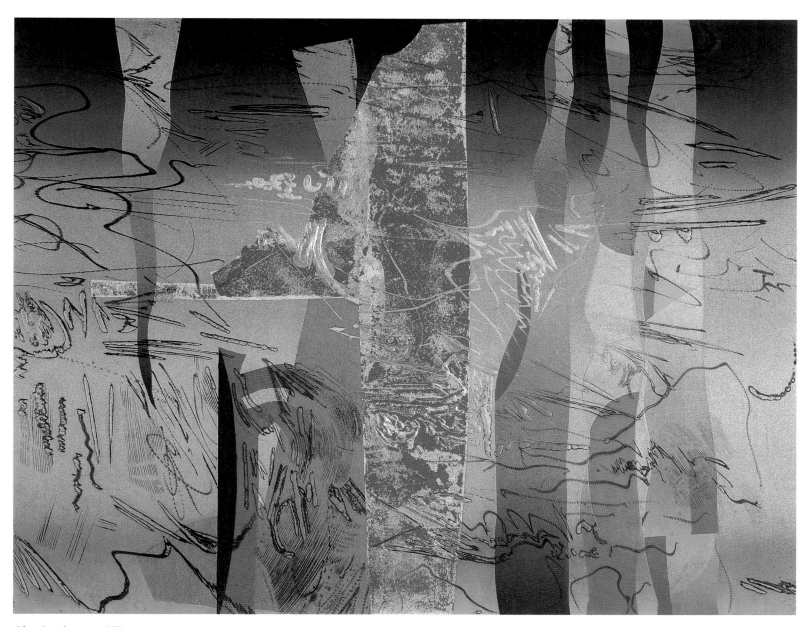

Blue Landscape, 1977
*Sugar-lift ground aquatint etching, engraving,
 chine collé with rainbow-roll color woodcut
14 x 17 7/8"*

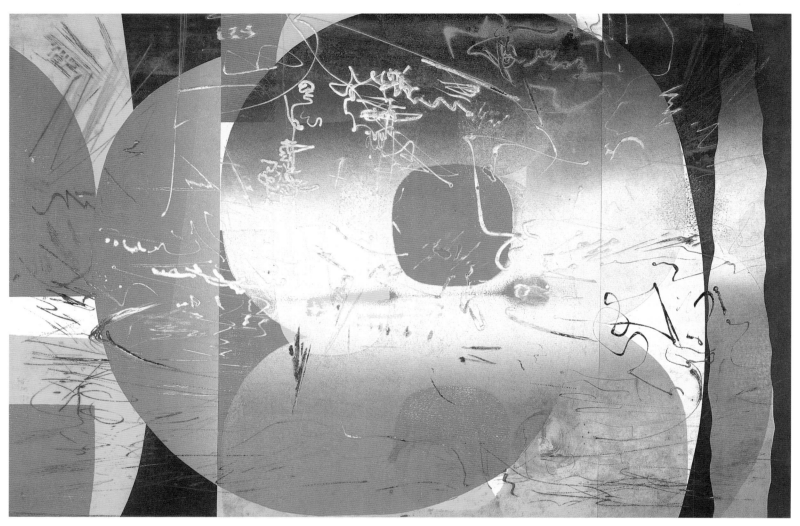

Eight, 1977
Lithograph overprinted with engraving, silver ink
15 7/8 x 23 5/8"

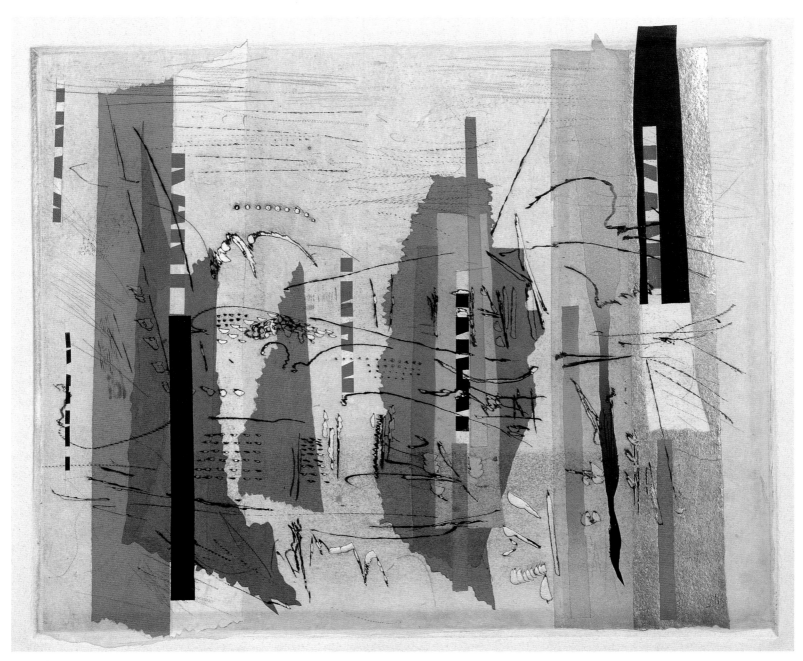

Gertrude's City, 1977
Sugar-lift ground aquatint etching, engraving, chine collé with
* rainbow-roll and color woodcut*
12 1/4 x 14 7/8"

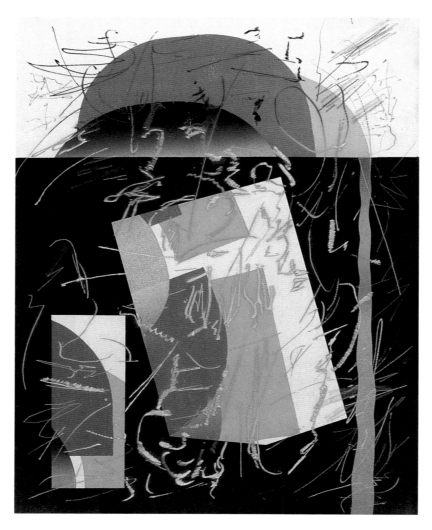

A Secret Place Remembered, 1977
*Sugar-lift ground aquatint etching, drypoint, engraving, silver
ink, chine collé with rainbow-roll and color woodcut
17 1/2 x 13 3/4"*

Autobiographical Print: Venezia, 1977
*Sugar-lift ground aquatint etching, engraving,
chine collé with metal leaf, color woodcut, and found objects
14 x 18 3/8"*

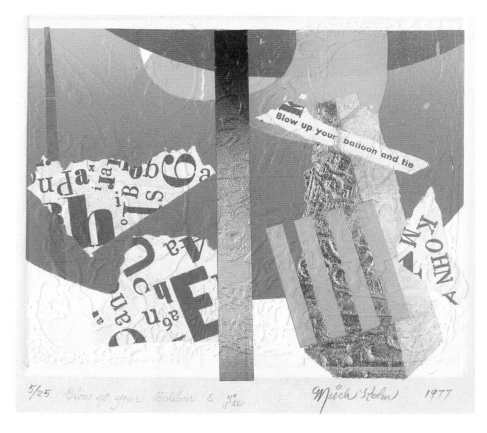

Blow Up Your Balloon and Tie with an E, 1976
Sugar-lift ground aquatint etching, engraving, embossing,
chine collé with silver leaf, metal-type engraving,
rainbow-roll and color woodcut
4 15/16 x 6"

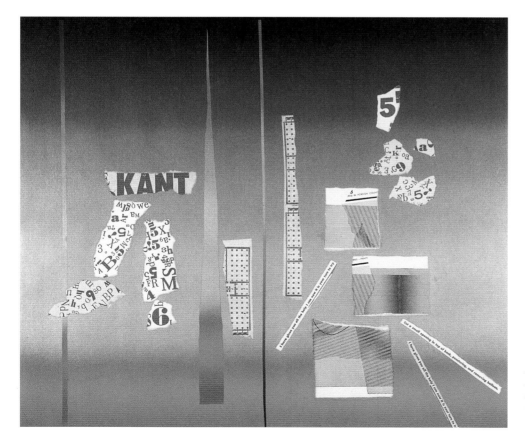

Blue Aquatint, 1976
Rainbow-roll color woodcut,
chine collé with metal-type engraving, photo-etching,
rainbow-roll and color woodcut, and found objects
17 1/4 x 19 7/8"

133

Magda, 1978
Monoprint, chine collé
22 x 13 3/4"

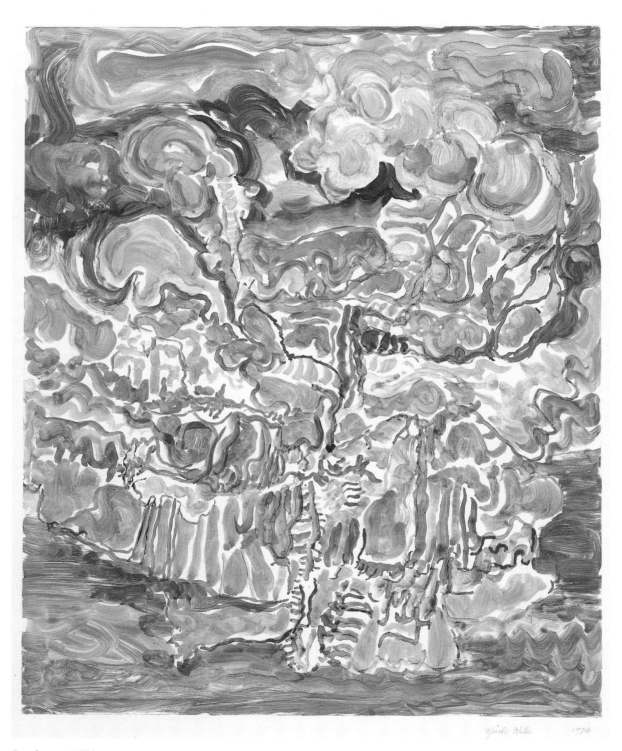

Landscape, 1974
Monoprint
19 3/4 x 16"

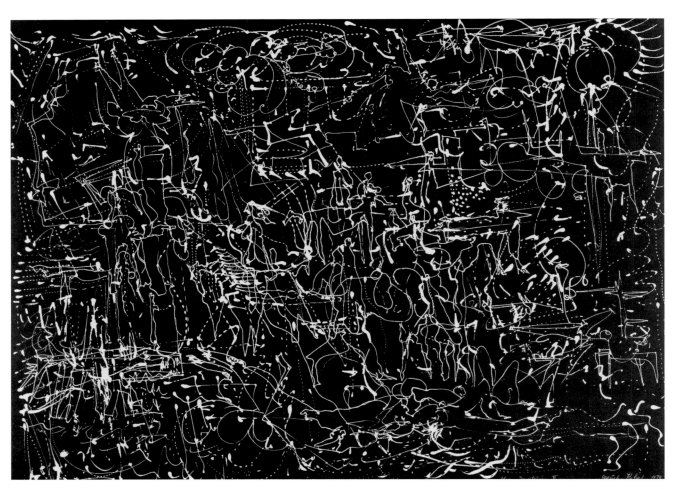

Temptation II, *1973*
Lithograph
22 3/8 x 30 1/4"

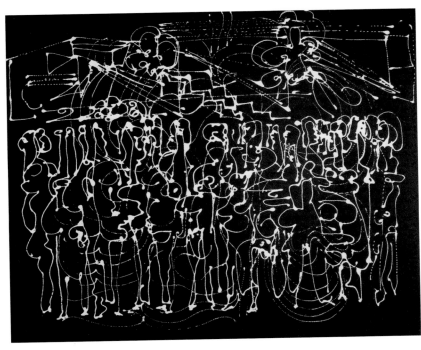

Cocktail Party, 1969
Sugar-lift ground aquatint etching, printed in relief
19 7/8 x 23 7/8″

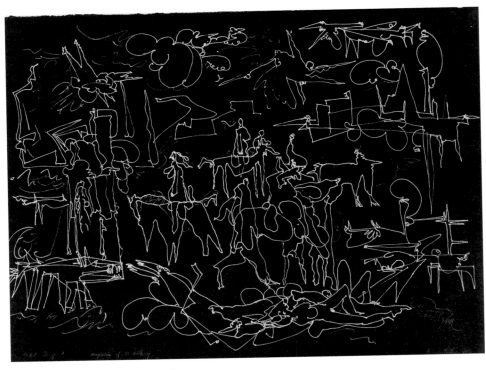

Temptation of St. Anthony, 1973
Lithograph
22 3/8 x 30 1/8″

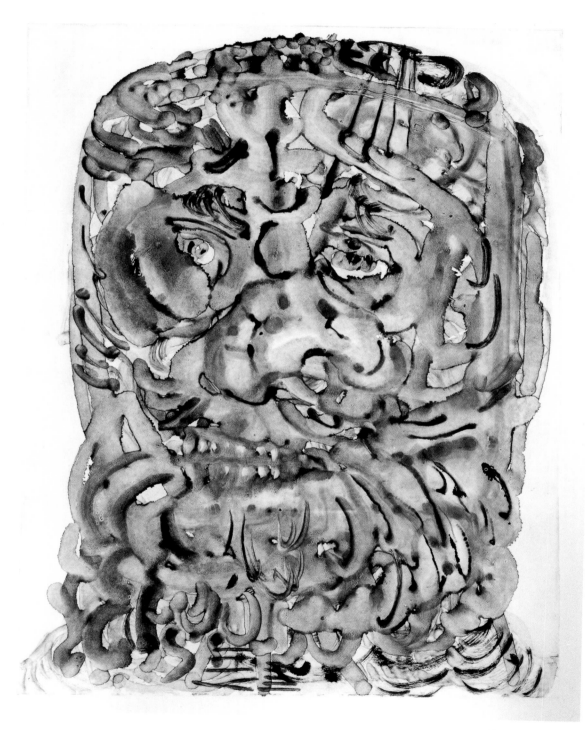

Bizarre Head, 1978
Monoprint
27 5/8 x 21 5/8"

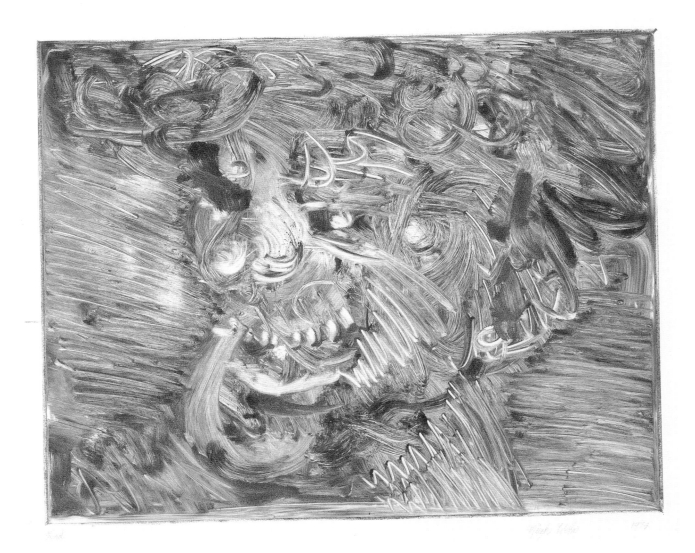

Head, 1974
Monoprint
13 13/16 x 16 7/8"

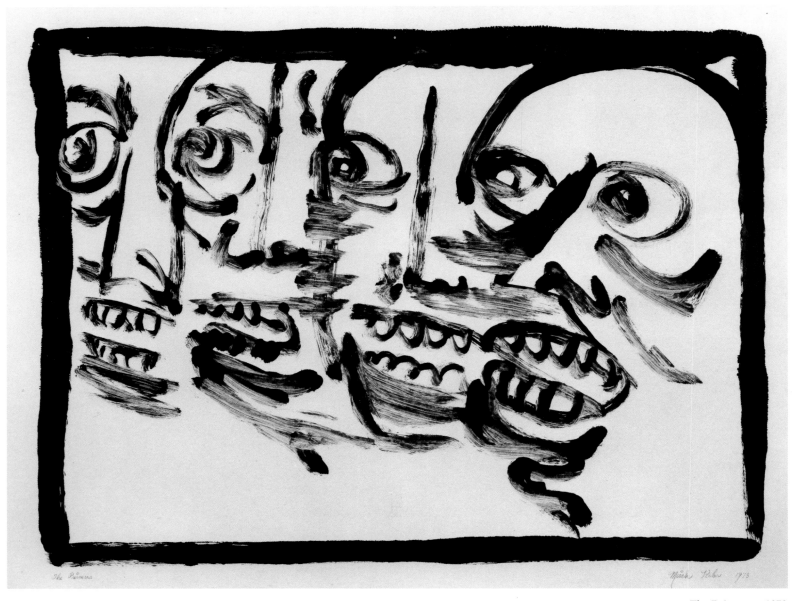

The Prisoners, 1973
Monoprint
17 3/4 x 23 1/4"

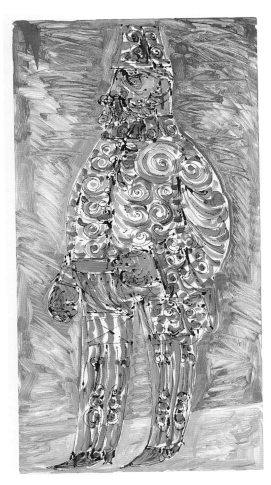

General, 1970
Sugar-lift ground aquatint etching, monotype
34 1/2 x 17 7/8"

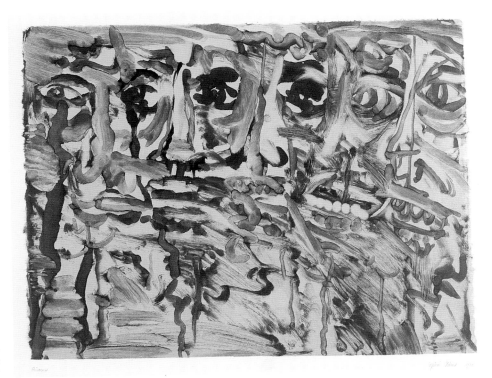

Prisoners, 1973
Monoprint
21 5/8 x 27 5/8"

Plates

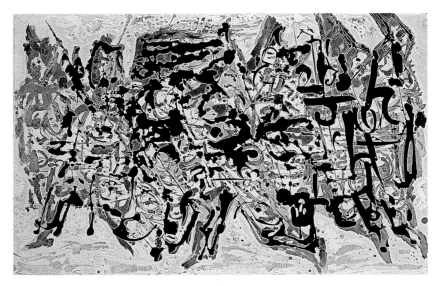

Mob, 1964
Sugar-lift ground aquatint etching, printed in relief
13 x 19 1/2"

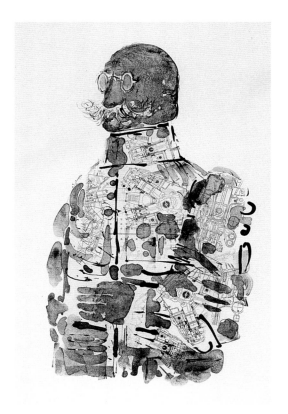

A Friend of the Family, 1965
Lithograph
14 x 8 1/4"

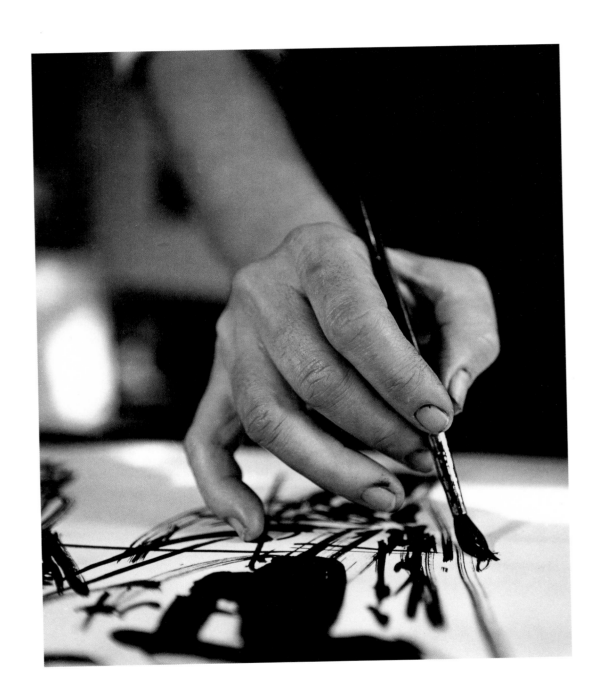

63 Misch Kohn, quoted in Lawrence Schmeckebier, *American Printmakers*. (Syracuse, NY: Syracuse University School of Art, 1962), p. 32.

64 Misch Kohn, interview with author, June 5, 1997.

65 See, for example, John Ross and Claire Romano's books *The Complete Intaglio Print, The Complete New Techniques in Printmaking,* and *The Complete Printmaker* (New York: The Free Press, 1972).

66 Misch Kohn, letter to Carl Zigrosser, October 4, 1969. Carl Zigrosser Papers, Archives of American Art, Reel 4629, Frame 868.

67 Maurice Dance, Vice-President, Academic Affairs, California State University-Hayward, letter to Misch Kohn, July 21, 1971. Unpublished papers, collection of the artist.

68 Gene Baro, *Misch Kohn: The California Years*. (Brooklyn: The Brooklyn Museum, 1981), p. 7.

69 Later, Tullis moved his shop to San Francisco.

70 Tullis had an assistant who later invented a vacuum press that would suck excess water out of the paper, enabling the artist to mold the pulp over three-dimensional forms. Kohn chose, however, not to become involved in that more sculptural aspect of papermaking. Misch Kohn, interview with author, March 14, 1997.

71 Misch Kohn, quoted in Baro, *Misch Kohn: The California Years*, p. 5.

72 Kohn eventually made four bent wire watermarks, because the first two were stolen; he also made a smaller one for small sheets of paper, but never used it. Misch Kohn, interview with author, March 14, 1997.

73 Misch Kohn, quoted in Rebecca Brooke, "Kokomo's Kohn," *Indiana Alumni*. (March/April 1993), p. 31.

74 Misch Kohn, quoted in Baro, p. 9.

75 Kenneth Baker, "A Life's Work of Puzzles and Master Printmaking," *San Francisco Chronicle*. May 18, 1988, p. E-3.

76 Misch Kohn, quoted in Kathryn Metz. *Misch Kohn: Three Decades of Printmaking*. (Santa Cruz: Eloise Pickard Smith Gallery, Cowell College, University of California-Santa Cruz, 1981).

77 Misch Kohn, interview with author, March 4, 1997.

78 *Ibid.*

79 *Ibid.*

80 He has also tended to shy away from having student assistants, as he has found that they interrupt, rather than support, his creative processes. Misch Kohn, interview with author, March 4, 1997.

81 Baro, p. 11.

82 Misch Kohn, interview with Isabelle Rubin LaBelle and Melanie Rubin, April 28, 1996.

83 Lore Kohn, quoted in Martha Kennelly, "Cal State Bids Goodbye to Art Prof Misch Kohn," *The Daily Review* (Hayward, CA). March 31, 1986, p. 12.

84 Allan Temko, quoted in Kennelly, "Cal State Bids Goodbye to Art Prof Misch Kohn," p. 12.

85 Misch Kohn, interview with author, May 14, 1997.

very small margins around his wood engravings in order to conserve his supply. Later, a small stock of similar paper was discovered in the late 1950s in the basement of a store in San Francisco's Chinatown by one of Kohn's former students, who had the crate of 1000 sheets of paper shipped back to Kohn in Chicago. Although the quality was not as high as the earlier batch, it has provided material for him until the present. Misch Kohn, interview with author, June 5, 1997.

34 Zigrosser, *Misch Kohn*, p. 8.

35 Misch Kohn, "Proposed Plan of Creative Work." Unpublished papers, collection of the artist.

36 Zigrosser, *Misch Kohn*, p. 8.

37 Jules Heller. *Printmaking Today*. (New York: Henry Holt and Co., 1958), p. 75.

38 Peter Selz, "Three-Dimensional Wood Engravings: The Work of Misch Kohn," *Print Magazine*. vol. VII, no. 5 (November 1952), p. 37.

39 Misch Kohn, interview with author, Isabelle Rubin LaBelle, and Melanie Rubin, April 27, 1996.

40 Suzanne Burrey. "Exhibition of Wood Engraving at Weyhe Gallery," *Arts Digest*. vol. 29, no. 11 (March 1, 1955), p. 25.

41 Gertrude Benson, "Rosenwald Collection of Engravings after Watteau Are Given to Museum," *The Philadelphia Inquirer*. April 4, 1954, p. 10C.

42 This print was also inspired by a poem, this time by Rimbaud.

43 Selz, "Three-Dimensional Wood Engravings," p. 41.

44 Zigrosser, *Misch Kohn*, p. 11.

45 Hayter's first studio, 1927–40, was at 17 Rue Campagne Premier. With the coming of World War II, he moved Atelier 17 to New York, where he set up shop in the New School for Social Research. He did not reestablish his printshop in Paris again until the early 1950s.

46 Misch Kohn, interview with author, February 12, 1997.

47 Carl Zigrosser, quoted in the catalogue for the *Fourteenth Exhibition of Prints* by members of the Atelier 17 group. (New York: Laurel Gallery, 1949), p. 6, reprinted from *The Book of Fine Prints*, revised edition (New York: Crown Publishers, 1948).

48 Serge Chermayeff, letter to Misch Kohn, May 4, 1949. Unpublished papers, collection of the artist.

49 Kohn's biggest regret from that time is that although he borrowed $300 from friends to buy a couple of African sculptures, he wasn't able to buy more. It is intriguing that although he has consistently been interested in African art, references to those aesthetics have never appeared in his work. He muses that he probably felt it was inconceivable that he could design figures exploring those kind of relationships, although he was well aware that Picasso and others had approached that challenge very successfully.

50 "In mentioning profusion of color as a possible threat to the oil painter's domain, a note regarding the size of prints can well be made....One of the noticeable trends within the past decade has been an enlargement of the print surface; and by combining these two qualities, size with color, the printmaker is truly entering into competition with the painter." Kneeland McNulty, "A Decade of American Printmaking," *The Philadelphia Museum Bulletin*. vol. 48, no. 235 (Autumn 1952), p. 14.

51 Misch Kohn, "Proposed Plan of Creative Work." Unpublished papers, collection of the artist.

52 Mourlot's shop walls were lined with stones from previously-printed lithographs; the stone was still good, so the printers polished the backs and new artists worked on this second surface, without destroying the previously drawn image on the front.

53 Massey Trotter, *Roger Lacouriere: Engraver and Master Printer*. (New York: American Institute of Graphic Arts, 1949), p. 8.

54 Misch Kohn, letter to Carl Zigrosser, August 1, 1960. Carl Zigrosser Papers, Archives of American Art, Reel 4629, Frame 794.

55 Misch Kohn, interview with author, April 24, 1997.

56 Misch Kohn, quoted in *American Prints Today/1959*. (New York: Print Council of America, 1959), re: *Three Kings* (1957), cat. #29.

57 Misch Kohn, letter to Carl Zigrosser, n.d. (c. September 17, 1959). Carl Zigrosser Papers, Archives of American Art, Reel 4629, frame 753.

58 Misch Kohn, interview with author, February 12, 1997.

59 James R. Spence, "Misch Kohn: A Critical Study of His Printmaking." Unpublished doctoral dissertation, University of Wisconsin-Madison, 1965, p. 154.

60 Misch Kohn, interview with author, February 12, 1997.

61 David Anderson, "Chicago Artist Loves That DAR," *Chicago Sun-Times*. December 11, 1961, p. 3.

62 Misch Kohn, unpublished papers, collection of the artist.

Endnotes

1 Lore Kohn, interview with Isabelle Rubin LaBelle, Jessica Kohn McGuire, and Melanie Rubin, April 26, 1996.

2 Misch Kohn, interview with author and Isabelle Rubin LaBelle, November 23, 1995.

3 Misch Kohn, "Early Biographic Material." Unpublished papers, collection of the artist.

4 Misch Kohn, interview with author, Isabelle Rubin LaBelle, and Melanie Rubin, April 27, 1996.

5 Misch Kohn, interview with author, April 24, 1997.

6 Misch Kohn, interview with author, Isabelle Rubin LaBelle, and Melanie Rubin, April 27, 1996.

7 Misch Kohn, letter to Carl Zigrosser, July 19, 1960. Carl Zigrosser Papers, Archives of American Art, Reel 4629, Frame 771.

8 Misch Kohn, interview with author, Isabelle Rubin LaBelle, and Melanie Rubin, April 27, 1996.

9 Barbara Bernstein, "Federal Art in Illinois." Unpublished manuscript, Illinois Arts Council, 1976, p. iii.

10 Carl Zigrosser. *Misch Kohn.* (New York: The American Federation of Arts, 1961), p. 6.

11 Kohn actually contributed the third press to the studio, which he had received in trade for printing two editions of work for Edward Millman and Associated American Artists. Misch Kohn, interview with Liz Seaton, February 28, 1996.

12 Robert J. Evans and Maureen A. McKenna. *After the Great Crash: New Deal Art in Illinois.* (Springfield: Illinois State Museum, 1983), p. 8.

13 Misch Kohn, interview with author, Isabelle Rubin LaBelle, and Melanie Rubin, April 27, 1996.

14 Other sources indicate that the salary may have been $94 per month. See Bernstein, "Federal Art in Illinois," p. iii.

15 Misch Kohn, interview with Liz Seaton, February 28, 1996.

16 *Ibid.*

17 Norman MacLeish, letter to Misch Kohn, September 23, 1941. Unpublished papers, collection of the artist.

18 Misch Kohn, interview with author, February 12, 1997.

19 Misch Kohn, letter to Leanora Kohn, Summer, 1940. Unpublished papers, private collection.

20 *Ibid.*

21 Misch Kohn, letter to his family, November 12, 1944. Unpublished papers, collection of the artist.

22 Misch Kohn, interview with author, Isabelle Rubin LaBelle, and Melanie Rubin, April 27, 1996.

23 Misch Kohn, letter to his family, December 3, 1944. Unpublished papers, collection of the artist.

24 Misch Kohn, letter to Benjamin Krohn, c. March 31, 1944. Ryerson Library, Art Institute of Chicago.

25 *Ibid.*

26 Although Kohn printed many examples of his Mexican prints at the *Taller,* he believes that his best examples of these prints were done upon his return to the States, due to the better quality of the equipment and studio. Misch Kohn, interview with author, Isabelle Rubin LaBelle, and Melanie Rubin, April 27, 1996.

27 However, during that time, more monies began to be funnelled toward the *Taller;* Hannes Meyer, the city planner for the *Distrito Federal,* had been the penultimate director of the Bauhaus, preceding Mies van der Rohe, and took over the direction of the *Taller* during Kohn's residency. With power and connections to the politicians in Mexico, Meyer was able to earmark funds for the *Taller* to publish books and prints. Among these projects was printing the portfolio of Posada's engravings.

28 Misch Kohn, letter to his family, c. January 4, 1944. Unpublished papers, collection of the artist.

29 Misch Kohn, quoted in Barbara Galuszka Parsons, "I Can't Go On; I'll Go On," *The California Printmaker.* Issue No. 1 (Winter 1993), p. 7.

30 Misch Kohn, letter to his family, May 23, 1944. Unpublished papers, collection of the artist.

31 Although Lore had earned her degree from the University of Wisconsin-Madison in economics/statistics, she had always been interested in and involved with textile design and production.

32 Misch Kohn, "Proposed Plan of Creative Work," proposal to the Guggenheim Foundation, late 1951 or early 1952. Unpublished papers, collection of the artist.

33 This type of paper had been widely used in France in the nineteenth century, and was adopted in the United States for use as lithographic transfer paper. By the 1940s, however, the inventories had been essentially depleted. Kohn's first major stock of it—2000 sheets— was purchased from the American Bank Note Company in Chicago. This was extremely high quality paper, and he took it with him everywhere he worked. Concerned that he would run out, he consistently cut

Several years ago Kohn was quoted as saying that he was looking for joy in his work, something to enlighten and entertain him. Presiding over the lifeless layers of paper, ink, and color as they magically coalesce into vital and treasured impressions, Kohn has certainly provided this emotion for his viewers. But beyond joy, we have been educated and illuminated; and above all, we have been privileged to share in these fruitful and successful moments of mastery.

Chris Chenard (American, b. 1952)
Misch Kohn, *c. 1989*
Castro Valley Studio

Epilogue

When asked about his current work, Kohn reiterates that he is always changing, always exploring. Although focusing on abstraction, he periodically returns to figurative and referential images, keeping his hand skilled in the painstaking work of wood engraving, or lyrically delineating the portrait of a friend with sugar-lift ground aquatint. As he has explained, he is always trying to "find out something" from his work, so he will never be done searching, and he will never consider his earlier printmaking as a plateau from which he need not seek to ascend. His path over these past six decades has been a broad and diverse one, as he has moved from black-and-white to color, from studies of individual and collective angst to explorations of light and form, embracing and exploring the range of printmaking media and technique. There is no doubt that in his future work Kohn will continue to offer the viewer a direct and intense personal narrative delineated through an individual symbology in which he shares his aspirations, his explorations, and his ideals.

The conceptual brilliance of Kohn's most recent work parallels the physical layering of its transparencies, as it provides structure and education while illuminating us with expressivity, creativity, and harmony. Bold yet sensitive, aggressive yet intricate, it reveals strength, grace, and that rare freedom that an artist achieves when image and technique, vision and process have successfully been merged.

paper created from unique batches of pulp, in 1987 he also began to explore embedding sections of colored handmade and Asian papers into the pulp itself, fusing and layering transparent strata. This has resulted in a complex printing surface that, more than ever before, has become an inherent component of the composition rather than simply a neutral passive substructure. The increased depth afforded by these transparencies further enhances the radiance of the work as well as its visual tension. Working as large as three 36 x 72" sheets joined together into a massive 6 x 9' triptych, he builds upon this foundation with additional color collaged materials (including previously printed woodcuts, metal leaf, etchings, or metal-type engraving), and overprints with engraving (occasionally inkless), and even drypoint as well. Working on lucite plates—the monumental size precludes being able to physically manipulate a metal plate—Kohn is energized not only by the imposing visual challenge resulting from the dimensions of the work, but by the ability to communicate his aesthetic in so different a way.

As is typical for him, this new process has required innovations with new techniques of printing. Laying in planes of color, or using a turkey baster to literally draw with contrasting strings of colored pulps into the background pulp, he designs his paper as carefully as he does the subsequent layers of media. Strata interweave and reconnect, porous and indistinct, painterly in their strength. Restricted by the size of his press

rollers to a 36" width and by the press bed to a 36" length, he compensates by running half of a 6' long length of handmade embedded paper through his press, then turns it around to engrave the second half. Precision is crucial, for each time the paper passes through the press it flattens out, so any overlapping or abbreviation of the run can negate or alter what has gone before, interrupting the fluidity of the lines of the entire surface. If careful to avoid running over what had already gone through the press, however, "you can just keep on going, keep on adding new things."[85]

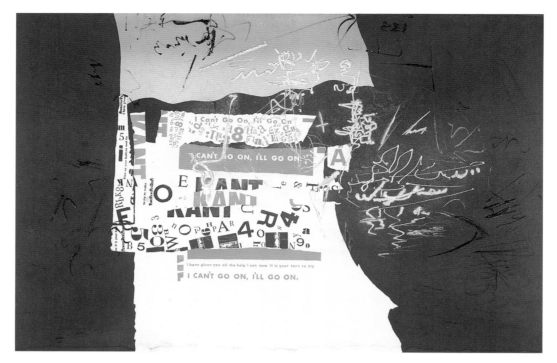

Beckett, 1977
*Sugar-lift ground aquatint etching, engraving, chine collé with
 metal-type engraving and color woodcut*
15 7/8 x 23 5/8"

them...take them away from their context," he says. "And if I do a good job, when I get through with them, they're brand new."[82] One is tempted to interpret these tokens as metaphors, as if they were teasing the viewer while providing clues to the artist's philosophical intent; Beckett and Kant still make their presence known (e.g.,"...I can't go on, I'll go on..."). The artist, however, is evasive on that score, and one feels constrained to check the impulse of being seduced by false clues.

In 1986 Kohn decided to retire from teaching. What had begun as a temporary semester replacement had turned into a career of 37 years, and in his quiet way, he had become the most admired teacher in the Art Department at Cal State Hayward, as he had been at the Institute of Design in Chicago. Periodic acknowledgment

of this during the years had taken place, with his award as an "Outstanding Educator of America" in 1972, and as an "Outstanding Professor" at Cal State in 1974. "Once you're Misch's student, you're his student for life,"[83] his wife, Lore, has emphasized; his students are devoted to him due to his relaxed and supportive teaching style, and respect him for his incredible mastery. Art and architecture critic Allan Temko has noted that, "I don't know anyone who has worked with the students in this way—as a friend. Everything comes from the heart. He gives things no one else in the world can give, technically and philosophically."[84]

Following his retirement, Kohn expanded the size of his work dramatically. Although he continues to produce multimedia intaglio prints on relatively standard-size sheets of handmade

Blow Up Your Balloon and Tie 5-8-0!, 1976
Sugar-lift ground aquatint etching, drypoint, engraving, chine collé
with metal-type engraving, rainbow-roll and color woodcut
5 1/8 x 7 1/2"

Black Pole, 1976
Sugar-lift ground aquatint etching, engraving,
chine collé with rainbow-roll and color woodcut
5 x 7 1/2"

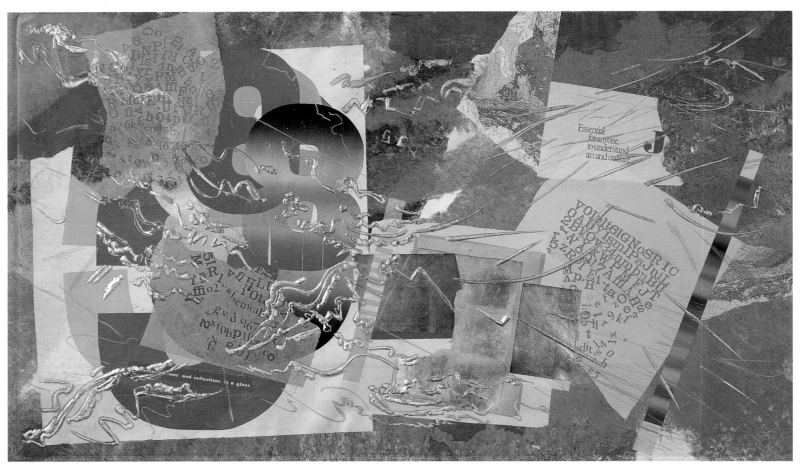

Transformation and Reflection on 8, 1992
Engraving, silver ink, chine collé with metal-type engraving,
rainbow-roll and color woodcut, wood type, and found objects
on handmade embedded paper
32 1/2 x 54"

always a delight, an excitement, to reach that [point]; it was always a surprise to me." Kohn, intrigued by artists who could design a work and then turn it over to master printers to create the edition, viscerally understood that he could not work like that. His process of printing is just as organic as his conceptualization, and thus he needs the freedom to compose the work both in time and in pictorial space at every point—mechanical as well as creative—in the process. "I admired the work that these master printers did, and I enjoyed when I worked with them, and it certainly is a lot easier on old bones," he confesses. "But there's a certain freedom [in] working by [my]self."[80]

Over the past two decades, Kohn has returned again and again to some of his favorite copper or lucite plates, reusing them in a different context with different media, and creating entirely new works from them. Although many of these are modest in scale, they are often monumental in impact; "their space is an analogue of space observed and experienced, but also of space imagined and reinvented."[81] He delights in viewing things from a fresh perspective, and in placing common objects or images in a new context, knowing that it forces people to look at things differently. He is intrigued, for example, by the topographical maps that he uses as raw material for his collages because he looks at them for their visual impression rather than for their informational content, as intended by the draftspersons who created them. "I change

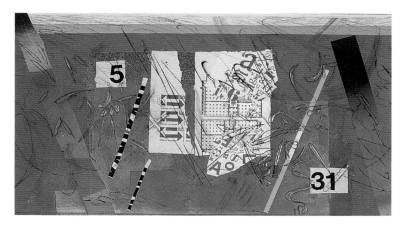

The Hayward Print, 1987
Engraving, chine collé with metal leaf, line etching on zinc,
* metal-type engraving, found objects, rainbow-roll and color woodcut*
12 5/8 x 24"

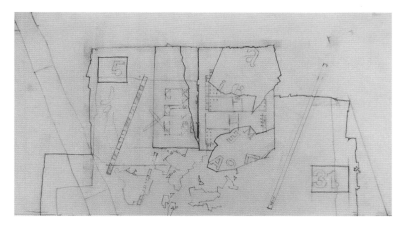

"Map" for The Hayward Print, 1987
Graphite on vellum
12 5/8 x 24"

artists who primarily work in other media and transfer their imagery for the print collectors' marketplace. In fact, rather than reiterating aesthetic concepts and moves found in other media, printmaking in the hands of masters such as Kohn has initiated the reverse process of influencing the allegedly more major media of painting and sculpture. Although Kohn continues to draw, and thinks about doing works in other media, it is through printmaking that the fundamental harmony of his intent is revealed.

Now, more than ever, it has become clear why Kohn chooses to work alone. Every stage in the process is important: as he has described himself in a "state of constant re-evaluation and development...constantly moving,"[76] he cannot leave any part of the evolution of his prints—unique or editions—to another:

> There was always so much change between my original conception and how [the work] finally developed. I change, I develop as I go along in the piece, so I become a different person at the end of the piece than at the beginning. I know there are people who just use the medium to do what they already know. And I just don't do that. I'm trying to find out something.[77]

As he has for years, Kohn begins his working process with a series of drawings that help him to organize his space, define the internal relationships, and solve the conceptual problems of his composition. Although he may start with the inspiration of a particular place, a narrative,

or another work of art, he soon moves into a creative zone in which his imagination takes over. From that point, he is no longer interested in what sparked his inspiration in the first place, and matter-of-factly acknowledges that often his resulting work may have no bond whatever to the original stimulus. In describing a work that he was doing that had been originally stimulated by seeing an etching by Antonio Pollaiuolo, Kohn said, "I don't know what supported it, what caused it, what the event was; it wasn't necessary for me to know. I was interested in the relationships of figures in space, and the movement, and what could be a ballet."[78] It is interesting that Kohn, whose written language has always been lyrical, speaks of his formalist concerns with the terminology of a dancer: he describes movement, rhythm, and relationships of shapes within the cosmos of his creation.

His preliminary drawings vary in complexity; some are very quick sketches, and some become quite detailed. Yet he regards them not as a blueprint, but more as a conceptual map, and is consciously not only accepting, but welcoming, of the changes that will occur between the "mapping out and the carrying out." As he works, he responds to the changing developments in the various components of the media and the processes, revising as he goes: "each thing I do influences the next thing I do."[79] Thus, it is with great anticipation that he looks forward to lifting the blanket off of the paper that has passed through the press for the last time: "It was

lier prints; letters, tickets, and personal memora-
bilia; wine and food labels; maps, train sched-
ules, and diagrams from old textbooks. Although
this list might mentally evoke a visual overload,
the clear, luminous colors he uses bind the for-
malist images in jewel-like mysteries that open
up successive layers of depth the longer they are
viewed. Laughing, Kohn tells an anecdote of
saving a 60-cent special delivery stamp for years,
waiting for the right opportunity to use it in a
piece. Finally he found a place for it, and, seeking
additional ones to round out the edition, he went
to the post office to buy more. "They told me
these stamps hadn't cost 60 cents for years. It
turns out they were 30 years old!...I had to go to
a rare-stamp dealer to get more."[73]

In addition to using "found objects," he
also specifically prints images, shapes, and colors
in advance so that he will have the right textures
and colors when he is ready to assemble the
work. He sets up single words and sentences
in type; taken out of context and included in the
work, this progression of visual ideas and sym-
bols enlightens the work with rhythm and
eloquence. Although he does use precolored
papers, he prefers to print his own colors so that
he can achieve exactly the right hue that he
knows will not fade. In contrast to the more
somber, limited colors of Chicago, the California
colors—often printed layer upon layer—are
bright and deep. An incalculable amount of time
goes into this preliminary work. Working in the
process of additive collage, "I take the plates and

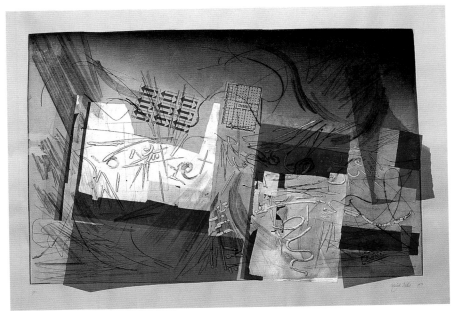

Special Delivery, *1979*
Sugar-lift ground aquatint etching, drypoint, engraving,
* chine collé with silver leaf, color woodcut, and found objects*
20 1/4 x 31 1/2"

add more to them, continuing to discover what
the possibilities are," he explains. "I work toward
a kind of richness of color that activates spaces,
suggests depth without describing it, and pro-
vides a richness of transparency not to be gotten
in any other way."[74] Although many reviewers
have been awed by the complexity of the
processes he utilizes, critic Kenneth Baker has
advised that we should be content to "take them
for what they most consistently are, little mira-
cles of skill and compositional grace."[75]

Because the imagery of his work is tied so
tightly to printmaking processes, it reveals a
unity and clarity not generally found in prints by

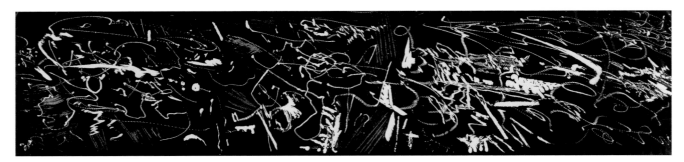

Disappearing 8 (I), *1975*
Engraving, printed in relief
5 3/8 x 23 5/8"

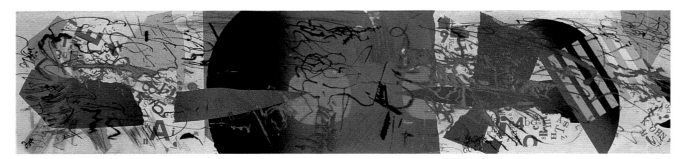

Disappearing 8 (II), *1975*
Sugar-lift ground aquatint etching, engraving, chine collé with metal-type
* engraving, silver leaf, rainbow-roll and color woodcut*
5 1/2 x 23 7/8"

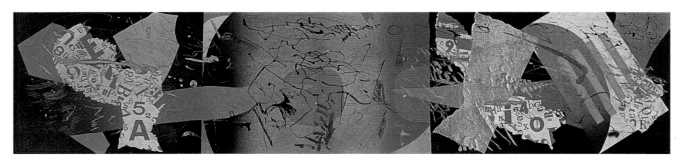

Disappearing 8 (III), 1976
Sugar-lift ground aquatint etching, engraving, chine collé with metal-type
* engraving, silver leaf, rainbow-roll and color woodcut*
5 1/2 x 23 7/8"

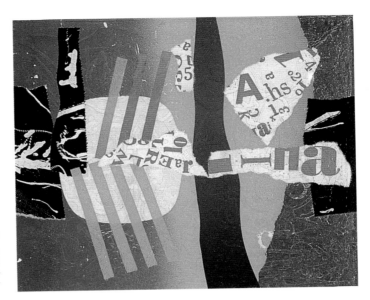

A Ha, 1976
*Sugar-lift ground aquatint etching,
uninked engraving, chine collé with metal leaf,
engraving, and rainbow-roll color woodcut
5 1/8 x 6 1/4"*

O Kant, 1975
*Rainbow-roll color woodcut, chine collé with metal-type
engraving, photo-etching, rainbow-roll and color woodcut
17 1/8 x 20"*

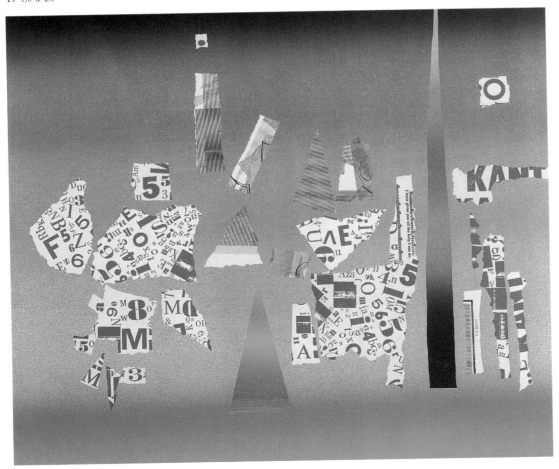

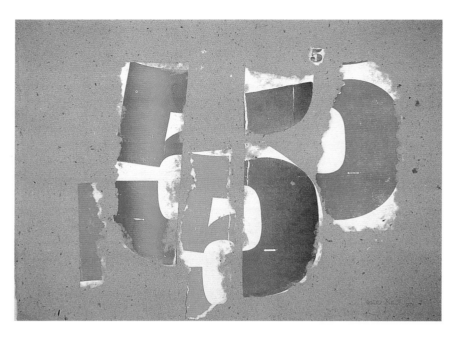

Disconnected 5, *1976*
Handmade paper embedded with rainbow-roll and color
 woodcut
18 1/2 x 24"
Private collection

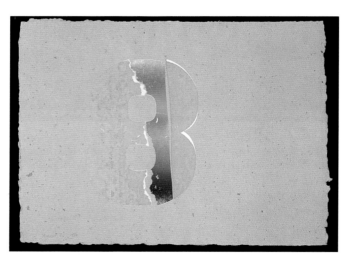

Fragmented 8, *1976*
Handmade paper embedded with color woodcut,
 overprinted with rainbow-roll and color woodcut
18 1/4 x 24"

Double Eight, *1976*
Handmade paper embedded with color woodcut and metal-type
 engraving, overprinted with rainbow-roll and color woodcut
18 3/4 x 25"

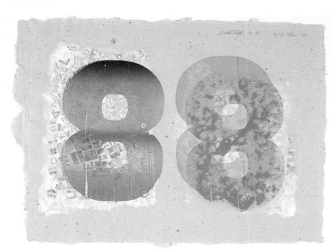

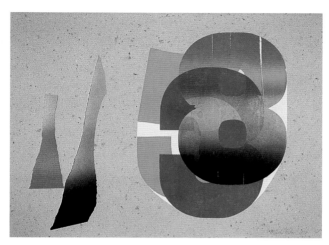

5-8-3 With Sails, *1976*
Handmade embedded paper overprinted with
 rainbow-roll and color woodcut
18 1/2 x 24"
Private collection

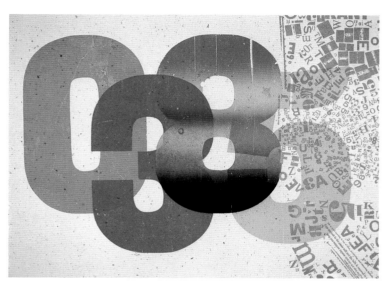

Kant and the Numbers Game, *1976*
Embedded handmade paper overprinted with
 metal-type engraving, rainbow-roll and color woodcut
18 1/2 x 24"

3, *1976*
Embedded handmade paper overprinted with rainbow-roll and color woodcut
18 1/2 x 24"
Private collection

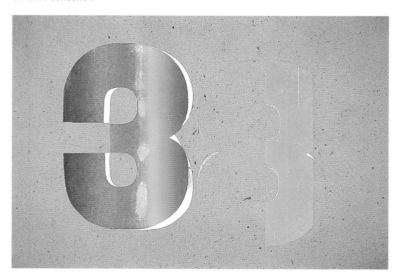

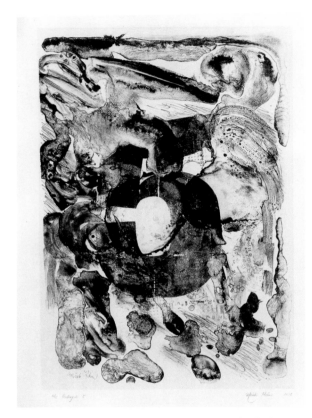

***Destruction of 5 (III)**, 1974*
Lithograph, chine collé
23 5/8 x 16"

Kohn continued to explore the medium of handmade paper as the background for his new work. He soon met Don Farnsworth, bought paper from him, and made some himself at Farnsworth's Oakland studio. In a single day, with the help of one of the assistants at the papermaking facility, Kohn was able to make 30 sheets of paper. He did this "quite often" until he had a sufficient inventory of paper for printing his work. (Although by this time he rarely—if ever—pulled large editions of prints,

he did do many series of "evolving editions" or *editions variées*. Each print from such an E/V was unique, but being part of an edition, it obliged him to at least consider the use of a consistent paper stock.) Kohn fashioned a watermark out of silver wire in the cursive shape of his first name; Farnsworth sewed this watermark onto his mold, and so during the time Kohn worked with Farnsworth, he was able to create this personalized watermarked paper.[72]

Although Kohn periodically continued to produce figurative or representational images, including some portraits, for the most part his work had become completely abstract. By this time, his technical virtuosity was affording him complete freedom in structuring his compositions: from the mid-1970s to the present, a single print might include engraving, aquatint etching, woodcut, and *chine collé*, printed on a finely embedded or fused piece of handmade paper. Unbound by academic or traditional conventions, feeling free to utilize whatever he needed to achieve the results he desired, Kohn has come to use plates of lucite as well as copper, zinc, or magnesium, and a variety of implements for scratching the image into the plate, including motorized tools like the dremel for drypoint or line-etching qualities. He values the distinctive effects he is able to achieve with the different tools.

Pursuing the visual properties of our alphabet and numerical systems, he incorporates symbols and calligraphic notations used in ear-

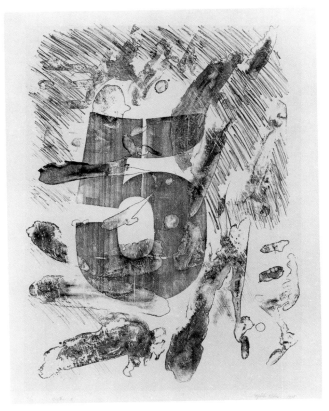

Destruction of 5 (I), 1974
Lithograph, chine collé
22 5/8 x 14 1/2"

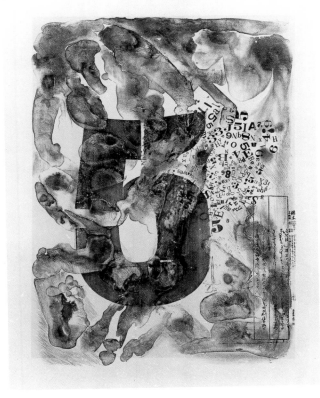

Destruction of 5 (II), 1974
Lithograph, chine collé
22 5/8 x 14 1/2"

better in another medium," he confessed in the early 1980s to Gene Baro, "and maybe I could do better by making statements of art rather than statements of the state of man."[71]

He set up his own papermaking facility at the university with a macerator that Garner Tullis had located, a hydraulic press the school technicians built, and a large press used by newspapers for embossing and stamping electrotype negatives (which Kohn had traded to Tullis for his old lithograph press). The fully operational paper-

making facility was a tremendous boon to the university; it brought in students from all over and provided Kohn with a shop he could work in as well. Still, sufficient university funding for the program did not materialize, so Kohn organized the creation of two portfolios of works by students and professors as a fund-raising project; sales were brisk and provided the department with the funds to purchase the additional elaborate papermaking and printmaking equipment that was needed.

contrast to the fluorescent-lit basement studio he had worked in for so long in Chicago, the natural light and air of his California studio infused his work with radically new direction. "Looking at Kohn's California prints," Brooklyn Museum curator Gene Baro wrote in 1981, "can be like opening the shutters on a brilliant morning, when the whole scene is energized, articulated, and dissolved in the vibrancy of air and light. At such a moment, one is unconscious of details and yields to the sensation of being."[68]

One of the first of many artists whom Kohn met when he came to California was Garner Tullis, who had just founded the Institute for Experimental Printmaking in Santa Cruz.[69] Tullis invited Kohn to come down and work with him there, which he did, beginning in July 1975 and continuing off and on for several months following. Accompanied at times by his wife or visiting friends, Kohn would drive to Santa Cruz for the day; Lore would often pack a picnic lunch, and they would relax and enjoy the change of scenery. Kohn was immediately energized and fascinated by the papermaking processes that Tullis introduced him to; he had always liked handmade papers, and had used them (primarily Japanese papers) from the late thirties on, whenever he could find and afford them. Kohn brought down some of his old prints (on a variety of French, Japanese, and Chinese papers, among others), experimental proofs that he hadn't liked, or numerous copies of editions that he didn't believe would ever sell, to add to the pulp they were

creating. They used some raw materials standard in papermaking, such as Japanese kozo, but also added linen (including Lore's old German linen sheets and damask tablecloths), and old blue jeans in addition to his earlier prints. Kohn liked the color that the bits and pieces of former work incorporated into the pulp and enjoyed experimenting with various materials to find those that he responded to most favorably. He made approximately 30 sheets of paper at Tullis's, and brought them home to print, emboss, and collage on top of. The irregular textural qualities of this handmade paper became integral to the new kinds of prints that Kohn was envisioning.[70]

The series of works that Kohn did on these Tullis papers were an evolving exploration of color and form. He had always been interested in typography and letter forms, a carryover, perhaps, from his early work in advertising art, so he began using preprinted woodcuts, metal-type engravings, and other "textures of pieces and things" that he prepared in advance specifically to use for collage. During this period he focused on large, rounded numerical digits—particularly the 8, 3, and 5—to form his abstract compositions. Working this way enabled him to experiment as he was composing his images, using the preprinted forms as a palette. Responding to the shapes as well as to the rich colors he created, he turned a crucial corner with his art and has never looked back. "The statements I thought I was making that were important about the state of the world or man's fate were able to be said

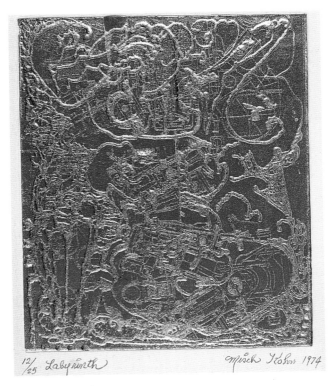

Labyrinth, 1973
Sugar-lift ground aquatint etching, engraving, chine collé
5 15/16 x 4 15/16"

prints. It was time to go, time to break from the past, one of those pivotal moments whose significance can only be guessed at initially, and whose true impact becomes clear only with the passing of time.

When Kohn had visited Hayward for his interviews, he had found a vital and lively department, with extra funding for visiting artist and lecture series and the promise of a graduate program in studio arts. But suddenly, California was in the midst of an economic recession, and the monies dried up for all of the "extras" that Kohn had been led to believe would be there. Despite these disappointments, however, the radical environmental change was invigorating for him and his work. He spent a year or more designing and constructing a studio next to his home in Castro Valley, a large, light-filled space with windows on three sides, nestled against a hillside and surrounded by exotic flowers and plants. In sharp

Isabelle Rubin LaBelle (American, b. 1925)
Misch Kohn, c. 1977
California studio
Collection of the photographer

The Turning Point
Color and Abstraction

Many people had assumed that Kohn would remain a midwesterner all his life, and the I.D. administration apparently didn't believe he would really ever leave. Even after an exploratory trip out to California, when he told them that he had been offered a salary exactly double what he had been receiving at the Institute of Design, they offered him only a marginal upgrade in income and promised a renovation of the ventilation system that he had been requesting for years. That they could have provided these changes and had chosen not to was the final straw. He tendered his resignation and joined the faculty at Cal State Hayward at the rank of full professor, class I, step 5; the CSU administration was savvy enough to bend the rules requiring the attainment of a doctorate or "terminal degree" for this position and determined that his "experience and attainments constitute the equivalency of the terminal degree in Studio Arts."[67] The next academic year he was accorded full tenure.

This move necessitated a complete upheaval of both professional and personal lives for Kohn and his family. Decades of accumulation needed to be sorted through, and although he brought two antique presses with him—one for lithographs and one for etchings—he sold two presses before he left. He brought 25 litho stones and many of the plates, but, sadly, some of his earlier plates and stones were left behind; some of the former were sold for scrap metal, without retaining reference examples of the

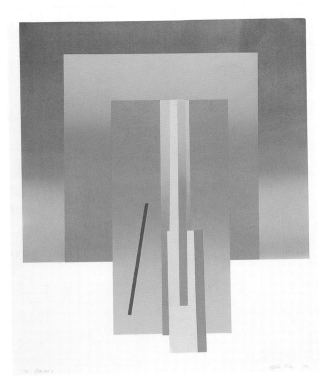

Pendulum II, 1973
Rainbow-roll color woodcut, chine collé
27 3/4 x 21 3/4"

favor of the cool, new "rainbow-rolls" of wood-cut color he had recently discovered.

Kohn was continuing to receive accolades for his work—he was included in the 1970 Biennial in Venice, in 1971 he was honored as an "Outstanding Educator of America," and in 1972 he was appointed to the Pennell Fund Committee of the Library of Congress, responsible for print acquisitions for this national collection—but he was feeling the need for change. In 1969 he taught a special summer course at the University of Chicago and was offered a "visiting professorial lecturer" position for the succeeding academic year, with the potential promise that this could develop into a regular full-time position. Neither the money nor the commitment was sufficient, however, and he declined the offer. Kohn was increasingly frustrated by the adminis-

tration at the Illinois Institute of Technology, which had taken over the New Bauhaus Institute of Design in 1952, and had promised autonomy to the latter, only to subsume it under the general auspices of the university. Prompted by the interest manifested by the University of Chicago, when his friend and colleague Aaron Siskind was abruptly and unwillingly "retired" from the I.D., he resolved to make a change. "I feel it is time to move on," he wrote to Zigrosser in 1969. "For years I misunderstood the adage 'a rolling stone gathers no moss' so I stayed put for 20 years. Suddenly I realized moss I didn't need."[66] When he received a call from California State University-Hayward in 1971 asking for recommendations for a printmaker, he decided to answer the call himself.

Photographer unknown
Faculty, Institute of Design, c. 1965
Illinois Institute of Technology, Chicago

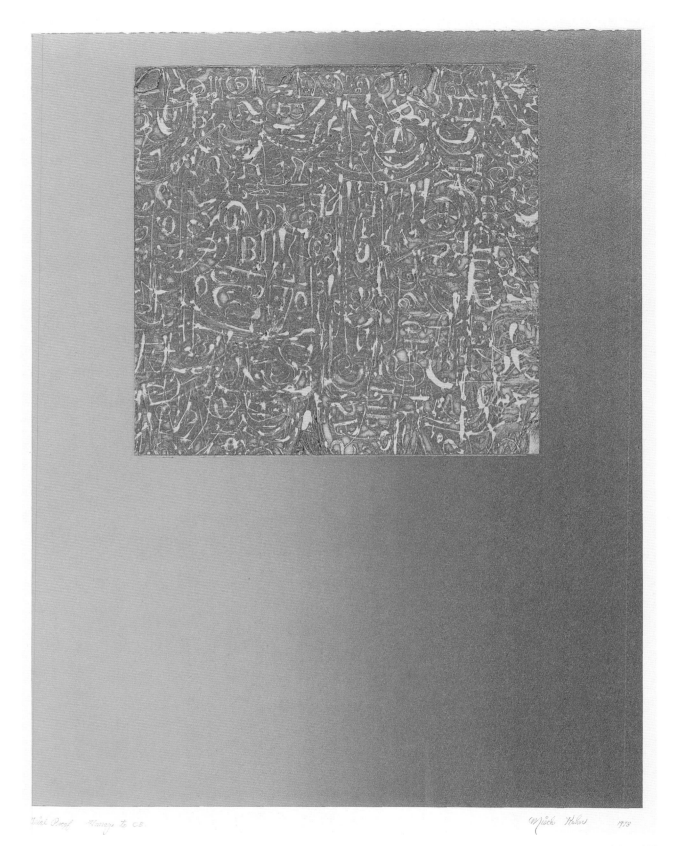

Homage to C.B., *1973*
Sugar-lift ground aquatint etching,
rainbow-roll color woodcut, chine collé
20 3/4 x 15 5/8"

and presenting aesthetic images. As was consonant with the times, artistic media were also being utilized in an increasing attempt to blur the boundaries between painting, sculpture, and printmaking. Although a less successful period in terms of his completed prints, Kohn's improvisations during the last years of the 1960s moved him toward increasing abstraction, color, and fluidity, which would gel into a significant new body of work by the middle of the next decade.

By 1970, Kohn began to work more seriously in the medium of monoprints, which he would return to periodically over the next several years. He enjoyed the process of moving paint around with a brush while making this "painterly print," in contrast to his more usual rubbing and rolling, and he was intrigued with the evolution of his images as he pulled each unique print from the painted plate. In 1970, too, he produced his first completely abstract photo-etching aquatint, *The Numbers Game,* using numbers, letters, and strips of collaged shapes to form a constructivist composition. More impersonal than earlier abstract wood engravings such as *Labyrinth* or *Barrier* which seemed to imply either an individual- or a culturally-shared symbolism, *The Numbers Game* coolly focused on purely formalist concerns, signifying the detachment of the artist (although, ironically, Kohn did spell his name out as part of the composition through randomly placed typeset characters). Although he did not return to this genre of work until the

The Numbers Game, 1970
Photo-etching aquatint, chine collé
11 1/2 x 8 3/4"

mid-1970s, this piece presaged a major transition in his oeuvre.

In the interim, Kohn embarked on a series exploring environmental phenomena—clouds, rainbows, and the like. Stylized or abstracted, these are the most purely formalist works of his entire career. Gone are the symbolic references to political events or personal malaise; even his characteristic calligraphic swirls disappeared in

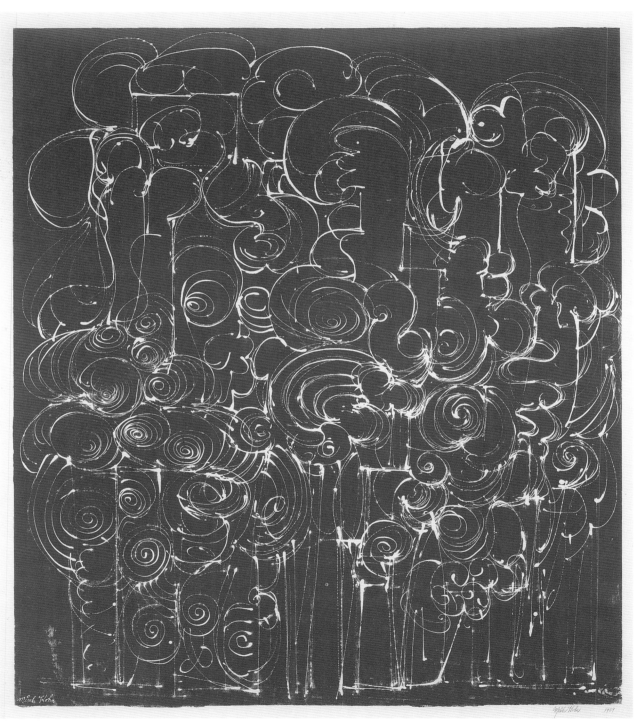

The Group, 1969
Serigraph
43 1/2 x 37 1/2"
Private collection

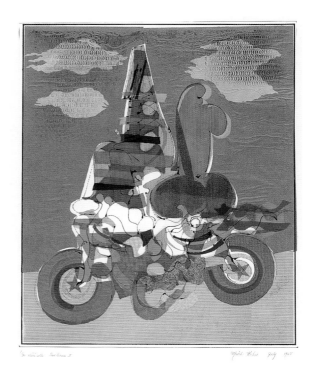

End Game 2, *1968*
Photo-etching, chine collé, printed in relief
18 x 14 9/16"

Figure, 1968
Photo-etching, aquatint
16 x 12 3/4"

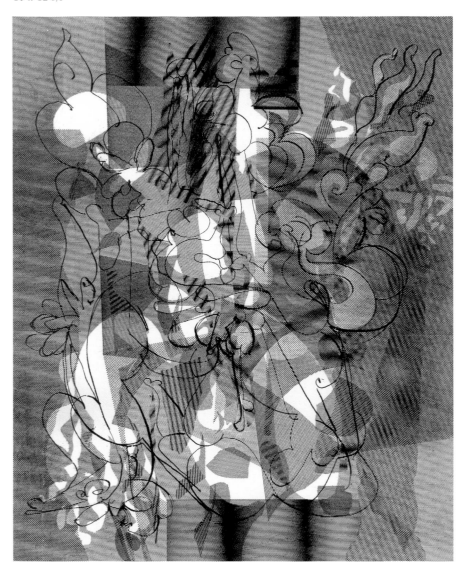

subconscious—and sometimes ambiguous—
emotional responses in viewers. He savored the
anticipation of this visual dialogue with his
audience.

Many of the works from this period use the
image of the motorcycle or automobile as a
theme, some with notable humor; others feature
a running or flying figure. Perhaps all of these
were representations of escape from the political
and social discord inherent in a cultural order
that seemed to be unraveling. Demonstrations,
assassinations, and new codes of social and sex-
ual conduct required new ways of thinking about

Kohn continued to produce a variety of birds and animals during the late 1960s, partially as a result of annual vacations in Florida, where the family stayed on the west coast near wildlife sanctuaries. However, some of his new work again began to address the existential futility of contemporary life. He saw Samuel Beckett's play *Endgame* in a Chicago production, and was very moved by the image of the main character, seated in a straight-backed chair with wheels, who remained on stage during the entire play with a bloody rag masking his face. Kohn first did a series of drawings of this image, each somewhat different, and then several mixed-media serigraphs. In his work, the chair was transmuted into a vehicle; sometimes the vehicle revealed images in the central structure that recalled intestines or other viscera. There are several variations of the enigmatic and evocative *End Game* image in different sizes, using bold, clear-cut shapes and contrasts of flat color.

Kohn's body of work in 1968–70 remained generally figurative, but in a way that redefined the parameters of what this meant. The subject, although primary in conceptualization, became equal to the concerns of the new technique; he utilized a variety of media for his works from this time, including photo-etching and multiple screens. Although he incorporated photo images in a few pieces (most notably in *Double Portrait of the Artists* in 1971), at this time he was more interested in using the dot and line patterns to create textural forms. Kohn hadn't worked with

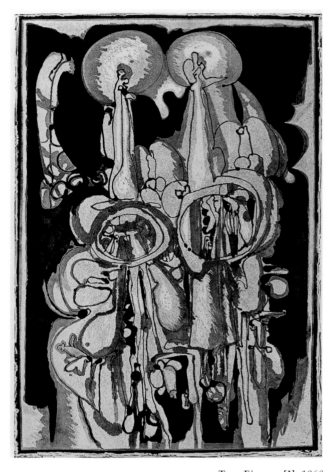

Two Figures [I], 1968
Sugar-lift ground aquatint etching, printed in relief
21 x 14 1/8"

serigraphy for many years, but it now began to suit his purposes, thanks to its ability to faithfully reproduce elements from the mass media for collage purposes, as well as its adaptability in transferring depth and volume from three-dimensional surfaces. Kohn understood that reconstituting forms from ready-made images found in preprinted commercial documents of mass media carried a load of inferences, arousing

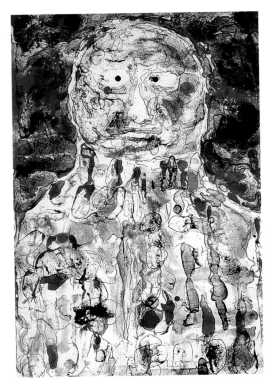

General, 1970
Lithograph
28 1/2 x 19 3/8"

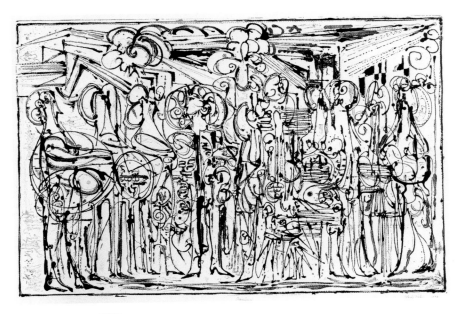

Cocktail Party, 1970
Sugar-lift ground aquatint etching, printed in intaglio
20 1/4 x 30"

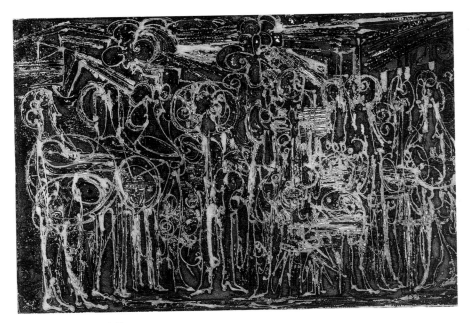

Cocktail Party, 1970
Sugar-lift ground aquatint etching, printed in relief
20 1/4 x 30"

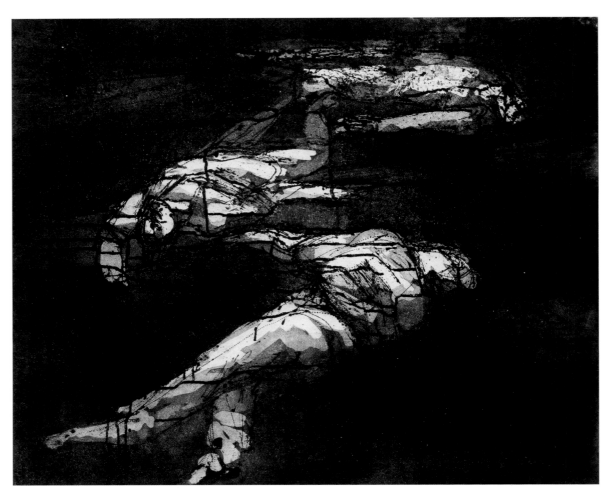

Requiem, 1968
Sugar-lift ground aquatint etching
19 5/8 x 23 3/4"

Wounded Soldier in a Sea of Grass, 1969
Monoprint
21 3/4 x 27 1/2"

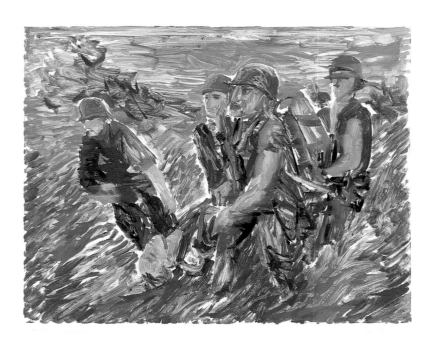

moved out west. He refers to this metal work as an "interim diversion,"[64] yet it appears to have been symptomatic of his increasing feeling of a need for change.

Perhaps Kohn's most elaborate figurative work in the sugar-lift ground aquatint etching with colored *chine collé* technique was *Ornate Figure,* a large work depicting another military-type figure done in 1968. The extremely complex collage elements had to be laid down in precise order so that their lamination as part of the printing process resulted in the correct layering of transparencies. This print was widely reproduced in contemporary technical literature as the pinnacle of this type of technique.[65] More than in Kohn's other *chine collé* work until this time, color was integrated into the design, rather than serving in a more limited way, almost as an addendum.

Although the official in *Ornate Figure* seemed unthreatening in his stasis—more ceremonial than competent—Kohn's imagery was once again darkening with the increasing debate over the Viet Nam war. Works such as the 1968 *Requiem* and *Viet Nam Soldier,* or the monoprint *Wounded Soldier in a Sea of Grass* (1969) specifically illustrated the antiwar sentiment almost universally shared by those on the political left. Paradoxically, so too did works such as the *Cocktail Party* series, which satirized with black humor the martini culture of aggressive forgetfulness.

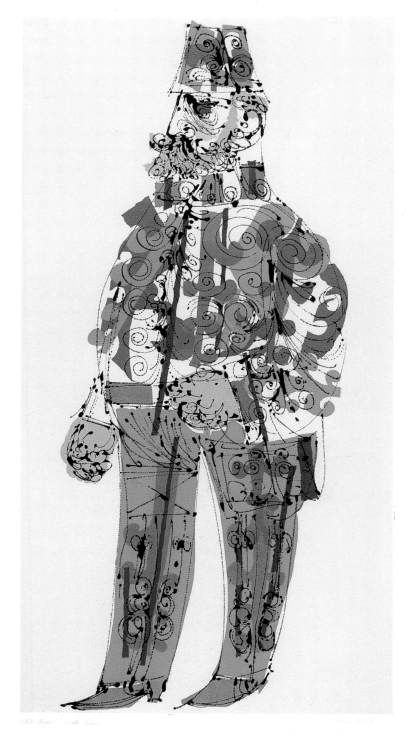

Ornate Figure, 1968
Sugar-lift ground aquatint etching, chine collé
34 11/16 x 17 3/4"

wall commission for the University of Chicago Hospital, and approximately 100 works of jewelry in silver and gold. Averaging 3" in height, these rather baroque pins and necklaces—elaborately wrought through the lost-wax casting process—are clearly evocative of the sugar-lift ground etchings he was doing at that time. Generally bas-relief, in some respects the jewelry pieces appeared to be extensions of the copper

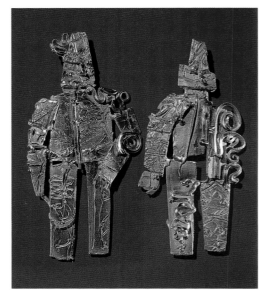

Two Kings, 1968
Gold
4 x 3 3/4"
Private collection

plate, substantiating his connection to the two-dimensional surface rather than establishing a new or latent correlation with three dimensions. Kohn describes his jewelry work as "engraving in the wax;" he used the same tools as he did with the metal plate engravings, and as the wax curled up as he cut it away, he used those shavings to form the image. The largest number of works—approximately 70—were of animals and birds; the balance were figures or portraits of "antique personages." Kohn worked intently in this media for three years (until his foundryman died and the price of gold skyrocketed), and then returned to it briefly with a small number of works cast at California State University-Hayward after he

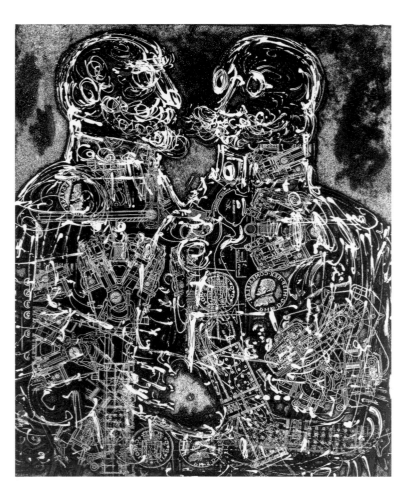

Two Generals, 1965
Sugar-lift ground aquatint etching, printed in relief
13 5/8 x 11"

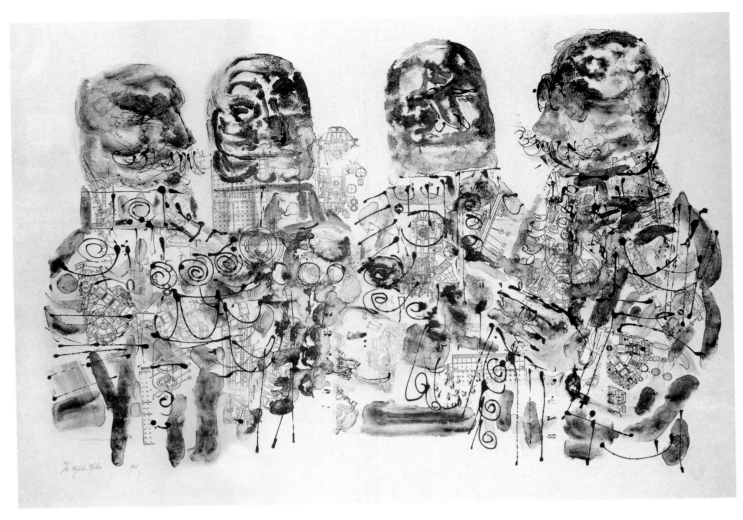

Conference, 1965
Lithograph
20 7/8 x 30 1/2"

personnel conspiring to make decisions that would affect millions of lives. *Two Generals* and *Two Generals II*, printed in relief as if their blackness would accentuate the potential of death they could effect, are among the most compellingly evocative images of this series. He underscored his visual concerns by donating prints to support a variety of leftist causes, from auctions supporting the Mississippi Summer Freedom Schools to Eugene McCarthy's run for president.[62]

Returning to Chicago, Kohn continued to exploit his technical prowess, yet always in an attempt to better explore his subject. Critical of

those who let the former overshadow the latter, he cautioned,

> it is essential with any medium to select those elements, and only those elements, which contribute to the ultimate image. I believe that the general graphic area can become a trap that one must be wary of, in that the infinite varieties of tone and texture can lead to empty virtuosity.[63]

Beginning in 1967 Kohn began to explore three dimensions with a few table-top size pieces of bronze relief sculpture, a large bronze

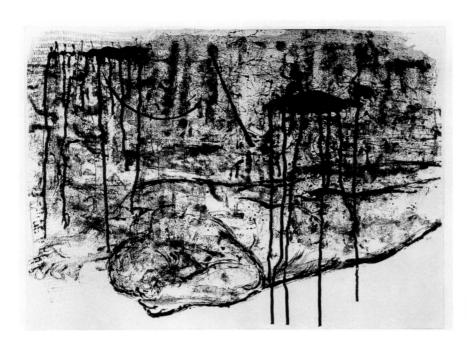

Fallen Figure, *1963*
Sugar-lift ground aquatint etching, chine collé
17 3/4 x 23 3/4"

Requiem, *1963*
Sugar-lift ground aquatint etching, chine collé
22 5/8 x 32 1/2"

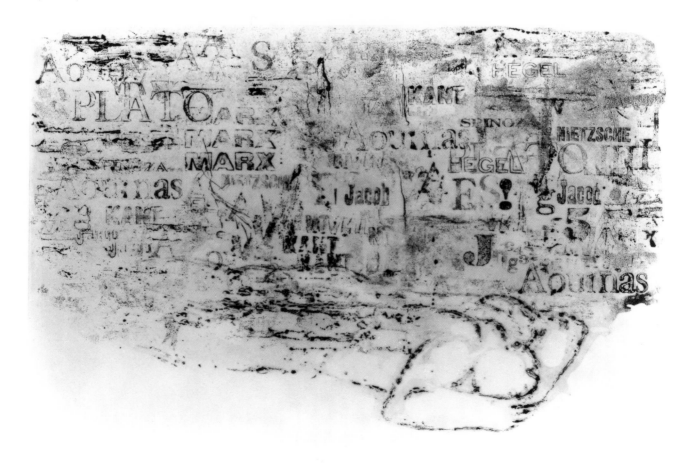

the surprise she felt as she saw how many people turned out to honor this gentle Jewish immigrant; she had never seen as large a funeral procession. His son's response was a series of three prints revealing both the anguish and solitude of a dying man: *Fallen Figure, The Wall,* and *Requiem* were all created that same year, variations on a theme. *The Wall* referred simultaneously to the newly constructed Berlin Wall, John Hersey's novel, and humankind's powerlessness against overwhelming political events; *Requiem* again featured the fallen figure, this time lying before a wall of names of famous and inspiring people who had gone before, such as Plato, Spinoza, Nietzsche, Aquinas, Kant, and Aristotle; his father's name, Jacob, was prominently displayed in a central location.

In 1965, Kohn was invited to return to Paris to teach the summer session for College Art Study Abroad, conducted under the auspices of the American Center for Students and Artists. The school paid all of their expenses, so the entire family traveled to France, enjoying a six-room apartment on Rue de L'Estrapade and the lovely gardens and swimming pool at the school. They made it a long "summer" and did not return to the U.S. until October. That summer session boasted an illustrious faculty: Roger Barr was the director, and other faculty members included William Rubin of the Museum of Modern Art and Albert Elsen from Stanford. While in Paris, Kohn did some etchings but spent most of his time on lithographs, working with Jacques Frelaut at

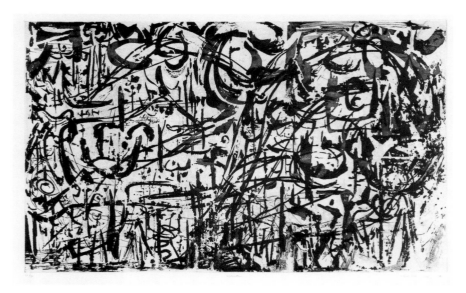

The Mountain, 1961
Sugar-lift ground aquatint etching, drypoint, chine collé
19 13/16 x 31 3/4"

Lacouriere's workshop, as well as at the personal studio of Bohuslav Horak, who had returned to Paris by this time. Among other projects, he worked on *Small Bird,* a work that had been commissioned by the University of California, Los Angeles.

Many of the works from this period were of milder subjects such as animals and birds, as well as vignettes of urban and genre scenes such as the men who sold lottery tickets on the streets of Paris. Others, however, reflected the progression of the pervasive Cold War anxiety into angry consciousness at the daily reports of body counts from Viet Nam. Kohn developed new images of military might and police power with such works as *The Conference* (also known as *Four Generals*), an unsettling depiction of anonymous military

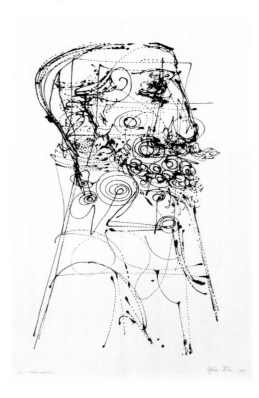

The Mathematician, 1963
Sugar-lift ground aquatint etching, chine collé
20 3/4 x 12 3/8"

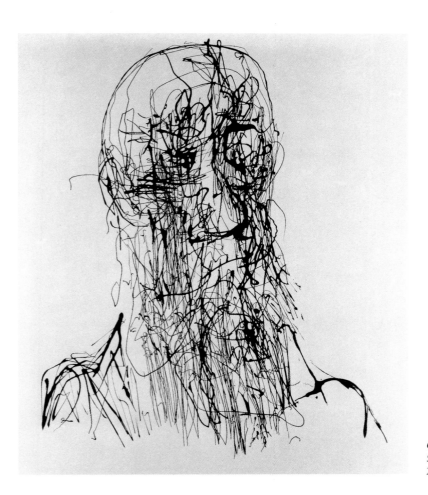

Stefan, 1960
Line etching, drypoint, chine collé
9 15/16 x 7 15/16"

G.B., 1963
Sugar-lift ground aquatint etching, chine collé
20 1/2 x 16 1/2"

Man of Fear, 1962
Sugar-lift ground aquatint etching
15 7/8 x 19 7/8"

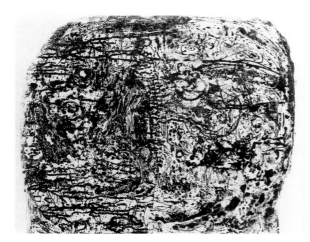

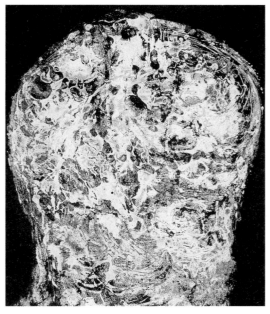

Contemporary Man, 1962
Sugar-lift ground aquatint etching
23 3/4 x 20"

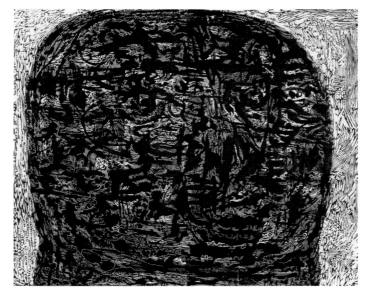

Man of Fear, 1962
Wood engraving
11 3/16 x 13 1/2"

Man Fragment, 1962
Sugar-lift ground aquatint etching, chine collé
10 3/4 x 15 5/8"

expressionist flux, they aptly serve as mordant chronicles of the times.

Kohn's continuing innovation and exploration of various media and imagery won him increasing success. He was the sole American artist invited to design a holiday card for the United Nations International Children's Emergency Fund in 1961; unexpectedly, this honor won him a surprising amount of publicity, for the Daughters of the American Revolution interpreted the UNICEF cards as "part of a broader Communist plan to destroy all religious beliefs."[61] The result was that all the cards became best-sellers (and, in some cases, apparently, sold out), and UNICEF reaped record profits for the year. Also in 1961 Kohn won a major prize in the Ljubljana Biennial, and in 1962 he was elected an Honorary Fellow of the *Academia della Belle Arti del Designo* in Florence, and was appointed to the Artist's Advisory Committee for the Guggenheim Foundation, on which he continued to serve through 1979.

Kohn had always been a sensitive draftsman, and a 1963 exhibition at the Art Institute of Chicago entitled "Rembrandt and His Art" apparently stimulated Kohn's desire to do a series of line etchings. Although he had periodically explored this genre with portraits of *Oma*, Lore's 90-year-old grandmother, or of their friend *Stefan*, new works such as *Portrait in the Manner of L* further revealed the fluency of his touch and the sympathy of his interpretations.

Little Herald, 1958, 1961
Sugar-lift ground aquatint etching, chine collé
12 x 7 1/2"

Kohn's essentially humanist point of view was simultaneously broadened and constricted in 1963, with the death of his father from lung cancer. Jacob's death was not unanticipated as he had been a lifelong smoker, but it was deeply felt, not only by all the family members but by many people in Kokomo, who considered him a friend and a philosopher. Even today Lore remembers

large with menacing brutality. Liberated from context by being placed against a stark white background, these prints were conceived by Kohn as antiwar pieces, dire prophecies of the future of humankind.[60]

The Tamarind works were not all imposing images of indescribable fear and alienation in an impersonal world, however. In *Red Beast*, for example, Kohn exuberantly used calligraphic swirls to style a fanciful Chinese-like animal, snapping in color and energy. *Landscape*, a haze of color referencing the shimmering orange-and-green vistas that attended the Kohns' trip by automobile through the Southwest to California, stands in significant contrast to the tectonic landscapes of the mid-1950s. Taken as a group, the Tamarind works are evocative testaments to Kohn's ability to condense the intrinsic nature of his subject into its essentials.

Following the Tamarind residency, Kohn continued to explore these same issues of man's defenselessness before extraneous circumstances that had inspired his strong work of 1949 and the early 1950s. Prompted by the Cuban missile crisis of 1962, he created two prints, severed heads titled *Man of Fear*, as he registered the rising temperature of the Cold War in both etching and wood engraving. Also, *Man Fragment*, a disquietingly cropped head, and several other prints simply titled *Man*, challenged the parameters of figuration while they simultaneously addressed issues of formalism and human vulnerability. Balancing indistinct physiognomic gestures with

Red Beast, *1961 [Tamarind #339]*
Lithograph
24 x 31 3/8"

Spotted Beast, *1961 [Tamarind #344]*
Lithograph
16 1/2 x 24 3/4"

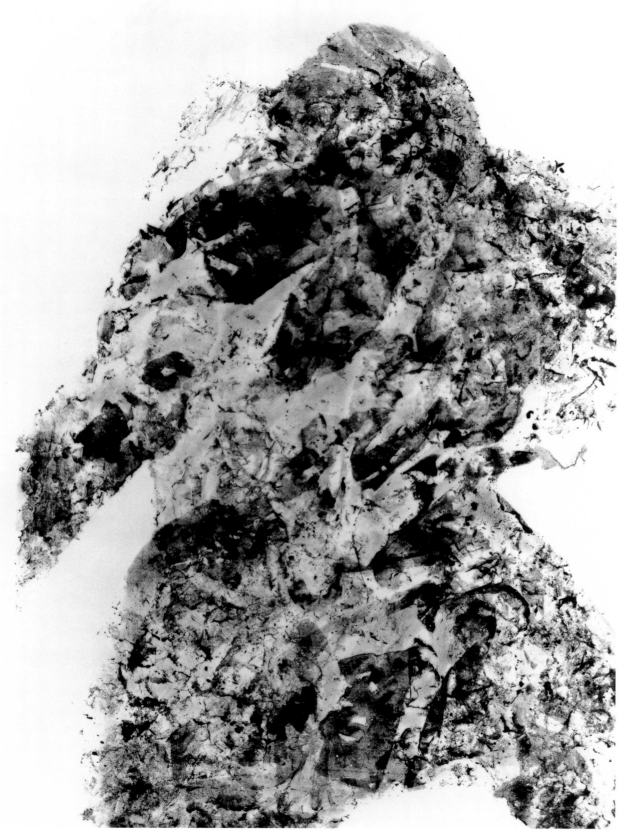

Woman, 1961 *[Tamarind #374]*
Lithograph
38 9/16 x 27 1/4"

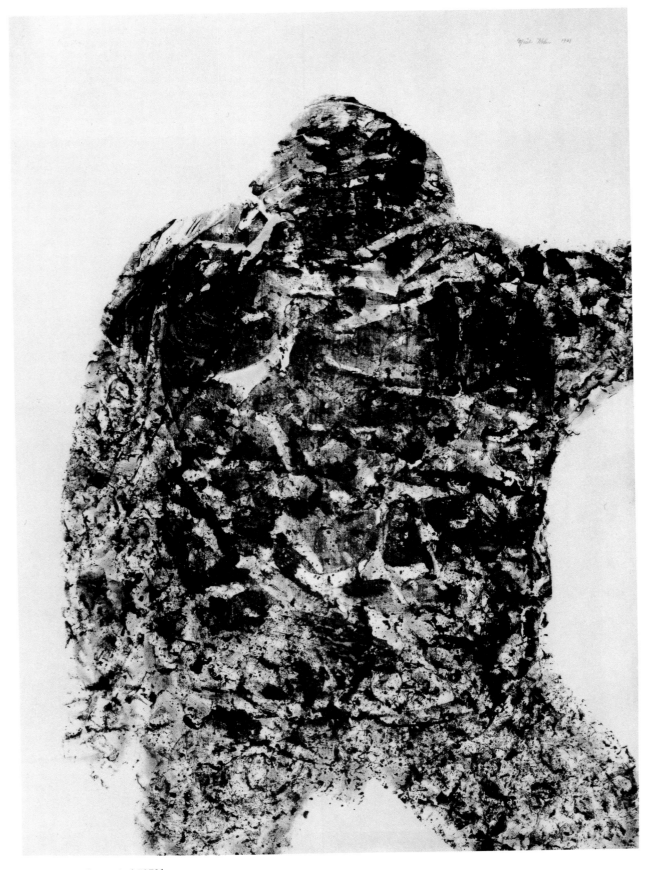

84

Giant, 1961 *[Tamarind #372]*
Lithograph
38 1/2 x 27"

and he was newly intrigued with exploring its possibilities. But an even greater influence was the growing societal anxiety resulting from the Cold War. Kohn tells an anecdote about how, early in their visit to Los Angeles, Lore became violently ill, and the doctor arrived in white-tie, ready to attend a concert, but instead accompanied the ambulance to the hospital, stayed with her the entire night, and missed the concert. Yet this same caring, sensitive doctor had built an air-raid shelter in his home, armed and protected so that only his family could use it. The incongruity of this paradox, as well as the paranoia the doctor felt, affected Kohn mightily.[58]

Although some of his Tamarind prints were abstracted landscapes or animals, perhaps the most compelling works from this period are the huge, distorted, anonymous black-and-white figures, presented in isolation without environmental background or interference from secondary images. Taking advantage of the organic properties inherent in the medium, the artist intended works such as *Giant, Woman,* and *Patriarch* to be frightening, in response to the unknown nuclear terrors and their disorienting effect on people's daily lives. Gone was the black humor and satire of the military figures of the late 1950s; in their place was an inchoate fear of a formless (or, as student James Spence characterized it, "protoplasmic"[59]) foe. Without facial delineation, these beings were reduced to little more than hunks of matter, unable to give out a message or to receive one. While evoking a dis-

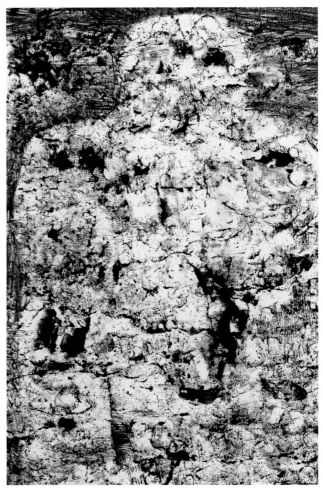

Figure, 1961 [Tamarind #347]
Lithograph [black trial proof for color run]
24 5/8 x 16 1/8"

turbing view of the future of humanity without humans, these detached figures—visually as encrusted as an ancient eroded stone—simultaneously evoked images of primeval man, a warning, perhaps, of the apocalypse that could reduce civilization back to a more primal savagery. Building up his forms with infinite textural variety and intricacy, Kohn compounded the strength of the image with the size of the print, looming

82

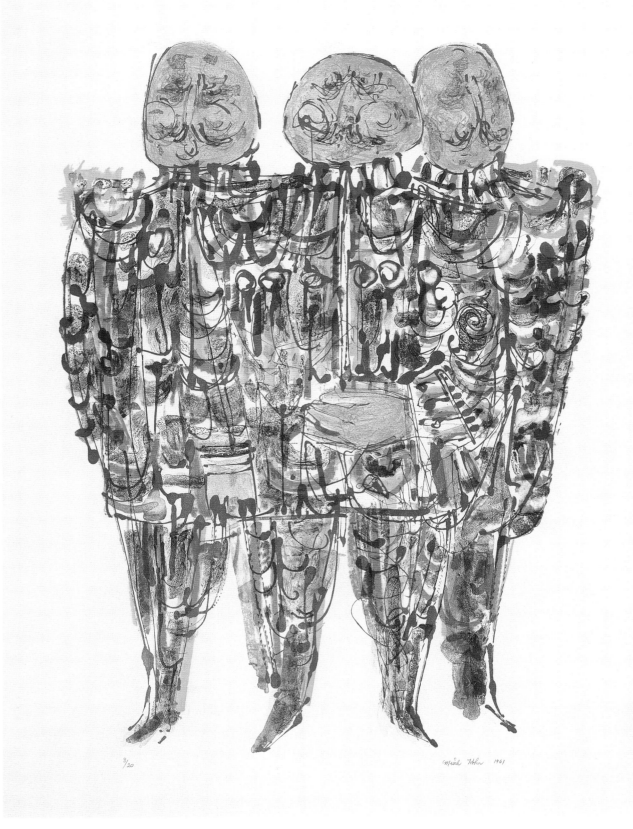

Three Generals, 1961 [Tamarind #359]
Lithograph
27 9/16 x 20 3/16″

l to r: Lessing Rosenwald, Collector and President, Print Council of America; Misch Kohn; June Wayne, Director of Tamarind Workshop; Bohuslav Horak, Master Printer Tamarind Lithography Workshop, Los Angeles, Summer 1961

Bohuslav Horak (recommended to Wayne by Kohn for the job), as well as with "printerfellows" Joe Funk, Harold Keeler, George Miyasaki, and John Muench, he completed 22 separate print editions during his two-month summer residency. Ten of Kohn's editions were in color, some using as many as six different stones, each in a different color. Enjoying the collaboration with the printers, Kohn explored a variety of ways to develop his images: drawing directly on the stone and zinc with tusche, using tusche mixed with solvent, using tusche mixed with water applied with brush, pen, and/or spattered, using lithographic crayons and pencils, and rubbing ink directly on the stones.

The imagery that emerged from the Tamarind prints was immediately and significantly different from the works that Kohn had been doing until that time. Certainly the change in medium was at least partially responsible; aside from one work in 1957, he hadn't seriously worked with lithography in over a decade,

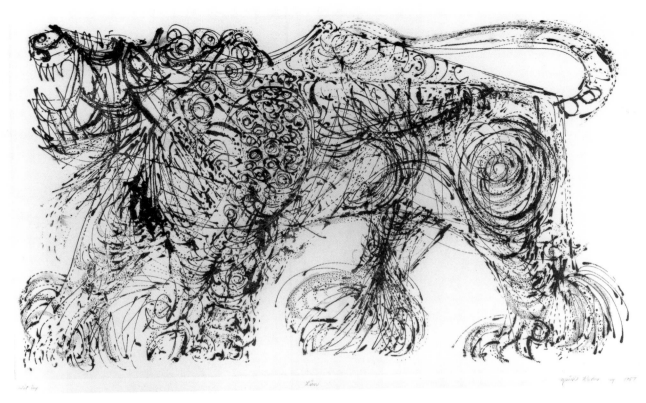

Lion, 1957
Sugar-lift ground aquatint etching, burin engraving, chine collé
17 3/4 x 29 5/8″

Tiger, 1963
Sugar-lift ground aquatint etching, chine collé
19 7/8″ x 31 7/8″

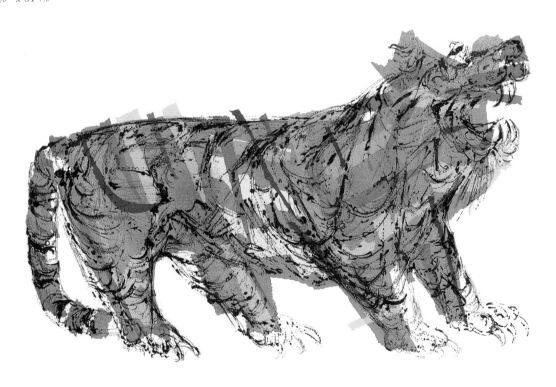

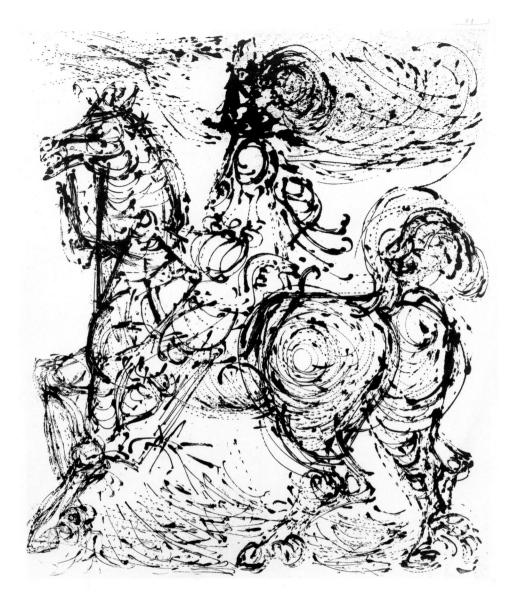

Horseman, *1957*
Sugar-lift ground aquatint etching
19 15/16 x 15 13/16"

the years: "It seems that my whole career has been punctuated at the critical moments by your presence and help," he wrote to Zigrosser in 1959. "I am aware of it and am very grateful for it."[57] This very successful exhibition, which circulated to 19 museums across the country in 1961–63, brought Kohn much broader national recognition and confirmed his status as one of America's foremost printmakers.

In 1961, Kohn was one of the first artists invited to work at June Wayne's newly-founded Tamarind Lithography Workshop in Los Angeles. One of the major aims of this venture was to foster collaboration between master printer and artist in an atmosphere in which both were encouraged to experiment in order to expand the technical and expressive power of the medium. Working in collaboration with master printer

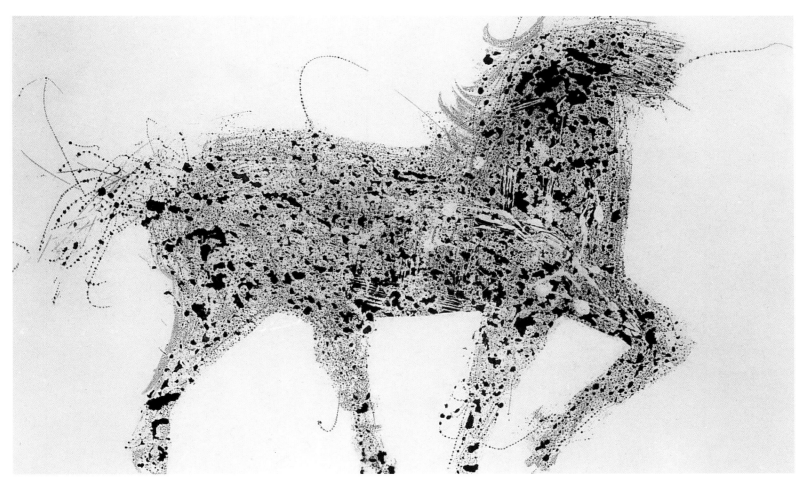

Horse as a Constellation, 1959
Sugar-lift ground aquatint etching, chine collé
17 3/4 x 29 1/2"

to the revolutionary changes in visual vocabulary by artists involved in the Pop Art movement as well as to his own talent for experimentation, he began using coins, mechanical parts, photo-engravings, and other materials to form the structure of his images. He also would, on occasion, explore the same image in different media; as a wood engraving and an etching, for example, or as an etching and a lithograph. He was intrigued by how the singular characteristics of the different media altered the presentation and contexts of his images, thus enabling distinctive aspects to become prominent at different times.

Kohn was awarded a Ford Foundation grant in early 1960 to support the organization of a 20-year retrospective of his work, accompanied by a catalogue and circulated by the American Federation of Arts. When asked to suggest a curator conversant with his work who might be willing to assemble the materials, Kohn recommended Carl Zigrosser, who readily accepted. Zigrosser had first had contact with Kohn in 1941, had followed his career with great interest, and was instrumental in ensuring his inclusion in numerous exhibitions and publications. Kohn was not unmindful of the value of this support over

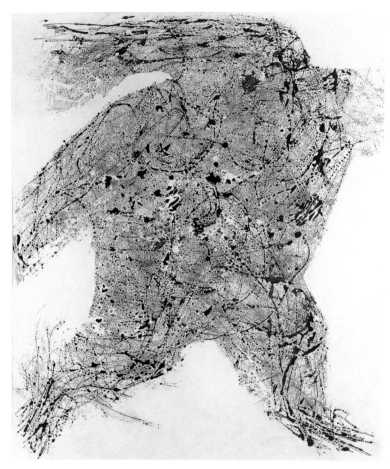

Absalom, 1959
Sugar-lift ground aquatint etching, chine collé
27 7/8 x 21 7/8"

tles may have been wars on paper. Some works from this period are more abstract, some are more figurative; Kohn was less concerned with how they might be defined than with their ability to emphasize and communicate both essence and content.

During these early years of exploring the sugar-lift ground process, Kohn's emphasis moved toward painterly issues and away from social concerns, presaging his later movement towards completely non-narrative art. Certain critics have dismissed these works from the late 1950s as decorative; clearly displaying a new playfulness, they may lack the monumental force of *A Season in Hell* or *Prisoners,* but they are neither without content nor viewpoint. Fluidity of line and modulation in value not only continue but are enhanced; further, tongue-in-cheek imagery satirizes an archaism that was too often the refuge of political and social conservatism.

Always pushing himself to expand ways to approach his media, Kohn began to explore the possibilities inherent in printing his etchings in multiple ways; we find single plates printed variously in intaglio, in relief (in which the ink, instead of being forced into the depressions of the bitten image, is applied to the surface of the plate—as in a woodcut—so that the printed image is revealed as white on a black background, rather than the more familiar intaglio printing of a black image on a white background); and with various (and sometimes evolving) editions of colored *chine collé.* Responding

of spatters of the sugar syrup off of a toothbrush, eliminating all hard edges. Kohn used these contemporary moves of spontaneity and action painting to suggest a literal framework while revealing the intrinsic nature of his subjects, as with the elegant mane and muscular ripples of the princely *Lion,* or the affected dignity and stodgy myopia of the *General,* whose major bat-

Figure with a 5, 1963
Sugar-lift ground aquatint etching, chine collé
23 3/4 x 17 3/4"

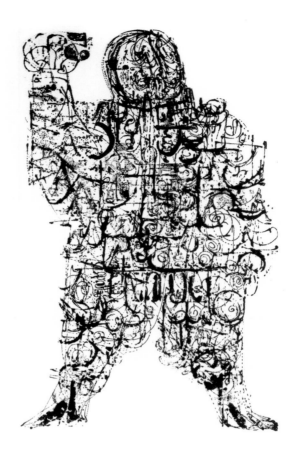

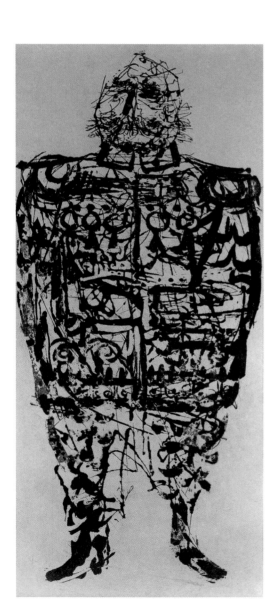

Baron von Z., *1960*
Sugar-lift ground aquatint etching, chine collé
32 3/4 x 13 7/8"

pieces as both enhancing and serving as a counterpoint to the figurative illusion of the etched images.

Kohn was immediately taken with the fluidity of the process and of the resulting image he was able to obtain with the sugar-lift ground etching process. Further, with or without the colored collage elements, it lent itself well to the semi-abstractionism with which he continued to approach figuration. He soon dispensed with using the brush entirely, allowing the viscous sugar-syrup solution to drip directly onto the metal plate, thus creating calligraphic swirls of drips and drops that defined his design. Pushing this procedure to the limit with *Horse I* and *Horse as a Constellation* in 1959, he defined his image without use of any linear profile: the forms were built up completely through the agglomeration

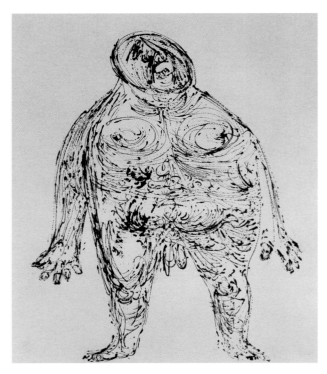

Goliath, *1959 [a.k.a.* ***Giant***]
Sugar-lift ground aquatint etching, chine collé
24 x 19 7/8"

In his classes at Wisconsin, Kohn demonstrated the use of the *chine collé* process to add background color to the black-and-white etchings. Back in Chicago, he returned to these etching plates and began to more seriously explore the use of color *chine collé* as an integral part of the conceptualization and presentation of his work. This was a radical experiment at that time, although Kohn saw it as a natural development in his oeuvre. From the beginning of his work in printmaking, in lithography, he had used China/India paper to collage to a backing sheet at the moment of printing in order to enhance the quality of the print. The thin and sensitive china paper would absorb more ink than the coarser backing sheet, and so would produce a better impression with stronger contrasts and clearer lines. Now Kohn, having seen a reproduction of

a work by Picasso with a cut piece of colored paper from the 1940s or 1950s, decided to explore color as part of the actual composition of his etchings, rather than using China/India paper solely as a technical device for enhancing contrast and paper receptivity. Thus began a series of etchings that brought him another round of significant success.

In order to produce an edition of these new colored *chine collé* etchings, Kohn would first draw a transparent "map" of the pieces he intended to collage, then would create template patterns for each color that formalized the rigid space relationships that suited these images. Each successive piece of colored paper would be scored through the template to provide for edition consistency, and then each individually predetermined shape was torn out. The etching plate was inked, then the surface cleaned well, allowing the ink to remain only within the lines of the image. The color pieces were then laid face down on a dampened blotter, and the backs coated with a thin, even mixture of a potato-starch glue. The copper plate was laid face up on the press bed, and the colored papers were placed, in sequence and paste-side up, followed by the China/India paper background sheet, also paste-side up, and, finally, the backing sheet, which was laid over the whole. As the bed passed through the etching press, the result was that all the colors and the backing paper were simultaneously and permanently laminated together, with the black line etching over the whole. Kohn conceived of the colored collage

experienced due to the directness and flexibility of this technique—and the increased capacity he had to improvise as he worked—soon led him to break new ground; again, being essentially self-taught in this medium, he was little constrained by precedents. Moving beyond older images, he began to create a new series of prints, several of which he did first in intaglio, and then explored subsequently in wood engraving as well. These were what he referred to as "imaginary ancestors," a tongue-in-cheek evolution of a new personal heritage. Perhaps the most powerful of these is the 1957 *Three Kings*, an experimental plate printed variously in intaglio and in relief and necessitating 12 successive dips in the acid bath to produce its striking three-dimensional effect. Kohn has described these pinheaded monarchs as "encrusted forms...like ancient vessels recovered from the sea. Impotent memories of lost grandeur."[56]

He also began a series of works of mythological, legendary, and Biblical figures, from Prometheus to Oedipus to Job, some of which he also considered as part of his heritage, imaginary or otherwise. This was not a thematic exploration unique to Kohn; other Chicago artists of this time—rebelling, perhaps, against the purist priorities of Abstract Expressionism—not only continued to concentrate on figurative images, but considered historical time a legitimate resource for incorporating past images or myths with contemporary experiences. In Kohn's hands, modern idioms became infused with the

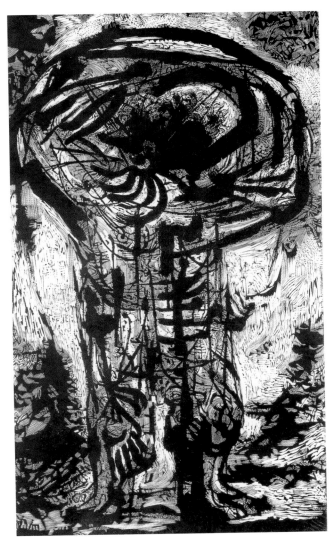

Job, 1959
Wood engraving
23 5/8 x 13 5/8"

symbolic presence of antecedent periods; semi-amorphous hybrids, they seemed to imply accidental creation rather than the conscious direction of an all-powerful being. In certain of these works the lines forming the bodies seemed to simultaneously describe and deface them; in others, three personages appear to share but four or five legs. These experimental forays into religious or mythological themes produced secularized icons, evocative yet enigmatic, befitting a man for whom ethics had replaced formal organized religion.

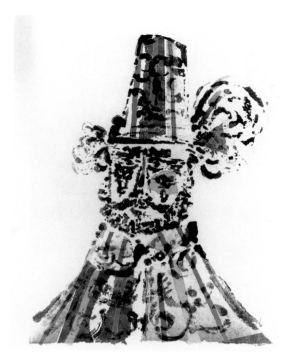

Imaginary Ancestor, 1957
Sugar-lift ground aquatint etching, chine collé
20 x 13 3/4"

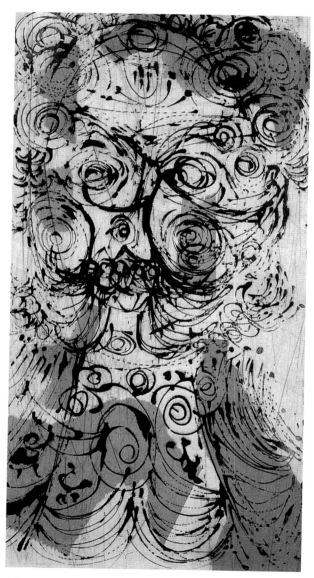

My Grandfather's Mustache, 1957
Sugar-lift ground aquatint etching, chine collé
17 x 9"

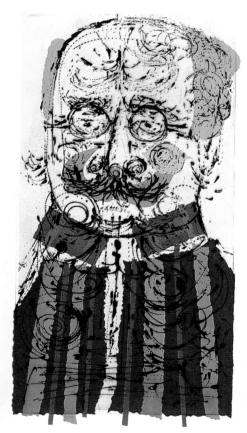

General, 1958
Sugar-lift ground aquatint etching, chine collé
17 5/8 x 9 1/8"

it with an acid-resistant asphaltum, and then dissolve the sugar mixture drawing with warm water while the asphaltum stayed on the plate, protecting it. Using Lacouriere's recipe as a starting point, Kohn began to experiment. He found that corn syrup was easier to use than block sugar, as there was no need to wait for it to dissolve. He did many drawings, both on the copper plates and on paper,

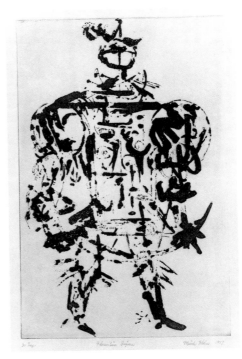

Florentine Figure, 1957
Sugar-lift ground aquatint etching, chine collé
16 x 9 15/16"

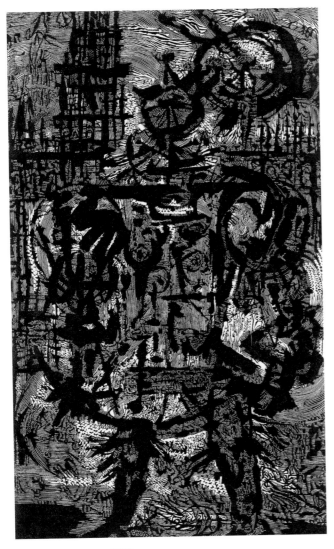

Florentine Figure, 1956
Wood engraving
15 1/4 x 8 1/2"

with this viscous sugar-syrup solution; he often used the plastic bottles with long tips and tiny openings intended for home hair-dye preparations as his "quill." Although the technique worked very well on the plates, the drawings on paper stayed permanently sticky, so he ended up using them only as preliminary conceptual studies.

Some of his first etchings explored the subjects of certain of his recently completed wood engravings—such as *Florentine Figure* and *Processional;* apparently these recapitulations of earlier images enabled him to ease into the new medium. However, the facility he immediately

Calligraphic Images/ Amorphous Forms
Blurring the Lines

In 1957 Kohn was invited to teach a summer class at the University of Wisconsin-Madison (Lore's alma mater), replacing the vacationing lithographer Alfred Sessler. Although Kohn was asked to teach lithography, he decided to include etching techniques in his syllabus as well, as he was personally interested in exploring this medium. The sole etching he had done was his self-portrait in 1938, and in the early 1950s he had observed the process at Lacouriere's in Paris, but he was still basically a novice. Kohn found a lovely antique press, long but with a narrow bed, and began experimenting. He was delighted, at long last, to have the opportunity to explore intaglio techniques, particularly given his difficulty obtaining large-scale blocks for wood engravings and the physical exertion and meticulous precision required for that medium and scale.

After Kohn committed to teaching etching that summer, he bought numerous large polished copper plates from Chicago-area photoengravers to work on. (Although the university supplied plates to the students, these had scratches and imperfections that made them difficult to work on.) When Kohn had observed Lacouriere, the latter had shared his recipe for the sugar-lift ground mixture: using a block of cane sugar with a brush full of black watercolor or india ink, Lacouriere would stroke his brush on a bar of soap, then add the color and mix it up on the block of sugar. He would then paint with this mixture directly on the copper or zinc plate, coat

Three Kings, 1957
Sugar-lift ground and regular aquatint etching
27 3/8 x 21 3/4"

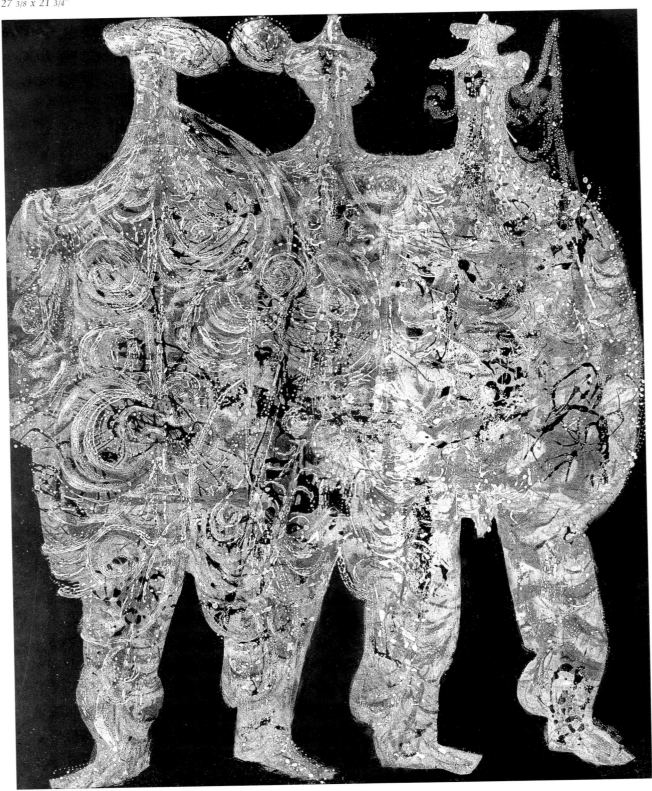

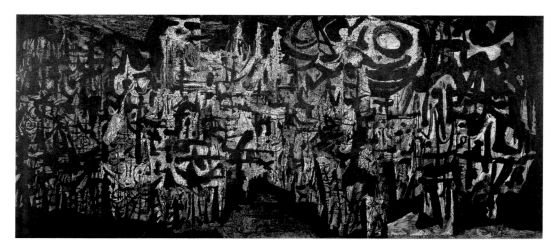

The City, *1957*
Wood engraving
13 7/8 x 30 7/8"

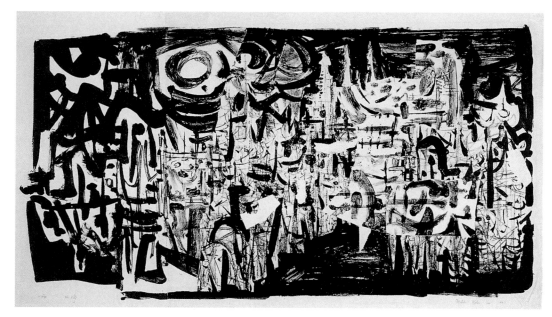

The City, *1957*
Lithograph
20 1/4 x 37"

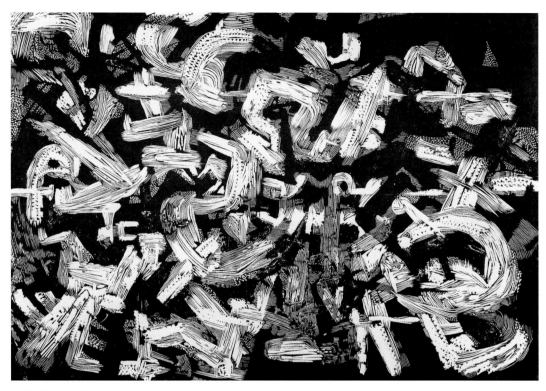

Labyrinth, *1955*
Wood engraving
8 5/8 x 11 13/16"

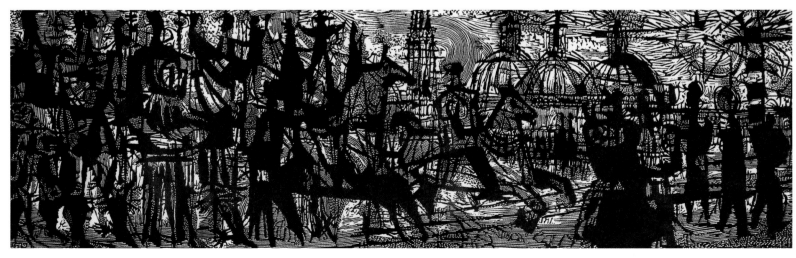

Processional, *1955*
Wood engraving
4 1/4 x 13 1/4"

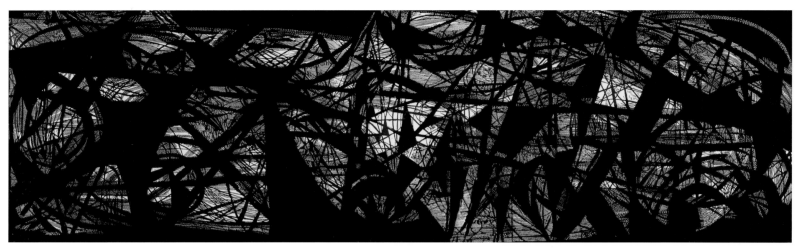

Hostile Landscape, *1953*
Wood engraving
8 5/8 x 27 1/4"

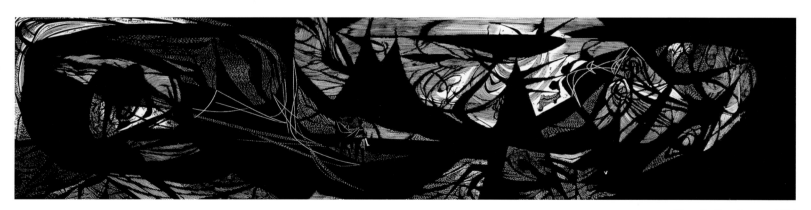

Hostile Landscape, *1954*
Wood engraving
5 7/8 x 23 1/4"

sionist canvases was a release from the concentration required for the wood engravings and an antidote to its tension and intensity. Too, although by then the art world had pigeonholed him as a printmaker, he still thought of himself as an artist working in a variety of media, and he enjoyed the freedom of movement and less-constricted time afforded him by the oils.[55]

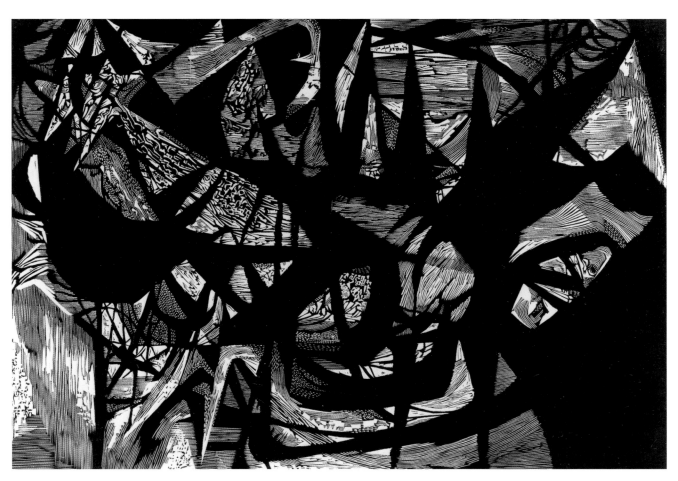

Prometheus, 1953
Wood engraving
8 5/8 x 12"
Collection Albion College

life was softening, with the luxury of a full-time salary (he had been promoted to associate professor in 1953), the birth of his first daughter, Jessica, in 1955, and the move to an expansive, light-filled apartment in Chicago's Hyde Park.

By 1955, his work began to respond to the change in his own personal environment. Works such as *Florentine Figure, The City,* and *Processional* once again alluded to the decorative, the ceremo-

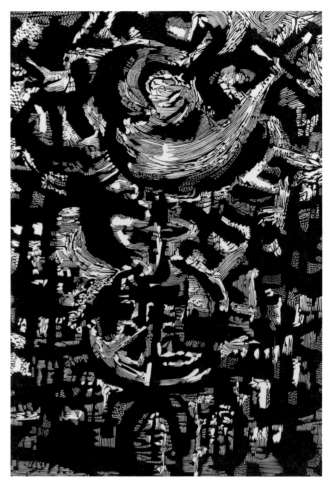

Cathedral No. 5, 1955
Wood engraving
10 1/4 x 6 5/8"

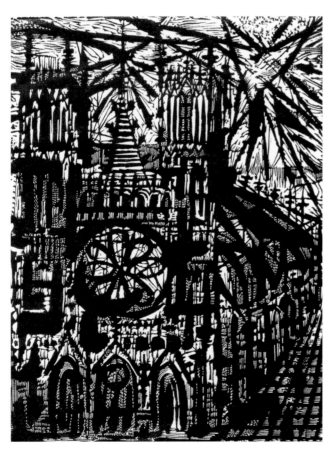

Cathedral I/ Notre Dame, 1954
Wood engraving
6 15/16 x 4 15/16"
Collection The Free Library of Philadelphia

nial, and the august. Always fascinated by pageantry and parades, Kohn had been particularly impressed by the processions he had seen in Italy during his European visits in 1950 and 1952–53, and commemorated them with these works, resonating with the rhythm and the movement of urban activity. He was also continuing to paint; in 1955, in particular, he was having trouble with his back, and painting large, expres-

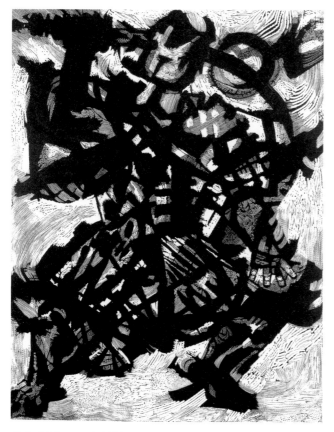

Kabuki Samurai, 1954
Wood engraving
20 x 14 7/8"

scapes. Less descriptive than conceptual, explorations of form and mood rather than topography, works with titles such as *Barrier, The Web, Labyrinth,* and *Hostile Landscape* sprouted jagged edges, extremes of mass, splintery spikes, and an almost palpable tension, surely rendering these among the more inhospitable environments one might encounter. Yet paradoxically, as his work continued to evoke malaise, his personal

portrait of the famous landmark; by the last, *Cathedral No. 5* (1955), the visual emphasis had moved to the spires and the heavens pulsating with the prayers and music of the devoted. Although no longer specifically recognizable as the ornate shrine, this print is much more interesting in terms of composition, movement, and gesture.

Concurrently, Kohn was also beginning to explore pure abstraction. At a time when Americans were coping with the consequences of the Cold War and the new world order, Kohn broadened the individualized angst of his 1949–51 wood engravings to a more environmental outlook with a series of abstracted land-

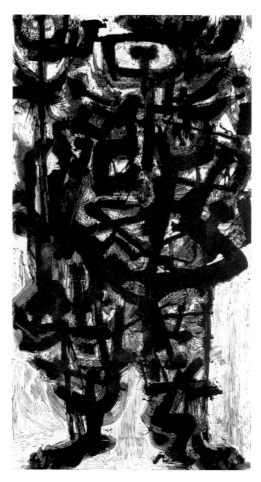

Warrior Jagatai, 1953
Wood engraving
23 x 11 5/8"

Kohn's work during this period exhibits influences of Surrealism as well as of the ornate, almost decorative quality of some of the ceremonial costumes (secular and sacred) that he saw in museums or worn by the visiting dance troupes that were newly popular in the postwar period. These impressions also sparked alternative choices for his recreational reading; he was particularly taken with Michael Prawdin's book *The Mongol Empire: Its Rise and Legacy*. Kohn did drawings—some of which resulted in finished prints—of some of the "personages" he read about; perhaps he was so powerfully influenced by this book in particular because it was his introduction to the history of this area. His manifest interest in the East at this time also recalls the *Ukiyo-e* prints of 18th and 19th century Japan; although celebrated for their narrative content or

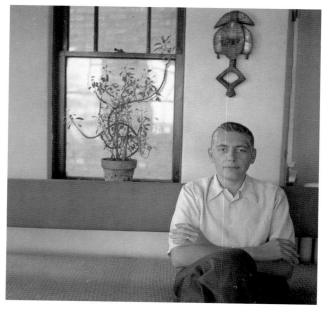

Isabelle Rubin LaBelle (American, b. 1925)
Misch Kohn, c. 1953
Chicago
Collection of the photographer

cultural context, the Japanese prints were also imbued with a symbolic—if not metaphoric—quality, illustrating not just the subject or object itself but its inherent essence. The ability of the *Ukiyo-e* artists to evoke an emotional response in the viewer with their prints was absorbed—albeit perhaps subconsciously—by Kohn, and became a hallmark of his work as well. Prints such as *Kabuki Samurai* and *Warrior Jagatai*, each revealing a different variant of semi-abstractionism with their rigid, stylized gestures, perhaps best illustrate this conceptual Asian connection.

While exploring such exoticism, he also embarked on a series of cathedrals, all images of the imposing Notre Dame de Paris. The first, although richly textured, is a rather literal frontal

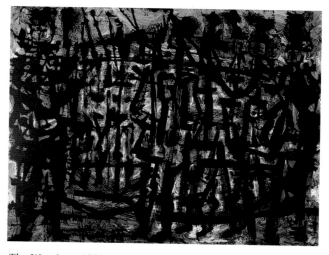

The Warriors, *1953*
Wood engraving
13 1/2 x 17 3/16"

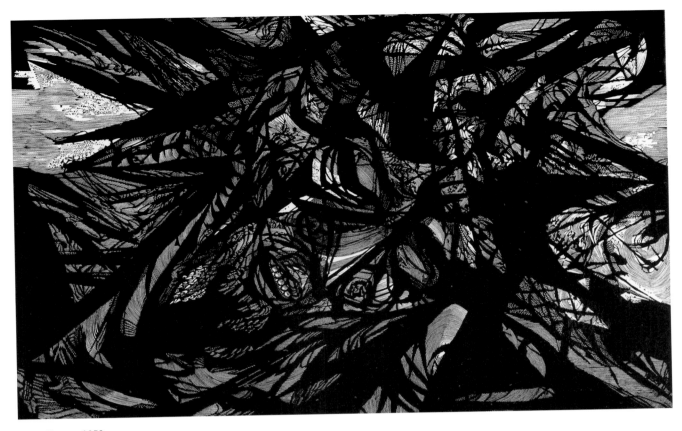

Ecce Homo, 1953
Wood engraving
17 5/16 x 26 7/8"

years. Upon his return to Chicago, Kohn contin-
ued to print from some of the blocks that he had
worked on in Europe as he waited for the crate
of new blocks to arrive. It was shipped back to
his Hyde Park apartment/studio and arrived late
in the afternoon a few months later—winter, by
that time, in Chicago. Because it was too late that
evening to unpack the new blocks, he left them
outside in the crate. In the middle of the night,
Kohn heard sounds like rifle fire. Horrified,
he realized that it was the cracking sound of the
wood blocks splitting, rent apart by the drastic
change in temperature and humidity between
France and Chicago. The glues that had been fine
in France could not hold up to the dryness and
cold of the midwest. Sadly, there were to be
no more large-scale wood engravings; all of the

long, narrow works he did in the mid- and late
1950s were engraved on the few leftover sections
he was able to salvage. Frustrated, he printed
no more than a couple of impressions of some
of these blocks.[54]

Kohn applied for and received a second
Guggenheim grant for $3,500 in 1953, this time
more broadly designed to foster his own "crea-
tive activity in the field of printmaking."
Although this grant was originally designated
for the period August 1, 1953–July 31, 1954, the
Institute of Design administration refused to
extend Kohn's leave of absence, so he received
permission from the Foundation to defer it.
Finally using it in 1955, he remained in Chicago
working in his home studio during a scheduled
sabbatical release.

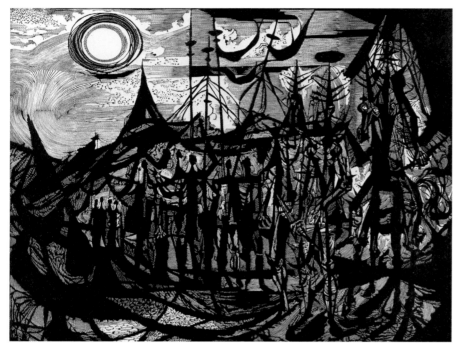

Three Visitors with Entourage, 1952
Wood engraving
13 3/4 x 17 1/2"

contrast to the generally accepted custom in France—but also because he was using the litho presses for these radically large wood engravings. In retrospect, Kohn regrets not having taken greater advantage of working with the master printers at the studios of Mourlot and Clot, as well as not having spent more time there so he could learn from the proximity of other artists—including Picasso, Miro, Chagall, and Giacometti—who were also working at Mourlot's at that time.

During this year abroad, Kohn was introduced to the sugar-lift ground process of printing etchings at Roger Lacouriere's printshop. This was Lacouriere's most significant contribution to the development of intaglio printing, for he revived this technique which had been little known or used since Gainsborough's experimentation with it prior to 1800.[53] Roger Lacouriere had learned this process from his father and grandfather, professional etchers and engravers, and was always pleased to demonstrate his technique and provide advice to those who visited or worked in his shop. Although Kohn had no access to an etching press at that time, he was intrigued by the process and drawn to the perfectionism with which Lacouriere worked. The latter shared his recipe for the sugar-lift ground aquatint process (which Kohn modified as soon as he started working with it), and the concept of this technique stuck with Kohn when he was able to put it to use some five years later.

While he was in Paris, Kohn had ordered the French wood block fabricators to make him a sufficient number of 24 x 36" blocks to last him for

with a professional master printer, he wanted to continue to print his own impressions rather than become involved in a more collaborative arrangement. Introduced to Mourlot by Hayter, Kohn struck a deal there that enabled him to personally print his wood engravings on one of Mourlot's shop litho presses one full day a week. Mourlot's shop was large: he had thirty printers working full-time on thirty presses.[52] Nevertheless, Kohn caused quite a stir: when he began printing his wood engravings on the large litho presses, all the master printers stopped what they were doing to watch him work. They were intrigued because not only was the artist printing his own work—in

the print workshops in Paris. These workshops have a long history of unexcelled craftsmanship.

As an American artist, I could absorb intangible values in Paris which not only will contribute to the work under consideration, but also will apply to my future teaching of American artists upon my return to this country.[51]

Although Kohn did explore color in his wood engravings after winning the fellowship, he was not enthused by the results of these experiments, and he followed through only minimally with this line of work.

The Kohns left for Paris in August 1952, and, funded in the princely amount of $3,500 for the year, settled into their walk-up across from the Beaux-Arts school of architecture at 21 Rue des Saints Pères in Paris's 6th district. This apartment, although small, had sufficient room that Kohn was able to use a portion as a workshop. At that time Paris was still the center of the art world, and the Kohns made the acquaintance of numerous artists from all over, many of whom became very good friends. Kohn was introduced to the various art-supply dealers and printers by Hayter, and printed variously at Roger Lacouriere's, Andre Clot's, and Fernand Mourlot's printshops during his year abroad.

Knowing that Clot's father had printed for Toulouse-Lautrec, Kohn began working there first, creating stones and printing his lithographs. However, he also needed a place to print some of his larger wood engravings. Accustomed to working by himself and uninterested in working

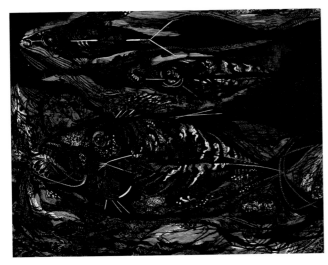

Sea Study, 1952
Wood engraving
13 3/4 x 17 1/2"

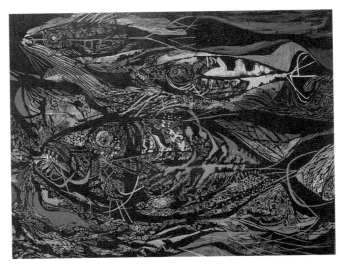

Sea Study, 1952
Wood engraving, tempera
13 3/4 x 17 1/2"

to Italy, went mountain climbing in Switzerland, and spent a lot of time looking at African art.[49]

Kohn also followed Hayter's advice to show his work to the print curator at the Bibliothèque Nationale, M. Valery-Radot, who immediately bought several engravings for the permanent collection. Valery-Radot was extremely impressed with his work, and said that Kohn was the greatest wood engraver of all time. He remained a loyal supporter throughout his years in that position.

After returning to Chicago from Paris, Kohn was promoted to assistant professor at the Institute of Design and director of its Graphic Workshop and Department of Visual Design. The next year he applied for and was awarded a Guggenheim Fellowship to travel back to France for "studies of color processes in the field of printmaking." Although his current preference was for working in black-and-white, such a proposal was in step with the current trend not only in printmaking, but in film production, house painting, interior furnishings and linen, and the like, and the Kohns felt that his application would be more competitive if he proposed to explore this field. There was much talk (and concern) at that time about color prints becoming a "threat" to—and perhaps ultimately a substitute for— oil painting;[50] other analysts thought that black-and-white images necessitated too detailed and intimate an inspection, and that the public, newly consumer-oriented and liberated with a postwar fervor, demanded an easier route to aesthetic satisfaction. Hayter had been in the forefront of using color, and many of the printers concurred with this new movement, including Fernand Mourlot, who had printed color lithographs for Picasso, and with whom Kohn planned to work while abroad. Kohn's proposal to the Guggenheim Foundation included the following:

An extension of the vast potentialities of the wood engraving medium could be made by employing color. Previous to this, the wood engraver has used color as a tint-block, or has been limited to local color areas, and, in some instances, has painted on the block in order to get full color variation, thus in effect creating a monoprint. I propose to print transparent color overlays from a series of fully engraved blocks whose textural variations will be designed in such a way as to modify colors.

In order to accomplish this work, however, it would be necessary for me to take full time off from my teaching and administrative duties for one year, and to travel to Paris. While on a short visit to France last year, I found that my materials, difficult to obtain in this country, are available there. Furthermore, while boxwood blocks are expensive in France, they are almost prohibitive in the United States. In addition, there are craftsmen in France able to join large blocks which will meet my needs. I intend to take advantage also of the technical facilities of

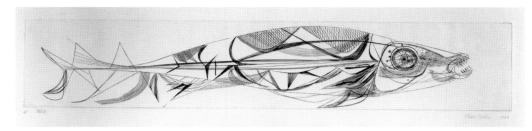

Fish, *1949*
Line engraving
5 1/8 x 27 1/2"

notice at all," Chermayeff asked Kohn whether he would help them out by taking over the print classes, just for that one semester. He did, and the following spring was reappointed to the I.D. faculty for academic year 1949–50, "subject to financial ability, scheduling conditions and sufficiency of registration." His first-year salary was $4000.[48]

A natural teacher who truly savored inspiring his students and watching as they grew to make their own way, Kohn stayed at the Institute of Design for 22 years. In addition to the print classes, he taught basic foundation courses, enjoying the plastic manipulation of varieties of visual materials in order to discover the range of their properties. The two-dimensional foundation courses concentrated on issues of communication, a natural crossover for Kohn as he moved into teaching from the advertising field.

At the end of that first spring session, Hayter decided that the Kohns should drive him back to New York and that they would make a fun "working" vacation out of the trip. Kohn hadn't been back to New York since he had left in

1939, so he was anxious to return; on their car trip back, they stopped at all the major museums between Chicago and New York, "peddling" their work—very successfully—and viewing the print collections. When they arrived in New York, the Kohns stayed with the Hayters for two weeks; they were most hospitable, and Hayter was gracious about giving Kohn entree to local collectors and curators in the city. Kohn pulled one print, a line engraving, at Atelier 17 while he was there, but spent most of his time sightseeing with Lore and the Hayters, and visiting the museums and galleries.

In 1950 the Kohns decided to go to Europe. It was his first trip, and Lore's first since she had left in 1939 as a German war refugee. Hayter suggested they go at that time because he was returning to Europe for the summer, looking for a permanent place to which he could move his Atelier 17 back from New York, and he offered to find them lodging for the summer in Paris. The result was a seventh-story walk-up apartment with no telephone. Nevertheless, the Kohns had a wonderful time, and while abroad, they traveled

to the academicism and classicism that it had connoted—opened this technology up as a new frontier for expressing the interests and images of 20th-century artists. It was a restless, experimental period in art, and Hayter's efforts provided artists with a "new" medium in which they could explore their conceptual and aesthetic concerns.

Hayter had a profound influence on American printmaking in general, and on Kohn particularly, although he spent little time actually working at the Atelier 17 studios in New York or, later, in Paris. "Hayter...was a big influence on me," Kohn recalls.

He had the ability to excite people into an area that they hadn't been before, and to be free in being able to automatically do art, to make a line that really worked, and was very free and unplanned....His influence on a lot of people was greater than they knew.[46]

Hayter's Surrealist tendencies, such as the automatic drawing that Jackson Pollock was so taken with, the application of a variety of different print media within the same composition, and the sculptural quality that his prints exhibited as a result of the deeply gouged plates, were equally matched in importance by the new international dimension and depth that he introduced to American artists. Although Hayter founded a modern graphic workshop, worked with printmakers, and was renowned for his technical virtuosity vis-à-vis printmaking processes, his

real interest was less in printmaking technique per se than in creative artistic expression. The atmosphere at his Atelier 17 studios challenged the conventions of traditional processes as well as aesthetics: the artists who worked there, "untrammeled by literal representation,...seek to explore the human subconscious and to render concrete the myths and intangibles of modern life."[47] Further, the Atelier provided an opportunity for well-known professionals, including many European refugees and emigrés, to work alongside young students in a collegial and open spirit. These seasoned exiles—as well as the returning war veterans—also revealed a deeper emotional response to aesthetic challenges as a result of their wartime experiences; this critically sharpened the perceptual and conceptual outlook of the younger artists. The result was a sweepingly innovative change in American printmaking in the decade following the war.

Hayter had been teaching a three-day class once a month at the Art Institute of Chicago, as he was doing in different schools around the country in order to raise money for the Atelier; he and Kohn became fast friends, and Hayter began staying with Kohn and his wife when he came to Chicago for his monthly class. Kohn's "English connection" in Chicago, established with Hayter's teaching visits, grew to include Serge Chermayeff, president of the Institute of Design at that time, as well as Michael Higgins, the head of I.D.'s print department. In 1949 Higgins had to leave suddenly, and "without any

Knows Best" society through apocalyptic symbols in black and white. The works from the early 1950s are consistent—through title and imagery—in overtly characterizing the angst and violence felt by contemporary society confronting an often terrifying world. "Everything he has learned... he has poured into painstakingly evolved epic concepts that go far beyond their immediate symbolism...into a monumental bravura," one Philadelphia critic wrote admiringly.[41] Kohn created tension in the interplay of negative and positive space, through the textures and patterns he developed, through his exacting obliques and verticals, and through the provocative, unsettling imagery: the *Sleeping Soldier* who will never again wake, the headless horseman in *Death Rides a Dark Horse,* the nightmarish web restraining the helpless victims in *A Season in Hell,*[42] the desperation of *Portrait of a Contemporary.*

Kohn's acknowledged precursors for this work included Grünewald, Bosch, and Pieter Breugel the Elder,[43] yet his wood engravings are perhaps even more responsive to the work of the German Expressionists, as well as to artists such as Callot, Kollwitz, Goya, Picasso, Munch, and the Mexican muralists. Semi-abstraction and distortion of idiom are used to great effect with these early, large-scale wood engravings, revealing a personal preoccupation with humanistic concerns about the "state of man." Perhaps most unusual was that his work showed effectively both intimately and from further away: such was his command that his minute and sensitive

textures enhanced rather than detracted from the monumentality of his overall design. "It is astonishing how he could always hold the big design intact while executing minute passages of textured pattern," Zigrosser enthused.[44] Evocative and thought-provoking, Kohn's technical virtuosity served him well as a means through which he could communicate his powerful statements.

There are three works from this period in which he turns his subject away from torment and distress toward what may broadly be termed vocation. *Trio,* although revealing significant similarities to the treatment of *Prisoners,* instead conjures up the smoky, crowded, funky improvisations of the jazz club, where musicians jam together in intoxicating abandon. *The Glass Blower,* a rather cool treatment of this most physical craft, is a reminiscence of workers he saw in Westphalia during his first trip to Europe. *Fishermen,* his most successful work of the three, although specifically referencing the fisherman with whom he lived in Acapulco, transforms these workers to international, archetypal status with a bifurcated composition that alludes to the natural power of the elements and humanity's paradoxical fragile isolation yet containment therein.

Kohn almost immediately received significant acclaim for this new and original work. He was taken to meet S. W. Hayter (born London, 1901–1988, founder of the Atelier 17 printshops),[45] who perhaps singlehandedly revived the art of engraving in a way that—in contrast

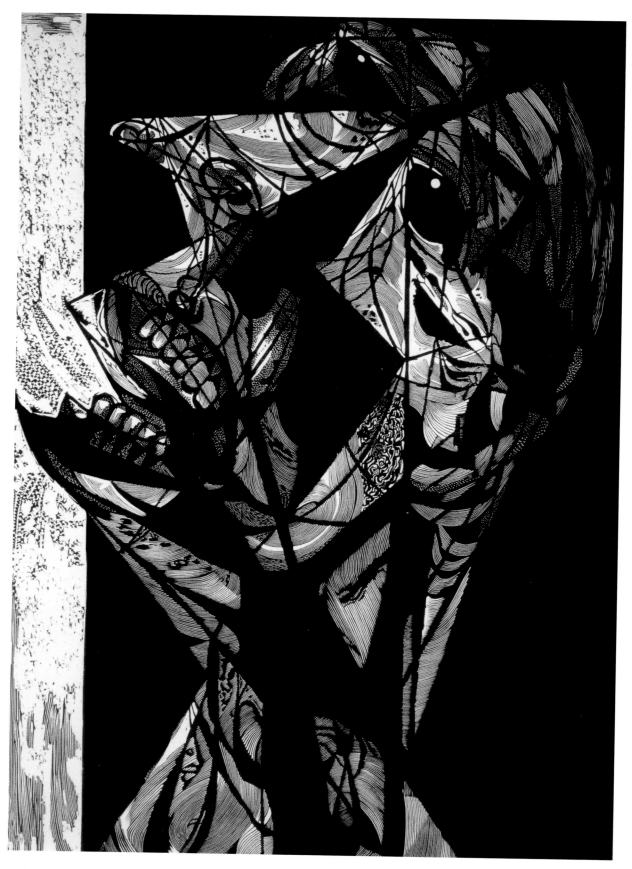

Portrait of a Contemporary, 1951
Wood engraving
21 1/8 x 14"

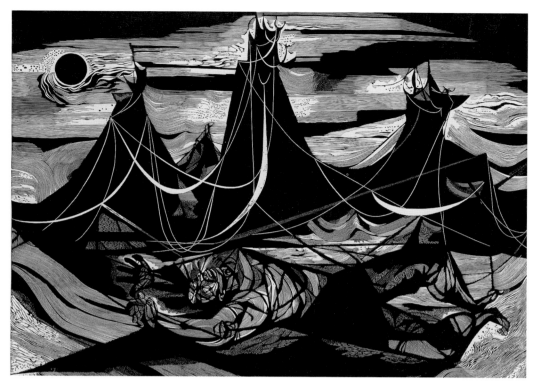

Sleeping Soldier, 1951
Wood engraving
17 1/2 x 23 1/2"

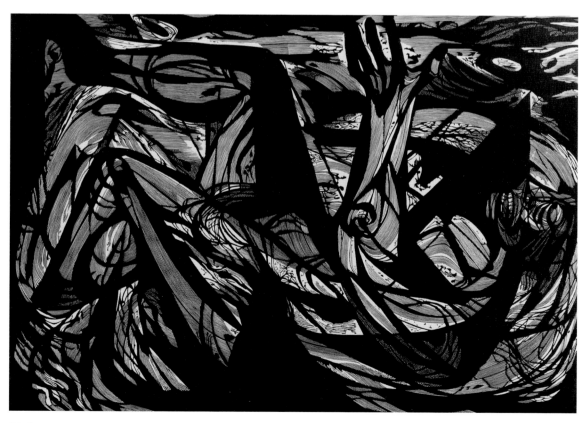

Medea, 1950
Wood engraving
16 1/2 x 22 9/16"

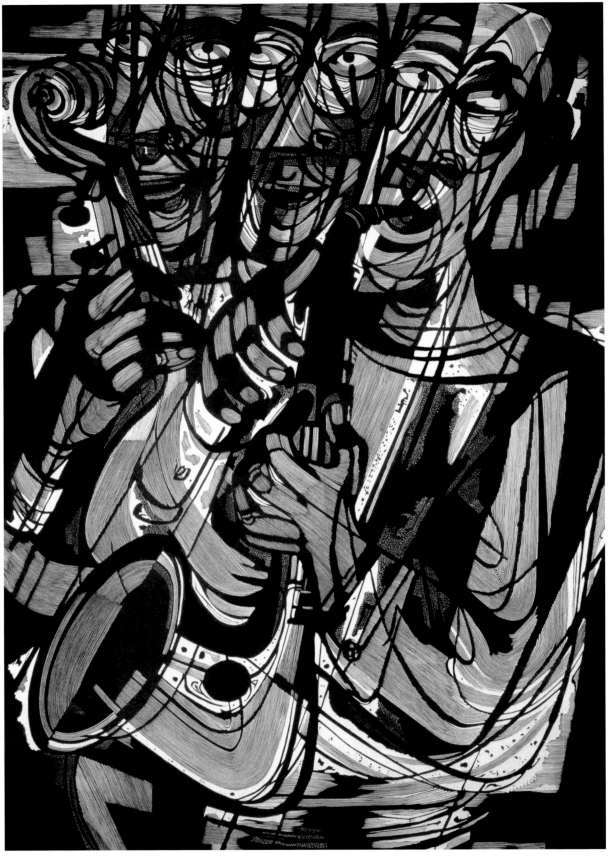

Trio, 1949
Wood engraving
23 1/4 x 15 13/16"

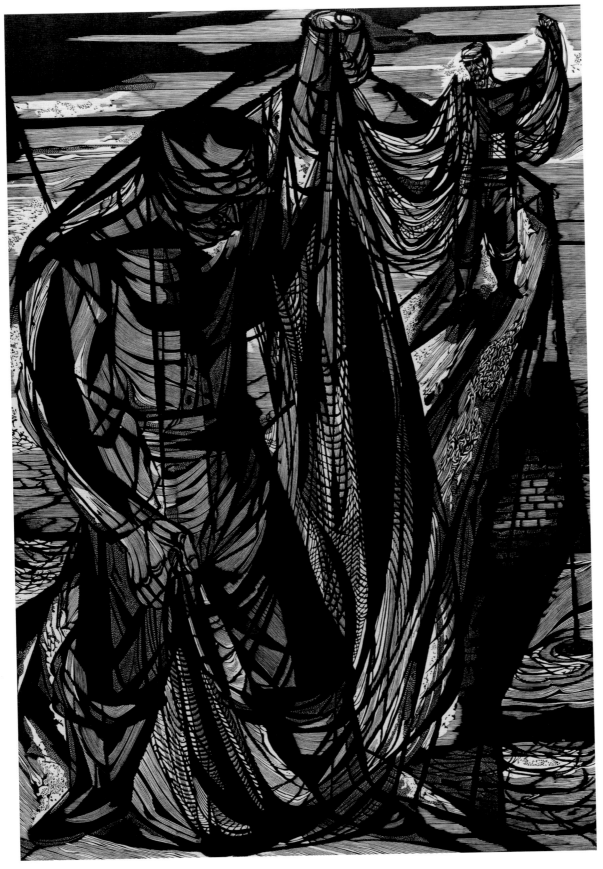

Fishermen, 1949
Wood engraving
23 3/4 x 15 13/16"

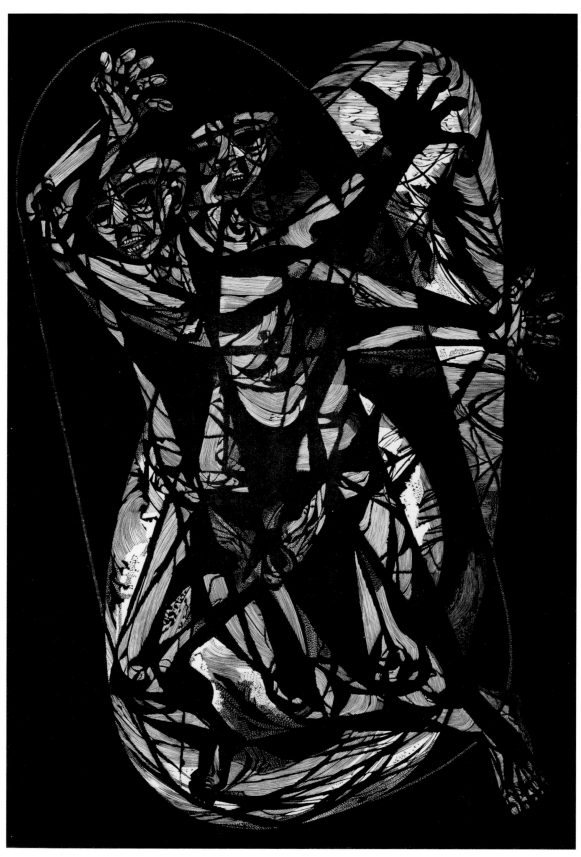

A Season in Hell, 1951
Wood engraving
II State
28 5/8 x 19 1/8"

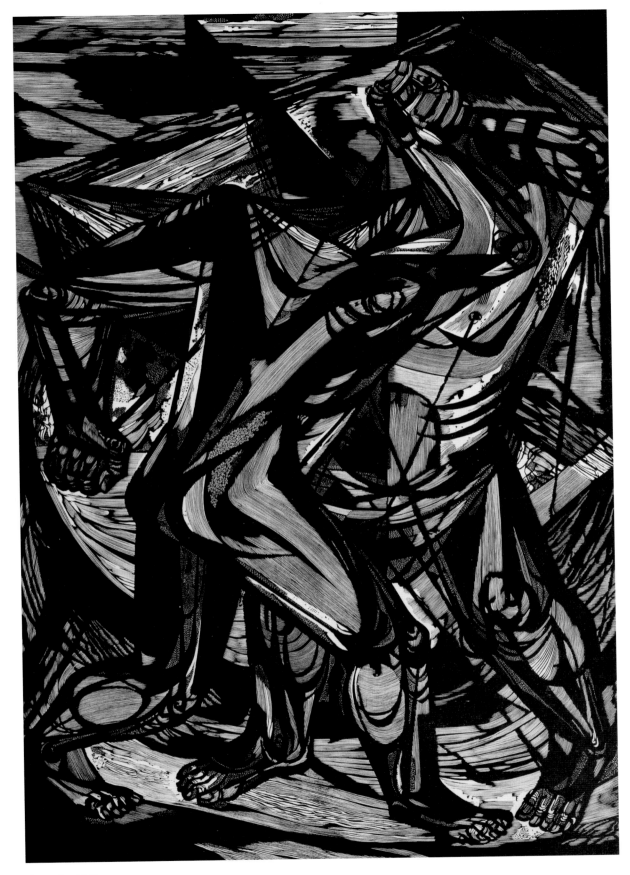

Struggle, *1949*
Wood engraving
23 1/8 x 15 7/8"

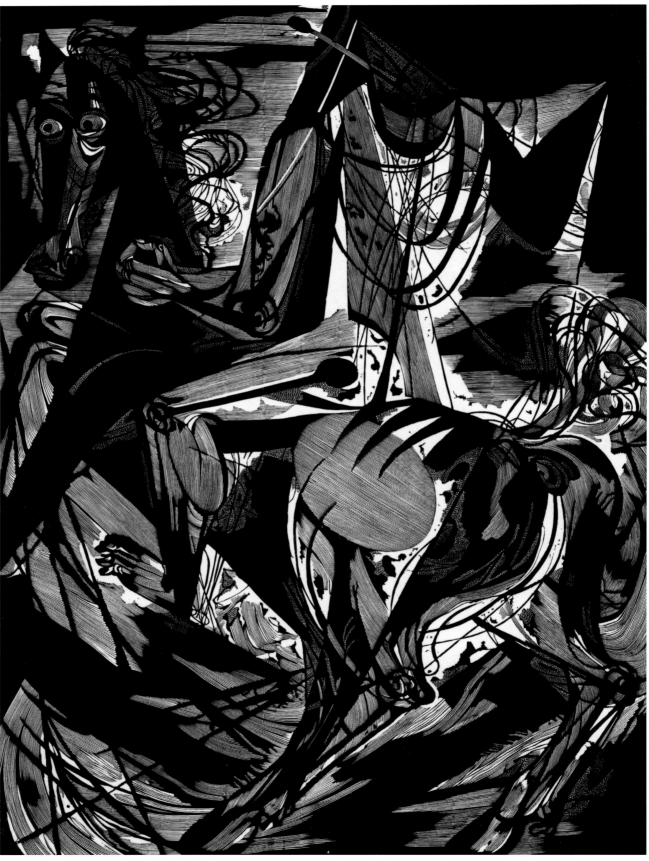

Death Rides a Dark Horse, *1949*
Wood engraving
21 7/8 x 15 3/4"

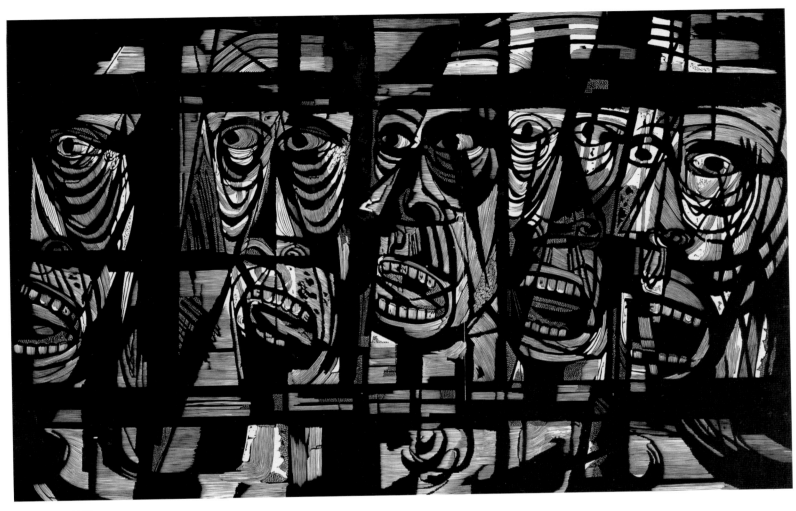

Prisoners, 1949
Wood engraving
15 3/8 x 23 1/2"

*Everything about it was divided up into planes,
triangles, and whatnot....I always manipulated
it that way, with certain qualities of organiza-
tion of the space, so that the movement would be
abstract, carried through the landscape.*[39]

Realistic representational components
seamlessly shifted into alternately intricate
or bold areas of pattern and texture, emphasizing
mass as they structurally integrated the figures

into their dynamic environment through continu-
ous flowing lines.

Kohn continued to explore this medium,
bringing a fresh and often piercing interpretation
to some familiar subjects, such as animals and
fishermen, but also creating some "marvelous
apparitions,"[40] such as *Sleeping Soldier* and *Portrait
of a Contemporary*. His explosive yet coherent
images belied the 1950s myth of a serene "Father

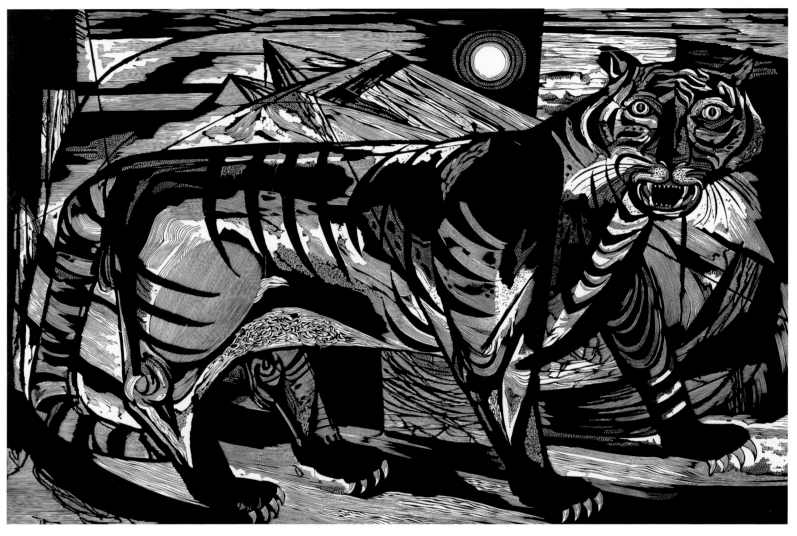

Tiger, 1949
Wood engraving
16 3/8 x 23 5/8"

bold, abstract planes with figurative imagery, contrasting these striking forms with stark embossing and interpenetrating textural intricacies. In so doing, Kohn revealed, really for the first time, a personal and emotional expressionist conflict.

The contents of the large engravings of this time period are perfectly compatible with their technical qualities. Visual clues are left with enough room for each viewer to make his or her own conceptual associations, and draw the eye across each composition in a way that confirms

that Kohn's intent was not purely narrative, but was formalist as well. Indeed, Kohn characterizes these works in abstract terms of space, volume, and relationships of planar forms, not in terms of the realism of the imagery. For example, although the next great piece, the acclaimed 1949 *Tiger*, was inspired by a poem by Blake replete with specific visual references, he describes this print not in terms of content or context, but in terms of form:

that he wanted to achieve. Although he used special adhesives that were supposed to have been able to withstand the tremendous pressure, they were not always capable of doing so, and sometimes his blocks would crack before he could complete an edition. This problem was exacerbated because the China/India paper that he preferred[33] needed to be printed while in a significantly dampened state; he found he could print only a half-dozen impressions before allowing the block to rest, and then counter warping it.[34] Printing on this thin and absorbent paper with such extraordinary printing pressure produced sharp forms that actually embossed the paper, and effectively contrasted the textural complexities of the image with the simple boldness of the black masses:

> *I wanted to overcome the limitations [of the wood engraving medium] so that not only could I engrave and print wood blocks of large size, but also widen the scope of the creative approach as an independent means of expression, and not as a mere reproduction device.*
>
> *I was able to develop a process of controlling the warping, and further, by adapting the hand-lithography press to the medium, I found it possible to control the surface of the block and achieve a uniform impression....By deep cutting, the use of damp paper in printing, and extreme pressure, I achieve brittle, embossed white surfaces which, I believe, add another dimension to the impression.[35]*

Carl Zigrosser, longtime curator at the Philadelphia Museum of Art, described this period as an almost-instantaneous maturation of Kohn's work; his coming-of-age as an artist, with exponentially increased clarity of vision shining through his technical virtuosity: "a transformation as sudden and dramatic as that from pupa to butterfly,"[36] he wrote. The response from other scholars was similarly enthusiastic: Jules Heller noted that he had managed to combine the "power of woodcut with the subtlety and delicacy of wood engraving;"[37] Peter Selz wrote that "Kohn has brought his medium, the wood engraving, to a state of highest development."[38] The 1948 *Fantasy*, the first large-scale wood engraving, is fanciful and rather surreal, confounding the eye with complex composition and the interweaving of intricate elements. Its labyrinthine movements presage the forceful drama and monumental power of the works immediately to follow.

Critics have anointed *Bull Fight*, finished in 1949, as the first of Kohn's wood engraving masterpieces. The several smaller prints he had done of this subject in Mexico revealed his careful study of the choreographed pageantry of this sport; now, through the contemplative lens of some five years' distance, this larger print achieved a more archetypal approach, distilling the dramatic tension in the movement and the bond among man, bull, and the clamorous pulsations of the crowd (irrespective that the latter was beyond the picture plane). Here Kohn balanced

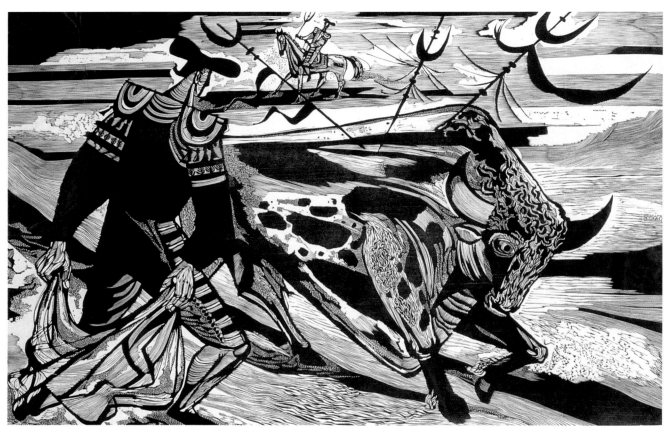

Bull Fight, 1949
Wood engraving
15 1/2 x 23 1/4"

for cutting the block, as framework rather than as blueprint. (Although he occasionally would draw or paint directly on the block, for the most part he relied on the drawings to provide his pattern.) The final form continued to evolve through the actual engraving process, cutting away parts of the wood block with his burin to reveal heavy blacks accented by areas of brilliant white: "the design is really adapted to the inherent qualities of the wood block," he wrote, "rather than being superimposed upon the medium."[32] Engraving on the heavy joined blocks of end-cut boxwood, he

added new textures and new dimensions to this medium with his radically large and intricate prints.

Kohn was then faced with the technical problem of printing. The enormous pressure necessary to print had—along with tradition—been the primary impediment to printing larger blocks. Kohn solved the problem by printing the blocks in a lithograph press at the immense pressure of 3,000 pounds per square inch, teaching himself how to adjust the press for the exact degree of control required for the specific effects

44

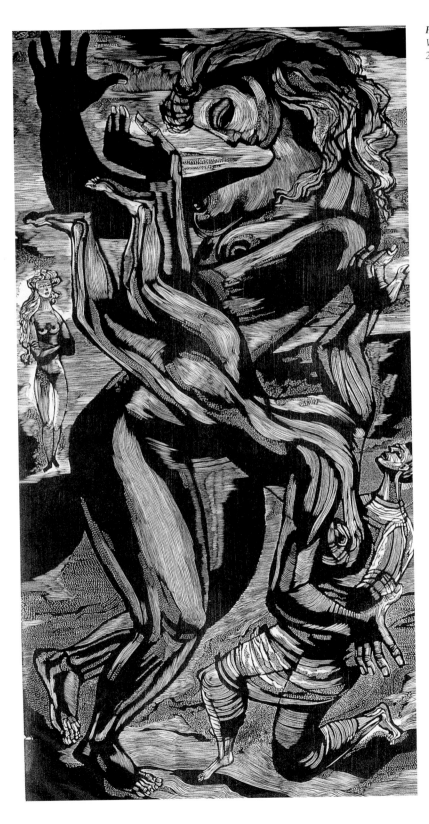

Fantasy, 1948
Wood engraving
24 1/4 x 12 1/4"

First Success
The Large Wood Engravings

In 1948 Kohn's work changed dramatically. Having worked on the *Pursuit of Freedom* project and then on the small wood blocks in Mexico, he was ready to create some larger images. Up until this time, although wood engraving was enjoying a revival in the United States, most artists were still using this medium primarily for the purpose of book illustration, which profoundly circumscribed their approach to the medium. Kohn wasn't interested any longer in making books; he wanted to move the print from a private, hand-held experience to a public scale, with work that would have strong visual impact when viewed on a wall, and the smaller wood engravings were clearly inadequate in that regard. Kohn began to investigate the possibility of obtaining larger blocks, and he found a Chicago company that fabricated blocks for wood-type engravers. The standard size for their blocks was 12 x 12", not large enough for what Kohn was envisioning. However, from the company's supply of aged African boxwood—which Kohn liked because of its almost imperceptible grain—they were willing to make him larger blocks. While he waited for his order to be fabricated, he began work on *Fantasy,* his first large work, engraved on a block that was stacked together from two standard-size sections.

Beginning with a general conception of what the finished work would be, Kohn initiated the development of his design in rhythmic, flowing sketches in graphite. Once satisfied with the basic flow of his image, he used it as the basis

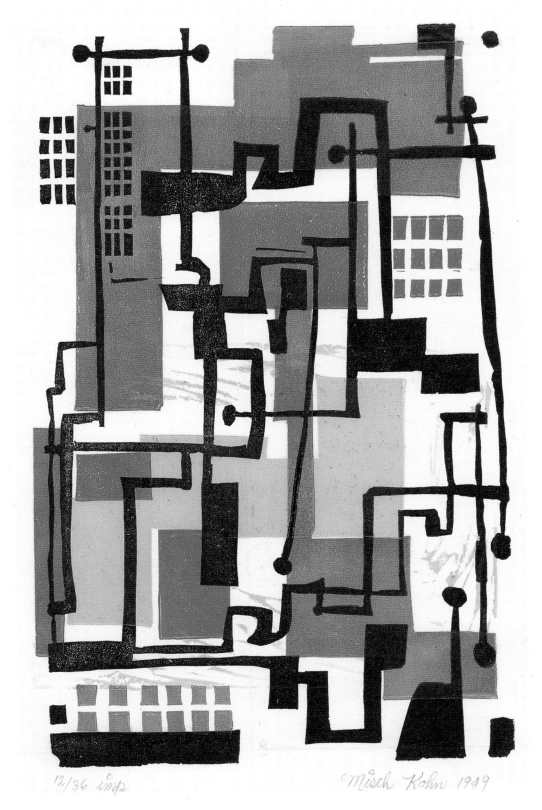

12/36 imp Misch Kohn 1949

The City, 1945 [dated 1949]
Linoleum cut
8 1/8 x 5"
Collection Indianapolis Museum of Art 1949.46-d, gift
 of the John Herron Art School Alumni Association

Photographer unknown
Misch Kohn, c. 1945
Tempo Advertising Company, Chicago

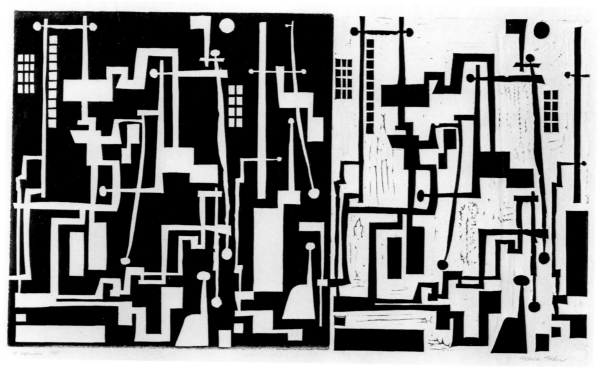

The City in Black and White, 1946
Linoleum cut
11 13/16 x 19 3/4"

of the work, Orozco was constantly being interrupted—"we'd work a week then stop and work again and stop. That went on for a whole year."[29] The church was closed after Orozco finished the mural in 1944, and, as far as Kohn knows, was never reopened.

In addition to being impressed with Orozco's bold figuration, Kohn was intrigued with the immediacy of his method, in which he would often work directly on the fresco without the use of preliminary graphics. Kohn also credits Orozco with teaching him how to respond to the oft-experienced conflict between mental preconceptions and material limitations; the sudden decisions that need to be made in such cases often determine the success or failure of a given work, and Kohn's facility with this became particularly important as he sharpened his personal aesthetic and own manner of working.

After teaching at the *Taller,* Kohn was offered a position teaching the summer course during July–August 1944 at the art school in San Miguel de Allende. Visiting, he loved the school and town immediately, and he planned to do so, but he received a letter from a friend advising him that his girlfriend Lore Traugott, whom he had known since 1943 and corresponded with throughout his Mexican sojourn, was beginning to go out with other men. So Kohn packed up all of his materials and by summer 1944 returned to Chicago. Although his emotions during his year in Mexico had been decidedly mixed, in the end he seemed to be pleased by what he had

accomplished, and felt that "this will have proved to be a good investment...this trip will prove to be the most sensible thing I ever did."[30]

In these letters from Mexico, Kohn indicated that he had begun to think about what he was going to do to earn a living upon his return. More and more he began to think about teaching, but nothing was available upon his return to Chicago. With no studio and no other options, he was asked by Earl Ludgin Associates to create some drawings for a book they were producing; thus began his work in the advertising field. He and Lore Traugott married in 1945, and Kohn worked at various agencies between 1944 and 1948. He did well in the field, with a monthly ad for United Airlines and bimonthly ads for an architectural materials company appearing in such magazines as *Time, Life,* and *Fortune.* Although at first he was "beguiled" by the business, later he was put off by the personal and political conflicts that seemed to be inherent in this profession, and by 1948 he had resolved never to do a commercial drawing again. Too, although he was able to save some money from these efforts, during this time he had little opportunity to concentrate on his own work; he pulled new (and higher quality) prints from the blocks he had engraved in Mexico, and, inspired by Lore, created several stylized, bold blocks that could be used for printing on textiles as well as on paper.[31] One of these, *Marionette Dance,* won a prize in the annual regional artists exhibition at the Art Institute of Chicago in 1948.

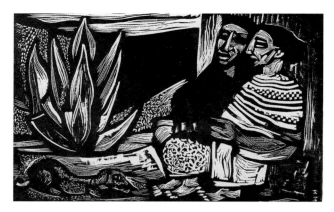

Two Mexican Women, 1944
Wood engraving
2 11/16 x 4 1/8"

to grind down the surfaces of their lithographic stones, which left a coarse and uneven surface.[27] However, their enthusiasm and motivation helped to instill in him the gratification resulting from experimentation with available materials. During the war years in the United States, although artists had access to newly developed papers, inks, and pigments, as well as innovative adaptations from commercial applications, true experimentation was rare; in Mexico, ingenuity stimulated a search for the possibilities inherent even in inferior materials and equipment.

In addition to his printmaking work at the *Taller*, Kohn did some mural painting with both Rivera and Orozco. "This was the day I came for," he wrote,

> *I really think I knew that some day I would climb a scaffold 3 stories high and put out my hand and say, 'Señor Orozco, how do you do?'...So I stayed and watched him paint...and the next day I climbed the scaffold again. For 4 days that's all I did...it is a really wonderful experience....[The mural] is the most powerful plastic expression I have ever seen.*[28]

Soon Orozco invited Kohn to help him; he began with tasks such as filling in the background behind figures within the fresco on the *Templo de Jesus* mural. The *Templo de Jesus*, once a Catholic church, had been taken over by the city government, which decided that the building would serve nicely as a public library. However, there was a tremendous amount of public opposition to the project, with great offense taken at the secular subject matter of the mural in this once-sanctified space. So despite the significance

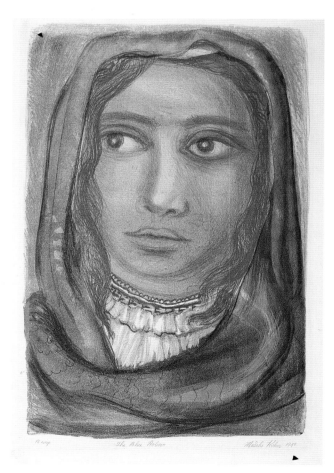

Blue Rebozo, 1943
Lithograph
13 5/8 x 8 7/8"

Mexican Landscape, 1944
Lithograph
9 1/4 x 13 3/4"

Photographer unknown
Pablo O'Higgins, Misch Kohn, Francisco (Pancho)
Mora, 1944
Ocoyacac, Mexico

Although he enjoyed Mexico, Kohn's finances were extremely tight, and he complained about not always getting enough to eat: "Mexico is not the idyllic spot it once was. Now prices are exorbitant [sic], more than the States! except banannas [sic] 1c a piece and I am sick of banannas."[25] Whenever possible, he cooked for himself, and was pleased and surprised with his growing skills.

During his year there, Kohn continued the printing project at the *Taller* that Kahn and Coney had been involved with, printing the engravings of Posada from the original wood blocks or metal plates, as well as pulling prints of his own wood-

cuts, wood engravings, and lithographs.[26] Bold figurative subjects with aggressive leftist political messages characterized the work of many Mexican artists at that time; inspired by the example set by Posada and reinforced by the political news of the day, the workshop artists at the *Taller* also produced large numbers of relief-printed propaganda posters and tracts, believing that these would serve as a major weapon for their political and social revolution. Kohn worked with them to produce these posters; this was no doubt instrumental in encouraging Kohn's own interest in wood engravings, and must have validated his earlier inclinations to use this medium as a means to foster cultural change. However, his own prints from this period tended towards genre scenes and archetypal images rather than political exhortations.

Kohn also taught a class in lithography at the *Taller* one day each week, although it was difficult, because the equipment was minimal and the workers did not have sufficient knowledge about or experience with the processes. He was particularly appalled that they used sand

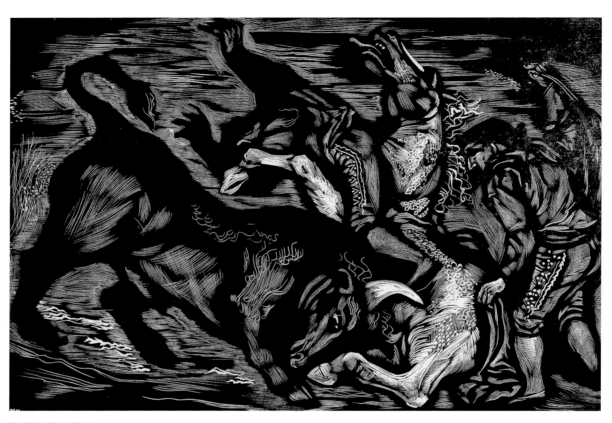

Bull Fight, *1944*
Wood engraving
6 5/8 x 9 9/16"
Private collection

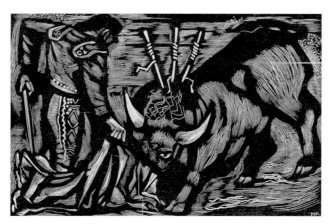

Bull Fight, *1944*
Wood engraving
4 3/8 x 6 5/8"

I spend a lot of time kicking up the dirt when I go out on sketching trips and as a result my shoes are in bad shape but my collection is growing....The history and the wealth of cultural material is endless. For a guy who thought America began with the Boston Tea Party I feel the proper amount of shame for my ignorance.[24]

Kohn would retain this interest in pre-Columbian and other non-European arts throughout his life.

While away from the capital, Kohn was painting two or three watercolors and casein temperas a day, and planned to use them as studies for oil paintings once he returned to Mexico City. (However, few, if any oils were ever finished). Primarily genre scenes and landscapes, the watercolors and temperas clearly reveal his attraction to the color and the exoticism of the country. It was physically and logistically much more convenient for him to paint than to pull prints while he was in Mexico, but the paintings were not just a way to spend time; his letters, full of self-doubt, reveal how he fretted and worried about their quality, and how he believed that success in this medium would help to bring him the recognition he craved.

On the beach in Acapulco Kohn met Carlos Arruza, one of Mexico's foremost *toreadores*, who was recuperating from a slash wound he had received from one of his "fans," who apparently had not liked the way he was fighting the bull. Arruza offered to put on his "Suit of Lights" for Kohn when they returned to Mexico City, and the latter did several drawings of Arruza, as well as two portrait wood engravings which he printed at the *Taller*. Several other small prints featuring images of bullfighter and bull also were created by Kohn that year.

Kohn traveled back and forth to Acapulco several times during his year in Mexico, and also made several side trips to communities such as Cuautla, Taxco, Oaxaca, and Pahuatlán in order to sketch—or "take notes" as he called it—for his paintings. He traveled by second- or third-class bus or narrow-gauge boxcar train, burro, and foot to see pre-Hispanic sites and traditional fiestas. He became very interested in Mexican archaeology and anthropology, bought a few textiles—including a beautiful embroidered blouse off a woman's back—and collected small pre-Hispanic pieces that he found:

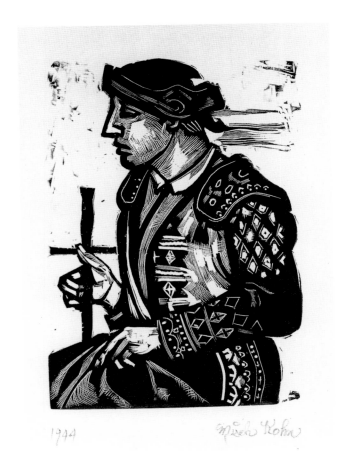

The Bullfighter, 1944
Wood engraving
4 3/4 x 3 1/2"

Rudolph Penn (American, b. 1916)
Misch Kohn, c. 1943
Acapulco
Private collection

I am sitting on the window sill of my room (it has 8 windows), looking out over the bay filled with little fishing boats. From where I sit I can see nearly all of Acapulco, the mountains, and the coconut groves. The houses all have tile roofs and are white cement; the little boats are brilliantly colored: rose-pinks, greens, and grays against the yellow sand and the prussian-blue water. I can walk across the road and there is the sandy beach and the water lapping gently against the shore....I walked to the water's edge and saw the fish, tiger-striped and spotted, and one fish so brilliant a blue it looked like a tube of cobalt blue had been emptied over it. I could easily paint here from the window a month or 2 or 3 without looking elsewhere for subject matter.[23]

names and addresses from Kahn and Coney, Kohn went directly to the studio of Pablo O'Higgins, one of the artists responsible for maintaining the *Taller*. O'Higgins immediately introduced him to other artists, including Alfredo Zalce, Leopoldo Mendez, Diego Rivera, and Jose Clemente Orozco. "Within the first two days, I knew everybody in the Mexican art world," Kohn remembers.[22] He spent the first night at the YMCA, and then was invited to stay at the Zalce's home. After a couple of weeks there, he moved to Acapulco for two weeks. There, he stayed at the home of a fisherman right on the water, and was entranced by the colors, the costumes, and the food:

Rudolph Penn (American, b. 1916)
Misch Kohn, 1943
Mexico
Private collection

Rudolph Penn (American, b. 1916)
Misch Kohn, 1943
Mexico D.F.
Private collection

Pressed Steel was slow, he was given special permission to leave to teach the summer classes. Although Kohn was hired to teach only one course, he was given classes in both painting and drawing. Despite the extra work, he found the people interesting, and enjoyed teaching and the classroom environment.

After his return, time at the tank factory doing nothing became increasingly unbearable. So, with permission from the company and from his draft board, Kohn quit his job, held an auction, sold art and furnishings, and raised $430—enough money to spend a year in Mexico. Kohn thought of Mexico because in 1942 Eleanor Coen had been awarded a traveling scholarship upon her graduation from the School of the Art Institute of Chicago; with her husband Max, she spent the year in Mexico. If the times had been

different, the pair would have undoubtedly chosen Europe, but the war effectively curtailed this as an option for study and travel. Mexico was an alluring alternative: warm and colorful, with an attractive economy that enabled artists to live and work on greatly reduced incomes, it provided a new kind of inspiration and source material. There Kahn and Coney became acquainted with many of the local artists, and worked at the *Taller de Grafica Popular,* beginning a project to print earlier Mexican woodcuts and engravings such as those of Jose Guadalupe Posada (1852–1913). During that year Kahn and Kohn carried on a correspondence, with Kahn writing Kohn for needed supplies. Kohn sent paper and other materials down to them and became more and more interested in their projects. The former teacher urged his friend and protégé to come down to continue this work after their own year was completed.

With the proceeds from his auction (and help from his girlfriend Lore Traugott), Kohn bought 250 sheets of Whatman watercolor paper and took the 14-hour train journey from Chicago to Mexico City in the fall of 1943. Fortified with a "care package" from his mother of sandwiches, deviled eggs, and fruit, Kohn wrote letters in transit that reveal interest in the novelty of the countryside he was passing through, homesickness for the family he had left, and "fervor" for the new and wonderful work he knew he would create in this "painter's paradise" he was approaching.[21] Upon his arrival, armed with

The River, 1943
Lithograph
10 3/4 x 16 1/8"

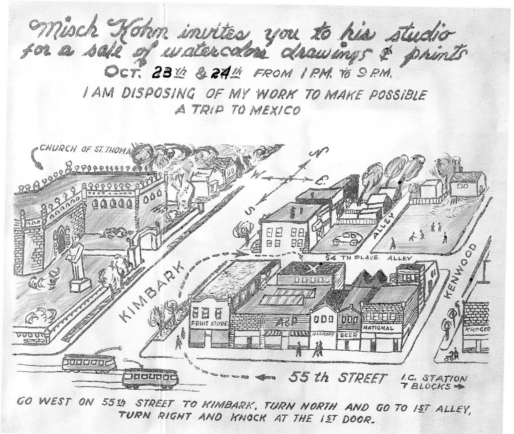

Announcement of art sale, 1943
Lithograph, colored pencil
8 x 9"
Private collection

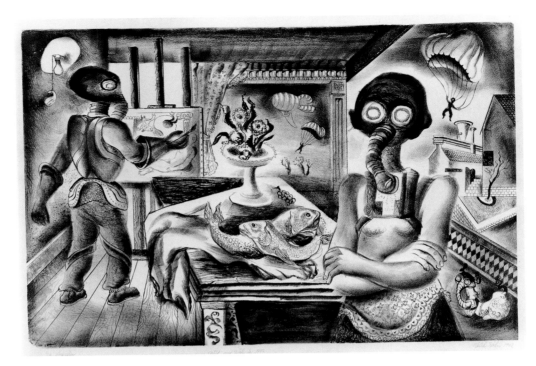

Artist and His Wife, 1942
Lithograph
13 1/2 x 19 5/8"

His Wife (also known as *Artist and his Wife with Gas Masks*); local personalities, as in *Junk Man;* and genre scenes, particularly of the park that Kohn could see from the window of a friend's apartment, is where he concentrated his efforts. Occasional images from the war effort—inspired from news stories from the front and recommended by the W.P.A. as suggested subject matter—did punctuate these generally melancholic efforts in such works as *Survivors, Camouflage,* and *Landscape in Sicily;* all envisioned events and scenes that he had not personally seen.

In early 1942, Henry Hope, head of the art department at Indiana University at Bloomington, visited Chicago and asked Kohn if he would teach the summer session. Kohn hadn't thought about teaching as a career alternative prior to this, and had never done any; he was surprised but intrigued with the offer. Because work at

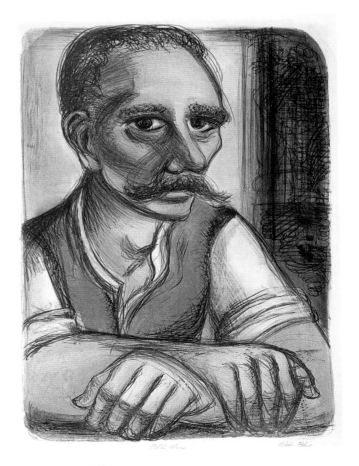

Polish Man, 1940
Lithograph
16 3/4 x 12"

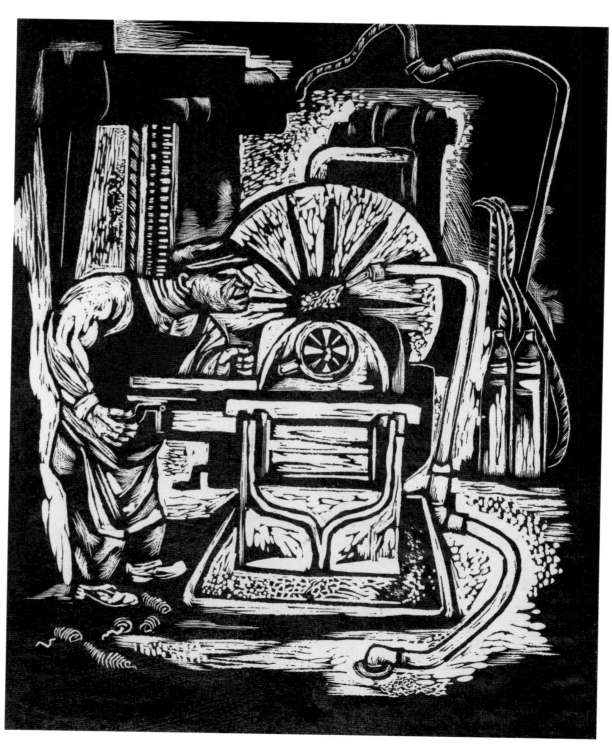

Piece Work, 1940
Linoleum cut
10 x 7 7/8"

secrets. So for several months, Kohn did nothing but sit around the plant and read mystery novels, chafing at the boredom, but continuing to receive his paycheck from the company. Management had little incentive to let the employees go, for they were receiving "cost-plus" from the government, and thus could make money whether or not their workers were actually producing.

Kohn's prints from this period were mostly lithographs, although one noteworthy linoleum cut, *Piece Work* (also known as *Machinist*), is a compelling treatment of the assembly-line fabricator. In these early war years, Kohn no longer created works with overt symbols of tyranny and injustice as he had with the *Pursuit of Freedom* series; rather, these prints explored the imagery of the home front. Black humor, as in *Artist and*

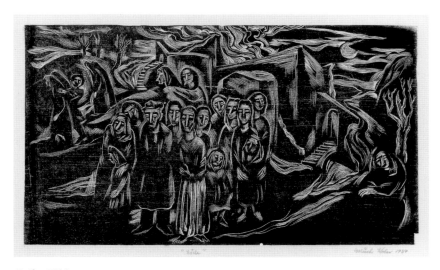

Exile, 1939
Wood engraving
7 5/8 x 13 1/8"
Collection The Art Institute of Chicago 1940.1262
Restricted gift of an anonymous donor

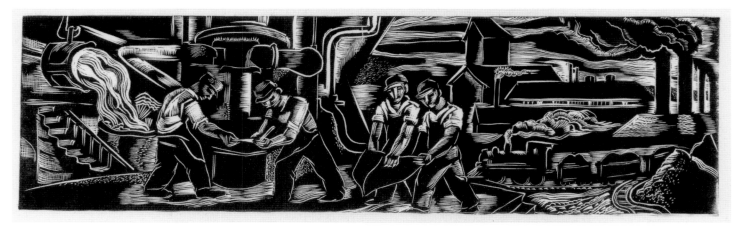

Untitled [Four Workmen in a Steel Factory Scene], 1940
Wood engraving
2 15/16 x 10 1/16"
Collection The Art Institute of Chicago 1940.1273
Restricted gift of an anonymous donor

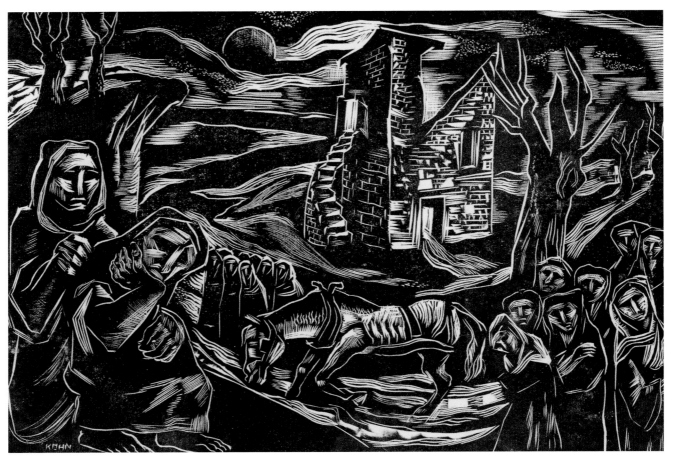

Lament, 1941
Wood engraving
4 15/16 x 7"
Private collection

because the publishers' concern was content rather than image, they were printed poorly and unevenly. To fit the format of the publication, the larger frontispiece is but 5 x 3 3/4"; the chapter headings are 2 7/8 x 4" each. For an artist whose first major success would come as a result of breaking away from the constraints of the book-size wood engraving, it is telling that he had experience working within those limitations.

Kohn continued on the W.P.A. until 1941; with Pearl Harbor and the declaration of war, he, along with most of his friends, left the Project to aid in the war effort. Classified 4-F for an endocrine deficiency, he took a job at the Pressed Steel Car Company as a draftsman; this railroad-car manufacturing plant had been completely retrofitted and retooled to produce military matériél, and Kohn worked on designs for the M-12 tank. It paid better than the Project, but, more importantly, "it was a principle call," states Kohn, "at that time everybody was gung-ho about the army."[20] This huge factory had the ability to line up a dozen tanks on an assembly line at once. Design of the tank took approximately one year, but then no new project was initiated. Even so, it was difficult to quit a job in a war plant; formal permission was needed, apparently to decrease the potential for leakage of design

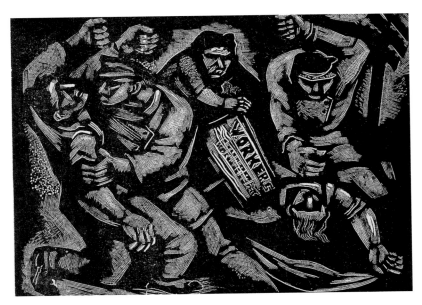

Chapter XIII: Rights of Labor, 1940
Private collection

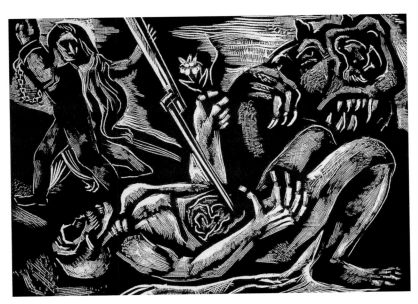

Chapter XIV: Freedom of Conscience, 1940

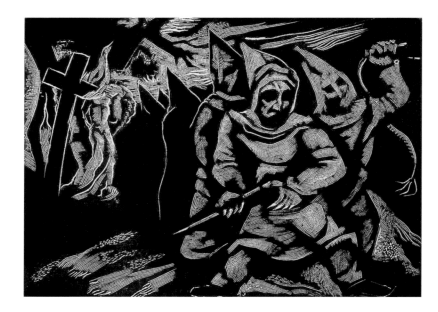

Chapter XI: Unconstitutional Police Methods, 1940

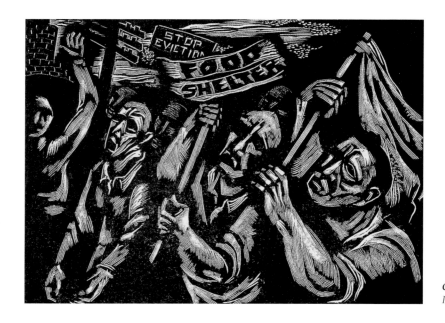

Chapter XII: Rights of the Unemployed, 1940
Private collection

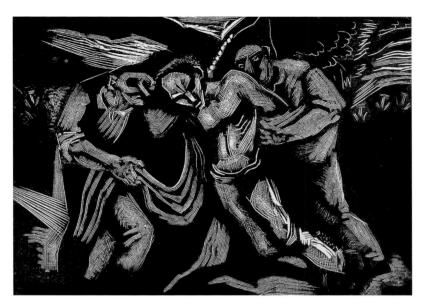

Chapter VII: Freedom Without Equality, 1940
Private collection

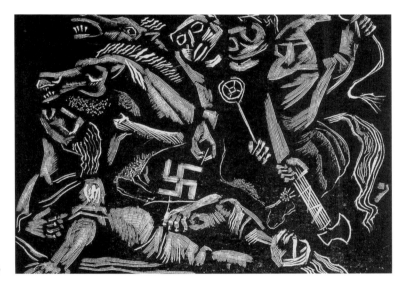

Chapter VIII: Rights of Aliens, 1940

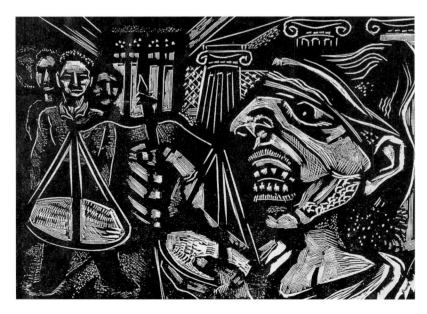

Chapter IX: Anti-Semitism, 1940

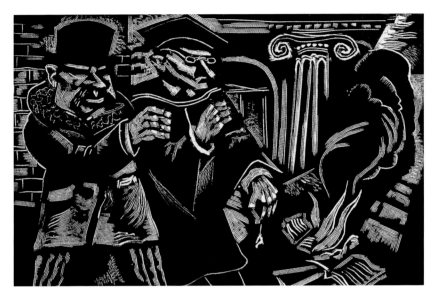

Chapter V: Academic Freedom, 1940

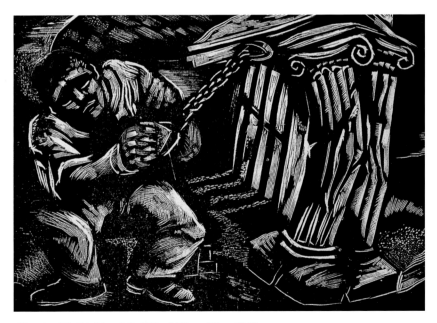

Chapter VI: Rights of Political Minorities, 1940

24

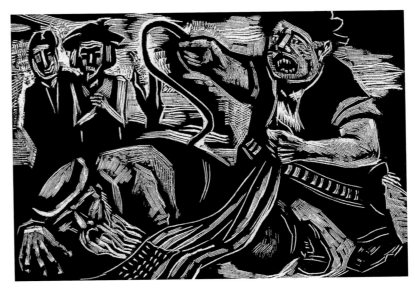

Chapter II: Freedom of Religion, 1940

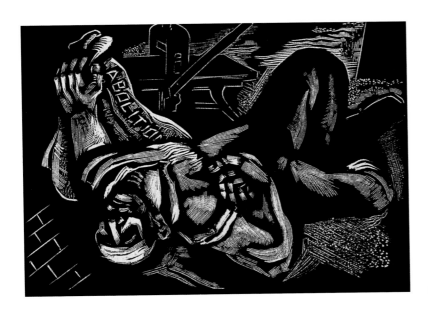

Chapter III: Freedom of the Press, 1940

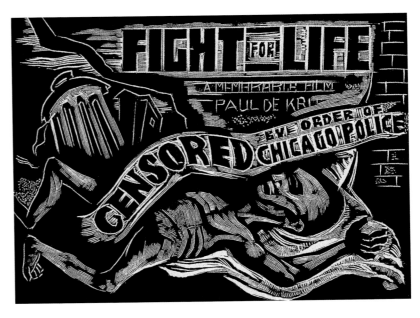

Chapter IV: Censorship, 1940
Private collection

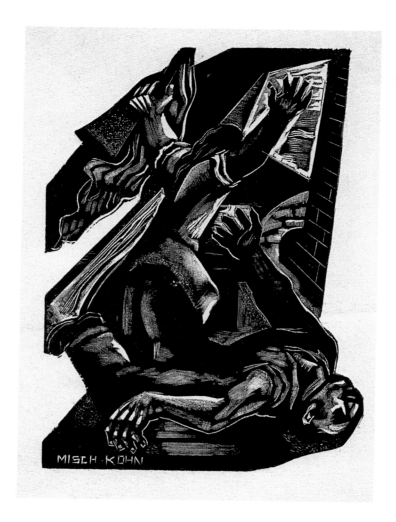

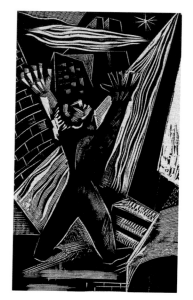

Frontispiece: **Pursuit of Freedom,** 1940
Wood engraving
5 x 3 3/4"
from the book, **Pursuit of Freedom**

Eternal Vigilance is the Price of Freedom, 1940
Wood engraving
3 x 1 3/4"
from the book, **Pursuit of Freedom**

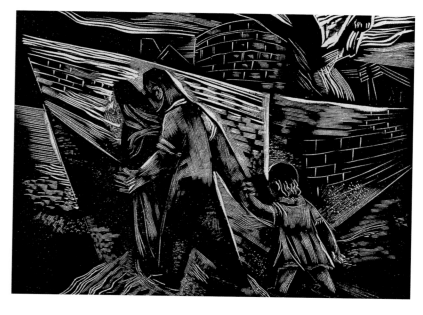

Chapter I: In Pursuit of Freedom, 1940
Wood engraving
2 7/8 x 4"
from the book, **Pursuit of Freedom**

cuts, the life story of John Brown.[19] He envisioned that this work, which would follow Brown's fight for his ideals from his early life in Ohio through the time of the Emancipation Proclamation, would contain no words except for the chapter titles. Although a few wood engravings were created for this project, it was never finished. However, it may have piqued Kohn's interest in becoming involved in illustrating a history of the civil liberties movement in Illinois, spearheaded by the W.P.A. and financed by the Chicago Civil Liberties Committee. This project, published in 1942 as a book called *Pursuit of Freedom*, included a series of 16 small wood engravings, each heading a chapter such as "Freedom of Religion," "Rights of Aliens," and so forth.

This elaborate project was a strong showcase for Kohn's early wood engravings. Although certain of the images are more forceful than others, they reveal rather complex formal compositions—significant for one whose work in this medium had been completely self-taught—and are consistent in the empathy they evoke. In tenor they are congruent with the political and social realities of the time; in outlook they are responsive to the locally oriented activism that was believed to be essential in order to bring about global change. Overall, the engravings reveal the ernest conviction that the printed image could hasten the advancement of the American ideal of full democracy into a working, everyday reality. The actual wood blocks were used to print the images in the books; however,

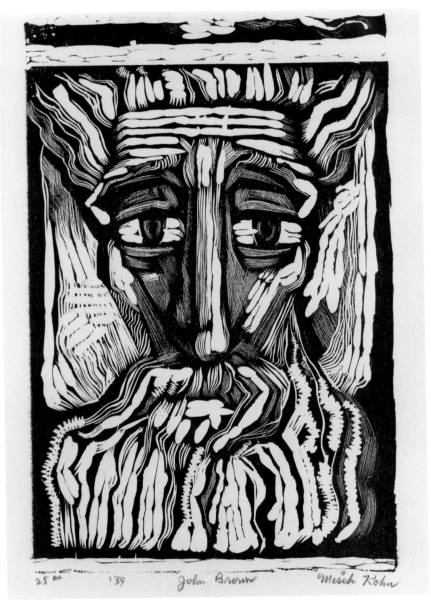

John Brown, 1939
Woodcut
9 1/2 x 6 1/8"

Others were composite portraits, combining features of people he knew with impressions from dreams or literature. Clearly influenced by the work of Kahn and Coen, most of these three-, four-, and even five-color lithographs feature a single, central image with minimal or sometimes enigmatic background. Some of these prints are somewhat constructivist in quality; others reveal a Chagall-esque fluidity. Although certain of his figures may have been inspired by specific individuals, they all tended to take on the character of archetypal portraits.

Always short of money in those days, Kohn was forced to work on a poor selection of stones; he used up "every square inch" of these stones, he remembered, and rationalized the imagery when the stone compromised his intent: in *Portrait of Franz Biberkopf,* for example,

> *the corner of the stone was chopped off, so the image ends at an abrupt point....In the actual novel...Franz Biberkopf had one arm that was cut off, so it was natural that the stone ended abruptly where it did. I didn't plan it that way, but I could rationalize it; I could get by with the stone because he didn't have an arm there.*[18]

In a letter home in 1940, Kohn wrote of running dry on ideas for additional lithographs and the need to do some "serious work" with wood engravings. He felt very involved politically at the time, leaning to the left with most of the other artists of that generation, and intended to produce the "novel of the century" in wood-

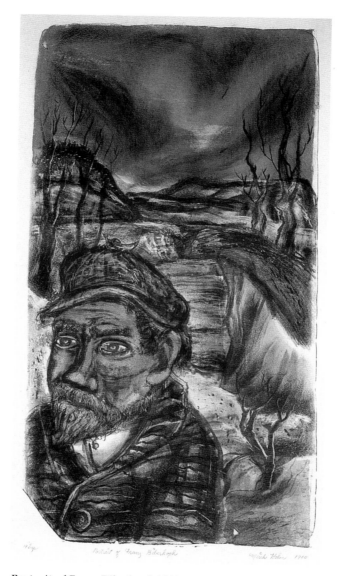

Portrait of Franz Biberkopf, 1940
Lithograph
19 5/8 x 10 1/2"

were illustrations for stories or articles; *Portrait of Franz Biberkopf,* for example, was an illustration inspired by the 1927 book by Alfred Doblin, *Berlin Alexanderplatz, die Geschichte vom Franz Biberkopf,* about the *lumpenproletariat* of Berlin.

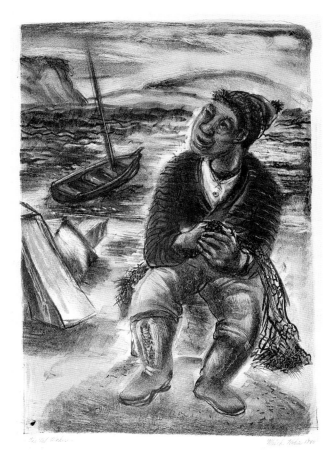

The Fisherman, 1940
Lithograph
14 7/8 x 10 1/4"

Man with a Pipe, stand with the best of his oeuvre from this time.

Although Kohn typically intended to print his impressions in an edition of 18, it is likely that few editions were completed; there were no fine-arts presses around with master printers who could pull the editions for the artists, and, being more interested in the creation of new images than in completing the editions, Kohn kept his numbers small. Several of the works

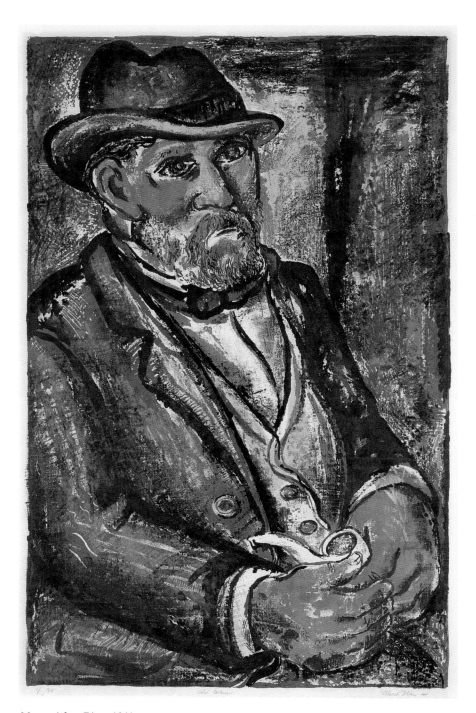

Man with a Pipe, 1941
Lithographic tusche drawing on serigraph
23 1/4 x 14 5/8"

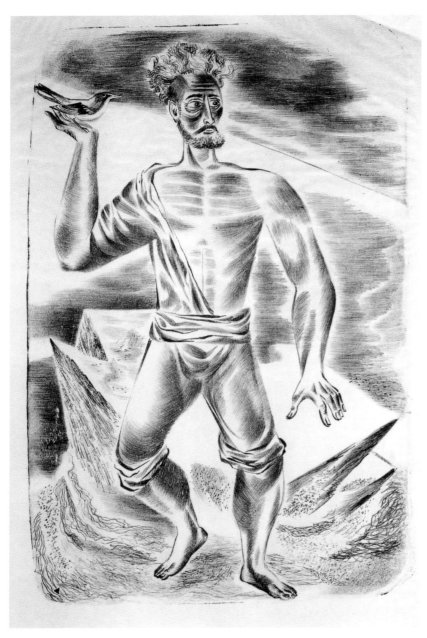

The Bird Catcher, *1940*
Lithograph
12 1/2 x 8"

He stayed in Kahn's loft for the rest of 1939 and most of 1940, but as soon as he had the wherewithal to do so he moved out and rented a studio apartment on 35th and Cottage Grove. Cottage Grove was the dividing line between white and black neighborhoods at that time; Kohn was just on the white side of the line. He had been introduced to these buildings—a row of studios facing an open court with a walkway, built for the 1890 World's Fair in Chicago—as a result of his work as Art Director on the leftist publication *The New Anvil* in 1940; Nelson Algren, the editor, had a studio there for publishing this short-lived but well-regarded literary magazine.

During this time Kohn was painting as well as making prints; in fact, in September 1941 he received a commendation from Norman MacLeish and the Technical Committee of the Illinois Art Project of the W.P.A. for a series of four watercolors that they regarded as "distinguished."[17] In graphics, he was working on lithographs—both black-and-white and color—and was also doing some serigraphy and wood engraving. Serigraphy was a new medium at that time for artistic exploration, but Anthony Velonis had begun to adapt this heretofore solely commercial process in 1938, and numerous W.P.A. artists experimented with it because of its adaptability and the economy of the equipment and processes. Although Kohn did few prints in this medium during these years, some, such as

With two—later, three—printing presses, the artists had no problems sharing the equipment.[11] Kohn lived there while he satisfied the requirements that the W.P.A. had for its artists, which included not only ascertaining that the work was up to certain professional standards, but also being on relief, and, in Illinois, taking a "pauper's oath."[12] Fully qualified, he received notice to report to work on December 8, 1939. Kohn was delighted to be working on the Project:

> It was absolutely great. You went to the W.P.A. every two weeks, and you would bring in what you did during the previous two weeks....You were not forced to do anything. You could do watercolors, you could do oils, but there was one provision, that you would get the materials for whatever you brought in. So if you brought an oil painting in, then you could take oil painting paints home with you to do other things....But if you brought a watercolor in, too, then you could take home watercolor [materials]....So I would go back to the studio—and every other artist was that way, too—just loaded down with all this wonderful stuff. And I still have the Winsor & Newton brushes that [I got then]; they're still usable, after all these years....It was the greatest thing.[13]

Kohn was paid $92-plus a month, for which he could live "in great style." This salary was for 6 1/2 hours work per day, five days a week; the equivalent of less than $2.90 per hour.[14] This sum seemed princely to him: he was able to afford

special papers, and he remembers that a used lithography press could be had for $35.[15] He even knew some artists who were able to maintain both an apartment and a studio on this salary, and remembers with relish the roast beef they used to have on Sundays.

The artist community in Chicago at that time was lively and mutually supportive, and they learned from each other by example. Among the artists that Kohn met and worked with were Mitchell Siporin, Edward Millman, Aaron Bohrod, June Wayne, Adrian Troy, and Carl Hoeckner. A group of them would often take studio mate Isadore Weiner's automobile on trips around the city and the surrounding areas to paint and sketch; these *plein air* landscapes and cityscapes often became the basis for more-formal studies in oil or in lithographs that revealed their painterly origins. Relatively straightforward interpretations of archetypical or even heroic American scenes were popular among artists during this time—often with a dash of socialist realism thrown in—and Kohn's work clearly displayed those tendencies. He valued the experiences he was having to such a degree that although he was asked by Laszlo Moholy-Nagy to teach at the Institute of Design (also known as the New Bauhaus, which Moholy-Nagy had founded on the South Side of Chicago in 1937), Kohn declined, enjoying the uninterrupted freedom that the W.P.A. gave him to concentrate on his work. "This was...the promised land," Kohn reminisced. "I really grew up on the Project."[16]

galleries, hungrily filling in the gaps of the art education that he had missed at school. One day, meeting a poet friend from school on the street, he went with him to Alfred Stieglitz' gallery An American Place on Madison Avenue. This poet had written a paean to Frank Lloyd Wright and had become friendly with Stieglitz through the residents of the Wright-designed house Fallingwater, so Kohn was warmly welcomed. Kohn responded to the work he saw at the gallery, and was stirred by Stieglitz's discussions

about abstraction, how to view color relationships and formalist compositions, and the like, although it would be many more years before he would attempt to work in this idiom himself. Kohn was made to feel at home, and felt honored that Stieglitz would take the time to explain to him the importance of the work. He returned to the gallery many times and met many people there, but no real leads on employment turned up.

At about that time, Kohn was visiting the Metropolitan Museum of Art when he ran into his old teacher, Max Kahn, with his wife, printmaker Eleanor Coen, and Norman MacLeish, who was the head of the Illinois section of the Works Projects Administration's Federal Art Project. Hearing of his troubles, they invited him to come to Chicago. MacLeish promised that he could get him on the W.P.A., and Kahn and "Coney" said that he could live and work in their studio. So Kohn left New York and hitchhiked back to the midwest. Arriving at Kahn's studio exhausted after his long trip, he saw a freshly prepared lithograph stone; Kahn told him to go ahead and use it, and, shrugging off his fatigue, Kohn sat down and completed *Sleeping Woman* that morning in one sitting.[10]

The studio that Max Kahn and Eleanor Coen shared was a high loft on the south side of town, in an alley overlooking a large Catholic church. Kahn and Coen had a separate apartment, so Kohn had the place to himself evenings; it lacked a bathtub, however, so he went to other friends' homes in the neighborhood to bathe.

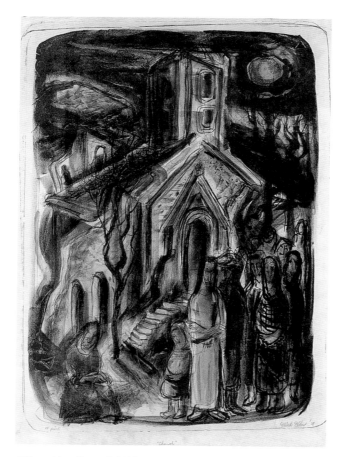

"They Also Serve," 1939
Lithograph
21 x 14 7/8"
Collection University of Oregon Museum of Art WPA56:1.246

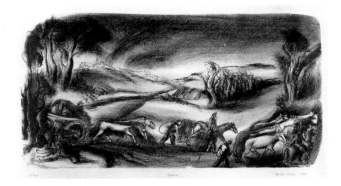

Exodus, *1940*
Lithograph
10 7/16 x 19 1/2"

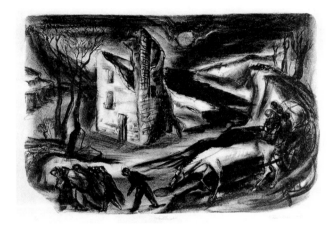

Wasteland, *1940*
Lithograph
12 3/8 x 17 5/8"

However, the New York section of the Works Projects Administration, which had begun employing artists in 1937–38, abided by the rule that limited such employment to 18 months. Consequently, those artists who had been on the project from its inception—including most of those who later became famous in the 1950s and 1960s—had just recently been disengaged from the Project when Kohn came to New York, and were again unemployed. Any job prospects for a green midwesterner right out of art school were immediately and consistently snapped up by any number of other artists with greater savvy, experience, and connections.

People were kind to Kohn, however, and gave him suggestions about who to approach. He scheduled meetings with these contacts near mealtimes, so he could sometimes arrange to be invited to share lunch or dinner—a major consideration in those lean days. For example, he had always admired the illustrations of Boris Artzybasheff, so made a cold call to him, told him that he was just out of art school and looking for work, and wanted to talk to him. Artzybasheff and his wife were very hospitable, and although they provided no information on employment, Kohn was introduced to something ultimately more important on that trip. He saw the black-and-white wood engravings that Artzybasheff was doing and was drawn to the quality of line that could be achieved. Also seductive was the fact that the engravings could be done without significant outlays for equip-

ment or space, and that, ultimately, the technique could be used to publish and disseminate work through books that were both fairly inexpensive and easy to produce. So Kohn began to explore the medium of wood engraving.

In the meantime, Kohn took whatever odd jobs he could find: he painted apartments and served as a chauffeur, but there were times that he was literally starving. Cognizant of the pinch his own large family was feeling back home, he refused to ask his father for money. He used his leisure hours—of which there were many—to do a lot of looking: he haunted the museums and

Finding a Voice

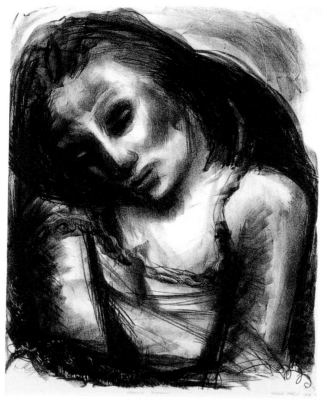

Sleeping Woman, 1939
Lithograph
18 1/2 x 14 1/2"

After graduation, sensing that Indiana could provide few opportunities for a budding artist, Kohn hitchhiked to New York and lived with a schoolmate in the latter's father's apartment during the summer of 1939. Although he had been given letters of introduction to artists such as Louis Lozowick and Theodore Roszak by Max Kahn, he was shy about approaching these artists and never delivered some of the letters. He was intent on making it big as an artist, however, and he spent many hours "pounding the pavement," his portfolio under his arm, showing it to people that he thought might give him a job as an illustrator. But it couldn't have been a worse time.

The national economic depression of the 1930s had had a swift and severe effect on the nation's artists, for their professional efforts were among the first to be deemed expendable. In an effort to address this, the federal government established the Works Projects Administration in 1935, setting up workshops and studios to provide meaningful employment for artists. Artists were supplied with materials and were unconstrained in terms of subject matter; they were thus enabled to develop new ideas and new forms of visual expression without need to be tied to market forces. Further, the subsistence they were provided enabled many to pass through their early experimental phases and find their personal artistic voices; people were known to give up well-paying jobs in order to be eligible for this program.[9]

Harry Callahan (American, b. 1912)
Misch Kohn, c. 1951
Chicago

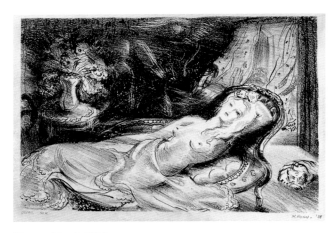

***Dream No. 4**, 1938*
Lithograph
6 1/4 x 9 1/8"
Private collection

Kohn had never seen anything like it and was immediately taken with the innovative treatment. He wondered why the work of such artists had never been introduced in his classrooms. Shortly thereafter, the museum connected to the art school had a small exhibition that included works by artists such as Picasso and Matisse; in a supplementary educational program, Gertrude Stein was invited to lecture about the work. Kohn was "terribly impressed" by her—although also a little shocked, no doubt—for it was his first real introduction to the work of the modernists and abstraction. He followed up by reading her published writings and the writings of others from that period, and was surprised that his teachers and fellow students seemed to be unaffected by this great upheaval in the art world. He remembers with amusement that the "best painting teacher we had" definitively stated that work such as this was "a flash in the pan."[8] By this

time, however, more exhibitions—even locally—were beginning to feature the work of the modernists, and even mainstream magazines were presenting the material. Kohn was particularly taken with the works of Picasso, and with Kathe Kollwitz, whose soulful expressionist prints affected him deeply.

In the last quarter of Kohn's final year, printmaking was introduced into the art department, as Max Kahn and Francis Chapin were invited to teach a five-week class and set up a lithography studio and curriculum for the school. Kohn was excited by the teachers and fascinated with the processes: he helped them install the presses, break in the rollers, and set up the studios—in general, he spent most of his time in the new printshop. In retrospect, it was an experience that changed the direction of his life.

of seven children of a shoe repairman, Kohn was interested not only in being an artist, but in being a *successful* artist.[4]

The teaching at Herron was generally uninspired. The classes were academically based, with each morning spent drawing or painting from the model. Saturdays they studied anatomy in both two- and three-dimensions, drawing and sculpting the flayed body, distinguishing each muscle and tendon. Kohn loved anatomy, and remembers, amused, that it made him want to concentrate on doing "muscle men."[5] The students also had short-term workshops with a series of visiting artists on the circuit of the art schools and clubs; he recalls going out to the limestone quarries on the outskirts of Bloomington with one of the watercolorists, who taught them how to paint the reflection of the water backed up in the gullies; he also particularly remembers the abstract, formalist qualities of the great blocks of limestone piled up at this site.

Perhaps the most innovative component of his studies at John Herron was a third-year project connected with the Beaux-Arts school in Paris, through which the students designed and rendered a building, and then painted a mural to adorn one of its facades. As part of the project, Kohn's class took a field trip to the Detroit Institute of Arts to see the work of the Mexican muralists. It was a memorable experience for him, and one which, in retrospect, was critical in shaping his early work. However, for the most part, the painting teachers—who favored landscapes and seascapes—were not impressed by Kohn's efforts. In fact, Kohn later discovered that one of his professors—a supporter, he thought—recommended that his father pull Harris out of school and send him to the university to study something—anything—else, because the professor felt certain that Kohn would not make it as an artist, that he was "doomed to fail." But Jacob continued to support his oldest child and only son.

During his last years at school, Kohn decided to change his name. He had never liked Harris, but at first he "had a hard time finding the right name."[6] He tried Mischa, but then he met someone he disliked who had that name, so discarded that too. His early work is signed variously: Harris Mischa Kohn, H. Misch Kohn, Harris Misch Kohn, and so on. He finally dropped Harris altogether by the end of 1940 (except for letters home), although he laughs that his alumni mail from John Herron is still addressed that way, some 60 years later. "Upon...reflection, I imagine that I was rejecting what I was and believed myself to be a new person in a new and wonderful world," he wrote in 1960, probably only half in jest.[7]

At that time, Kohn was still woefully ignorant of the larger art world. In his first few months at school, a roommate from out-of-state—a journalism student from Antioch College working at the local newspaper—showed him a reproduction of a painting by Paul Gauguin.

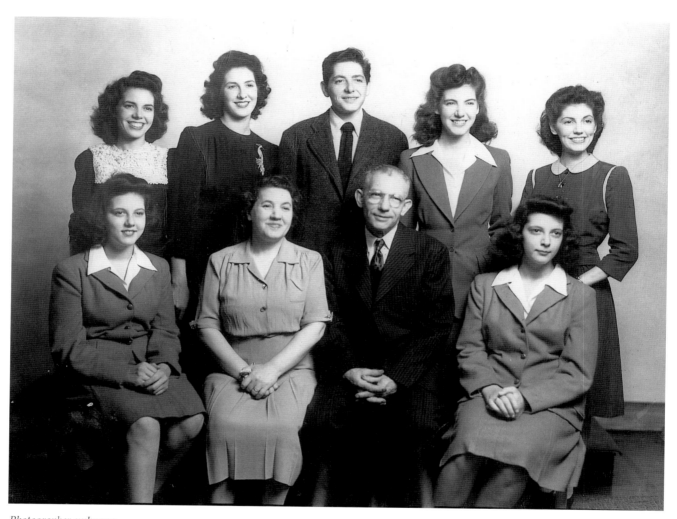

Photographer unknown
Jacob and Anna Kohn and family, c. 1940
Private collection

modernists—his work was good enough that on the basis of such submissions, he won a scholarship to go to art school.

In 1934 Kohn entered John Herron Art Institute in Indianapolis, a private art school funded by wealthy local industrialists and filled with students on scholarships. At that time Kohn was ambivalent about whether he would become a painter or an illustrator; the latter concept had been suggested by the son of a family friend who lived in New York and illustrated stories for magazines such as *The Saturday Evening Post*. While home on a visit to his family, this illustrator was introduced to young Harris, and Kohn was intrigued by his tales of the big city. Growing up in the depression years in a family

Photographer unknown
Misch Kohn, c. 1938

Archives of American Art at the Fine Arts Museums of San Francisco; Sam Carini and Mark Pascale, Art Institute of Chicago; Karen Smith Shafts, Boston Public Library; Deborah Wythe, The Brooklyn Museum of Art; Sylvia Medeiros, California State University-Hayward; Jennifer Karsting, Carnegie Museum of Art; Margarete Gross, Chicago Public Library; Kenneth Brown, The College Board; Lynn Traub, DeCordova Museum; Susan Ellefson, Fairmount Hotel, Chicago; Kathy Erickson, Fine Arts Program of the General Services Administration, Washington, DC; Joseph A. Haller, S.J., Georgetown University; David Hunsucker and Diane S. Kroll, Indianapolis Museum of Art; Archana Horsting, KALA Institute, Berkeley, CA; Charles N. Joray, Kokomo-Howard County Public Library; John D. Wilson, Lakeside Gallery, Lakeside, MI; Lu Harper, Memorial Art Museum, University of Rochester; Joann Moser and Denise Dougherty, National Museum of American Art; Nancy Finley, New York Public Library; Jo Burke, Northern Illinois University Art Museum; Lee Williams, Smithsonian Institution Traveling Exhibition Service, Washington, DC; Annette Dixon, University of Michigan Museum of Art; Will South, Utah Museum of Fine Arts; Martin Manning, U.S.I.A. Library; and David Acton, Worcester Art Museum. Further thanks to Victor Barocas; Jan Brown and Richard Cohn; Joan Cherry and John Cara; Sylvan Cole; Kay Conner and Dick Walton; Sarah and Jack Conner; Al and Edith DuGott; Phil and Michelle Dow; Arlene Effron; Shirley and Ben Eisler; Thelma Feldman; Robert M. Frasche; Betty Friedman; Gert Gendel; Steve and Ruth Grant; Jim Greene; James N. Heald II; Harold Heyward; Catherine G. Jessup; Marieluise Kailing; Tamara Kohn; Jessica Kohn McGuire; Stef Leinwohl; Dr. and Mrs. Ned Ostenso; Dolly and Joe Portnuff; Michael C. Powanda; Melanie Rubin; Liz Seaton; Gary Shapiro; Joe Sterling; Allan Temko; June Wayne; James Wechsler; Bernice Weissbourd; Bill Welte; Anthony White; and David H. Williams.

Thanks go also to the Monterey Museum of Art staff, particularly Richard Gadd, Director; Donna H. Kneeland, Development Director; and Patricia Seiling, Mary Murray, Barbara Call, Michael Thomas Kainer, John Kennedy, Cara Wilson, and Marc Chatwin; and to Ben Blackwell, photographer; Jeanne Lance, editor; and Mark Ryan, for graphic production.

And finally, special and heartfelt thanks to my parents, to whom this book is dedicated, and to Sam and Larissa, who put up with my many hours in front of my computer, at Misch's studio, or traveling to libraries and collections, with good humor and grace. Without the help and support of everyone listed above, this project would not have come to fruition, and I am most appreciative.

j.f.h.

4

Kohn built and maintained his reputation as an innovator, always pushing the limits of his chosen media and techniques. But of even greater significance is that, taken individually or as a whole, his work is a lexicon which symbolizes a personal narrative. It is a quiet narrative, told without fanfare or self-aggrandizement but often with humor, and it traces an honorable life that in a variety of ways can truly be said to have changed the course of postwar printmaking.

An exhibition of this magnitude could not have been possible without the support of literally hundreds of people. From California to Slovenia, Chicago to Melbourne, print curators, collectors, dealers, and friends dug into their archives to help reconstruct the history of one man's incredible 60 years of aesthetic exploration. Although questions remain unanswered, the positive results of these investigations have been overwhelming, and are presented for the first time in this volume and the accompanying retrospective exhibition. All data in this publication is current as of August 1, 1997.

My first and warmest thanks go to Misch and Lore Kohn, who have worked so closely with me for the past two years, giving me free access to their files, their library, and their print cabinets. They were always ready and willing to answer any question, and to provide names and access to people who might have additional information to share. I am similarly indebted to the funders who have recognized the importance of this project, and who have so generously and graciously acknowledged the need to exhibit and publish this information: the Cherry Family Foundation, particularly Charlotte and David Cherry, and John Cara; the Richard Florsheim Art Fund and A. L. Freundlich; the Waletzky Charitable Lead Trust and Jeremy Waletzky; and an anonymous donor.

Those who have been of special importance to me in my research have included Misch's siblings and their spouses, who measured prints, took photographs, unearthed old letters and snapshots, and provided anecdotes: Mary and Harold Cohen; Lucy and Norman Cohn; Leonora and Len Farb; Isabelle Rubin LaBelle; Bobbie and Mike Levine, and Mildred and Sol Reich. Special thanks also to Alan Fern, Director of the National Portrait Gallery, for his insightful and personal introduction; Jane Haslem of the Jane Haslem Gallery in Washington, DC, who spent hours with me tracking down collectors and providing archival information and photographs; Helaine Glick, who helped me uncover elusive data and followed through with all aspects of this project; and Marc D'Estout, who designed and produced this beautiful publication out of the maze of text and photos that he was provided.

I am also most appreciative of the help afforded me by the registrars, curators, and administrators at the more than 100 museums, libraries, universities, and galleries that responded to my queries. Particular thanks to Anne Mills McCauley, Albion College, Albion, MI; Jane Glover, American Art Study Center,

Preface and Acknowledgments

Approaching a milestone in life, be it a personal one like a "big" birthday, or a shared one, like the end of the millennium, tends to give one pause. People make changes at times like this: they quit their jobs, get a divorce, move to a new city, buy a new car. But it is also a time for reflection, a time to examine what has been satisfying about the past, and a time to size up what might have been handled differently.

Art historians are among those most susceptible to the introspection that such milestones inspire. Each anniversary, each landmark event of the past makes us take stock, review our past choices about our studies, and note what remains to be explored.

The initial decision to prepare an in-depth retrospective examination of the six decades of work by master artist Misch Kohn was a result of such introspection. Kohn was approaching his 80th birthday; too, we are all approaching the millennium, and looking back to see what has been important in this century, and what recent scholarship has missed. It became clear that although Kohn has enjoyed significant successes over the course of his long and illustrious career—successes that were unprecedented in some areas—it was time for a reexamination of his work. Such a reexamination would, in a very real sense, restore his rightful place in the art history of the 20th century while introducing his innovative explorations to an entirely new generation of viewers.

Misch Kohn: Beyond the Tradition

Monterey Museum of Art
January 17–March 22, 1998

Richard L. Nelson Gallery
University of California, Davis
April 13–May 22, 1998

The Print Center
Philadelphia, PA
September 11–October 24, 1998

Grinnell College Art Gallery
Grinnell, IA
February 1–March 15, 1999

Purdue University Galleries / Greater Lafayette Museum of Art
Lafayette and West Lafayette, IN
August 23–October 17, 1999

Illinois Art Gallery
Illinois State Museum
Chicago, IL
November 12, 1999-January 8, 2000

Published by the Monterey Museum of Art, 559 Pacific Street,
Monterey, CA 93940 on the occasion of the retrospective exhibition
Misch Kohn: Beyond the Tradition.

Support for this project has been provided by the Cherry Family
Foundation, the Richard Florsheim Art Fund, the Waletzky Charitable Lead
Trust, and an anonymous donor.

Text and compilation © 1998 Jo Farb Hernandez

Graphic Design and Production:
 Marc D'Estout

Graphic Production:
 Mark Ryan

Editing:
 Jeanne Lance

Photography:
 Art Institute of Chicago, ©1997, All Rights Reserved, pp. 30, 54 (top).
 Ben Blackwell, Oakland, pp. 2, 13, 16, 19–20, 22–24, 26 (top, bottom),
 27 (bottom), 28 (top), 29, 31–32, 33 (bottom), 36, 37 (bottom),
 39, 41 (bottom), 50–52, 54 (bottom), 58, 60 (right), 61–62, 63
 (bottom), 65 (right), 67, 68 (top), 69, 72 (right), 75, 80 (bottom),
 82–84, 86–88, 89 (top, right), 90, 91 (top), 94, 95 (bottom), 96
 (right top and bottom), 97, 98 (left), 100–101, 102 (top), 106–107,
 109 (center), 110 (bottom), 111 (top), 126–133, 134 (top), 138,
 140-141, 142 (bottom), 145-146, 149, 150 (bottom), 153, 158 (bot
 tom), 165–168.

 Chris Chenard, courtesy Californa State University-Hayward, p. 120.
 Marc D'Estout, Santa Cruz, p. 114 (bottom).
 Richard Hoyt, Berkeley, pp. 142 (top), 143 (top, center), 147 (top),
 148 (center).
 Indianapolis Museum of Art, ©1997, All Rights Reserved, p. 42.

 Isabelle Rubin LaBelle, Cambridge, pp. 63 (top), 104 (bottom).
 Precision Photographics, Ann Arbor, p. 66.
 James Prinz, Chicago, pp. 37 (top), 156–157.
 Professional Color Processing Laboratories, Inc., Philadelphia, p. 65 (left).
 Larry Sanders, Sanders Visual Images, Milwaukee, p. 99.
 Ira Schrank, 6th Street Studio, San Francisco, pp. 15, 21, 25, 26 (center), 27
 (top, center), 28 (bottom), 33 (top), 38 (right), 44–45, 73 (right), 110
 (top), 125 (top), 135 (bottom), 136-137, 139, 142 (bottom), 143 (bot
 tom), 144, 147 (center, bottom), 148 (top, bottom), 150 (top), 151–152,
 154–155, 158 (top), 159 (top), 160-164.
 Standard Studios, Chicago, pp. 47–49, 55, 60 (left), 68 (bottom), 70, 72
 (left), 76 (left), 77–79.
 John R. Tennant, courtesy Jane Haslem Gallery, Washington, DC, pp. 53,
 64, 73 (top), 74, 76, 80 (top).
 University of Oregon Museum of Art, ©1997, All Rights Reserved, p. 17.

Printed in Hong Kong

Library of Congress Catalogue Card Number: 97–069905

Misch Kohn
Beyond the Tradition

Jo Farb Hernandez

with an Introduction by Alan Fern

Monterey Museum of Art

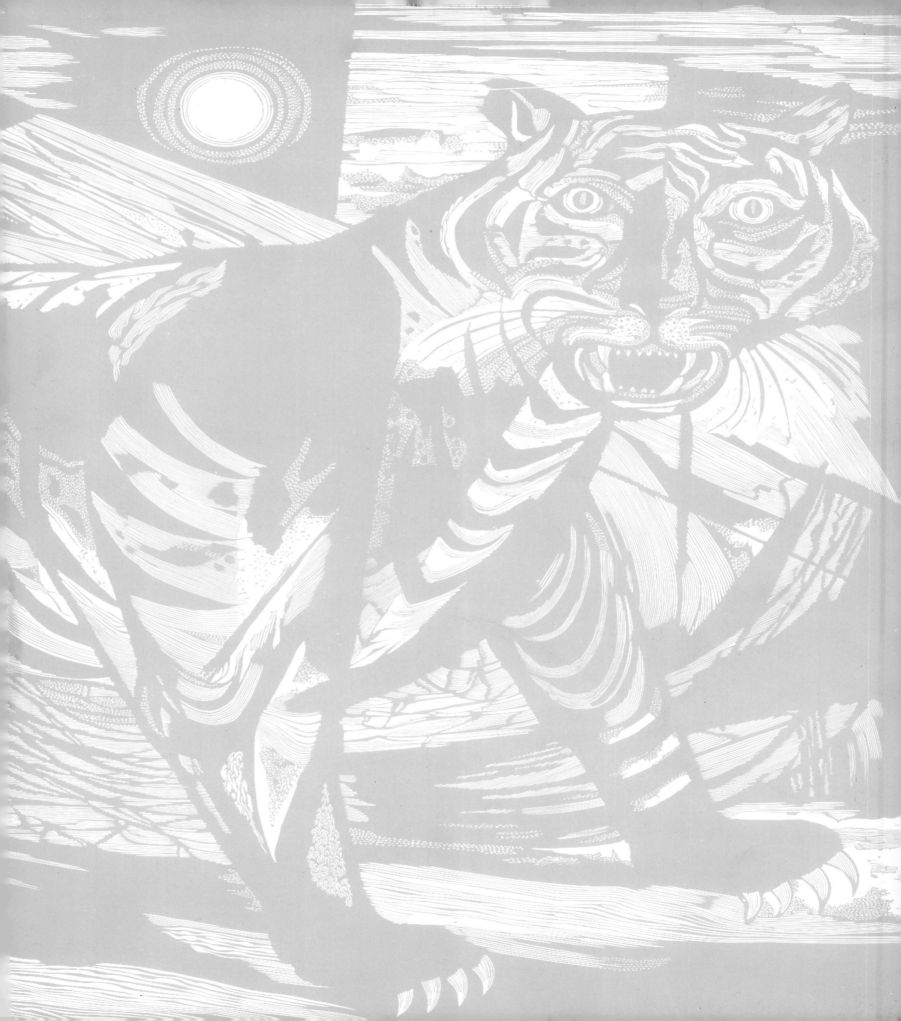

WINE COUNTRY TABLE

With Recipes that Celebrate California's Sustainable Harvest

JANET FLETCHER

PHOTOGRAPHS BY ROBERT HOLMES AND SARA REMINGTON

IN COLLABORATION WITH WINE INSTITUTE

RIZZOLI
NEW YORK

New York · Paris · London · Milan

Wine Country Table
With Recipes that Celebrate California's Sustainable Harvest
By Janet Fletcher

First published in the United States of America in 2019
By Rizzoli International Publications, Inc.
300 Park Avenue South
New York, NY 10010
www.rizzoliusa.com

Conceived and edited by Nancy Light and Allison Jordan
Copyright © 2019 Wine Institute

2019 2020 2021 2022 / 10 9 8 7 6 5 4 3 2 1

Distributed in the U.S. trade by Random House, New York
Printed in China

ISBN-13: 978-8478-6543-7

Library of Congress Control Number: 2018951617

For information, contact:
communications@wineinstitute.org or visit:
www.wineinstitute.org
www.discovercaliforniawines.com
www.sustainablewinegrowing.org

Produced and designed by Jennifer Barry Design, Fairfax, CA
Winery, wine, and vineyard photography © by Robert Holmes
Farm, produce, and recipe photography © by Sara Remington
Design and production assistance by Shelly Peppel
Food styling by Jeffrey Larsen
Prop styling by Sandi Allison

RIGHT: Employees of Capay Valley's Full Belly Farm enjoy a lunch break.
The sustainable farm provides fresh produce and flowers to several
hundred Bay Area families through its CSA (community-supported
agriculture) offering.

CONTENTS

FOREWORD

Twenty-five years ago, I moved from New York (then a city of just over seven million people) to the top of a mountain in the Napa Valley (no people, but lots of vines and one companionable dog).

When a friend asked me why, I could only offer that I wanted to be close to grapevines. She shook her head disapprovingly. Give up a career in one of the most exciting cities in the world for … grapes? It made no sense.

I wish I had had a copy of *Wine Country Table* back then. I would have implored her to lose herself in its stunning pages, and I know that within a short time, she would have *understood*. For in California, wine country is not just an alluring place. It is a set of values.

Today we have so many things that to have has sometimes become more important than to be. But to live among vineyards and farms is to be drawn back to those old values, to a place where the window into joy is more likely to be a great peach than a Gucci purse.

Janet Fletcher, Robert Holmes, and Sara Remington have brilliantly captured the spirit of California wine country—its seasons, its harvests, its flavors, its delights, and its humility. Page after page, farmers and winemakers share their stories and in so doing, they wrap us up in their profound love of the land and the delicious things the land gives us.

Our own worlds may occasionally seem digitized to distraction, but as this book so beautifully reminds us, it's through eating and drinking that our bond with nature is welded deep.

— Karen MacNeil, author of *The Wine Bible* and creator of *WineSpeed*

ABOVE: Quiet moment at Cambria Estate Vineyard & Winery in Santa Maria
RIGHT: Sunset is wine time at a winery in the southern end of the Napa Valley.

INTRODUCTION

Pull up a chair. It's time for dinner in Wine Country. In California, that could be just about anywhere, from rural Humboldt County, near the Oregon border, to a fancy beach house in La Jolla. Wherever you are in the Golden State, you are not far from wine grapes and the passionate people who transform them into wine.

The Pacific Ocean has blessed much of the state with a classic Mediterranean climate—the mild, wet winters and dry summers that wine grapes love. Produce likes it here, too. From the cool coastal settings where raspberries, artichokes, and apples thrive to the desert-like date farms of the Coachella Valley, there's a sweet spot for every crop. But beyond enviable weather and fertile soil, California boasts an equally powerful asset: the diverse and open-minded people who farm and cook here.

California's farmers are relentlessly entrepreneurial. They seek out fresh ideas, innovative techniques, and cutting-edge crops that just might be the next kiwi. California's many immigrant communities create demand for a huge range of fruits, vegetables, and herbs. Finger limes, anyone? The state's chefs, keen to maintain their reputation for setting national trends, embrace these edible novelties and often collaborate with farmers to develop an audience for little-known ingredients.

LEFT AND ABOVE: Friends gather for an alfresco dinner at Hilltop & Canyon Farms, a sustainable avocado grower in Carpinteria.

It's astonishing to think of the California crops that have transitioned from ethnic or rare to mainstream in a generation, among them arugula, Asian basil, baby bok choy, broccoli rabe, endive, clementines, frisée, green garlic, lemongrass, pomegranates, and radicchio. Thanks to California farms, US produce markets have never been more enticing. Fortunately, the sustainable-farming movement has flourished in tandem with this produce boom, creating a golden age for conscientious cooks.

Recognizing that their livelihoods depended on it, California's farmers and vintners were early advocates of sustainability. Today, as a whole, they are global role models for environmental stewardship. A vintner from fifty years ago would be astonished by viticulture and winemaking today: the thick stands of cover crops in place of the weed-free vineyards of the past; the solar

panels and wind turbines that power wineries and irrigation; and the pervasive recycling mind-set.

Each grower, each winery faces a different set of challenges and opportunities in conserving resources, sustaining a business, and nurturing community. But although the approaches vary, the farms and wineries profiled in these pages demonstrate a shared commitment to the natural environment, to their employees, and to their neighbors.

In the stories that follow, you'll meet enlightened vintners who cover college tuition for employees' children or provide subsidized housing in a high-rent area; an avocado grower who mulches his trees with coffee grounds; and two sisters from a winemaking family who award generous grants to women improving lives in Third World communities.

The beautiful harvest from these sustainable farms makes food lovers eager to cook. Every season brings produce to celebrate: spring artichokes, asparagus, and fava beans; summer's tomato and stone-fruit deluge; the autumn bonanza of pomegranates, Brussels sprouts, and new-crop nuts; followed by winter's just-pressed olive oil and citrus windfall. No wonder the California way of eating puts produce first: fragrant pears and perky greens deserve the limelight.

Wherever you are, you can set a Wine Country table. Toss a simple salad of arugula, shaved persimmons, and fennel (page 178). Braise juicy lamb meatballs with fresh artichokes and olives (page 293) or make a meatless frittata with broccoli rabe and sheep cheese (page 274). For dessert, whip up a fluffy wine sabayon for sliced nectarines or a bowlful of berries (page 301).

AVA DEFINED

Many California wines include an AVA (American Viticultural Area) on the label to let consumers know the origin of the grapes in the bottle. AVAs are defined areas recognized by the federal government. Some are extensive, like the North Coast AVA, which embraces six Northern California counties. In contrast, the Cole Ranch AVA in Mendocino County, the nation's smallest, contains only 60 acres (24 ha) of grapes.

Introduced in 1980 and inspired by the European system of appellations, AVAs typically identify areas with shared features—similar soil type, microclimate, or elevation, for example. When vintners and grape growers apply for a new AVA, they must delineate its boundaries and make the case for approval: what are the characteristics of the proposed AVA that would give its wines a recognizable regional character?

AVAs are a bit like Russian nesting dolls. The larger ones encompass smaller AVAs, often referred to as sub-appellations. For example, the North Coast AVA includes the Napa Valley AVA, which includes the Stags Leap District AVA. Wineries using grapes from these sub-appellations believe in the distinctiveness of the *terroir* and rely on the AVA to communicate that distinction to consumers.

If a wine label bears an AVA from within California, 85 percent of the grapes in the wine must come from that AVA and all of the grapes must be grown in the state.

Sustainably grown flowers will make your table bloom, and a bottle of California wine will spark conversation. The following stories and recipes bring the Golden State to you: its natural beauty, its incomparable bounty, and its determination to remain just as productive for generations to come.

RIGHT: California's wine grape–growing regions stretch the length of the state.

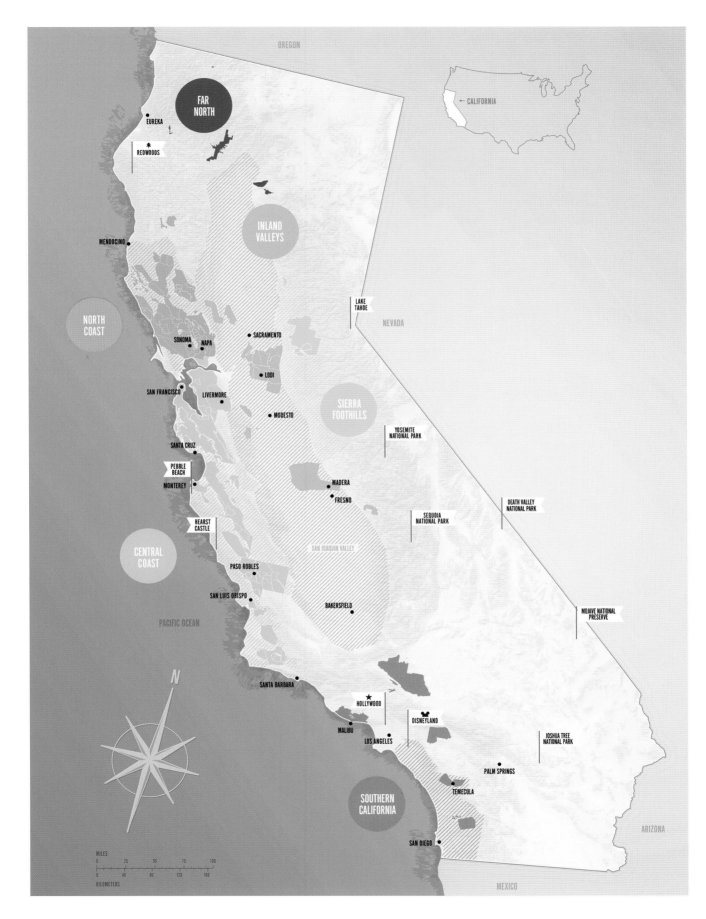

OREGON

FAR
NORTH

EUREKA

REDWOODS

INLAND
VALLEYS

MENDOCINO

NORTH
COAST

LAKE
TAHOE

NEVADA

SONOMA NAPA SACRAMENTO

LODI

SAN FRANCISCO LIVERMORE

MODESTO

SIERRA
FOOTHILLS

YOSEMITE
NATIONAL PARK

SANTA CRUZ

PEBBLE
BEACH MONTEREY

MADERA

FRESNO

DEATH VALLEY
NATIONAL PARK

SEQUOIA
NATIONAL PARK

HEARST
CASTLE

CENTRAL
COAST

PASO ROBLES

SAN JOAQUIN VALLEY

SAN LUIS OBISPO

BAKERSFIELD

MOJAVE NATIONAL
PRESERVE

PACIFIC OCEAN

N

SANTA BARBARA

HOLLYWOOD

DISNEYLAND

MALIBU

LOS ANGELES

JOSHUA TREE
NATIONAL PARK

PALM SPRINGS

SOUTHERN
CALIFORNIA

TEMECULA

SAN DIEGO

ARIZONA

MILES
0 25 50 75 100

0 40 80 120 160
KILOMETERS

MEXICO

← CALIFORNIA

FROM THE
NORTH COAST
Fog-Friendly Farming

From the patchwork fields of a West Marin lettuce farm to Napa Valley's leafy vineyards, North Coast agriculture is some of the state's most picturesque. Boutique farms, many resolutely sustainable, supply Bay Area chefs with the heirloom apples and pristine Little Gem lettuces that make their menus so inspirational, influencing dining trends nationwide. From Mendocino to southern Marin County, coastal growers benefit from "nature's air-conditioning," the cool, foggy air that rises off the ocean and sweeps inland, preserving acidity in wine grapes by moderating summer's heat. The Russian River in Sonoma County, San Pablo Bay in Carneros, and Lake County's Clear

PRECEDING PAGES: Grape leaves near the end of their working life, changing color in tandem with the arrival of autumn rains.

LEFT: A choice table awaits visitors at Goldeneye, a Pinot Noir producer in the Anderson Valley.

Lake also provide a cooling effect desirable for both greens and grapes.

Proximity to San Francisco has helped small farms thrive in Marin and Sonoma since gold rush days. Italian and Swiss immigrants established dairies and wineries in these North Bay counties in the early 1900s, and dairy cows still graze on the lush pasture along the Point Reyes National Seashore. The average temperature rises steadily with distance from the coast, creating prime growing conditions for apples in Sebastopol; plums, peppers, and heirloom tomatoes in warmer Healdsburg and Santa Rosa; and mountain-grown pears in Lake County.

Luther Burbank, the legendary plant breeder, called Sonoma County "the chosen spot of all this earth as far as nature is concerned" and did most of his groundbreaking work in Santa Rosa and Sebastopol. The Santa Rosa plum, Burbank russet potato, and the plumcot—a plum and apricot cross—are among his storied successes. Today, small North Coast farms contribute diversity to America's shopping cart, while North Coast vintners produce some of the world's most esteemed wines.

BELOW: Napa Valley mountain vineyards; winery vegetable garden at Alexander Valley Vineyards

RIGHT: (clockwise from top) Pruning at Domaine Carneros; dinner event at Six Sigma Winery; Anderson Valley visitors; Lake County pears await harvest

NORTH COAST WINES

Almost half of the wineries in California call the North Coast home, "neighbors" in a vast viticultural area acclaimed for its wine grapes. Seemingly any variety, red or white, can find a suitable home here, from Sonoma County's cool coastal vineyards dependably shrouded in morning mist to high-elevation sites perched above the fog line. And while a delicate Anderson Valley Gewürztraminer doesn't share much stylistically with an inky Howell Mountain Cabernet Sauvignon from Napa Valley, the Pacific Ocean puts its stamp on both.

Mendocino County, at the region's northern end, has some of the state's coolest vineyards. The so-called Deep End of the Anderson Valley, near Navarro, is a mere 10 miles (16 km) from the chilly coast and the ideal setting for Riesling, Gewürztraminer, and Pinot Noir. Grapes for sparkling wine also excel there, retaining high acidity. Sonoma County offers every location a wine grape could want: cool coastal and Russian River Valley sites for Chardonnay and Pinot Noir and warm Dry Creek Valley settings for Zinfandel. To the east, across the Mayacamas range, Napa

Valley is Cabernet Country, the grapes cooled by afternoon breezes off San Pablo Bay. Before Prohibition, Lake County surpassed Napa Valley in number of wineries; today its winery count and vineyard acreage are climbing as growers search for affordable yet proven land for wine grapes. These high-elevation vineyards benefit from the moderating influence of Clear Lake, California's largest natural lake. Dramatic diurnal swings—the temperature difference between day and night—can reach 50 degrees Fahrenheit (28 degrees C) here, ripening heat-loving wine grapes like Tempranillo, yet preserving the acidity that makes for well-balanced wine.

MENDOCINO COUNTY

LAKE COUNTY

SONOMA COUNTY

NAPA VALLEY

SOLANO COUNTY

LOS CARNEROS

FACING PAGE: (clockwise from top left) Scenic Sonoma Coast; Domaine Carneros in spring; Russian River view; mustard bloom in Napa Valley vineyards

PINOT NOIR FOR EVERY TASTE

Winemakers call it the heartbreak grape for a reason: Pinot Noir is finicky to make and picky about where it grows. Finding the right sites in sunny California for this cool-climate variety has taken decades of trial and error, with Sonoma County emerging as a top contender. Not all of this vast county is suited to Pinot, of course; the county is geographically and climatically diverse. But three Sonoma County sub-regions have, over time, shown major promise, luring more growers and vintners determined to conquer this grape. In all three areas, a body of water moderates summer temperatures, allowing grapes to ripen slowly and retain color and acidity.

The Russian River Valley AVA spans considerable ground, embracing both warm sites near Healdsburg and the cool, foggy vineyards around Occidental. Predictably, Pinots from the warmer zones are more full-bodied and powerful, while wines from the cooler areas show refreshing acidity and lively cherry-raspberry aromas. Joseph Swan and Rochioli were among the wineries that pioneered Pinot Noir here in the 1970s.

Pinot Noir plantings in Los Carneros AVA, which also spans Napa County, benefit from the cooling influence of nearby San Pablo Bay. Many of these grapes are destined for use in the state's finest sparkling wines.

Despite its name, the Sonoma Coast AVA encompasses a lot of inland vineyards. That's why some Pinot aficionados specify the "true" Sonoma Coast to refer to those sites that truly do hug the ocean. The prized vineyards here are on ridgetops, perched above the summer fog yet still cooled by the coastal breezes, arguably the best of all settings for Pinot Noir.

LEFT: (clockwise from top left) Russian River; ripe Pinot Noir; Sonoma Coast vineyards and fog

ABOVE: (left to right) Domaine Carneros in late autumn; Pinot Noir ready for the crusher

MENDOCINO COUNTY

HANDLEY CELLARS

L ocals call it the Deep End, the northern-most limit of the fifteen-mile-long (24-km) Anderson Valley. For years, people said the Deep End was too chilly for wine grapes except those intended for sparkling wine.

But Milla Handley has often been a contrarian, and in 1989, she and her husband, Rex McClellan, released the first Handley Cellars estate wine, a Chardonnay from their new Navarro vineyard where the grape wasn't supposed to thrive. Over the next thirty-six years, until turning the winery over to her daughters, Handley proved herself right. Chardonnay, Gewürztraminer, and Pinot Noir from this Deep End site have helped validate the region's potential for still wines.

"If you follow trends, you're always behind," says Randy Schock, Handley's wine-maker. Schock collaborates with Milla's younger daughter, Lulu McClellan, to perpet-uate her mother's nonconformist philosophy.

A VALLEY OF FREE SPIRITS The truth is, Schock says, Milla never planned to be in the wine business. She didn't want to run a business. A horse enthusiast who grew up in semirural Los Altos Hills, California, Milla enrolled at

LEFT: Summer bloom at Handley Cellars in Anderson Valley, a sea of penstemon and yarrow. The winery is at the far northern end, sometimes called the Deep End, of this scenic Mendocino County growing region.

the University of California, Davis, because she could keep her horse there. One of the first female graduates of the university's renowned fermentation science program, Milla, with Rex, bought 59 acres (24 ha) in the densely forested Anderson Valley in 1978, largely because the area was secluded, unspoiled, and populated with free spirits. Milla's father, a successful real-estate developer and interna-tional folk-art collector, prodded her to build the winery. Even today, the tasting-room furnishings and the Handley label nod to the family's appreciation for African tribal art.

Milla and Rex planted 25 acres (10 ha) and began, gradually, to understand what the landscape could do. Handley's RSM vineyard, named for Rex, sits above the fog line, in a "banana belt" at 1,000 feet (305 m). "It looks like you're on an island," says Schock, "with a sea of fog all around you." Meyer lemons, oranges, and avocados can survive on these warm ridges. The RSM vineyard is low yield-ing—2 tons (1,815 kg) to the acre (0.4 ha), maximum—and the Pinot Noir is correspond-ingly rich and concentrated.

Anderson Valley's remote location, accessible from the San Francisco Bay Area after a long stretch on a hairpin-turn road, keeps bus-group tourism at bay. For years, the valley was a drive-through wine country, with visitors stopping at a tasting room or two before venturing on to Mendocino. But Anderson Valley wineries like Handley have worked hard to promote overnight stays, with a winter white-wine festival and spring Pinot Noir fest that raise funds for local health clinics, an elder home, and other community causes.

BUILDING COMMUNITY In this tiny valley with its shifting demographics—the population is now almost half Hispanic—supporting local causes has become a Handley imperative. "Sustainability comes back to community," says Schock. "What are we trying to sustain?" Schock and McClellan believe deeply that they can't have a successful winery without contented employees, a healthy family-oriented community, and strong schools. Handley employees can work "on the clock" for community causes, like coaching a high-school sports team or doing maintenance work at a senior center. "So many wineries give wine, but it's also about giving time and expertise," says Schock.

After working on small East Coast farms and studying new models for rural communities, Lulu has returned to Navarro to continue her parents' work. (Rex passed away in 2006.) "It took me a while to realize I had a farm," says McClellan, who had long viewed the family vineyard as simply the place where she played after school. Now she hopes to bring

more diversity to the enterprise by introducing farm animals to the landscape. As some of the vineyards here are replanted, trellis wires will be moved higher to allow for miniature Baby-doll sheep to graze underneath, providing natural weed control and fertilization. "Animals can help regenerate the soil," says McClellan, who also fantasizes about adding food preserving to the Handley enterprise. Expanding beyond wine grapes and enriching the guest experience will help the winery write its next chapter, she and Schock believe.

Milla's reluctance to bow to trends has preserved some diversity in Handley's vineyards, says Schock. When so many others were planting exclusively Dijon clones of Pinot Noir, she refused, resisting pressure—even from Schock, he admits—to make her Pinot in a richer, riper style. "Our Pinot Noir tends to be leaner, lower in alcohol, and with more acid," says Schock, who is now grateful that his boss stood her ground. Handley's signature style has become a point of distinction.

"My mom planted these vines the same year she gave birth to me," says McClellan. The prospect of using this inheritance to demonstrate rural sustainability is largely what lured McClellan home. "Giving back to the community has been a really important part of our story."

ABOVE: (clockwise from top left) Handley vineyard; portrait of Handley Cellars; owl box with current resident; autumn vineyard; Randy Schock of Handley Cellars

FOLLOWING PAGES: Sheep provide sustainable weed control in an Anderson Valley vineyard.

HEIGHT OF COOL

The grape varieties that thrive in Germany and the Alsace region of eastern France find another welcome mat in the Anderson Valley. In this tucked-away nook in coastal Mendocino County, Riesling, Pinot Gris, Pinot Blanc, Gewürztraminer, and Muscat Blanc encounter the cool weather they like.

Only 10 miles (16 km) separate Boonville at the southern end of the valley from Navarro to the north, but because the valley runs roughly northwest to southeast, Boonville vineyards are farther from the ocean and experience less summer fog. On warm days, temperatures can be 20 degrees Fahrenheit (11 degrees C) cooler in Navarro, which also enjoys some cooling effect from the Navarro River.

Many Anderson Valley wineries, even in the northern Deep End, have abandoned white grapes in favor of the more profitable Pinot Noir. The winemakers who persist with vinifying cool-climate aromatic whites often say they do so because they love drinking them. At wineries such as Navarro Vineyards, Handley, and Goldeneye, these wines are typically fermented dry, in the Alsatian style, and spend little or no time in oak barrels. The aim is to produce refreshing wines of crisp acidity, moderate alcohol, and abundant perfume. Every year, in February, Anderson Valley vintners celebrate these fragrant white wines with a two-day Aromatic White Wine Festival.

Among these highly perfumed white varieties, Gewürztraminer leads the pack. It was one of the grapes chosen by Donald Edmeades in the mid-1960s, when he planted the first post-Prohibition vineyards in the Anderson Valley. Although Riesling, Pinot Gris, Pinot Blanc, and Muscat Blanc acreage is modest, the wines made from these varieties deliver tremendous pleasure.

ABOVE: (left to right) Riesling grapes at harvest time; a ripe grape cluster awaits the harvester's knife.

RIGHT: Anderson Valley Pinot Noir vineyards

SIX SIGMA WINERY

The real-estate broker was starting to lose patience with Kaj Ahlmann. Nineteen vineyard properties viewed; nineteen no's. Finally, on the twentieth attempt, Ahlmann found the parcel that seduced him: 4,000 acres (1620 ha) of oak-covered hills and pasture in rural Lake County.

The vast site had everything he desired for his future winery: high-elevation slopes with fast-draining volcanic soils, warm days to ripen wine grapes, and cool nights to preserve their acidity. A longtime cattle ranch, the landscape also offered miles of unspoiled beauty, a draw for Ahlmann and his nature-loving wife, Else.

The Ahlmanns purchased the ranch in 2000 and began its transformation into Six Sigma Winery, a multifaceted enterprise with 50 acres (20 ha) of grapevines and small-scale production of beef, lamb, and heritage-breed pork. Son Christian manages the vineyards—Tempranillo is the estate's signature red, Sauvignon Blanc the predominant white—while Christian's wife, Rachel, oversees the livestock.

From the start, family members knew that they wanted to farm more than grapes. "I like wine—don't get me wrong—but land is my big passion," says Kaj. "Wine is a way to make it profitable."

His romance with dirt blossomed early. As a fourteen-year-old in his native Denmark, Kaj asked his parents for a patch of land to mark his confirmation in the Lutheran Church. (Other teens had parties.) He grew potatoes, carrots, lettuces, and plums, inspired by his grandfather. Later, as a prominent insurance executive in the United States, Kaj joined the board of The Nature Conservancy and helped spearhead efforts to restore endangered prairie grass in Kansas.

COMMITTED TO PRESERVATION Shortly after purchasing the ranch, the Ahlmanns put most of it in a conservation easement, thus preserving it in agriculture forever. The move calmed the area's environmentalists, who had feared the worst when they learned that the parcel had changed hands. Kaj and Christian encouraged locals to come see what they were doing, how they were planting vineyards with the natural contours of the land. "It's not financially the best approach compared to straight rows that you can easily service with a tractor, but we like how it feels," says Kaj.

Today, many formerly apprehensive neighbors are members of Six Sigma's wine club. The Sierra Club has invited Christian to speak about the Ahlmanns' approach, as an example of conscientious environmental management. "We're a role model now, and I love that," says Kaj. "You don't buy this much land to destroy it."

FACING PAGE: Six Sigma proprietor Kaj Ahlmann

ABOVE: Six Sigma's ranch-to-table dinners always draw a sellout crowd to enjoy wines and pork produced on the property. For many vintners, such gatherings are a highlight of the winemaking year.

The livestock contribute to the sustainable practices. The miniature Babydoll sheep reliably mow down vineyard weeds and fertilize as they go. Black Angus cattle thrive outdoors year-round here, rotating among multiple pastures. When wildfires devastated their neighbors, Six Sigma escaped largely unscathed because the cattle had kept the brush in check. Even so, compared to the previous owner, the Ahlmanns maintain a much-reduced herd, limited to numbers they believe their land can support.

RANCH LIFE FOR ALL Over the years, the family has recognized that customers want a taste of life on their ranch. In a restored Pinzgauer, a rugged all-terrain Austrian military vehicle, the Ahlmanns take visitors to see the property's highest-elevation vines, the Diamond Mine

Vineyard at 1,700 feet (518 m). Named for the tiny nuggets of quartz that glisten in rocks on the site, the scenic spot offers a view of distant Mount Konocti, a dormant volcano on the south shore of Clear Lake, and overlooks vineyard blocks named for each of the Ahlmanns' four children.

The winery's popular ranch-to-table dinners, served family-style at one long table, give participants a chance to savor grilled steaks or braised lamb from animals raised on the property, local vegetables with raw-milk butter, and perhaps flatbreads from Rachel's hand-built wood-burning oven. In early spring, Six Sigma's annual Pruning & Pastries competition pits local vineyard workers against one another in a test of speed and expertise. Professional judges award cash prizes, wine-club members provide the cheers, and culinary

students from the local community college supply the *pains au chocolat.*

"People really care about being part of the ranch experience," says Kaj, who rigorously gathers and analyzes the consumer data that determine many of the winery decisions. Indeed, the Ahlmanns named their business after the influential Six Sigma techniques, a data-driven management tool that manufacturers use to improve processes.

Data points like ratings and consumer feedback help winemaker Sandy Robertson decide how to shape Six Sigma's wines, but only passionate environmentalists could have shaped this property. Just inside the front gate, sheep graze in a vineyard's knee-high cover crop. Nearby, wild turkeys strut about on spindly legs, flashing splendid tail feathers. Around a curve, a dozen ebony-skinned cattle may be lumbering across the road, oblivious to traffic. Is this a nature preserve, a wildlife corridor, a vineyard, a ranch, or a winery? Thanks to the Ahlmanns, it is successfully all of the above.

ABOVE: (clockwise from top left) Six Sigma's summer ranch-to-table dinners bring the winery's fans together to enjoy the beauty of this remote Lake County ranch. Estate wines, local produce, and meats from livestock raised on the property are part of the draw, along with ranch tours in a 1973 Pinzgauer, an Austrian all-terrain vehicle built for the Swiss military.

WHERE SAUVIGNON BLANC SHINES

Lake County's reputation as a source for well-priced Sauvignon Blanc continues to climb as growers home in on the best sites for this variety. The grape loves the plentiful sunlight the county's high elevation provides, assuring ripeness and the development of tropical-fruit and citrus aromas, while cool evenings preserve the crisp acidity that makes Sauvignon Blanc so refreshing.

"Lake County has diurnal swings that other regions can't duplicate," says Christian Ahlmann of Six Sigma Ranch & Winery. The difference between daytime high and nighttime low temperature can reach more than 50 degrees Fahrenheit (28 degrees Celsius) in summer in some areas, as afternoon breezes sweep down off the mountains. This natural daily cool-down helps extend the growing season, producing more complex flavors and balance in both grapes and wine.

Sauvignon Blanc grown in cooler climates tends to have grassy or herbaceous aromas; in hot regions, it loses its steely backbone. Lake County's high-elevation vineyards deliver the climatic middle ground: abundant sunlight that translates to thick skins and generosity of fruit but brisk acidity thanks to the moderating effect of nearby Clear Lake.

Lake County's Big Valley District AVA, where most of the county's Sauvignon Blanc vines are planted, has predominantly alluvial soil and yields relatively lush wine with pineapple and guava aromatics. But some growers are finding another rewarding spot for Sauvignon Blanc at higher elevations, moving their plantings from the fertile valley to the foothills and slopes of the High Valley and Kelsey Bench AVAs, where rocky volcanic soils bring stingier yields but racier acids.

Thanks to the rising prestige and price for Lake County Sauvignon Blanc, wineries outside the county who relied on it to lower the cost of their blends may have to look elsewhere. Embraced by Lake County vintners, the grape that dominates France's Loire Valley has found another comfortable home. Says Ahlmann, "Sauvignon Blanc practically grows itself in Lake County."

ABOVE AND RIGHT: (clockwise from top left) Six Sigma vines coexist with oaks; Sauvignon Blanc clusters; good times at Six Sigma; fresh pour of Sauvignon Blanc; thriving cover crop at Six Sigma

ABOVE, RIGHT, AND FACING PAGE: A stately entrance welcomes guests to Francis Ford Coppola Winery in Healdsburg; Oscar statues, one of many displays of movie memorabilia at the winery, recall a legendary career; Eleanor Coppola inspects the winery garden.

SONOMA COUNTY

FRANCIS FORD COPPOLA WINERY

Would a famous film director known for his epic and fearless productions own a winery that operates under the radar? One of those tucked-away estates that only the cognoscenti know and only insiders can visit?

Don't bet on it. Francis Ford Coppola Winery is as open-armed, original, and unconventional as its namesake, the winery equivalent of larger than life. Coppola, a cinema pioneer, "runs his winery with that creative mind-set," says Ryan Stapleton, the winery's director of grower relations. "He likes to be the first pancake."

After Coppola and his wife, Eleanor, purchased the historic Geyserville property, the former Chateau Souverain, they began reimagining what a California winery could be. Francis envisioned a venue that would lure visitors not for an hour but for an entire "daycation," a leisurely afternoon of swimming, snacking, wine tasting, and dining. Having watched youngsters beg their parents to let them play in the massive fountain at Inglenook, his Napa Valley estate, Francis resolved that his new winery would have a spectacular child-friendly swimming pool with *cabines*—European-style personal changing rooms—and lounge chairs for the grown-ups. A poolside alfresco café serves pizza and

gelato, while a nearby band shell and terrace provide a venue for salsa bands and other evening entertainment. Kids gravitate to the tepee lined with rugs and filled with books, while their parents relax by the pool and sip sparkling wine from a can.

Unprecedented? Check. Family oriented? Check. Fun? Unquestionably. "Francis changed the way people think about a winery visit," says Corey Beck, the winery's CEO. Sample a flight of wines before you slip into your swimsuit, or peruse the movie memorabilia in the retail shop. Test your acting chops with *The Godfather* script, then view the envelope ("May I have the envelope, please?") and card announcing the film's Academy Award for Best Picture.

FROM SUSTAINABLE METHODS, BETTER WINE But brush away the Hollywood glitter and Francis Ford Coppola Winery is a serious business. The winemaking is ambitious and the grape growing is, too, with sustainability a core objective in every aspect of the enterprise. The production team buys fruit from more than two

FROM THE NORTH COAST **39**

hundred California growers and has incentivized them all to become certified sustainable by 2019.

"It's my belief that sustainability is going to be the next common measure of performance," predicts Stephan Micallef, vice president of winery operations. "If you approach your problems with sustainable methods, you make better wine."

Micallef points to a new device the winery purchased for pump-overs, the practice of cycling fermenting red juice from the bottom of a tank to the top to extract more color and flavor from the skins floating on the surface. The new pump is more compact than older models—the initial selling point—but it also saves energy, requires less labor, and extracts more color more consistently.

In the vineyard, the winery's approach favors natural controls for pests, but sometimes nature's predators need an assist. Coppola's viticulture and winemaking team once spent an entire Saturday in a staffer's home woodshop building bluebird houses from blueprints. "It was a fun team-bonding exercise," recalls Stapleton, "but at the same we were encouraging biodiversity in our estate vineyard. Western bluebirds made nests in eleven out of the fourteen boxes we put up, and they help us keep the insect population down."

FROM VINES TO VEGETABLES Convinced that a diverse landscape invites natural predators, Stapleton was unfazed when vine rows were sacrificed for an edible garden. The lost revenue was easy to calculate, but the benefits are obvious, too, says the viticulturist. The extensive vegetable plots and orchard not only enhance the visitor experience but also yield a 3,000-pound (1,630 kg) annual harvest for the winery restaurant.

Many wineries shy away from activities aimed at children out of concern about public perception. But the Coppolas view things differently. The winery's annual Easter egg hunt brings five hundred youngsters, their parents, and a petting zoo to the property, with ticket sales benefiting local organizations. Tuesday evenings in the winery restaurant are expressly aimed at families and billed as

FACING PAGE: (clockwise from top left) Eleanor Coppola in the winery garden; alfresco dining at the winery restaurant; winery CEO Corey Beck

ABOVE: California poppies brighten the winery vegetable garden; rare quiet moment at the winery's tasting bar

a tavola, with a whim-of-the-chef menu served family-style, reduced pricing for youngsters, and some theatrical role-playing by the wait-staff. Delivering pleasure is part of the winery's mission statement, says Beck, an objective "deeply rooted in what the Coppolas believe."

The sustainability commitment also starts at the top, says the CEO. A request from Francis for ideas to reduce water use generated 160 staff suggestions, including several from his wife. (An easily implemented one: refillable water bottles for all.)

FACING PAGE: Movie memorabilia and family-friendly fare are part of the visitor experience at Coppola.

ABOVE: Guests enjoy a day of sunning, swimming, and casual dining.

Employees receive an annual wellness stipend and an arts stipend to spend as they like—to subsidize a gym membership, perhaps, or a child's piano lessons. The winery's largesse extends to the wider community, especially if the cause concerns children or local arts groups. "We're privileged to be here, and this is about giving back," says Eleanor, who traces her activism and environmentalism to a forty-five-year friendship with Chez Panisse cofounder Alice Waters. What's more, the Coppolas hope that the winery's generosity inspires employees. "Giving," says Eleanor, "should be a part of everyone's life."

CABERNET COUNTRY

Universally prized for yielding fine, age-worthy wine, Cabernet Sauvignon excels consistently in Napa Valley, where it thrives in almost every nook of the valley's 30-mile (48 km) length. Only in cool Carneros does this heat lover underperform. While frequently blended with Merlot, Petit Verdot, and Cabernet Franc, Cabernet Sauvignon can stand alone; indeed, many of the most sought-after Napa Valley bottlings are 100 percent Cabernet Sauvignon.

Although Napa Valley winemakers can shape a style with their picking decisions, fermentation techniques, and oak-aging regimen, *terroir* speaks even more loudly. Aficionados can often distinguish mountain Cabernets from valley-floor Cabs, or Rutherford Bench wines from those made from Stags Leap District fruit. In general, mountain vineyards—whether from Howell Mountain on the east side of the valley or Diamond Mountain or Mount Veeder on the west—have thinner soil, producing more tannic and concentrated wines that reward long aging. From the benchland or valley floor, Cabernet Sauvignon tends to have more bright berry aromas and silky tannins.

Distance from cool San Pablo Bay also has an impact, with fruit intensity increasing and acidity decreasing subtly from south to north. Cakebread Cellars winemaker Julianne Laks, who works with grapes from many valley sites, finds an east side–west side dichotomy as well. Mayacamas Mountain Cabernet tends to be more supple and elegant than Howell Mountain wines, which are typically more structured and tight. In a tasting with Bordeaux and Washington State Cabernets, Napa Valley Cabernets would stand out, says Laks. "Their ripeness and richness of fruit would be obvious. The others are not as opulent."

ABOVE: (clockwise from top left) Pruned vines; bud break; Lake Hennessey viewed from Napa Valley's Pritchard Hill; harvesting Cabernet Sauvignon grapes; harvested vines along the Silverado Trail prepare for a winter rest.

ABOVE AND RIGHT: Chef Brian Streeter starts his meal planning in Cakebread Cellars's extensive year-round vegetable garden. Streeter's popular cooking classes often center around the winery's outdoor pizza oven.

NAPA VALLEY
CAKEBREAD CELLARS

If Cakebread Cellars represents a high-water mark in Wine Country hospitality, it's because Jack and Dolores Cakebread have always viewed their winery as an extension of their home. Since 1973, when they bought a Napa Valley cow pasture and began planting vines, the Cakebreads have believed that a gracious welcome and good food would persuade even novices to feel comfortable around wine. In an era when fancy French food signified sophistication, Dolores wasted no time in planting a vegetable garden and establishing a reputation for the sort of casual, simple, seasonal cooking that now defines California Wine Country style.

The winery has grown exponentially since then, but understatement and lack of pretension remain hallmarks here. The barn-like redwood buildings blend serenely into the landscape, their roofline poking up above silvery olive trees and pecan trees. Jack and Dolores created the property's relaxed California aesthetic, but sons Bruce and Dennis now perpetuate it.

"Wine should give you good memories," says Bruce, the winery's president. Even the company's mission statement refers to "creating remarkable experiences through our wines, with food and friends." To that end, Cakebread's inviting, home-style kitchen—overseen by longtime culinary director Brian Streeter—rarely sees a quiet day.

FRESH FROM THE GARDEN Whether he's teaching a class around the outdoor pizza oven or planning the American Harvest Workshop—an annual culinary camp for chefs—Streeter begins his menu making in the garden. Bordered by poppies, yarrow, alyssum, and borage to lure beneficial insects, the ¾-acre (0.3 ha) parcel yields a year-round harvest, from spring fava beans to winter beets. Nourished by composted kitchen scraps and by biochar, a carbon-rich, nonpolluting charcoal from grapevine prunings, the raised beds supply Cakebread's chefs with more than 2 tons (1,815 kg) of fruits and vegetables a year. Head gardener Marcy Snow replenishes the soil between plantings. "Always give back," advises Snow, "and be one with the insects."

Director of viticulture Toby Halkovich follows the same principles in the vineyard. "We have a high tolerance for pests," says Halkovich, an advocate of integrated pest management (IPM) practices, which look first to nature to correct imbalances. "If leaves are chewed, what's wrong with that? You have to back out of the mind-set that every pest is a problem."

In times past, many growers sprayed preventively, on a regular schedule, to keep mildew and mites at bay. "We've broken free of that," says Halkovich, who relies on vineyard weather stations to indicate when pest or disease pressure is high. More often than not, admits Halkovich, the data suggest that it's safe to stand down.

Responsible for managing the family's estate vineyards, including its twelve far-flung ranches in Napa Valley, Halkovich says his attitudes about vine health have evolved. "In the past, you would see a nutrient deficiency and treat it," explains the viticulturist. "It became a fertilizer treadmill."

Now, he and others focus on creating and maintaining healthy soil with amendments like fish emulsion and compost, which nourish the soil organisms that store nutri-

ents. The vines enjoy more consistent nutrition throughout the growing season compared to the feast-or-famine conditions that prevail with synthetic fertilizers.

FROM BALANCED VINES, BALANCED WINES

The transition has yielded more balanced vines, with the optimum ratio of leafy growth to fruit. Vigorous vines may look healthy, but balanced vines yield better grapes, giving winemaker Julianne Laks a running start on quality.

In the cellar, the main objective is "to let the fruit shine through," says Laks, who has notched more than thirty vintages at Cakebread. The winery's Cabernet Sauvignon–based bottlings capture the essence of each vineyard site, from the famed Rutherford Bench on the valley's west side to the slopes of Howell Mountain on the east. The Chardonnay routinely tops lists of the

nation's best-selling restaurant wines, and the Sauvignon Blanc has influential devotees, too.

"It's Dolores's favorite wine and one of mine as well," says Laks. "It's so bright and refreshing. We blend in a little Semillon to lower the acidity, but it still has a lot of tension and verve. I can pick it out in a tasting anytime."

Laks, Streeter, and Halkovich, like many of their Cakebread Cellars colleagues, have lengthy tenures because the family continually demonstrates its values: integrity, honesty, and respect for each member of the team.

The sense of community here extends beyond the property line. Streeter, on company time, volunteers monthly at a local elementary school, teaching fourth graders healthy cooking techniques. The Cakebreads are major donors to a health clinic for Napa Valley's neediest, and the family has chaired the annual Napa Valley Wine Auction, which raises millions for local charities. Jack, Dennis, and Bruce are all past presidents of Napa Valley Vintners, donating hundreds of hours to protecting and promoting the valley's reputation.

Working with Robert Mondavi and other prominent vintners, Jack Cakebread put Napa Valley on the international map. "Now it's our responsibility to build on that for the next generation," says Bruce. "Napa Valley wine is known around the world because of so many people collaborating. If it were just us, consumers would still be saying, 'What's a cakebread?'"

LEFT AND ABOVE: (clockwise from top left) Bruce and Dennis Cakebread; the winery's Dancing Bear Ranch on Howell Mountain; under chef Streeter hospitality is a fine art; ladybug; Halkovich; Cakebread gardener Marcy Snow

FOLLOWING PAGES: Working closely with the garden staff, Streeter has a year-round cornucopia to inspire his menus.

MERLOT STANDS ALONE

Valued for its lush red-fruit aromas and gentle tannic structure, Merlot is a crucial component in many of Napa Valley's most sought-after red wines. It helps soften the tannic edges of Cabernet Sauvignon, yet it makes a delightful wine in its own right, too. Some wineries, such as Duckhorn, have made Merlot their focus and demonstrated its greatness as a stand-alone variety in Napa Valley.

Merlot vines produce loose bunches of large, thin-skinned berries, a characteristic that manifests in the winery as a high skin-to-juice ratio. Because a red wine's tannin comes from the skins, Merlot has less tannin than Cabernet Sauvignon, and its tannins are softer, not as gripping. A 100 percent varietal Napa Valley Merlot will have complex and inviting aromas—cherry, plum, and mocha are common descriptors— and a full body but a round, supple quality that makes it easy to drink. It typically matures faster and costs less than Cabernet Sauvignon from the region, making it especially popular in restaurants.

Merlot also ripens earlier than Cabernet Sauvignon, so it can achieve full ripeness in cool areas like Los Carneros. It's the dominant variety in the Oak Knoll District, a relatively cool appellation at the southern end of Napa Valley. But Merlot can excel in warmer zones, too. Duckhorn's Three Palms Vineyard, which yields one of the state's most critically acclaimed Merlots, is in a warm up-valley location near Calistoga. In 2017, the *Wine Spectator* declared the 2014 Duckhorn Vineyards Three Palms Merlot its top wine of the year, yet another validation that this variety shines alone.

ABOVE AND RIGHT: (clockwise from top left) Night harvesting of Merlot at Three Palms Vineyard; just-picked Merlot grapes; grapes await the crusher at Duckhorn Vineyards; Duckhorn Vineyards; grape sorting enhances quality.

ABOVE: Manicured grounds and vines surround the elegant Domaine Carneros, a faithful replica of the Château de la Marquetterie in the Champagne region of France.

RIGHT: Vineyard manager Alberto Zamora (left) monitors the early spring growth.

FACING PAGE: CEO and winemaker Eileen Crane

LOS CARNEROS
DOMAINE CARNEROS

The grandness of Domaine Carneros—a hilltop château with a sweeping double staircase and masterfully clipped hedges—evokes a period in France when nobility reigned. A replica of the eighteenth-century mansion that houses Champagne Taittinger, which owns Domaine Carneros, the stately edifice surveys the slopes of Los Carneros from behind a long balustrade.

In reality, the warm welcome and environmental sensitivity at Domaine Carneros are second to none. And the company's progressive employee practices, beginning with its commitment to open-book management, dispel any hint of hierarchical culture.

Under the management of Eileen Crane from its inception, Domaine Carneros unites French château style and California innovation. Crane was an early solar-power enthusiast, convincing her Gallic bosses that while the costly investment admittedly did not make sense in Champagne—France's chilliest wine region—it would quickly pay for itself in sunny California. When installed in 2003, Domaine Carneros's solar collection system was the largest of any winery in the world. It generates enough electricity each year to power an estimated 230 homes.

With a spacious terrace that overlooks manicured gardens and vine-carpeted hills, Domaine Carneros resonates with visitors who perennially rank it among Napa Valley's top winery experiences. Some merely pause here for a glass of *brut* with a view on their way up valley, but the smarter patrons reserve a tour, a carefully choreographed look at all the steps that produce a fine bottle of bubbly.

VINES THAT FOLLOW THE LAND What casual visitors don't see is the rigor that goes into the farming. To minimize erosion on the winery's 350 acres (142 ha) of vineyard, all new plantings follow the rippling contour of the land. "We no longer build terraces," says vineyard manager Alberto Zamora. "Terraces obstruct natural runoff. We don't carve into the topography."

As a result, Zamora and his crew manage an estate with eighty different exposures, complicating their job but adding complexity to the winery's blends. Throughout the property, ground-level "drop inlets" collect rainwater before it runs downhill, channeling it into a settling pond where stones filter it and the silt

settles out, yielding clean water to replenish nearby Huichica Creek.

On summer mornings, fog drifts in from nearby San Pablo Bay and often cloaks the vines with cool, damp air until eleven o'clock. "The mildew pressure here is three hundred times what it is in St. Helena or Calistoga," says Zamora. Elemental sulfur, a fungicide approved for organic farming, effectively controls mildew but can reduce populations of beneficial insects, too. In the past, growers sprayed regularly to prevent a mildew outbreak. Today, three weather stations at Domaine Carneros supply up-to-the-minute data so Zamora always knows the actual risk. "That helps me determine if and when to spray," says the viticulturist, "as opposed to spraying on a schedule."

Sometimes Zamora asks his crew why they like working at Domaine Carneros. To his surprise, they rarely mention the benefits or the perks. "They say they like that they're treated with respect," reports Zamora. "This winery is big on making sure everybody feels respected."

OPEN-BOOK WINERY Several years ago, Crane learned about the work of management consultant Ari Weinzweig, founder of Zingerman's Delicatessen, the Ann Arbor, Michigan, specialty-food purveyor. Weinzweig is a longtime proponent of open-book management, which requires company leaders to operate transparently and share financial details with employees. Crane and her executive team read Weinzweig's books, attended his workshops, and implemented many of his methods.

"We show cash flow, income, labor costs, safety records, our wine-club signups, what we've got in the bank," says Crane. "And we teach Finance 101 so employees can read the reports."

Employees are encouraged to question management, and Crane is also asking employees more questions now. "It used to be that the human-resources person and I would get together and decide on the benefits," recalls Crane. "Now we ask. Some people want a subsidy for a gym membership, while vineyard workers appreciate having a catered lunch every Friday. People are happier because they have input."

A "passport" program rewards employees for continuing education or achievement, and managers find other ways to incentivize good performance. Zamora may devise a pruning competition designed to spur productivity; if

successful, the pruning team shares in the company savings.

At department meetings, known as huddles, managers promote positive energy and attempt to help employees who report feeling low. "I was skeptical," admits Crane of the Zingerman's energy workshop she attended, "but it's the best thing we ever did. It will change your life if you decide not to be angry or upset."

Whether contented employees produce better wine may be difficult to prove, but they clearly enhance the workplace. It's not difficult to imagine that a shared positive outlook makes the sparkling wines here gleam a little brighter.

ABOVE: (clockwise from top left) Guest tasting at Domaine Carneros; San Pablo Bay, visible in the distance, moderates the temperatures in Carneros; harvesting Chardonnay in small bins; magical autumn landscape; sparkling-wine time; Chardonnay cluster

SHOWPLACE FOR SPARKLING WINE

Cooled by morning fog and afternoon winds from San Pablo Bay, the Carneros region has been recognized for decades as a choice location for Chardonnay and Pinot Noir. In the 1960s, pioneering grower Rene di Rosa established his Winery Lake vineyard there, charging prices for his grapes that turned heads. More growers joined him in developing Carneros vineyards in the 1970s, and by the early 1980s, sparkling-wine producers—both French and Californian—were moving in, persuaded that the cool region could produce premium sparkling-wine grapes.

Today, many of California's top sparkling-wine producers own or purchase grapes from Los Carneros vineyards. The appellation straddles two counties—Napa and Sonoma—and includes the coolest, windiest sections of both. At Domaine Carneros, afternoon breezes can topple the flutes of guests gathered on the terrace. Not surprisingly, French firms that invested in Carneros, such as Mumm (Mumm Napa) and Taittinger (Domaine Carneros) were seeking conditions similar to Champagne. They found the closest equivalent here, although Carneros is warmer and much farther south. Tellingly, Champagne's vintage years are the warm ones when the weather approximates that of Carneros.

Unlike Champagne, Carneros-based sparkling wines rarely include Pinot Meunier, a red grape planted in France because it ripens in difficult years. Chardonnay and Pinot Noir, considered superior varieties, comprise the blend for most Carneros sparkling wines, the ratio determined by house style and whether the bottling is a *blanc de blancs* (100 percent Chardonnay), *blanc de noirs* (predominantly Pinot Noir), or *brut* (a blend of Chardonnay and Pinot Noir).

The rolling hills of Carneros can create multiple microclimates within the same vineyard, with blocks distinguished by different exposures and ripening times. For the winemaker, this diversity contributes complexity to the final blend.

ABOVE: Cover-cropped Carneros vineyard in winter
RIGHT: Early-morning Carneros Chardonnay harvest

NORTH COAST HARVEST

F irst planted on California's North Coast in the early nineteenth century, the Gravenstein apple still persists in scattered Sonoma County orchards, but the harvest is dramatically down from its heyday. Luther Burbank was a fan of this exquisite baking and eating apple and reportedly said that if everyone could get it (it doesn't ship or store well), no farmer would need to grow any other type. The town of Sebastopol continues to celebrate this heritage apple with festivals in spring and fall.

Today, the North Coast's primary harvest is wine grapes—among the finest in the world—but small family-run farms on parcels less conducive to viticulture harvest high-value produce for chefs and farmers' markets. These enterprises, many fewer than 10 acres (4 ha), keep Bay Area kitchens supplied with succulent Comice pears, heirloom apples, quinces, persimmons, golden beets, leafy cooking greens, and salad-starring lettuces that are the envy of cooks elsewhere.

LEFT: (clockwise from top left) Pear harvest at Henderson Farms. Apples, Bartlett pears, leafy red chard, and lush salad greens are among the top crops from North Coast farms and orchards.

RECIPES

Mixed Chicory Salad with Red Pears
and Blue Cheese

Little Gem Lettuces with
Olive Oil–Poached Tuna

Braised Pork Shoulder with Apples,
Carrots, and Parsnips

Zinfandel-Poached Pears with
Mascarpone Cream

Heirloom Apple Galette with
Honey Ice Cream

APPLES Western Sonoma County has long been apple country, especially around the town of Sebastopol. The annual Apple Blossom Festival in spring and Gravenstein Apple Fair in late summer testify to the historical importance of apples in the region. Although wine grapes have replaced many of the orchards, such dedicated apple growers as Stan Devoto of Devoto Orchards thrive by growing heirloom varieties for farmers' markets and local chefs.

APPLE HEAVEN: Morning fog moderates Sebastopol's summer temperatures, which rarely top 85°F (30°C), and winter brings the 600 to 1,000 chill hours—hours below 45°F (7°C)—that most apple varieties need. "We farm trees that are ninety years old," says Devoto. "As long as you prune, fertilize, spray, and thin them, they'll continue to produce."

HARVEST: Devoto harvests entirely on flavor, not on any sugar measurement. "When they start tasting good is when we start picking," says the grower. The process starts in early August with Gravensteins and Pink Pearls and ends around Thanksgiving with such late varieties as Rome Beauty, Pink Lady, Granny Smith, Black Twig, Fuji, and Arkansas Black.

STORAGE: Refrigerate apples loose in the fruit drawer. They will sweat in a plastic bag. Enjoy Jonathans and Gravensteins within a week or two; pippins last a little longer, and Fujis stay crisp for up to one month.

TOP PICKS: Devoto's favorites for eating out of hand include Ashmead's Kernel, Empire, Mutsu, and Black Twig. Especially prized are apples with a translucent streak of condensed sugar, known as a water core. For applesauce and apple butter, Gravenstein and Jonathan are good choices. For tarts and pies, try pippin, Sierra Beauty, or Golden Delicious. For baking whole, it's hard to top the familiar Rome Beauty, cored and stuffed with walnuts, raisins, brown sugar, and cinnamon, then served warm with cold cream. "They don't store well, but they are so good right off the tree," says Devoto.

PEARS Since gold rush days, when entrepreneurs first planted Bartletts for the state's booming population, California has proven itself to be "gold country" for pears. Some of these original orchards around Sacramento are still farmed by the same families and still yielding pears fit for the gods. The Sacramento River Delta remains the state's premier pear-growing region, with orchards in Lake County and Mendocino County supplying luscious late-season fruit.

HARVEST: Unlike most fruits, pears are harvested hard and complete their ripening process off the tree. Growers strip the trees by hand as soon as the fruit reaches full size and detaches easily when lifted. Depending on the variety and region, harvest lasts from mid-July to November.

SELECTION AND STORAGE: Hard, green Bartlett pears will ripen on a kitchen counter in three or four days, becoming juicy and sweet. They are ready when the skin turns yellow and the flesh gives to slight pressure around the stem. The smaller Forelle variety also transitions from green to yellow, with red freckles. Other varieties—Bosc, Comice, French Butter, Starkrimson (a red-skinned pear), and Seckel—don't change color as they ripen, so rely instead on the pressure test around the neck. Once pears have ripened fully, refrigerate them to extend their life.

TOP PICKS: Bartlett, the mainstay of California orchards, is an all-around great pear for cooking and eating. For poaching, consider Bosc, which holds its elegant shape when cooked. Silky Comice is the sweetest variety; enjoy raw or pureed for sorbet. The petite Seckels are fun for children, and Starkrimsons are gorgeous sliced into salads. French Butter, a succulent, creamy variety, is divine out of hand but also works well in tarts and other pastries.

TRY THIS: Add sliced pears to a grilled cheese sandwich. Braise red cabbage with grated pear. Cook chopped pears with cranberries and raisins for a Thanksgiving relish.

RIGHT: (clockwise from top left) Pristine apples; Diane Henderson inspects pears; Lake County pear orchard

SALAD GREENS

SALAD GREENS The cool, misty farmland in western Marin, Sonoma, and Mendocino Counties is no place for tomatoes. But lettuces love it. Both delicate baby greens and sturdier chicories, such as escarole and frisée, appreciate the many overcast days and fog along the coast; in hot weather, greens become bitter and tend to bolt. Although other areas of the state have vastly more acreage in salad greens, especially head lettuce, North Coast growers pioneered the colorful French-style mixes of loose young lettuces that are ready for the salad bowl.

HARVEST: With mild summers and winters, many North Coast growers can cultivate salad greens year-round. Some, such as Dennis Dierks of Bolinas's Paradise Valley Produce, take a months-long break to give the soil a rest and replenish nutrients with a cover crop. During this abbreviated growing season—roughly, June to November—the crew plants new seedlings from the greenhouse every three weeks to keep the harvest coming. The greens aren't uprooted for sale; instead, the crew picks individual leaves or cuts the plant at ground level so new leaves can continue to push. After washing on the farm in water acidified with local cider vinegar, the greens are spun dry and sold at local farmers' markets.

SELECTION AND STORAGE: Look for perky greens, with no sign of wilting or decay. Discard any decayed leaves, pat the greens dry, and refrigerate in an airtight container. Try to use within three to four days, though Dierks says his salad mix lasts two weeks after harvest.

VARIETIES TO TRY: Among the varieties that Dierks grows, favorites include Salanova® Red Sweet Crisp, a frisée; Panisse, a green oakleaf; Alkindus, a red-tipped butterhead; and the romaine-like Little Gem.

KITCHEN TIPS: Make sure salad greens are well dried before dressing. After spinning dry, lay them out on paper towels, roll up like a jelly roll, and place inside a plastic bag. Refrigerate until serving time. Dress delicate greens with vinaigrette; save creamy dressings for hearty greens like escarole and romaine.

PARADISE FOUND

In midsummer, the morning fog at Bolinas's Paradise Valley Produce can be so thick it feels like rain. Humans have to don hoodies, but lettuces love the cool, misty air and gentle afternoon sunshine on this 4-acre (1.6 ha) farm in a hidden pocket of West Marin. Since 1972, Dennis Dierks has been harvesting leeks, herbs, chard, kale, and heirloom salad greens here for discriminating restaurants such as Berkeley's Chez Panisse.

A pioneer grower of Little Gem lettuces, the popular mini-romaine, Dierks is also a passionate advocate for some unconventional practices aimed at replenishing soil life. In large fermentation vessels, he concocts a lactose spray and another microbially rich "witch's brew" from nettles, kelp, and compost tea. His wife, Sandy, jokes that the farm smells like a pickle.

"My job is growing soil," says Dierks, whose lush results speak for themselves. "If you have living soil, plants are healthier."

An early adopter of cover cropping, Dierks says his customers often comment on the endurance of his greens. "The soil gives plants this longevity," claims the grower.

LEFT: (clockwise from top left) Henderson pear harvest; carpet of mixed lettuces and leafy greens at Paradise Valley Produce
ABOVE: Dennis Dierks and daughter, Sierra Miller

HENDERSON FAMILY FARMS
PEARS

When Diane Henderson faces a tough decision about her Lake County pear orchard, she consults its oldest residents: two massive, thick-trunked trees, stooped and misshapen after 140 summers and winters but still bearing fruit. Planted by her great-great-grandfather, these senior citizens seem to harbor wisdom in their ragged, timeworn branches. Standing under them and pondering a problem, "I have a sense of my ancestors," says Henderson, a fifth-generation pear grower. "What would they do?"

Henderson, a former community-college teacher, has devoted herself to this family farm since returning in 1982, after the death of her only child at seventeen. "I was devastated and I wanted to exhaust myself physically to help heal," recalls Henderson, who grew up among the pear trees, setting out smudge pots for frost protection at 5 a.m. and driving a tractor before she could drive a car.

When she returned in her midthirties, she had a business to learn. Her father had passed away and she felt too old to enroll in an agricultural college. "I went to work for our ranch foreman for $4.50 an hour," says Henderson. The foreman wouldn't allow her on the 15-foot (4.5 m) ladders, but she pruned, mowed, irrigated, and sprayed along with the Mexican crew, learning "field Spanish" at the same time.

"That's why I succeed as a woman farmer," says the feisty Henderson. "I worked right alongside them, and they knew I knew it."

PEARS KISSED BY THE SUN Today, Henderson and her husband, Syd Stokes, a fourth-generation pear grower, are preparing to turn management of the 63-acre (25.4 ha) orchard over to Greg Panella, Syd's nephew. In what may be her last harvest in charge, Henderson patrols the shady rows between the trees, pointing out the blush on pears that have gotten "kissed by the sun" and watching the crew strip the shapely green fruit from the trees, dropping the pears into a hefty pouch slung around their neck. Experienced harvesters know to start at the top of the tree and work down, so the bag gets heavier as they descend. They don't use knives; the pear, stem attached, releases readily when lifted. Paid by the bin, the men work rapidly, their only diversion the *ranchera* and *banda* music from battling boom boxes.

RIGHT: Diane Henderson, husband Syd Stokes (far right), and Stokes's nephew Greg Panella prepare for harvest at their pear orchard in Kelseyville in Lake County. The trio grows premium Bartletts for fresh eating, not for drying, at an elevation of 1,300 feet (400 m).

Henderson's Bartletts—the only variety she grows—are typically ready in August. When they reach full size and the green color lightens slightly, it's time. The fruits are still rock-hard; ripening comes later. "A tree-ripened pear is awful," says Henderson. "Pithy, grainy, and mealy."

At the nearby packinghouse, gloved workers determine the fate of each pear, diverting blemished fruit to the cannery. An electronic sorter separates the pears by size, then they are packed into cartons—hand wrapped in tissue if they must travel far. Within twelve hours, they are chilled to 30°F (-1°C) and can remain slumbering in cold storage for months. Once they break refrigeration, however, ripening begins.

WAITING GAME At home, Henderson's pantry is stocked with canned pears she preserves with her mother, and a garage refrigerator is packed with pears for fresh eating. She puts a few at a time on her kitchen counter and waits until they turn golden and give to slight pressure around the neck. Do the same with hard store-bought pears and they will turn creamy, buttery, and juicy, promises the grower.

Although Lake County is becoming well-known for wine grapes, the region's pears remain prized. The climate is ideal, says Henderson, with warm days, cool nights, and dry air. Sustainable practices, like the use of pheromone traps to control codling moth, have largely replaced the harsh chemical sprays of times past, and owl boxes and bat houses lure a nighttime pest-control team.

"In the old days, you wanted a cleanly disked orchard floor," says Henderson, whose trees now thrive with a carpet of cover crops and native grasses. Such progressive management offers hope that the ranch's three thousand century-old trees will remain fruitful and full of wisdom for the next generation.

ABOVE: (clockwise from top left) Pears are harvested hard and ripen off the tree; harvesting the massive trees requires tall orchard ladders; pheromone traps provide natural control of codling moth; at the packing shed

MIXED CHICORY SALAD WITH RED PEARS AND BLUE CHEESE

SERVES 6

The sturdy greens in the chicory family include escarole, curly endive, frisée, radicchio of all types, and California-grown Belgian endive. They have a pleasantly bitter flavor that's refreshing at the end of a meal and that welcomes some sweet fruit for contrast. Substitute apples or persimmons for the pears if you like. Serve after Roast Chicken with Meyer Lemon and Smoked Paprika (page 339) or braised short ribs.

WINE SUGGESTION: *California Pinot Gris/Grigio*

DRESSING:

1 small shallot, finely minced

½ teaspoon Dijon mustard

1 tablespoon white wine vinegar

3 tablespoons extra virgin olive oil

Kosher or sea salt and freshly ground black pepper

1 small head escarole

½ head radicchio (5 ounces/150 g)

1 large head Belgian endive (4½ ounces/130 g)

¾ cup (75 g) walnut halves, toasted and coarsely chopped

1 small red pear, ripe but firm

3 ounces (90 g) blue cheese, such as Point Reyes Farmstead Original Blue, crumbled

Make the dressing: In a small bowl, whisk together the shallot, mustard, and vinegar. Gradually whisk in the olive oil, then season with salt and pepper.

Trim the escarole, removing the core and coarse outer leaves. Reserve the outer leaves for soup or for cooking with other sturdy greens. Tear the pale inner leaves into bite-size pieces and place in a large salad bowl. Cut the radicchio into two wedges, core them, and then slice the radicchio thinly or chop coarsely. Add to the escarole. Halve the endive lengthwise, then cut crosswise into ½-inch (12 mm) pieces, discarding the core. Add to the salad bowl along with the walnuts.

Halve and core the pear, then shave it crosswise or lengthwise with a mandoline or other vegetable slicer, or slice as thinly as possible with a chef's knife. Add the pear to the salad bowl.

Toss the greens and pear with just enough dressing to coat them nicely; you may not need it all. Add the cheese and toss again gently. Taste for salt and vinegar. Serve immediately.

LITTLE GEM LETTUCES WITH OLIVE OIL–POACHED TUNA

SERVES 4

This dish requires a lot of olive oil for poaching, but you won't waste a drop. Use some of the flavorful poaching oil in the salad dressing; strain and refrigerate the remainder for cooking greens or for dressing future salads. The strained oil will keep for a month.

WINE SUGGESTION: *California rosé or Sauvignon Blanc*

1 albacore tuna steak, about 10 ounces (315 g) and ¾ to 1 inch (2 to 2.5 cm) thick

¾ teaspoon ground fennel seed

¾ teaspoon kosher or sea salt

1 large fresh thyme sprig

1 bay leaf

1 clove garlic, halved

6 black peppercorns

1¾ to 2 cups (430 to 500 ml) extra virgin olive oil

DRESSING:

6 tablespoons (90 ml) extra virgin olive oil (from the tuna baking dish)

3 tablespoons red wine vinegar

1 tablespoon salt-packed capers, rinsed and finely minced

1 teaspoon dried oregano

1 small clove garlic, finely minced

Kosher or sea salt and freshly ground black pepper

1½ cups (280 g) cooked chickpeas (drain and rinse if canned)

½ pound (250 g) Little Gem lettuce or romaine hearts

¼ pound (125 g) radicchio

½ red onion, shaved or very thinly sliced

¾ cup (125 g) halved cherry tomatoes

¼ cup (10 g) chopped fresh flat-leaf parsley

Preheat the oven to 200°F (95°C). Remove the tuna from the refrigerator 30 minutes before baking.

Season the tuna on both sides with the fennel seed and salt. Put the tuna in a deep ovenproof baking dish just large enough to hold it. Add the thyme, bay leaf, garlic, and peppercorns. Pour in enough olive oil just to cover the tuna.

Bake until a few white dots (coagulated protein) appear on the surface of the fish and the flesh just begins to flake when probed with a fork, 30 to 40 minutes. The tuna should still be slightly rosy inside. Remove from the oven and let cool to room temperature in the oil.

Make the dressing: In a bowl, whisk together the olive oil, vinegar, capers, oregano, garlic, and salt and pepper to taste. Add the chickpeas and let them marinate for 30 minutes.

With a slotted spatula, lift the tuna out of the olive oil and onto a plate.

Put the lettuce in a large salad bowl. Tear the larger outer leaves in half, if desired, but leave the pretty inner leaves whole. Tear the radicchio into bite-size pieces and add to the bowl along with the onion, tomatoes, and parsley.

Using a slotted spoon, add the chickpeas, then add enough of the dressing from the chickpea bowl to coat the salad lightly. By hand, flake the tuna into the bowl. Toss, taste for salt and vinegar, and serve.

BRAISED PORK SHOULDER WITH APPLES, CARROTS, AND PARSNIPS

SERVES 4

Autumn brings apples and root vegetables to market simultaneously, so it's a no-brainer to combine them in a braise. They will cook in the same time if cut as described, and they add irresistible sweetness to the dish.

WINE SUGGESTION: *California Chardonnay or Pinot Noir*

1½ pounds (750 g) well-trimmed boneless pork shoulder, cut into 1½-inch (4 cm) cubes

Kosher or sea salt and freshly ground black pepper

1 tablespoon extra virgin olive oil

¾ cup (125 g) minced shallots

½ cup (125 ml) white wine

About 1½ cups (375 ml) chicken broth

1 fresh rosemary sprig, 6 inches (15 cm) long

1 small fresh sage sprig

3 carrots, peeled

2 parsnips, peeled

1 large apple, peeled, halved, cored, and cut into 8 wedges

3 tablespoons crème fraîche

2 tablespoons chopped fresh flat-leaf parsley

Season the pork all over with salt and pepper. In a large, heavy pot, heat the olive oil over medium-high heat. Working in small batches, brown the pork on all sides, adjusting the heat so the pork browns well without burning. As the pork is browned, use tongs to transfer it to a plate.

Pour off all but 1 tablespoon fat and return the pot to medium-low heat. Add the shallots and cook, stirring with a wooden spoon, until they soften and brown lightly, about 3 minutes. The moisture from the shallots should dissolve some of the browned bits on the bottom of the pot. Add the wine, raise the heat to medium, and simmer until it is reduced by half, scraping up any remaining browned bits on the bottom of the pot with the wooden spoon.

Return the pork to the pot along with any accumulated juices from the plate. Add the broth, rosemary, and sage, tucking them into the liquid. Bring to a simmer, then cover and adjust the heat to maintain a gentle simmer. If necessary, use a flame tamer to keep the liquid from boiling. Cook until the pork is fork-tender, 1¼ to 1½ hours.

Cut the carrots into pieces 2 inches (5 cm) long. Quarter the thickest chunks lengthwise and halve the remaining pieces lengthwise, so all the pieces are about the same size. Cut the parsnips in the same manner. If the parsnips have a woody core, cut it out of each quartered piece with a small paring knife. Add the carrots to the pot. Return the braise to a simmer, cover, and cook gently for 5 minutes. Add the parsnips and apple, re-cover, and continue simmering gently, stirring occasionally to ensure even cooking, until the vegetables and apple are just tender, 15 to 20 minutes. Taste and adjust the seasoning.

You should have about 1 cup (250 ml) braising liquid in the pot. If you have more, uncover the pot during the final few minutes to allow liquid to evaporate until you have about 1 cup (250 ml). Remove and discard the rosemary and sage. Put the crème fraîche in a small bowl and whisk in a few tablespoons of the braising liquid to thin it, then add to the pot along with 1 tablespoon of the parsley.

Divide the braise among four soup bowls and top each serving with some of the remaining 1 tablespoon parsley. Serve immediately.

ZINFANDEL-POACHED PEARS WITH MASCARPONE CREAM

SERVES 6

After several hours of steeping in a red wine syrup, these poached pears turn a rich ruby color. But that inky hue is only skin deep; slice and fan the pears to reveal their pale interior. The pears can be poached a full day ahead for an easy fall or winter dinner-party dessert. Bartlett and Bosc pears are both good choices for poaching.

WINE SUGGESTION: *California Port-style Zinfandel*

2 cups (500 ml) Zinfandel
2 cups (500 ml) water
¾ cup (150 g) sugar, plus more if needed
2 lemon zest strips
1 whole clove
3 large, ripe but firm pears

MASCARPONE CREAM:
½ cup (125 g) mascarpone
¼ cup (60 ml) heavy cream
2 teaspoons sugar
¼ teaspoon vanilla extract

Put the Zinfandel, water, sugar, lemon zest, and clove in a saucepan large enough to hold the pears in a single layer. Bring to a simmer over medium heat, stirring to dissolve the sugar.

Peel the pears with a vegetable peeler. Add them to the simmering wine mixture and turn them gently with two rubber spatulas or wooden spoons to coat their whole surface evenly with the wine. Cut a round of parchment paper slightly larger in diameter than the saucepan and place it over the pears, tucking the edges under the liquid to hold the round in place. Adjust the heat to maintain a gentle simmer and cook the pears for 10 minutes. Remove the parchment, gently turn the pears over in the liquid, replace the parchment, and continue simmering until the pears are barely tender when pierced, 10 to 12 minutes longer. (They will soften more as they cool.)

With a slotted spoon, transfer the pears to a deep refrigerator container. Raise the heat to medium-high and simmer the poaching liquid until reduced to 1 cup (250 ml), 10 to 15 minutes. Let the wine syrup cool to room temperature, then pour it over the pears. Cover and refrigerate for 8 hours, turning the pears in the syrup every couple of hours so they are deeply and evenly colored. Remove and discard the clove.

Shortly before serving, make the mascarpone cream: Put the mascarpone, cream, sugar, and vanilla in a bowl and whisk until soft peaks form.

To serve, cut each pear in half lengthwise and core with a melon baller. Put each pear half, cut side down, on a work surface. Thinly slice lengthwise, leaving the slices attached at the stem end. Gently press on the pear half to fan the slices.

Divide the wine syrup among six plates. Top with a fanned pear half and put a dollop of mascarpone cream alongside. Serve immediately.

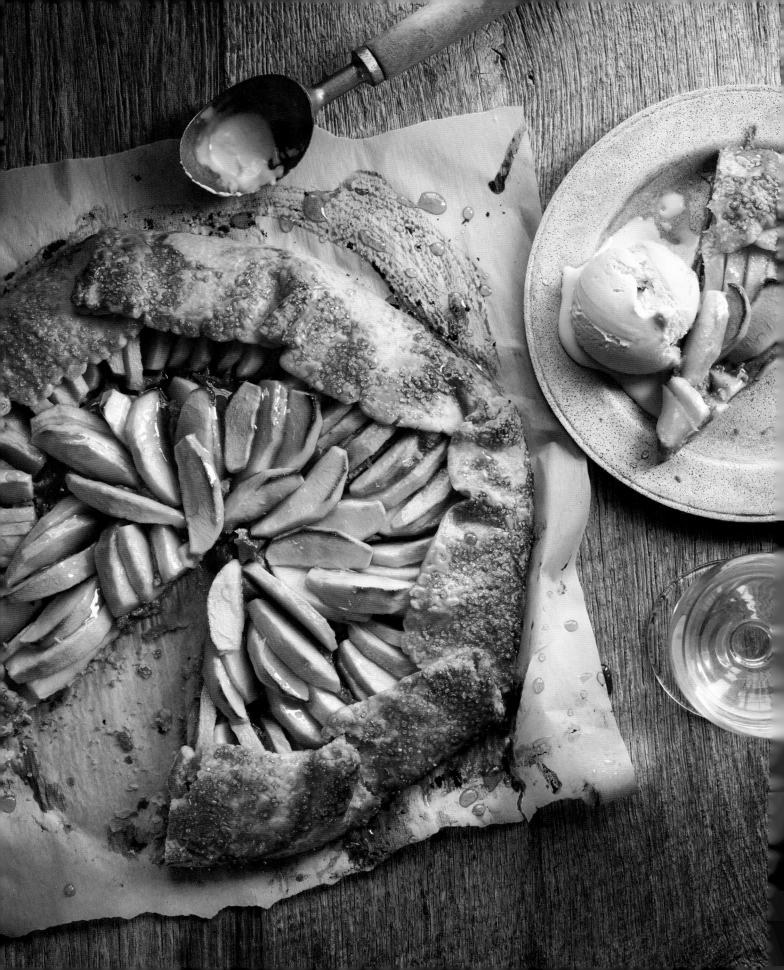

HEIRLOOM APPLE GALETTE WITH HONEY ICE CREAM

SERVES 8

A walnut filling similar to frangipane makes this galette stand out from the crowd, and sparkling sugar on the pastry rim makes it gleam. Keep the honey ice cream in mind for other fruit desserts, such as grilled apricots or figs, baked pears, persimmon pudding, and peach or berry crisp.

WINE SUGGESTION: *California late-harvest dessert wine from Semillon, Sauvignon Blanc, or Riesling*

HONEY ICE CREAM:

1½ cups (375 ml) heavy cream

1½ cups (375 ml) half-and-half

6 large egg yolks

½ cup plus 2 tablespoons (210 g) honey

Pinch of kosher or sea salt

GALETTE DOUGH:

2 cups (250 g) unbleached all-purpose flour, plus more for dusting

2 teaspoons granulated sugar

¾ teaspoon salt

½ cup plus 7 tablespoons (230 g) unsalted butter, chilled, cut into small pieces

¼ cup (60 ml) ice-cold water

WALNUT FILLING:

1 cup (100 g) walnut halves

3 tablespoons granulated sugar

1 tablespoon packed brown sugar

1 tablespoon unbleached all-purpose flour

¼ teaspoon kosher or sea salt

3 tablespoons unsalted butter, softened

1 large egg

½ teaspoon vanilla extract

2 pounds (1 kg) heirloom apples, such as Golden Delicious, Gravenstein, Jonathan, or Newtown Pippin

1½ tablespoons fresh lemon juice

2 tablespoons granulated sugar

1 large egg, lightly beaten

2 teaspoons decorative sparkling sugar

Warm honey, for glazing

Make the ice cream: Prepare an ice bath in a large bowl. In a saucepan, whisk together the cream and half-and-half. Bring just to a simmer over medium-low heat, whisking occasionally to keep the mixture from scorching. Meanwhile, in a large bowl, whisk together the egg yolks, honey, and salt until well blended and noticeably paler. Gradually whisk in half of the hot cream mixture to warm the eggs, then transfer the contents of the bowl to the saucepan, whisking constantly. Cook, stirring constantly with a wooden spoon, until the mixture visibly thickens and registers 180°F (82°C) on an instant-read thermometer. Do not allow the custard to boil or it will curdle. Remove from the heat and place the saucepan in the ice bath. Stir frequently until cool, then transfer the custard to a bowl, cover, and chill thoroughly.

Freeze the custard in an ice-cream machine according to the manufacturer's directions. Transfer to an airtight container and store in the freezer until serving.

Make the galette dough: Put the flour, granulated sugar, and salt in a food processor and pulse a few times to blend. Add half of the butter and pulse a few times until the fat is evenly distributed and coated with flour. Add the remaining butter and pulse a few times, just until the fat is coated with flour and about the size of large peas. Add the ice-cold water and pulse briefly until the dough just begins to come together; do not overmix.

Turn the dough out onto a work surface and gather together with your hands. You may need to knead it

(continued next page)

very gently to get it to hold together, but do not over-work it. Transfer it to a large sheet of plastic wrap, enclose it in the wrap, and then use the wrap to help you pat and shape the dough into a disk about ¾ inch (2 cm) thick without it sticking to your hands. Refrigerate for 1 hour.

Make the walnut filling: Preheat the oven to 350°F (180°C). Spread the walnuts on a rimmed baking sheet and toast until lightly colored and fragrant, about 15 minutes. Pour onto a plate to cool. Put the walnuts, granulated sugar, brown sugar, flour, and salt in the food processor and pulse until the walnuts are as fine as meal. Add the butter and pulse until blended, then add the egg and vanilla and pulse until blended and smooth, scraping down the sides of the bowl once or twice. Transfer the filling to a bowl.

Raise the oven temperature to 425°F (220°C). If you have a pizza stone, put it in the oven on the middle rack to preheat for at least 30 minutes before baking.

Peel, quarter, and core the apples. Cut lengthwise into slices about ¼ inch (6 mm) thick and transfer to a bowl. Sprinkle with the lemon juice and granulated sugar and toss the apple slices to coat evenly.

Remove the galette dough from the refrigerator and let stand until it is soft enough to roll out without crumbling, 10 to 15 minutes.

Cut two sheets of parchment paper at least 16 inches (40 cm) square. Place one sheet on a work surface and dust lightly with flour. Unwrap the dough and set it on the floured parchment. Lightly dust the top of the

dough with flour and lay the second parchment sheet on top. With a rolling pin, roll out the dough into a 15-inch (38 cm) circle of even thickness. To keep the dough from sticking to the parchment, frequently flip the dough with its parchment cover, lifting the parchment sheets and flouring the dough lightly under them each time. Use as little flour as possible to prevent sticking.

When the dough is 15 inches (38 cm) round, remove the top sheet of parchment and slide a rimless baking sheet or pizza peel under the dough, still resting on the bottom sheet of parchment. Spread the walnut filling evenly over the surface, leaving a 2- to 2½-inch (5 to 6 cm) border all around.

Top the walnut filling with the apple slices, placing them in concentric circles and overlapping the slices slightly. Fold the exposed dough over the apples to make a wide rim. (If the dough is sticking to the parchment, slide a palette knife or chef's knife between the dough and the parchment and use the knife to help you flip the dough over the apples.) Brush the rim with the beaten egg and sprinkle with the sparkling sugar. With scissors, trim the excess parchment. Slide the galette, still on the parchment, off the baking sheet and onto the preheated baking stone, if using, or bake directly on the baking sheet.

Bake until the crust is golden brown and the apples are tender and lightly browned on the edges, about 45 minutes. Remove from the oven and brush the apples with just enough honey to make them glisten. Transfer the galette to a rack to cool for 20 minutes before slicing. Serve warm with the honey ice cream.

FROM THE
SIERRA FOOTHILLS
Big Flavors from Old Vines

T he discovery of gold in the Sierra Nevada Foothills in 1848 lured a flood of starry-eyed immigrants to California, not yet a state. More than three hundred thousand people eventually arrived, hoping to make their fortune, and some of these hardworking miners liked to drink. By 1856, an entrepreneurial Swiss immigrant had planted the first grapevines in the Sierra Foothills, in the Shenandoah Valley, demonstrating that there was more than one way to profit from the gold rush. By the turn of the century, the region had more than one hundred wineries, with Zinfandel already the leading grape.

Prohibition brought an end to most of the wineries, although some vineyards survived, their grapes destined for home

LEFT: A thick cover crop carpets the vine rows at Starfield Vineyards in El Dorado County.

winemakers or sacramental use. Consequently, the Sierra Nevada Foothills AVA—a narrow appellation that runs 170 miles (275 km) across eight counties, from Yuba County in the north to Mariposa County in the south—has some of the oldest, gnarliest vines in the state. Turley Wine Cellars still harvests Zinfandel from Amador County's Judge Bell Vineyard, planted in 1907.

Thriving on the western slopes of the Sierra Nevada, most Sierra Foothills vineyards lie at elevations between 1,500 and 3,000 feet (457 and 915 m). Many towns, like Sutter Creek and Placerville, retain an Old West charm, and most of the wineries here are small and family run. Amador County's annual Four Fires Festival, typically in May, showcases open-flame cooking and provides an enjoyable opportunity to taste a variety of the county's wines.

In many parts of the region, such as Placer County, orchards far outnumber vineyards. Walnuts top the list of fruit and nut crops in much of the region, with mandarin oranges on the rise in Placer County.

BELOW: (from left) In Nevada City, the National Hotel is a registered historical landmark and the oldest continuously operating hotel west of the Rockies; wine tasting in Amador County

RIGHT: (clockwise from top) Old-vine Zinfandel; mountain vineyard in El Dorado County; local walnuts and grapes; sheep provide natural weed control in a Sierra Foothills vineyard

SIERRA FOOTHILLS WINES

The early Sierra Foothills grape growers got it right: Zinfandel belongs here. This heat-loving variety responds well to the region's elevated summer temperatures, as do other warm-climate grapes like Tempranillo, Cabernet Sauvignon, and Barbera. Zinfandel accounts for about one-third of the grape crush, with Cabernet Sauvignon a distant second. Red grapes predominate in the appellation, but white Rhône varieties, such as Viognier and Roussanne, also produce impressive wines here.

The vineyards are high enough to benefit from breezes that vanquish mildew, while the climate is hot enough to bring Zinfandel to full ripeness. Cool evenings help the grapes retain their natural acidity. Soils vary from ruddy, iron-rich volcanic to granite, but they are universally well draining and low in fertility, so vines must send their roots deep for water and nutrients. Yields are low from these hardworking vines, but the fruit flavor is correspondingly intense.

NEVADA COUNTY

PLACER COUNTY

EL DORADO COUNTY

AMADOR COUNTY

CALAVERAS COUNTY

Stylistically, Zinfandels from the Sierra Foothills AVA have no readily identifiable signature. Historically, the region has a reputation for big, jammy, robust wines, relatively high in concentration, but some vintners are aiming for a more refined style. In general, the red wines tend to be good companions for grilled red meats and hearty dishes in the Mediterranean spirit. At their Four Fires Festival, Amador vintners pay homage to grape varieties from Spain, southern France, and Italy, so it's hardly surprising that their wines work so well with foods inspired by these regions.

LEFT: (clockwise from top left) Turley Wine Cellars in Amador County; El Dorado County cattle; California poppies beautify Madroña Vineyards in El Dorado County; vineyards in Calaveras County

ABOVE AND RIGHT: Grilled meats, live music, and free-flowing Zinfandel draw fans to the outdoor events at Turley Wine Cellars. Vintner Larry Turley enjoys a glass of Zin before donning an apron to man the barbecue.

AMADOR COUNTY
TURLEY WINE CELLARS

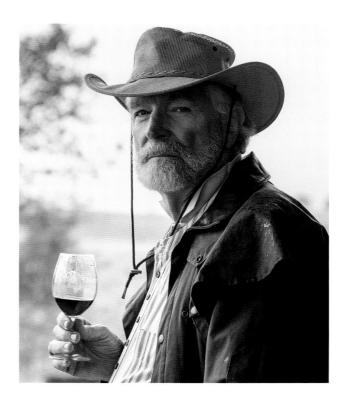

Despite his renown for elevating the stature of old-vine Zinfandel, Larry Turley would rather talk about something else. Ask him about vineyard soils, about dry farming, about the superiority of head-pruned vines. But invite him to describe what he tastes in one of his sought-after wines and he will likely demur.

Other winemakers readily pontificate about silky tannins and the scent of cassis, but Turley dislikes dissecting wine in that manner. "You're going to have to talk to Tegan about that," he says, deferring to his director of winemaking, Tegan Passalacqua. Turley, a plainspoken southerner from humble roots, doesn't do winespeak.

But if the subject is live-fire cooking and the synergy between mountain Zin and grilled lamb, he turns almost poetic. "I like to cook with fire," says the winemaker, who admits to owning, at last count, seven grills and four smokers. "Fire-kissed dishes go with mountain wines."

The proprietor of Turley Wine Cellars is a former emergency-room doctor, a towering 6 feet 6 (2 m) and lanky, with a radio-worthy baritone and a slow, honeyed drawl. An avid cook and protégé of Argentinean grill master Francis Mallmann, Turley prizes simplicity and seasonality over showmanship. ("'Spontaneous' would be kind," he says about his own kitchen style.) But whether he's preparing ceviche—a favorite—or grilling beef tri-tip, he's probably drinking Zin.

EXCEPTIONAL FOOD WINES "Zins are the most fabulous food wines in the world," claims Turley. He should know. Turley makes twenty-four different bottlings of that varietal, from vineyards throughout the state. With seafood, he favors the more lightly structured Zins from grapes grown in sandy soil. The granite soil in Plymouth, in the scenic Sierra Foothills of Amador County, yields wines with a strong backbone, perfect with ribs from his smoker.

At Turley's Plymouth winery, one of three he operates in the state, the crew vinifies Zinfandel grapes from each parcel in the same minimalist manner; any differences in the vineyard-designated bottlings reflect the site. The surrounding Amador County parcels that supply Turley grapes range in soil type from iron-rich volcanic to flaky schist to granite.

"The Amador County foothills have some of the most complex geology in the state," says Turley. "And we still have work to do to understand what the soil gives."

Capturing that essence in a bottle is what the best winemakers do, according to Turley. Born on an organic cotton and tobacco farm in Tennessee, the vintner remains devoted to his parents' natural methods. He is also a fierce protector of old vineyards, convinced that they withstand heat and drought better and deliver more balanced wines. The vineyard that yields Turley's Judge Bell Zinfandel was planted in 1907 and, despite some replanting, the average vine age is still eighty years.

His crew vanquishes weeds with shovels or with a mechanical cultivator that senses the vine's trunk and skirts around it. In these heritage vineyards, a fatal nick from a wayward plow is painful to contemplate. "You do that in front of a person whose grandfather planted the vineyard, they cry," says Turley. "We view these old vines as irreplaceable."

FEELING LIFE UNDERFOOT Cover crops replenish the soil each year, while worm castings and compost tea get new vines off to a healthy start. Once established, young vines get nothing more to drink beyond what nature provides; so-called dry farming forces roots to plunge deep. Walk between freshly tilled rows here and the ground feels springy, not hard and compact. "That's a sign of soil health," says Passalacqua. "You can almost feel the life under your feet."

In modern vineyards, most grapevines are trained on trellises, but the old Zinfandel vineyards that Turley loves are largely head pruned, an old-world practice that permits the vines to sprawl. A head-pruned vineyard may

look unruly, but there is a method to it. Viewed from above, a head-pruned vine should have a wagon-wheel form, with evenly spaced arms that admit sun and wind from every direction and with just enough leaf canopy to create dappled light. As in politics, sunlight is the best sanitizer. Before there were chemicals for mildew control, growers relied on sun and wind. Turley takes the same natural approach, pruning to hit the happy medium between not enough sun on the grapes and too much.

Gradually, Turley is modifying the existing winery he purchased, adding solar panels and creating a canopy over the sorting table to enhance worker comfort. The former owner had excess cellar capacity and stacked his barrels only three high. Turley took one look and saw wasted energy. "If you're going to cool and humidify a room, then more barrels keep it cooler," says the vintner. "You use a lot less energy when there's critical mass." By installing more racks, he accommodated more barrels and lowered his energy draw.

In lieu of a mission statement, Turley Wine Cellars highlights values. Having fun is a core value, as is generosity and continued education. In practice, these written principles mean Turley will cover state-college tuition for any employee's children. He has done so for four young people already and hopes to help the forty-eight more who might qualify.

"Many people work for nasty bosses," he says, citing his father's civil-service career. "You can learn to be like them, or you can say, 'When I have the chance, I won't be like that.'"

ABOVE: (left to right) Larry Turley helps man the grill at many winery events; Turley Zinfandel planting; when properly head-pruned, Zinfandel has an open, wagon-wheel shape

FOLLOWING PAGES: Turley Wine Cellars Zinfandel vineyard in Amador County

GREAT REDS FROM GOLD COUNTRY

Gold mines brought fortune seekers to the Sierra Foothills in 1849, and vineyards soon sprang up to slake the miners' thirst. Many of these new settlers planted Zinfandel, and within a few decades, the Amador County's Shenandoah Valley was California's leading wine region, with more than one hundred wineries.

Although Prohibition shuttered most of the wineries, a handful of the mid-nineteenth-century Zinfandel vineyards still survive in Amador County. Documents suggest that the Original Grandpère Vineyard in Plymouth was planted by 1869, making it the oldest Zinfandel vineyard in the state. The vineyard's owner, Terri Harvey, believes that many of the vines are original.

Amador County, one of California's tiniest, remains the "mother lode" for many Zinfandel fans. The variety accounts for two-thirds of the county's wine grapes, and enthusiasts seek out bottlings from the Sierra Foothills and Shenandoah Valley AVAs. Most of the vineyards are on hillsides, at elevations from 1,200 to 2,000 feet (365 to 610 m), and benefit from cooling late-afternoon breezes from the Sierra Nevada.

Although the region has a reputation for yielding robust, powerful, almost rowdy Zinfandels, a signature style is hard to pin down. Turley Wine Cellars winemaker Tegan Passalacqua describes Amador County Zinfandels as "pretty wines" that "are all about red fruit." Others find aromas such as licorice, chocolate, and graphite. Soils are complex and varied—some volcanic, some granitic—and young vineyards tend to produce more vivid fruit character than the centenarians. The stylistic range makes it likely that every wine enthusiast will find an Amador Zinfandel to love.

SIERRA FOOTHILLS HARVEST

When it comes to farming, wine grapes are the big story in the Sierra Foothills today. They are the number-one crop in Sacramento and Amador Counties; no other fruit or vegetable comes close in dollar volume. Farther north, in Butte County, walnut, almond, and plum orchards dominate the farm economy, cloaking the landscape around Chico and Gridley with clouds of white blossoms in spring.

In the wake of the gold rush and the establishment of communities throughout the Sierra Foothills, settlers planted peaches, cherries, figs, plums, and apples in these high-elevation settings. The trees thrived there, producing mountain fruit famed for its flavor. Small pockets of mountain-grown fruit persist from holdouts, such as the celebrated Goldbud Farms in Placerville. Until disease claimed the farm's cherry trees in the late 1990s, Goldbud Farms's plump sweet cherries were legendary. Today, owner Ron Mansfield focuses on apples, pears, nectarines, and peaches and claims that the long, slow growing season explains his fruit's exceptional size and taste.

LEFT: (clockwise from top left) Since gold rush days, stone fruits and nuts have been important crops in the Sierra Foothills. Orchards produce luscious peaches, nectarines, plums, almonds, and walnuts.

RECIPES

Golden State Granola

Dried Plum–Buttermilk Smoothie

Peach and Rhubarb Jam

Walnut and Green Olive Dip with
Pomegranates and Pistachios

Pappardelle with Walnut-Kale Pesto

Red Wine–Braised Duck Legs with Dried Plums

Almond, Orange, and Olive Oil Cake

Nectarines in Raspberry Wine Sauce with
Toasted Almond and Anise Biscotti

DRIED PLUMS

Harvested when they are almost one-quarter sugar, amber-fleshed French plums are a summer-only fresh treat. But by drying them, California growers enable consumers to enjoy them year-round as a healthy snack or plump embellishment to a stew. These dried plums—known to many as prunes—concentrate all the sweetness in the fruit on harvest day, preserving it for future enjoyment.

Today, the Sacramento Valley produces about 80 percent of the nation's crop, with the remainder coming from the San Joaquin Valley. Old-timers still recall prune trees in Napa and Sonoma Counties before grapes staked their claim; today, Sutter and Butte Counties lead the pack.

The industry instituted the name change—from prunes to dried plums—in part because many consumers were unaware that prunes are plums. The preferred variety for drying is a small, egg-shaped French plum that withstands the warmth of the dehydrator without turning to jam.

HARVEST: Growers schedule the harvest as soon as the fruits develop sufficient sugar and begin to soften, typically in mid-August. In California, sun drying is a thing of the past. Immediately after harvest, trucks transport the plums to the drying facility, and within twenty-four hours they are warm, soft, and wrinkled. Placed in cool storage, they are steamed, pitted, and packed to order. Only about 5 percent of dried plums are sold with pit intact.

SELECTION AND STORAGE: Growers receive a higher price for larger plums because jumbo dried plums are so prized. From a bulk bin, dried plums should look relatively moist and plump; a dusting of white on the outside is sugar, a promising sign. Store dried plums in an airtight container in a cool, dark place; they should keep for months. In a warm, humid climate, refrigerate them for longer keeping.

KITCHEN TIPS: Simmer dried plums in water to cover until softened, sweeten if desired, then chill and enjoy for breakfast with a dollop of yogurt. Add to braised chicken, rabbit, brisket, or pork.

PEACHES AND NECTARINES

California harvests more peaches and nectarines than the rest of the nation combined. Although most of the commercial crop is in the Sacramento and San Joaquin Valleys, a few small, high-elevation orchards in the Sierra Foothills produce peaches that are especially prized. The cool nights allow the fruit to mature slowly and grow large, achieving a pleasing balance of sweetness and acidity.

Nectarines, all but unknown until the 1950s, are simply peaches without the fuzz, due to a recessive gene. The popularity of white-fleshed peaches and nectarines is even more recent, thanks in large part to the work of California fruit breeder Floyd Zaiger. He helped introduce these delicate, highly fragrant, low-acid fruits from Europe to California orchards in the 1990s.

TOP VARIETIES: Breeders have developed dozens of peach varieties to extend the harvest season from May to October. The state's acreage is roughly equally divided between clingstone and freestone types. Juicy clingstones—so-called because the flesh clings to the pit—show up in mid- to late summer, but most of the harvest goes to processors for canning and drying. Among the best-tasting freestone varieties are O'Henry, Elberta, Suncrest, and the white-fleshed Babcock. Among nectarines, the yellow-fleshed Fantasia and white-fleshed Arctic Rose are standouts.

SELECTION AND STORAGE: Let fragrance be your guide when selecting peaches and nectarines. If they have little or no aroma, put them back. Firm peaches and nectarines will soften at room temperature within a day or two. Enjoy them as soon as they give to gentle pressure. If the fruits are dead ripe, refrigerate them, but for best flavor, bring to room temperature before eating. White peaches and nectarines are easily bruised; handle them gently to prevent blemishes.

RECIPE TIPS: For a wholesome snack, nothing beats a ripe peach or nectarine bursting with sweet juice. But these stone fruits enhance savory dishes, too. Slice them into green salads along with nuggets of goat cheese, or drape slices with prosciutto or *serrano* ham for a summer first course.

ALMONDS

Covering almost 500,000 acres (202,350 ha), almond trees blanket the state's interior valleys with cotton candy–like clouds during bloom. They are California's number-one nut crop, in acreage and value, and the number-one export crop, too. An ambitious sustainability program funded by the state's growers has helped them reduce water use dramatically and support research on critical issues like the health of honey bees.

FROM BLOOM TO YOU: Almonds are among the first fruit or nut trees to bloom each year, opening their buds between late February and early March. The delicate blossoms require bees for pollination, keeping commercial beekeepers moving their hives from orchard to orchard throughout the bloom period. By late spring, the young almond resembles a small, hard, fuzzy green apricot. In midsummer, the hull splits open naturally so the nut inside, still in its shell, can dry. A mechanical harvester shakes the nuts from the trees in late summer to early fall; processors remove the spongy hull and hard ivory shell, then the nuts are sorted by size. Some markets carry unshelled nuts in the fall, a great treat. Get out a nutcracker, open a bottle of wine, and enjoy the sweet flavor of new-crop almonds.

STORAGE: Put whole raw almonds in a lidded container or resealable plastic bag and keep in a cool, dark, dry place. They will stay fresh for at least one year. Refrigerate or freeze blanched, sliced, or slivered almonds to slow oxidation; they should retain quality for at least six months. Once toasted, keep in an airtight container in a cool place and use within two weeks.

TOASTING FOR FLAVOR: Keep home-toasted almonds in the pantry for a quick, wholesome snack or hors d'oeuvre. With a jar of crunchy toasted almonds in the pantry, you are always ready for drop-in guests at wine time. For an easy but irresistible dessert, set out a bowl of toasted almonds and a bar of fine bittersweet chocolate, broken into bite-size pieces.

LEFT: (clockwise from top left) Almonds ready for harvest; freshly shelled almonds; almond blossoms and pollinator bee; spring bloom in an almond orchard

WALNUTS

With more than four thousand growers, California walnuts dominate the international stage, filling 75 percent of the world's walnut needs. At maturity, the trees are massive and graceful, with thick canopies that cast plentiful shade. They don't yield a crop until five to seven years after planting, but a healthy walnut tree will bear for decades, producing 100 to 200 pounds (45 to 90 kg) of unshelled nuts annually. California grows the English walnut, not the black walnut common to other parts of the country.

Breeders have made big improvements in disease resistance so growers can minimize treatments. The use of soil-moisture sensors and targeted drip irrigation has reduced water needs dramatically.

HARVEST AND PROCESSING: Walnuts develop inside a thick, spongy green husk; when the husks start to dry and split open, it's time for harvest. From late August until November, mechanical shakers lumber through the orchards, agitating the trees until the walnuts drop. They are gathered and taken to a facility that removes the husks and dries the nuts to a target moisture level. Another processor cracks and shells them mechanically, then sorts the halves from the bits; nuts shipped in shell are simply sized, washed, and bagged.

PURCHASING POWER: Save money by purchasing nuts from bulk bins in stores that turn their nuts over quickly. Small packages of nuts fetch a premium.

SELECTION AND STORAGE: Nuts in the shell should feel heavy for their size. They make a delightful and wholesome autumn dessert with a wedge of cheese and some red wine. When purchasing shelled walnuts in bulk, sample one to make sure it does not taste rancid, as the oil in walnuts oxidizes quickly. Light brown walnuts come from the early harvest; dark nuts were likely harvested late in the season.

Keep in-shell nuts in a cool, dry place. Shelled nuts will last several months if refrigerated or frozen in an airtight container. Toast them shortly before using and don't chop them until you need them.

TAYLOR BROTHERS FARMS
DRIED PLUMS

A warm, wrinkled plum, just out of the drying oven, is one of the most succulent pieces of fruit imaginable. Eighteen hours in the oven's steadily decreasing heat have concentrated its flavor, leaving it moist, slightly chewy, and deeply sweet, like sun-warmed jam.

"My father-in-law eats ten prunes a day, in his oatmeal," says John Taylor, whose family business, Taylor Brothers Farms, is the world's largest producer of organic prunes. (The industry's marketing experts prefer the term "dried plums," but to a grower they are still prunes and nothing to laugh at.)

With his brother, Richard, John manages more than 1,000 acres (400 ha) of Improved French plum trees in California's Sutter County, a heavily agricultural region carpeted with fruit and walnut orchards. Instead of the bare, tilled dirt that used to be the hallmark of a well-run operation, the ground under the Taylors' trees is a green thicket of weeds, wildflowers, and cover crop. Since transitioning to organic methods in 1990, the brothers have learned to live with the unkempt appearance of an herbicide-free farm. Their payoff is soil that is healthier than ever.

ONE TREE, FIVE THOUSAND FRUITS "My fertility program is compost, cover crops, fish fertilizer, and heat-treated chicken manure," says John. All are natural, yet costly, contributors to the microbial life of his soil and the longevity and productivity of his orchard. A mature tree in a good year can yield five thousand plums, hanging in clusters so profuse that branches threaten to break under the weight.

Luther Burbank introduced the Improved French plum in 1898, and for drying it has never been surpassed, says John. The golden flesh is dense, meaty, and sugary, and the powdery, amber-flecked purple skin remains intact during the lengthy drying. (One tasty but thin-skinned variety, an attempted improvement by breeders, melted in the dryers.)

LEFT: A prolific crop of Improved French plums at Taylor Brothers Farms is destined for drying. Sweet and succulent when fresh, the meaty plums hold up well in the heat of a commercial dehydrator.

ABOVE: Taylor Brothers' organically farmed plum trees

Taylor aims to harvest when the plums reach 24°Brix, a measurement indicating the fruit is almost one-quarter sugar. By mid-August, the mechanical shakers are snaking their way through the orchard rows, grabbing each tree one at a time and jostling its fruits loose and into a receiver, then onto a conveyor belt where a fan dispatches leaves and twigs then directs the fruits into a bin. Ten seconds later, the rig moves to the next tree.

"When I was little, prunes were hand-picked," says John. "The men knocked the fruit off with a maul, like a sledgehammer with a rubber head, and the women and kids picked the fruit up. You had to kneel to collect everything." Mechanical harvesters are vastly more efficient and ergonomic; a four-person crew can harvest 15 acres (6 ha) a day.

WAITING FOR WRINKLES

At the drying yard, the plums are rinsed in a dip tank, then spread on trays. The trays are stacked on carts and rolled into the drying tunnels, where the plums will slowly give up their moisture, lose two-thirds of their weight, and develop their signature wrinkles.

Weeks or months later, as orders arrive, the dried plums will be steamed to soften them, then pitted mechanically. Alas, the demand for unpitted dried plums has plummeted in recent decades, although connoisseurs like the Taylors prefer them.

In the past, the sugary processing water was pumped to aeration ponds so it could be treated and reused for irrigation. But Taylor Brothers Farms has embraced a new technology, a clever water-treatment system that relies on nature's hardest-working creatures. Now the sugary water is filtered to remove solids, then sprinkled over thick, layered beds of earthworms, wood shavings, and river rock. The industrious worms digest the biomass and produce their valuable castings; the water filters through the layers, emerging fit for orchard use. With no need for the high-horsepower motors that aeration ponds require, the worm-powered system produces huge energy savings, says John. Solar panels have also slashed the farm's energy bills, now a whopping nineteen dollars a year.

The brothers export much of their dried fruit—to Europe, Japan, and Korea. Europeans consume a lot of dried-plum yogurt, says John, and often braise meat with dried plums. For his part, he enjoys his dried plums stuffed with almond paste or chopped into salads, and a jar is always on his kitchen counter for a quick hand-to-mouth snack.

ABOVE: (clockwise from top left) Brothers John (left) and Richard Taylor inspect a plum tree in bloom; cover crop blankets a flowering plum orchard, smothering weeds; Feather River slough provides irrigation water; plump dried plums

FOLLOWING PAGES: (left) The spring bloom in Sutter County's plum orchards is a captivating sight, the dark, graceful tree branches flecked with tufts of white. (right) Happy bees swarm a hive in a blooming plum tree.

GOLDEN STATE GRANOLA

MAKES 4 QUARTS (4 L)

This irresistible granola was adapted from the version served at the luxurious Auberge du Soleil in Napa Valley. Nuts and long, slow baking make it extra crunchy.

½ pound (250 g) walnuts (about 2½ cups)

1¼ cups (125 g) sliced or slivered almonds

6 cups (550 g) rolled oats

1¾ cups (100 g) wheat bran

1 cup (80 g) unsweetened shredded dried coconut

½ cup (70 g) raw pumpkin seeds

1 teaspoon kosher or sea salt

¾ cup (180 ml) canola oil

½ cup (185 g) honey

½ cup (110 g) packed brown sugar

2 tablespoons vanilla extract

1 teaspoon ground cinnamon

½ pound (250 g) pitted dates, coarsely chopped

Preheat the oven to 350°F (180°C). On separate rimmed baking sheets, toast the walnuts and the almonds until lightly colored and fragrant, 15 to 20 minutes for the walnuts and 12 to 14 minutes for the almonds. Let cool, then chop the walnuts. Reduce the oven temperature to 250°F (120°C).

In a large bowl, combine the oats, bran, coconut, pumpkin seeds, and salt. Stir well. In a medium bowl, whisk together the oil, honey, brown sugar, vanilla, and cinnamon. Add the liquid ingredients to the dry ingredients and stir until thoroughly combined.

Line two heavy rimmed baking sheets with parchment paper. Divide the mixture evenly between the baking sheets and spread into an even layer. Bake, stirring every 30 minutes or so and switching the placement of the baking sheets in the oven if necessary so the granola cooks evenly, until golden brown, about 2 hours.

Let cool completely. Stir in the walnuts, almonds, and dates, then mix well with your hands to break up any clumps of dates. Store the granola in an airtight container at room temperature for up to 6 weeks.

DRIED PLUM–BUTTERMILK SMOOTHIE

MAKES 1½ CUPS (375 ML); 1 LARGE OR 2 SMALL SERVINGS

You can make a low-fat, high-fiber breakfast in 5 minutes if you keep buttermilk on hand and bananas in the freezer. Let bananas ripen fully, then peel, cut in half, and freeze. The combination of dried plums and banana yields a luscious smoothie the color of a caramel latte.

1 cup (250 ml) buttermilk

6 pitted dried plums

½ frozen ripe banana (see note), cut into small chunks

1½ teaspoons packed brown sugar

⅛ teaspoon vanilla extract

Pour the buttermilk into a blender and add the plums, banana, sugar, and vanilla. Blend until completely smooth. Pour into 1 or 2 glasses.

PEACH AND RHUBARB JAM

MAKES 3 PINT (500 ML) JARS

Peaches rarely make a satisfying jam on their own. They need a tart partner, like rhubarb, to heighten their flavor. Together, this summer duo yields an unusual preserve that you will delight in gifting, but be sure to stock your own pantry, too. No jam is more appealing with English muffins, hot corn bread, or whole-grain toast. A spoonful in yogurt is sublime as well. The lemon seeds add natural pectin; extract them from a halved lemon with the tip of a small knife and use the rest of the lemon for juicing.

5 cups (1 kg) peeled, pitted, and chopped peaches (about 8 medium peaches)

4 cups (500 g) trimmed and diced rhubarb, in ⅓-inch (9 mm) dice

5 cups (1 kg) sugar

24 lemon seeds, in a cheesecloth bag or tea strainer

Combine the peaches, rhubarb, and sugar in a large bowl. Stir well. Cover and let stand for 12 hours, stirring occasionally, to draw out the peach juice and dissolve the sugar.

Transfer the mixture to a heavy 8-quart (8 l) pot. Add the lemon seeds in the bag or strainer. Bring to a boil over medium heat, stirring often and skimming any surface foam. Adjust the heat to maintain a steady but gentle boil and cook, stirring occasionally to prevent the fruit from sticking to the bottom of the pot, until the mixture thickens to a jam consistency, about 30 minutes. The jam is ready when it registers 220°F (105°C) on an instant-read thermometer. You can also test for doneness by slipping a couple of saucers into the freezer while the jam cooks, then spooning a little of the cooked jam onto a chilled saucer and returning the saucer to the freezer for a couple of minutes to cool quickly. The jam should firm to a soft jelly consistency. If it has not thickened enough, cook for a few minutes longer, then test again on another chilled saucer.

Have ready three sterilized pint (500 ml) canning jars and new lids with screw bands. Remove the cheesecloth bag or tea strainer. Spoon the hot jam into the jars, filling to within ½ inch (12 mm) of the top. Wipe the rim clean with a towel dipped in hot water. Top the jars with the lids and twist on the screw bands.

Set the jars, not touching, on a rack in the bottom of a pot. Fill the pot with water to cover the jars by 1 inch (2.5 cm), cover the pot, and bring the water to a boil over high heat. Boil for 20 minutes, then turn off the heat and use tongs to transfer the jars to a rack to cool.

Let the jars cool completely, then press on the center of each lid. If the lid remains concave, the seal is good. Store the jars in a cool pantry for up to 1 year. If a lid fails the seal test, store the jar in the refrigerator for up to 3 weeks.

WALNUT AND GREEN OLIVE DIP WITH POMEGRANATES AND PISTACHIOS

MAKES ABOUT 2 CUPS (330 G)

This Middle Eastern dip is captivating. Scoop it up with store-bought pita chips, warm pita triangles, or crisp lettuce hearts. A garlicky tahini dressing brings all the elements together. Add more jalapeño chile if you want the dip spicier, or more pomegranate molasses if you want it sweeter.

WINE SUGGESTION: *California rosé or sparkling wine*

²/₃ cup (125 g) pitted and diced green olives (about 24 olives)

½ cup (60 g) chopped toasted walnuts

½ cup (80 g) pomegranate arils (seeds)

¼ cup (30 g) coarsely chopped roasted pistachios

¼ cup (10 g) chopped fresh cilantro

2 green onions, white and pale green part only, minced

½ jalapeño chile, seeded and finely minced

½ teaspoon pomegranate molasses

1 small clove garlic, finely minced

Kosher or sea salt

DRESSING:

¼ cup (60 g) tahini, stirred until smooth before measuring

3 tablespoons cold water

2 tablespoons fresh lemon juice, or more if needed

1 tablespoon finely minced fresh cilantro

1 small clove garlic, finely minced

Kosher or sea salt

2 heads Little Gem lettuce, romaine hearts, or Belgian endive, separated into individual leaves, and/or pita chips

In a bowl, combine the olives, walnuts, pomegranate arils, pistachios, cilantro, green onions, chile, pomegranate molasses, and garlic. Stir with a fork to blend. Season to taste with salt.

Make the dressing: In a bowl, whisk together the tahini, water, lemon juice, cilantro, and garlic. Season to taste with salt and add more lemon juice if desired. The dressing will thicken as it stands. Whisk in a little more cold water if needed to thin to a pourable consistency.

Spoon the dip onto a platter or into a bowl and drizzle with the dressing. Serve with lettuce hearts and/or pita chips and a spoon for scooping.

PAPPARDELLE WITH WALNUT-KALE PESTO

SERVES 4 TO 6

Unlike basil pesto, this kale pesto keeps its bright color for at least a day. Spoon it into a lidded container, press plastic wrap against the surface, and cap tightly. You can also use the pesto as a topping for crostini, bruschetta, or minestrone.

WINE SUGGESTION: *California Chardonnay or Pinot Gris / Grigio*

½ pound (250 g) Tuscan (lacinato) kale

1 cup (120 g) chopped toasted walnuts

1 large clove garlic, sliced

⅔ cup (160 ml) extra virgin olive oil

½ cup (35 g) freshly grated pecorino romano or Parmigiano Reggiano, plus more for serving

Kosher or sea salt

1 pound (500 g) fresh pappardelle or dried linguine

Cut out and discard the tough central rib from each kale leaf. Bring a large pot of salted water to a boil over high heat. Add the kale leaves and boil until tender, about 5 minutes. Drain and rinse under cold water to stop the cooking. Squeeze dry and chop coarsely. You should have about ¾ cup (75 g).

Put the kale, ½ cup (60 g) of the walnuts, and the garlic in a food processor and blend until finely chopped. With the motor running, add the olive oil gradually through the feed tube and blend until smooth, scraping down the sides of the work bowl once or twice. Transfer to a bowl and stir in the cheese. Season the pesto highly with salt.

Bring a large pot of salted water to a boil over high heat. Add the pasta and cook until al dente. Just before the pasta is done, scoop out ½ cup (125 ml) of the boiling pasta water and whisk it into the pesto to thin it. Scoop out and set aside another 1 cup (250 ml) of the pasta water. Then drain the pasta and return it to the warm pot off the heat. Add as much of the pesto as you like; you may not need it all depending on how well sauced you like your pasta. Toss with tongs, adding as much of the reserved pasta water as needed to keep the noodles from clumping.

Divide among individual bowls. Top each portion with a shower of cheese and with the remaining ½ cup (60 g) nuts, dividing them evenly. Pass additional cheese at the table. Serve immediately.

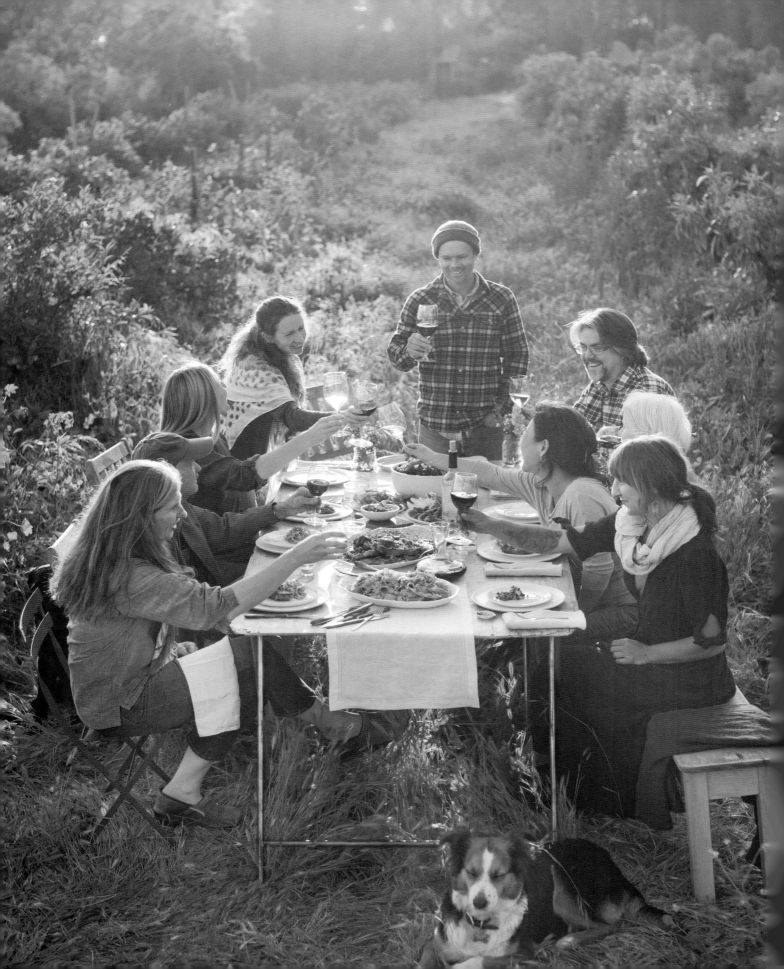

RED WINE–BRAISED DUCK LEGS WITH DRIED PLUMS

SERVES 4

Dried plums soften in the braising juices and contribute their sweet, fruity flavor as the duck legs slowly braise to tenderness. Red wine adds depth and a touch of acidity to balance the richness of the duck. Preliminary roasting renders most of the duck fat, which you can use to sauté turnips or carrots to serve alongside. Creamy polenta would also be an appealing companion.

WINE SUGGESTION: *California Merlot or Pinot Noir*

4 duck legs, about 2 pounds (1 kg) total

½ teaspoon black peppercorns

6 juniper berries

1½ teaspoons kosher or sea salt

½ cup (125 ml) dry red wine

½ bunch thyme sprigs, tied in a bundle with kitchen twine

12 cloves garlic, peeled

2 bay leaves

1½ cups (375 ml) chicken broth

12 pitted dried plums

2 tablespoons chopped fresh flat-leaf parsley

Trim any excess fat from the duck legs. In a mortar, pound together the peppercorns and juniper berries until medium-fine, then add the salt and pound until fine. Alternatively, finely grind the spices in a spice mill. Season the duck on both sides with the spice rub. Place the legs on a rack set inside a tray and refrigerate, uncovered, overnight.

Preheat the oven to 400°F (200°C). Remove the duck legs from the rack and arrange them in a single layer in a ceramic or terra-cotta baking dish. Roast for 1 hour. Remove the dish from the oven and leave the oven on. With tongs, set the duck legs aside on a plate and pour off the fat in the baking dish, reserving it for another use if desired.

Add the wine to the baking dish and deglaze with a wooden spoon, scraping up any meaty residue on the bottom of the dish. Return the duck legs to the baking dish. Put the thyme bundle, garlic cloves, and bay leaves in the dish. In a small saucepan, bring the broth to a simmer and pour it over the duck.

Return the baking dish to the oven and braise the duck legs for 15 minutes. Reduce the heat to 350°F (180°C) and add the dried plums. Baste the duck with the pan juices and push the dried plums down into the liquid. Continue to cook until the duck is very tender and the dried plums are soft, about 30 minutes longer.

Transfer the duck and dried plums to an ovenproof serving platter and keep warm in the turned-off oven. Discard the thyme bundle and bay leaves. Transfer the pan broth to a saucepan and cook over high heat until reduced to a sauce consistency (about ¾ cup/180 ml).

Spoon the sauce over the duck and dried plums. Garnish with the parsley and serve immediately.

ALMOND, ORANGE, AND OLIVE OIL CAKE

SERVES 8 TO 12

With a glass of dessert wine or extra-dry sparkling wine, this exceptionally tender cake needs no enhancement. Even so, no one could object to some lightly sweetened berries and a dollop of Greek yogurt alongside. Napa Valley cooking teacher Julie Logue-Riordan shared the recipe.

WINE SUGGESTION: *California dessert wine of any type or extra-dry sparkling wine*

1 cup (140 g) whole raw almonds
Unsalted butter for greasing the pan
¾ cup (80 g) twice-sifted cake flour
1½ teaspoons baking powder
Pinch of kosher or sea salt
4 large eggs
1 cup (200 g) sugar
1 teaspoon vanilla extract
Finely grated zest of 1 small navel orange or Meyer lemon
⅔ cup (160 ml) extra virgin olive oil
3 tablespoons sliced almonds (optional)

Preheat the oven to 325°F (165°C). Toast the almonds on a heavy rimmed baking sheet until golden brown inside, 25 to 30 minutes. Break one open to check for doneness. Let cool completely.

Raise the oven temperature to 350°F (180°C). Butter the bottom and sides of a 9-inch (23 cm) round cake pan, then line the bottom with parchment paper.

Put the whole almonds in a food processor with one-third of the cake flour and process until almost as fine as sand. In a bowl, whisk together the remaining cake flour, the baking powder, and salt, then whisk in the ground almonds until well blended.

In a stand mixer fitted with the whisk attachment, whip the eggs on high speed until well blended. Add the sugar gradually, then add the vanilla and orange zest. Continue whipping on high speed until the mixture triples in volume, about 3 minutes.

On low speed, add the flour mixture in three batches alternating with the olive oil and beating just until the batter is blended. Pour the batter into the prepared pan. Sprinkle the top evenly with the sliced almonds, if desired.

Bake until the cake is golden brown and just firm to the touch in the center, 40 to 45 minutes. Let cool in the pan on a rack for 10 minutes, then invert onto another rack, remove the parchment paper, and invert again. Finish cooling right side up on a rack. Transfer to a serving plate and cut into wedges to serve.

NECTARINES IN RASPBERRY WINE SAUCE WITH TOASTED ALMOND AND ANISE BISCOTTI

SERVES 6

Fresh raspberry puree stirred into white wine syrup yields a gorgeous garnet sauce. Add bite-size nectarine or peeled peach pieces to the chilled sauce for an easy height-of-summer dessert. The crunchy biscotti are irresistible on their own but even better when dipped in the wine sauce or in a little sweet wine. Pack them in a tin as soon as they are cool and hide them from yourself. They improve in flavor and texture after a day. Julie Marchini, the matriarch of the fig-growing Marchini family (page 169), makes similar biscotti with dried chopped figs in place of the raisins.

WINE SUGGESTION: *California Orange Muscat or late-harvest Semillon or Sauvignon Blanc*

1½ cups (375 ml) Gewürztraminer, Muscat, or other fragrant white wine, or more to taste

1 cup (250 ml) water

⅓ cup (65 g) sugar

6 ounces (185 g) raspberries (about 1⅓ cups)

3 large, ripe nectarines or peaches

BISCOTTI

1 cup (140 g) whole raw almonds

2 cups plus 2 tablespoons (250 g) sifted unbleached all-purpose flour, plus more for dusting

2 teaspoons baking powder

2 teaspoons whole aniseed

½ teaspoon kosher or sea salt

½ cup (125 g) unsalted butter, softened

1 cup (200 g) sugar

2 large eggs

1 teaspoon anise extract

1 teaspoon vanilla extract

2 tablespoons brandy

1 cup (145 g) raisins

In a small saucepan, combine 1 cup (250 ml) of the wine, the water, and the sugar. Bring to a simmer over medium heat, stirring to dissolve the sugar. Simmer until reduced to 1½ cups (375 ml). Transfer to a bowl, cover, and chill thoroughly.

Puree the raspberries in a food processor, then strain through a fine-mesh sieve into a bowl, pressing on the solids with a rubber spatula so only the seeds are left behind. Add the raspberry puree and the remaining ½ cup (125 ml) wine to the chilled wine syrup and stir to mix. If the wine sauce still seems too sweet, add a splash more wine. Re-cover and chill thoroughly.

Make the biscotti: Preheat the oven to 325°F (165°C). Toast the almonds on a heavy rimmed baking sheet until golden brown inside, 25 to 30 minutes. Break one open to check for doneness. Let cool completely.

In a bowl, whisk together the flour, baking powder, aniseed, and salt.

In a stand mixer fitted with the paddle attachment, beat the butter on medium speed until smooth and creamy. Gradually add the sugar, continuing to beat until the mixture is light. Add the eggs one at a time, beating after each addition until blended. Add the extracts and beat until well mixed. Reduce the speed to low and add the flour mixture in two batches alternating with the brandy, beating just until blended after each addition. Add the raisins and whole almonds and beat just until blended. Remove bowl from the mixer stand, cover the bowl, and chill the dough for 2 to 3 hours.

(continued next page)

NECTARINES IN RASPBERRY WINE SAUCE WITH TOASTED ALMOND AND ANISE BISCOTTI *(continued)*

Preheat the oven to 350°F (180°C). Line two rimmed baking sheets with silicone baking mats or parchment paper. On a floured work surface, divide the dough into three equal portions. It will be very sticky. Using your hands, shape each portion into a log 13 inches (33 cm) long, using as little flour as possible to keep the dough from sticking to the work surface or your hands. Put two logs on one baking sheet and one log on the second baking sheet.

Bake one baking sheet at a time until the logs are golden brown and firm to the touch, 20 to 25 minutes. (If you have two ovens, preheat them both and bake both pans at the same time.) Remove from the oven and let cool completely on the pan on a wire rack. Leave the oven on. Transfer the cooled logs to a cutting board and cut on the diagonal into slices ⅓ to ½ inch (9 to 12 mm) thick. Return the slices, one cut side down, to the baking sheet and bake until lightly colored, 10 to 15 minutes longer. Transfer to a rack to cool. Repeat with the second pan. You should have about 6 dozen biscotti.

About 1 hour before serving, halve and pit the nectarines or peel, halve, and pit the peaches. Cut into bite-size pieces and add them to the raspberry sauce. Cover and refrigerate until serving time.

With a slotted spoon, divide the nectarines or peaches among six martini glasses or other stemmed glasses. Top with the raspberry wine sauce, dividing it evenly. Serve immediately.

FROM THE
INLAND VALLEYS
America's Eden

Stretching for 450 miles (725 km), from Redding to Bakersfield, California's interior valley nourishes the nation. This incomparably productive basin represents only 1 percent of the country's farmlands yet produces one-quarter of its food. No wonder many refer to it as the Great Central Valley; in variety and output, no other agricultural region in the world compares.

Yet, in truth, it is not one vast valley but two: the Sacramento Valley and the San Joaquin Valley, watersheds whose main rivers merge at a delta that feeds into San Francisco Bay. Before California was a state, settlers recognized the potential in these valleys' alluvial soils and unrelenting sunshine.

LEFT: A Heringer Estates vineyard in the Clarksburg AVA in the Sacramento Valley

But the promise wasn't fully realized until the mid-twentieth century, with the construction of reservoirs and aqueducts to collect and direct the snowmelt from the Sierra Nevada. Nature is stingy in the San Joaquin Valley—some areas receive less than 10 inches (25 cm) of rain a year—but drip irrigation makes this semi-arid landscape bloom.

Today, the Inland Valleys include eight of California's top nine agricultural counties. (Monterey is the outlier.) And their diversity is mind-boggling. Farmers here harvest more than 250 different crops, from Asian basil to Zinfandel, a cornucopia that keeps adventuresome cooks in ingredient heaven.

Farming drives the Inland Valleys' economy, supported by the agricultural expertise at the University of California, Davis, and California State University, Fresno. The Sacramento Valley is a quilt of small family farms and vineyards, many of them models of sustainability. San Joaquin Valley growers tend to have larger enterprises and to embrace technology to conserve water and other resources.

BELOW: Adventure awaits the wine-loving visitor to Lodi; figs begin the color change that signals imminent harvest.

RIGHT: (clockwise from top left) Muscat cluster; chilled Verdelho, an up-and-coming white variety from Lodi's Lucas Winery; vineyard at dawn; old head-pruned vines

INLAND VALLEYS WINES

With some of the state's warmest viticultural regions and pockets of coolness as well, California's Inland Valleys can successfully grow almost any wine grape. Cool-climate lovers like Chardonnay thrive in the Clarksburg area, near Sacramento, benefiting from refreshing afternoon breezes from San Pablo Bay. In the warmer Lodi area, the bay influence lessens and wineries pride themselves on their full-bodied, old-vine Zinfandel.

For many years, grapes from these vineyards in the northern Sacramento Valley vanished into blends made by wineries elsewhere. Today, Lodi and the Sacramento–San Joaquin Delta are developing a premium-wine identity as growers build their own wineries and focus on quality over yield. Winemakers with long experience in the area, like Heather Pyle-Lucas (page 137), advocate for Lodi as a white-wine region, as well. Lodi Chardonnay is bright and crisp, like a pippin apple, says Lucas, and Albariño and Verdejo, popular white varieties from Spain, perform well, too.

SACRAMENTO VALLEY

LODI AND THE DELTA

MADERA COUNTY

SAN JOAQUIN VALLEY

As one of the state's older wine regions, Lodi boasts many multigenerational farming families with dozens of vintages under their belts. "You can't transfer that kind of knowledge in ag school," says Lodi vintner David Lucas.

The warm San Joaquin Valley produces more than half of the state's wine grapes, supplying much of the California wine that the nation enjoys. Grapes ripen early here and achieve the high sugar levels that sunlight brings. Chardonnay and Zinfandel are among the most widely planted varieties. Advances in rootstocks, trellising, and drip-irrigation techniques have had a dramatic impact on quality and are transforming the valley from a generic to a varietal wine producer.

LEFT: (clockwise from top) Sacramento Valley vineyard; whimsical fermentation tanks at Michael David Winery in Lodi; beehives at rest near a Lodi vineyard

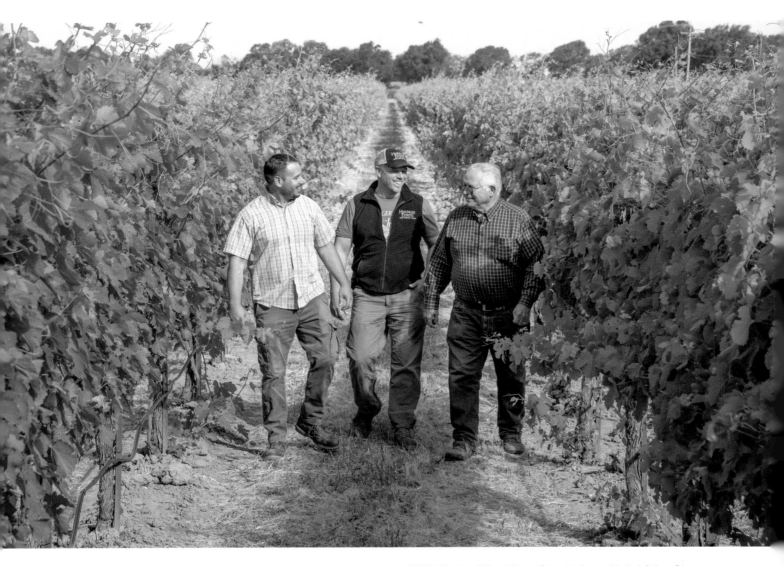

ABOVE: Brothers Mike (left) and Steve Heringer with their father, Steve, patrol their Clarksburg vineyard. Descendants of Dutch immigrants who settled in the area in the 1860s, the brothers are sixth-generation farmers, overseeing an operation that has transitioned over the decades from dairy cows to tomatoes to wine grapes.

SACRAMENTO VALLEY
HERINGER ESTATES

California, the mythic Golden State, has long lured drifters, dreamers, and immigrants. Among the latter, in 1868, were John and Geertje Heringa, Dutch dairy farmers looking for better opportunities for their growing family. An acquaintance in Clarksburg, a fellow Dutchman, sold them 30 acres (12 ha) on the Sacramento River Delta, launching their new, hope-filled lives as California dairy farmers.

Five generations later, brothers Mike and Steve Heringer (the family name was anglicized years ago) farm the same land, although the dairy cows are long gone. Today, Heringer Estates grows exclusively wine grapes—two dozen different varieties, from the little-known Teroldego to Tannat. The farm's fortunes and size have fluctuated over the years, and the crops have evolved with the times. The Heringer family is now betting on the Clarksburg AVA as a wine region with under-realized potential.

LESS FOG, MORE SUN "Clarksburg is unusual in that we're hot enough to ripen Petite Sirah but cool enough for Pinot Noir," says Mike, who oversees the winemaking and viticulture. "We get less fog than Carneros and more sunshine. Temperaturewise, we're like Napa, although we have a temperature drop in the evening because of the delta breezes."

To understand the family's transition from cows to Cabernet Sauvignon, imagine the Sacramento River Delta in the late 1800s, before levees were built to prevent near-annual flooding. Dairy farmers like John and Geertje Heringa gave up on the area, weary of having to move their herd to higher ground in wet years. But the riverbed silt deposited over centuries created a fertile alluvial fan, attracting farmers who planted row crops like corn, tomatoes, and sugar beets. Lester Heringer, Mike and Steve's grandfather, tested (and helped design) the first mechanical tomato harvester. At its peak, in Lester's day, the family farm covered 7,000 acres (2,835 ha).

"But we were price takers," recalls Lester's son, Steve (known in the family as Papa Steve to distinguish him from his son). "There was little opportunity to differentiate. You could grow the best tomatoes in the world, but if they went into ketchup, who knew?"

The family planted its first wine grapes in 1972, mostly Petite Sirah and Chardonnay, and began building sales to wineries who liked the low price and good quality of the Clarksburg fruit. Then, in the early 1980s, the local

tomato-processing cooperative failed, and the Heringers lost their farm. Papa Steve and his brother eventually bought some of the land back, starting over with 360 acres (146 ha).

AIMING HIGHER The big leap forward for the family business came in 2005, when Mike returned to the farm after a few years of winemaking elsewhere. Convinced that Clarksburg could aim higher and sell branded wine, not merely grapes that vanished into blends, he nudged the family into the bottled-wine business and into planting more offbeat varieties.

ABOVE: (clockwise from left) Two generations; tasting barn; Clarksburg vineyard; Clarksburg visitor center in restored sugar mill; historic Clarksburg building preserved at Heringer Estates

Brother Steve now oversees the business side of an operation that includes managing 270 acres (110 ha) of certified-sustainable grapes for Heringer and 500 acres (200 ha) for others. Not all of their grape customers care about the sustainable certification, "but it's important to us," says Steve.

In Clarksburg, the Heringers were early adopters of weather-monitoring technology that alerts growers when mildew pressure is high. The information helps them minimize fungicide use rather than spraying on a schedule. Row-by-row irrigation allows Mike to direct water only to vines that need it, and practicing deficit irrigation—a sort of "tough love" strategy—conserves even more of this scarce resource.

In the past, many Clarksburg growers relied on the vigor of their soil to produce large

crops. Today, the Heringers and other quality-minded growers are managing that vigor with pruning, spacing, and training techniques that produce better fruit. Training vines in high-vigor soils to have four cordons, or arms, rather than two ensures that the canes that emerge from these cordons will not grow too long and shade the grapes. The method also improves air circulation and sunlight access, so grapes ripen better and suffer from fewer fungal diseases.

Well-used owl boxes keep the vineyards' vertebrate pests under control. And once every summer, at a benefit party on the family estate, owls are the honored guests. Sacramento's Wildlife Care Association, which rehabilitates injured raptors, brings owls ready to be reintroduced to the wild, and the party's raffle winners, with a little guidance, perform the dramatic release.

To support the picturesque rural town they have been part of for 150 years, the Heringers donate 10 percent of sales from their Purple Thread wine, a red blend, to Clarksburg. Beneficiaries include the library, the volunteer fire department, and the high school. Sales from another wine, Hope's Thread Rosé, benefit breast-cancer research and support groups.

A prosperous community, pristine river, and healthy soil are all key to the Heringers' succession plan. "You don't pass a farm down for six generations by destroying it," notes Steve. "You improve it."

UP-AND-COMING REDS

Zinfandel is definitely top dog in the Lodi and Delta winegrowing region—it excels here—but the area's growers are developing a reputation for emerging red varieties, too. California winemakers are now looking to Lodi for wine grapes that are well-known in Europe but new to the Golden State, such as Spain's Tempranillo, Italy's Aglianico and Teroldego, and Portugal's Touriga Nacional.

Especially for young winemakers trying to make their mark, working with these unfamiliar varieties offers an opportunity to make a splash. The expanded varietal selections also give winemakers more "paints in their paint box," allowing them to create more complex and cutting-edge blends.

Although Lodi is a relatively warm and sun-blessed region, its vineyards enjoy cooling delta breezes in the afternoon. Similarities to the climate in some of Spain's premier red-wine regions have encouraged growers to try such varieties as Graciano and Garnacha. In Portugal, Touriga Nacional and Souzão are components of fine port; in California, a few curious winemakers are bottling them as single varieties, using Lodi-grown fruit. Cinsault and Tannat, valued grapes in France's warmer regions, are also making themselves at home in Lodi and inspiring winemakers to try their hand at vinifying grapes they don't know well.

For consumers, the experimental attitude of these Lodi and Delta grape growers means more enticing choices at the wine shop and a chance to explore the nuances of the world's numerous wine grapes.

ABOVE: Tannat vines thrive at Heringer Estates, producing big, bold, deeply colored red wine with considerable tannic structure.

RIGHT: (clockwise from top left) A lineup of unusual red varieties, including Teroldego and Aglianico; Cunoise grapes; head-pruned Zinfandel vineyard in Lodi

FOLLOWING PAGES: Training new spring growth on a wire trellis at Heringer Estates

ABOVE AND RIGHT: On a warm summer night in Lodi, David Lucas and Heather Pyle-Lucas welcome wine-club members and their guests for a harvest dinner. The annual tradition typically features paella prepared outdoors and, of course, a generous supply of Lucas Winery wines.

LODI AND THE DELTA
THE LUCAS WINERY

Magdalena is the most photographed. Cindy is deceased. And, yes, vintner David Lucas knows his grapevines by name.

Many are eighty-year-old damsels, their arms twisted and gnarly, their life force dwindling. Losing even one of these precious head-pruned Zinfandel vines feels like a death in the family, which is why Cindy—mortally wounded by wayward tractor blades—has a place of honor in the barrel room, mounted on the wall like a cross. Rest in peace, Cindy.

As proprietors of The Lucas Winery in Lodi, David and his winemaker wife, Heather Pyle-Lucas, know they own a rare gem, 18 acres (7 ha) of old-vine Zinfandel, some planted at the end of Prohibition. Although the couple bottles a sought-after Chardonnay as well, Zinfandel is the core of their family business and the pride of the Lodi appellation.

David was not driven by interest in wine when he purchased the parcel in 1976. A former Peace Corps volunteer and US Foreign Service employee with expertise in Asian rice cultivation, he simply wanted to own land and grow something. The seller had neglected the property, reflecting the poor image of Lodi wine grapes at the time. "The reason I could get it was because no grape grower would touch it," recalls David.

But the region's prospects were about to shift. The Robert Mondavi Winery was buying up Lodi grapes for its popular Woodbridge brand and urging growers to focus on quality over quantity. Mondavi's viticulture experts—including, eventually, David, who worked for sixteen years for the company—helped Lodi growers appreciate the potential in their heritage vineyards.

Today, The Lucas Winery is one of nearly ninety in the appellation, many of them—like Lucas—boutique operations dedicated to showcasing the region. Even so, most Lodi grapes still go to other wineries, where they are valued for adding color and heft to blends.

"A lot of people say, 'I've never had Lodi wine,'" says David. "And I say, 'Maybe not, but you've been drinking them for years.'"

David and Heather, too, sell most of their Zinfandel grapes to their larger neighbors. For their own label, they reserve a choice 3-acre (1.2 ha) block, the ZinStar vineyard, which they began farming organically in 2006 as an experiment.

EMBRACING THE WEEDS "Since going organic, the vines look healthier and the leaves stay greener through the summer," says Heather. The couple battles vine mealybug—their primary pest—with predatory ladybugs, and they have learned to tolerate the weeds that inevitably blanket a vineyard farmed without herbicides.

"In the old days, spick-and-span was so important," says Heather. "We have to push away from 'tidy is better' and feeling like we have to react to everything. When you wipe out one pest, you wipe out more than you bargained for."

Like her viticulturist husband, Heather believes the region can produce world-class red wine. A long growing season and abundant sunshine bring heat-loving Zinfandel to ripeness, while cool delta breezes chill the grapes at night, preserving acidity. But the winemaker

is even more convinced that growing practices, not site, separate good Lodi wine from great. After veraison, the late-summer color change that turns grapes from green to red, Heather removes any fruit that lags behind. With Zinfandel, which notoriously ripens unevenly, the sacrifice can be huge.

"You don't look down," says David, "because 30 to 40 percent of the crop is on the ground." The payoff for the labor cost and lower yield is more uniform ripeness, essential for Zin with lively red-fruit flavors and no "green" aromas.

A VINE IN 3-D The couple also believes in the superiority of head-pruned Zinfandel, but such old-style vineyards are vanishing. Labor shortages are prompting growers to train Zinfandel on wire trellises, like other wine varieties, so the grapes can be machine harvested. A head-pruned vine, in contrast, is "a vine in 3-D," says Heather, with arms radiating like spokes on a wheel. "The light environment is special, and sunlight creates color and aromatics."

The Lucases aim for a lighter, fresher, more fruit-forward style than the syrupy, high-alcohol Lodi Zinfandels of the past. Tasting-room visitors and wine-club members purchase most of it, leaving little for restaurants or retailers. Wine tourism has indeed blossomed in Lodi, says David, who jokes that his winery's first visitor, in sleepier days, was a passerby collecting aluminum cans.

Today, visitors who enjoy venturing off the beaten path seek out the Lucases' rustic tasting room, its walls paneled in redwood salvaged from a pre-Prohibition wine tank. Note the hanging surfboard, purchased at auction. Signed by surfing-world greats, the prized possession speaks to David's second love. When the vines don't need him, he'd rather be surfing.

With David's daughter, Mitra Lucas Grant, taking over some duties, David and Heather should have more time at the beach. Mitra, who divides her time between Lodi and Manhattan, is determined to continue her father's work, raising the stature of the appellation. "Lodi is like Brooklyn," says the part-time New Yorker. "The cool people know about it."

ABOVE: (clockwise from top left) A vine named Cindy; dining among the vines; a prized 3-acre (1.2 ha) head-pruned vineyard at The Lucas Winery; old-vine Zinfandel; Lucas Winery sign; winery staffer Stacie Cummings and guest

INLAND VALLEYS HARVEST

The straight asphalt ribbon that is Interstate 5 links Redding to Bakersfield, a mesmerizing 450-mile (725 km) journey through nearly nonstop farmland. Orchards extend for miles, followed by vast seas of tomatoes or freshly disked carpets of black dirt ready for planting. The valley gets warmer from north to south and from west to east, but many fruit, vegetable, and nut crops succeed in multiple areas.

Almonds, walnuts, cherries, olives (both for oil and for the table), and canning tomatoes are among the stars of the Sacramento Valley. Asparagus thrives in the Sacramento–San Joaquin Delta but performs well as far south as Kings County. Brentwood, in Contra Costa County, produces sought-after corn, apricots, and peaches in a rapidly urbanizing area. San Joaquin Valley is likewise a major producer of all of these crops in addition to such heat lovers as figs, table grapes, kiwifruits, persimmons, pistachios, pomegranates, and fresh tomatoes. Adding variety to this bounty are the many Asian and Asian American farmers in the San Joaquin Valley, growing crops such as Chinese long beans, bitter melon, baby bok choy, daikon, and lemongrass. These fertile valleys are truly America's Eden.

LEFT: (clockwise from top left) Fresh-picked olives; olive grove at Enzo Olive Oil Company; kiwifruit; Chinese broccoli (gài lán); sun-drying figs at J. Marchini Farms; olives ready for pressing

RECIPES

Breakfast Bruschetta

Potato Focaccia with Olives and Rosemary

Arugula, Fennel, and Persimmon Salad

Kale Salad with Red Grapes, Walnuts, and Feta

Warm Salmon Salad with Asparagus, Farm Eggs, and Fingerling Potatoes

Golden Beet, Pomegranate, and Feta Salad

Chinese Chicken Soup with Egg Noodles, Baby Bok Choy, and Pea Shoots

Roasted Tomato Soup with Tortilla Crisps

Ramen with Asparagus, Shiitake, and Edamame

Polenta with Slow-Roasted Tomatoes and Teleme Cheese

Baked Lingcod with Green-Olive Salsa Verde

Grilled Lamb Shoulder Chops with Pomegranate Marinade

Grilled Pork Loin, Sausage, and Fig Skewers

Seared Duck Breasts with Port and Cherry Sauce

Stir-Fried Skirt Steak with Chinese Broccoli and Shiitake

Old-Fashioned Chocolate Sheet Cake with Bing Cherry Sauce

Warm Apricot and Cherry Crisp

Greek Yogurt Parfait with Baked Figs and Sesame Brittle

APRICOTS When fresh apricots arrive at California farmers' markets in late spring, few shoppers leave without some. Californians treasure these fragile stone fruits and know that they are difficult to ship. The shorter the distance between tree and table, the better. California grows 95 percent of the nation's apricot harvest, but only half of that is marketed fresh. The rest are canned, dried, or processed for juice.

Apricot trees are finicky. They bloom early so they do best in areas where spring frosts are rare. Most of the commercial crop is in San Joaquin, Stanislaus, and Merced Counties. But the state's planted acreage is declining because of competition from Turkish dried apricots. Contra Costa and Santa Clara Counties were bigger fresh-market suppliers than they are today, but small orchards persist, and apricots remain prized backyard trees in those areas.

SELECTION AND STORAGE: Harvest typically begins in late May with the Apache variety and concludes by early July. Pattersons and Goldensweets will be tasty if picked ripe, but connoisseurs know the crème de la crème is the Blenheim, also known as the Royal or Royal Blenheim. It doesn't have the seductive blush of other varieties, but it has juicy, nonmealy flesh and intense, off-the-charts aroma and flavor. Alas, Blenheims bruise at a glance, so select firm ones, transport them as carefully as eggs, and leave them at room temperature. They will soften in a day or two.

HOW TO USE: During their short season, enjoy ripe apricots for breakfast with a dollop of plain yogurt and handful of granola. Halved or quartered, apricots make a beautiful tart or galette. Consider pairing them with cherries, which nature thoughtfully ripens at the same time. Replace pineapple with fresh apricots and cherries in an upside-down cake. Blenheim apricots also make exquisite jam. At the height of their fleeting season, in June, many Blenheim enthusiasts will invest in a 40-pound (18 kg) lug and spend a weekend putting up jam for the year.

ASIAN GREENS Many of California's Asian immigrants have found a foothold in their new country via farming. Especially in the years following the Vietnam War, when many Southeast Asian immigrants settled in the Fresno area and began growing the vegetables of their homeland, the selection of Asian greens available to shoppers mushroomed. Produce markets today would seem incomplete without Chinese cabbage, Chinese broccoli, and baby bok choy, but now farmers' markets and Asian grocery-store chains, especially in towns with large Asian populations, may also have pea shoots, amaranth, mizuna, mustard cabbage, tatsoi, and water spinach. For adventurous cooks, these greens provide a tantalizing opportunity to explore.

Small-farm advisors with the United States Department of Agriculture, the University of California, and nonprofit organizations have worked closely with immigrant farmers to develop marketing channels and use resources efficiently. Outreach has often focused on teaching sustainable farming practices that prevent soil erosion or minimize air pollution, concerns that may not have been priorities in these farmers' countries of origin.

SELECTION AND STORAGE: Delicate leafy greens like pea shoots and mizuna deteriorate quickly; inspect closely for signs of decay and use within a day or two. As with any leafy green, the leaves should be perky, not limp. Greens with thick ribs or sturdy stems, such as baby bok choy and Chinese broccoli, have a little more endurance but should be refrigerated in a sealed plastic bag and used within three to four days. Avoid Chinese broccoli with open flowers.

HOW TO USE: Add quartered baby bok choy to a beef or pork-shoulder pot roast in place of Western cabbage, or add to any Asian-style noodle soup or vegetable stir-fry. Treat Chinese broccoli to Asian seasonings, such as ginger, sesame oil, chile paste, and oyster sauce, or steer it in a Western direction with garlic and anchovies.

RIGHT: (clockwise from top left) Bunches of baby bok choy; fresh apricots; tree-ripened 'cots

ASPARAGUS

The ten-week asparagus harvest at Couture Farms is highly labor-intensive, but the fields get a long rest after that. Between May and October, they receive steady drip irrigation while the plants produce their fern-like fronds, gathering and storing the sun's energy for the following season. In fall, the watering ceases and the fronds turn brown and die down. In January, the ferns are cut at soil level, chopped, and incorporated into the soil to add organic matter. A single acre (0.4 ha) of asparagus is home to thirteen thousand plants, each one producing only about ½ pound (250 g) of spears after trimming.

SELECTION: Look for spears with compact, tight tips and a rich green color from tip to butt. Thick spears tend to be more juicy and sweet; thinner ones taste more "grassy" because of the high proportion of green peel to flesh. Age has nothing to do with circumference; the same crown produces thick and thin spears. Contrary to what most shoppers think, thick spears are often more tender.

Because of the labor involved, few California farmers cultivate white asparagus, so prized in Europe. It's the same variety as green asparagus but blanched by covering it to limit sun exposure.

STORING: Treat asparagus spears like cut flowers. Trim the bases and stand the spears upright in water, then refrigerate. You don't need to cover them. They will last two to three days, but the sooner you cook them, the better the flavor.

KITCHEN TIPS: You can peel the bottom 2 to 3 inches (5 to 7.5 cm) of each spear to make it more tender, or you can snap it off. "I grew up with the snap method," says Caitlin Couture of Couture Farms. Hold a spear in both hands and bend it; it will break naturally at the point where it becomes tough. Boil, roast, or grill asparagus, but avoid overcooking. Like pasta, spears should be al dente, not limp.

LEFT: (clockwise from upper left) Bee boxes in a Lodi cherry orchard; cherries fit for royalty; cherry harvest at Lodi Farming; farmers' market asparagus

CHERRIES

When plump, carmine-red cherries hit produce stands, summer can't be far behind. Along with apricots, cherries are California's first-of-the-year stone fruit, prompting home bakers to dig out their recipes for fruit pies, tarts, and crisps. The state boasts 40,000 acres (16,200 ha) of cherries, in orchards from Bakersfield to Sacramento. The area around Lodi is a prime spot. In that location, the trees get sufficient winter chill—hours below 45°F (7°C)—to break dormancy and bloom properly in the spring but typically avoid the hot weather that can make ripe cherries flabby.

HARVEST: The final two weeks of May are peak season for California's cherry harvest, although early varieties like Brooks get the season rolling in late April. With orchards extending from Sacramento to Bakersfield, growers can often keep consumers supplied with fresh cherries through June. Color is the best indicator of ripeness, so growers wait until the red varieties turn fully crimson before picking. Rainiers should have a rich custard-yellow background color with a red blush.

SELECTION AND STORAGE: Most cherry enthusiasts consider the Bing to be the choicest variety, although it's hard to resist the blushing beauty of the Rainier. A few small growers cultivate sour cherries (also called pie cherries), such as Montmorency; look for them at farmers' markets and specialty-produce markets. Choose firm, unblemished cherries with stems attached. A green stem signals the fruit was freshly picked. If you can taste before you buy, look for crispness and a refreshing balance of sweetness and acidity. Refrigerate cherries in a plastic bag; don't rinse them until you're ready to eat them.

FREAKS OF NATURE: If the temperature climbs above 95°F (36°C) during fruit formation, the fruit ovary may divide. If both halves get fertilized, a double cherry is produced. If only one gets pollinated, the result is a spur: a deformed cherry with some hardened external pit. Both occurrences are considered cosmetic flaws, although the flavor may not suffer.

FIGS For many California fruit enthusiasts, a tree-ripened fig is possibly nature's most luscious creation. Fragile, short-lived, and challenging to ship, plump figs at full ripeness are an uncommon treat and all the more desirable for it. Although California produces almost all of the nation's commercial crop, planted acreage has dwindled over time, in large part because other tree crops are more profitable. Fig trees must be hand harvested; on most farms, unblemished fruits are packed for the fresh market while the remainder are sent to processors for transformation into fig paste or concentrate.

Spanish friars introduced figs to California in the eighteenth century and planted them at missions from San Diego to Sonoma. Although today most of the harvest comes from Madera County—fig trees like heat—Sacramento Valley had its fig heyday in the late 1800s. Fruit-tree preservationists still find old fig trees in Gold Country, in the Sierra Foothills, believed to have been imported and planted by Felix Gillet, a French immigrant and influential nurseryman of the late nineteenth century.

SEASONS: Rare among fruit trees, some fig varieties ripen two crops a year. The early crop, sometimes called the breva fig, typically ripens in June and is smaller in quantity but larger in fruit size. At J. Marchini Farms (page 169), the breva harvest represents only 10 percent of the year's production. The bulk of the crop ripens in August and September, producing smaller but tastier fruit. Some fig varieties, like the Kadota, don't produce a breva crop.

SELECTION AND STORAGE: It's hard to beat a Kadota (green to amber skin with blush-colored interior) or Black Mission (purplish-black skin with red interior). But the tasty Tiger fig (aka Panache) is on the rise, thanks to its striking green-and-yellow stripes and raspberry-red flesh.

Ripe figs are soft, even slightly shriveled, and may have slits in the skin or drops of nectar at the base. Keep them at room temperature if you plan to eat them within a day. Otherwise, refrigerate and use quickly.

TABLE GRAPES More than five hundred growers cultivate table grapes in California, in sunny vineyards from the San Joaquin Valley to the Coachella Valley desert. They satisfy almost all of the nation's appetite for fresh grapes and still divert about one-third of the harvest for export. Although most shoppers think of table grapes as simply red, green, or black, and stores rarely name them by type, the state's vineyards encompass more than eighty varieties.

In recent years, breeders have greatly expanded the selection of seedless varieties beyond the familiar green Thompson's Seedless and red Flame. American consumers clearly prefer these easy-to-eat seedless grapes, so seeded varieties like Red Globe largely go to foreign customers.

SEASON: The Coachella Valley harvest lasts from late May to mid-July; the San Joaquin Valley's season extends from late June to mid-November. Growers determine ripeness based on sugar content, color, and size; grapes don't sweeten off the vine. Hand harvesting is standard practice for table grapes. Workers snip ripe bunches off the vines and pack them in the vineyard. Within hours, the grapes are in cold storage.

SELECTION AND STORAGE: A pliable green stem is the best indication of freshness. Look for plump berries with well-developed color; reject bunches with shriveled grapes or signs of mold. Don't be concerned if you note a powdery white surface bloom; this waxy coating is nature's way of preventing moisture loss. Refrigerate grapes, unwashed, in a perforated plastic bag; they should last for at least ten days.

BEYOND A SNACK: In addition to their considerable appeal as a health-promoting no-fuss snack, grapes make a beautiful accompaniment to any cheese board and can add juiciness and color to fruit and vegetable salads. Halve them and add to chicken or turkey salad, to coleslaw, or to green salads with nuts and cheese. Press grapes into the surface of a focaccia dough, brush with olive oil, and sprinkle with sugar before baking.

RIGHT: (clockwise from top left) Plump Mission figs; table grapes ready for the cheese board; sun-ripening figs at J. Marchini Farms

PISTACHIOS

Relative to the other major nut crops in California, pistachios are new on the scene. A few growers experimented with the trees in the late nineteenth and early twentieth century, eventually acknowledging that the available cultivars were unsuitable. In 1929, an American botanist visited Iran and brought back several different varieties for growers to try. The standout, now known as the Kerman, excelled, but farmers showed little interest until the 1980s. Since then, California pistachio orchards have grown exponentially—from 1,700 acres (690 ha) in 1977 to 250,000 bearing acres (101,200 ha) today, almost all of them planted to the Kerman variety.

The long-lived trees appreciate the hot, dry summers and relatively cold winters in the San Joaquin Valley; they need some winter chill to produce well. The nuts grow in grape-like clusters, with thirty to fifty nuts in a bunch. As the edible green kernel develops over the summer, it pushes against the still-soft shell, creating a split. In early September, the hull surrounding the shell splits, a sign that it's harvesttime.

TREE TO TABLE: Mechanical harvesters shake the crop loose onto nets or catch frames. At the processing facility, a mechanical abrader removes the hull, a step that can't be delayed or the hull will stain the shell. Then the nuts are washed and any "blanks"—shells with no kernel inside—float to the top. After sizing and drying, a sorter removes nuts with closed shells (although any avid pistachio consumer knows some evade detection). Finally, the split nuts are salted, roasted, and shipped.

SELECTION AND STORAGE: Choose pistachios with pale ivory shells with no discoloration. Roasted pistachios go stale more quickly than raw (unroasted) nuts. Unless you plan to eat them within a few days, keep roasted pistachios in the refrigerator or freezer. If they soften, you can crisp them up again by toasting them in a 325°F (165°C) oven for about 10 minutes.

LEFT: (clockwise from top left) Pistachios; Vincent Ricchiuti with vintage truck; canning tomatoes; olive branch; farmers' market shopper; vine-ripened beauties; cherry tomatoes; tomato medley

TOMATOES

Many of the huge haulers that barrel down California's Interstate 5 in summer leave a warm, sweet tomato fragrance in their wake. Piled precariously high in their bins are 50,000 pounds (22,680 kg) of tomatoes on the next leg of their journey to America's tables. Within hours, most will be in a can—whole or diced, concentrate or paste—destined to become marinara sauce, pizza sauce, or ketchup. In the height of summer, California growers harvest 2 billion pounds (907,200,000 kg) of vine-ripe processing tomatoes each week from 250,000 acres (101,200 ha). Bred for thick skins and sturdy flesh, these tomatoes withstand machine harvesting and transport and enable California to meet half the world demand for processed tomatoes.

The state's fresh-tomato crop is considerably smaller and hand harvested, but those are the juicy, thin-skinned tomatoes that moisten burgers and BLTs and elevate an *insalata caprese*. The harvest starts in May in some warm-winter areas and continues until the end of the year, thanks to a second autumn planting in some regions.

SELECTION AND STORAGE: Processing tomatoes, marketed as plum or Roma tomatoes, should have full red color, some aroma, and no blemishes. Tomatoes intended for eating fresh should be firm and have well-developed color, but a sweet, seductive tomato fragrance is the best indicator of flavor. Keep tomatoes at room temperature; refrigeration deadens their flavor.

HEIRLOOM VARIETIES: The contemporary interest in heirloom vegetables, usually defined as varieties more than fifty years old, has revolutionized the fresh-tomato marketplace. At California farmers' markets and specialty-food stores, shoppers will find summer tomatoes in a dizzying array of colors, sizes, and shapes. Some of the tastiest, like the yellow cherry tomato Sungold, are hybrids, not heirlooms, but the breeders put flavor foremost. Look for dark-fleshed types like Black Krim and Cherokee Purple, the reliably delicious Early Girl, and striated beauties like Marvel Stripe. A little sea salt and extra virgin olive oil are all these succulent tomatoes require.

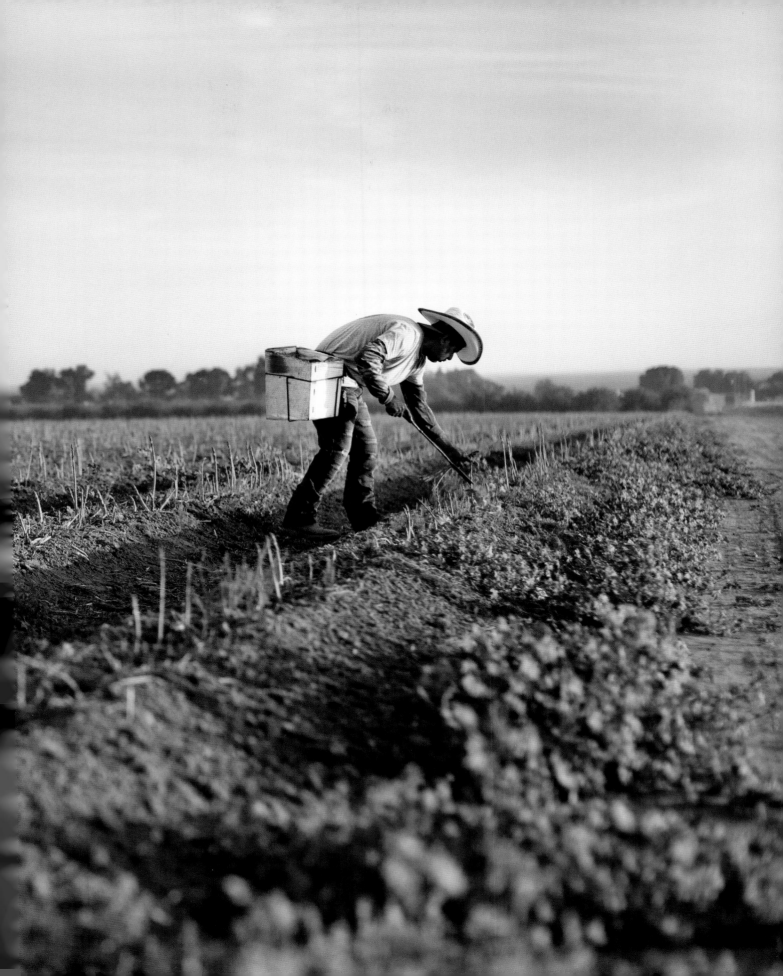

COUTURE FARMS
ASPARAGUS

Thick or thin? Fortunately for California asparagus grower Caitlin Couture, customers clamor for every size. Caitlin and her father, Chris, cultivate 110 acres (46 ha) of organic asparagus in Kettleman City, between Fresno and Bakersfield, and they have takers for every spear. Swiss buyers prize the farm's finger-thick jumbos, while American consumers gravitate to pencil-thin spears. Caitlin has her own preference (thick, please), but freshness tops her priority list.

Between mid-February and early May, the harvest season at Couture Farms, Caitlin's farmers' market customers can experience asparagus harvested just hours before. But even with a few days of travel time, this farm's soldier-straight spears, green from tip to butt, merit a course all to themselves on the menu.

The Coutures have been farming in the Central Valley for four generations. Caitlin's great-grandfather, an immigrant from Quebec, grew table grapes in Modesto and operated one of the area's first fruit dehydrators, to produce golden raisins. During World War II, her grandfather used the equipment to dehydrate carrots for military rations. The family didn't plant their first asparagus until 1982, persuaded by a San Francisco wholesaler that the high-priced vegetable would do well in their sandy, fast-draining soil.

FROM AN UNDERGROUND FACTORY Asparagus are perennial plants that will yield spears for fifteen years if well treated. The hard-working spear "factory" is underground, the so-called crown with its many tentacle-like roots. Spears emerge from the crown, with the first ones poking through the cold ground in early February. The spears continue to push for several weeks, thick and thin from the same crown, growing as much as 6 inches (15 cm) a day in warm weather. Cold nights produce crooked spears. Hailstorms leave ruinous pockmarks. Hail-damaged spears have to be felled by hand and discarded, but replacement spears soon emerge.

The Coutures transitioned to organic production in 2006, largely for competitive advantage, but they like the changes they have noted in their ecosystem. "We've seen the roadrunners return," says Caitlin, "and I have to believe our native bee population is better off." Fertilizing with compost tea keeps soil microorganisms happy, and eliminating herbicides has improved soil health, too.

PRECEDING PAGES: Early-morning asparagus harvest at Couture Farms in Kettleman City

ABOVE AND RIGHT: Sustainable practices at Couture Farms continually renew the soil; fourth-generation Central Valley farmer Caitlin Couture

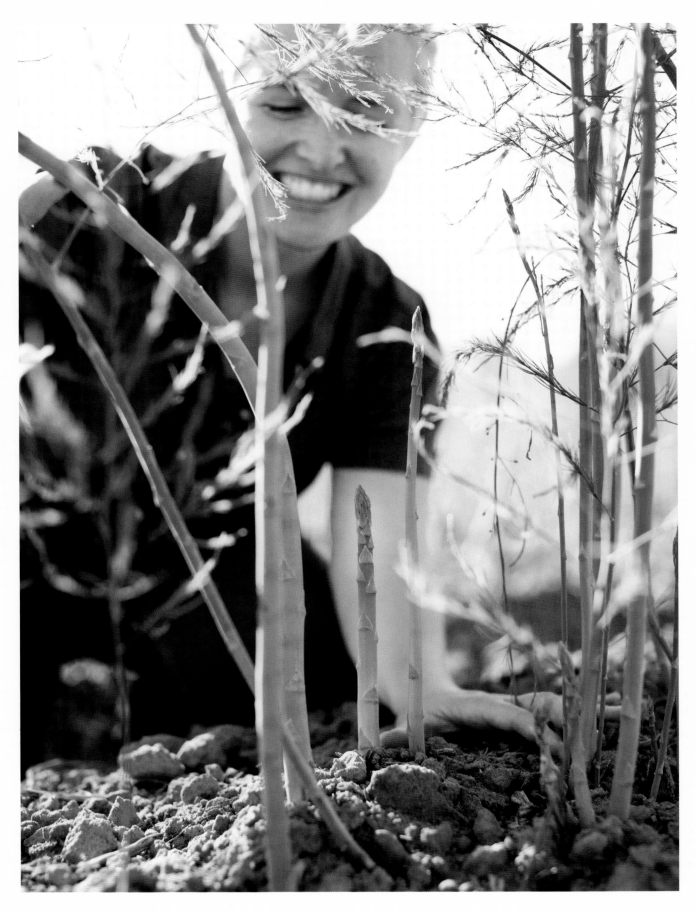

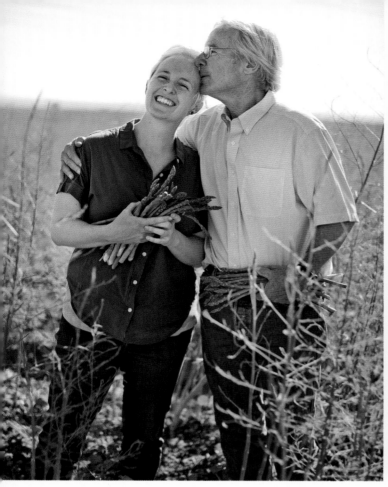

On a mild, sunny April morning, workers with bins slung around their hips patrol the long, mounded beds, armed with 30-inch (76 cm) asparagus knives. A red line on the knife's blade, 9 inches (23 cm) from the tip, indicates the ideal length of a spear ready to harvest. When workers spot a full-grown spear, they plunge the blunt-edged tool into the soil, releasing the spear without harming the crown.

ABOVE: (clockwise from top left) Father-daughter asparagus growers Chris and Caitlin Couture; after harvesting stops in May, remaining spears produce ferns, gathering energy for the following year's crop; a specialized tool detaches asparagus cleanly; Caitlin Couture's toddler son; after sorting by size, asparagus are banded for shipping

REPEATING THE HARVEST For ten weeks, the crew will return to this same field daily and retrace their steps. Every day, a crown might have three or four more spears to offer; they will weaken the crown if allowed to grow too tall. By early May, Chris and Caitlin expect each acre to have yielded about 6,000 pounds (2,720 kg) of "grass," in grower lingo. Then it's time to give the crowns a rest until the following spring.

At the packing shed, the spears are washed and mechanically cut to an exact 9 inches (23 cm). Women on either side of a conveyor belt sort them by eye, their hands deftly assembling bundles of spears of similar thickness. In the cooler, the packed boxes get an icy shower to chill the spears quickly. Slightly blemished spears are collected for a nearby senior center; packing-house trimmings return to the farm for composting.

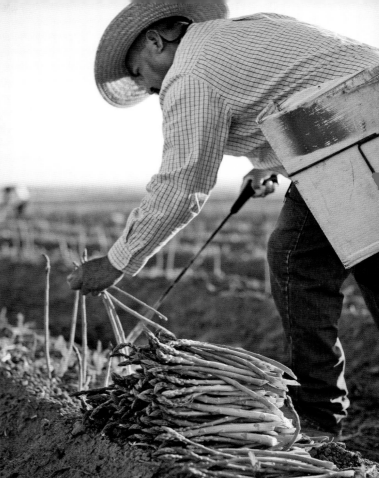

Caitlin's toddler son, Dylan, is already an enthusiastic consumer, clutching a raw spear in his pudgy fist. Caitlin's husband, Ed Drake, is chef-owner of a Paso Robles bistro, but even so, the couple treats fresh asparagus simply at home: grilling or roasting it with olive oil and sea salt, sometimes blanketing the spears with a fried egg.

"When people don't like asparagus, I think it's because they've only had it overcooked," says Caitlin. "Just put in boiling water and wait for that electric-green color to come up. Any longer and you've lost what asparagus has to offer."

LODI FARMING
CHERRIES

O n a warm, fresh morning in early June, under a cloudless sky, two hundred workers are stripping the fruit from Jeff Colombini's Bing cherry trees. Temperatures can soar in Stockton in summer, so the workday starts at dawn and concludes by noon for the crew's comfort. The cherries suffer, too, if picked in the heat of the day. They lose their crunch, says Colombini, the quality consumers value above all.

Colombini's thick-trunked trees are trained to branch low, to keep most of the fruiting zone at face level. Even so, these twenty-year-old specimens have grown beyond arm's reach, and the clanking of aluminum orchard ladders, mingled with muffled voices and the occasional snatches of song, creates a symphony of sound in these shade-dappled rows. Workers garbed in hoodies for sun protection pluck the cherries by hand, with stems attached to prevent decay, and toss them into the plastic buckets slung around their necks. Hands—some ungloved and sporting polished nails—race through the glossy leaves, probing for clusters of fully colored fruits. Women make better pickers, says Colombini; they have more nimble fingers and a more delicate touch. A swift worker can pick 1,200 pounds (545 kg) a day and take home four hundred dollars.

LEFT: Cherries are hand harvested with the stems attached to prevent decay; full red color is the best indicator of ripeness.

ABOVE: Lodi Farming partners Ray Avansino (left) and Jeff Colombini

AN EARLY ADOPTER Colombini and his business partner, Ray Avansino, farm 300 acres (120 ha) of cherries in the northern San Joaquin Valley, the trees benefiting from the cool marine breezes that rush in after the daytime air warms and rises. "There are no barriers between here and the Pacific Ocean," says Colombini, a third-generation farmer whose Italian-immigrant grandfather first settled in the area in 1906. But despite the agricultural genes and mind-set he inherited, Colombini is an experimenter and early adopter, an eager collaborator with university researchers on rootstock trials, and a relentless pursuer of ways to save water.

"I was raised to think you don't want to stress cherry trees," says Colombini. "But one year after harvest we quit irrigating an orchard that we were going to pull out, and a month later it looked great." The experience convinced the two partners that they had been overwatering; they have since cut their post-harvest water use by half.

But what Colombini is more likely to boast about is the improvement he has seen in his soil, largely the result of annual cover cropping with deep-rooted triticale. Besides this "green manure," tree prunings are chipped and tilled into the soil now; in the old days, cherry farmers burned them, to the detriment of air quality.

"Twenty-five years ago, the organic matter in this soil was 1 to 2 percent," says the grower. "Now it's 3 to 4 percent. This soil is alive." He bends down and grabs a fistful to show off its sweet, earthy aroma and clumpy yet crumbly texture. "That's because of the organic matter," says the grower. The cover cropping has improved drainage and made the soil's calcium more available, and calcium makes cherries firmer.

VARIETIES ADD OPTIONS To extend their season, Colombini and Avansino grow several cherry varieties. In May, harvest begins with the firm, high-acid Chelan, followed by the Coral Champagne, a variety developed by the University of California. Consumers love its low-acid flavor and sweetness; growers have embraced it because it is more crack resistant than the Bing if it rains during harvest, and the tree doesn't require as many hours of winter chill to yield well. The familiar Bing, full flavored and deeply colored, remains Colombini's favorite, but he believes the Coral will soon outpace it in acreage. The Tulare variety, large and dark red, ripens before the Bings. The mottled Rainier, a golden cherry with a pink blush, is undeniably delicious but easily bruised and needs pampering to get it

to market unblemished. Colombini grows it primarily as a pollinator.

The hefty bins filled by Colombini's harvest crew are at the packinghouse by afternoon. There, the cherries are sorted by color, then sized; underripe fruits go to a processor and reemerge as maraschino cherries, destined to grace the top of sundaes and Manhattan cocktails. Colombini, who loves Manhattans, makes his own house version with Rainier cherries cured for a minimum of two months in equal parts brandy and sweet vermouth. Shaken with ice and strained, the steeping juice "tastes just like a Manhattan," says the farmer.

ABOVE: (clockwise from bottom left) Cherries awaiting harvest; cherry blossoms; hand harvesting; pristine cherries, sustainably grown; workers are paid individually for each full bucket; bath time

ENZO OLIVE OIL COMPANY

OLIVE OIL

In the world of extra virgin olive oil, long dominated by Europe, California is coming on strong. New, quality-obsessed growers like Enzo Olive Oil Company, near Fresno, are giving consumers reason to reconsider their long-held preferences and to proudly dress their salads with California olive oil.

The Ricchiuti family behind Enzo has a long history in California agriculture but had no experience with growing olives for oil. Over four generations, the family had amassed 5,000 acres (2,000 ha) in the San Joaquin Valley, largely devoted to stone fruits, citrus, and almonds. But by the time Vincent Ricchiuti graduated from Fresno State with a degree in agricultural business, the farm's labor costs were rising and profits were dwindling. To thrive, the Ricchiutis needed to adapt.

At a family meeting in February 2008, the twenty-four-year-old Vincent proposed some alternative crops. Oil olives—not the more widely grown table olives—sounded promising and cutting edge. (At the time, California accounted for less than 1 percent of the nation's extra virgin olive oil sales.) The family green-lighted the risky idea, and "by that fall, we were planting," says Ricchiuti.

BOOMING DEMAND Today, California's share of the nation's extra virgin olive oil market is 7 percent and rising, with demand outpacing supply. Olives intended for oil are a booming specialty crop in the state, with planted acres expected to spike tenfold between 2008 and 2020. The big breakthrough in California— allowing growers like the Ricchiutis to control labor costs—is "super-high-density" planting, a method of growing olives on wire trellises, like wine grapes. By keeping the fruiting zone low, the trees can be mechanically pruned and harvested, at huge savings in the cost of production. "You can't afford to do it any other way," says Ricchiuti.

Not every oil-worthy olive variety can be cultivated this way; some varieties just want to be big. But Spanish Arbequina and Arbosana and the Greek Koroneiki trees perform well in this system. With advice from experts at Fresno State, the Ricchiutis planted 400 acres (160 ha) of these varieties and milled their first organic olives in 2011.

ABOVE: Olives darken as they ripen and their oil content grows.
RIGHT: Green olives produce a more piquant, peppery oil, higher in antioxidants.

In the San Joaquin Valley's hot, dry climate, olive trees thrive and encounter few pests. Ricchiuti applies compost after harvest and digs chipped prunings into the soil, but the trees need no additional feeding. He uses sophisticated techniques, like aerial monitoring, to know when and where to irrigate—"using water more precisely," says the grower.

GAMBLING ON WEATHER By mid- to late October, the olives have sufficient oil content to launch the harvest. "The longer they hang, the more they yield," says Ricchiuti, "but it's a gamble. Frost would ruin the crop." Once harvest begins, it proceeds almost without pause, six days a week and around the clock until all the trees are stripped of fruit, typically by Thanksgiving.

Before milling, the olives are separated from leaves and twigs and rinsed of field dust. A hammer mill pulverizes the olives, pits and all, yielding a paste resembling tapenade. Next, a malaxer kneads the paste to break the cells and release more oil. A two-part centrifuging follows—first, to separate solids from liquid, then to extract the oil from any remaining water. Stored separately and bottled on demand, the varietal oils have distinct personalities: the Arbequina is delicate, the Koroneiki robust, and the Arbosana somewhere in between.

To Ricchiuti, Enzo Olive Oil is like an ambassador for this farming community, raising its stature among serious foodies. "The majority of what this nation eats is from here, but people don't know it," says Ricchiuti, who encourages others in Fresno to develop branded

food products. Celebrity chefs are using and recommending Enzo Olive Oil, and college friends report sightings in East Coast gourmet stores. "We are making something special and winning awards for it," says Ricchiuti. "Our town is excited and proud because that doesn't happen much around here."

ABOVE: (clockwise from top left) Enzo olives are machine harvested with the help of a trained crew; olive bins head for the press; Vincent Ricchiuti with consultant Kathryn Tomajan; high-quality oil comes from a blend of green and partially ripened olives; milling manager Ryan Grossman and mill manager Richard Montalvo; bottles ready for salads; filling machine

CALIFORNIA CLASSIC: RIPE OLIVES

The pitted black olives that garnish Thanksgiving relish trays from coast to coast originate in California's 27,000 acres (10,900 ha) of olive groves. Some of these orchards are a century old, with thick-trunked, silver-leaved trees, each of which may have contributed more than one hundred thousand olives to America's tables over that time.

The state's olive orchards span the Sacramento and San Joaquin Valleys, but the highest concentration is in Tulare County. The town of Lindsay is there, although olives for the well-known Lindsay brand are now canned elsewhere. Harvest typically launches in September, when the olives just begin to turn from green to black. Crews remove the fruit by hand, a task so painstaking that one worker can finish only two or three trees per day. At the cannery, the olives are sorted by size—from small to super colossal—and then the curing procedure begins.

Unlike most other fruits, olives straight off the tree are too bitter to enjoy. In a process that takes several days, the bitter compounds are removed with a lye cure, while air bubbled through the curing tank turns the olives fully black. Some batches are cured without the air to leave the olives green. After rinsing and pitting, the now-mellow olives are packed in a light brine.

The early-ripening Manzanillo variety dominates the ripe-olive world in California. The Sevillano, also known as Spanish Queen, is considerably larger and suited to stuffing. If it's super colossal, it's a Sevillano.

J. MARCHINI FARMS

FIGS

The cool, dappled shade underneath a fig tree makes a pleasant haven on a hot day. And for a fig fan, it is the best seat in the house—an all-you-can-eat buffet within arm's reach. A knowledgeable enthusiast will look for plump fruits with a split skin and a drop of liquid sugar at the blossom end. If they're a tad shriveled, so much the better. Wrinkled figs have started to dry on the tree and are likely to be as sweet as candy.

If you can't be under a fig tree, at least you can seek out a quality-minded grower. Figs aren't the main crop at J. Marchini Farms—radicchio is—yet the Marchini family is among California's leading fig growers and shippers. The lion's share of the state's harvest is dried (think of all those fig Newtons), but the Marchinis persist in the challenging task of shipping fragile, tree-ripened fresh fruit.

Siblings Marc, Nic, and Francesca Marchini represent the fourth generation of their family to farm this fertile parcel, part of the vast tapestry of fruit and nut orchards in the San Joaquin Valley. Their great-grandfather, Florindo Marchini, left Lucca, Italy, in the early 1920s, lured by the promise of opportunity in America. He settled in Le Grand, where the family remains today, and thrived as a grower and shipper of fresh tomatoes. His son, Joe, spotted the potential in crisp, colorful radicchio, now considered an essential component of bagged salad mix.

A FAMILY HERITAGE But if radicchio pays most of the Marchinis' bills today, figs are part of their heritage. Grandmother Marchini's biscotti recipe includes chopped dried figs, and the twenty-something siblings love the contemporary fashion for fig and arugula pizza. Some of the fig trees they cultivate are sixty years old—and may still be producing when they're ninety, says Marc.

On the home property in Le Grand are 175 acres (71 ha) of Mission figs, pruned hard every winter to keep them low, at 8 or 9 feet (2.4 to 2.7 m). An older orchard that the family leases has trees 20 feet (6 m) tall that have to be harvested from an aerial platform. Missions, unlike many other fig varieties, produce two crops each year. The early figs, known as the breva crop, grow on old wood and ripen in June. They are typically larger and less sweet than the main crop, which develops on the tree's new growth and begins to ripen about a month later.

LEFT: Francesca Marchini inspects trays of figs drying in the warmth of the San Joaquin Valley sun.

ABOVE: Francesca Marchini with (left to right) brother Nic, father Jeff, grandfather Joe, and brother Marc

Marchini's harvest crew has to visit each tree repeatedly to get fruit at peak ripeness. For the main crop, they might return to each tree fifteen times over the course of three or four weeks. They are looking for figs with the full color—purple to black in the case of Missions—and soft texture that indicate they're ripe. With a gentle tug, the figs release, and workers place each fruit carefully in the bucket slung around their neck.

FROM PICKING TO PACKING The fig's beautiful lobed leaves are fiendishly prickly, and the fig stems release a sticky, milky sap that irritates skin. Workers wear gloves and keep their neck and arms covered for protection.

In the cool packing shed, the laborious hand sorting begins. Each packer works at her

own ergonomically tilted table, nestling the largest, most shapely figs in cushioned trays destined for retailers that sell them by the piece. The runners-up go into pint (500 ml) baskets or clamshells, then all the packed fruit is palletized and chilled to 34° F (1°C). Less-than-impeccable figs are diverted to drying trays and will spend five to ten days giving up their moisture under the steady California sun.

Compared to such orchard fruits as apples or almonds, figs are undemanding. They have few pests and require no spraying.

A generous helping of compost in the fall, before the rainy season, prepares them for a flush of growth in spring—"like they've had a meal already," says Marc—and drip irrigation allows the Marchinis to water sparingly and only as needed.

If Florindo Marchini could return to the property he purchased a century ago, he might be mystified by the solar panels and the drip hose. But he would likely not be surprised that his heirs remain devoted to one of the most luscious, prized, and mythologized fruits of the Mediterranean.

ABOVE: (clockwise from top left) Freshly harvested figs; Marchini fig orchard; raking dropped fruit; sun drying takes five to ten days; packed fruit ready for shipping; young fig tree; sustainably grown Black Mission figs
FOLLOWING PAGES: Sun worshippers, figs of all types ripen reliably in Inland Valley orchards, even in dry years. Mature fig trees can reach 20 feet (6 m) in height and yield 75 pounds (34 kg) of fruit per tree.

BREAKFAST BRUSCHETTA

SERVES 2 TO 4

The contrasts are what make this simple idea so delightful: crisp toast juxtaposed with creamy ricotta; sugar-sweet persimmon with tart, tropical kiwi; vivid orange against emerald green. Take advantage of the few weeks in November and December when these two fruits are in season together but improvise freely in other seasons. Try strawberries with apricots, peaches with blueberries, or figs with raspberries.

¼ pound (125 g) fresh whole-milk ricotta

1 tablespoon plus 1 teaspoon granulated sugar

Finely grated lemon zest

4 slices pain au levain or other country-style bread, each about 4 by 3 inches (10 by 7.5 cm) and ½ inch (12 mm) thick

1 small Fuyu persimmon, stem removed, quartered vertically, and thinly sliced

2 kiwis, peeled, halved lengthwise if large, and thinly sliced crosswise

Coarse sparkling sugar (optional)

In a small bowl, combine the ricotta, granulated sugar, and lemon zest to taste. Stir with a spoon until smooth and creamy.

Toast the bread to desired doneness. Spread one side of each slice with the sweetened ricotta, dividing it evenly. Top each toast with persimmon and kiwi in alternating and overlapping slices, so that all four toasts have some of both fruits. Scatter a little coarse sugar on top, if desired, and serve immediately.

BRIDGE FEST

Hoping to showcase Sacramento's contribution to the American table, city boosters dreamed up an annual event that has become the hottest ticket in town. The first Farm-to-Fork Dinner, in 2013, sold out in a few hours. The following year, it took a few seconds. Now, organizers rely on a random drawing to handle demand for seats at the late-summer dinner, held alfresco on the city's historic Tower Bridge.

Metaphorically, the bridge venue reinforces the event's objective to link local farmers with the community they feed. Growers collaborate with local chefs on the menu, sometimes planting a crop just for the dinner. As daylight wanes, eight hundred guests gather on the bridge, which spans the Sacramento River, for wine and hors d'oeuvres. The sit-down dinner at two long tables winds down as the bridge lights go on, their reflection sparkling in the river.

"The chefs are integral but the farmers are the rock stars at this event," says Mike Testa, president and CEO of Visit Sacramento. Given the city's location at the heart of the fertile Sacramento Valley, it is more than just the state capital, says Testa. "It's America's farm-to-fork capital."

Funds raised at the dinner underwrite a two-day Farm-to-Fork Festival, which lures sixty thousand people to the Capitol Mall to celebrate the local bounty. Dinner proceeds also support scholarships to Sacramento State University for the children of migrant farmworkers. Both the dinner and festival are part of a month of activities highlighting local agriculture, kicking off with a fresh-food drive that raises 500,000 pounds (226,800 kg) of donated produce.

Photo by Octavio Valencia Photography

POTATO FOCACCIA WITH OLIVES AND ROSEMARY

MAKES ONE 11-BY-17-INCH (28-BY-43 CM) FOCACCIA

Welcome guests to your home for dinner with a glass of wine and a slice of warm olive focaccia. If you've baked the focaccia hours before, you can reheat it quickly in a hot oven, although it's plenty tasty at room temperature, too. Pack it on a picnic or a hike with your favorite salumi and cheeses. Adding cooked potato to the dough produces an especially moist and tasty result.

WINE SUGGESTION: *California Sauvignon Blanc or rosé*

½ pound (250 g) Yukon Gold potatoes, unpeeled

1½ teaspoons active dry yeast

3¾ cups (465 g) unbleached all-purpose flour, plus more for kneading

2½ teaspoons kosher or sea salt, plus more for sprinkling

¼ cup (60 ml) extra virgin olive oil, plus more for coating and brushing

24 California olives, pitted and halved

1½ teaspoons finely minced fresh rosemary or dried oregano, finely crumbled

Put the potatoes in a small saucepan and add water to cover by 1 inch (2.5 cm). Do not add salt. Bring to a simmer over high heat, adjust the heat to maintain a gentle simmer, and cook until the potatoes are tender when pierced, 15 minutes or more, depending on size.

Remove from the heat, set aside 1⅓ cups (330 ml) of the potato water, and then drain the potatoes. When cool enough to handle, peel the potatoes and pass them through a ricer or food mill fitted with a fine disk into a bowl. If you don't have a ricer or food mill, mash the potatoes well with a potato masher.

Refrigerate the potato water until it cools to 105° to 115°F (40° to 46°C). Put ⅓ cup (80 ml) of the cooled potato water in a large bowl and sprinkle the yeast over it. Let soften for about 3 minutes, then whisk with a fork to dissolve and let stand until bubbly, about 10 minutes.

Meanwhile, in a bowl, combine the flour and salt and whisk to blend.

Add the olive oil, riced potato, and the remaining 1 cup (250 ml) potato water to the proofed yeast. Stir to combine, then add the flour gradually, stirring with a wooden spoon until the dough clears the sides of the bowl. Keeping the dough in the bowl, knead it gently by hand until smooth, adding just enough additional flour to keep it from sticking to your hand. You should not need more than 1 to 2 tablespoons. Shape the dough into a ball and coat lightly with olive oil. Cover the bowl tightly with plastic wrap and let the dough rise until doubled, 1½ to 2 hours.

Punch the dough down. Using 1 tablespoon olive oil, grease the bottom and sides of an 11-by-17-inch (28-by-43 cm) rimmed baking sheet. Transfer the dough to the baking sheet. With well-oiled fingers, poke and prod the dough into a rectangle that fits the pan. The dough is elastic and will want to spring back. If it resists your attempts to flatten it enough to cover the pan, let it rest for 5 minutes and try again. If it still springs back from the edges, let it rest for 5 minutes longer and try once more. You should be able to flatten it sufficiently after a couple of rests, but don't worry if the dough doesn't completely fill the pan. Let rise, uncovered, until puffy, about 1½ hours.

While the dough rises, preheat the oven to 400°F (200°C). If you have a pizza stone (or baking tiles), put it in the oven on the middle rack to preheat—ideally for at least 30 minutes before baking.

Arrange the olives, evenly spaced, on the surface of the focaccia, then gently press them into place. Brush the surface of the dough with 1 tablespoon olive oil, then scatter the rosemary and a little salt on top. Place the pan on the baking stone, if using, and bake until the focaccia is golden brown, 20 to 25 minutes, rotating the baking sheet back to front halfway through.

Immediately slide a long metal offset spatula under the focaccia to make sure it is not sticking to the baking sheet, then slide the focaccia onto a rack to cool. Slice into desired portions with a bread knife and serve warm or at room temperature.

ARUGULA, FENNEL, AND PERSIMMON SALAD

SERVES 4

Fuyu persimmons add sweetness to autumn salads, especially welcome with slightly bitter greens like arugula, escarole, and frisée. Against pale shaved fennel and deep green arugula, their vivid color gleams. It's such a simple salad, but the vivid contrasts of color, texture, and flavor make it work.

WINE SUGGESTION: *California rosé or Viognier*

DRESSING:

1 tablespoon fresh lemon juice
1 small shallot, minced
1 teaspoon Vietnamese fish sauce
3 tablespoons extra virgin olive oil
Kosher or sea salt and freshly ground black pepper

¼ pound (125 g) young arugula or other baby greens
1 small Fuyu persimmon, halved vertically and cored
½ large fennel bulb

Make the dressing: In a small bowl, combine the lemon juice, shallot, and fish sauce. Gradually whisk in the olive oil. Season to taste with salt and pepper.

Put the arugula in a salad bowl. With a mandoline or other vegetable slicer, or with a sharp knife, shave the persimmon into half rounds, then shave the fennel. Add the persimmon and fennel to the salad bowl and toss with your hands to mix.

Add just enough dressing to coat the greens lightly, tossing gently with your hands; you may not need it all. Taste and adjust the seasoning. Serve immediately.

KALE SALAD WITH RED GRAPES, WALNUTS, AND FETA

SERVES 3 OR 4

The secret to an irresistible kale salad is the pre-dressing massage. Rubbing the sturdy leaves with salt and lemon breaks down cell walls, softening the greens and allowing the dressing to penetrate. If your market offers more than one variety of kale (such as both Tuscan and Russian), choose the type with the most tender leaves. Feel free to improvise with this recipe, replacing the grapes on occasion with figs, persimmons, or apples.

WINE SUGGESTION: *California Chardonnay or rosé*

¼ pound (125 g) curly kale leaves (no ribs), coarsely chopped

2 teaspoons fresh lemon juice, plus more if needed

Kosher or sea salt

2½ tablespoons extra virgin olive oil

1 cup (135 g) halved red seedless grapes

2 green onions, white and pale green part only, thinly sliced or finely chopped

1 to 2 tablespoons minced fresh dill

1 small clove garlic, peeled

1 small romaine heart, about ¼ pound (125 g), halved lengthwise and very thinly sliced crosswise

½ cup (50 g) walnuts, toasted and coarsely chopped

2 ounces (60 g) feta, finely crumbled

In a large bowl, combine the kale, lemon juice, and ½ teaspoon salt. Massage the kale, kneading it vigorously with your hands for a couple of minutes to soften it. It will shrink in volume. Add the olive oil, grapes, green onions, and dill. With a rasp grater, add a few scrapings of garlic, or add a pinch of finely minced garlic. Toss well with a fork and let the kale relax for 15 to 30 minutes.

Just before serving, stir in the romaine, walnuts, and feta. Toss well, then taste and adjust the seasoning with salt and lemon juice if needed. Serve immediately.

WARM SALMON SALAD WITH ASPARAGUS, FARM EGGS, AND FINGERLING POTATOES

SERVES 4

For a late-spring lunch or light dinner, make a salmon salad the centerpiece. Surround with tender hearts of butter lettuce and seasonal vegetables: California asparagus, radishes, and the first new potatoes in late spring; tomatoes, corn, and sweet red onions in summer. A vinaigrette whisked with fresh herbs and capers brings all the elements together.

WINE SUGGESTION: *California rosé, Sauvignon Blanc, or Chardonnay*

VINAIGRETTE:

3 tablespoons white wine vinegar, plus more if needed

1 tablespoon Vietnamese fish sauce

1 large shallot, finely minced

3 tablespoons minced fresh flat-leaf parsley

1 tablespoon minced fresh tarragon

1 tablespoon salt-packed capers, rinsed and finely chopped

½ cup (125 ml) extra virgin olive oil, plus more if needed

Kosher or sea salt

1 pound (500 g) fingerling potatoes

4 large eggs

1 pound (500 g) medium asparagus, tough ends removed

Extra virgin olive oil for oiling the pan

4 skin-on wild salmon fillets, about 6 ounces (185 g) each

Kosher or sea salt and freshly ground black pepper

1 soft butter lettuce heart, separated into leaves

12 radishes, trimmed and halved

12 ripe olives

Make the vinaigrette: In a bowl, whisk together the vinegar, fish sauce, shallot, parsley, tarragon, and capers. Whisk in the olive oil. Season to taste with salt, then adjust the balance with more oil or vinegar if needed. Set aside for 30 minutes to allow the flavor to mellow.

Put the potatoes in a saucepan and add salted water to cover by 1 inch (2.5 cm). Bring to a simmer over high heat, cover partially, adjust the heat to maintain a gentle simmer, and cook until the potatoes are tender when pierced, about 15 minutes. Drain the potatoes, let stand just until cool enough to handle, then peel. Let cool completely and slice crosswise or halve lengthwise.

Preheat the oven to 400°F (200°C). Put enough water in a saucepan to cover the 4 eggs generously but do not add the eggs yet. Bring the water to a boil over high heat, then reduce the heat to a simmer so you can add the eggs without jostling them. While the water is heating, prepare a large bowl of ice water. With a large spoon, lower the eggs into the simmering water, working carefully so they do not crack. Adjust the heat so the eggs cook at a gentle simmer. Cook the eggs for 7 minutes exactly. (The yolk will be runny; cook for another minute or two if you prefer a firmer yolk.) Transfer the eggs to the ice water with a slotted spoon. When cool, lift them out of the water and peel.

Bring a large frying pan half full of salted water to a boil over high heat. Add the asparagus and boil until just tender, 3 to 5 minutes. Drain and chill quickly under cold running water. Pat dry.

Lightly oil a rimmed baking sheet. Season the salmon with salt and pepper. Place skin side down on the baking sheet and bake until the flesh just flakes when probed with a fork, about 12 minutes.

While the salmon bakes, arrange a few lettuce leaves on each of four plates. Leaving room in the center for the salmon, arrange an equal amount of the potatoes slices, asparagus, radishes, and olives and 2 egg halves on each plate. With an offset spatula, lift the salmon fillets off of their skin and transfer to the plates, leaving the skin behind. Whisk the dressing and spoon it over the salads; you may not need it all. Serve immediately.

SALMON SPOTLIGHT: California's wild king (chinook) salmon is the most prized among several varieties found in West Coast waters. It has delicate flavor and lean flesh early in the season, becoming richer and fattier by late summer. To protect the stock from overfishing, fisheries experts carefully monitor populations and determine the length of the season and total size of the catch every year.

GOLDEN BEET, POMEGRANATE, AND FETA SALAD

SERVES 4

This salad is equally tasty with red or pink (Chioggia) beets, of course, but golden beets are the prettiest choice. Their color doesn't bleed like red beets, so the feta stays pristine. Radicchio contributes a pleasantly bitter edge to balance the sweetness, and fresh mint adds zip. Serve as a first course followed by roast chicken or lamb.

WINE SUGGESTION: *California Gewürztraminer or Pinot Gris / Grigio*

4 golden beets, about 1½ pounds (750 g) total, greens removed

2 tablespoons white wine vinegar

6 fresh thyme sprigs

3 allspice berries

1 whole clove

1 clove garlic, halved

DRESSING:

1½ tablespoons white wine vinegar

1 tablespoon finely minced shallot

3 tablespoons extra virgin olive oil

Kosher or sea salt

¼ head radicchio, 3 ounces (90 g), thinly sliced

½ cup (60 g) chopped toasted walnuts

12 fresh mint leaves, torn into smaller pieces

2 to 3 ounces (60 to 90 g) Greek or French feta

⅓ cup (60 g) pomegranate arils (seeds)

Preheat the oven to 375°F (190°C). Put the beets in a small baking dish and add water to a depth of ¼ inch (6 mm). Add the vinegar, thyme, allspice, clove, and garlic. Cover and bake until the beets are tender when pierced, about 1 hour, depending on size. Remove from the oven and peel when cool enough to handle. Let cool completely, then slice thinly with a mandoline or other vegetable slicer or with a sharp knife.

Make the dressing: In a small bowl, combine the wine vinegar and shallot. Whisk in the olive oil. Season with salt and let stand for 15 minutes to allow the shallot flavor to mellow.

In a bowl, toss the beets and radicchio gently with enough of the dressing to coat lightly; you may not need it all. Taste for salt and vinegar and adjust as needed. Add the walnuts and half the mint leaves and toss gently. Transfer to a wide serving platter. Crumble the feta on top, then scatter the pomegranate arils and remaining mint leaves over all. Serve immediately.

CHINESE CHICKEN SOUP WITH EGG NOODLES, BABY BOK CHOY, AND PEA SHOOTS

SERVES 4

You can easily reproduce at home the sort of meal-in-a-bowl soup that lures hungry customers every day to Chinese noodle shops. For each diner, you'll need a bowl large enough (at least 1 quart/1 l) to accommodate the noodles, vegetables, and broth. Be sure your guests are seated and ready before you ladle the hot broth into the bowls. Noodle soup waits for no one.

WINE SUGGESTION: *California Chardonnay or Riesling*

½ ounce (15 g) dried shiitake mushrooms

1 cup (250 ml) cold water

10 to 12 ounces (315 to 375 g) fresh Chinese egg noodles

1 tablespoon plus 1 teaspoon Asian sesame oil

7 cups (1.75 l) rich chicken broth, preferably homemade

8 thin slices fresh ginger, peeled and smacked

2 green onions, cut into 2-inch (5-cm) lengths, smacked, plus 4 green onions, white and pale green part only, thinly sliced

Kosher or sea salt and freshly ground black pepper

½ pound (250 g) pea shoots (see Note), watercress, or baby spinach, thick stems removed

2 teaspoons Chinese chile-garlic paste

¾ pound (375 g) baby bok choy

2½ tablespoons peanut oil

2 cloves garlic, minced

¼ cup (10 g) coarsely chopped fresh cilantro

In a bowl, soak the mushrooms in the water for 4 to 12 hours. Lift them out of the soaking liquid. If they are not already sliced, slice them, removing any tough bits. Strain the liquid through a sieve lined with a damp paper towel to remove any grit and set aside.

Bring a large pot of salted water to a boil over high heat. Add the noodles, stir well to keep the noodles from clumping, and boil according to package directions, undercooking them slightly as they will cook more in the broth. Drain into a sieve or colander and immediately rinse with cold water. Shake well to remove any excess water, transfer to a bowl, and toss with the sesame oil to prevent clumping.

In a saucepan, combine the broth, ginger, and smacked green onions. Bring to a simmer over medium heat and simmer until reduced to 6 cups (1.5 l), about 10 minutes. Add the mushroom soaking liquid, season with salt and pepper, then strain through a fine-mesh sieve into a bowl.

Divide the pea shoots among four large soup bowls. Put ½ teaspoon chile-garlic paste in each bowl.

Halve the bok choy lengthwise, then cut crosswise to separate the tender green leaves from the bulbous white ribs. Chop the ribs into 1-inch (2.5 cm) pieces.

Heat the peanut oil in a large saucepan over medium-low heat. Add the garlic and sauté until fragrant, then add the shiitake and sauté for 1 minute, stirring. Add the bok choy ribs, season with salt, and cook, stirring constantly, until slightly softened, 1 to 2 minutes. Add the bok choy leaves and the broth and bring to a simmer. Add the noodles and return to a simmer. Taste for salt.

Ladle the hot soup into the four bowls, dividing it evenly. Mix briefly with chopsticks so the pea shoots wilt in the hot broth. Top with the sliced green onions and cilantro, dividing them evenly. Serve immediately.

PEA SHOOTS AND SPROUTS: The leafy, green tendrils, or shoots, of the snow pea vine are tender and tasty when young. You will need to remove any tough or woody stems that won't wilt in the heat of the broth, so be sure to buy enough shoots to yield $\frac{1}{2}$ pound (250 g) after trimming. Some markets carry packaged pea sprouts, which are very delicate and perishable. If you can find only the sprouts, inspect the package carefully to make sure the sprouts are perky and not mushy. Sprinkle them on the soup when you add the green onions and cilantro, then push them down into the broth.

ROASTED TOMATO SOUP WITH TORTILLA CRISPS

SERVES 6

Roasting tomatoes, onions, and garlic is a common technique in the Mexican kitchen. The slight charring intensifies flavor and heightens the sweetness of the vegetables, yielding a soup with a deep, rich taste. Pureed chickpeas give the broth body, and chipotle chiles warm it up. Pass tortilla crisps for diners to add as they like; softened in the broth, the crisps seem almost like noodles. Substitute packaged tortilla chips if you prefer.

WINE SUGGESTION: *California Sauvignon Blanc or Zinfandel*

2 pounds (1 kg) tomatoes

1 large white onion, sliced into rounds ⅓ inch (9 mm) thick

4 large cloves garlic, unpeeled

2 tablespoons extra virgin olive oil

1 teaspoon dried Mexican oregano

Kosher or sea salt

2 cups (370 g) cooked chickpeas (drain and rinse if canned)

2½ to 3 cups (625 to 750 ml) chicken or vegetable broth

Chipotle chile in adobo

Canola oil for deep-frying

4 corn tortillas, about 6 inches in diameter

⅓ cup (25 g) finely grated queso Cotija or pecorino romano

Chopped fresh cilantro, for garnish

Preheat the broiler and position an oven rack about 8 inches (20 cm) from the heating element. Line two rimmed baking sheets with aluminum foil. Put the tomatoes on one baking sheet and broil, turning the tomatoes as needed, until their flesh is soft and the skin is charred in spots and splitting. It should take about 20 minutes. Don't rush this process, as you want the tomatoes to develop a deep roasted flavor. Move the rack down if the skin threatens to char too much before the tomato is cooked through. Set aside.

Put the onion slices and garlic cloves on the second foil-lined baking sheet. Broil, turning the vegetables as needed, until the onion is soft and lightly charred on

both sides and the garlic is soft, 15 to 20 minutes. Remove the garlic if it softens before the onions. Don't allow it to blacken or it will taste bitter. When cool enough to handle, core and peel the tomatoes and peel the garlic.

Put the tomatoes, onion, and garlic in a blender and puree until smooth.

Heat the olive oil in a pot over medium-high heat. When the oil is hot, add the tomato puree and the oregano, crumbling it between your fingers. Season with salt and cook at a vigorous simmer, stirring, for 2 to 3 minutes to deepen the flavor.

In the blender, puree the chickpeas with 1 cup (250 ml) of the broth. Add to the tomato mixture along with enough of the remaining broth to bring the soup to the consistency you like. You may not use it all. Stir until smooth. Season to taste with salt and with as much finely chopped chipotle chile as you like. Keep the soup warm.

In a deep, heavy pot, pour the canola oil to a depth of 2 inches (5 cm) and heat to 375°F (190°C). Have ready a tray or baking sheet lined with a double thickness of paper towels. While the oil is heating, stack the tortillas and cut them in half. Stack the halves with the cut side facing you, then slice into strips ½ inch (12 mm) wide. Discard the short end pieces.

In small batches, fry the tortilla strips in the hot oil until golden brown, 1½ to 2 minutes. Use a wire-mesh skimmer to keep them moving in the oil so they brown evenly. Transfer them with the skimmer to the paper towels and sprinkle generously with salt. Check the oil temperature between batches and adjust the heat as necessary to keep it at 375°F (190°C). Put the cooled tortilla crisps in a bowl.

Reheat the soup to serving temperature if needed, then divide among six bowls. Garnish each portion with the queso Cotija, dividing it evenly, and cilantro. Serve immediately, passing the tortilla crisps for diners to add to their soup as desired.

RAMEN WITH ASPARAGUS, SHIITAKE, AND EDAMAME

SERVES 2

Everybody loves ramen. The noodles are slippery and satisfying, the broth nourishing, and it's okay to slurp. Use this recipe as a template for your own inspirations. When asparagus is not in season, substitute spinach or mustard greens. If you can't find edamame (soybeans), try green peas. A quivering six-minute egg continues to cook in the hot broth and adds richness.

WINE SUGGESTION: *California Riesling or Gewürztraminer*

3½ cups (875 ml) rich chicken or vegetable broth

½ cup (5 g) dried bonito flakes

1 large egg

½ pound (250 g) fresh ramen noodles

2 teaspoons Asian sesame oil

4 fresh shiitake mushrooms, about 1½ oz (45 g), stems removed, then sliced

Kosher or sea salt

½ cup (70 g) fresh or frozen shelled edamame

⅔ cup (70 g) diagonally sliced asparagus tips, in slices ¼ inch (6 mm) thick

¼ cup (65 g) white miso

¼ cup (30 g) minced green onion, white and pale green part only

Shichimi togarashi (Japanese seven-spice blend), for garnish

Bring the broth to a simmer in a small saucepan. Remove from the heat and add the bonito flakes, sprinkling them on the surface. Let them steep for 3 to 4 minutes, then strain through cheesecloth and return the strained broth to the saucepan.

Put enough water in a small saucepan to cover the egg generously but do not add the egg yet. Bring the water to a boil over high heat, then reduce the heat to a simmer so you can add the egg without jostling it. While the water is heating, prepare a bowl of ice water. With a large spoon, lower the egg into the simmering water, working carefully so it does not crack. Adjust the heat so the egg cooks at a gentle simmer. Cook the egg for 6 minutes exactly. Transfer the egg to the ice water with a slotted spoon. When cool, lift it out of the water and peel.

Bring a large pot of unsalted water to a boil over high heat. Add the ramen noodles and stir well to keep the noodles from clumping. Cook, stirring often, until the noodles are al dente (the timing will depend on their freshness). With tongs, lift the noodles out of the pot and into a sieve or colander. Rinse with cool water and shake well to remove any excess water. Transfer to a bowl and toss with 1 teaspoon of the sesame oil to prevent clumping.

Fill two large soup bowls with hot water from the ramen pot to warm them.

Heat the remaining 1 teaspoon sesame oil in a small nonstick frying pan over medium-high heat. Add the mushrooms and sauté until softened, 1 to 2 minutes. Season with salt and set aside.

Return the broth to medium heat and bring to a simmer. Add the edamame and simmer gently until they are almost tender, 3 to 5 minutes. (You can add frozen edamame without thawing.) Add the asparagus and cook for 1 minute.

Put the miso in a small bowl and whisk in enough of the hot broth to make a smooth, pourable mixture. Stir the thinned miso into the broth. Taste for salt.

Drain the hot water from the soup bowls. Divide the noodles and mushrooms between the bowls. Top with the steaming-hot broth, dividing it evenly. Halve the boiled egg and nestle one half in each bowl. Garnish generously with the green onions and shichimi togarashi and serve.

POLENTA WITH SLOW-ROASTED TOMATOES AND TELEME CHEESE

SERVES 4 TO 6

Patience pays off with this recipe. It takes two to three hours for meaty plum tomatoes to lightly caramelize in a slow oven and a good hour for polenta to become perfectly creamy on top of the stove. Pour the polenta onto a board and top with the juicy tomatoes and soft, melting slabs of Teleme cheese and your patience will be rewarded.

WINE SUGGESTION: *California Cabernet Sauvignon or Zinfandel*

1½ pounds (750 g) plum tomatoes, halved lengthwise

¼ cup (60 ml) extra virgin olive oil

3 cloves garlic, minced

1 teaspoon dried oregano, finely crumbled

Kosher or sea salt

4 tablespoons (60 g) unsalted butter

1 yellow onion, minced

2½ quarts (2.5 l) boiling water

1 bay leaf

2 cups (345 g) polenta

6 to 7 ounces (185 to 220 g) Teleme or crescenza, thinly sliced

Crushed red pepper flakes or coarsely cracked black pepper

Preheat the oven to 300°F. Put the halved tomatoes, cut side up, in a single layer in baking dish just large enough to hold them. Drizzle with the olive oil. Scatter the garlic and oregano evenly over the tomatoes. Season generously with salt. Bake the tomatoes, basting occasionally with the dish juices, until they begin to caramelize around the edges and are completely soft but still hold their shape, 2½ to 3 hours.

Melt the butter in a pot over medium heat. Add the onion and cook, stirring often, until softened and beginning to color, about 5 minutes. Add the boiling water and bay leaf. Gradually add the polenta, whisking constantly. Reduce the heat to maintain a gentle simmer and continue to whisk. When the polenta becomes too thick to whisk, switch to a wooden spoon. Cook until the polenta is thick and creamy, about 1 hour. Stir often to keep the polenta from scorching on the bottom of the pot. Remove the bay leaf and season the polenta with salt and pepper.

Pour the polenta onto a large wooden board or rimmed serving platter and spread it to an even thickness. Top with the Teleme slices, then arrange the tomato halves, cut side up, on top, pressing them gently into the polenta. Spoon any juices from the baking dish over the polenta, sprinkle with pepper, and serve immediately.

BAKED LINGCOD WITH GREEN-OLIVE SALSA VERDE

SERVES 4

An Italian salsa verde *doesn't typically include olives, but they contribute a bright, briny note and some welcome texture. You can use any olives you like but avoid those that are already flavored with herbs, as the* salsa verde *has its own distinctive seasoning. Any firm white fish can replace the lingcod if it's unavailable. Accompany with steamed creamer potatoes or asparagus. The* salsa verde *complements many other cooked vegetables, such as cauliflower, carrots, and green beans.*

WINE SUGGESTION: *California Sauvignon Blanc*

SALSA VERDE:

⅓ cup (80 ml) extra virgin olive oil

¼ cup (10 g) finely minced fresh flat-leaf parsley

2 tablespoons finely minced fresh cilantro

3 olive oil–packed anchovy fillets, minced to a paste

1 tablespoon salt-packed capers, rinsed and soaked in water for 30 minutes, then drained and finely chopped

1 small clove garlic, grated with a rasp grater or very finely minced

2 teaspoons fresh lemon juice

½ teaspoon finely grated lemon zest

8 green olives, pitted and quartered

¼ cup (15 g) soft fresh fine bread crumbs

6 lingcod or other firm white fish fillets, 6 ounces (185 g) each

Extra virgin olive oil for coating

Kosher or sea salt and freshly ground black pepper

Preheat the oven to 375°F (190°C).

In a bowl, combine all the salsa verde ingredients and stir to blend. Let stand for 30 minutes to allow the bread crumbs to swell and the flavors to merge. Taste and adjust the seasoning. The salsa will likely need no salt.

Coat the fish fillets lightly with olive oil and season lightly with salt, remembering that the salsa verde is salty. Grind a little pepper on top. Place the fillets on a rimmed baking sheet and bake until they just flake when probed with a fork, 10 to 12 minutes, depending on thickness.

Transfer the fillets to individual serving plates and spoon any juices from the baking dish over them, then top with salsa verde, dividing it evenly. Serve immediately.

GRILLED LAMB SHOULDER CHOPS WITH POMEGRANATE MARINADE

SERVES 4

Fresh pomegranate juice tenderizes these chops and helps them brown appetizingly on the grill. After the marinade does its job, it's reduced to a near glaze and brushed on the chops for a sweet-tart finale. Shoulder chops are chewier than loin or lamb chops but bigger in flavor. Ask your butcher for blade chops, not arm chops.

WINE SUGGESTION: *California Zinfandel or Syrah*

MARINADE:

¾ cup (180 ml) fresh pomegranate juice (page 149)

1 teaspoon kosher or sea salt

12 black peppercorns

4 large fresh thyme sprigs

2 large cloves garlic, thinly sliced

2 tablespoons extra virgin olive oil

4 lamb shoulder blade chops, ½ to ¾ pound
 (250 to 375 g) each

Make the marinade: In a small saucepan, bring the pomegranate juice to a simmer over high heat. Add the salt, peppercorns, thyme, and garlic and remove from the heat. Let steep until cool. Whisk in the olive oil.

Put the chops in a glass or ceramic baking dish just large enough to hold them. Pour the marinade over them. Tuck the thyme sprigs and garlic underneath the chops. Cover and marinate in the refrigerator for 4 to 6 hours. Turn the chops every hour or two and baste with the marinade.

Prepare a medium-hot charcoal fire or preheat a gas grill to medium-high. Lift the chops from the marinade and bring to room temperature before grilling. Season the chops on both sides with salt and pepper.

Strain the marinade through a fine-mesh sieve into a small saucepan. Simmer over medium heat until reduced to a near glaze; you should have about 2 tablespoons.

Grill the chops over direct heat, turning once, to desired doneness. Unlike rib or loin chops, shoulder chops taste better when cooked to at least medium, 5 to 7 minutes per side. Watch carefully and adjust the distance from the fire as needed; because of the pomegranate marinade, they can char easily.

Transfer the chops to a platter and spoon the reduced marinade on top, dividing it evenly. Let rest for 5 minutes before serving to allow the juices to settle.

GRILLED PORK LOIN, SAUSAGE, AND FIG SKEWERS

SERVES 4

Grilling softens figs and makes them as sweet as honey. Skewered with balsamic vinegar–marinated pork loin and Italian sausage, they provide a warm, jammy complement that makes a sauce unnecessary. Serve on a bed of arugula for a light summer dinner or, for a heartier meal, accompany the skewers with polenta.

WINE SUGGESTION: *California Zinfandel or Petite Sirah*

1 pound (500 g) boneless pork loin, trimmed of excess fat and cut into ¾-inch (2-cm) inch cubes

1 teaspoon kosher or sea salt

Freshly ground black pepper

1 tablespoon plus 1 teaspoon balsamic vinegar

2 teaspoons extra virgin olive oil

1 teaspoon finely minced fresh rosemary

VINAIGRETTE:

2 tablespoons extra virgin olive oil

2 teaspoons balsamic vinegar

Kosher or sea salt and freshly ground black pepper

1 large red onion

Kosher or sea salt

8 large fresh figs, halved through the stem

2 hot or mild fresh Italian sausages, about ¼ pound (125 g) each, cut into slices 1 inch (2.5 cm) thick

6 ounces (185 g) arugula (about 4 generous handfuls)

Chunk of pecorino romano, Parmigiano Reggiano, or ricotta salata, for shaving

Put the cubed pork in a small bowl and add the salt, pepper, vinegar, olive oil, and rosemary. Toss to coat the pork evenly. Let stand at room temperature for 1 hour, or cover and refrigerate for up to 8 hours, then bring to room temperature before grilling.

Make the vinaigrette: In a small bowl, whisk together the olive oil, vinegar, and salt and pepper to taste.

Peel the red onion and cut into quarters through the stem. Separate each quarter into individual layers. Cut the outer layers crosswise to make pieces suitable for skewering. (Reserve the small inner layers for another use.) Bring a small saucepan of water to a boil over high heat and add the onion pieces. Boil for 1 minute, then drain in a sieve and cool quickly under cold running water. Drain again and pat dry. Salt lightly.

On four long metal skewers, alternate pieces of marinated pork, onion, fig, and sausage. Set the skewers aside on a tray.

Prepare a hot charcoal fire or preheat a gas grill to high. Grill the pork skewers, turning once, until the meat is firm but still juicy inside and the onion is lightly charred, about 8 minutes.

While the pork cooks, toss the arugula with just enough of the vinaigrette to coat it lightly; you may not need it all. With a cheese plane or vegetable peeler, shave 3 to 4 ounces (90 to 125 g) of cheese into the arugula and toss again.

Mound the dressed arugula on four dinner plates, dividing it evenly. Top each portion with a skewer and serve immediately.

SEARED DUCK BREASTS WITH PORT AND CHERRY SAUCE

SERVES 4

Cooking duck breasts slowly, skin side down, helps eliminate almost every speck of fat. After about 20 minutes, the skin will be crisp and the flesh as rosy and tender as a fine steak. A silky port and cherry sauce makes this a restaurant-caliber dish. Serve with wild rice.

Duck breasts vary tremendously in size; scale up the spice rub if the breasts you buy are considerably larger.

WINE SUGGESTION: *California Cabernet Sauvignon or Merlot*

SEASONING RUB:

8 juniper berries

2 teaspoons minced fresh thyme

2 teaspoons kosher or sea salt

1 teaspoon black peppercorns

4 boneless duck breasts, about ½ pound (250 g) each

SAUCE:

1 cup (250 ml) Zinfandel Port or ruby port

1 shallot, minced

3 fresh thyme sprigs

1 strip orange zest, removed with a vegetable peeler

1 tablespoon balsamic vinegar

24 cherries, pitted and halved

½ cup (125 ml) strong chicken broth, reduced from
 1 cup (250 ml)

½ teaspoon sugar

Kosher or sea salt and freshly ground black pepper

1 tablespoon unsalted butter

Make the seasoning rub: Put the juniper berries, thyme, salt, and peppercorns in a mortar or spice grinder and grind to a powder.

Slash the skin of each breast in a crosshatch pattern, stopping short of the flesh. (The slashes help render the fat.) Sprinkle the seasoning rub evenly onto both sides

of each breast. Put the breasts on a flat rack and set the rack inside a tray. Refrigerate uncovered for 24 to 36 hours. Bring to room temperature before cooking.

Choose a heavy frying pan large enough to accommodate all the duck breasts comfortably. (If necessary to avoid crowding, use two frying pans.) Put the breasts, skin side down, in the unheated frying pan and set over medium-low heat. Cook until the skin is well browned and crisp, about 15 minutes, frequently pouring off the fat until the skin no longer renders much. (Reserve the fat for frying potatoes, if you like.)

Turn the duck breasts and continue cooking flesh side down, turning the breasts with tongs to sear all the exposed flesh, until the internal temperature registers 125°F (52°C) on an instant-read thermometer, about 3 minutes longer. Transfer the breasts to a cutting board and let rest for 5 minutes before slicing.

While the duck cooks, make the sauce: In a small saucepan, combine the port, shallot, thyme, orange zest, vinegar, and half of the cherries. Bring to a simmer over medium heat and simmer until reduced to ¾ cup (180 ml). Add the broth and sugar and simmer until the liquid has again reduced to ¾ cup (180 ml). Remove from the heat and, with tongs, lift out the thyme sprigs and orange zest and discard.

Puree the sauce in a blender. Set a very fine-mesh sieve over the saucepan and pass the sauce through the sieve, pressing on the solids with a rubber spatula. Return to medium heat, season with salt and pepper, and simmer until reduced to ½ cup (125 ml). Stir in the remaining cherries and remove from the heat. Add the butter and swirl the saucepan until the butter melts.

Slice the duck on the diagonal. Spoon some of the sauce on each of four dinner plates, dividing it evenly. Top with the sliced duck. Serve immediately.

STIR-FRIED SKIRT STEAK WITH CHINESE BROCCOLI AND SHIITAKE

SERVES 2 TO 4

Compared to the broccoli familiar to most non-Asian shoppers, Chinese broccoli (known as gài lán in Cantonese) is prized more for its dark, tasty leaves and sweet stalks than for its flowering heads. In Chinese restaurants, the brilliant green vegetable is often stir-fried with oyster sauce and silky ribbons of beef, a dish that is easy to reproduce at home. Easy, that is, if you are organized and have all your ingredients prepped and next to the stove before you start to stir-fry. Tender skirt steak—Mexican markets call it arrachera*—is the best choice for this dish, but flap meat or flank steak can substitute. Look for Chinese broccoli with stalks no more than ³⁄₄ inch (2 cm) in diameter. Served with rice, the recipe will satisfy two or three diners for dinner. If you add more dishes to the menu, the recipe will serve four.*

WINE SUGGESTION: *California Cabernet Sauvignon or rosé*

MARINADE:

2 tablespoons soy sauce

2 teaspoons Chinese rice wine (Shaoxing) or dry sherry

2 teaspoons cornstarch

1 teaspoon Chinese chile oil

1 teaspoon peanut oil

½ teaspoon sugar

¾ pound (375 g) skirt steak, thinly sliced across the grain

1½ tablespoons sesame seeds

¾ pound (375 g) Chinese broccoli, stalks pared with a vegetable peeler

2 tablespoons Chinese oyster sauce

1 tablespoon Chinese chile sauce

3 tablespoons chicken broth

5 tablespoons (80 ml) peanut oil

¼ teaspoon sugar

Kosher or sea salt

1 tablespoon Chinese rice wine (Shaoxing) or dry sherry

¼ pound (125 g) fresh shiitake mushrooms, stems discarded and caps sliced

1 tablespoon peeled and finely minced fresh ginger

1 tablespoon finely minced garlic

⅓ cup (15 g) coarsely chopped fresh cilantro

In a bowl, combine all the marinade ingredients and whisk to blend. Add the skirt steak and toss to coat well. Cover and refrigerate for 2 to 12 hours. Bring to room temperature before cooking.

Preheat the oven to 350°F (180°C). Toast the sesame seeds on a heavy rimmed baking sheet until golden brown, about 5 minutes. Pour onto a plate to cool.

Bring a large pot of salted water to a boil over high heat. Prepare a large bowl of ice water. Blanch the broccoli in the boiling water for 2 minutes, then transfer with tongs to the ice water. When cold, drain well and squeeze dry. Separate the leafy branches from the main stalks. Slice the stalks in half on the diagonal.

In a small bowl, stir together the oyster sauce, chile sauce, and 1 tablespoon of the broth.

Heat a wok over high heat until a bead of water evaporates on contact. Add 1 tablespoon of the peanut oil and swirl to coat the surface of the wok. When the oil is hot, add the broccoli, sugar, and a generous pinch of salt and stir-fry until the broccoli is hot throughout. Add the wine and let it sizzle, then add the remaining 2 tablespoons broth, cover, and steam until the broccoli is crisp-tender, 2 to 3 minutes. Transfer the broccoli to a platter and return the wok to high heat.

Add 2 tablespoons of the peanut oil and swirl to coat the surface of the wok. When the oil is hot, add the mushrooms, season with salt, and stir-fry until just tender, about 2 minutes. Transfer to the platter with the broccoli. Return the wok to high heat, add the remaining 2 tablespoons peanut oil, the ginger, and the garlic, and stir-fry, stirring and tossing constantly, until the ginger and garlic are fragrant, about 15 seconds. Add the beef and its marinade and stir-fry until it just changes color, about 2 minutes. Return the mushrooms and broccoli to the wok, toss the vegetables until hot, and add the oyster sauce–broth mixture. Toss quickly to coat everything evenly and then remove from the heat.

Transfer to a platter and top with the sesame seeds and cilantro. Serve immediately.

OLD-FASHIONED CHOCOLATE SHEET CAKE WITH BING CHERRY SAUCE

MAKES 12 TO 16 SERVINGS

There are fancier chocolate cakes but few more tender or moist than this time-tested sheet cake from Napa Valley caterer Mari Havens. The recipe is a treasured hand-me-down from her grandmother, and a Bing cherry sauce dresses it up.

WINE SUGGESTION: *California Port-style Zinfandel*

1 cup (250 g) unsalted butter, plus more for greasing the pan

⅔ cup (160 ml) water

½ cup (55 g) unsweetened cocoa powder, preferably Ghirardelli or Guittard

2 cups (250 g) sifted unbleached all-purpose flour, plus more for preparing the pan

2 cups (400 g) sugar

1¼ teaspoons baking soda

1 teaspoon kosher or sea salt

2 large eggs, lightly beaten

1 cup (250 ml) buttermilk

2 teaspoons vanilla extract

SAUCE:

½ cup (100 g) sugar

1½ teaspoons cornstarch

⅔ cup (160 ml) water

1 pound (500 g) Bing cherries, pitted and halved

2 teaspoons kirsch, or more to taste

Fresh lemon juice (optional)

2 cups (500 ml) heavy cream

2 tablespoons sugar, or to taste

½ teaspoon vanilla extract

Preheat the oven to 350°F (180°C).

Lightly butter and flour the bottom and sides of a 9- by-13-inch (23-by-33 cm) baking pan.

Melt the butter in a large, heavy saucepan over medium heat. Remove from the heat, add the water and cocoa, and stir until well blended. In a bowl, whisk together the flour, sugar, baking soda, and salt to blend. Stir the flour mixture into the chocolate mixture just until thoroughly combined.

In a large bowl, whisk together the eggs, buttermilk, and vanilla. Add the chocolate mixture and mix well. Spoon the batter into the prepared pan. Bake until a toothpick inserted into the center comes out clean, about 30 minutes. Let cool completely on a rack.

Meanwhile, make the sauce: In a saucepan, combine the sugar, cornstarch, and water. Whisk well to blend, then bring to a simmer over medium heat, whisking until the sugar dissolves. Add the cherries and simmer, stirring often, until they have softened and released their flavor to the sauce, 7 to 10 minutes; do not let them collapse completely. Remove from the heat, pour into a bowl, and let cool. Stir in the kirsch and, if desired, a few drops of lemon juice, then cover and chill thoroughly.

At serving time, in a bowl, whip together the cream, sugar, and vanilla until soft peaks form.

Cut the cooled cake into 12 to 16 pieces. Accompany each portion with some of the cherry sauce and a dollop of whipped cream.

WARM APRICOT AND CHERRY CRISP

SERVES 8

*How clever of nature to ripen apricots and cherries at the
same time; the two fruits are so compatible. Toss them
with a little sugar and tapioca to thicken their juices, add
a crunchy oat and walnut topping, and bake until bubbly.
This home-style summer dessert can stand alone, but
vanilla-bean ice cream mingling with the warm juices
would make it even more luscious. Allow time for cooling.
The crisp is much better warm than hot.*

WINE SUGGESTION: *California late-harvest dessert wine
from Semillon, Sauvignon Blanc, or Riesling*

TOPPING:

¾ cup (95 g) unbleached all-purpose flour

3 tablespoons packed brown sugar

2 tablespoons granulated sugar

¼ teaspoon ground cinnamon

Pinch of kosher or sea salt

6 tablespoons (90 g) unsalted butter, firm but not chilled,
 cut into 12 pieces

½ cup (50 g) chopped toasted walnuts

⅓ cup (35 g) old-fashioned rolled oats

1½ to 1¾ pounds (750 to 875 g) apricots, halved and pitted

½ pound (250 g) cherries, halved and pitted

½ cup (100 g) granulated sugar

2 tablespoons quick-cooking tapioca

Preheat the oven to 375°F (190°C).

Make the topping: In a stand mixer fitted with the
paddle attachment, combine the flour, brown sugar,
granulated sugar, cinnamon, and salt. Mix on low speed
until blended. Add the butter and continue to mix on
low speed until the mixture resembles coarse crumbs.
Add the walnuts and oats and mix just until clumps
form. You can refrigerate this mixture, covered, for up
to 2 days.

Cut the apricot halves into 2 to 4 wedges, depending
on their size. Combine the apricots, cherries, sugar,
and tapioca in a bowl and toss well. Let stand for
10 minutes to draw some juices out of the fruit. Transfer
the mixture to a 9 ½-inch (24 cm) pie pan. Spread the
topping evenly over the surface; it should cover the fruit.

Put the pie pan on a rimmed baking sheet to catch any
drips. Bake until the fruit is bubbling and the topping
is lightly browned and crisp, 45 to 50 minutes. Let cool
on a rack for 45 minutes before serving.

GREEK YOGURT PARFAIT WITH BAKED FIGS AND SESAME BRITTLE

SERVES 4

This recipe makes more sesame brittle than you need, but you won't be sorry. Store it in an airtight container at room temperature and enjoy over the next few days, while it remains crisp.

BRITTLE:

½ cup (100 g) sugar

¼ cup (85 g) light corn syrup

2 tablespoons water

⅛ teaspoon kosher or sea salt

¾ cup (95 g) sesame seeds

1 tablespoon unsalted butter

1 teaspoon vanilla extract

½ teaspoon baking soda

3 tablespoons water

1 tablespoon Greek ouzo or other anise liqueur (optional)

10 large fresh figs, halved through the stem

1 tablespoon sugar

2 cups plain Greek yogurt

Make the brittle: Line a rimmed baking sheet with a silicone baking mat. In a small, heavy saucepan, combine the sugar, corn syrup, water, and salt. Bring to a simmer over medium heat, stirring to dissolve the sugar. Add the sesame seeds and cook, stirring often, until the mixture turns a rich caramel color and registers 300°F (150°F) on an instant-read thermometer, about 5 minutes. (Be careful, as boiling sugar can produce a nasty burn.)

Remove from the heat and immediately stir in the butter and vanilla. When the butter has melted, stir in the baking soda. The mixture will foam slightly. Working quickly, pour the mixture onto the prepared baking sheet. Let cool completely. With a mallet or rolling pin, coarsely crush one-third of the brittle (90 g) between two sheets of parchment paper. Reserve the remainder for snacking (see introduction).

Preheat the oven to 425°F (220°C). Put the water in the bottom of a baking dish just large enough to hold the figs in a single layer. Add the ouzo if desired. Arrange the figs, cut side up, in the baking dish. Sprinkle with the sugar.

Bake the figs for 10 minutes, then remove from the oven. With a pastry brush, baste the figs with the pan juices. Return to the oven and continue baking until the figs are soft and the juices are reduced to a glaze, about 10 minutes longer. Let cool for 10 to 15 minutes before serving.

Divide the yogurt among four compote dishes, stemless glasses, or wineglasses. Top each portion with 5 warm fig halves, then sprinkle with the crushed brittle, dividing it evenly. Serve immediately.

FROM THE

CENTRAL COAST

Salad Bowl for the Nation

Dubbed "America's Riviera," the dramatic California coastline between Santa Cruz and Santa Barbara draws visitors from around the globe to experience its spellbinding beauty. They drive the coast-hugging Highway 1 with its hairpin turns and jagged cliffs, browse the chic shops and galleries of Carmel, and nosh their way through some of the nation's most bountiful farmers' markets. For wine lovers, the region's tasting rooms provide many hours of discovery and diversion, while the charming small towns of San Luis Obispo and Paso Robles offer up their polished farm-to-table restaurants.

LEFT: Halter Ranch in San Luis Obispo County is a model of environmental stewardship, developed while conserving the property's natural oak woodland.

But to view the real engine of the region's economy, a visitor would have to venture inland, to the farms of the Salinas and Santa Maria Valleys. There, in the "Nation's Salad Bowl," growers take advantage of the cool maritime climate to harvest lettuces, berries, broccoli, and other fog-loving produce year-round.

Although temperatures can be a little more extreme at the southern end of the Salinas Valley, most of the region enjoys consistently mild weather: cool summers and warm winters with relatively modest fluctuations. In such a hospitable climate, farmers routinely get more than two harvests per year.

The environmentally and socially responsible mind-set that prevails in so many farming operations here derives in some measure from sustainability pioneers at the University of California, Santa Cruz. In 1967, the university persuaded Alan Chadwick, a visionary English gardening expert, to launch a student garden project on the campus. His many disciples have perpetuated sustainable practices around the state, but his influence remains especially perceptible on the Central Coast.

BELOW: (left to right) Owl boxes host rodent predators; Santa Maria broccoli fields

RIGHT: (clockwise from top) Cabernet Sauvignon; punching down Pinot Noir grapes extracts color; sought-after Pinot Noir; Ridge Vineyards's famed Monte Bello vineyard

CENTRAL COAST WINES

Extending from San Francisco to Santa Barbara, a distance of 325 miles (523 km), the Central Coast AVA encompasses some of the state's oldest and newest wine regions. Among the oldsters, the Livermore Valley has nurtured wine grapes since 1882, when Charles Wetmore planted Sauvignon Blanc at his Cresta Blanca Winery. Three decades prior, Charles Lefranc planted the New Almaden Vineyard in the Santa Clara Valley. Today, emerging wine regions like Ballard Canyon and Happy Canyon in Santa Barbara County are expanding the boundaries of California wine country.

Distance from the ocean largely determines what thrives where on the Central Coast. The coolest sites, such as the northern Salinas Valley and the Santa Maria Valley, produce exemplary Chardonnay and Pinot Noir, while vineyards in the southern Salinas Valley, where marine air rarely reaches, can ripen a heat lover like Cabernet Sauvignon.

Paso Robles, one of the warmest AVAs on the Central Coast, excels with red Rhône varieties, such as Syrah and Mourvèdre, and Zinfandel. But the AVA is large, and the climatic differences between its cool western end, near the ocean, and the dryer, warmer east side are dramatic. Wineries in the Templeton Gap District, in the west, have

FACING PAGE: (clockwise from top left) Victorian home preserved at Concannon Vineyard; Ridge Vineyards's Monte Bello vineyard; Chamisal Vineyards; stirring beauty of Paso Robles wine country

SAN FRANCISCO BAY

LIVERMORE VALLEY

SANTA CLARA VALLEY

SANTA CRUZ MOUNTAINS

SAN BENITO COUNTY

MONTEREY COUNTY

PASO ROBLES

SAN LUIS OBISPO COUNTY

SANTA BARBARA COUNTY

an easier time ripening Pinot Noir than a warm-climate grape like Mourvèdre.

Santa Barbara County boasts a rare geologic feature in the transverse Santa Ynez Valley. Oriented east-west, rather than north-south, this corridor funnels ocean air eastward, creating one of the coolest viticultural areas in the state. At Point Conception, the California coastline makes almost a right angle. As a result, some Santa Rita Hills vineyards experience sea breezes from two directions.

In recognition of its unique geography, the Santa Cruz Mountains AVA is not part of the larger Central Coast AVA (page 222). It stands alone.

TRIPLE PLAY: GRENACHE, SYRAH, MOURVÈDRE

Situated midway between San Francisco and Los Angeles, the Paso Robles AVA is three times the size of Napa Valley and one of the fastest growing in wine grape acreage. The appellation's success with Rhône grape varieties has helped it develop a distinctive identity and enthusiastic consumer following. Blends of Grenache, Syrah, and Mourvèdre are so popular in Paso (as locals call it) that they have their own abbreviated code name: GSM.

No rules or required percentages govern this blend, but Grenache typically dominates. Of the three varieties, it is the lightest in color, contributing red-fruit aromas and generous alcohol to the mix. Syrah adds the scent of darker fruits, such as black currant and black olive, along with savory, meaty notes. Mourvèdre often brings up the rear percentagewise, valued for its inky color and tannic strength. In most iterations, GSM blends are robust and rich in alcohol, fruit depth, and tannin—ideal partners for grilled lamb, braised lamb shanks, or cassoulet.

The biannual Hospice du Rhône event, a two-day conclave in Paso Robles, provides the perfect opportunity to taste GSM wines from this appellation. The eleven sub-appellations within the Paso Robles AVA provide a remarkable variety of soils and growing conditions, from the cool, ocean-influenced Templeton Gap to the warm, relatively dry Paso Robles Highlands. Grenache, Syrah, and Mourvèdre have somewhat different needs for peak performance, so the region's diversity enables wineries to site each variety where it does best.

ABOVE AND RIGHT: (clockwise from top left) Grenache cluster; harvest at Tablas Creek; Syrah at harvesttime; Mourvèdre vineyard at Tablas Creek; Grenache grapes from a Paso Robles vineyard

LIVERMORE VALLEY
CONCANNON VINEYARD

"We were always taught that it is an honor to have our wine on someone's table," says John Concannon, a fourth-generation vintner whose family has been supplying the tables of wine lovers for more than a century. John's entrepreneurial great-grandfather, James Concannon, helped introduce wine grapes to California's Livermore Valley in the 1880s, and his heirs have made wine there ever since. Even during Prohibition, Concannon Vineyard kept the harvests going, producing sacramental wine for the Catholic Church.

The church figures in the birth of Concannon Vineyards as well. James, an Irish immigrant, initially landed in Boston knowing just enough English to understand the "Irish Need Not Apply" signs. In San Francisco's heavily Irish Mission District, he found a more hospitable home and went to work as a traveling salesman, covering his western territory on horseback.

WINDSWEPT VALLEY Joseph Alemany, the first archbishop of San Francisco, encouraged Concannon to buy land in Livermore Valley and produce wine for the rapidly expanding church. Geological maps indicated that the valley had an unusual east-west orientation,

inviting cool breezes from the Pacific Ocean through what is now known as the Altamont Pass. Wine grapes would love that.

Today, more than four thousand wind turbines line the Altamont Pass, their arms slowly swirling like synchronized swimmers, converting that airflow into energy. And the archbishop's instincts were right. The marine influence produces large diurnal swings, with the valley's warm-to-hot days pushing the grapes to ripeness and its reliably chilly nights preserving acidity.

Just as important for wine quality, the estate's soil is rocky and fast draining, so roots dive deep. Winemaker James Foster has seen vines with roots that extend 30 feet (9 m). Such vines are survivors, able to scavenge for water and nutrients in dry years.

Recognizing similarities between the soils in Livermore Valley and Bordeaux, James Concannon traveled to the famous French wine region to get cuttings of Cabernet Sauvignon, Sauvignon Blanc, and Semillon. Alas, phylloxera, a root-eating aphid, devastated his vineyard and many others in the 1880s, so Concannon returned to Bordeaux in 1893. The vintner could not have foreseen that the Cabernet Sauvignon cuttings he brought back from Château Margaux would have a lasting impact on the California wine industry.

By the mid-1960s, many North Coast vineyards were suffering from viruses, but Concannon's vines appeared healthy. Researchers from UC Davis visited the property in 1965, selected the heartiest-looking Cabernet Sauvignon vine and took three cuttings from it.

LEFT: Concannon family portrait, including John (standing), father Jim, and niece Shannon Lessard

To make sure the cuttings were virus-free, they subjected each one to heat treatment but for different amounts of time.

After propagation, these virus-free vines were released in the early 1970s as Concannon Clones 7, 8, and 11. "Growers felt confident with these cuttings," recalls John Concannon, and they planted them widely. Today, California has 90,000 acres (36,420 ha) of Cabernet Sauvignon and an estimated 80 percent is from Concannon clones. Warren Winiarski, who started Napa Valley's Stag's Leap Wine Cellars, remembers Jim Concannon, John's father, bringing him newspaper-wrapped cuttings of Concannon Clone 7. This prized clone became the foundation of the acclaimed Stag's Leap Cask 23 Cabernet Sauvignon.

HONORING AN HISTORIC VINE As Concannon plans for the future, with "green" investments like a sophisticated water-treatment plant that will enable process water reuse, the winery takes pains to preserve its illustrious past. Just steps from its historic tasting room is the ½-acre (0.2 ha) Mother Vine Vineyard, home to the head-pruned vine that yielded those three now-famous clones. Concannon's Mother Vine Cabernet Sauvignon comes from this pocket-size vineyard, each vine descended from that hardy parent.

Among the noteworthy old bottles on display at Concannon, their labels yellowed and their fill height reduced by time, is a 1961 Concannon Vineyard Petite Sirah. Jim Concannon, a pioneer like his grandfather, was the first to bottle this sturdy, inky variety

on its own. "Petite Sirah was the secret backbone in a lot of red wine," says John, "but my father knew it could stand alone."

It's not the easiest grape to vinify, but the winery's devotion to it has helped raise Petite Sirah's profile and build its fan base. Today, California counts more than 10,000 acres (4,000 ha) planted to this heritage grape.

"Historical preservation is a big theme around here," says John. The company has placed 200 acres (80 ha) of estate vineyards in a conservation trust, and upon learning that a historic Victorian home nearby was about to be demolished, the winery bought it, moved it, restored it, and now uses it for special events. The past is a fitting preoccupation for a winery whose white wine was served to Franklin Roosevelt and whose many "firsts" include

hiring America's first professional female winemaker, Katherine Vajda, a former Hungarian ballerina with a chemistry background. With time, perhaps a fifth generation of Concannons will step up to lead this groundbreaking winery into the future.

ABOVE: (clockwise from top left) Barrel room dinner; Victorian home among the vines; historic marker; drought-resistant landscaping; winery guests; Concannon library bottlings

PETITE IN NAME, BIG IN FLAVOR

It is not Syrah, the eminent Rhône variety, and it is hardly petite. In fact, Petite Sirah is a variety of stature in the Livermore Valley, where it has been grown for more than a century and bottled as a single varietal for more than fifty years.

Jim Concannon, father of Concannon Vineyard's current CEO, was the first to believe in this grape as a stand-alone variety. Before Concannon bottled the state's first 100 percent Petite Sirah, in 1961, most vintners considered the grape as a blending variety. Inky in color and rich in tannin, Petite Sirah had been used for decades to shore up thinner wines.

"You have to tame its vigor," says John Concannon, Jim's son and a fourth-generation Livermore Valley vintner. "It has big clusters and you don't want bunches touching, so you have to walk the vineyard and drop fruit." Left to its own devices, Petite Sirah can easily produce in excess of 8 tons per acre (7,260 kg per 0.4 ha).

A cross between Syrah and Peloursin, Petite Sirah is known as Durif in France, the name of the original breeder. The bunches aren't petite, but the individual berries are, so the skin-to-juice ratio is low, yielding a deeply colored purplish-red wine with substantial tannin, strength, and aging potential. The gravelly soils of Livermore Valley concentrate the grape's flavors all the more, so to produce a balanced wine of moderate intensity, vintners press the grapes gently and aerate the young wine frequently. With care, Livermore Valley Petite Sirah can successfully produce everything from rosé to dessert wine. Even in restrained renditions, it is a hefty wine to pair with hearty stews, grilled meats, burgers, and barbecue.

LEFT AND ABOVE: Petite Sirah cluster; Livermore Valley vineyard view; Petite Sirah starts veraison, the coloring stage that gradually transforms hard green grapes to ripe, juicy red grapes

FOLLOWING PAGES: A former dentist's office in Livermore, slated for demolition, was moved to Concannon, restored, and is now used for special events.

SANTA CRUZ MOUNTAINS
RIDGE VINEYARDS

On a clear day, the view from Ridge Vineyards's famed Monte Bello Vineyard encompasses seven counties, with vistas that stretch north to Mount Tamalpais, east to Mount Diablo, and southeast to Mount Hamilton. Nearly 3,000 feet (900 m) below, on the valley floor, are the influential think tanks, venture-capital firms, and technology heavyweights of Silicon Valley. Do these digital-age disrupters ever gaze up at the rugged Santa Cruz Mountains and realize that they are eyeing some of California's oldest vineyards?

Cabernet Sauvignon vines planted in the 1940s persist on these steep slopes, still ripening grapes on the edge of the variety's climatic comfort zone. "They would say we couldn't grow Cabernet here," admits David Gates, who oversees Ridge's vineyards, "but it's all about elevation. We're above the inversion layer, so the days are cooler and the nights warmer than in the valley. Our grapes are still ripening at night."

WHEN PLATES COLLIDED A century-old limestone quarry near the narrow road that snakes up to Ridge hints at another factor in the longevity of these vines. Millions of years ago, two tectonic plates collided and an ancient seabed, lifted seismically, became the future home of Ridge Vineyards. The near-neutral pH limestone soil on the

mountaintop makes minerals more available, so the vines can naturally access micronutrients. "Geologists call it 'foreign exotic terrane,'" says Gates, "because it's different from everything else around." This uniqueness earned the Santa Cruz Mountains its own AVA, distinct from the Central Coast AVA or San Francisco Bay AVA.

Early Italian immigrants recognized the promise of the soil here and began planting vineyards and establishing wineries. By the 1890s, there were seven Santa Cruz Mountain wineries, with such names as Mira Valle, Montebello, and Picchetti. Prohibition sealed the fate of most of them, but some replanting resumed in the 1940s. In 1959, four friends bought 17 acres (7 ha) of vineyard near the summit to take their winemaking hobby to the next level. Three years later, they converted an abandoned winery—now the tasting room—

LEFT AND ABOVE: (clockwise from bottom left) Ridge Vineyards viticulturist David Gates; Ridge Vineyards Monte Bello, a destination for fans of mountain-grown Cabernet Sauvignon; Ridge vineyard at sunset

into Ridge's first home. The 4-acre (1.6 ha) block behind the tasting room, planted in 1949, contains some of the oldest Cabernet Sauvignon vines in the state.

"Any grapevine that has been in the ground for fifty-plus years has something going for it," says Gates, a founder of the Historic Vineyard Society (page 227), which aims to protect the state's heritage vineyards. "Old vines do a better job at regulating the crop; it's rare to have to thin them. And they tend to be more distinctive—to display *terroir* better. Deep-rooted old vines also do a better job withstanding extreme heat and cold."

Winter cover crops minimize erosion on this steep site; mowing them in spring rather than disking them helps keep soil in place. Gates is also attempting to establish insectary cover crops, such as wild carrot and blue tansy,

to draw beneficial insects in summer when most needed. Thanks to these practices, the organic matter in the soil has doubled since Gates started at Ridge in 1989, and the hilltop sites have more topsoil.

Silicon Valley residents help fill Ridge's tasting room on weekends, but the tech boom has taken a toll in soaring residential prices. "To survive on this mountain, we have had to go into the real-estate business," says winemaker Eric Baugher. For Ridge's vineyard and cellar workers, housing now comes with the job. Fifteen families live in homes on the property, and others reside in

company-owned apartments in nearby Cupertino. "We need to keep these people," says Baugher. "They have such specialized skills, and otherwise they couldn't afford to work here."

MAKING WHAT THE VINEYARD WANTS Mentored by Paul Draper, Ridge's esteemed winemaker emeritus, Baugher advocates minimal intervention in the cellar: no commercial yeast to launch fermentation, no fining, no filtering. The less manipulation, the more the wine will express the site, he believes. "We're making what the vineyard wants to make," says Baugher.

In the case of Monte Bello, that means Cabernet Sauvignon with inviting herbal aromas, a scent that merges the perfume of the

forest with wild chaparral, mint, blackberries, and crushed rock. Other mountain vineyards yield big, bold, jammy Cabernets, says Gates. What this cool site gives is more elegant.

The winemaking may be minimalist and low-tech, but Ridge's infrastructure is cutting edge. A sophisticated bioreactor system recycles every drop of winery process water, while storm water that falls on hard surfaces is collected and channeled underground so it can percolate back into the aquifer, a sort of "reverse well."

Surely, after five decades of grape growing at Monte Bello, Ridge has its playbook written. But no, says Gates. "You never have it all figured out," explains the viticulturist. "We're always fiddling, always trying to improve. In California, you'll fall behind if that's not your attitude."

ABOVE: (clockwise from bottom left) Winemaker Baugher serves guests; hospitality at Ridge Vineyards; Ridge Monte Bello; harvesting Chardonnay; Cabernet Sauvignon cluster; Ridge winemaker emeritus Paul Draper

A REGISTRY FOR SENIOR CITIZENS

Any vineyard that has offered up fifty harvests of quality wine grapes deserves recognition, respect, and a dignified old age. Such long-lived vines have survival lessons to impart, and their caretakers have accumulated wisdom. For these reasons and more, several prominent California winegrowers established the Historic Vineyard Society in 2011, to document, celebrate, and preserve the state's oldest wine-grape vines.

When a person achieves centenarian status, questioners inevitably ask, "What's your secret?" The society's burgeoning registry of productive historic vineyards should shed some light on this question in the viticultural world. Why are some vineyards super-survivors, thriving well beyond the expected lifespan? On average, California vineyards are renewed every fifteen to twenty years because production has declined enough to repay replanting.

To qualify for the society's registry, a vineyard must be at least fifty years old, currently producing, and with at least one-third of its vines from the original planting. In the eyes of David Gates, who oversees viticulture for Ridge Vineyards and is a founder of the society, these senior citizens represent natural selection. They are the right plants in the right place.

The society periodically conducts tastings and historic-vineyard tours to educate the industry and public about the nature of the wine made from these sites and to advocate for their preservation. Registered vineyards range from Lodi's Bechthold Vineyard, planted to Cinsault in the 1880s, to the esteemed Hanzell Vineyards, purported to have the oldest continuously producing Chardonnay and Pinot Noir vineyards in North America. As the registry grows, students of viticulture will have yet more clues to the mystery of vine longevity.

LEFT AND ABOVE: Old Cabernet Sauvignon vines at Ridge's Monte Bello Vineyard; old Cabernet Sauvignon vines in winter; Zinfandel vines at Ridge's Lytton Springs vineyard

FOLLOWING PAGES: Albatross Ridge vineyard in Carmel Valley at sunset

MONTEREY COUNTY
SCHEID VINEYARDS

Feisty. A serial entrepreneur. A man un-afraid to leap into a business he knew nothing about. That's how Heidi and Scott Scheid describe their father, Al Scheid, a sharp-penciled investor who sensed opportunity in California viticulture in the early 1970s. The state's proliferating wineries were going to need grapes, and Monterey County was the place to plant them. "It was the sweet spot of quality and affordability then," says Scott.

Al found a few partners, purchased land near Greenfield, about 30 miles (48 km) southeast of Salinas, and had all the grapes sold before he even planted a vine. Eventually, he figured, he and his partners would exhaust the tax benefits, sell the vineyards, and exit the wine business.

Not quite. Today, the Scheid family farms 4,000 acres (1,600 ha) of wine grapes in Monterey County. Three of Al's four children run this sizable enterprise now, selling grapes, making custom wine, and bottling their own Scheid Vineyards wines. Al is largely retired, but the company culture he fostered persists. Collaboration, innovation, and constant questioning are its hallmarks, along with respect for a long list of Al-isms. (Scott's favorite: When two people in business always agree, one of them is unnecessary.)

LEFT AND ABOVE: Siblings Scott and Heidi Scheid patrol a vineyard; Scott Scheid in winery tasting room

The family's vineyards stretch for 70 miles (113 km) in the Salinas Valley, across four AVAs and four distinct climate regions. With such diversity, the Scheids can successfully grow thirty-nine different varieties, from cool-climate types like Chardonnay and Pinot Noir in the northern part of the valley, nearest Monterey Bay, to heat lovers like Cabernet Sauvignon and Petite Sirah at the southern end.

HARNESSING WIND POWER Gusts of cool marine air whip through the valley in the afternoon, which motivated the Scheids to explore the potential for wind power. "We met with a lot of solar companies," says Scott, now the company's chief executive officer, "but a wind turbine is the right technology for this location. It blows here like crazy." Installed in 2017, Scheid's turbine, which stands 400 feet (122 m) tall, occupies a much smaller footprint than solar panels and, at a leisurely 20 rpms, it doesn't endanger birds. The mesmerizing machine provides 100 percent of the winery's energy needs and enough surplus power for 120 homes.

Technology is enhancing other aspects of the business, like irrigation management. The viticulture team is testing a cutting-edge automated system that analyzes data from weather stations and soil-moisture probes to determine which vines need water and how much. This "smart" setup triggers the drip irrigation automatically.

"I think we're leading the pack here," says chief operating officer Kurt Gollnick. "The irrigation pumps are variable speed, and the system figures out just how much energy to turn on to meet water demand."

Water is precious in Monterey County, but skilled agricultural labor is perhaps the scarcest resource. For an operation of Scheid's size, mechanization of such tasks as pruning and harvesting is or soon will be imperative.

Fortunately, advances in vineyard technology mean mechanized processes can actually boost quality.

"You don't have a win if mechanization delivers less quality," says Gollnick, who is excited about developments like pre-pruning machines with optics. These sophisticated devices remove much of the vine's woody growth, allowing the skilled human pruners who finish the job to work much faster.

"Mechanization is not pushing people out. It's empowering people," says Greg Gonzales, Scheid's director of vineyard operations. Gonzales's vineyard crew carry tablet computers so they can record data in the field; a worker might use GPS to flag a block that needs a pest-control advisor's attention. "The next generation of viticulturist is going to be a technologist," predicts Gonzales.

FROM GROWERS TO VINTNERS After forty-seven years as growers, the Scheids entered the wine business, building a winery in 2005 that prioritizes worker comfort and safety. Skylights and a large window bring the outside in, and mobile presses and automated pumping equipment make hauling heavy hoses unnecessary.

The family focuses much of its philanthropy on helping local youth. A high-school writing competition that Al instigated has awarded $330,000 in college scholarships over the years, says Heidi, who oversees the company's sales and marketing. Through its sponsorship of the Monterey Jazz Festival, Scheid supports music education in Monterey County schools, reaching kids who might otherwise have no music training. An underperforming Scheid vineyard is now a 20-acre (8 ha) soccer park in the nearby city of Greenfield, a

transformation overseen by Gollnick. A former youth soccer coach, he is working on a similar project for Salinas. "This has nothing to do with selling grapes, but it fills a tremendous need," he says. "The communities where our employees live need to be healthy."

Gollnick has been honored for his advocacy on behalf of Salinas Valley farmworkers, efforts that reflect his employer's core values. "Scheid can be found in most of the important causes in this community," says Gollnick. "We use our political capital to activate change."

ABOVE: (clockwise from top left) Scheid billboard; Scheid wind turbine; harvest-ready grapes; Heidi Scheid welcomes guests; rows of grape compost alongside vineyards at Scheid

CHARDONNAY BY THE BAY

Planted primarily at the northern end of Salinas Valley, Monterey County Chardonnay benefits from a near-daily embrace with cool marine air. On a typical afternoon, as valley temperatures climb and the warm air rises, chilly breezes from the Pacific Ocean race in to fill the gap. The marine effect is so strong that these northernmost vineyards are on the cusp of viability for wine grapes, deemed Region 1—the coolest viticultural category—on the UC Davis heat-measuring scale.

Chardonnay welcomes this daily cool-down. The grapes maintain acidity and yield steely wines with distinctive lemon-lime and tropical-fruit aromas. Thanks to Monterey Bay's proximity, the frost season is short here and the vines leaf out comparatively early in spring. Moderate summer temperatures—thank the bay again—enable a leisurely growing season, with the Chardonnay harvest typically lagging a couple of weeks behind other regions. The extended ripening period, which growers call "hang time," contributes to intensity of fruit flavor. In some years, the growing season in these Chardonnay vineyards is one to two months longer than elsewhere.

Monterey County boasts more Chardonnay acreage than any other California county. This single variety accounts for 40 percent of the grapes planted in the county, reflecting prevailing opinion about Chardonnay's fitness in this climate. One major influence on growing conditions here can't even be seen. Beneath the waters of Monterey Bay, a deep gorge slices through the ocean floor, causing a phenomenon known as upwelling, the rise of deep, frigid water to the ocean's surface. This hidden geologic feature, dubbed the Blue Grand Canyon, links the deep sea to vineyards 40 miles (64 km) away.

ABOVE AND RIGHT: (clockwise from top left) Chardonnay cluster; Thomas Fogarty Winery in Woodside; Chardonnay at harvesttime; harvest scene; Scheid estate

PASO ROBLES
TABLAS CREEK VINEYARD

Limestone soil and a long growing season topped the shopping list when the Haas and Perrin families went looking for California vineyard property in the mid-1980s. Only bare ground would do because they intended to plant clones of Rhône vines imported from the Perrins' Château de Beaucastel in Châteauneuf-du-Pape. The partners found the dream site for their Tablas Creek Vineyard west of Paso Robles: 120 acres (49 ha) in a secluded valley 12 miles (19 km) from the Pacific Ocean.

"In most places in California where there's limestone, it's too close to the coast to ripen Rhône varieties," says Jason Haas, general manager of Tablas Creek. But this unusual high-elevation parcel had it all: the limestone that would give acidity to the grapes; the warm, extended growing season that would ripen late-maturing varieties like Mourvèdre and Roussanne; and winter rains sufficiently generous to permit dry farming.

A CHALLENGING PARCEL "It's a tough piece of property," acknowledges Tablas Creek winemaker Neil Collins, "very cold, very hot, very steep in areas, and extremely rocky. When our

vineyard crew has nothing to do, they pull rocks out of the vineyard. But that's why we're here."

Today, Tablas Creek and the Haas family are regarded as Central Coast pioneers, prime movers in raising the profile of the Paso Robles AVA and promoting the area's suitability for Rhône varieties. After importing the Beaucastel clones and seeing them through a three-year quarantine at considerable expense, they made cuttings available to all.

"It was a radical idea at the time, but the decision from the beginning was not to keep them proprietary," says Haas. "The best thing we could do for ourselves was get these clones into wider circulation and raise the quality of the category. We've always felt that being generous with our knowledge is an easy way to help the communities we're part of."

LEFT: Rocky limestone soil helps give acidity to the Rhône-variety wines made at Tablas Creek Vineyard.

ABOVE: Jason Haas now manages the winery that his father, Robert, started; limestone boulders removed from the vineyard site

Inspired by Beaucastel practices, the partners have farmed Tablas Creek Vineyard organically from the start. In recent years, they have embraced selected biodynamic methods as well. In keeping with biodynamic principles, they introduced livestock—chickens and Gloucestershire Old Spots pigs, as well as sheep and their guardian llamas—and planted fruit trees and a vegetable garden. The livestock improve the soil with their manure; the fruit trees lure birds and beneficial insects and provide shade for the vineyard crew on break. All employees enjoy the fringe benefits: complimentary ground lamb, just-picked produce, farm-fresh eggs, and compost for their own gardens. Every year, 20 gallons (76 l) of the property's olive oil is set aside for the staff, who can fill bottles for home use at no cost.

Nathan Stuart, the winery shepherd, brews hundreds of gallons of compost tea to feed hardworking soil microbes. "I can't see them," says Collins, "but I know they're creating great soil, and great plants grow out of that."

MAKING ROOTS DIVE DEEP Haas and Collins also believe that dry farming—growing vines without irrigation—contributes to the continued improvement they note in Tablas Creek wines. "A grapevine is going to take the easy path if there is one," says Haas. "If you're providing water at the surface, the root growth will be at the surface—in the topsoil rather than the bedrock. The root system is taking up what you give it rather than what it finds for itself. But the specific mix of minerals in deep soil is more distinctive. I have to believe that's where the distinctiveness of a site is communicated."

Dry-farmed vines also tolerate drought more easily and yield more elegant and complex wines, says Collins. As the partners plant more vines on an adjacent parcel purchased in 2011, the winery's percentage of dry-farmed grapes will climb. "We will be even less dependent on water than we are now," says Haas.

Although the original "mother" vines from Beaucastel, in terra-cotta pots, have a place of honor on the winery terrace, the objective has never been to make a Beaucastel twin. Haas and Collins want the Central Coast site to speak with its own voice. "From viticulture to winemaking, our goal is to emphasize the character of our place," says Haas. Using native yeast and aging in large neutral oak barrels help with that mission. The winery's signature bottlings, such as Esprit de Tablas, are multivariety blends

meant to showcase the estate rather than a particular grape.

The Paso Robles AVA has grown exponentially since Tablas Creek's debut — from fewer than twenty wineries to more than two hundred. Even with this competition, employees rarely leave Tablas Creek, and not just because of the free eggs. The family pays for employee education—"anything that's vaguely job relevant," says Haas—and contributes generously to community organizations that its employees support. "If it's something they're passionate about," says Haas, "we're going to see if we can support it, too."

ABOVE: (clockwise from top left) Guardian llama protects sheep; Mourvèdre grapes; punching down grapes to extract color and tannin; Tablas Creek tasting room; "mother vine" imported from Château de Beaucastel; Tablas Creek garden yields pomegranates and other fruits for employees

SAN LUIS OBISPO COUNTY
CHAMISAL VINEYARDS

Only 5 miles (8 km) from the Pacific Ocean, in California's coolest appellation, Chamisal Vineyards enjoys the steady, mild growing season that Pinot Noir and Chardonnay love. Although no part of the appellation borders the ocean, all of it is close—at most 10 miles (16 km) from the water that helps keep temperatures in the Edna Valley AVA in a narrow range year-round. It rarely gets hot here, and it rarely gets cold. "The vines sometimes struggle to go dormant," says Chamisal general manager and winemaker Fintan du Fresne.

Two hundred years ago, the 90-acre (36 ha) parcel that is now Chamisal was part of a vast Mexican land grant, the Rancho Bolsa de Chamisal. The landscape still looks a bit like it might have in Alta California days, with cattle ranches, lemon groves, and lightly trafficked winding roads. With the southern end of the Santa Lucia Range as scenic backdrop, the Chamisal estate was the first vineyard planted in Edna Valley, in 1973. Today, two dozen wineries have taken root here, drawn by the protracted growing season—as much as sixty days longer than some of the state's other appellations.

PRECEDING PAGES: Chamisal vineyard in autumn; grapevines rapidly change color after harvest.

LEFT: The Santa Lucia Range provides a scenic setting for Chamisal Vineyards.

ABOVE: Winemaker Fintan du Fresne patrols the vineyards with Lola, a Queensland heeler.

That leisurely amble from bud break to harvest yields "dark, dense, brooding" Pinot Noirs, says du Fresne, with dark-fruit aromas, such as blackberry, black cherry, and plum. The Chardonnays, nourished by those extra weeks of sunlight, can be exuberant with fruit, says the winemaker. "I'm sometimes trying to rein them in."

FARMING BLOCK BY BLOCK Du Fresne, a geologist by training, knows that soil is as important as sun. Scooping up a handful of dirt in one vineyard block, he points out the plentiful shale—chalky chunks that contribute to that parcel's rapid drainage. Such free-draining soil needs more frequent, short-duration watering than other parts of the estate.

By studying the property's varied soils and subdividing blocks based on soil type, du Fresne is achieving dramatic water savings. It's time-consuming to farm multiple small blocks differently—with different rootstocks, vine densities, and irrigation plans—but there's a payoff in conservation and quality.

"My intent is to halve our water use, or more," says the winemaker. "We can almost dry farm some parts."

Growing up in New Zealand, where environmentalism is part of the national psyche, du Fresne has a relentless recycling agenda. Rainwater is captured on the winery's roof and rerouted to irrigation. All winery process water is treated in remediation ponds and reused. "We offset 5 million gallons (19 million l) a year," says du Fresne. "We have plenty of well water, but that's not stopping our steps to curtail our use. It's a shared resource, so it's the right thing to do."

The winery discontinued herbicide use years ago in favor of a mechanical "weed knife" that dives beneath the soil surface and swerves around the vines. All the property's organic waste is composted, and each spring, the crew brews and applies 500 gallons (1,900 l) of compost tea in hopes of boosting soil microbes.

OWLS ON THE JOB "I like to think we've got more life in the soil," says the winemaker. Certainly, the earth is more friable now, with better tilth. It holds together in healthy clods; it's not dusty or clay-like. Alas, gophers appreciate all these vineyard changes, too. These pesky rodents are more than a nuisance—they chew irrigation lines and destroy young vine roots—but Chamisal fights back with strategically placed owl boxes. An owl raising a brood can eliminate one thousand rodents in a season, says du Fresne.

Even the Chamisal tasting room reflects this company's repurposing ethos. Originally the winery, it now welcomes visitors in a rustic space paneled with planks salvaged from an old barn. A collection box for used corks reminds customers not to toss this easily recycled resource. In this informal space, with light streaming in from roll-up doors, patrons can sample the winery's silky, single-block Chamise Chardonnay, its smoky estate-grown Pinot Noir, or Malene, a pretty, pale Rhône-style rosé.

"I'm more pragmatic than dogmatic," says du Fresne about his efforts to operate Chamisal more sustainably. Natural practices are always his first approach, but mildew pressure can be intense in this coastal climate; sometimes, if a crop is threatened, a fungicide may be the sustainable solution.

In any event, du Fresne welcomes a challenge. A distance runner, he often hits the trail with his Queensland heeler rescue dog, Lola, setting the pace. Du Fresne once completed a 54-mile (87 km) Grand Canyon run, but even Lola, he boasts, can finish a 25K.

ABOVE: (clockwise from top left) Chamisal's rustic tasting room was originally the winery; Edna Valley view; owl boxes lure residents that help with gopher control; Pinot Noir; quality check; Chardonnay vineyard

ROSÉ ON THE RISE

A crisp, dry rosé has few equals as an aperitif. With fresh goat cheese, charcuterie, and olives, it launches a dinner party. Long a favorite in warm Mediterranean regions, such as Provence and Apulia, dry rosé is building its fan base in the United States, especially among younger consumers. Their parents may have considered rosé as appropriate only for summer drinking, but wine enthusiasts today make room for rosé year-round. Whether dinner is an improvised grain bowl, grilled fish, rotisserie chicken, or take-out Chinese food, a dry rosé completes the meal.

The San Luis Obispo area produces some of California's tastiest rosés, in a range of styles. In the coolest zones, such as the Edna Valley AVA, the wines are fresh and zippy, with bracing acidity and thirst-quenching appeal. From warmer areas farther inland, rosé will have more flesh, more fruitiness, and possibly more color, although variety influences color as well.

The Rhône grape varieties popular among San Luis Obispo vintners make superb, sprightly rosés. Chamisal's pale peach Malene, a blend of Grenache Noir, Mourvèdre, Cinsault, Counoise, and the white Vermentino, is a fine example of the attention that the region's vintners are giving to rosé.

For the palest rosé, red grapes are crushed and immediately pressed, or sometimes pressed as whole clusters. Both methods minimize skin contact, so the juice doesn't absorb much color. To make a rosé with a deeper hue, the grapes are crushed and the juice and skins macerated briefly until the skins float to the surface. Then the colored juice is drawn off and fermented.

LEFT: (clockwise from bottom) Chamisal Vineyards's Malene, here in a signature glass, is among the San Luis Obispo region's standout rosés. The Rhône varietals that produce the region's noteworthy red wines make equally engaging rosés. At Cambria, Pinot Noir is the starting point for a refreshing rosé.

FOLLOWING PAGES: Chamisal's hillside vineyards, like others in the Edna Valley, benefit from an especially long growing season.

PEPPERY AND PROFOUND SYRAH

It isn't Santa Barbara County's most-planted grape—that honor goes to Chardonnay—but Syrah brings the region a lot of buzz. The premier Rhône variety seems at home in many of the county's diverse microclimates, from cool sites in the Santa Rita Hills appellation to such warmer inland appellations as Ballard Canyon and Happy Canyon. The outcomes differ, of course. Cooler vineyards in northern Santa Barbara County highlight the spicy, peppery, lively side of Syrah. In warmer locations, the wine is fleshier. Winemakers often blend grapes from different parts of Santa Barbara County to create a more balanced wine that captures what both warm and cool sites give.

Zaca Mesa planted the first Syrah in Santa Barbara County in 1978 and now has the oldest Syrah vineyard on the Central Coast. Qupé's success with Syrah lured more growers and producers eager to find the most compatible setting for this compelling variety. Today, winemakers can draw from the 2,000 acres (810 ha) of Syrah planted in this geologically noteworthy region.

In a rare formation, the region's two main valleys are transverse—running east-west rather than north-south. Both the Santa Maria Valley and the Santa Ynez Valley channel cool air from the Pacific Ocean through an unobstructed corridor, the average temperature rising steadily with distance from the coast. Syrah ripens slowly in western Santa Barbara County, producing wines with lighter texture. Ballard Canyon, a relatively new appellation in the heart of the Santa Ynez Valley, trumpets its suitability for Syrah, citing a "mixed climate" of warm days and cool nights. Indeed, many of the most sought-after Syrah producers have a Ballard Canyon AVA address.

ABOVE AND RIGHT: (clockwise from top left) Autumn in the Santa Ynez Valley; Zaca Mesa Winery; pioneering Santa Barbara Syrah producer Zaca Mesa; Santa Rita Hills view; autumn at Zaca Mesa

IDEAS FROM THE GROUND UP The winery engages all of its employees in friendly competition to achieve sustainability targets. The winner is announced at the annual company-wide meeting, a potential victory that motivates employees all year. Staffers are encouraged to offer ideas and contribute to their department's goals, nurturing a company culture that has helped Shurtleff reduce the winery's water use by almost 50 percent.

To Banke and her daughters, Cambria is not just a model of sustainable wine growing; it's a symbol of female achievement. The owners, the general manager, and the winemaker are all women, a rare confluence in the wine industry. In hopes of inspiring and enabling other strong women, Julia and Katie established Seeds of Empowerment, an international grant-making program that awards $100,000 annually to women making a difference in their communities. One early recipient launched a microlending program to help impoverished women start small businesses in her native Tanzania.

Closer to home, Cambria gives all its employees two paid days off a year for charitable work. One day is devoted to a winery-wide project, such as cleanup at a local lake; the other is for a project of their choosing. Clearly, Banke and her daughters believe in leading by example and making their core values known. Perhaps, in the end, Cambria's low turnover has less to do with compensation and pats on the back than with a sense of shared mission. Says Shurtleff, "Employees feel good about what the company is doing."

ABOVE: (clockwise from bottom left) Katie Jackson, Barbara Banke, and Julia Jackson; Cambria vineyard manager Matt Mahoney; picnic area for visitors; Cambria winery overlooks the Santa Maria Valley; cellar work

FOLLOWING PAGES: Cambria landscape

CENTRAL COAST HARVEST

Framed by the Gabilan Mountains on the east and the Santa Lucia Range to the west, the Salinas Valley, at some 90 miles (145 km) long, is an agricultural powerhouse. Monterey Bay is its natural fog machine, keeping coastal towns like Castroville and Watsonville blanketed in the cool, moist air that artichokes, fava beans, Brussels sprouts, and lettuces love. (Roll up the car windows if you don't appreciate the pervasive perfume of Brussels sprouts.) Five miles (8 km) from the coast, in the Pajaro Valley, strawberries are big business, with raspberry production on the rise. Proximity to San Francisco has allowed many small sustainable farms to thrive here, delivering baby vegetables, radicchio, green garlic, and delicate "spring mix" salad greens to demanding Bay Area chefs. The broccoli and cauliflower fields around Santa Maria seem vast enough to feed the planet. Farther south, avocados are the pride of the coastal town of Carpinteria, which hosts a festival in their honor every fall.

LEFT: (clockwise from top left) Paso Robles farmers' market; Central Coast Brussels sprouts; ripening avocados; produce gems at the Paso Robles market; avocado grower Robert Abbott and daughter; zucchini

RECIPES

Fava Bean Toasts with Ricotta and Mint

Frittata with Broccoli Rabe and Sheep Cheese

Scallop Crudo with Avocado and Pink Peppercorns

Shrimp, Artichoke, and Farro Salad

Spring Vegetable Tabbouli with Fava Beans, Radishes, and Spring Herbs

Gilroy Garlic and Potato Soup

Pizza with Artichokes and Arugula Pesto

Risotto with Radicchio and Pancetta

Steamed Dungeness Crab with Green Garlic Aioli

Grass-Fed Burger with Avocado and Chipotle Mayonnaise

Lamb Meatballs with Artichokes and Olives

Brussels Sprouts with Brown Butter and Tarragon

Strawberry Sherbet with Sparkling Wine

Farmers' Market Berries with Late-Harvest Wine Sabayon

ARTICHOKES

The cool, foggy climate on California's Central Coast is just what artichokes want. Heat toughens the leaves of these edible flower buds, which would blossom if left unharvested. Two-thirds of the state's crop comes from the Castroville area, thriving in the chilly mist off the Pacific Ocean.

HARVEST: California growers harvest artichokes year-round, but peak season is March through May, with another little blip in October. Workers harvest the mature buds by hand, slicing them off the stalks and tossing them into a large basket on their back. Instead of transporting them to a packing shed, most growers pack them in boxes in the field to minimize bruising. The boxes are quickly hydrocooled to remove field heat, a process that technology has accelerated dramatically, enhancing quality.

SELECTION AND STORAGE: An artichoke's size reflects its position on the plant, not its maturity. The largest buds are at the top, at the end of long stalks. Medium artichokes grow on the side shoots. The so-called babies—1 to 2 ounces (30 to 60 g) each—are fully mature but grow at the base of the plants. The Green Globe is the main variety and still widely considered the meatiest and most tender. Modern thornless varieties are easier to handle, but connoisseurs prefer the flavor of the Green Globe.

Look for firm, tightly closed artichokes that feel heavy for their size; they should squeak when squeezed. Scratches on the outer leaves are caused by frost. Growers call such artichokes "frost-kissed" and say the chill improves flavor.

Store artichokes in a plastic bag in the refrigerator crisper; a few drops of water in the bag will help keep the artichokes moist. Use within three to four days.

HOW TO STEAM: For large chokes, cut the stem flush with the base. With scissors, cut across the outer leaves to remove the prickly tips. With a serrated knife, slice off the top 1 inch (2.5 cm) of the artichoke. Rub all exposed surfaces with a lemon half to prevent browning. Steam upside down on a rack over simmering water in a covered pot until a knife pierces the base easily.

AVOCADOS

The avocado that bears his name never made Rudolph Hass wealthy, but the Hass avocado has certainly enriched America's tables. In the mid-1920s, Hass was a mailman in Pasadena, California, struggling to feed his family on his meager salary. Hoping to make extra income from growing avocados, then an exotic and high-priced fruit, he purchased $1^1/_2$ acres (0.6 ha) in San Diego County and planted seeds. His plan was to graft the popular Fuerte variety onto the seedlings, but one seedling refused to accept the graft. A consultant persuaded Hass not to uproot it, and the tree soon produced abundant fruit, different from the thin-skinned Fuerte and much richer in flavor. In 1935, Hass patented the variety, which has since gained dominance worldwide. The mother tree survived for seventy-five years, outliving Hass, who remained a postal worker until his death.

THE HASS ADVANTAGE: Thanks to its thick, bumpy skin, the Hass avocado travels well without blemishing. It darkens from green to black when ripe. The tree yields fruit for eight months a year, much longer than other varieties. And its buttery texture and nutty flavor make many other types seem watery.

San Diego County bills itself as the avocado capital of the nation, but growers as far north as Carpinteria can succeed with the fruit.

HARVEST: California's harvest season lasts from spring through fall. Like pears, avocados are picked when they are full-size but hard and complete their ripening in one to two weeks after harvest. The fruit can hang on the tree for months without declining, so growers may pick multiple times over the season to take advantage of price spikes. A healthy, mature tree may produce three hundred to four hundred fruits a year.

SELECTION AND STORAGE: Look for firm, dark-skinned avocados with a matte appearance. Keep them at cool room temperature until they give to gentle pressure, typically within a couple of days. They dislike refrigeration, so buy only as many as you can eat before they soften.

RIGHT: (clockwise from top left) Picture-perfect artichoke; rich and buttery Hass avocados; coastal avocado orchard, Vista Punta Gorda Ranch, photo courtesy of the California Avocado Commission

BROCCOLI RABE
Introduced to California by Italian immigrants, broccoli rabe (also known as rapini) remained little known beyond Italian-American kitchens for decades. Now the surge of interest in southern Italian cooking has made it a culinary star and a supermarket staple. D'Arrigo Brothers, a Central Coast farming company founded by two Sicilian immigrants, helped popularize the vegetable and improve the seed.

Despite the name, broccoli rabe is genetically closer to turnips than to broccoli. Its pleasantly bitter, mustard-like flavor often surprises people accustomed to the sweetness of broccoli, but lovers of sturdy greens quickly become addicted.

Broccoli rabe needs a cool growing area, thriving in the coastal Salinas Valley and, in winter, in the inland Coachella Valley. Hot weather causes it to bolt. Fall and winter are peak seasons, but growers harvest the vegetable year-round.

SELECTION AND STORAGE: Choose broccoli rabe that looks perky and crisp, with no limp, yellow, or wilting leaves. The green flower buds should be tight, with few or no yellow flowers, and the stem ends should not be dried out or show white cores. Remove any banding and store in a plastic bag in the refrigerator crisper for up to four days.

PREPARATION: Trim the ends of the broccoli rabe. Slit thick stems so they cook quickly. Cook in a large pot of boiling salted water until the stems feel tender, 2 to 3 minutes, then drain, shock with cold water, and squeeze dry. Chop and reheat in extra virgin olive oil with garlic; add to a stir-fry, omelet, or frittata; or stir into polenta. Combine broccoli rabe with chard, mustard greens, or Tuscan kale as a side dish for panfried sausage; a mix of hearty greens, cooked together, can be more intriguing than any one green alone. Sautéed broccoli rabe tossed with *orecchiette* (ear-shaped pasta) is a specialty of Italy's Apulia region; many versions also include crumbled spicy Italian sausage.

BRUSSELS SPROUTS
After years of being overcooked and disrespected, Brussels sprouts have leaped into the limelight. Breeders have improved their flavor, eliminating some of the bitterness and boosting the sweetness. Chefs have embraced them and unleashed their creativity on these mini-cabbages, a vegetable that many people simply boiled and overboiled at that. The widely touted health benefits of eating Brussels sprouts, a cruciferous vegetable like broccoli and kale, have elevated its desirability, too.

California grows more than 90 percent of the nation's Brussels sprouts, in the cool coastal counties of San Mateo, Santa Cruz, and Monterey. Growers say the salty mist off the Pacific Ocean enhances their flavor. Certainly sprouts appreciate the long growing season: Brussels sprouts require eight to nine months to reach maturity, an eternity compared to fast-growing lettuces.

HARVEST: Picking begins in August and concludes in February, with a peak in November, just in time to get sprouts on Thanksgiving tables. The sprouts grow on waist-high stalks and mature from the bottom up, so some growers handpick repeatedly, starting with the full-size sprouts at the base. Others wait until the entire stalk has matured and harvest by machine.

SELECTION AND STORAGE: In the fall, markets sell Brussels sprouts still on the stalk, a good sign that they were recently harvested. At home, snap the sprouts off the stalk and store them in a plastic bag in the refrigerator crisper for up to one week. When buying loose sprouts, choose those with full green color and no yellow leaves. The sprouts should feel firm and compact, not puffy. Try to choose sprouts of equivalent size so they cook evenly. Big sprouts tend to be a little stronger in flavor; 1 to $1\frac{1}{4}$ inches (2.5 to 3 cm) in diameter is ideal.

FAVA BEANS They may be a minor crop in California, but for their many fans, fava beans are a major spring treat. Their popularity among Californians has soared along with interest in Mediterranean cooking, and during the beans' brief season, restaurant chefs and knowledgeable home cooks scoop them up at farmers' markets. The vegetable's preparation is labor-intensive but repays the effort with its sweet, delicate flavor, resembling a cross between a fresh lima bean and a pea.

These leafy legumes prefer the same cool growing climate as artichokes, Brussels sprouts, and peas. Small coastal farms between Salinas and Lompoc grow them for the wholesale trade, as do small family farms that sell primarily at farmers' markets or direct to consumers through CSAs (community-supported agriculture). The harvest lasts roughly from April through June and then the favas vanish for another year, leaving their audience feeling barely satisfied.

SELECTION AND STORAGE: Look for unblemished fava pods with fully formed beans inside. Avoid limp pods or any that have overlarge beans (they'll be starchy). Store them in a plastic bag in the refrigerator crisper and use within a couple of days. Their sweetness is fleeting.

PREPARATION: Most recipes for fava beans call for double peeling: remove the beans from the fuzzy pod, then remove the skin from each bean. To remove the skins quickly, blanch the beans in boiling water for about 1 minute, then drain and shock in ice water. Pinch the skin open and the moist green bean inside will slip out easily. When the beans are young and tender, they don't require the second peeling, and many people prefer them unpeeled.

Fava beans can be braised with other early spring vegetables, such as artichokes, green garlic, and leeks. In Italy, the first young fava beans of the season are often enjoyed raw, removed from the pods and consumed, unpeeled, with sheep's milk cheese. In early spring, some California farmers sell the leafy fava greens when they are still tender enough to stir-fry.

GARLIC What good cook is ever without a bulb of garlic? This fundamental seasoning lends its mouthwatering aroma to innumerable savory dishes. California produces 90 percent of the nation's harvest, but China is a major competitor. And one California company, Gilroy-based Christopher Ranch, grows more than half of the nation's crop. Don Christopher launched the family's garlic business in Gilroy in 1956, but most of the garlic acreage has moved inland, to the San Joaquin Valley, as Gilroy has become more urban.

SEASON: Garlic is a slow-growing crop. Cloves planted in the fall won't be ready to harvest until the following summer. Before then, a small percentage of the crop will be sold as green (immature) garlic, which can be used in its entirety—a fleeting treat for chefs and consumers who appreciate its mild taste. Uprooted in spring, green garlic resembles a thick scallion or slender leek. Harvested a few weeks later, the base will have swelled into a bulb, though with undifferentiated cloves. By early summer, the cloves will be apparent, each one sheathed in a fine skin. At full maturity, the bulbs are carefully dug up and air-dried to extend their storage life. Before shipping, the dried leaves are cut off and some of the papery outer skin is removed.

SELECTION AND STORAGE: Garlic should feel firm and heavy for its size; reject any bulbs with soft or shrunken cloves or signs of mold. You can identify Chinese-grown garlic by examining the root end. California growers leave a little "brush" of roots, while Chinese garlic is shaved clean. Store garlic in a cool, dry place with air circulation, such as a wicker basket—never in a plastic bag.

KITCHEN TIPS: For best flavor and aroma, buy whole garlic bulbs; peel and chop only as needed. Unless you are using it right away, cover chopped garlic with olive oil to prevent oxidation. A few months after harvest, even properly stored garlic may begin to sprout. If you see a green sprout, halve the garlic clove lengthwise and cut it out for milder flavor. Although we treat garlic as a storage crop, it is at its best when fresh picked.

RADICCHIO

When radicchio got its big break in the 1980s, American salad took a great leap forward. The vegetable's stunning burgundy hue added glamour to the salad bowl, and Americans quickly came to appreciate its refreshing bitterness. Joe Marchini (page 169) brought seed back from Italy in 1978, believing that this specialty of the Veneto region had commercial potential in the United States. But he struggled mightily with it. Radicchio is temperamental, and it took many years to get the right seed varieties planted at the right time.

In the 1980s, when growers introduced salad mix (often called spring mix), radicchio sales took off. It contributes eye-catching color and crunch to these soft, leafy blends and adds style to a platter of crudités.

Radicchio doesn't like hot weather but is right at home in the cool coastal growing areas around Salinas and Watsonville. By rotating growing areas, farmers are able to harvest radicchio year-round.

VARIETIES: The round, purplish-red Chioggia variety is the most widely grown. The elongated Treviso type, burgundy with white ribs, is prized for grilling. Castelfranco, a loose, nonheading type, is yellow to pale green with burgundy streaks. Look for this beauty at farmers' markets and specialty-produce stores.

SELECTION AND STORAGE: Heading types should be large, compact, and firm. Small heads are probably older ones that have been trimmed repeatedly. Look for a pristine appearance, with few blemished or shriveled leaves. Refrigerate in a plastic bag and use within one week.

IN THE KITCHEN: Radicchio is particularly appealing in autumn and winter salads with pears, persimmons, or citrus and with dressings made with balsamic or sherry vinegar. Hot dressings made with pancetta or bacon also complement radicchio. Braised radicchio makes an appealing side dish for pork chops or sausage. Halve Treviso radicchio lengthwise, grill it, and top with anchovy butter.

LEFT: (clockwise from top left) Juicy farmers' market strawberries; newly harvested mature garlic; radicchio

STRAWBERRIES

Few fruits are more beloved than strawberries. Almost everyone has a taste memory of a perfect, sun-ripened strawberry, red throughout and dripping with juice. Piled on top of a split and buttered biscuit, with clouds of whipped cream, they star in the most American of summer desserts. Farmers' markets and specialty markets that buy from local growers offer the best chance of securing strawberries that match the memories.

California is by far the nation's largest commercial producer, with nearly 35,000 acres (14,200 ha). The state's coastal areas between Santa Cruz and Oxnard provide the sandy soils and natural air-conditioning that strawberries like. Strawberry farms tend to be small because much of the work can't be mechanized; many are immigrant owned and augment their income with U-pick and farm stand sales. Hand harvesting is the rule. With the state's moderate climate and such a large production zone, California growers can harvest nearly year-round to complement regions with shorter seasons, but summer berries will almost always win the flavor contest.

SELECTION AND STORAGE: Look for aromatic, red-all-over berries with no white shoulders. Size is less important than a seductive fragrance. Fresh-picked strawberries are shiny and have bright green caps. If you can't eat them the day of purchase, refrigerate them in their cartons. Just before you are ready to eat or use them, rinse quickly, pat dry, and remove the hull.

Strawberries aren't typically marketed by variety, but if you shop at farmers' markets, keep an eye out for Chandlers and Seascapes. These two varieties are not widely planted by the state's large growers. But some small farmers remain loyal to these tasty University of California hybrids, and aficionados prize them.

USES: Strawberries marry well with stone fruits and other berries. Jam aside, cooking rarely enhances them. Slice and sweeten strawberries as an accompaniment to custards and cakes, or as a topping for a pastry cream–filled tart. Add them to smoothies, fold into plain yogurt, or serve with honey-drizzled ricotta.

HILLTOP & CANYON FARMS
AVOCADOS

Surely any definition of paradise would include all-you-can-eat avocados. And by that definition, the Abbott family's Hilltop & Canyon Farms is paradise on earth. With 50 acres (20 ha) of organically farmed trees in the coastal community of Carpinteria, these third-generation growers keep Santa Barbara–area farmers' markets steadily supplied with one of nature's most luscious fruits.

Rich and buttery, Abbotts' Hass avocados need only lemon and a pinch of salt to complete them. "I'm not big on recipes," admits Robert Abbott, the farm's current manager, who prefers his daily avocado served as simply as possible. From August through fall, when the fruits reach their flavor peak and the oil content climbs above 20 percent, they amply demonstrate why the thick-skinned Hass variety rules the avocado world.

After college and a couple of unsatisfying office jobs, Abbott returned to the farm where he grew up, eager to work outdoors again. Today he manages the two parcels planted by his grandfathers—a hilltop property, where he lives with his wife, Tessa, and three young daughters, and the larger and better-performing canyon orchard just down the road. Both grandfathers were lemon

growers who transitioned gradually to avocados, a "boutique" fruit in those days. American consumption has grown fivefold since Robert's father, Duncan, ran the business, but now California growers compete with Mexico and Chile.

SLOW GROWTH, GREAT FLAVOR Typically, the Hass blooms in March and the commercial harvest begins in December or January. But the fruits can remain unpicked for several months longer without softening, while the oil content climbs. Because Carpinteria has a relatively cool, maritime climate, Abbott's canyon-raised avocados can hang "for a good twenty months," claims the farmer.

The canyon grove resembles a dense, shady forest, with sunlight filtering through the trees' broad canopies. Young, spindly plantings grow alongside eighty-year-old behemoths that have reached 50 feet (15.2 m), with sturdy trunks and low, leafy skirts that skim the ground. The orchard floor is soft underfoot,

ABOVE: Robert and Tessa Abbott with their daughters and Robert's parents

RIGHT: The Abbotts grow lemons and avocados on their Carpinteria farm, at the northern limits of where avocados thrive.

heavily mulched with leaf litter, chipped prunings, and even coffee grounds from a nearby Starbucks Frappuccino producer.

Mulch is a critical element of the farm's certified-organic methods, keeping weeds under control and building soil fertility. "We used to add urea for nitrogen," says Abbott, "but that's like adding salt. You see things perk up, but that's not real fertility."

Mulch also conserves moisture, boosts microbial life in the soil, and protects against phytophthora, a root disease that can fell an avocado tree. Abbott believes that mulching and other organic practices have helped buffer the avocado's tendency to follow a big harvest with a sparse one. His yield curve is much smoother now, says the grower, with a happy tree in a good year providing four hundred fruits or more.

GAMBLING ON PRICES Because the Hass variety offers growers such a long harvest window, many wait to pick their entire crop until the wholesale price is high. It's a gamble with a good return for those who guess right, as prices can fluctuate by 200 percent over the season. For the farmers' market, Abbott takes a different approach. He and his crew make multiple passes over several months, looking for full-size fruit with a relatively smooth surface, some color darkening, and a matte appearance. By hand, they snap the avocado off with a piece of stem attached so they don't breach the skin. (The stem falls off naturally as the avocado ripens.) Perched on three-legged orchard ladders or stooped under a tree's lowest, ground-hugging branches, they gradually fill their picking bags, 60 pounds (27 kg) at a time.

The fruit is rinsed of field dust and sorted for size and blemishes. Then the 40-pound (18 kg) crates are stacked in the farm's small packing shed, its walls decorated with the Abbott daughters' chalk murals. It can take seven to twenty days for the rock-hard fruit to reach its silky, spreadable, buttery best, ready for slathering on toast or slicing into leafy salads. "Growing well is only half the battle," admits Abbott. "Ripening is the other half."

ABOVE: (clockwise from top left) Mulching is key to the Abbotts' sustainable practices; full-grown avocados can hang on the tree for months; fruit in upper branches requires a special harvest tool; headed for the packing shed

FOLLOWING PAGES: Heavy mulching has helped the Abbotts build soil fertility and control weeds naturally. Fava beans ripen in late spring.

FAVA BEAN TOASTS WITH RICOTTA AND MINT

SERVES 6 AS AN APPETIZER

This recipe was inspired by the bruschetta at Bruschetteria, a kelly-green food truck in St. Helena, California. When fava beans are unavailable, you can substitute ½ cup (70 g) fresh or frozen shelled green peas.

WINE SUGGESTION: *California Sauvignon Blanc or sparkling wine*

1 pound (500 g) fava beans in the pod

½ cup (125 g) whole-milk ricotta

1 tablespoon freshly grated pecorino romano or Parmigiano Reggiano

2 tablespoons plus 1 teaspoon extra virgin olive oil, plus more for drizzling

2 teaspoons finely minced green onion or fresh chives

½ teaspoon finely grated lemon zest, or more to taste

1 small clove garlic, grated with a rasp grater or very finely minced

Kosher or sea salt and freshly ground black pepper

12 slices day-old country-style bread, each about 4 by 2 inches (10 by 5 cm) and ½ inch (12 mm) thick

Fresh mint leaves, torn into pieces, for garnish

Remove the fava beans from their fuzzy pods. Bring a small pot of water to a boil over high heat. Have ready a bowl of ice water. Plunge the fava beans into the boiling water, return to a boil, and cook until they are tender, about 1 minute if small and 2 minutes if large. (Test a few to be sure.) Drain in a sieve and immediately transfer to the ice water. When cool, drain again, then peel each bean by pinching the skin open on one end, then slipping the bean free.

Put the fava beans in a small food processor and pulse until coarsely chopped; do not puree. (Alternatively, you can chop them with a knife.) Transfer to a bowl and fold in the ricotta, pecorino, 1 teaspoon of the olive oil, green onion, and lemon zest. Add the garlic a little at a time, tasting as you go; you may not want it all. Season to taste with salt and several grinds of pepper. Taste and add more lemon zest if desired. The mixture should have a lively lemon taste.

Toast or grill the bread on both sides; the center should remain soft. Using the remaining 2 tablespoons olive oil, brush both sides of each toast with oil.

Transfer the toasts to a work surface. Top with the ricotta spread, dividing it evenly. Drizzle with additional olive oil and garnish with mint. Serve immediately.

FRITTATA WITH BROCCOLI RABE AND SHEEP CHEESE

SERVES 3 FOR LUNCH OR 4 AS A FIRST COURSE

This warm frittata makes a nourishing lunch or rustic first course; accompany with a tuft of lightly dressed salad greens, if you like. Leftover frittata can be sliced and tucked inside a length of baguette with some soft lettuce and a swipe of mayonnaise.

WINE SUGGESTION: *California Sauvignon Blanc or rosé*

¾ pound (375 g) broccoli rabe, tough stems trimmed

6 large eggs

½ cup (35 g) grated aged sheep's milk cheese, such as Bellwether Farms Pepato or pecorino romano

1 teaspoon kosher or sea salt

Freshly ground black pepper

2 tablespoons extra virgin olive oil

Preheat the oven to 400°F (200°C).

Bring a large pot of salted water to a boil over high heat. Add the broccoli rabe and boil until just tender, about 3 minutes. Drain in a sieve and cool quickly under cold running water. Drain and squeeze well to remove excess moisture. Chop coarsely. Measure out 1½ cups (250 g) chopped broccoli and reserve the remainder for another use.

In a large bowl, whisk the eggs until blended, then whisk in the cheese, salt, and several grinds of black pepper. Stir in the broccoli rabe.

Heat a 10-inch (25 cm) nonstick frying pan over medium heat, then add the olive oil. When the oil is hot, add the egg mixture and use a rubber spatula to spread into an even layer. Reduce the heat to medium-low. Cook without stirring until the frittata is about two-thirds set, 6 to 7 minutes. Transfer to the oven and bake just until the frittata feels firm on top and has puffed slightly, 9 to 10 minutes.

Immediately slide the frittata onto a cutting board or wooden serving board. The frittata should slip out easily, but if not, use a rubber spatula to loosen it. Let cool for 15 minutes, then slice into wedges and serve.

TRIMMING TIP: The thick stems of broccoli rabe are often more tender than the thin stems. If a stem feels tough or woody, remove it. Otherwise, just trim any dry ends.

SCALLOP CRUDO WITH AVOCADO AND PINK PEPPERCORNS

SERVES 4

When it's too hot to cook, it's time for crudo. *Italian for "raw,"* crudo *prepared with scallops takes all of 10 minutes and is as refreshing as a chilled glass of rosé. It's hard to imagine a more inviting first course. Ideally, every bite will include a bit of tender scallop, creamy avocado, fragrant herbs, and spice. If you're not a big fan of spicy fare, go easy on the chile.*

WINE SUGGESTION: *California rosé or Riesling*

½ pound (250 g) sea scallops, about 8 large, foot removed

¼ cup (60 ml) extra virgin olive oil, preferably olio nuovo

3 tablespoons fresh lemon juice

Kosher or sea salt

½ ripe but firm avocado

1 tablespoon very thinly sliced fresh chives

About 12 blemish-free cilantro leaves (no stems)

1 small serrano chile, halved lengthwise, seeded if desired, and then very thinly sliced crosswise

1 teaspoon pink peppercorns, crushed in a mortar

With a sharp knife, slice the sea scallops crosswise into 3 or 4 thin rounds (thinner is better).

In a small bowl, whisk together the olive oil, lemon juice, and salt to taste.

Use a large spoon to scoop the avocado half out of its skin and place it cut side down on a work surface. Slice thinly crosswise.

On four salad plates, arrange the scallop slices in a rosette alternating with the avocado slices. Spoon the dressing over the top; you may not need it all. Season the scallops and avocado with a little more salt. Scatter the chives, cilantro, chile, and peppercorns on top. Serve immediately.

SHRIMP, ARTICHOKE, AND FARRO SALAD

SERVES 4 TO 6

Farro, the Italian name for a type of whole wheat, makes a superb base for a hearty grain salad. It holds up well after dressing, and its nutty flavor is appealing with baby artichokes. Shrimp make the salad more substantial and colorful, but you could replace them with cooked chickpeas. Pearling, a mechanical process that abrades the exterior of the whole grain, makes farro *cook more quickly. It does remove some (semipearled) or all (pearled) of the nutritious bran, but whole, non-pearled* farro *takes a long time to cook. Serve the salad for lunch or as a cool dinner on a hot night.*

WINE SUGGESTION: *California Chardonnay or sparkling wine*

4 quarts (4 l) water, divided, plus 2 quarts (2 l) if using fresh artichokes

Kosher or sea salt

1 cup (170 g) farro, pearled or semipearled

12 large shell-on shrimp, about 9 ounces (280 g) total

1 lemon

10 baby artichokes, 1½ to 2 ounces (45 to 60 g) each, or 1 package (8 to 10 ounces/250 to 310 g) frozen artichoke hearts

DRESSING:

5 tablespoons (80 ml) extra virgin olive oil

¼ cup (60 ml) fresh lemon juice, plus more if needed

1 teaspoon Vietnamese fish sauce

1 small clove garlic, grated with a rasp grater or very finely minced

Kosher or sea salt and freshly ground black pepper

½ small red onion, very thinly sliced

2 inner celery ribs, cut into neat small dice

¼ cup (10 g) coarsely chopped fresh mint

¼ cup (10 g) finely chopped fresh flat-leaf parsley

(continued next page)

SHRIMP, ARTICHOKE, AND FARRO
SALAD *(continued)*

In a saucepan, bring 2 quarts (2 l) of the water to a boil over high heat and season with salt. Add the farro and adjust the heat to maintain a steady simmer. Skim off any foam. Cover partially and simmer gently until the farro is just tender, 25 to 30 minutes. Drain in a sieve and rinse briefly under cold running water to cool. Drain well and let cool completely.

In another saucepan, bring 2 quarts (2 l) of the water to a boil over high heat and season with salt. Add the shrimp and boil until just cooked through, about 1½ minutes, depending on size. Drain and let cool, then peel. Cut in half lengthwise and remove any vein.

Grate the zest of the lemon finely and set it aside for the salad. Cut the lemon in half.

If using fresh artichokes, fill a bowl with cold water and add the juice of the 2 lemon halves. To trim the artichokes, peel back the outer leaves until they break off at the base. Keep removing leaves until you reach the pale green heart. Cut across the top of the heart to remove the pointed leaf tips. If the stem is still attached, cut it down to ½ inch (12 mm), then trim the stem and base to remove any dark green or brown parts. As the artichokes are trimmed, add them to the lemon water to prevent browning.

In a saucepan, bring the remaining 2 quarts (2 l) water to a boil over high heat and season with salt. Drain the artichokes and add them to the boiling water. Boil until the base of an artichoke is just tender when pierced, about 5 minutes. Drain and cool under cold running water, then drain again and pat dry. Cut each artichoke lengthwise into 6 to 8 wedges.

If using frozen artichoke hearts, cook according to package directions. Drain, let cool, and pat dry. Cut any large wedges in half.

Make the dressing: In a small bowl, whisk together the olive oil, lemon juice, fish sauce, and garlic. Season generously with salt and pepper.

Put the artichokes in a small bowl and add just enough of the dressing to coat them lightly. Toss gently and let stand for 5 minutes to absorb the dressing.

In a large bowl, combine the farro, shrimp, artichokes, onion, celery, mint, parsley, and lemon zest. Toss to mix, then add enough dressing to coat the salad lightly; you may not need it all. Taste and adjust the seasoning. The salad should be lemony. Serve immediately.

SPRING VEGETABLE TABBOULI WITH FAVA BEANS, RADISHES, AND SPRING HERBS

SERVES 4

An abundance of fresh-chopped herbs and colorful, crunchy vegetables makes this salad as refreshing as spring rain. It resembles tabbouleh, but here the vegetables play a bigger role. Serve it for lunch with a chunk of feta and ripe olives, or for dinner with grilled lamb or salmon.

WINE SUGGESTION: *California Chardonnay or Pinot Gris/Grigio*

¾ cup (125 g) extra-fine bulgur (#1 grind)
¾ cup (180 ml) water

DRESSING:

3 tablespoons extra virgin olive oil
3 tablespoons fresh lemon juice
1 teaspoon Vietnamese fish sauce
1 small clove garlic, grated with a rasp grater or very finely minced
Kosher or sea alt

1 pound (500 g) fava beans in the pod
½ cup (60 g) thinly sliced radishes
½ cup (60 g) thinly sliced cucumbers
⅓ cup (35 g) minced green onion
½ to ¾ cup (20 to 30 g) chopped mixed fresh herbs (flat-leaf parsley, dill, mint, cilantro)
Ground Aleppo chile or freshly ground black pepper

Shake the bulgur in a fine-mesh sieve to remove any particles as fine as dust. Transfer the bulgur to a bowl and add the water. Stir briefly, then let stand undisturbed for 15 minutes. The bulgur will absorb all or most of the water. Pour the bulgur into a sieve lined with a double thickness of cheesecloth, then gather the cheesecloth into a bag and squeeze to remove any excess moisture. The bulgur should be quite dry. Transfer it to a large bowl and fluff with a fork.

Make the dressing: In a bowl, whisk together the olive oil, lemon juice, fish sauce, garlic, and a large pinch of salt.

Remove the fava beans from their fuzzy pods. Bring a small pot of water to a boil over high heat. Have ready a bowl of ice water. Plunge the fava beans into the boiling water, return to a boil, and cook until they are tender, about 1 minute if small and 2 minutes if large. (Test a few to be sure.) Drain in a sieve and immediately transfer to the ice water. When cool, drain again, then peel each bean by pinching the skin open on one end, then slipping the bean free.

Add the fava beans, radishes, cucumbers, green onion, herbs, and ¼ teaspoon Aleppo chile or black pepper to taste to the bulgur and toss gently with a fork. Add the dressing and toss well. Taste and adjust the seasoning. Serve immediately.

BULGUR VS. CRACKED WHEAT: These two grain products are the same but different. Cracked wheat is simply the whole wheat kernel (also called the berry) cracked coarsely, like steel-cut oats. To make bulgur, the wheat berries are cooked first, then dried and cracked. Bulgur has a toastier flavor than cracked wheat and is produced in a range of sizes, from #1 (extra-fine) to #4 (coarse). Look for bulgur #1 in Middle Eastern markets, where the size is usually indicated on the package. In supermarket bulk bins, the size of the bulgur may not be indicated; most likely, the bulgur is medium-fine and will need longer soaking to soften. If it doesn't soften sufficiently in cold water, add a little boiling water and let stand until al dente.

GILROY GARLIC AND POTATO SOUP

SERVES 4

*This rustic, farmhouse-style soup is a meal in itself,
especially with crusty bread for dipping. Perfumed
with saffron, cilantro, and Spanish smoked paprika
(pimentón), it fills the kitchen with its seductive aroma.
When the potatoes are tender, divide the soup among
heatproof bowls, break an egg on top of each serving, and
transfer the bowls to the oven until the eggs are barely set.
Encourage diners to break up the egg and stir it in so the
yolk thickens the soup. If you don't have heatproof bowls,
you can add the eggs to the pot of soup and complete the
cooking on top of the stove.*

WINE SUGGESTION: *California Grenache, Carignane, or
Grenache/Syrah/Mourvèdre (GSM) blend*

¼ cup (60 ml) extra virgin olive oil

12 cloves garlic, thinly sliced

1½ pounds (750 g) Yukon Gold potatoes, peeled, halved
 lengthwise (or quartered if large), and thinly sliced
 crosswise

¼ cup (10 g) chopped fresh cilantro, plus more for garnish

1 teaspoon dried oregano, finely crumbled

¾ teaspoon pimentón de la Vera (Spanish smoked paprika)

Generous pinch of saffron threads

4 cups (1 l) chicken broth

⅔ cup (90 g) frozen petite peas

Kosher or sea salt and freshly ground black pepper

4 large eggs

Preheat the oven to 425°F (220°C).

Heat the olive oil in a large, heavy pot over medium-low
heat. Add the garlic and sauté until it starts to color,
2 to 3 minutes. Add the potatoes, cilantro, oregano,
pimentón, saffron, and broth. Bring to a simmer, then
cover partially and simmer gently until the potatoes
are just tender, about 15 minutes. Stir in the peas and
return to a simmer. Season with salt and pepper.

Put four heatproof bowls on a heavy rimmed baking
sheet. Divide the hot soup evenly among the bowls. One
at a time, break an egg into a cup and carefully slide it
onto the surface of each soup. Transfer the baking sheet
to the oven and bake until the egg whites are set but the
yolks are still runny, 5 to 10 minutes. Serve immediately.

PIZZA WITH ARTICHOKES AND ARUGULA PESTO

MAKES ONE 13- TO 14-INCH (33 TO 35 CM) PIZZA, TO SERVE 2

Once you master the method for preparing baby artichokes (it's easy), you'll never want to pass them by. They are not a common sight in produce markets, so grab them when you can. The pesto is slathered on the hot pizza when it comes out of the oven for a burst of garlicky aroma. You will use only half of the pesto, so save the rest for pasta the next day. In a hurry? Substitute frozen pizza dough, frozen baby artichoke hearts, and/or store-bought pesto. This recipe is the purist's version.

WINE SUGGESTION: *California Grenache or Grenache/Syrah/Mourvèdre (GSM) blend*

PIZZA DOUGH:

1½ teaspoons active dry yeast

¾ cup (180 ml) warm water (105° to 115°F/40° to 46°C)

1 tablespoon extra virgin olive oil, plus more for oiling the bowl

1 teaspoon kosher or sea salt

About 1¾ cups (220 g) unbleached all-purpose flour, plus more for the work surface

½ lemon

10 baby artichokes, 1½ to 2 ounces (45 to 60 g) each

1 tablespoon extra virgin olive oil

½ teaspoon dried oregano, finely crumbled

Kosher or sea salt

PESTO:

2 cups (100 g) tightly packed arugula leaves, thick stems removed

2 tablespoons skinless whole almonds

1 small clove garlic, thinly sliced

6 tablespoons (90 ml) extra virgin olive oil, or more if needed

⅓ cup (25 g) freshly grated Parmigiano Reggiano or pecorino romano

Kosher or sea salt

Cornmeal or semolina, for dusting

6 ounces (185 g) low-moisture mozzarella, coarsely grated

2 teaspoons extra virgin olive oil, for brushing the dough

Make the dough: Sprinkle the yeast over the warm water in a large bowl and let stand for about 3 minutes to soften. Whisk with a fork to dissolve and let stand until bubbly, about 10 minutes. Whisk in the olive oil and salt. Add 1½ cups (185 g) of the flour, stirring with a wooden spoon until the dough clears the sides of the bowl.

Turn the dough out onto a lightly floured work surface and knead until smooth and elastic, about 5 minutes, using as much of the remaining flour as needed to keep the dough from sticking to the board or your hands. Shape the dough into a ball, transfer to an oiled bowl, and turn to coat the dough with oil. Cover the bowl tightly with plastic wrap and let the dough rise at room temperature for 2 hours.

Punch the dough down and reshape into a ball. Re-cover the bowl and let the dough rise again for 4 hours.

Prepare the artichokes: Fill a bowl with cold water and add the juice of the lemon half. To trim the artichokes, peel back the outer leaves until they break off at the base. Keep removing leaves until you reach the pale green heart. Cut across the top of the heart to remove the pointed leaf tips. If the stem is still attached, cut it down to ½ inch (12 mm), then trim the stem and base to remove any dark green or brown parts. As the artichokes are trimmed, add them to the lemon water to prevent browning.

Bring a saucepan of salted water to a boil over high heat. Prepare a bowl of ice water. Drain the artichokes and add them to the boiling water. Boil until the base of an artichoke is just tender when pierced. Drain and transfer to the ice water to stop the cooking. When they are cool, drain again and pat dry. Halve the artichokes lengthwise and pat dry again, then cut each half into 3 wedges. Toss the wedges in a bowl with the olive oil, oregano, and salt to taste.

(continued next page)

Make the pesto: Bring a pot of salted water to a boil over high heat. Prepare a bowl of ice water. Add the arugula to the boiling water and blanch for 15 seconds, then drain and plunge immediately into the ice water. When cool, drain again and squeeze to remove excess water.

Preheat the oven to 350°F (180°C). Toast the almonds until lightly colored and fragrant, 12 to 15 minutes. Let cool.

Put the arugula, almonds, and garlic in a food processor and pulse until well chopped. With the motor running, add the olive oil through the feed tube and puree until nearly smooth, stopping to scrape the sides of the bowl

as needed. Transfer to a bowl and stir in the cheese and salt to taste. Add a little more olive oil if the pesto seems too thick to spread.

Position a rack in the upper third of the oven. Put a baking stone on the rack and preheat the oven to its highest setting for at least 30 minutes. Fifteen minutes before you are ready to bake the pizza, turn on the broiler.

Generously dust a baking peel or rimless baking sheet with cornmeal. Transfer the dough to a well-floured surface and flatten it into a round. Pick it up with floured fingertips and stretch it into a 13- to 14-inch (33 to 35 cm) round by rotating the dough between your fingertips and letting the weight of the dough stretch it. Try to keep it evenly thin, with no tears. Transfer the dough round to the prepared baking peel. Working quickly to prevent the dough from sticking to the peel, top with the cheese, scattering it evenly and keeping it about 1 inch (2.5 cm) from the edge. Scatter the artichokes on top of the cheese. Brush the rim with the olive oil.

Turn the broiler off and return the oven to the highest bake setting. Slide the pizza onto the baking stone. Bake until the crust is puffy and browned and the topping is bubbling, about 6 minutes. Transfer to a cutting board or serving platter. With a rubber spatula, gently daub half of the pesto on top. (Reserve the remaining pesto for another use.) Cut into wedges and serve immediately.

PRESERVING PESTO: Blanching the arugula helps keep the pesto from browning. To store the remaining pesto, put it in a small container and press plastic wrap against the surface. Cover and refrigerate for up to 2 days.

RISOTTO WITH RADICCHIO AND PANCETTA

SERVES 4 TO 6

The radicchio practically melts into this risotto, tinting the rice as if it were cooked with red wine. The flavor is sweet from the onion and savory from the pancetta; surprisingly, the radicchio contributes no bitterness. Carnaroli, like Arborio, is a medium-grain Italian rice variety. It is more costly than the better-known Arborio but is worth seeking out for the superior risotto texture it yields.

WINE SUGGESTION: *California Riesling or Pinot Gris / Grigio*

6 cups (1.5 l) chicken broth, homemade or store-bought (if store-bought, dilute half and half with water)

2 tablespoons extra virgin olive oil

3 ounces (90 g) pancetta, finely diced

1 small yellow onion, minced

1 small round head radicchio, quartered through the stem, cored, and thinly sliced crosswise

½ cup (125 ml) white wine

1 ½ cups (10 oz/315 g) Carnaroli or Arborio rice

Kosher or sea salt and freshly ground black pepper

¼ cup (10 g) chopped fresh flat-leaf parsley

½ cup (35 g) freshly grated Parmigiano Reggiano, plus more for garnish

Put the broth in a small saucepan and bring to a simmer over medium heat; adjust the heat to maintain a bare simmer.

Heat the olive oil in a heavy pot over medium-low heat. Add the pancetta and cook, stirring, until it renders much of its fat and begins to crisp, 5 to 10 minutes. With a slotted spoon, transfer the pancetta to paper towels to drain, leaving the rendered fat in the pot. Add the onion to the pot and sauté until softened, about 5 minutes. Add the radicchio, mix well with a wooden spoon, then raise the heat to medium, add the wine, and cook until it evaporates.

Add the rice and stir until it is hot, then begin adding the hot broth ½ cup (125 ml) at a time, stirring frequently and adding more broth only when the previous addition has been absorbed. Adjust the heat to maintain a steady but gentle simmer. Cook until the rice is just shy of al dente, 16 to 18 minutes. The risotto should be creamy—neither soupy nor stiff; you may not need all the broth.

Stir in the reserved pancetta and salt and pepper to taste. Cover, remove from the heat, and let rest for 3 minutes, then stir in the parsley and cheese. Serve immediately in bowls, topping each portion with a light sprinkle of cheese.

STEAMED DUNGENESS CRAB WITH GREEN GARLIC AIOLI

SERVES 4

Green garlic turns up in farmers' markets just in time for the end of the Dungeness crab season. Although more subtle than mature garlic, it is fibrous and benefits from cooking. Softened in olive oil, then pureed, it can be stirred into homemade mayonnaise to make an enticing aioli. While the green garlic harvest lasts, enjoy the aioli as a dip for steamed artichokes or asparagus.

WINE SUGGESTION: *California Chardonnay or Viognier*

GREEN GARLIC AIOLI:

¾ cup (180 ml) extra virgin olive oil

1 cup (100 g) thinly sliced green garlic, white and pale green part only

Kosher or sea salt

1 large egg yolk

2 tablespoons finely minced fresh flat-leaf parsley

Fresh lemon juice (optional)

2 live Dungeness crabs, about 2 pounds (1 kg) each, or 2 store-bought cooked crabs, cracked

Kosher or sea salt

Make the aioli: Put 1 tablespoon of the olive oil in a small frying pan and warm over medium-low heat. Add the green garlic and a generous pinch of salt and stir to coat with the oil. Add enough water just to cover the garlic and bring to a simmer. Cook at a gentle simmer, stirring occasionally, until the garlic is completely soft and the liquid has evaporated, about 30 minutes. Add a little more water if needed or raise the heat if the garlic softens before all the liquid has evaporated. Let cool.

Put the softened garlic in a small food processor and puree until completely smooth. Add the egg yolk and puree again. With the motor running, add the remaining olive oil very slowly in a fine, steady stream, processing until all of the oil is incorporated and the mixture is thick and emulsified. Transfer the aioli to a bowl and stir in the parsley, then season with salt. Add a little lemon juice to brighten the flavor, if desired.

To cook live crabs, fill a large pot with enough water to cover the crabs generously. Add salt in the ratio of 1 tablespoon per quart (l) of water. Bring the water to a rolling boil over high heat. Add the live crabs and cover. When the water returns to a boil, uncover and begin timing. Figure 15 to 17 minutes for 2-pound (1 kg) crabs. Coagulated white protein at the joints is a sign of doneness. Lift the crabs out with tongs and rinse briefly under cold running water to cool them enough to handle.

Twist off the legs and claws from a crab and set them aside. Turn the crab onto its back and, using your fingers or the tip of a small knife, pry off the triangular-shaped shell flap and discard. Turn the crab over and, grasping the large top shell firmly, lift it up and away from the body and discard. Scrape out and discard the deep gray organs from the center of the body, then remove and discard the long, spongy white gills from either side. With a heavy knife, cut the body in half lengthwise. Using a mallet, crack the shells on the legs and claws in a few places. Repeat with the second crab. Arrange the crabs on a large platter.

Serve the crabs warm or chilled with the green garlic aioli.

GRASS-FED BURGER WITH AVOCADO AND CHIPOTLE MAYONNAISE

SERVES 4

Buttery avocados make any sandwich better, and they put this burger over the top. Grass-fed beef can be lean, but the sliced avocado and spicy chipotle mayonnaise ensure that this burger is a luscious, moist, flavor-packed experience.

WINE SUGGESTION: *California Cabernet Sauvignon or Syrah*

BURGERS:

1½ pounds (750 g) grass-fed ground beef chuck

Scant 1½ teaspoons kosher or sea salt

¾ teaspoon garlic powder

Freshly ground black pepper

CHIPOTLE MAYONNAISE:

¼ cup plus 2 tablespoons (90 ml) mayonnaise, homemade or store-bought

1 tablespoon extra virgin olive oil, if using store-bought mayonnaise

1 small clove garlic, grated with a rasp grater or very finely minced

1½ teaspoons very finely minced chipotle chile in adobo, or more to taste

1 tablespoon extra virgin olive oil

4 hamburger buns, split

1 ripe but firm small avocado

½ lime

About ½ cup (20 g) loosely packed fresh cilantro leaves

4 large, soft lettuce leaves

Make the burgers: Put the beef in a bowl and add the salt, garlic powder, and several grinds of black pepper. Mix quickly with your hands; try not to overwork the mixture. Divide into four equal portions, each 6 ounces (185 g), and shape into balls. Flatten each ball into a round patty about ¾ inch (2 cm) thick. Make the patties a little thinner in the center. They shrink a bit when cooked, and this step ensures they will be of even thickness after cooking. Place them on a tray and refrigerate.

Make the mayonnaise: Put the mayonnaise in a small bowl. If it is store-bought, whisk in the olive oil to improve the flavor. Whisk in the garlic and chile. Taste and add more chile if you like. Cover and refrigerate until needed.

Preheat the broiler. Heat a large cast-iron frying pan over medium heat. Add the olive oil and swirl to coat the bottom of the pan. When the oil is hot, add the patties and fry until nicely browned and done to your taste, flipping them with a spatula two or three times and adjusting the heat to keep them from getting too crusty on either side. For medium doneness, the total cooking time will be about 10 minutes.

Set the burgers aside on a platter to rest for about 3 minutes. Meanwhile, toast the buns, cut side up, under the broiler. Halve, pit, and peel the avocado and slice thinly.

Spread chipotle mayonnaise on both halves of the toasted buns. Top the bottom half of each bun with a burger. Divide the avocado slices evenly among the burgers. Sprinkle the avocado lightly with salt and a squeeze of lime. Top with a tuft of cilantro leaves, then with a lettuce leaf, and finally the top half of the bun. Cut in half with a serrated knife and serve immediately.

LAMB MEATBALLS WITH ARTICHOKES AND OLIVES

SERVES 4

These succulent, fork-tender meatballs cook directly in the sauce—no browning required. Flavored with capers, black olives, fennel seed, oregano, and hot red pepper, the sauce tastes like you learned it from your Sicilian grandmother. You can substitute frozen baby artichoke hearts, which are precooked and only need to heat through, for the fresh ones. Serve the meatballs with orzo, tossing the pasta with a little of the flavorful lamb sauce before spooning the meatballs and vegetables on top.

WINE SUGGESTION: *California Petite Sirah or Pinot Noir*

MEATBALLS:

1 pound (500 g) ground lamb

1 large egg, lightly beaten

½ cup (75 g) finely minced yellow onion

½ cup (30 g) soft fresh bread crumbs

¼ cup (15 g) freshly grated pecorino romano

1 teaspoon garlic powder

1½ teaspoons kosher or sea salt

Freshly ground black pepper

SAUCE:

4 cups (1 l) peeled, seeded, and diced fresh plum tomatoes, or 1 can (28 ounces/875 g) plum tomatoes

2 tablespoons extra virgin olive oil

2 large cloves garlic, minced

2 teaspoons dried oregano

1 teaspoon ground fennel seed

Pinch of red pepper flakes (optional)

Kosher or sea salt

Pinch of baking soda, or more as needed, if using canned tomatoes

1 tablespoon salt-packed capers, rinsed and chopped

24 oil-cured black olives, pitted

4 tablespoons (10 g) chopped fresh flat-leaf parsley

2 large artichokes

1 lemon, halved

⅓ cup (25 g) freshly grated pecorino romano

Make the meatballs: Combine all the ingredients in a bowl, including a few grinds of pepper, and blend well with your hands. Shape into 16 meatballs of equal size. Set the meatballs on a tray and refrigerate while you prepare the sauce.

Make the sauce: If you are using canned plum tomatoes, put the contents of the can in a blender and blend until smooth. In a large frying pan that can accommodate all the meatballs and artichokes, heat the olive oil over medium heat. Add the garlic and sauté until fragrant, about 1 minute. Add the fresh tomatoes or tomato puree and bring to a simmer. Add the oregano, rubbing it between your fingers to release its fragrance, then add the ground fennel, red pepper flakes, and salt to taste. Adjust the heat to maintain a gentle simmer and cook until the sauce is smooth, thick, and tasty, about 30 minutes, adding water as needed if the sauce threatens to cook dry.

If you are using canned tomatoes, the sauce will probably be too tart; stir in a pinch of baking soda and cook for another minute or two. Taste and add more baking soda if needed to make the flavor more mellow. Stir in the capers, olives, and 2 tablespoons of the parsley. Keep warm over low heat.

Prepare the artichokes: Fill a large bowl with cold water and add the juice of ½ lemon. Peel back the outer leaves of each artichoke until they snap at the base. Continue removing the leaves until you reach the pale green, tender inner leaves. With a large, sharp knife, cut about 1 inch (2.5 cm) off the top of each artichoke, then cut off the stem flush at the base. Rub the cut surfaces with the other lemon half. With a small knife, pare the base of each artichoke, removing any dark green parts to reveal the pale yellow-green bottom. Halve each artichoke lengthwise. With a small spoon, scrape out the hairy

(continued next page)

LAMB MEATBALLS WITH
ARTICHOKES AND OLIVES *(continued)*

choke and prickly inner leaves with sharp tips. Cut
each half into 6 wedges and immediately place them in
the lemon water to prevent browning. Set an inverted
plate in the bowl to keep the wedges submerged.

Drain the artichoke wedges and add them to the frying
pan. Stir to coat them with the sauce, then cover and
simmer gently for 10 minutes, adding water to thin the
sauce as needed. Add the meatballs, cover, and simmer
gently for 10 minutes. Use two spoons to turn the
meatballs over in the sauce, then re-cover and continue
cooking until the artichokes are tender and the meat-
balls are fully cooked, about 10 minutes longer, adjust-
ing the sauce with water if needed.

Divide the meatballs and artichokes among four bowls.
Top each portion with some of the grated pecorino and
the remaining chopped parsley. Serve immediately.

DON'T THROW IT AWAY: When trimming the artichokes
for this recipe, save the outer leaves in a plastic bag.
Steam them the following day and serve with aioli,
vinaigrette, or another dipping sauce.

BRUSSELS SPROUTS WITH BROWN BUTTER AND TARRAGON

SERVES 4

Serve these aromatic Brussels sprouts with pork chops, roast chicken, or the Thanksgiving turkey, or as part of an all-vegetable dinner. Nutty brown butter makes them glisten. This recipe makes more clarified butter than you need, but you won't regret having extra. Refrigerate it and use it on fried eggs, steamed asparagus or cauliflower, or white-fleshed seafood such as petrale sole, scallops, or halibut.

½ cup (125 g) unsalted butter
1 pound (500 g) Brussels sprouts, trimmed
1 tablespoon minced fresh flat-leaf parsley
2 teaspoons minced fresh tarragon
Kosher or sea salt and freshly ground black pepper

Make the brown butter: In a small saucepan, melt the butter over medium-low heat. It will sizzle and sputter, indicating that moisture is evaporating. A foamy film will form on top; leave it untouched until the film begins to turn light brown and the butter smells nutty, which may take 20 minutes.

Remove the pan from the heat. Skim off and discard the surface foam. Pour off the clear butter, leaving any sediment behind. You should have 6½ to 7 tablespoons (100 ml) clarified brown butter. You will need 2 tablespoons for this recipe; reserve the remainder for another use (see introduction).

Bring a large pot of salted water to a boil over high heat. Add the Brussels sprouts and cook until just tender, about 10 minutes. Drain and return them to the hot pot. Set the pot over low heat until any excess moisture evaporates. Remove the pot from the heat and add 2 tablespoons brown butter, the parsley, tarragon, and a generous amount of salt and pepper. Brussels sprouts need a surprising amount of salt. Serve immediately.

STRAWBERRY SHERBET WITH SPARKLING WINE

SERVES 6

Adding a splash of sparkling wine just before serving makes this sherbet particularly festive. The wine continues to fizz as the sherbet melts, imparting brisk refreshment. Serve in glasses so guests can sip the last delicious drops.

SHERBET:

1 pound (500 g) strawberries, hulled and sliced

⅔ cup (140 g) superfine sugar

1½ teaspoons kirsch

½ pound (250 g) strawberries, hulled and sliced

Superfine sugar to taste

Kirsch to taste

¾ cup (180 ml) chilled sparkling wine

Make the sherbet: In a food processor or blender, combine the strawberries and sugar and puree until smooth. Transfer the mixture to a fine-mesh sieve set over a bowl. Press with a rubber spatula to force the pulp through while leaving the seeds behind. Stir in the kirsch. Cover and refrigerate until thoroughly chilled. Freeze in an ice-cream machine according to the manufacturer's directions. Transfer to an airtight container and store in the freezer until serving.

About 15 minutes before serving, sweeten the sliced berries to taste with superfine sugar. Toss gently and let stand to release some of the berry juices. Stir in kirsch to taste.

To serve, scoop the sorbet into stemmed glasses. Spoon the berries over the sorbet, dividing them evenly. Pour 2 tablespoons of the sparkling wine over each portion and serve immediately.

FARMERS' MARKET BERRIES WITH LATE-HARVEST WINE SABAYON

SERVES 6

Italian restaurants in San Francisco's North Beach neighborhood used to be famous for their zabaglione (Italy's counterpart to the French sabayon), whisking it to order for customers and spooning the warm, frothy wine custard into goblets. When chilled, then lightened with whipped cream, the same concoction makes a luscious, fluffy topping for summer's juiciest berries.

WINE SUGGESTION: *California late-harvest Semillon or Riesling*

SABAYON:

4 large egg yolks

2 tablespoons sugar, plus more if needed

½ cup (125 ml) late-harvest dessert wine, such as late-harvest Semillon or Riesling

½ cup (125 ml) heavy cream

1½ pounds (750 g) mixed berries (strawberries, blackberries, blueberries, raspberries)

1 tablespoon sugar

Make the sabayon: Prepare a large bowl of ice water. Pour water to a depth of about 1 inch (2.5 cm) into the bottom pan of a double boiler and bring to a simmer. Adjust the heat to maintain a gentle simmer.

In the top pan of the double boiler, using a whisk or handheld electric mixer, whip the egg yolks and the 2 tablespoons sugar until pale. Set the top pan over the simmering water, making sure the bottom of the pan does not touch the water. (Or use a heatproof bowl that fits snugly over a saucepan of simmering water, again making sure the bottom of the bowl does not touch the water.) Whip constantly until the mixture is light and thick, about 3 minutes. Add the wine gradually while whipping constantly, then continue to whip until the mixture is thick, pale, fluffy, and roughly doubled in volume, 7 to 8 minutes. Do not let the mixture get too hot or the eggs may scramble; lower the heat if necessary or lift the upper pan for a few moments to cool slightly while continuing to whip.

Place the top pan of the double boiler in the ice water to chill quickly. Whisk the mixture occasionally to cool it faster.

When the egg mixture is cool, in a bowl, whip the cream until soft peaks form. Taste the egg mixture, and if it is not as sweet as you would like (dessert wines vary considerably in sweetness), add 1 teaspoon or more sugar to the cream and continue whipping until firm peaks form. Fold the whipped cream into the cooled egg mixture. Use immediately or cover and refrigerate for up to 4 hours.

About 20 minutes before serving, hull and slice the strawberries, if using. Combine all the berries in a bowl and sprinkle with the sugar. Toss gently with a rubber spatula and let stand for about 10 minutes to dissolve the sugar and draw out some juices.

Divide the berries and any juices among 6 stemmed glasses or compote dishes. Top each portion with a dollop of the sabayon, dividing it evenly. Serve at once.

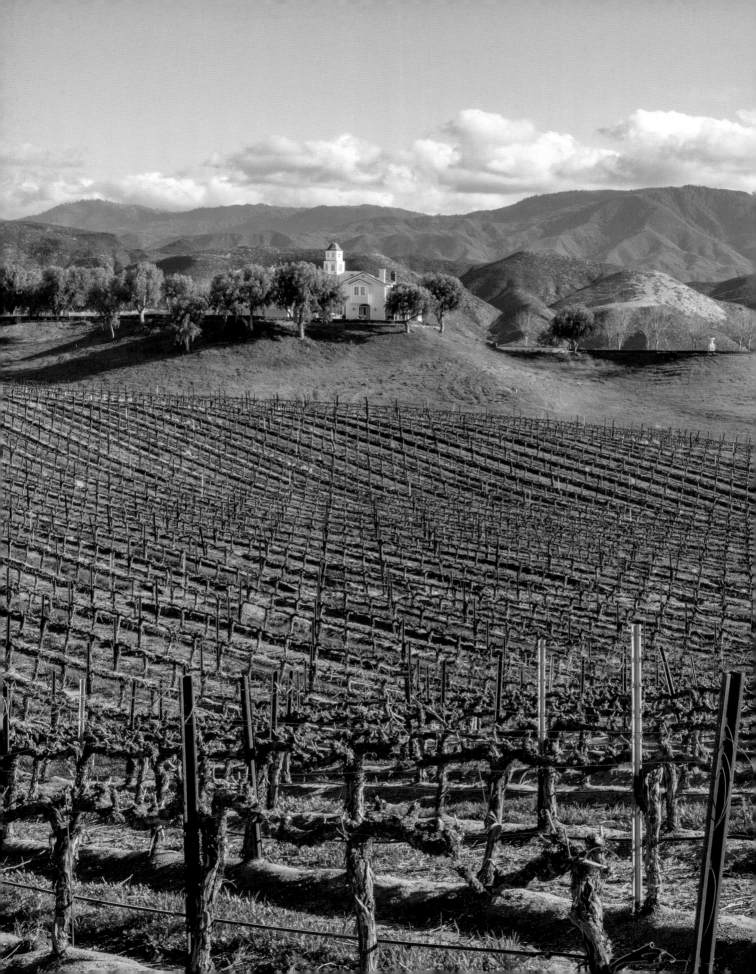

FROM

SOUTHERN CALIFORNIA
Where Sunshine Reigns

In 1967, a prominent Hollywood lighting director and his wife bought a former cattle ranch in Temecula and planted a vineyard. Vincenzo and Audrey Cilurzo knew nothing about grape growing or winemaking, but they were looking for a rural home and a consultant assured them that the area's climate was similar to Napa's. Advised to grow Petite Sirah and Chenin Blanc, the Cilurzos planted 40 acres (16 ha), launching Temecula Valley as a modern grape-growing region.

In the ensuing years, Vincenzo mentored those who followed him into Temecula Valley viticulture, and he believed fiercely in the region's potential for red wine. (He also continued his career in television, lighting the Academy Awards ceremony and the game show *Jeopardy* and winning an

LEFT: Temecula Valley vineyard in winter, with a cover crop between vine rows

Emmy for his work on *The Merv Griffin Show*.) Ely Callaway, a former textiles executive, also helped boost the profile of the area in the 1970s with Callaway Vineyards, the first to make wine in Temecula Valley from local grapes.

Thanks to the proximity of Los Angeles and San Diego, the thirty-plus wineries in the Temecula Valley today tend to sell most of their output direct to consumers or local restaurants. Many have ambitious hospitality programs, fueling weekend wine tourism. The city of Temecula, with its boardwalk and charming Old Town steeped in early California character, makes a convenient base for exploring the state's southernmost wine regions.

A first-time visitor may be taken aback by the dramatic landscape around Temecula, with its steep chaparral-covered hills and massive granite outcroppings. How can grapevines thrive in such a rugged setting? Yet not far off the highway, past lush golf courses, ranchettes, and horse crossings, lie high-elevation vineyards that appreciate that fast-draining granitic soil and need only judiciously timed water to produce premium grapes for fine wine.

BELOW: (from left) Micole Moore at his Ramona Ranch vineyard in the San Diego AVA; Cabernet Sauvignon grapes at Palumbo Family Vineyards

RIGHT: (clockwise from top left) Ramona Ranch bloom; fine dining at Temecula's Ponte Winery; proprietor Claudio Ponte; Malibu's Saddlerock Ranch

SOUTHERN CALIFORNIA WINES

Most of the wineries in this semi-arid region focus on grape varieties that respond well to the warm climate: Syrah, Grenache, Aglianico, Tempranillo, and Zinfandel for red wines; Roussanne and Viognier for whites. For the most part, the vineyards producing the highest quality grapes are at 1,400 to 2,000 feet (400 to 600 m) above sea level, and in the path of daily ocean breezes.

Wineries in the Temecula Valley AVA benefit from afternoon fog pulled in through a gap in the mountain range that separates the valley from the ocean. Nights can be chilly and the fog can linger until midmorning. "It is cooler here than people think," says Nick Palumbo of Temecula's Palumbo Family Vineyards. By training the vines on trellises (many people used to let them sprawl) and removing leaves to open the canopy, growers rely on breezes for mildew prevention.

Pierce's disease, a bacterial infection that won't harm grapes but can kill grapevines, took a heavy toll in this region in the 1990s, but growers replanted with disease-resistant

LOS ANGELES AREA

CUCAMONGA VALLEY

TEMECULA VALLEY

SAN DIEGO COUNTY

clones and have learned how to minimize the threat with sustainable methods. An insect, the glassy-winged sharpshooter, spreads the bacterium from infected plants to grapevines. By clearing vegetation around vineyards and releasing parasitic wasps, Temecula Valley growers are controlling Pierce's disease; university research has also developed some long-term solutions.

The smaller Ramona Valley AVA lies just northeast of San Diego, separated by about 30 miles (48 km) from both the coast and the desert. The average vineyard here is less than 2 acres (0.8 ha), and some bask in the sun above the fog line. Ocean breezes cool the vineyards in the evening, but heat-tolerant varieties, such as Aglianico, Tempranillo, and Sangiovese, are delivering the best results in this first-generation AVA.

PRECEDING PAGES: Hillside vineyards at Rosenthal in Malibu's Newton Canyon, with the Pacific Ocean in view

LEFT: (clockwise from top left) Cypress trees line a vineyard in Temecula Valley; Malibu's Saddlerock Ranch; coastal fog cools Ponte Winery vines; Bernardo Winery vineyard in San Diego

FOLLOWING PAGES: Early spring at Ponte Winery in the heart of Temecula's wine country

PALUMBO FAMILY VINEYARDS

Before he was a vintner, Nick Palumbo was a chef, an experience he considers among his most pertinent winemaking credentials. "I make wine like I make *mole*," says Palumbo, proprietor with his wife, Cindy, of Palumbo Family Vineyards in Temecula. "I'm building layers of flavor. Most of my winemaking skills I attribute to cooking."

It was food that brought Palumbo back to Southern California, where he grew up, after several years of playing bass guitar in a band and touring college towns. Dissatisfied with that unsettled life, Palumbo enrolled in a culinary course in New York City. An internship led to a restaurant job, and another, and then, well before he felt ready, to the chef's post at a resort near Temecula.

In retrospect, Palumbo's mother had planted the seeds for this career change in childhood. "My mother was a Midwest farm girl and she never got that out of her blood," says Palumbo, who was raised in a San Diego suburb. "Other houses in our subdivision had lawns and swimming pools; we had a vegetable garden and chickens."

LIFE-CHANGING WHIM In 1998, commuting to his chef job, Palumbo pulled off the highway on a whim and discovered the Temecula

LEFT AND ABOVE: Nick Palumbo, chef-turned-vintner, enjoys the harvest from his Temecula garden. Palumbo often cooks for his family in an outdoor kitchen overlooking the vineyard.

Valley, a little-known, tucked-away, nascent wine region a mere hour from his home. Within six months, he lived there. Smitten with the scenic valley, he purchased a modest home on a crest with 7 acres (2.8 ha) of vineyards. "My mom was thrilled because now I was a farmer," recalls Palumbo.

Not exactly. A local winery had a contract for the grapes and did the farming, but that arrangement gave Palumbo the chance to observe and learn. He soon bought another 5 acres (2 ha) and began working in the tasting room and cellar at Cilurzo Winery. Owner Vincenzo Cilurzo was an early believer in Temecula Valley's potential and bought Palumbo's grapes for his own wines. In 2002, when Palumbo decided to launch a brand and needed cases to sell for quick income, he asked Cilurzo if he could buy some of his wine back.

"He said, here's some chalk and a thief; go pick out what you want," says Palumbo, who was astonished by that response. A thief is a device that draws a wine sample from a barrel; the chalk was for marking his barrel of choice. Cilurzo's willingness to part with the

best in his cellar reflects the generosity of the valley's wine community, says Palumbo. "That's the Temecula Valley spirit."

Nick and Cindy converted their garage into a rustic tasting room and tiny winery, using exotic hardwood salvaged from a fancy home renovation for the bar top and alder scraps from the nearby Fender guitar company for the base.

"I had no idea then what sustainability meant," admits Palumbo. Frugality spurred his repurposing, and a desire to improve grape quality prompted him to look more critically at his vineyard practices. Data from soil-moisture probes revealed that he was overwatering and allowed him to cut water use by half and reduce vine vigor.

The original owner had let the vines sprawl, common practice in those days.

Palumbo installed trellises and trained the vines upward and outward on wires, which improved airflow and lowered disease pressure. These steps helped bring the vines into better balance, yielding a smaller but higher-quality crop. "I saw that when I got the crop down, the pyrazines went away," says Palumbo, referring to the green-vegetable aromas that can plague some wines.

A self-described beach bum and goof-off in college, Palumbo became a relentless student of viticulture. And the more he learned, the more convinced he became of the promise of Temecula Valley. With proximity to millions of wine lovers in San Diego, Los Angeles, and Palm Springs, several area wineries had made hospitality a top priority. Palumbo set his sights on demonstrating the quality possible from this underappreciated appellation.

DOUBLE-COOLING EFFECT Surrounded by mountains, the Temecula Valley's vineyards occupy a sort of bowl, with the snow-capped San Jacinto and San Bernardino Mountains to the northeast, Mount Palomar with its famous observatory to the southeast, and foothills on the west providing a break for winds off the ocean. But in the afternoons, when the desert east of Temecula heats up, ocean air rushes through a gap in those western foothills and cools the grapes, preserving acidity. Cold air also flows down from the eastern mountains at night, providing a "double-cooling" effect. The dramatic granite outcroppings along the highway just south of Temecula are precursors of the decomposed granite soils that provide such good vineyard drainage.

Nick and Cindy have raised four children here, on the property that lured Nick decades ago, now landscaped with rosemary, olive trees, wisteria, and geraniums. Some wineries nearby offer more glamour, more polish, more amenities. But Palumbo's visitors get a glimpse of the rural lifestyle that the couple has chosen, a pace that allows Nick time to cook, to make sausage with the meat from pigs he has raised, and to go deep-sea fishing for fish that he turns into ceviche and *crudo*.

Winemaking, like cooking, requires impeccable ingredients and confidence in your own palate, says Palumbo. Lab results have to be heeded, he knows, but he's inclined to let taste guide him. That's a habit from his chef training, and he swears by it. Says Palumbo, "Any winemaker who's never spent time cooking is doing himself a disservice."

ABOVE: (clockwise from bottom left) Palumbo vineyards and cellar; Palumbo with son Dominick; vineyard tour; meal time for the family goat

SOUTHERN CALIFORNIA HARVEST

In the densely populated counties between Santa Barbara and the Mexican border, cities have largely claimed the valuable real estate along the coast. The farms lie inland, primarily in northern San Diego County, Riverside County, and Imperial County, unleashing their bounty when many of the nation's farms are under blankets of snow. Visit the colorful Santa Monica Farmers Market in winter to experience this cornucopia firsthand.

The persistently balmy weather in northern San Diego County and the Coachella Valley (Riverside County) all but guarantees abundant harvests of avocados, lemons, oranges, mandarins, grapefruits, kumquats, and dates. Vast greenhouses nurture culinary herbs and nursery seedlings; cut flowers for the florist trade are big business, too. Many coastal vegetable growers transition to the warm Imperial Valley to grow the lettuce, onions, broccoli, and spinach that keep America well fed in winter. From vegetables and melons alone, Imperial County farms generate a billion dollars in annual sales.

LEFT: (clockwise from top left) Lemon grove; blood oranges; mixed citrus; flower harvest at Resendiz Brothers; kumquats; lemon tree; ripening date clusters in protective sheaths before harvest

RECIPES

Mixed Citrus Salad with Fennel and Dates

Steamed Clams with Lemongrass, Coconut Milk, and Thai Basil

Dungeness Crab and Avocado Tostadas

Vietnamese Chicken Pho

Roast Chicken with Meyer Lemon and Smoked Paprika

CITRUS With more than 250,000 planted acres (101,200 ha), citrus is big business in California. Spanish missionaries introduced orange trees, but commercial production didn't blossom until the 1840s, with the first commercial planting in what is now downtown Los Angeles. Citrus acreage grew rapidly in Southern California—Orange County was so named for good reason—but with urbanization, production largely shifted to the San Joaquin Valley, especially for oranges and tangerines. Lemons, both Eureka and the sweeter Meyer, thrive in the cooler coastal areas from Santa Barbara to Riverside; grapefruits dominate in the desert areas of the Coachella and Imperial Valleys. Southern California specialty growers harvest kumquats, limes, blood oranges, and pomelos, but that acreage is comparatively minor.

Navel oranges far outnumber the juicing Valencia type in California orchards. For the most part, California's citrus crop is eaten fresh.

SEASONS AND VARIETIES: By shifting the growing areas, growers are able to harvest citrus almost year-round. Even so, winter and early spring are prime time.

Since the late 1990s, plantings of slip-skin mandarin oranges have increased tenfold in California. Consumers love these easy-peeling fruits, particularly the petite seedless varieties marketed as Cuties and Halos. Among the larger mandarin varieties, some of the best-tasting include Sumo, Page, Pixie, and Kishu. The coral-fleshed Cara Cara orange, also known as a pink navel, has become a favorite since its introduction in the late 1980s.

TIPS FOR USE: Petite seedless mandarins seem perfectly sized for children's lunch boxes. Meyer lemons, with their seductive orange-blossom scent, enhance custards and cakes and make fragrant lemonade. Pair blood oranges, Cara Cara navel oranges, and mellow pomelos with beets, avocados, fennel, and radicchio for winter salads. For a refreshing winter dessert, combine segments of mixed oranges with sliced dates in light sugar syrup. Kumquats require seeding, but they make wonderful marmalade.

DATES Date palms have thrived in California's arid Coachella Valley since the 1890s. With its triple-digit summer temperatures and measly rainfall—an annual average of only 3 inches (7.5 cm)—this irrigated desert is the only suitable site for dates in the state. The trees need water, but they hate being wet. To conserve water, growers have transitioned to drip irrigation for the thirsty palms, replacing the flood irrigation of times past.

Mature date palms can reach 75 feet (23 m), and most of the considerable work they require is done by hand. In January, workers must remove fearsome 5-inch (13 cm) thorns so they can maneuver safely within the trees during the season. Pollen has to be gathered from the male trees in late February and introduced to the female trees multiple times. Once the fruit sets in April and May, it has to be thinned. In early August, the heavy bunches of ripening fruit must be sheathed in muslin bags to protect them from birds and insects. In late August or September, workers will be hoisted on platforms to remove the bags, cut the enormous bunches free, and strip the dates.

The reward for all this labor is a harvest of exquisite fruit rightly dubbed "nature's candy." Dates can be 60 to 70 percent sugar, but they offer fiber, vitamins, and minerals along with the sugar, making them a wholesome dessert or snack.

VARIETIES: The principal date varieties grown in California are the Deglet Noor, a small date with amber, relatively dry flesh; the Medjool, a large, elongated type prized for its exceptionally moist, sweet, and creamy flesh; and the Barhi, a small, oval, soft-fleshed amber date. Farmers' markets are the best source for other varieties. In late summer, some growers bring fresh Barhi dates, still on the stem, to farmers' markets. They are crunchy and sweet, a novel taste experience.

STORAGE: Dates keep well at cool room temperature. For extended storage—four months or more—refrigerate or freeze them in airtight bags.

RIGHT: (clockwise from top left) Southern California oranges; fresh dates; Oasis Date Gardens, an organic Coachella Valley grower

HERBS Fresh culinary herbs, rich in aromatic oils, contribute vitality to dishes. A generation ago, America's supermarkets offered fresh parsley, cilantro, chives, and perhaps mint. Today, reflecting America's immigrant mix and our fascination with foods from afar, the fresh-herb display is likely to include Thai basil, dill, savory, sage, and tarragon. Ambitious merchants stock fresh kaffir lime leaves, curry leaves, lemon basil, chervil, and lovage, bringing new aromas into America's kitchens.

California herb growers often have operations in multiple locations to keep the harvest going year-round. The cool summers and moderate winters of coastal Monterey County are ideal for herb farming. In winter, some production moves into greenhouses or to the typically frost-free Coachella Valley.

Advances in packaging have helped bring fragile fresh herbs to consumers in pristine condition. By selling herbs with roots attached, California growers have also extended the postharvest life.

SELECTION AND STORAGE: Herbs should be perky, with no yellowing or signs of decay. If they are bunched with wire or rubber bands, remove the banding. For tender herbs such as parsley and cilantro, trim the stem ends and place the bundle in a glass partly filled with cool water, with no leaves submerged. Cover loosely with a plastic bag and secure to the glass with a rubber band. Refrigerate. They will stay fresh for several days. Basil is finicky, but one approach, often successful, is to treat it like flowers: trim the stems, stick the bunch in a glass of water with no leaves submerged, and leave at room temperature. Woody herbs like rosemary and sage can be stored in a sealed plastic bag in the refrigerator for about one week.

KITCHEN TIPS: Add chervil to egg salad or to a vinaigrette for asparagus or seafood. Add a few leaves of lemon basil to a favorite pesto recipe. Steam clams with curry leaves. Sturdy herbs like rosemary, sage, and savory don't bloom in fragrance until they are cooked.

THE HERBS ARE ALIVE

As every good cook knows, fresh herbs contribute alluring scent, flavor, and eye appeal to dishes. And they speak volumes about a recipe's origins, since most culinary cultures have a distinct herbal signature. Although California farms harvest fresh herbs year-round by moving their growing grounds, greenhouse-grown "living herbs" with roots attached have soared in popularity, thanks to their promise of extended shelf life.

North Shore Living Herbs, in California's Coachella Valley, helped pioneer this innovation in the mid-1990s. Founders Leo and Suzette Overgaag now operate 10 acres (4 ha) of hydroponic greenhouses that nurture staples like parsley and thyme, novelties like lime basil, and trendy microgreens. Some of the herbs are potted and can reside on a kitchen counter, ready for snipping. Others are tucked into a recyclable plastic clamshell— the company calls it a mini-greenhouse—where they remain perky in the refrigerator for days.

Solar panels supply much of the operation's power needs, and geothermal energy keeps the greenhouses warm. Every week, workers release beneficial insects, such as ladybugs, for natural pest control, eliminating the need for chemical pesticides. Overhead water that the herbs don't absorb is captured and reused. For these progressive practices and others, the company holds both organic and certified-sustainable status.

Photo courtesy North Shore Living Herbs

RESENDIZ BROTHERS
CUT FLOWERS

The flowers that captivated Mel Resendiz as a teenage immigrant from Mexico look like something a Disney animator would sketch: fantastic blooms with enormous spiky heads in lipstick pink and blazing orange. Some resemble giant apricot pincushions; others look like firecrackers exploding in the night sky or like fuzzy bottle brushes in the improbable hues of lime green and orange sherbet. Resendiz fell in love then and remains smitten with these showy starlets of nature, all members of the Proteaceae family and now the backbone of his cut-flower business.

Resendiz Brothers Protea Growers, in the aptly named town of Rainbow, an hour north of San Diego, ships its stunning blooms around the world, to Canada, South Korea, and Japan. Floral designers pay twelve dollars a stem and more for these limelight-stealing divas, which thrive on steep, scrubby, dry granitic hillsides. Avocados, citrus, and macadamia nuts can survive here with enough irrigation, but few other edible crops are possible. "We're taking scrub and turning it into a floral paradise," says Resendiz.

With a great deal of effort, it must be said. Tractors and other labor-saving farm equipment aren't practical on these pitched slopes, so Resendiz's crew must clear parcels by hand with machetes, shovels, and hoes.

(Terracing would waste too much plantable acreage, he believes.) Rattlesnakes lurk in the foliage, and irrigation lines must be checked constantly because coyotes chew through them. Harvesting and pruning require the agility of a mountain goat.

STUNNING BLOOMS FROM DESERT HILLS The astonishing beauty of what Resendiz coaxes from these hillsides is apparent in the packing shed, where masses of *Leucospermum, Leucadendron, Grevillea, Banksia,* and *Protea* varieties fill white plastic buckets. Workers carefully tuck the long-stemmed blooms into newspaper-lined boxes for trucking to San Francisco's wholesale flower market or airfreighting to New York and beyond.

Resendiz Brothers farms 300 acres (120 ha) in San Diego County, 250 acres (100 ha) of which are company owned—a success story that began in 1978 when seventeen-year-old Mel landed a job as a farmhand for a prominent protea grower. "I was making twenty dollars a

ABOVE AND RIGHT: Mel Resendiz and the Resendiz Brothers crew harvest a bounty of colorful blooms from the desert hills.

day, but I had a lot of energy, so that climbed to twenty-two," recalls Resendiz. "I was hired for a week, then a month, and I stayed twenty years."

Resendiz learned to grow the blooms from seed and from cuttings during his long stint at Zorro Protea Farms, and he rose to farm manager. With the help of a fellow protea enthusiast and local physician, Resendiz bought his first 10-acre (4 ha) parcel in Rainbow in 1995 and began clearing and planting it with his three brothers. Four years later, when Zorro folded, Resendiz launched his own venture.

STUNNING BOUQUETS, SUSTAINABLE METHODS

Today he employs twenty-five people year-round and is trying, unsuccessfully, to slow down. A small, sturdy man with a square face, a ruddy complexion, and a diamond-studded horseshoe ring on one finger, he can assemble a stunning 2-foot (60 cm) bouquet in two minutes. An industry leader—he has served, simultaneously, as president of the International Protea Association and the California Protea Association—he leaves the impression that no one around him is working quite as efficiently as he would like.

An early adopter of BloomCheck, a sustainable certification for California's cut-flower growers, Resendiz Brothers keeps a watchful eye on energy and water use. Certified growers must maintain detailed logs to verify that they aren't wasteful. Fortunately,

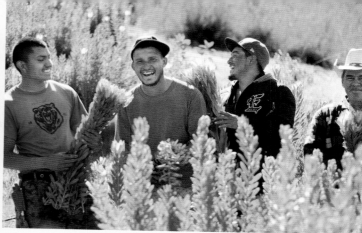

proteas don't ask for much. These rugged plants want little water and even less fertilizer. Ponds in the hills capture rain for irrigation, and any plant debris, including trimmings from the packing shed, becomes mulch that conserves soil moisture.

Diana Roy, a longtime employee and protea grower herself, has helped the company raise the profile of these theatrical blooms. Wedding designers are requesting them now, and the leading floral wire services are adding proteas to everyday bouquets. "With the Internet, it's much easier to share their beauty and build a following," says Roy. And as Mel Resendiz knows, most people who encounter these drama queens are going to be seduced.

ABOVE: (clockwise from top left) Orange banksia; leptospermum; desert hills of San Diego County yield prolific blooms for Resendiz Brothers; harvest crew; pink protea; star-shaped *Serruria florida*; spidery pink beauty; greenhouse seedling; field bouquet

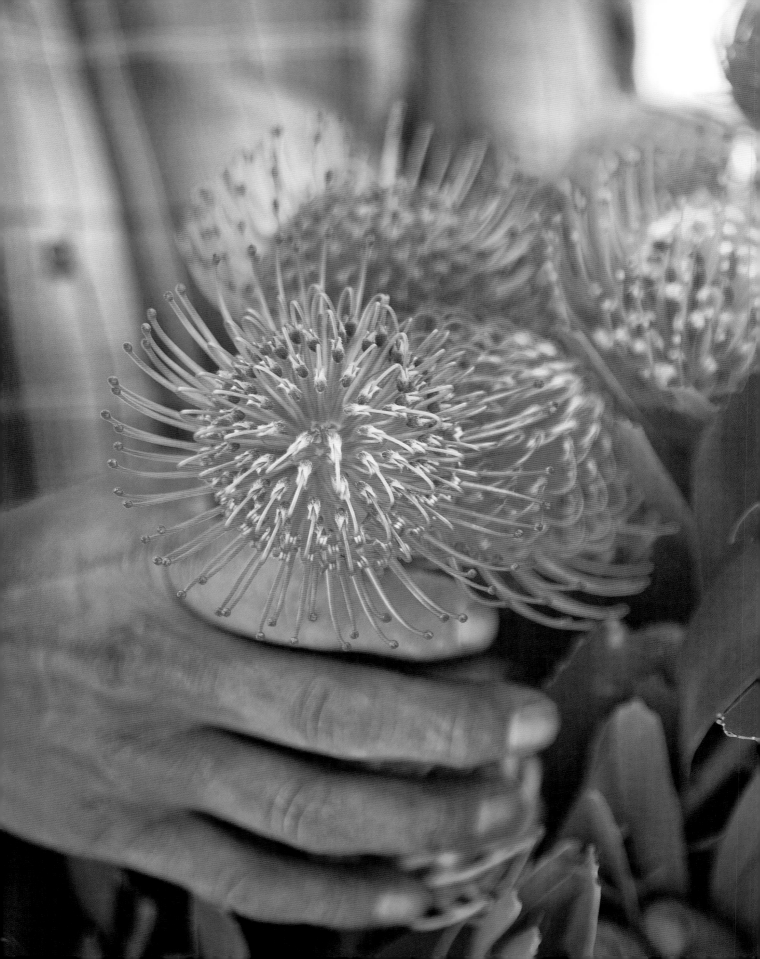

PROTEAS: LONG MAY THEY LIVE

Treated properly, cut flowers in the *Proteaceae* family should last at least two weeks in a vase. And to top that impressive endurance, they dry well. "We always say proteas don't die, they just dry," says Diana Roy, who handles marketing for Resendiz Brothers, leading protea growers in San Diego County.

Roy recommends treating a bouquet of proteas as you would other cut flowers. Fill a vase with water and add a splash of bleach or commercial flower preservative to keep the water from turning murky. Remove any leaves that are submerged. Slice about ½ inch (12 mm) from each flower stem, on a slant. Immediately place the stem in the water.

Proteas drink a lot, so check the water level in the vase daily. Reclip stems and change the water every other day to maximize their life. Keep them out of direct sunlight.

After you have enjoyed them for a couple of weeks as a fresh flower, you can dry them for longer keeping. Simply let the vase go dry or lift the stems out of the vase and hang them upside down to dry in a cool place away from direct sunlight.

Growing proteas commercially is laborious and physically demanding. To connect consumers with the farm families who grow America's flowers, Resendiz Brothers and similar growers occasionally host Farm to Vase Dinners for their community. Attendees feast alfresco surrounded by colorful blooms, learn a little about floral cultivation, and typically go home with a bouquet as well.

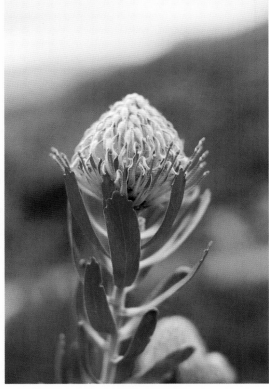

Photo by Carrie McCluskey, courtesy Resendiz Brothers

MIXED CITRUS SALAD
WITH FENNEL AND DATES

SERVES 4

This winter salad revives the palate with its startling contrasts: soft lettuces with crunchy fennel, tangy citrus with sugary dates, and a balanced olive oil dressing to link all the elements. Serve it before or after a substantial main course such as braised short ribs or lamb shanks.

WINE SUGGESTION: *California sparkling wine or Viognier*

1 large navel orange

1 large blood orange

1 small bulb fennel, halved

4 large Medjool dates, pitted and sliced lengthwise

¼ pound (125 g) mixed baby lettuces

3 tablespoons extra virgin olive oil

1½ teaspoons honey

Kosher or sea salt

Cut a slice off the top and bottom of each orange to expose the flesh. One at a time, stand each orange upright on a cutting board and, using a sharp knife and following the contour of the fruit, slice off the thick peel to reveal the flesh. Holding each peeled orange over a bowl, cut along both sides of each orange segment to free it from the membrane and let the segments drop into the bowl. Squeeze the emptied membranes of the oranges to release any juice and set aside 1 tablespoon juice for the dressing.

With a mandoline or other vegetable slicer, shave the fennel thinly crosswise, or slice as thinly as possible with a sharp knife. Put the fennel, dates, and lettuces in a large bowl.

In a small bowl, whisk together the olive oil, reserved 1 tablespoon orange juice, the honey, and a pinch of salt. Drain the orange segments of any accumulated juice (a few sips for the chef), then add the oranges to the large bowl. Add enough of the dressing to coat everything lightly and toss gently. You may not need all the dressing. Taste and adjust the seasoning before serving.

STEAMED CLAMS WITH LEMONGRASS, COCONUT MILK, AND THAI BASIL

SERVES 4 AS A MAIN COURSE OR 6 AS A FIRST COURSE

The Asian basil, fresh ginger, and lemongrass that make Thai food so seductive work their magic on these clams, but the typical chile heat is restrained to make the dish wine-friendly. The kaffir lime leaves aren't essential, but they will contribute a captivating tropical scent. Note that the lemongrass, halved chiles, and lime leaves aren't meant to be eaten; remove them before serving if you prefer or warn your guests not to eat them. Brands of coconut milk vary in thickness; use the reserved clam juices to adjust the thickness of the sauce to your taste. Serve this dish in small portions as a first course, or with rice or rice noodles as a main course.

WINE SUGGESTION: *California Riesling or Gewürztraminer*

1 cup (250 ml) water

4 pounds (2 kg) clams, well rinsed

12 cloves garlic, peeled

4 shallots, about 6 ounces (185 g) total, coarsely chopped

2-inch (5 cm) piece fresh ginger, peeled and thickly sliced

4 serrano chiles, 2 coarsely chopped, 2 halved lengthwise

2 lemongrass stalks

¼ cup (60 ml) peanut or canola oil

2 ½ cups (625 ml) coconut milk, whisked until smooth

½ cup (20 g) chopped fresh cilantro

4 fresh kaffir lime leaves (optional)

2 tablespoons Vietnamese fish sauce

2 large handfuls fresh Asian basil leaves

4 lime wedges

In a large pot, bring the water to a boil over high heat. Add the clams, cover, and cook just until they open, 2 to 3 minutes, shaking the pot once or twice to redistribute the clams. With tongs, transfer the opened clams to a large bowl; discard any clams that failed to open. Line a sieve with a damp paper towel and set it over a small bowl. Pour the clam juices through the paper towel to catch any grit. Reserve the juices.

In a food processor, combine the garlic, shallots, ginger, and chopped chiles and pulse until finely chopped.

Cut off the splayed, leafy tops of the lemongrass and the tough base. Remove an outer layer or two of the bulb-like stalks to reveal the pale, smooth interior. Cut the stalks into 2-inch (5 cm) lengths and smack them with the side of a cleaver or a rolling pin to bruise them and release more aroma.

Heat the oil in a large pot over medium heat. Add the contents of the food processor and the lemongrass and cook, stirring, for 2 to 3 minutes to release the fragrance. Add the coconut milk, halved chiles, cilantro, lime leaves (if using), fish sauce, and ½ cup (125 ml) of the reserved clam juices. Bring to a simmer and simmer for about 2 minutes to extract the flavor of the seasonings, thinning if desired with more clam juices. Add the clams, stir to coat with the sauce, and cook until they are hot throughout. Stir in the basil.

Serve immediately in bowls. Pass the lime wedges at the table.

DUNGENESS CRAB AND AVOCADO TOSTADAS

SERVES 4

Unlike the bean- and cheese-laden tostadas served in many restaurants, these are featherlight and heart-healthy. The salad-like topping helps stretch the costly crabmeat, and you'll save money by buying a cooked crab and extracting the meat yourself. Packaged tostada shells come in a variety of sizes; use any size you like.

WINE SUGGESTION: *California Chardonnay or Sauvignon Blanc*

²/₃ cup (130 g) **finely diced tomato**

¹/₃ cup (40 g) **finely minced green onion, white and pale green part only**

¼ cup (10 g) **chopped fresh cilantro, plus whole leaves for garnish**

1 clove garlic, **finely minced**

1 serrano chile, **finely minced**

2 large, **ripe avocados**

2 limes, **1 halved, 1 quartered**

Kosher or sea salt

8 corn tostada shells, **about 5 inches (13 cm) in diameter**

1 head pale, crisp romaine lettuce, **about 6 ounces (185 g), halved lengthwise, then very thinly sliced crosswise**

½ pound (250 g) **Dungeness crabmeat**

¹/₃ cup (75 g) **crema (Mexican-style sour cream)**

Mexican-style hot sauce or Tabasco sauce, for serving (optional)

In a large bowl, combine the tomato, green onion, chopped cilantro, garlic, and as much of the minced chile as you like. Halve and pit the avocados, then scoop the flesh from the skin and add to the bowl. Squeeze the juice of ½ lime over the avocado. Using a fork, mash the avocado coarsely, incorporating the other ingredients in the bowl as you work. Season with salt and add more juice from the other ½ lime as needed to achieve a guacamole with good flavor.

Top the tostada shells with the guacamole, dividing it evenly and spreading it to the edges. Top each tostada with the romaine and then with the crab, dividing them evenly. Drizzle each tostada with 2 teaspoons crema. Garnish with cilantro leaves and serve immediately with the lime wedges and with the hot sauce, if desired.

VIETNAMESE CHICKEN PHO

SERVES 6

Vietnamese immigrants introduced California to pho *(pronounced "fuh") in the 1980s, and the fragrant noodle soup has become a widespread favorite. Scented with star anise and fish sauce, the steaming broth isn't complete until diners add lime juice, chiles, and the herbs of their choice (see How to Eat Pho, page 336). Although beef* pho *is more common, chicken* pho *is equally irresistible and easier to make at home.*

Preparing pho *isn't difficult, but it does take time to produce the rich, aromatic broth that is its signature. If possible, make the broth a day ahead so you can chill it and remove any congealed fat. You will need deep 4-cup (1 l) bowls for each diner; look for them in Asian housewares shops. Pho should be served piping hot, so be sure to have all the finishing ingredients nearby before you cook the noodles.*

WINE RECOMMENDATION: *California Riesling or Gewürztraminer*

BROTH:

2 large yellow onions

4-inch (10 cm) piece fresh ginger, scrubbed but unpeeled

2 pounds (1 kg) meaty chicken bones, such as backs and necks

6 quarts (6 l) cold water

2 half chickens, about 3½ pounds (1.75 kg) total

1 whole star anise

1 tablespoon sugar

Kosher or sea salt

2 tablespoons Vietnamese fish sauce, or more to taste

1 pound (500 g) dried rice-stick noodles (rice vermicelli), about 1/16 inch (2 mm) wide

1 cup (120 g) thinly sliced shallots

¼ cup (60 ml) canola oil

6 tablespoons (15 g) coarsely chopped fresh cilantro, plus ½ bunch sprigs

6 fresh Thai basil sprigs

¾ pound (375 g) bean sprouts

3 limes, quartered

3 jalapeño chiles, sliced

3 green onions, white and pale green part only, thinly sliced

Sriracha sauce, for serving

Hoisin sauce, for serving

Make the broth: Preheat the oven to 500°F (260°C). Line a rimmed baking sheet with aluminum foil. Cut 1½ of the onions into slices about ½ inch (12 mm) thick. Arrange the onion and ginger in a single layer on the baking sheet. Roast until the onions are lightly charred on the bottom, about 20 minutes. Lift them off the foil with a spatula and set aside, then return the baking sheet to the oven and continue roasting the ginger until it has softened slightly and is lightly charred, about 10 minutes longer. Set the ginger aside with the onions.

Rinse the chicken bones well, removing any excess fat and the two reddish kidneys on either side of the backbone. Put the bones in a stockpot, add 2 quarts (2 l) of the water, and bring to a simmer over high heat. Immediately drain into a sieve and rinse the bones with cold running water. Rinse the pot. (You don't need to scrub it.) Return the bones to the pot and add the chicken halves, charred onions and ginger (the ginger broken in half), star anise, sugar, 2 tablespoons salt, and the remaining 4 quarts (4 l) water. Bring to a simmer over medium heat, skimming off any surface foam. Adjust the heat to maintain a gentle simmer and cook for 25 minutes.

Prepare a large bowl of ice water. With tongs, transfer the chicken halves to the ice water to chill quickly and firm the meat. When cool enough to handle, lift them out of the ice water. Discard the skin. Separate the thigh-drumstick sections from the half breasts. Refrigerate the thigh-drumstick sections for another use, such as chicken salad. Separate the wings from the breasts and add the wings to the stockpot. Lift the breast meat off the bones, keeping each half breast intact. Add the bones to the stockpot. Refrigerate the breast meat.

(continued next page)

VIETNAMESE CHICKEN PHO *(continued)*

Gently simmer the broth for 2 hours longer, then strain through a fine-mesh sieve. If time allows, chill the broth overnight so you can lift off and discard any congealed surface fat. Alternatively, let the broth rest at room temperature for 1 hour, then skim off as much of the surface fat as possible. Stir in the fish sauce, then taste the broth and add more if needed. Finally, taste and adjust with salt if needed.

In a large bowl, soak the noodles in hot water to cover for 30 minutes, tossing them occasionally to separate them.

Thinly slice the remaining ½ yellow onion. Transfer to a small bowl, add cold water to cover, and soak for 30 minutes to mellow the flavor. Drain and set aside.

Bring the chicken breasts to room temperature, then slice across the grain ⅓ to ½ inch (9 to 12 mm) thick. Set aside.

Spread the shallot slices on paper towels. Separate the slices into rings and pat thoroughly dry. Heat a 10-inch (25 cm) frying pan over medium-low heat and add the canola oil. When the oil is hot, add the shallots and cook, stirring often, until they turn a rich golden brown, about 12 minutes. During the final few minutes, stir the shallots almost constantly so they brown evenly. Drain them in a small sieve set over a small heatproof

bowl, then spread them out on a double thickness of paper towels to cool and crisp. Save the flavorful shallot oil for other uses.

On a large platter, in separate mounds, arrange the cilantro sprigs, basil sprigs, bean sprouts, lime wedges, and chiles.

For cooking the noodles, bring a large pot of salted water to a boil over high heat. You will need a long-handled sieve that fits inside the pot and is large enough to hold two portions of noodles (one-third of the total) at a time.

While the water heats, bring 3 quarts (3 l) of the defatted broth to a simmer in another pot and keep hot. (Use any remaining broth over the next 2 or 3 days or freeze for longer keeping.)

Preheat six large, deep soup bowls with boiling water, then drain. Drain the rice noodles. Working with two portions of noodles at a time, put them in the sieve and lower the sieve into the boiling water. Cook, separating the noodles with chopsticks, until they are al dente. Begin checking 30 seconds after the water returns to a boil. Lift them out of the boiling water and divide between two of the bowls. Repeat with the remaining noodles in two batches.

Working quickly, divide the sliced chicken among the bowls. Ladle 2 cups (500 ml) simmering broth into each bowl. Top each portion with green onions, chopped cilantro, sliced yellow onion, and fried shallots, dividing them evenly. Serve immediately with the platter of garnishes, Sriracha sauce, and hoisin sauce. Provide small dipping saucers for mixing the sauces.

RIGHT: Fragrant Thai basil, an essential garnish for *pho*

HOW TO EAT PHO

Each bowl of *pho* is unique because each diner finishes it to his or her taste. Before the soup arrives at the table, prepare your personal dipping sauce by combining Sriracha sauce and hoisin sauce to taste in a dipping saucer. (Start with equal parts, mix, taste with the end of your chopstick, then adjust.) As soon as a bowl of *pho* is set before you, add a generous squeeze of lime and, if you like spicy food, a slice or two of jalapeño. Add bean sprouts, cilantro, and basil a little at a time so they don't overcook. Hold the chopsticks in your dominant hand and a soup spoon in the other. Use chopsticks to dip chicken into the spicy Sriracha-hoisin mixture and to lift the slippery noodles from the broth; it's okay to slurp them. Alternate with sips of broth from the spoon. *Pho* enthusiasts consume the dish quickly, before the noodles cool off.

ROAST CHICKEN WITH MEYER LEMON AND SMOKED PAPRIKA

SERVES 4

Spain's aromatic pimentón de la Vera *(smoked paprika) gives these succulent chicken thighs a deep, ruddy color as they roast on a bed of red onion and sliced Meyer lemon. You'll want to serve every drop of the lemony, garlicky pan juices. The lemon slices can be eaten or not, as you prefer.*

WINE SUGGESTION: *California Cabernet Sauvignon or Merlot*

4 bone-in, skin-on chicken thighs, about 1½ pounds (750 g) total
1 tablespoon extra virgin olive oil

SPICE RUB:

1½ teaspoons kosher or sea salt
1½ teaspoons dried oregano, crumbled
1½ teaspoons garlic powder
1½ teaspoons pimentón de la Vera (Spanish smoked paprika)

1 Meyer lemon, ends removed, then thinly sliced
1 small red onion, halved and thinly sliced from stem to root
24 green olives (optional)

Coat the chicken thighs all over with the olive oil. In a small bowl, combine all the rub ingredients, mixing well. Sprinkle on both sides of the chicken. Set the seasoned thighs on a rack over a plate or tray and refrigerate, uncovered, for 8 to 24 hours. Remove from the refrigerator 30 minutes before roasting.

Position a rack in the upper third of the oven and preheat the oven to 425°F (220°C). Choose a shallow baking dish just large enough to hold the thighs in a single layer without touching. Put the lemon and onion slices in the baking dish and toss them together. Remake them into a flat bed and set the thighs directly on top.

Roast the chicken for 20 minutes, then baste with the pan juices. Continue roasting until the chicken skin is well browned and crisp and the onions and lemons are just beginning to caramelize, about 20 minutes longer. Add the green olives, if using, about 10 minutes before the chicken is done.

Let the chicken rest for 15 minutes before serving to allow the juices to settle.

FOLLOWING PAGES: Lemon grove; daughters of avocado and citrus growers Robert and Tessa Abbott of Hilltop & Canyon Farms

ACKNOWLEDGMENTS

We're fortunate that our work takes us to the many breathtaking regions of the state where wine and food grow so prolifically, and we find ourselves falling in love with California again and again. We've had the chance to get to know the people—wine-grape growers, vintners, and farmers—who are passionate, innovative, and environmentally and socially responsible while producing a bounty of mouthwatering fruits, vegetables, nuts, wines, and more. *Wine Country Table* is intended to give you a taste, figuratively and literally, of what it means to be "California Grown," an approach to eating and drinking that gives the same consideration to who produced the food and how it was made as it does to flavor.

We are grateful to the exceptional team who helped make this book a reality: award-winning author and journalist Janet Fletcher, for so artfully bringing the stories of California winegrowers and farmers and their sustainable practices to life, then creating recipes that showcase their crops and wines; photographers Robert Holmes and Sara Remington, for their talent at capturing stunning images of farms, wineries, food, and wine; and designer Jenny Barry of Jennifer Barry Design, for designing and producing a truly sumptuous book, keeping us on track, and making the project so gratifying.

We are also indebted to the vintners and farmers for their gracious hospitality, for sharing their stories, and for allowing their vineyards, wineries, and farms—and themselves and their families—to be photographed. They represent just a sampling of the thousands of California agricultural operations that are implementing sustainable practices every day and have a deep and active commitment to their land and community.

Bobby Koch, president and chief executive officer of Wine Institute; the Board of Directors of Wine Institute; and the executives and board members of the California Association of Winegrape Growers, the California Sustainable Winegrowing Alliance, and numerous regional grower and winery associations deserve recognition for their leadership and dedication of resources to sustainable winegrowing throughout the state.

We particularly thank the California Department of Food and Agriculture (CDFA) for the 2016 Specialty Crop Block Grant that partially funded this book. CDFA Secretary Karen Ross has been a fierce advocate for California agriculture and its use of sustainable practices, and we are grateful for her leadership. California Grown, focused on connecting Californians with the people who grow and produce their food, and its member organizations, California Asparagus Commission, California Cherry Board, California Cut Flower Commission, California Dried Plum Board, California Fig Advisory Board, California Pear Advisory Board, and California Olive Oil Council, were very helpful in identifying featured farmers. Visit California is also an important partner, enticing visitors from around the globe to enjoy the state's world-class food and wine.

Together, these individuals and organizations planted and then nurtured the land, plants, trees, vines, wines, and ideas that have grown into the statewide sustainable culinary movement that is the basis for this book. With it, we invite you to enjoy a slice of the Golden State wherever you are—along with one of the delicious recipes in these pages and a glass of your favorite California wine!

—Nancy Light, Vice President, Communications, Wine Institute
—Allison Jordan, Vice President, Environmental Affairs, Wine Institute

I would like to express my deep gratitude to Wine Institute for providing me the opportunity to write about California farmers and vintners, whose beautiful products enrich my life every day. A sincere thank you to all those who welcomed me onto their farms and into their wineries to share their stories. Photographers Robert Holmes and Sara Remington brought my text and recipes to life with their stunning images, and copy editor Sharon Silva helped me polish my prose. I would like to acknowledge the recipe assistance I received from friends and colleagues Janice Beaman, Pam Elder, Mari Havens, and Julie Logue-Riordan. Above all, I want to thank designer and project manager Jenny Barry, who held this complex endeavor together.

—Janet Fletcher

RECIPE INDEX BY CATEGORY

INDEX

Pappardelle with Walnut-Kale
Pesto, 112
Paradise Valley Produce, 65
Parsnips, Braised Pork Shoulder
with Apples, Carrots, and, 75
Paso Robles, 157, 211, 212, 237,
239, 259
Passalacqua, Tegan, 89, 90, 93
pasta and noodles
Chinese Chicken Soup with Egg
Noodles, Baby Bok Choy, and
Pea Shoots, 184–85
Lamb Meatballs with Artichokes
and Olives, 293–94
Pappardelle with Walnut-Kale
Pesto, 112
Ramen with Asparagus, Shiitake,
and Edamame, 189
Vietnamese Chicken Pho, 334–37
peaches, 96
Peach and Rhubarb Jam, 108
pears, 62, 66, 68–69
Mixed Chicory Salad with Red
Pears and Blue Cheese, 71
Zinfandel-Poached Pears with
Mascarpone Cream, 76
pea shoots and sprouts, 185
Chinese Chicken Soup with Egg
Noodles, Baby Bok Choy, and
Pea Shoots, 184–85
persimmons, 149
Arugula, Fennel, and Persimmon
Salad, 178
Breakfast Bruschetta, 174
pesto
Arugula Pesto, 285–86
Walnut-Kale Pesto, 112
Petite Sirah, 216–17, 219
Pho, Vietnamese Chicken, 334–37
Pinot Blanc, 30
Pinot Gris, 30
Pinot Noir, 21, 23, 30, 58, 211, 252
pistachios, 151
Walnut and Green Olive Dip with
Pomegranates and Pistachios, 111
Pizza with Artichokes and Arugula
Pesto, 285–86
Placer County, 84, 87
Placerville, 95

plums, dried, 96, 101–3
Dried Plum–Buttermilk
Smoothie, 107
Red Wine–Braised Duck Legs with
Dried Plums, 115
Polenta with Slow-Roasted
Tomatoes and Teleme Cheese, 190
pomegranates, 149
Golden Beet, Pomegranate, and
Feta Salad, 183
Grilled Lamb Shoulder Chops with
Pomegranate Marinade, 194
Walnut and Green Olive Dip with
Pomegranates and Pistachios, 111
Ponte, Claudio, 304
Ponte Winery, 304, 309
pork
Braised Pork Shoulder with Apples,
Carrots, and Parsnips, 75
Grilled Pork Loin, Sausage, and
Fig Skewers, 195
Risotto with Radicchio and
Pancetta, 287
potatoes
Gilroy Garlic and Potato Soup, 282
Potato Focaccia with Olives and
Rosemary, 177
Warm Salmon Salad with
Asparagus, Farm Eggs, and
Fingerling Potatoes, 180
proteas, 322–27
Pyle-Lucas, Heather, 127, 136–39

Q

Qupé, 250

R

radicchio, 169, 265
Golden Beet, Pomegranate, and
Feta Salad, 183
Little Gem Lettuces with Olive
Oil–Poached Tuna, 72
Mixed Chicory Salad with Red
Pears and Blue Cheese, 71
Risotto with Radicchio and
Pancetta, 287
radishes
Spring Vegetable Tabbouli with
Fava Beans, Radishes, and
Spring Herbs, 281

Warm Salmon Salad with
Asparagus, Farm Eggs, and
Fingerling Potatoes, 180
Rainbow, 322, 324
Ramen with Asparagus, Shiitake,
and Edamame, 189
Ramona Ranch, 304
Ramona Valley, 309
raspberries
Farmers' Market Berries with
Late-Harvest Wine Sabayon, 301
Nectarines in Raspberry Wine
Sauce with Toasted Almond and
Anise Biscotti, 119–20
Resendiz, Mel, 322, 324, 325
Resendiz Brothers, 317, 322–25, 327
Rhubarb and Peach Jam, 108
Ricchiuti, Vincent, 151, 162, 164–65
rice
Risotto with Radicchio and
Pancetta, 287
Ridge Vineyards, 208, 211,
222–25, 227
Riesling, 21, 30
Riverside County, 317
Robert Mondavi Winery, 137
Robertson, Sandy, 35
Rochioli, 23
rosé, 247
Roussanne, 309
Roy, Diana, 325, 327
Russian River, 17, 21, 23
Russian River Valley, 21, 23

S

Sacramento County, 95
Sacramento River, 62, 129, 174
Sacramento Valley, 96, 123–24, 127,
141, 146, 148, 167, 174
Saddlerock Ranch, 304, 309
Salinas Valley, 208, 211, 231, 234,
259, 262
salmon, 180
Warm Salmon Salad with
Asparagus, Farm Eggs, and
Fingerling Potatoes, 180
Salsa Verde, Green-Olive, 193
San Benito County, 211

FOLLOWING PAGE: Old Zinfandel vine up close